D1478658

HISTORIC COSTUME
FOR THE STAGE

CONTENTS

ILLUSTRATIONS

HISTORIC COSTUME
FOR THE STAGE

by
LUCY BARTON

ILLUSTRATED BY
DAVID SARVIS

BOSTON
WALTER H. BAKER COMPANY

To
FRITZ

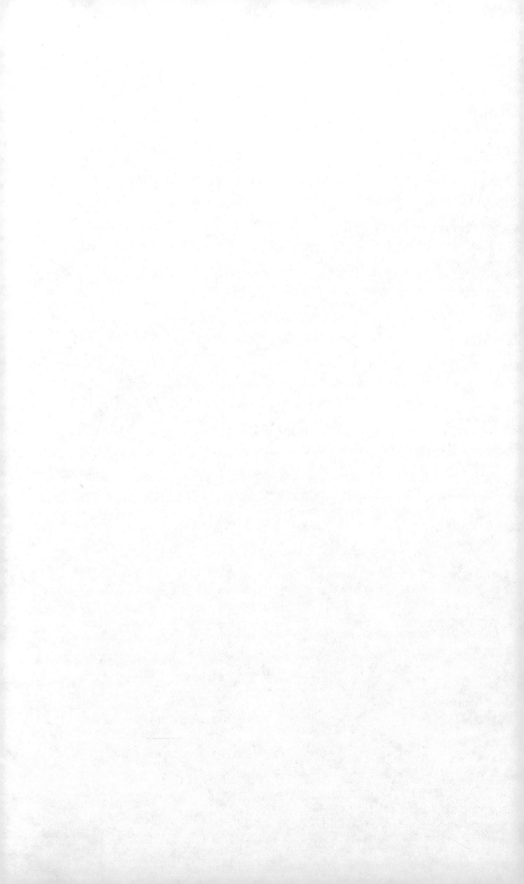

FOREWORD

I⊤ is not sufficiently realized that costume is not accidental and arbitrary but is founded upon a definite and psychological basis. Costume, in short, is the outward and visible sign of the inner spirit which informs any given period and nationality. The comparative uniformity of dress adopted by all peoples who have come under the influence of modern industrialism is a case in point.

For this reason it is impertinent, and generally disastrous, for the designer of costumes for an historical play to utilize a superficial knowledge of the dressing of the period involved as an excuse for exercising his inventive faculties by the imposition of his own fanciful notions in embellishments and exaggerations. This book should help to correct this attitude. It is, I believe, unique in its scope. It is founded not only on research but experience, and so is eminently practical. The admirably concise yet comprehensive sketches of the historical background of each period, which precede each chapter, together with the precise descriptions of the garments and the manner in which they were put together and actually worn should, with the assistance of the adroit illustrations, make it possible for any designer who can supply the necessary color sense to provide costumes for an historical play which will be true and satisfying. The reward is certain for there is no field in which correctness is more gratifying not only to the informed but, howbeit unconsciously, to the average spectator.

Whilst this book will probably prove most valuable in schools and colleges where interest in the drama extends, as it should do, to the performance of plays of historical import, and to those who are engaged in producing pageants, it can be studied with profit by the professional costumier who takes his calling seriously. That there are those who do not is the deplorable fact. " Historic Costume for the Stage " should help to rectify it.

B. IDEN PAYNE.

Stratford-upon-Avon.

PREFACE

D URING the years since 1935 when this book was first published the text has been gone over and added to here and there: footnotes, a supplement to the chapter on construction, and an extra page of bibliography. Now, in this newest printing, a further addition has been made to the construction chapter (pp. 589–590) to call the reader's attention to recent useful publications in the field of costume. This edition also allows space in this new preface to emphasize the contribution of costume to the total production of a play and to consider the " why " of period costume for period plays.

Such an apologia is timely, for nowadays the strictly archaeological approach to stage costuming is often belittled. " Mere slavish concern with accuracy." The air is full of such exclamations of impatience with the " scholarly " but " untheatrical " approach that stifles imagination, trammels the free flight of invention, and bores the audience with unfamiliar and irrelevant details. When historically accurate costumes are also stodgy and meaningless (as indeed they sometimes are) they had better be rejected. Literal copying is not *per se* theatrical truth. That a costume is a faithful copy of the beautiful dress worn by Mme. de Pompadour in Boucher's portrait does not necessarily make it right in some eighteenth century play. Erudition alone has no theatrical significance.

But scholarship can and should serve the artistic needs of the theatre, it should lead to a familiarity with the past and its men and women in their habits as they lived. Such an understanding of social history is a help rather than a hindrance to the creative artist whose business with a play is to contribute to characterization through costume—what the actors wear. If a play is concerned with a special moment in the past, it will partake of that moment's flavor, which will find expression not only in the spoken words, but also in movement, gesture, and dress. For this reason the unity of such a play is best served by a dècor in harmony with the time-spirit.

Admittedly, not all workers in the modern theatre agree. Many feel that a fresh and significant approach to the classics is better achieved by turning them out in modern dress, in clothes of a period other than their own, or in completely fanciful costumes. The timeless essence of *Hamlet* survives almost any interpretation in terms of acting styles and décor; even lesser dramas may be excitingly produced in unexpected costumings. Be that as it may, this book is concerned only with helping the costumer who, once it has been determined that a play is to be set in a recognizable past time, wants to be shown how to dress it.

In the following pages the director and the costumer will find information about what people in a given time were likely to be wearing, and advice on making garments that will resemble these originals. The business of a costume history is to instruct its readers in what people wore—kings and common folk, priests and soldiers, scholars and children. What cannot be set down specifically in such a book is how to dress the individual characters in a given play so that their appearance will conform not only to the story the play unfolds but also to the individualized personalities the playwright has invented. In other words historians discuss known facts of the past; the theatre presents living people—people, moreover, who must be made quickly understandable to an audience; men and women whose appearance must reflect their characters as revealed in word and action.

Consequently the stage costume designer must first know the range of garments out of which he is to make his choice; then he must imagine each individual character in a special version of those clothes. (This process must be followed for every play, whether the central figure be Julius Caesar or Fiorello LaGuardia.) Naturally the greater the designer's familiarity with history, the more quickly he goes through the stage of "research" and into that of imagining for this play of an earlier time who would wear what when.

This book offers its readers an open door to the past; once through that door the designer is on his own. No author, however familiar with historic periods, should presume to tell him how to dress the characters in a given play. That problem is his business. But his solution will depend on many factors which taken together make every production different.

First and foremost is the director's interpretation of the play and how he wants it to look; next, the physical peculiarities of the actors who are to play the parts and wear the costumes. Once familiar with the period and the customs governing dress for different categories of people, the designer may move freely, choosing line, color, and fabric for their appropriateness to the character and becomingness to the actor. All this is easy enough if he will remind himself of what is all too often ignored—that the past was as full of individuals as the present. Nobody, not even a servant in livery, looked exactly like anyone else. Then as now, clothes were made to be worn and would not have been worn if they had not been suited to the wearer's activities. Even in periods of fashions that seem to modern eyes most impractical, the garments were actually "functional," since they filled the purpose for which they were intended.

Next, the costumer must be prepared to find that his actors too are individuals and will not necessarily look well in just any costume he might design for the character. In addition to dressing King John appropriately to his station and personality, the designer must plan clothes for John Doe the actor so that he will give audiences the illusion that he is King John. It is not obligatory to copy a portrait of the historical king, even if one is available (though it *is* important to provide the right sort of crown, since crowns change

from century to century). Probably the actor will not resemble the original anyway. And why should he? This is a drama, not a "documentary." In summary, the more a theatre worker knows of the historic past, the more freedom will he have in planning costumes for the stage, since he may then confidently design clothes to fit the time-spirit, the character, and the actor.

Drama students and beginning designers often ignore the fact that in the past as in the present clothes were made to be worn and soon took on with wearing something of the personality of the wearer. They adjusted themselves or were adjusted to function comfortably. It can be assumed that nobody would wear things in which he or she could not carry on the business of living. The procedure then is not to reject the strange garment as hampering and "unwearable," but rather to find out how the wearers managed it in its day and follow their example. No actor needs to be inhibited in gesture or movement by his clothes, provided he will adjust to the limitations that in their day wearers of such clothes accepted.

Take as an example the long, long skirts that ladies in the fifteenth century thought so essential as symbols of prestige. The modern young actress, jumped suddenly from her knee-length dress or her pants into such a skirt finds it, at first, impossible to act in. She cannot " express herself." But given a mock-up of the skirt similar in bulk to the eventual costume, shown how to use it, she will presently find that she is better able to express, not herself, but Lady Percy or the Princess Katherine of France.

Consider the perhaps more familiar costume of a mid-nineteenth century lady which will hamper the actress in various ways. The drop-shoulder bodice restricts her gestures to those originating close to the body and raised not much higher than the elbow. If properly costumed, she is corseted so that her torso is rigid. She carries around a little tent of a hoop-skirt. Inside the tent her legs are free, but if she steps out in a modern stride she will trip.

Given the hoop to walk in at rehearsals, she will learn that only small steps are safe. When she walks thus, feet not much raised from the floor, her progress becomes a glide in which the gentle swaying of the tent enhances the effect of what was in her time described as a " swimming gait." Together the limitations imposed by the costume lend an actress who adapts to them a ready-made visual interpretation of the ideal mid-century lady. In such examples may be read the strongest arguments for the intelligent use of period costume.

Unsophisticated reporters of a college production are prone to write admiringly that the costumes and props were "authentic in every detail." If authenticity was the sole aim in the designing, a fig for authenticity! Only if an authentic detail expresses something that needs expressing (or if an inaccuracy shatters the illusion that is the theatre-goer's right) does authenticity become of prime importance. A quizzing-glass identifies the Regency dandy, a monocle the swell of the 1890s; the ritual of snuff-taking belongs to a Georgian gentleman, the business of cigarette-lighting to the modern man or woman. However

important the contribution of an individual item, it is nevertheless the eloquent ensemble speaking to an audience of time and place and mood that creates theatrical truth.

So much for the "why" of period costume.

HISTORIC COSTUME FOR THE STAGE was written in response to the plea of my students at the University of Iowa for a book like my lectures, expanded. Its scope and aim were described in the preface thus:

The information in the following pages does not differ markedly from that set forth in trustworthy predecessors; but it has been corroborated by independent study of source materials. Of necessity a book which undertakes to survey for theatre use the dress of Occidental civilization, with a glance at its origins in Egypt and Mesopotamia, will be too superficial to satisfy specialists of any one period. Those students who wish to go deeper will find at the end of each chapter suggestions for additional reading; those who prefer to study only source material as illustrations may seek it in the books and pictures listed. Our sketches are made from such sources and the illustrator has been at particular pains to draw typical people, standing in attitudes fashionable at the period, engaged in popular occupations, and sometimes accompanied by appropriate pets.

Each chapter follows in so far as possible the same outline and each is an independent unit except for its occasional references to illustrations in another chapter. If the reader cannot at the moment stop to consider the historical background, he may ignore it; if he wants to know how people looked and what they were thinking about but doesn't care to learn how to imitate their raiment, he may leave off before the "practical reproduction" paragraphs; if he is actually costuming or directing a play he will profit by reading the whole chapter.

While the book was in manuscript, many accommodating friends listened to one chapter or another and made valuable suggestions; some lent old illustrated books, old magazines, pictures, and dresses; to all I am most grateful. Thanks are particularly due to Dr. Eunice Rathbone Goddard, who, as an authority on French costume of the eleventh and twelfth centuries, gave advice on Chapter V. But the burden of reading each chapter patiently, of checking facts and weighing phrases, from their two widely different points of view, was borne by my friends Ruth Linda Allen and Harold Geoghegan. Theirs is a service for which a mere thankful acknowledgment is quite inadequate.

White Plains, New York, *University of Texas,*
September, 1935. *January, 1961.*

Chapter I

EGYPTIAN

APPROXIMATE DATES:

4000 B. C.–30 B. C.

Some Important Names

The Pharaoh of Abraham (" Pharaoh " was the title of the Egyptian ruler, as " Cæsar " of the Roman Emperor).

The Pharaoh of Joseph.

Joseph himself, as revealed in the story in Genesis.

Amenhotep III, the great man of the " Empire " p e r i o d, during whose reign architecture and other arts especially flourished.

The Empire includes the XVIII–XX dynasties (from 1580–1090 * B. C.) ; it is for us the most important period, because it affords the greatest variety of costume representations for reproduction, and because it is the period of most of our dramas.

Amenhotep IV (Aknaton, "the Heretic ").

Tutankhamen, the discovery of whose tomb in 1923 revealed a great store of art objects.

The Pharaoh of Moses: Rameses II or another Pharaoh of the XIX dynasty.

Moses himself, as revealed in Exodus.

Cleopatra, whose period is the first century B. C., contemporaneous with some of the greatest characters in Roman history. Egypt was no longer independent, having been ruled successively by Babylonia, Persia, and Macedonia, and being now in the power of Rome. Culturally, Egypt was dominated by Greece, and Cleopatra herself was partly Greek.

A Few Plays to Be Costumed in This Style

All the Biblical dramas (religious or otherwise) which deal with Abraham, Joseph, or Moses.

Lord Dunsany's " The Queen's Enemies."

Shaw's " Cæsar and Cleopatra."

Shakspere's " Antony and Cleopatra."

The Cleopatra plays introduce many characters dressed in Roman costume (Chap. IV). Much latitude may be allowed in the costuming of Cleopatra herself, who might well wear Greek or Roman garments if it were not that the Egyptian elements are more picturesque. It must be remembered, too, that she laid stress on her descent from the Pharaohs and therefore from the gods, and exercised her right to wear the traditional headdresses of the god-kings.

* All dates mentioned in this text conform to those in New Century Cyclopedia of Names, edited by Charles N. Barnhart, Appleton-Century-Crofts, Inc., 1954.

EGYPTIAN

CONCERNING THE EGYPTIANS

YEAR by year archæologists push further into the past and reveal to us long-vanished peoples; some day we may talk familiarly of costumes worn by folk who died before the Egyptians had a civilization. At present, however, most of us, and especially those who dress plays, will begin our consideration of historic costume in Egypt.

While the Egyptian civilization developed and decayed, that of other ancient nations also flourished: the Chaldean, the Assyrian and Babylonian, the Cretan, and the Persian, all influencing and influenced by Egyptian culture. It will be remembered that the patriarch Abraham set forth from Ur of the Chaldees and that his story in Genesis includes a Pharaoh; and that the history of the Ægeans is partly legend, like the stories of Minos with his labyrinth and his monstrous Minotaur, of Trojan Priam, Hector, Cassandra, and Paris who stole immortal Helen. When the Golden Age of Greece arrived, Egypt was already spent, but her art and her learning colored Greek development. Indirectly, through Greece and Rome, Egypt affected the art of Western Europe and therefore its dress, which is the province of this book. From time to time, also, the influence has been direct as, for instance, when Napoleon's Egyptian campaign inspired the cabinetmakers who were producing that style of furniture which we call " Empire." Again, in our own time the spectacular discoveries at the tomb of Tutankhamen and elsewhere turned the minds of dress-designers toward Egypt; we had textiles and costume jewelry decorated with the lotus, the scarab, the winged disk; and our clinging, hip-girded gowns made us of an evening into pseudo-Cleopatras.

The actual relics of Egyptian life in 1500 B. C. are more numerous than those of Western European life in 600 A. D. The reason is twofold: a strong belief in the continuity of life after death impelled the Egyptians to build burial-places that would endure; a favorable climate preserved those burial-places. Skilfully mummified kings and nobles have rested all these ages in their tombs surrounded by effigies of their retainers, their robes, their jewels, and the paraphernalia of their daily lives; now they are in museums, transported there willy-nilly for our instruction. From them, as well as from the wall-paintings, pictures on papyri, relief sculpture, and portrait statues, we may learn what manner of people the Egyptians were. Briefly, Egyptian civilization in the period of the Empire and later was highly developed and sophisticated,

3

with a learned, artistic, and refined upper class supported by the labor of slaves. The religion of the Egyptians inspired much of their art: poetry, sculpture, painting, and especially architecture. Huge and awe-inspiring remains of temples and tombs attest their skill.

The paintings on walls and papyri, among our chief sources of costume information, are executed in a very unrealistic style, not, we are told, because technical limitations forbade realism, but because this convention was preferred. Imagination is needed, therefore, to reconstruct pictured garments so that they will fit real people and yet preserve the essential characteristics of the originals. Such imagination we have brought to our sketches, made after experimentation with the draperies depicted and described. For a more complete understanding of how Egyptian garments should look on their wearers it is well to consider three factors: the climate in which they were worn, the materials of which they were made, and their predominating colors.

Climate. Egypt is dry, sunny, and usually warm. Therefore, even in the complex civilization of the later centuries, a semi-nudity prevailed for slaves of both sexes and for upper-class persons engaged in active pursuits.

Materials. The usual material for garments of all classes was linen. Animal skins were occasionally employed as cloaks, but more often as couch covers; dressed leather was made into protective body-covering for warriors. After the first century B. C. both wool and the rarer silk were doubtless introduced from other countries; but linen remained the principal fabric. This linen was made in a great variety of weaves, from a grade as thick and coarse as crash to one as fine and transparent as organdie. This sheerest linen was sometimes soft, like thin pongee, lending itself to subtle draperies; and sometimes crisp, easily crêped or laid in fine pleats. It could be natural-colored, bleached, dyed; woven in colored patterns, worked as tapestry, or otherwise embroidered with thread and jewels.

Color. The Egyptians were a dark-skinned people; they are represented all the way from light tan to deep chocolate-brown. However, in this as in other periods, ideals of feminine beauty demanded that ladies should be fairer than either gentlemen of their own class or female slaves. Frequently in wall-paintings this convention of pallor is expressed by a clear lemon-yellow; but it is more attractive to modern eyes to use the make-up called " Chinese." Speaking of make-up, Egyptians used it and very obviously. Its essentials are rouged lips and eyes shaded with blue and further intensified by heavy lines of kohl (black cosmetic) entirely around the eyes, extending far out to the sides. Pink cheeks seem not to have been affected, but the finger-tips and toes were touched with henna.

With these richly tinted flesh-tones the dazzling bleached white so often present in Egyptian dress was particularly effective. It was used without any color for slaves and was often the basis of any costume enriched by bright borders and accessories. Black was skilfully employed to contrast with white and to set off the other colors. A good deal of black hair showed, too.

The colors of jewelry, stones, enamelling, faïence, and gold, were pure and brilliant: clear yellow, blue-green or emerald, vermilion, carnelian, garnet, and some lovely blues (especially typical of the glazes on "faïence" or pottery) e. g., very bright cerulean, green-blue, and intense violet-blue. The dyed colors (those incorporated into the woven linen or embroidered on it with threads) were somewhat less pure: dark or paler indigo, red bordering on henna, yellow ochre, rather dull yellow-green, and dark wine-purple. Hence a wide range of colors is possible for an Egyptian scene.

GENERAL CHARACTERISTICS OF COSTUME

Silhouette. The Egyptian clothed figure exhibits two typical features: the extreme scantiness of simple, undraped garments reveals the figure even when the garment extends from neck or waist to heel; where drapery is employed, the fullness is invariably concentrated at the *front,* the material being drawn around the body in such a way as to reveal the outlines of the back.

Variation. The cut and construction of Egyptian garments was always simple. The changes that occurred from early times to the period of the Empire were principally in the direction of greater ampleness. This meant more opportunity for graceful draping, which was further facilitated by an increasing delicacy and flexibility in the material used. Along with these innovations, however, the earlier and simpler styles were retained, and thus we see in the period of the Empire examples of all styles used simultaneously. The clothes of men and women were fundamentally alike, although we shall treat them separately.

MEN

Men were usually scantily clad. However, it should be noted that in this as in all other periods until comparatively recent times, dress was influenced by two considerations, its adaptation to the convenience of the wearer and its function in proclaiming his rank, wealth, and importance. Thus, slaves wore few and very simple garments because they toiled (fig. 2). On the other hand, the Pharaoh wore equally scanty attire when he was engaged in active pursuits such as hunting, but his single garment was rich in color and highly ornamented; when he donned official robes they were frequently long and elaborately draped, and his headdress towered in top-heavy impressiveness (fig. 1).

Heads. Egyptian hair seems to have been always black and abundant, and curly, but not tight wool like that of the Ethiopians. A simple but characteristic style of hair-dressing for men, seen on slaves, scribes, and even on more important persons, is a sort of round bob (what used to be called a "Dutch cut"), in overlapping layers round and round the head (fig. 4). Later, for all classes, this style was worn longer in back, exposing the ears as in fig. 2, or covering them, as in fig. 3. In the Empire period this hair is supposed to have been a wig, not meant to appear natural (fig. 1). Another, longer wig was cut square across the bottom, the ends curled in little corkscrews (fig. 5).

It is said that in the period of the Empire and the later Decadence (after 1150 B. C.) these wigs were sometimes dyed in fantastic colors, such as blue or red. A more naturally dressed wig (perhaps *bona fide* hair), also of the XVIII dynasty, was simply parted in the middle and allowed to ripple (in carefully set waves) to the shoulders. In another fairly simple style shown on the Pharaohs the hair is smoothly arranged, parted, drawn back of the ears, allowed to fall upon the neck in back, but in front arranged in neat rolls to lie along the neck to below the collar-bone (fig. 6). Something of the same shape is retained when the wig is shown covered with a cloth, usually striped horizontally, a style familiar to us in representations of the greatest Pharaohs (fig. 7). A simple fillet an inch or two wide like the one shown on a woman (fig. 11c) might be worn around hair or wig by a gentleman not of royal blood.

Certain other headdresses belonged exclusively to members of the royal family. Some important ones are:—The uraeus or hooded cobra, attached to the front of any crown or headdress (figs. 1 and 8), or to a fillet or a diadem with ribbon ends; it is almost always present on any headdress worn by the Pharaoh and frequently on his queen. The mitre of Osiris or crown of the North (fig. 9). The white crown of Lower Egypt (fig. 8). The red crown of Upper Egypt (fig. 14a, shaded part). A combination of the two (fig. 14a), as it is often seen on the god Osiris and on the Pharaoh, his descendant and representative.

Beards. The face was ordinarily smooth. Only one style of beard is shown: more or less slender, cylindrical, not much more than six inches long, protruding at the tip of the chin, with or without a slender line along the jawbone. It usually looks almost ludicrously false (as in fig. 9) and is generally supposed to have been artificial, being attached to the chin by that thin line and donned for ceremonial purposes.

Bodies. The earliest garment is a small piece of linen wrapped around the loins. This continued to be the sole covering of most slaves and apparently the usual undergarment for all men. It may be put around the loins (back to front) and have one end tucked in the top, the other falling in front (fig. 2); it may be caught between the legs (fig. 3); it frequently has the end hanging down underneath instead of on top (fig. 7).

Later a *skirt* appeared, longer, fuller, and stiffer than the loincloth. The length varied from just above the knee to near the ankle. The skirt was arranged in one of two ways: (1) with a large stiff box-pleat in front (fig. 4); (2) drawn tight across the back, the extra fullness pleated together in front and tucked up under the belt, the drapery radiating from there (figs. 1 and 6). The second method required softer material. A good many variations of this second draping are possible, depending on the amount of material used and the way the front-pleating is done. Such a skirt might have a soft girdle around the hips, as with the *robe* in fig. 5, or an ornamented wedge-shaped tab depending from a waist-belt, as shown in figs. 1 and 6. The tabs shown

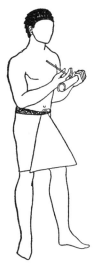

FIG. 4.
A scribe in a skirt with a box pleat. Note papyrus scroll and stylus.

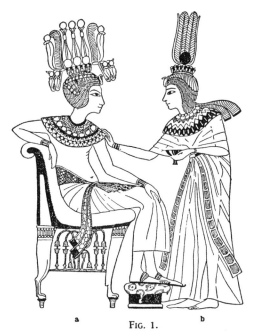

a FIG. 1. b
From a carving upon a throne of Tutankhamen. The Pharaoh and his queen.

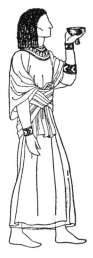

FIG. 5.
Nobleman in a girded robe.

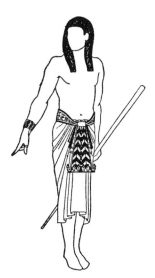

FIG. 6.
A draped skirt and decorated girdle.

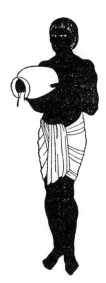

FIG. 2.
A slave in simply-draped loincloth.

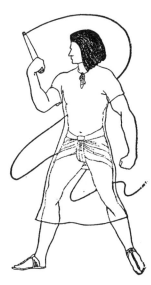

FIG. 3.
An overseer in loincloth and transparent tunic.

are elaborate, being made of leather with metal and enamel decorations. A simple tab would be made of cloth, and if it were worn by a slave, would be marked with his master's name in hieroglyphs. The Pharaoh himself, along with lesser but important persons, is frequently represented clad only in some version of the skirt, his torso nude (fig. 1).

The *tunic* was a simple, scant garment, made with very short sleeves cut in one with the body (like a " kimono " nightgown), and a round neck, slit in front to allow it to go over the head (fig. 3).

Three versions are noted: (1) of heavy linen, reaching about to the knee, unbelted, and with no superfluous fullness; (2) of transparent linen also scant and unbelted (fig. 3); (3) of opaque but soft material, girded (fig. 8). The tunics of the finer sort were of varying length, often to the ankle.

The *robe* was an ampler, more graceful and dignified garment. It consisted of a rectangle, in length about double the measurement of the wearer from shoulder to floor and in width the distance from elbow to elbow or wrist to wrist. A hole was cut in the middle for the head and the garment was sewed up under the arms from the hem to about the breast-line, the openings forming sleeves. It was draped in various ways, but always with the surplus folds drawn to the front, and was girded with a wide hip-girdle whose ends fell over the front drapery (fig. 5). On occasion the robe was worn entirely unsewed, ungirded, and undraped (fig. 9). Musicians as well as kings wore it thus. It is shown made of transparent, figured material, revealing underneath what appears to be a long tight tunic.

The *shawl*, which we shall meet throughout our costume studies under a variety of names, is an unshaped, unsewed rectangle of varying size. In Egypt it was usually ample, about four yards long by forty inches or more wide. There were various ways of draping it; fig. 8 shows a shawl not so long as some, worn over a tunic and held by a girdle and clasp. Its draping is explained on p. 14.

WOMEN

Women's tunics were generally belted higher than men's, the masculine garment shown in fig. 8 being an exception to the rule of low-girded male tunics. Particularly in the period of the Empire, the feminine silhouette is decidedly short-waisted, the drapery being confined immediately under the breasts and radiating from a center almost between them (figs. 1 and 10). Women's skirts were longer than men's, to the calf, the ankle, or even the ground.

Heads. Occasionally women's hair was cut short like the men's, in a " shingled roof " effect (figs. 3 and 1b). As a rule the hair, black and curly, was worn long, about to the breast, tucked behind or hanging over the ears, and loose over the back and shoulders. The ends were even and frequently curled in tight ringlets. Women, as well as men, substituted wigs in this style for natural hair, and they too indulged in wigs of strange colors. Black wigs were ornamented with gold; fig. 12 shows a coiffure where gold spirals alter-

nate with braids, fig. 11b one in which alternate ringlets are sewed with small gold plaques. This dense, bushy wig was varied in the later periods by hair in more natural curls, a good deal longer, hanging to the waist at least, and arranged more softly about the face (figs. 11c, 13, 15).

The hair was further adorned with a headdress, the simplest being a ribbon fillet about two inches wide, tied at the back, with floating ends (figs. 11c and d and 13). The diadem shown in fig. 12 is a gold imitation of such a ribbon. Frequently there was an ornament in the front of the fillet, most often, as in fig. 11d, a naturalistic lotus, the stem of which lay along the top of the head. Alone or in addition to this women wore a cone, four or six inches high and perhaps three inches in diameter, on the crown of the head (figs. 10, 11d). These cones are said to have held perfumed ointment. Sometimes the long-haired wig was covered by a decorated cloth (fig. 11e).

The more elaborate headdresses were reserved for the family of the Pharaohs. The royal uraeus adorned numerous crowns, as, for instance, the diadem shown in fig. 12, and the crowns in fig. 1; the asp, others, as on figs. 14b and c. The latter head wears the vulture cap, symbolic of Maati, goddess of Truth. A queen had the right to wear the feather (fig. 15) or the plumed headdress of Isis (fig. 1b), and the crowns of Lower and Upper Egypt (figs. 8 and 14a), like the Pharaohs themselves. The high stiff turban with uraeus and painted fillet is another royal headdress (fig. 14b).

Bodies. Primitive women and some female slaves of later times wore only the *skirt.* This in its simplest form was a "wrap-around," whose like can be seen on the Moro women of the Philippines and other present-day primitive women. It was a straight piece of cloth, in width from the wearer's waist to about her instep and in length about three yards or less. Another skirt, also made of a straight piece, but not so long, had holes punched along a line an inch or more from the top, through which a cord was run. The ends were seamed together and the skirt drawn up on its cord to fit the wearer (fig. 12). As shown in this sketch, the top was often covered by a belt whose decorated ends fell down the front. The skirt was sometimes worn alone, leaving the torso nude; but it was often combined with a *cape,* three-quarters circular in cut, long enough to cover neck and shoulders, shoulder-blades and breast. The two front corners were knotted together (fig. 12).

There were two versions of the *tunic* as worn by women. The first was like the man's, *i. e.,* a scant, form-fitting garment with short "kimono" sleeves, put on over the head (fig. 13). It might be belted or confined at the low waistline by a girdle with a decorated tab (fig. 6). When women of consequence wore the tunic, they accompanied it with the round collar (figs. *passim*). The more generally seen version of the feminine tunic is the one with no sleeves and indeed nothing above the breasts but wide shoulder-straps. It was rather like the "suspender" dress which recurs in modern styles every few years (fig. 15). The collar was its usual accompaniment.

The *robe* (fig. 10) and the *shawl* (fig. 1b) are probably the most attractive

garments of Egyptian women, and the most satisfactory for our modern reproduction, because they display less of the body and are at the same time ampler and easier to get about in. In cut they were exactly like those of the men, but the draping very markedly demonstrates that feature already mentioned—the high waistline. The material was sheer and soft and displayed the second characteristic of Egyptian draping, *i. e.*, radiation from the front. In the case of the robe, this gives the effect sometimes of a shoulder-cape, or of a dress with " dolman " sleeves (fig. 10).

As with men, so with women, active pursuits called for scanty garments; and since ladies apparently did not indulge in sports, it was the slaves who wore the skimpier raiment. Indeed, dancing-girls at banquets are pictured in only earrings and narrow belts! What attractiveness the ladies, in their turn, may be thought to have sacrificed by voluminousness they made up by transparency, for the sheer and delicate quality of their linen veiled rather than concealed their charms (fig. 1b).

Feet. The foot covering for men and women was the same, sandals; more often feet were bare. These sandals (fig. 1) differed from the familiar classic sort in having a pointed, turned-up toe. They were generally simple, with no more than an ornamented clasp over the instep; but they could be beautifully decorated in gold and enamel, like a pair found in the tomb of Tutankhamen.

CHILDREN

Of children not much need be said. They are represented as small-scale adults, either nude or clad like their elders.

MOTIFS

The many motifs used in Egyptian decoration were complex and beautiful. They can be divided into three classes: (1) those of abstract and geometric forms, having, to our knowledge, no especial significance; (2) those derived from indigenous vegetable and animal forms, many certainly symbolic; (3) primarily symbolic designs, usually animal. Some examples of each kind are:

1. Geometric (generally used in repetition). Perpendicular lines in various color-groups, horizontal lines, squares, lozenges, beads, zigzags, dots, rosettes (figs. 16f and g), scales (fig. 15), and almost any combination of these (figs. *passim*).

2. Often symbolic. Lotus and bud in many forms and arrangements (figs. 1 and 16b and h) from the conventionalized to the naturalistic (fig. 11d); the palm (fig. 16d), almost as variously used; the papyrus or reed (fig. 16c), which lends itself especially well to conventionalizing; ducks' heads and leopards' heads, especially as termini of canes and armchair ornaments.

3. Primarily symbolic. The solar disk, symbol of eternity, alone or with the vulture wings (fig. 16a) or the royal uraeus (hooded cobra) (fig. 1); the scarab (beetle) (fig. 16e); the hawk, attribute of a god or a royal person (fig. 17e); the plumes, attribute of a god or royalty (figs. 1, 12, 15); the

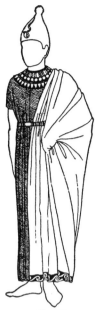

FIG. 8.
White crown of
Lower Egypt.

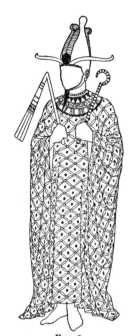

FIG. 9.
A Pharaoh wearing mitre of Osiris
and ceremonial beard, carrying sym-
bols of sovereignty and dominion.

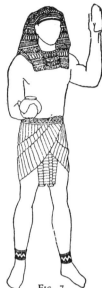

FIG. 7.
Cloth wig-cover;
pleated and draped
loincloth.

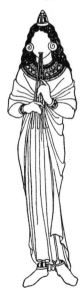

FIG. 10.
A flute-girl in a draped
robe. Note the perfume
cone on her head,

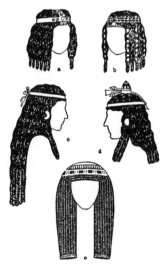

FIG. 11.
a, Wig and diadem. b, Disks on wig.
c, Ribbon fillet. d, Lotus and scent-
cone. e, Cloth-covered wig.

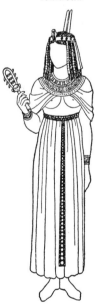

FIG. 12.
Cobra and Isis-feathers. On
wig gold spirals alternate
with braids. Sistrum.

life-symbol (fig. 15), attribute of Maati, carried by her or used as a talisman or object of worship, often made of blue faïence; and the attributes of Osiris and the Pharaohs, *i. e.,* the symbols of sovereignty and dominion, the crook and the whip (fig. 9).

APPLICATION OF DECORATION

Design was applied to dress on borders, collars, headdresses, girdles, and jewelry. A great deal of it was of the horizontal repeat type, one design below another, as on the collars (figs. *passim*). Such borders were also applied on a white or colored garment of a plain weave. Whole garments were also made of all-over patterned material, the design rather small and of the simple geometric type (figs. 9 and 15).

ACCESSORIES

Dress. The dress-accessory most typical of the Egyptians, indeed almost always present in their costume, is the *collar* (figs. *passim*). It was round and flat, and extended from the base of the throat to the shoulders and breast; the style being the same for men and women. It was made of beads, woven or strung on flexible wires in a variety of beautiful patterns, usually in rows. The beads were made of faïence (glazed and baked clay), shells, semi-precious stones like carnelian, and gold. Many colors, well set off by black and white, appeared in one collar.

The *pectoral* (fig. 17e) was a semi-official ornament, worn by royalty and other important people. It was flat and fairly large, made of gold and enamel in a cut-out design; it was hung on a gold chain over the collar, and reached to the breast or lower. Other chains frequently worn were of cowrie shells, at first real (fig. 13) then beautifully imitated in gold; and still others were of semi-precious stones, faïence, and gold, strung or woven in simple patterns; these were either long or short.

Both men and women adorned themselves further with flat bracelets and arm-bands, occasionally joined together (fig. 15), and sometimes with anklets of gold and enamel (figs. *passim*). Seal rings were officially important. They were large, worn on any finger or the thumb (fig. 6), and had the wearer's symbol or his name in hieroglyphs cut either in the gold or in a stone. Earrings (not often seen) take the form of gold disks, as large as three inches in diameter (figs. 10, 11c and d). The ornamented girdle, mentioned above, was an important item of decoration. It may have been made of painted leather, embroidered linen, or linen and leather with metal mounts (figs. 1 and 6).

Fighting. Over the ordinary tunic or skirt soldiers wore a protection of leather: a broad band reaching from breast to waist, with or without shoulder-straps. This was further strengthened with large metal disks. For weapons they had short sturdy daggers, short swords like those used by the Romans

(Chap. IV), or longer two-edged swords (fig. 18c), small battle-axes, spears with sharp heads, bows, and arrows with delicate stone heads.

Household. Large and medium-sized jars of baked and glazed clay, small jars of faïence for cosmetics, bronze or silver mirrors (fig. 17d), ivory combs and other toilet articles, and fans manipulated by slaves (fig. 13) were all part of Egyptian daily life.

Musical Instruments. Harps, four to twelve-stringed (fig. 18a) and, in the later centuries, large, with a sound-box (fig. 18b); small, barrel-shaped drums, to be beaten with the hands; sistrums, a kind of rattle used in temple-worship (fig. 12); castanets made of ivory and carved like hands; and reed flutes, double or triple (fig. 10).

Tools of Learning. Books of papyrus; scrolls of papyrus, accompanied by brushes made from reeds (fig. 4) and inkpots (fig. 17a); rolls covered with wax for writing on with a stylus (fig. 17c) (erasures to be made with the blunt end).

Toys and Games. Dolls of wood (flat) and of terra cotta, clay animals, balls of colored leather, balls of hollow clay (for rattles), marbles, ivory or stone dice, knucklebones (to play a game like jacks), and draughts-boards with men made of blue faïence.

SOMETHING ABOUT THE SETTING

Egyptian architecture, definitely horizontal in character, is further notable for the qualities of size and durability: doors are high and pillars are big around and lofty. Two characteristic details are huge round columns with capitals of a floral motif, all painted brightly, and the portal called a pylon, which stands in front of and somewhat detached from the temple building. The interiors of temples and probably also of palaces were further decorated with carved and painted columns and wall-paintings, also in brilliant colors. The decorative motifs described for costumes appear also on architecture and furniture.

Furniture was simple in line and beautiful in detail, being made of ivory, wood, or metal, and embellished with inlay, carving, or painting. The best " modernistic " furniture, both the angular and the curved styles, often seems reminiscent of Egyptian (fig. 1). There were chairs, stately ones with carved arms, and small sturdy ones with straight legs and rush seats; stools, especially the kind with curved cross-ties and a leather seat, like our camp-chairs; and chests, small and beautifully inlaid. Beds and couches were narrow, of the size and general structure of folding cots, having a low foot-board but no head-board; no mattress, but a cover of rich tapestry or an animal skin; no pillow, but a head-rest of wood or ivory like those still in use in Japan (fig. 17f).

PRACTICAL REPRODUCTION

An Egyptian play can be costumed with comparatively little money and not very expert dressmaking, but with a good deal of enthusiasm and ingenuity on the part of the designer and the decorators. None of the materials needs be

expensive (from fifteen to fifty cents a yard), and the accessories can be made from the cheapest of ingredients.

Material. Economy will probably dictate the substitution of cotton for linen. This may be bleached or unbleached sheeting (prepared as described in Chap. XX, p. 574), Japanese cotton crêpe, or cheesecloth. Inexpensive pongee, sometimes as low as twenty-five cents a yard, very closely resembles the fine linen found in mummy-cases. It can be bleached white with color-remover or used in its natural color. Rough-dry it has a slightly crêpy surface.

To make cotton crêpe very crinkled and clinging, cut the garment, sew as required, wet, and twist lengthwise very tightly; tie it up in a knot to hold the twisting, and "bake" it, actually, in a very slow oven or plate-warmer or upon the steampipes, till it is dried through; on the steampipes the drying will take twenty-four hours. Keep it tightly twisted when not in use. For the crisp transparent crêped effect, you may twist and bake batiste or organdie in the same way; or have it knife-pleated, if economy is no object. Uncrêped draped dresses can be made from pongee or cheesecloth, the latter in the weight retailed at about fifteen cents a yard, used single thickness, or in the much thinner "gauze," doubled and pressed together while it is damp. Single cheesecloth also has a better texture if it has been washed and dried smooth, but not pressed.

For costumes of a very late period, or for costumes in a dance-drama, crêpe de chine or chiffon is permissible, smooth or crêped (as above).

If the audience will not object to the implication of nudity, transparent materials can be worn over full-length tights or "fleshings," dyed to the desired brunette shade, with the arms, neck, and face made up to match. With thicker materials, of course, one need not worry about the underneath, so long as there is nothing bulgy or bulky.

Cutting and Draping. It is evident that the actual cutting of Egyptian costume presents few difficulties. If any pattern is needed, that for a "kimono" nightgown will prove the most useful; fitted more closely, probably, to the torso, but with its full width left in the skirt, it will adapt very well for both the sleeved tunic and the style with suspenders.

The cut of robe and shawl has been explained above. To drape the robe as in figs. 5 and 10: round its four corners and leave it unsewed under the arms; bring the front edges around to the back and pin; pull the back part tightly toward the front and drape; tie it on itself, high-waisted (fig. 10); or confine it with a hip-girdle as in fig. 5. Both robe and shawl measure according to the size of the wearer.

Fig. 8 shows a shawl made of a strip double the wearer's length from shoulder to ankle and about forty inches wide. To drape: extend it in front from ankle to left shoulder and let the rest hang down the back at the left; confine it with a belt put on at a high waist-line; bring it back again over the left shoulder and drape over the arm as shown. The shawl in fig. 1b must be in length about twice the distance from the wearer's shoulder to the floor,

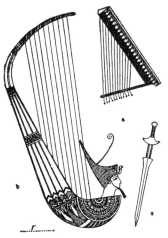

FIG. 18.
a, Primitive harp. b, Harp of
the XVIII dynasty. c, Sword.

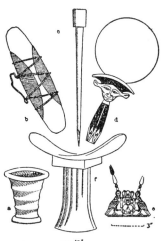

FIG. 17.
a, Inkpot. b, Wax scroll. c,
Stylus for writing on it. d,
Silver hand-mirror. e, A pec-
toral. f, Head-rest.

FIG. 14.
a, White crown of
Lower Egypt and red
crown of Upper Egypt.
b, Queen's headdress. c,
Vulture headdress.

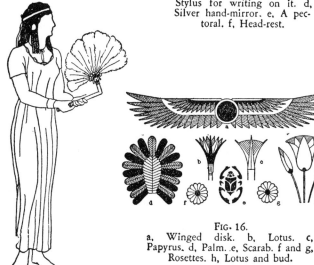

FIG. 16.
a, Winged disk. b, Lotus. c,
Papyrus. d, Palm. e, Scarab. f and g,
Rosettes. h, Lotus and bud.

FIG. 13.
A slave-girl ready to fan
her mistress. Her necklace
is of cowrie shells.

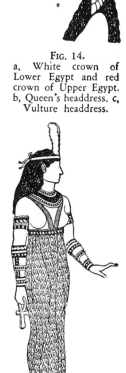

FIG. 15.
The royal feather. Armbands
from a queen of early period.
Life-symbol.

and forty inches or so wide. Put it around the shoulders, draw it forward, and knot the two inside edges together at the breast; put a narrow belt around it at the high waist-line already defined by the draping.

Millinery. The notes on millinery in Chap. XX (p. 582) explain in general the materials to be used. Add to these some heavily insulated electric-light cord about half an inch thick. This forms a good foundation on which to build a cobra or other large projection, and split open it makes a good asp, the copper wire showing for a tongue. Buckram, or muslin stretched on a wire frame, makes any large high crown, like those in figs. 8, 9, and 14a and b. Build the towering headdress from fig. 1 of papier-mâché or plastic wood (Chap. XX, p. 578) on a wire foundation. Use a buckram hat-crown for the beginning of any of these large structures. Apply decorations as suggested in Chap. XX, p. 581.

To make the headdress in fig. 7, use stiff material like heavily starched percale (which can sometimes be bought in wide stripes), heavy sheeting on which you have stencilled a pattern (Chap. XX, p. 578), or buckram, which you may paint in oil-paints and gold after the headdress is made. You will need a piece about forty inches by thirty-six inches. Take two-inch belting or doubled cloth, enough to go around the head and fasten behind. Attach the center of one long side of your material to the center-front of the head-band and sew material to band till you come to the back. Put it on the model, the band low across his forehead as shown in the sketch, and fasten the band behind, under the cloth. The loose ends will fall forward. Trim these to the wedge-shape shown in the sketch, and sew the two thicknesses together, flat. Take up a large dart in the center back, seam, and cut off so that there is no superfluous fullness there. Trim off the material across the back about at the shoulder line. Bind raw edges or paint with shellac; decorate the head-band; stuff crumpled paper up into the sharp points above the forehead to keep a rounded shape, as in the sketch.

Accessories. The collar may be simulated in heavy unbleached muslin or canvas (Chap. XX, p. 578). Cut it circular and fit it with darts on the shoulders. Open it in the back, punch holes and lace it together; shellac the raw edges; decorate with tempera or oils (Chap. XX, p. 578). You may also use oilcloth painted in oils, or you may make the collar in the real way, of beads strung together in a pattern. The collar thus made is more flexible, hangs with the proper heaviness, and is durable; but it is slow to make, and more expensive. Make the girdle with its decorated tabs of canvas, painted; it will hang better with a row of weighted tape at the bottom.

For ways of making jewelry see Chap. XX. Do not use glass jewelry cut faceted for Egyptian ornaments; they should appear somewhat dull, " uncut." Arm-bands and anklets are most secure when made of wide elastic, painted and gilded; elastic is also satisfactory for girdles.

Make sandals of slipper-soles long for the wearer, cut to a point which is edged with wire and turned up. Fasten over instep and toes (figs. 1a and 3)

with elastic, gilded and ornamented *ad lib.* However, it is much more comfortable and often as appropriate for the actor to go in his stocking feet or barefoot.

For methods of applying decoration to garments, see Chap. XX, p. 577.

Suggested Reading List

A History of Egypt—James Henry Breasted.
For Egyptian life in general. Has good pictures.

Osiris and the Egyptian Resurrection—E. A. Wallis Budge.
One of the best of reference books not purporting to be a book about costume. It is freely illustrated, in line or color, with reproductions of papyri in the British Museum and of other art works elsewhere.

Ancient Egyptian, Assyrian and Persian Costume—Houston and Hornblower.
The best short handbook I know. It has excellent colored pictures taken from British Museum originals, and sketches of actual garments from those pictures, as well as plans and measurements. It is not expensive.

A History of Costume—Köhler and von Sichert (translated).
The Egyptian chapter is detailed, clear, and well illustrated, though not in color.

The Arts and Crafts of Ancient Egypt—Flinders Petrie.
For costume and accessories. A standard book on Egypt.

Grammar of Ornament—Jones.

History of Ornament—Hamlin.

Encyclopedia of Furniture—Schmitz.

The Styles of Ornament—Speltz and Spiers.

A Dictionary of Architecture and Building—Russell Sturgis.
These or other books on the same subjects will be of assistance for further information on the setting.

Where Further Illustrative Material May Be Found

It is always desirable in studying the costumes of a period to see for oneself the sources from which information comes. In the case of Egyptian costumes the sources are: statues, wall-paintings, records on papyrus, tombs, funerary tablets, mummy-cases, and actual objects preserved during all these centuries.

Examples of these are to be seen in museums in various parts of the world, and the most famous are represented by copies in other art museums, so that they are in some manner accessible to a great many people. Moreover, photographic reproductions occur in books about Egypt (see above) and in the handbooks published by museums; these books and handbooks are available in the larger public libraries.

Sources of Sketches in This Chapter

These sketches are adaptations from original Egyptian figure representations. The separate details have been studied from the following:

Photographs made by Mr. Harry Burton for the Metropolitan Museum of New York Expedition to the tomb of Tutankhamen.

Reproductions of XVIII Dynasty wall-paintings from Thebes, in the British Museum. Reproductions of papyri, mummy-cases, and sarcophagi and portrait statues in the British Museum.

Portrait statues in the Museum at Cairo (reproductions).

Figurines in the Art Institute, Chicago, and in the Metropolitan Museum; numerous objects, like jewelry and household implements, as well as the larger objects mentioned above. All these have been studied first-hand.

Reproductions of originals in books as follows:

Houston and Hornblower, op. cit. figs. 7 and 11, plates VIII and XX.

Mariette, " Abydos," plate 27, vol. I.

Budge, op. cit., p. 56, vol. I.

Chapter II

BIBLICAL.

APPROXIMATE DATES:
From an Unknown Time to 30 A. D.

Some Important Names

HEBREW	EGYPTIAN	ASSYRIAN	PERSIAN	GREEK
Abraham c. 1550–		(Chaldean, Assyrian, Babylonian)		
1450 B. C.	An Early Pharaoh	Hammurabi 2100 B. C.		
Isaac				
Jacob				
Joseph	A Pharaoh			
Moses	A Pharaoh of the XIX Dynasty, possibly Rameses II			
Solomon	A daughter of the Pharaohs			
Jehu, king of Israel, c. 850 B. C.				
		Shalmaneser II		
Ruth		Sargon II, 722 B. C., captured Samaria		
Isaiah		Sennacherib; Nineveh destroyed, 606 B. C.		
Jerusalem destroyed, 586		Nebuchadnezzar (the Babylonian Captivity)		
Daniel Rebuilding the Temple		Belshazzar	Darius Cyrus	Marathon, 490 B. C.
Esther			Ahasuerus (Xerxes)	Thermopylæ and Salamis, 480 B. C. Alexander of Macedon, d. 323 B. C.

Plays to Be Costumed in This Style

All the plays based on Old Testament subjects. They introduce foreign characters, or foreign elements in the dress of Hebrew characters, as explained below.

BIBLICAL

CONCERNING THE HEBREWS AND THEIR NEIGHBORS

A SURVEY of Biblical costume must include that of other ancient peoples who appear as actors in the story of the Hebrews, and whose culture profoundly affected the Hebrews themselves and consequently their dress. Palestine, the home of the Hebrews when they emerge in history, is on the main travelled way between the two fertile areas of the Tigris and Euphrates valleys in Asia and the Nile Valley in Africa. It was, therefore, exposed to the cultures as well as the domination of the early civilizations developed there, and took something of the stamp of each conquering power as it rose, flourished, declined, and made way for the next. While one influence probably overlapped another, and each left its mark, the order is something like this: Early Chaldean, Egyptian, Canaanite, Phœnician, Assyrian, Chaldean-Babylonian, Persian, Macedonian-Greek, Roman.

The climate of Palestine is more like that of the Northern valley than of the Southern, so that in the matter of clothing the Hebrews would naturally more closely resemble the Assyrians, Babylonians, and Persians, with their draperies and wrappings, their woolen and even skin garments, than the Egyptians, who, as we have seen, were either semi-nude, or draped in light, often transparent materials. Greek and Roman fashions in their turn followed naturally enough after the Asiatic styles as influences on Palestinian dress.

The first stories in Genesis belong to that vague time when men and women were merely covered with whatever came to hand. We are told that immediately after the Expulsion Adam and Eve were clothed in " coats of skins " (fig. 1). Cain and Abel would be clad in that way, also. Noah and his family lived in an agricultural period, when flocks and herds were tended, when the soil was tilled, and when artizans, following in the footsteps of Tubal-Cain, made bronze and iron implements. They would have had cloth woven of wool and flax. Appropriate garments are the loincloth, the simple tunic, and the rectangular drape or shawl; appropriate colors are those available to country-people,—white, ecru (the natural color of linen), tan, and such hues as brown, ochre, blue, rust-color, and dull green, produced with common mineral and vegetable dyes.

In historic times, Abraham, we are told, migrated from Chaldea, which had a considerable civilization even a thousand years before him; and when he had come to the land of Canaan he went on to Egypt. There enter into the

Abraham stories, therefore, two influences, ancient Chaldean and early Egyptian. The stories of Isaac and Jacob involve the people of neighboring tribes, a people somewhat more civilized than the still partially nomadic Hebrews. The Canaanites in particular seem to have left their mark on the dress of Abraham's descendants. The story of Joseph connects the Hebrews with Egypt again, and the Moses stories introduce both Egyptians and Hebrews, the latter (as shown in rare contemporary records) dressed practically like the humblest Egyptians.

When they settled in the Promised Land, the Hebrews borrowed styles of the Canaanites whom they ousted. Judah, in the southern and more rugged part of Palestine, remained a simple shepherd state, but Israel, in the north, was influenced by Phœnicia, which was Assyrian in its culture (for by this time Assyria had succeeded Chaldea-Babylonia as the dominant power). The Judean actors in the stories of Saul and David were for the most part simply-clad shepherds, though Saul's armor may have been of the Assyrian type; their enemies the Philistines were dressed more consistently in the Assyrian mode. A decidedly Assyrian atmosphere surrounds Delilah and her Philistine countrymen, as opposed to the simpler Israelitish milieu native to Samson (Judges 15: 14–16).

Solomon (whose dates are about 975–935 B. C.) imitated the gorgeousness of Assyrian art in his dress and furnishings, and so did the Phœnician Hiram, king of Tyre. Solomon, however, was the son-in-law of an Egyptian Pharaoh, and his wife probably continued to wear her native dress (Chap. I). The Queen of Sheba (from Ethiopia or Abyssinia) doubtless followed the Egyptian mode.

After Judah and Israel were separated, Assyrian influence continued strong upon prosperous Israel. King Ahab and his Tyrian wife Jezebel must have maintained a court as nearly as possible like the one at Nineveh. Assyria gradually encroached upon the independence of Israel. About 850 B. C. Jehu was sending tribute to Shalmaneser II, and in 722 Sargon captured Samaria, the capital, and deported many Israelites to Nineveh. But Judah, whose capital was Jerusalem, maintained her independence a while longer. This is about the period of the story of Ruth, laid at Bethlehem of Judea; its costuming would be of the simple Hebrew type, with Assyrian touches, perhaps, in the decorative motifs. In 701, when Isaiah was prophet, Jerusalem barely escaped destruction at the hands of Sennacherib. In 606 Nineveh itself was destroyed and Chaldea-Babylonia again ruled, with Babylon as the capital city. In 586 Nebuchadnezzar destroyed Jerusalem and carried away the people of Judea (the Babylonian Captivity). All dramas dealing with the subsequent period will have a Babylonian atmosphere. Stories about Daniel, including the highly dramatic " Feast of Belshazzar," belong in this group.

Belshazzar's Feast marked the end of Babylonian power, for on that very night the king was slain and Darius, ruler of the Medes and Persians, assumed dominion over the ancient world. From about 528, under the liberal policy

of Darius and Cyrus, the Hebrews were at liberty to return to Palestine, and eventually they rebuilt the Temple. Many, however, did not go back, and there was a permanent Jewish population at Susa, the Persian capital. Thus Persian styles must be consulted for costuming the story of Esther, who was the queen of Ahasuerus. (Historically, this king is identified with Xerxes, the opponent of the Greeks in 480 B. C. at Thermopylæ and Salamis.)

Persian influence continued to dominate until 331 B. C., when Alexander the Great finally crushed the Persian empire and assumed control of its provinces, including Palestine. The costume influence was Greek (Chap. III) and remained so until 164, when Rome took over Palestine. The brief Hebrew independence under the Maccabees (142 B. C.) came in the midst of the Græco-Roman period. New Testament costumes reflected Roman modes (Chap. IV).

NON-HEBREW COSTUMES

EARLY CHALDEAN-BABYLONIAN (about 3000 B. C., before Abraham)

MEN

Outstanding features of these early people are the shaven head and upper lip and the fringe of chin-beard (fig. 1). The men represented in the few surviving pieces of sculpture look surprisingly like some Victorian ancestor in our family picture-albums, that is from the neck up; for their bodies are very lightly clad: the torso nude, the feet bare. A petticoat, reaching to the calf or ankle, looks in the sculpture like an arrangement of overlapping petals, but that may be only the primitive artist's effort to represent shaggy sheep-skin, which seems more likely clothing for a shepherd people (fig. 1). Such a sheep-skin garment (or one fastening higher, on the shoulder) is suitable for Cain and Abel and the later shepherd characters, like Esau. To about the same time as the bearded Chaldean heads belong some Sumerian reliefs of men in hoods which fit close around the face and have a short point on top. This may represent a helmet of hammered metal, but it might also be a woolen hood. Like other primitive hoods, *e. g.,* that of the Roman paenula (fig. 8, Chap. IV) it would probably have been merely a rectangular piece doubled, one side sewed together, one left open for the face, the two edges of the third resting on the neck. The men in these reliefs are beardless.

In the time of Hammurabi (2100 B. C.) a headdress had developed which seems to have started the style for many caps and turbans of its kind (fig. 2), a shape still used in Palestine as a foundation for the wrapped turban. This round hat goes with either a smooth face or a long square-cut beard like those worn in later Assyria.

At about the same time appeared the large draped shawl, common to so many ancient peoples and depending on the decoration and method of draping for its distinctive character (fig. 2). Heuzey (see p. 46) reconstructs it thus: Material, soft, fine, long-haired woolen, like Indian cashmere, fringed;

measurements, about nine feet by four feet. Hold one corner under left armpit and draw the shawl across the back, under right armpit, across chest, under left armpit, across back, under right armpit again, throw across chest over left shoulder, bring the rest around back and tuck in just in front of right arm. Abraham might have worn such a shawl. It continued in use during the entire Assyrian-Babylonian period.

It is said that men always carried tall walking-sticks or staves (fig. 2) and wore cylindrical seals on chains (fig. 4c).

WOMEN

Even in the time of Abraham hair-dressing was elaborate. The hair (or a wig) was arranged in complicated coils and braids. In the tomb of a queen of this period was found a structure of gold ribbon, gold wire, loops, leaves and rosettes. Gold rings fringed the forehead and at the back rose a triangular piece made of seven long thin points with a gold rosette at each tip. Lapis lazuli was set in the gold. We may guess that the general effect might be as in fig. 3. The statue of another Chaldean lady, from the time of Gudea (2500 B. C.) has hair drawn back from the ears, hanging in a thick lock down the back, and encircled by a heavy twisted fillet or round crown.

A scant, unbelted tunic with short tight sleeves, like the Egyptian tunic shown in fig. 13, Chap. I, constituted the feminine dress, to which might be added the cape shown in fig. 3, which seems to be a straight piece, gathered at the neck and tied in front. To be sure, from this period come other statues, of goddesses, who wear gowns made in a series of ruffled flounces from neck to ankle, but the straight tunic seems to have been the dress of *mortal* women.

JEWELRY

In early tombs have been found gold rings, dog-collars (like that on the Assyrian lady of fig. 13), large pins, earrings, necklaces, bangle bracelets, and simple, heavy rings. The grave which yielded the remarkable head-dress described above had also a beaded cloak, of the style shown in the cloth cape on fig. 3. All the jewel-work *except* the cloak is represented in Assyrian art.

Abraham's wife Sarah would be dressed as these Chaldean ladies were.

ASSYRIAN-BABYLONIAN

Early Babylonian costume continued into Assyrian times; Assyrian merges again with *later* Babylonian. The stamp of Assyria was so definite on the smaller peoples, Phœnicians, Philistines, and the tribes with whom the Hebrews contended or traded, that they can all be described together.

CONCERNING THESE PEOPLE

"Nineveh and Babylon" has become a synonym for worldly splendor. Nineveh, the northern city, was the capital of Assyria; Babylon, in the south, of Babylonia. Of the two influences, the Babylonian has been called the cul-

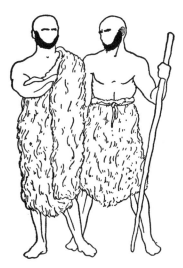

FIG. 1.
Two men from Early Chaldean times wearing sheepskin garments.

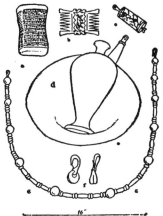

FIG. 4.
a, Babylonian clay tablet with cuneiform writing. b, Assyrian comb. c, Chaldean or Assyrian seal-cylinder. d, e, Bowl and jug from Kish. f, Earrings from early Sumeria. g, Necklace from Kish.

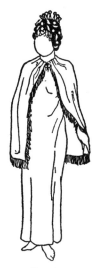

FIG. 3.
An Early Chaldean lady, wearing a headdress of gold.

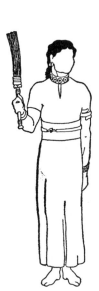

FIG. 5.
Eunuch with a fly-whisk. Note his double girdle.

FIG. 6.
An Assyrian nobleman hunting. His tunic is cut up in a V for greater freedom.

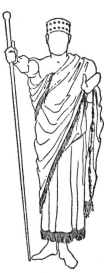

FIG. 2.
Headdress and shawl, time of Hammurabi, 2100 B. C.

tural, the Assyrian the military; blended, they produced that art we name " Assyrian," whose characteristics are cruelty and ostentation. It is a masculine art, in which there is little room for the depiction of women. Relief sculpture and brilliantly glazed bricks show men and animals with admirable fidelity to nature. The tense muscles of the men add to the effect of power and virility; their stern, implacable, bearded faces alone are enough to strike terror to the hearts of weaker peoples.

GENERAL CHARACTERISTICS OF COSTUME

Never again till the time of the Byzantine emperors was there such a display of ornamentation on dress; these Assyrian garments seem literally stiff with gold and jewels. Armlets, earrings, gold collars, and rings clasp the hard muscles, set off the grim black beards of warriors made, paradoxically, more brutal by these bedizenments. Yet the actual structure of the clothes remained very simple. There were but two type-garments, i. e., the shawl and the tunic. Variations of these lasted throughout the period.

MEN

Heads. Hair was black and bushy. It was worn approximately shoulder-length, cut in a straight bang across the forehead, and tucked behind the ears. It must have been artificially " set " to result in such regular waves and tight curls; or, very likely, wigs were substituted for natural tresses. (The convention of sculptural rendering must also be taken into account.) With the exception of eunuchs, all grown men wore beards and moustaches curled at the ends. The beard (again it looks false, though probably natural) was fairly long, cut off square and thick at the bottom, and elaborately curled.

Occasionally the hair was unadorned, a fashion frequently seen on eunuchs attending the king (fig. 5); more often it was confined by a head-band or fillet, simple or elaborate (fig. 6). A hat much like the familiar Turkish fez, but without any tail on top (fig. 7) seems to have been worn by non-royal persons.

The tiara, an elaboration of this " fez," was restricted to royalty; this royal headdress always had a point on top. It increased in height from early to late times, but otherwise did not change (figs. 8, 9, 10). The mitre, a headdress for kings and gods, was a high, dome-shaped turban, draped with a soft cloth, parted in the middle. Fig. 12c shows the conventionalized version (from a relief), fig. 12d a realistic draping drawn from a model.

Bodies. Assyrian-Babylonian body-garments appeared in this order: the *shawl* alone, the *tunic* and *shawl*, the *tunic* alone; but as we have noted in considering the Egyptians (Chap. I), these styles overlapped and might have been seen all at the same time.

The tunic was cut on the same lines as all primitive garments of this character, those of the " kimono nightgown " (Chap. XX). Its length varied from a point well above the knee for active occupations like war and hunting

(fig. 6) to the instep. Length was not necessarily a matter of class distinction, for the king is often shown with short skirts, his servants with long ones (fig. 5). The better-class tunic was accompanied by a belt distinctively Assyrian; wide, close-fitting, and probably made of leather. Over it was another, much narrower belt, also leather, which seems designed to keep the wide one in place (figs. 5, 6, 8, 9). The knee-length tunic worn by ordinary men had a narrower belt and, frequently, a fringed tab at one side. Horsemen wore tunics cut up in the front in an inverted V (fig. 6).

The shawl described for the Chaldeans (fig. 2) continued in use, but as the fashion for wearing a tunic under it became established it grew smaller and its adjustment more complicated. A simple style is shown on fig. 7. It is draped thus: throw one corner forward over the left shoulder, bring the shawl across the back and under the right arm, gather it up and throw it again over the left shoulder, letting the end fall down the back.

A somewhat larger shawl was worn by kings in their priestly function (fig. 10). It may be reproduced thus (fig. 11): take a rectangular piece, ninety by seventy-two inches, fringed on the two long sides (the measurements are those given by Houston and Hornblower, see p. 46). Fold it so that there are two tiers of fringe, and attach a cord at the fold. Hold the cord at the waist, beginning at the right side (a). Now put all the material over the right shoulder, cross it at the back of the neck to the left shoulder, making a sling for the left arm (b). Bring the folded edge around the waist, passing the right elbow (b), then around the back and the left hip until about six inches in front of the left side of waist (c and d). At this point in the draping, fold the extra drapery underneath and confine the whole by a second cord, to which the first cord is tied (c and d).

Much narrower shawls (fig. 8) were wrapped diagonally in various ways and might be little more than a scarf or baldrick. Small shawls, like large square handkerchiefs (fig. 9) and longer ones, reaching to the heels, were put across the back only.

SOLDIERS

Helmets were made of metal (bronze or brass) in three shapes: pointed (fig. 12a), crested (fig. 12b), and round.

Warriors wore tunics, of chain or link mail, shaped like the woolen ones; fig. 15b shows a detail of such mail. Occasionally the mail tunic was ankle-length, but more often reached to the knee or a few inches below.

WOMEN

(See also the Chaldean woman, fig. 3.)

Hair was arranged not very differently from the men's, in a long bushy bob, exposing the ears, encircled by a fillet or crown (fig. 13). In common with women of neighboring countries, ordinary women doubtless protected their heads with shawls or veils.

The feminine tunic was like the masculine, except that the tight sleeves were three-quarter length. The high round collar shown was worn by men also, as may be seen on the figures of eunuchs, where it is not hidden by the beard (fig. 5). A jewelled dog-collar, like those found in Chaldean graves, decorated the throat of a noble lady. Feminine tunics were long and unbelted. A large rectangular shawl, covering either the right or the left shoulder, completed the costume (fig. 13). It may be reproduced thus (fig. 14): Take a rectangular strip thirty-six inches wide, or the distance from waist to ankle and about three yards long; it should be fringed on one long side. Holding one end in front of the left hip, bring the shawl around the back, under the right arm and across the front (a), around the back and under the right arm again (b), then diagonally across the front, over the left shoulder (c) and, like a tightly-drawn shawl, across the back (d), throwing the final end over the right shoulder (fig. 13).

SHOES (men and women)

Often the Assyrians, like the Chaldeans, went barefoot, but they also wore sandals (figs. 7, 9 and 10) and soft shoes (fig. 13), and, for war and hunting, high boots (fig. 6).

MATERIAL

Woolen, linen, and dressed leather were employed for Assyrian garments. Silk was made into luxurious raiment (cf. Ezekiel 16: 10–13).

COLORS

White, black, green, red, and Tyrian purple (which is also a variation of red) are among the colors which still glow upon Assyrian glazed tiles. Probably the whole color-scheme was not different from that of the Egyptians (Chap. I) except for a less frequent use of bleached white. The excessive amount of decoration in vari-colored embroidery, gold-woven textiles, and gold ornaments produced a magnificent if somewhat gaudy effect.

MOTIFS

Essentially, the motifs were like the Egyptian, but they underwent changes characteristic of the people. Some Assyrian motifs are (fig. 16): the winged globe (a) (a variation of this motif shows the god Assur between the wings in place of the globe); lotus and bud (b); scale (c); cone (d); chevron leaf (e); sacred tree (f); palm tree (g); chevron (h); palmette (i); rosette (j and k); glyph (m); and step (n).

APPLICATION OF DECORATION

The sketches hardly give an idea of how profusely design was applied. Actually the surface of a garment was seldom left plain; rather it was covered with decoration in borders or all-over patterns. Patterns were woven or

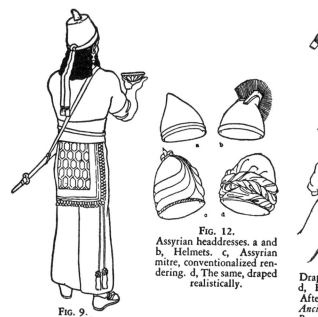

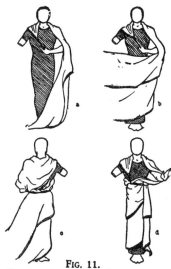

FIG. 12.
Assyrian headdresses. a and
b, Helmets. c, Assyrian
mitre, conventionalized ren-
dering. d, The same, draped
realistically.

FIG. 9.
The small Assyrian shawl
drapery.

FIG. 11.
Draping the shawl in fig. 10. a, b,
d, Front views. c, Back view.
After description on p. 62,
*Ancient Egyptian, Assyrian and
Persian Costume,* Houston and
Hornblower.

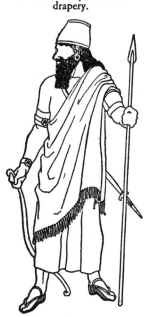

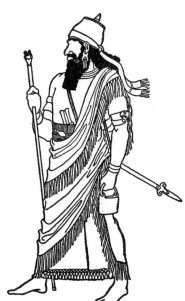

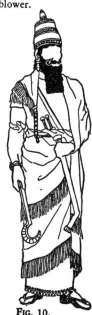

FIG. 7.
An Assyrian hunter, wearing
a tailless hat and a simply-
draped shawl.

FIG. 8.
An Assyrian king wearing
a tiara and a narrow shawl.

FIG. 10.
Assyrian king as priest;
for draping, see fig. 11.
Symbols of sovereignty
and dominion.

embroidered on the woolen material or painted on leather or enamelled and inlaid on brass, bronze, gold, and silver.

The most indispensable feature of Assyrian dress-decoration is fringe. It is said that the length of the fringe proclaimed the wearer's rank. Fringe was sewed on the bottom of tunics, around shawls, and at the ends of turban ribbons; it was sometimes straight, sometimes intricately knotted. Tassels decorated sword-belts and the corners of shawls (fig. 9).

JEWELRY

Both men and women wore large, heavy earrings, bracelets at the wrists, armlets on the upper arms, rings, and crowns, all in great profusion (figs. *passim*).

ACCESSORIES

Military and hunting. A large sword hung on a diagonal belt or baldrick, right shoulder to left hip (figs. 6, 8, 9). Frequently one or two daggers were thrust into the belt at the right side. Javelins (fig. 7), bows and arrows (figs. 6 and 7), and large quivers (fig. 6) were carried in battle and hunting. Shields (fig. 15), variously decorated, were round and flat (a), round and convex (d), and long, rectangular, and convex (e).

Personal. The mace, a stick about two feet long, with an ornamental knob, like the one carried by the High Priest (fig. 27), was an attribute of the king, carried by him or before him. Assyrian kings are shown with the Egyptian symbols of sovereignty and dominion (fig. 10; cf. fig. 9, Chap. I). The umbrella (fig. 13) was an article in frequent use by Assyrian royalty. Though in our sketch it is held over a queen, as a matter of fact reliefs show it protecting kings, even when they are in their chariots. It seems to have been constructed like a modern umbrella. The piece hanging down behind is not always present. Fans (fig. 30c) and fly-whisks (fig. 5) were manipulated by slaves. Mirrors resembled the Egyptian one shown in fig. 17d, Chap. I. Ivory combs, (fig. 4b) handsomely carved, were common.

Household equipment. Fig. 4 (d and e) shows the way jugs and basins looked at Kish, a style which had not changed centuries later, in Assyria. Graceful pottery for various household uses existed throughout the time. The Babylonian-Assyrians wrote in cuneiform with a stylus on clay tablets or cylinders (fig. 4a). Harps were popular musical instruments among the Assyrians (fig. 30b).

SOMETHING ABOUT THE SETTING

The arch was employed in Assyrian architecture, indoors and out. During the later years of Assyrian power huge painted columns adorned palace as well as temple interiors, their capitals carved in designs derived from the lotus, the palm, human heads, or bulls' heads. Walls glowed with decorations

in glazed brick, showing men, animals, and gods, or those mythological beings with men's heads, animal or bird bodies, and great wings, known as cherubim.

Furniture included couches and armchairs, simple in line but highly ornamented with inlay of gold and ivory, carving, painting, and gilding; and stools or small tables (fig. 17a). A footstool was an invariable accompaniment of the king's throne (fig. 17b), a familiar figure of speech in Hebrew poetry, e. g., " Thus saith Jehovah, Heaven is my throne and the earth is my footstool " (Isaiah 66: 1).

PERSIAN

In addition to its use in Old Testament stories, as noted above (p. 22), Persian costume is needed for Greek dramas dealing with the Græco-Persian wars, such as Sophocles' " The Persians," and for dramas of Marathon, Thermopylæ, and Salamis. Moreover, if a nativity play is to be costumed in its actual period rather than in mediæval style, the Magi will wear Persian dress. (Note that *Mediæval* Persian costume, while logically descended from ancient Persian, underwent many changes, and is a study in itself.)

Architecture, decoration, the dominion of the known world, these the Persians took over from the vanquished Babylonians; but their religion was their own (Zoroastrianism) and their costume differed in many ways from that of their predecessors.

GENERAL CHARACTERISTICS OF COSTUME

Persian dress has elements in common with that of Western Europe: the tunic, the hood which covers neck and chin, the coat with set-on sleeves, and the trousers. Coat and trousers continued in mediæval and modern Persian dress, whence the coat (it has been said) was introduced into Europe in the seventeenth century, this introduction marking the beginning of modern masculine attire. But trousers were not unknown to other ancient peoples and were independently used by the tribes of Northern Europe when Cæsar discovered them.

Ancient Persian dress had in common with Assyrian the tunic and the shawl. It differed from that dress in a less ostentatious display of ornament, in an infrequent use of fringe, and in a return to the robe, shaped like the Egyptian robe (fig. 9, Chap. I), but differently draped.

MEN

Heads. Hair, somewhat shorter than in the Assyrian fashion, was bushy and curly and is represented as arranged in small round curls rather than in waves or more complicated ringlets (figs. 18, 19); it covered or revealed the ears. Beards were black like the hair, and trimmed round (fig. 18b) or in a long point on the breast (figs. 18a and c and 19). Thick moustaches joined the beards. Hair was unadorned, or encircled by a band about three inches wide, low upon the forehead, often made of twisted cloth (fig. 18b). Another

headdress was a wide fillet almost as high as the king's crown and shaped like it; it is frequently represented as having a feather edging (fig. 18c). The king's crown was six or eight inches high all around, and wider at the top than around the head (fig. 19).

The hood was the usual head-covering of servants or anyone engaged in warfare or hunting. Of the examples sketched (figs. 18d and e, 20b, and 21) the hood covering the chin is most frequently seen. It varies in details: the peak can fall at the back (fig. 18d) or stand straight up (fig. 20b); or be lacking entirely. Peakless hoods show a stiff round top like that of a derby hat. For warriors this last hood might be made, like mediæval helmets, of plate and chain mail. The domed stiff cap, with ribbons hanging from the back (fig. 18a), is a style worn by men apparently not servants.

Bodies. The *tunic* differed from that of the Egyptians and Assyrians in that it sometimes had sleeves to the wrists, as shown on warriors. It was a fairly close-fitting garment and the sculptural rendering suggests that it might have been made of leather. Its belting was not important and was often entirely omitted. It was worn with trousers like those sketched in fig. 21, and was knee-length or longer. Fig. 22c shows its construction.

The *robe,* shaped like that of the Egyptians (fig. 9, Chap. I) can be reproduced thus: Fold the rectangle (its measurements are about twice the length of the wearer from shoulder to floor, by the distance from wrist to wrist) and cut a hole for the head. Seam it at the sides, leaving an arm-opening of about twenty inches, and put it on the model. Wrap a girdle tight around the waist, and draw the fullness up in great draperies under the arms; this makes the garment shorter at the sides than at the back and front, draws the material tight across the back and makes the front of the skirt-part fall in diagonal folds from the center to the sides (fig. 19). This robe was worn over another robe, or a tunic, and displayed trousered legs. It was tucked up high in front for active pursuits. This was the king's costume, though worn by noblemen also.

The *coat* was in two styles. One (fig. 23a) was ankle-length, open down the front, and had sleeves, the same size all the way down, set without fullness into an armhole. The sleeves were finished by turn-back cuffs and the neck by a simple rectangular collar, also turned back and fastened by ribbons. The other style of coat, reaching about to the knees in front, had cut-away skirts and folded over in front in a "surplice" effect (fig. 21). It was collarless and cuffless.

Legs. Trousers were a regular part of masculine dress. They were simply cut and tapered from hips to ankles, so that they fitted the legs neatly, almost like tights (fig. 21). They are sometimes represented with perpendicular trimming along the outer seam, adding to the slender effect.

Outer Garments. Occasionally, over the tunic, the Persians wore a semi-circular cape, fastened with ribbons. The long coat opening over a tunic may also be considered a wrap, especially when it was worn, as it is sometimes represented, cape-wise, without using the sleeves.

WOMEN

The data for Persian women's dress are as slight as for Assyrian. A tunic like the Assyrian (fig. 13) would seem to be the most probable body garment. There is in the Louvre the statue of a woman which shows such a long, straight dress, close-fitting, with tight sleeves above the elbow and a fringed scarf or cape. The scarf has one end hanging down the right front and the other down the left back (fig. 24). The effect of this drapery may be obtained thus: Take a scarf about twelve inches wide and three yards long, fringed on one side and both ends. Hold it with one end falling from the right shoulder to a little above the knee. Pass the rest of the scarf over the right shoulder, across the back, over the left shoulder, and diagonally across the breast to the right hip. Now bring the scarf across the back to the left armpit and, with fringe turned *inward,* forward and up to the left shoulder, letting the last end hang down the back. Pin the folds together on the left shoulder.

The Louvre statue is headless, but has a collar around the throat, like that on the Assyrian lady (fig. 13), and bracelets on the arms. The head of fig. 24 you will find explained on p. 38. Persian women also covered their heads and shoulders with large scarves.

Feet (men and women).

Bare feet were frequent, but when they were shod, it was with soft shoes having either turned-up points like Turkish slippers or naturally shaped toes (fig. 19).

MATERIALS

Like the Assyrians, the Persians made their clothes of linen, fine woolen, and leather. Silk was also known to them.

COLORS

Dyed colors were the same as with the Assyrians and Egyptians. The beautiful Persian tiles and ceramics have led us to associate their name exclusively with a certain vivid blue and blue-green; that glaze is, however, common to the pottery of Egypt and Assyria also. Persian glazes include a soft yellow and yellow-green, applied with pleasing effect to the costumes on the famous Frieze of the Archers.

MOTIFS

Persian designs were much the same as Assyrian, but were used with more restraint. The Persians borrowed details direct from Egypt, too, and from Greece, e. g., the anthemion (fig. 1i, Chap. III). The rosette (figs. 16j and k) appears frequently, for instance, as used on the robe (fig. 19).

The lion and bull were favorite beasts in decoration. The Persians took over the winged disk (fig. 16a), or substituted for the god Assur (p. 28) their god, Ahura Mazda, who looks exactly like the robed king in fig. 19, except that his skirt consists of two tiers of long feathers.

Application of decoration was the same as with the Assyrians, except that, as has been noted, the decoration was less profusely distributed.

Jewelry was like the Assyrian, but, again, was worn more sparingly. Earrings were general for men (and probably women) (figs. 18c and 19). Heavy chains or collars of gold, like a twisted cable, may have had some official significance, as did seal rings.

ACCESSORIES

Warfare. Persian warriors (who dressed in the enveloping coat or tunic, and wrapped their heads and chins in hoods) carried javelins like the Assyrian (fig. 7), simple bows (fig. 20a), and round, convex shields, scooped out at the sides and equipped with stout hand-grips on the inner surface (figs. 20b and c).

Personal. Walking-sticks were a regular part of a gentleman's equipment. There was a pleasant custom (still existing in Persia, it is said) of carrying a flower and presenting it to the first person one met, with a " good day " (fig. 19).

Other accessories, such as the writing-equipment, umbrellas and fly-whisks, do not differ from those described for the Assyrians (p. 30).

SOMETHING ABOUT THE SETTING

Glazed tiles formed the typical interior decoration. The furnishings of a palace did not differ materially from the Assyrian, unless in the direction of greater luxury; Susa, where Queen Esther lived, was an elaboration of the earlier grandeur of Egypt and Assyria.

The Persians show Egyptian rather than Assyrian influence in the use of the square lintel in preference to the arched doorway. Their columns were tall, slender, with fluted shafts. Furniture differed little from Assyrian and Egyptian.

Greek and Roman costume, the last styles to affect the Hebrews, are described in Chaps. III and IV.

DRESS OF THE HEBREWS

For first-hand information about Hebrew dress, we can turn only to those few foreign monuments which show Hebrews paying tribute to the king of the country, being made prisoners by him, or working as his slaves—not the way to see national styles at their best—and to word-pictures in the Bible. The latter, while vivid, are rather ambiguous. From a careful study of these two sources and from a long residence in Palestine, where living has in many respects not changed since Scriptural days, Tissot (p. 45) evolved his illustrations for the Old and New Testaments. The costumer should consult those illustrations for further details in a reconstruction as authentic as can be hoped for. The endeavor in the following pages will be to pick out the strictly national elements in the Old Testament Hebrew dress, elements which, originally borrowed from the various sources described earlier in the chapter, were fixed by tradition and persisted in the face of changing subjections.

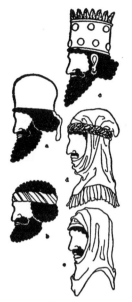

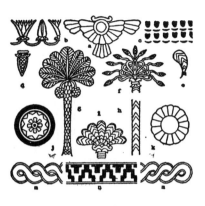

FIG. 16.
Assyrian motifs. a, Winged globe. b,
Lotus and bud. c, Scale. d, Cone. e,
Chevron leaf. f, The sacred tree. g,
Palm tree. h, Chevron. i, Palmette. j,
Rosette. k. Rosette. m, Glyph. n, Step.

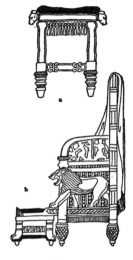

FIG. 17.
a, Stool or sacrificial
table. b, Solomon's
throne might have
looked like this.

FIG. 18.
Persian heads. a, High
cap. b, The archers'
fillet. c, An attendant's
feathered headdress. d
and e, Attendants' or
soldiers' hoods.

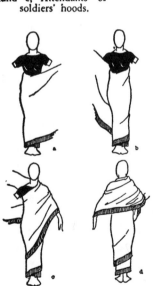

FIG. 15.
Assyrian war-gear. a, Shield of
hide and metal. d, Shield of
wicker-work. c, Tall shield for
archers. b, Detail of link
armor.

FIG. 14.
Draping the shawl in fig. 13. a, b,
c, Fronts. d, Back.

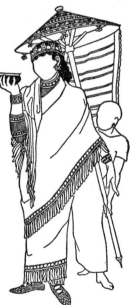

FIG. 13.
An Assyrian queen; to
drape shawl, see fig. 14.

GENERAL CHARACTERISTICS OF COSTUME

The Hebrews were originally a desert people, and they kept those traits common to the dress of the desert and persisting even today in Algeria and Morocco: large, enveloping garments and a drapery that protects the head and neck from fiery sun and penetrating sand.

Apparently from the Canaanites whom they dispossessed, they took the art of weaving cloth in wide perpendicular stripes, a dress feature which distinguished them throughout their Biblical days. Joseph's " coat of many colors " may well have been a garment of such stripes.

MEN

Heads. Hair was semi-long. Those who had made vows, like Samson, cut it not at all; others trimmed it. Tissot represents Samson with his long hair braided in seven braids. Fashionable people had their locks set in waves or curls, and anointed them to produce an admired glossiness. All Hebrew men wore beards, which were fairly long and neatly trimmed (figs. *passim*) but not cut square across or dressed in complicated curls, unless worn by one who imitated Assyrian styles, as Solomon probably did.

The shepherd people of Judea continued to wear the head-cloth of their nomad ancestors (fig. 25a) bound with a twisted cloth or cord. Contemporary carvings represent the Hebrews (in common with neighboring people) wearing pointed caps. The point might fall back (fig. 25c) or forward. Earflaps show plainly on the blunt-pointed caps worn by Hebrew captives depicted on a relief at Nineveh—wedge-shaped pieces falling just below the jaw-line or turned back upon the head. A cap with a small, limp, turn-down brim might have been made of leather (fig. 25b). A stiffer cap, or turban, rounded on top, often had a drapery depending from the back (fig. 25d). Tissot draws the Pharisees with such turbans of white linen, over-large.

Bodies (and legs). The loincloth was occasionally the sole garment, especially in the earlier periods. Priests and Levites were expressly enjoined to wear " drawers " or breeches of fine linen. Since it is said that the Laws were assembled in written form *after* the restoration from the Babylonian captivity, it is reasonable to suppose that these breeches were made like those of the Persians (fig. 21).

Setting aside details of foreign dress, described above, men's garments were: A short-sleeved tunic, cut in the usual way (fig. 5), probably ankle-length, and often fringed around the bottom; a rectangular shawl, wrapped as described earlier, *e. g.,* figs. 2 and 7—in the earlier days sometimes this shawl alone; around the loins over the tunic a wide girdle, reminiscent of Assyrian girdles; originally of leather, it was later made of rich materials, such as gold-woven fabric or jewelled metal.

As time went on, two tunics were often worn together, the first linen, the second wool. The top tunic then had wide-open sleeves, reaching about to the

elbow, under which emerged the sleeves of the lower, linen garment, which was cut like the diagram (fig. 22b).

Instead of the open-sleeved tunic, men might wear, over a close-sleeved, long-skirted tunic, the *caftan* (fig. 23b) trimmed with fringe or tassels on the edges.

The robe, resembling the Egyptian and Persian garments described above (p. 32), was, actually, narrower, measuring only from elbow to elbow or even less. It was left unseamed at the sides and held in place by cords under each arm. A garment of virtually the same shape, seamed at the sides and open up the front, was put on like a coat (fig. 22a). This is still worn in Palestine and called the " *aba.*"

Shawl, *caftan* and robe or *aba* had purple tassels attached by a purple or violet thread, one on each corner, which stood for the four consonants of the Holy Name, JHVH (see Deuteronomy 22: 12 and Numbers 15: 38). Scribes and Pharisees went in for extra long tassels.

The prayer shawl, a fringed square, seems to be the shawl described for the Assyrians and sketched in fig. 9, taken over by the Hebrews as a ritual garment. Wrapped around the waist at times, at times folded triangularly and laid across the back of the neck, it is especially associated in our minds with the Pharisees of the New Testament stories.

ECCLESIASTICAL VESTMENTS

Levites (under-priests) wore the linen breeches described above (p. 36), and the tunic. It was made of fine, soft linen which clung to the body, and had close, wrist-length sleeves and skirts ankle-length or longer (fig. 26). Its shape would be that of the Persian tunic (fig. 22c). It was wrapped about with an elaborate girding: a long ribbon of fine woven linen, heavily embroidered in blue (or violet), purple, and scarlet (the ritual colors). According to Tissot this was brought stole-like across the back of the neck, crossed to form a V in front, then wrapped four times around the waist, one row above another, each time knotted and looped in front, the final ends hanging down to the ankles (insert, fig. 26, shows the method of crossing in the back). Seven and a half or eight yards of ribbon about three inches wide would be needed for such a girdle. On their heads the Levites wore white linen caps, peaked, like those described above (p. 36) for the laity.

In addition to these garments the High Priest was dressed thus (fig. 27):

Over the white tunic went a narrow version of the robe described above, knee-length, seamed under the arms (as shown in the sketch). Its color was deep blue (or violet), and it was trimmed all around the hem with pomegranates embroidered in blue, purple, and scarlet, in pairs; between each pair of pomegranates was placed a golden bell (a real bell, which tinkled).

On top of the robe went the " ephod " (King James Version), a word variously translated as " tunic " (Jackson), " surplice " (Perrot and Chipiez) and " apron " (Moffat's Bible). It seems to have been a kind of scapulary,

i. e., two rectangles, about thirty by ten inches, fastened together by shoulder-straps about ten inches long. Attached to it was a girdle like that of the Levites, wrapped around the waist and tied in front. Ephod and girdle were made of " fine twined linen," violet, purple, and scarlet, woven with flattened gold strips (metallic cloth). On each shoulder-strap was a rosette of gold set with a beryl, which was " engraved like a seal " with the names of the Israelites.

The "breastplate of judgment" (a pouch or burse) was of the same brocade as the ephod. It was a nine-inch rectangle, doubled over to form a four and a half inch pocket, and was ornamented with four rows of jewels, three in a row, which stood for the twelve tribes of Israel. These jewels were set in rosettes of gold wire and were as follows (Moffat's translation):

1. Jasper (red-brown or yellow), chrysolite (olive-green), crystal (clear).
2. Garnet (deep red), sapphire (deep blue), sardonyx (reddish).
3. Cairngorm (smoky-yellow or brown), agate (moss-green), amethyst (purple).
4. Topaz (yellow), beryl (emerald green, light blue or yellow), onyx (black).

The pouch was attached to the ephod thus: gold rings were placed at the four corners of the breastplate, and chains of twisted gold linked to them. On the fronts of the shoulder-straps were gold rosettes, and low down on the ephod, just above the girdle, two more gold rings. To these were fastened the gold chains (by means of blue cords), thus keeping the breastplate secure on the ephod. (In our sketch only the upper chains show.)

The High Priest's diadem or mitre was in form like that of the Levites, but exaggerated in height. It was blue (or violet), and put on over the white turban of the ordinary Levite. It is not unlike the mitre of Assyrian king-priests or gods (figs. 12c and d). The mitre of the High Priest had an important ornament across the front, attached by violet-blue lacings: a golden plate upon which was engraved, in Hebrew characters, " Holiness to the Lord." There is a diversity of opinion about the appearance of the mitre. Tyack (see p. 46) describes it and Tissot illustrates it as shown on our figure, but we have sketched two other versions. Fig. 27a conforms to Josephus' description of the mitre as a triple crown with the golden plate hanging upon the forehead; 27b shows another version, according to both Smith and Maillot (see p. 46)—a dome-shaped crown covered with a puffed cloth, having a decorated head-band and a cloth hanging down the back.

WOMEN

Heads. Women, except harlots, always covered their heads. Their hair was arranged in elaborate braids. For the origin of these braids and the dangling gold ornaments which still remain a characteristic of Palestinian headdress, we may perhaps go back to early Chaldean styles (fig. 3). The high cap sketched in fig. 24 is a present-day Palestinian type, but Tissot puts it upon Queen Esther, with a Persian dress, about as we have done. Another cap, low

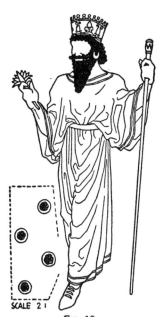

FIG. 19.
A Persian king. Inset—allover design on robe.

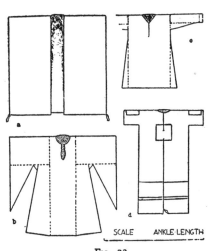

FIG. 22.
a, Hebrew outer coat or aba. b, Palestinian smock, worn by men and women. c, Persian tunic. d, Palestinian woman's upper garment, from *Oriental Costumes.* Max von Tilke, pls. 33, 28, 35, and 37.

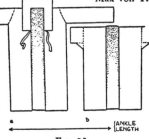

FIG. 23.
a, Persian coat. b, Hebrew coat or caftan, from *Ancient Egyptian, Assyrian and Persian Costume.* Houston and Hornblower, figs. 46a and 45a.

FIG. 21.
A Persian serving-man in hood, coat, and trousers.

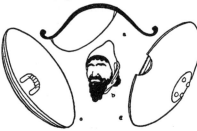

FIG. 20.
Persian. a, Bow. b, Soldier's or servant's hood. c, Inside of shield, showing handgrasp. d, Outside of shield.

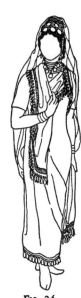

FIG. 24.
Queen Esther, in Persian dress and a Bethlehem headdress.

and close-fitting, was made of rich material and adorned with sequins (fig. 28). Over it was wrapped a cloud of white gauze, or, if preferred, a large heavy scarf with an embroidered border. Either the filmy veil or the scarf might also be worn directly over the intricate braids, which were adorned with sequins. Tissot pictures one other curious headdress: a pair of large drum-shaped ear-coverings studded with gold nails. This is attached to a small pointed cap which is trimmed across the forehead with sequins (fig. 29). The simple pointed cap (fig. 25c) was also a feminine head-covering, and so was a large shawl, wrapping head and shoulders.

Bodies. A simple tunic, almost sleeveless and rather loose, girded around the hips and falling to the ankle, was the primitive dress. Fig. 22d shows its type. This same tunic continued in use, the embroidery in the front and on the sleeves being, apparently, a later development. An equally simple dress was sleeveless and scant, made to overlap in a V in the middle of both front and back, then sewed up. A cord girded it (fig. 29). Finally, there was a gown with long, pointed, open sleeves, like the man's (22b), but longer-skirted (fig. 28). It was worn alone or with the large cloak (fig. 28) open in front (the *aba* shown in fig. 22a). It varied in length. The gown was ungirded or had a hip-girdle, as we have sketched it. The growing tendency was toward more voluminous garments; by New Testament times women were heavily swathed. Women were enjoined to wear, in the Temple, a veil which was to cover the entire head and face. It was transparent or had eye-holes cut in it. In New Testament times a woman's forehead and throat were sometimes closely wrapped in a veil like the gorget and wimple of mediæval times (Chap. VI), with the large veil put on top.

Feet. Both men and women frequently went barefoot. If not, they wore sandals (fig. 27) or shoes in the styles of their conquerors.

CHILDREN

Children in all the countries we have considered either went nude or were clad about like their elders. A Hebrew boy, for instance, would wear a loin-cloth and girdle, or a simple tunic, belted or unbelted, and a small cap; a girl would wear a simple tunic and a small cap on her loose hair.

MATERIALS

Linen, woolen, and, to a certain extent, silk, were all made into garments. Silk was frowned upon as too luxurious and savoring of the foreign oppressor (*e. g.,* by Ezekiel even before the Babylonian Captivity). Nevertheless, the "virtuous woman" in Proverbs 31: 22 wore silk.

COLORS

Especially in Old Testament times, colors were like those of the Assyrians and Persians (pp. 28 and 33). Under Roman influence there was probably

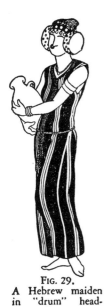

FIG. 29.
A Hebrew maiden in "drum" head-dress. She wears a nose-ring.

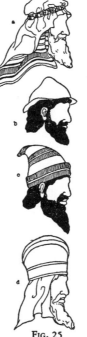

FIG. 30.
a, Hebrew scroll. b, Assyrian or Hebrew harp. c, Assyrian or Hebrew fan. d, Timbrel. e, Cymbals

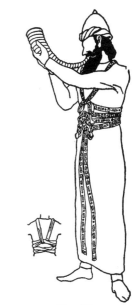

FIG. 26.
Levite. (Inset shows method of draping girdle in back.)

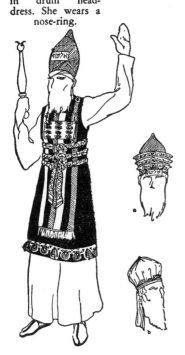

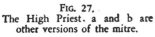

FIG. 27.
The High Priest. a and b are other versions of the mitre.

FIG. 25.
a, Headdress for a nomad: Abraham or a shepherd. b, Cap with brim. c, Pointed cap. d, Domed turban for a Pharisee.

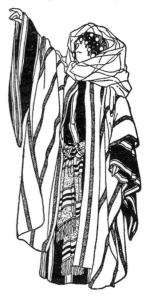

FIG. 28.
Hebrew woman (diagrams fig. 22 a and b).

a larger proportion of white and cream-color. As always, the rank and file wore dark, dull tones of blue, brown, tan, red, gray.

MOTIFS

Stripes are most typically Hebrew. They were perpendicular and woven in various arrangements such as two or more colors in alternating broad stripes, alternating broad and narrow stripes, or broad alternating with a group of narrow. Simple all-over geometric designs, usually large and crude, were employed in primitive times, and it was the geometric rather than the floral or animal motifs that the Hebrews copied from their various conquerors. Garments were frequently of plain, strong, rather dark colors, but variety was gained by wearing one garment over another of a different color.

APPLICATION OF DECORATION

Stripes and simple patterns were woven into the material; more elaborate designs were embroidered upon it. The applications of motifs followed the fashions of the dominant nation.

JEWELRY

In the strictly Hebrew practice jewelry seems to have been worn only by women, who displayed it in profusion. Ezekiel mentions rings and bracelets of " gold, silver or less," bangles, earrings and " splendid crowns," a necklace, and a nose-ring (fig. 29). It is said that the royal crown which Ahasuerus placed on Esther's head was only a purple or blue ribbon streaked with white, bound around the forehead—an attribute of the Persian royal family.

ACCESSORIES

Devout men wore " phylacteries " (narrow bands of parchment with sacred passages written upon them) bound about their foreheads and around their wrists. The Hebrews wrote in ink on parchment or papyrus, with reed pens, which they dipped into ink-horns. The written scrolls were rolled as shown in fig. 30a and read *down*, not like the Roman and Greek scrolls, from left to right. Women frequently carried mirrors of the general shape shown for the Egyptians (fig. 17d, Chap. I). Musical instruments included: a trump of ram's horn (fig. 26), psaltery (apparently about like the mediæval one shown in fig. 3, Chap. VI), tabret (a small drum), a pipe like the Egyptian (fig. 10, Chap. I); cymbals (fig. 30e), and a timbrel (fig. 30d), like a tambourine. David's harp was like the Assyrian harp shown in fig. 30b.

SOMETHING ABOUT THE SETTING

There seems to have been no distinctively Hebrew contribution to architecture or decoration—their building was in the style of the dominating race. I Kings, 6 and 7 and II Chronicles, 2 to 5, describe Solomon's temple and

the temple-furniture. Here and in I Kings 10, which tells of his palace, it will be noticed that gold predominates in the color-scheme and that the decorative motifs are suggestive of Assyria. Exodus 36–38 gives a detailed description of the Tabernacle furniture. The hangings were all of linen in the ritual colors, blue, purple, and scarlet. Josephus, speaking of the veils of the later Temple (in New Testament times), says that they were embroidered with purple flowers and had a gold vine spread over them. The furniture of the Tabernacle was constructed of acacia-wood overlaid with gold; of gold were the seven-branched candlesticks and all the altar vessels; those implements that went into the fire were of brass, and the curtain-rings of silver.

Solomon's throne (I Kings 6–7, II Chronicles 2–5) was of ivory, overlaid with gold. It had six steps and the top of it was round behind. A carved lion stood on either side and twelve more guarded the six steps. The throne in fig. 17b is an attempt to suggest this throne, which must have had an Assyrian model. The interior of any wealthy man's house would have had canopies, curtains, coverlets and cushions for the couch, and carpets and tapestries or other rich hangings decorated with Assyrian or Persian designs and imported from Damascus or Tyre. Even Saul's tent would doubtless have been hung with rich curtains. Besides the king's throne and footstool, furniture, as in Assyria and Persia, included chests, tables, and chairs, all made of cedar, cypress, or olive, inlaid with wood or ivory. As in Assyria, more ordinary furniture was made of reed.

After Alexander's conquest, many Hebrews had houses more like the Greek (Chap. III) and in New Testament times the Roman influence (Chap. IV) was evident, especially in the house of the Roman Pilate. The palace of the High Priest, however, would probably have retained its oriental atmosphere.

PRACTICAL REPRODUCTION

Materials. The woolens mentioned above can be represented adequately by different weights of flannelette (Chap. XX). Heavy muslin, dyed and rough-dry, does for heavy linen, and cheesecloth and cotton crêpe for softer stuffs. The latter materials make good veils; but organdie, nainsook, or tarlatan are better for the crisp white veils of Hebrew women. Materials like cretonne, mull, and silkaleen can sometimes be found in appropriate geometric designs. For the Persian costumes, where a silk effect is desired, soft sateen and pongee decorated (see Chap. XX) are appropriate also. Striped curtain or upholstery material is excellent to use for Hebrew costumes, because the stripes are wide; ticking, awning-canvas, and wide-striped dress-materials work in well for the less pretentious garments. The shawl type of cloak can be made from an old portière or couch-cover woven in stripes or large geometric patterns. Large silk handkerchiefs in modern Persian design work in for head-scarves, and India-printed table-cloths and bedspreads for tunics or shawls.

Application of ornament. Consult Chap. XX for ways of applying design. Tie-dyeing is appropriate for the earlier stages of Hebrew costume. Lavish a

great deal of gold paint on the Assyrian costumes and accessories and to a lesser degree on the Persian.

Millinery. Consult Chap. XX for ways to make the various hats, caps and crowns.

The headdress of two drums (fig. 29) is constructed thus: make a wire frame about seven inches in diameter (larger or smaller according to the size of the wearer's face), and about two and a half inches thick; join the two circles by two and a half inch wires in four places. Around the circumference and over one flat plane stretch heavy unbleached muslin, sewed firmly to the wire edges. Gild and decorate, simulating the nail-heads by outlining squares in black paint. Make a pair and attach them to a soft peaked cap. Add a forehead-band, gilded and decorated with sequins and jewels.

Jewelry. Buy sequins at a theatrical supply house (Chap. XX) or a costumer's. Milliner's wire, cotton-covered, can be twisted to make some of the jewelry, and then gilded. For jewels on the breastplate of judgment and elsewhere, use colored cellophane (Chap. XX). Large gilt or brass buttons can be use to simulate some of the other ornaments. Consult Chap. XX for further suggestions.

Hair. You can rent good wigs in the Assyrian or Persian styles, but if renting is too expensive, make them from black woolen yarn, thus: make a skullcap to fit the wearer tight and dye it the color his make-up will be. Sew the wool on in overlapping rows, fairly close together. Sew a parting down the middle and a fringe across the front, if that is your style; sew the hair close to the head according to your design, using a large back-stitch; and, finally, trim the wig. You can make the wool frizzy by braiding it in small tight strands, wetting and drying it. It is a long job, but the result is effective. If the actor is to wear a hat or a crown, you may fake the wig by sewing the wool as a fringe only around the headdress. Beards may be made in somewhat the same way, sewing them on a cloth foundation which has been fitted to the chin, and attaching the ends to the wig. For Assyrian beards, which look artificial anyway, this works very well. Hebrew beards, however, are supposed to be natural, and they ought to be of crêpe hair, in the usual manner of make-up.

Accessories. Recut shoes from soft felt slippers, or from heavy socks, decorating with paint. For ways of making sandals, see Chap. IV, p. 90. Socks, dyed leather-color and painted to suggest lacings and other decorations, imitate the high Assyrian boots (fig. 6). Run an elastic in the top to hold them up. Boots may also be fashioned from brown or black felt, seamed up the back, laced up the front and attached to slipper-soles.

For ways of making armor, see Chap. XX. Make the harp of wire—thin (like picture-wire) for the strings, heavy for the frame, which you will build out with papier-mâché (Chap. XX). Wrapping-paper, or, better still, window-shade material, on a wooden or heavy cardboard roll, makes good imitations of papyrus or parchment scrolls. Ink-pots, clay tablets, and cylinders can all be fashioned of papier-mâché, appropriately colored. A bamboo paint-brush

handle, whittled, makes a good reed pen. Reed-pipes like the instrument pictured in fig. 10, Chap. I, are easily made of rolls of buckram, held together with adhesive tape and some stitches and painted the right color.

Cutting. The construction and draping of the garments has been described. To make the Persian coat, either follow the diagram (fig. 23a) or cut the garment by a pajama coat pattern, putting on the collar that you see in the sketch. Use the pajama pattern for the Persian trousers. The legs taper more than those of the pattern, so you must narrow it from above the knee to the ankle, taking off on both the outside and the inside of the leg. You may find it convenient to cut the skimpier tunics by a kimono nightgown pattern.

Suggested Reading List

Ancient Times—By James Breasted.
Gives much information about all the people considered in this chapter and has a number of good illustrations.

The Civilization of Babylonia and Assyria—By Morris Jastrow.
Splendid for background reading, and has many excellent pictures.

History of Art in Judea, Chaldea and Assyria, and Persia—
Separate volumes, by Perrot and Chipiez (translated)—a standard authority.

Nineve et Assyrie—By Victor Place.

Monuments of Nineveh—By Layard.
Both of these are large books of illustrations in line and color. They are standard reference books and to be seen in the larger libraries.

The Old Testament—Illustrated by Tissot.
Full of beautiful pictures of great value to the costumer of Biblical drama.

Ancient Egyptian, Assyrian and Persian Costume—By Houston and Hornblower.
Has excellent pictures, drawn and painted from British Museum originals, and practical sketches and text explaining how to reproduce them.

History of Costume—Köhler and von Sichert.
Deals competently with the Hebrews as well as the other ancients.

Where Further Illustrative Material May Be Found

The costumes of these ancient people are to be seen on the surviving carved stone where they recorded their triumphs and on the glazed tiles with which they ornamented their walls, as well as on a few portrait statues and figurines. New excavations are constantly bringing to light more details, the jewelry found in graves being of especial interest to the costumer.

The British Museum and other important museums house many remains of these civilizations, and smaller art galleries often have a few originals and more casts. Photographic reproductions are frequent, and illustrate most of the books recommended above.

Sources of the Sketches in This Chapter

The existing art works as noted above, either the originals, or reproduced in casts or photographs. Such photographs are included in many books of art and archæology; those from which the illustrator principally worked are:

Assyrische Plastik—Ernest Wasmuth, publisher.
Die Kunst des Alten Orients—Schaefer u. Andrae.
Die Kunst des Alten Persien—Friedrich Sarre.
Perrot and Chipiez op. cit.
Morris Jastrow op. cit.
Breasted op. cit.
Bronze Reliefs from the Gates of Shalmanezer—British Museum publication, edited by L. W. King.

Other Sources Are:

Oriental Costumes, their Design and Colors, pls. 33, 28, 35, 37—Max von Tilke. (By kind permission of the publisher, Ernest Wassmuth, Berlin.)

The National Geographic Magazine (for Modern Palestinian dress).

Photographs in the *New York Times* for March 24, 1929, of the Field Museum Expedition discoveries at Kish, Sumeria.

Photographs in the *New York Times* for January, 1933, of the University of Chicago excavations at Persepolis.

" *Le Costume Oriental dans l'Antiquité*," Chap. II, by Leon Heuzey: an article in the *Gazette des Beaux Arts*, vol. LXVIII, 1926. For suggestions for draping the Chaldean shawl and the early Assyrian shawl, which we made and drew from our model.

Houston and Hornblower op cit.: for the analysis of draping the Assyrian priestly shawl, p. 62, figs. 34, 35 and 36, which we made and drew from our model; and for the plan of the Persian coat, fig. 46a and Hebrew coat, fig. 45a. (By kind permission of the publisher, The Macmillan Company, New York.)

Recherches sur les Costumes, etc. *Des Peuples de l'Ancien Continent*, Partie II, Asie, J. Maillot—only for his picture of the High Priest's mitre, a picture repeated in Smith's Bible Dictionary.

The high priest's robes have been reconstructed after studying Tissot op. cit., the opinions of the Rev. George Tyack in his " *Historic Dress of the Clergy* " and those of the editor of the Temple Bible; and the Biblical descriptions of the vestments of Aaron and his sons. Comparison was made between the texts of the King James Version and the recent translation by James Moffat.

Chapter III
GREEK

APPROXIMATE DATES:

Cretan (the Pre-Hellenic civilization of the Ægean Isles), 3000 to about 1200 B. C. (the supposed date of the Trojan War).
Archaic Greek, 600–480 B. C.
The "Golden Age" (Fifth Century), 480–400 B. C.
The Fourth Century, 400–320 B. C.
The Hellenistic Period, 320–100 B. C.

Cretan Costume

Regretfully, Cretan costume must be dismissed with only a word. This book must cling to its purpose of describing costume for the *stage,* and as yet the Cretan styles have not proved very practical for theatrical dress. The earliest events recorded in Greek literature, the adventures of the Homeric heroes, while they probably occurred at the end of the Cretan period, are costumed (following Homer's own descriptions) in Hellenic fashion.

The dress of Cretan men was not very different from that of their Asiatic neighbors (Chap. II) *i. e.,* variations of the tunic and loincloth. Women's costume, however, was unique: cut, shaped, fitted dresses of the bodice-and-gored-skirt type, with flounces, bands, and aprons, looking startlingly like the costume of our respected forebears of the 1870's, except that the breasts were entirely exposed—an impractical style for the stage.

Cretan decorative and architectural details are beautiful and adaptable to stage use. The Reading List suggests some books to consult for this interesting period.

Some Important Events and Names

ARCHAIC

The Homeric poems were committed to writing about 700 B. C.

Greek Mythology was crystallized at about the same time.

The Tyrants ruled in Athens during the Sixth Century.

The Drama developed.

Pindar, poet; Sappho, poetess.

THE GOLDEN AGE

Battle of Marathon (490): Darius the Persian vs. Miltiades the Athenian.

Battle of Thermopylæ (480): Xerxes the Persian vs. Leonidas the Spartan.

Battle of Salamis (480): Xerxes vs. Themistocles the Athenian.

The end of P e r s i a n domination in Greece.

Pericles, statesman; Herodotus, historian; Phidias, sculptor; Æschylus, Sophocles, and Euripides, writers of tragedy; Aristophanes, writer of comedy; Socrates, philosopher (died 399).

FOURTH CENTURY

Alexander the Great, of Macedon (d. 323), dominated the second half.

Plato, philosopher; Xenophon, historian; Demosthenes, orator; Praxiteles, Scopas, and Lysippus, sculptors.

HELLENISTIC

Greek political power faded, Greek culture spread.

Euclid, mathematician; Archimedes, scientist; Aristotle, Zeno the Stoic, and Epicurus, philosophers.

Some Plays to Be Costumed in the Period

All the plays, ancient and modern, based on the Homeric tales of Helen, Odysseus, the gods and heroes, and dance-dramas of mythological inspiration, *may* be costumed in the archaic style, but equally well in the simpler and more graceful manner of the Golden Age. "Greek Games" and all dances of the "interpretive" type usually take their inspiration from art examples of the Golden Age or later. Aristophanes' comedies should be dressed in contemporary fashion, that of the Fifth Century, *e. g.,* "Lysistrata," which has recently enjoyed a Broadway success.

GREEK

G REEK life seems to many of us as remote in experience as in years, a fabulous and withal pallid existence where everything was "classic" and everybody highbrow enough to appreciate the "classics" of art and literature. One reason for this feeling may be our American unfamiliarity with the language; another and more potent reason is that our visual knowledge of the Greeks is gained through the cold medium of photographs and plaster casts. Dutifully we agree that they are beautiful, but our interest is tepid. The costumer, however, must put aside any idea of Greek life as pale and conventional—he must see the Greeks and their art in terms of color as well as form. The antique Greeks were a Southern people, positive, vivacious, passionate. They lived under intensely blue skies, in a country sometimes carpeted with flowers—Athens is still known as the "violet-crowned." They painted their buildings and their statues, painted, gilded, and inlaid their furniture, dyed their garments, and adorned themselves with jewelry of yellow-gold. Ancient Greece witnessed the youth of Western culture, when learning was an exciting adventure, when all those arts, sciences, philosophies, and theories of government which have become commonplaces to us were new. The Spartans at the pass of Thermopylæ, the runner with the news of Marathon, Phidias creating his heroic Athena, Sophocles writing and directing the "Electra," Socrates questioning his disciples—no frigid academic figures these, but men like ourselves, only more creative, more passionate, more alive.

GENERAL CHARACTERISTICS OF COSTUME
MATERIALS

Since all draped garments, such as the Greek, depend for their beauty very largely on the quality of their material, a consideration of Greek dress may well start with Greek textiles. The Greeks wore woolen, linen, and to some extent silk.

Woolen was most generally employed, and was made in a variety of weaves, all the way from coarse to very fine—but always, apparently, loose and supple, capable of falling in soft folds; like "homespun," for instance, rather than suiting-flannel, like "wool georgette" rather than twill. The woolen blankets hand-woven in country districts not so long ago are probably like the coarser textures. Fine woolen fabrics are said to have had a sheen, the natural gloss of animal-hair textile.

Linen was also woven in grades from coarse to fine, and must have displayed the same suppleness. Even in the archaic representations of sheer linen garments we do not as a rule see the suggestion of stiff, crisp folds which is noticeable in Egyptian pictures (Chap. I). An exception is the stiffly pleated skirt showing under armor. This might have been made of very heavy linen or of wool like suiting-flannel or even felt; again, the stiffness may be only a convention of the artist.

Silk was worn, but rarely; until the Hellenistic period at least it seems to have been lustreless, like our raw silk or Shantung, though sometimes more transparent. It was occasionally woven with gold threads.

COLORS

As we have noted, the Greek scene was not one in which white and pastel shades predominated. If the colors still clinging to once polychromed statues may be taken as a guide, dresses were bright-hued, and that impression is borne out by references in Homer and by the few fragments of actual textiles still existing. (To be sure, in the Golden Age, when moderation was an ideal in dress as in other departments of life, colors were perhaps less vivid than in the more barbaric periods, but that does not mean a uniform paleness, a series of pastels, or a predominance of white.) Homer mentions yellow, indigo, green, violet, dark red, dark purple (for the tone, see p. 88), and these were undoubtedly supplemented by the ordinary colors obtained with vegetable and earth dyes, such as rust, henna, nut brown, and dull green and by white and black.

MOTIFS

Out of an almost endless variety of motifs, we can name and picture only ⅎ few. They fall into convenient classifications (fig. 1):

Geometric, such as the rosette (a), key or fret (b), dentil (c), guilloche (l), and many arrangements of circles, squares, diamonds, stars, etc.

Those derived from natural forms, such as the egg-and-dart (f), wave (j), and meander (k).

A large number derived from vegetable forms, including the acanthus (d and e), laurel (g), waterleaf (h), anthemion (i) and ivy (fig. 12), and many medallions inspired by leaf-forms, inclosing other motifs.

Designs of men, animals, and birds, in great variety. More common in the archaic period than later were very wide borders displaying processions of men and horses.

APPLICATION OF DECORATION

Dress materials were dyed, and, except the very plainest, were embellished with decoration, if only a bordering stripe. Small motifs dotted over the material were often used in connection with borders. Such borders, wide, were

arranged one above another till the effect was obtained of an all-over patterned material. Designs were woven on the loom, woven or darned in like tapestry, embroidered on a plain fabric, or painted on the cloth, evidently with dye.

THE TYPICAL GARMENTS

The purely Greek garments, untouched by foreign influences and essentially the same for men and women, were neither shaped nor fitted, but were draped upon the body in the piece as it came from the loom, and sewed, if at all, only in straight seams. There were four types, all rectangles: the *chiton* (dress), (a) Doric and (b) Ionic, and two over-draperies, the *himation* and the *chlamys*.

The Doric chiton (figs. 2a and 3), called also the *peplos,* was the earlier and simple dress and more often a woman's garment than a man's. It was woven to the wearer's measurements, frequently with a border on all four sides of the rectangle. For women, its measurements were: double the distance from elbow to elbow or a few inches wider, by from one foot to eighteen inches more than the wearer's height. In adjusting, the superfluous length was folded over till the garment reached from shoulder to floor (or longer, if blousing was intended). The chiton was put around the wearer, the open side usually at the right, and pinned on the shoulders, back over front (fig. 2). Thus both neck- and sleeve-openings came from the folded-over top of the rectangle. Variations of this style will be noted below.

The Ionic chiton differed from the Doric in having no overfold, but was, like the Doric, a single strip woven in a size appropriate to the wearer. Some writers assert that the true Ionic garment always formed the sleeves from the sides instead of from the top of the rectangle, but this does not always seem to be so. Especially as a woman's garment, the Ionic chiton was wider than the Doric. It was bordered at top and bottom, not at the ends of the rectangle, for the ends were ordinarily seamed together. There were many variations of the true Ionic chiton, which will be discussed below.

The himation was a large rectangle, in appearance and in use the same as the shawl described in Chaps. I and II. It was an outer garment for both men and women, and for men (according to artists' representations) sometimes the only garment. Its measurements varied according to the size of the wearer and the use he made of it. Generally speaking, it was larger in the later centuries than in the archaic period. Frequently it was woven with a border all around. For a fair-sized himation the measurements are seven or eight feet long, by the wearer's height in width.

The chlamys, a smaller rectangular shawl, was especially useful to horsemen, foot-soldiers, and travellers, but was worn by women also. Sometimes men wore the chlamys alone, and then it was fairly large, though never so long or wide as the himation. Average measurements are six or seven feet long, by three and a half feet wide.

MEN

Heads. In the archaic period, men wore their hair long (fig. 8). The early statues show men with curled locks, and later on with their abundant hair gathered into a knot at the back. Sometimes the hair was twisted into a great club bound with ribbons, sometimes it was braided and wrapped around the head in a coronal, as women wear it now. The Spartans, who clung longest to older fashions, wore long hair at the battle of Thermopylæ, but by that time the Athenians were having theirs clipped. When long hair was the mode, it was a token of mourning to cut off locks and dedicate them to the deceased. In the fifth century and afterwards, men's hair was fairly short (figs. 4, 6, 7), either like an overgrown modern trim or as long as the average " bob." Athletes particularly had short hair.

Archaic men put various ornaments such as gold pins in their long tresses, but in the later periods men's hair was unadorned. Charioteers and runners kept their locks out of the way with wide bands (fig. 7), as tennis-players do now. *Fillets, i. e.,* ribbons to tie around the head, and wreaths were given as prizes to the victors in athletic and musical contests. The victor in the great Olympics received a wreath of olive placed over a woolen fillet; he who triumphed at Delphi, a laurel wreath; and both the successful competitor in the recitations in honor of Dionysus, and the victor in the dramatic contests of the Dionysia, an ivy wreath. At banquets men adorned their heads with wreaths of fresh flowers.

Stiff pointed beards, without moustaches, are typical of the archaic period; young men, however, are often represented as beardless. In the fifth century and later, young men were smooth-shaven while their elders wore moustaches and trimmed beards (fig. 4). A moustache without a beard is not a Greek fashion.

Hats. Of hats there were two sorts, one the simple cap, not unlike those worn by Hebrews (fig. 25b and c, Chap. II), the other the *petasos,* a traveller's sun-hat. The latter (fig. 6) was woven from grass or palm-leaves, and had a shallow, slightly pointed or round top and a wide brim. The brim was sometimes made in four petals, one or more of which might be turned up. The Phrygian cap (fig. 10, Chap. V) was occasionally worn by Greek men. In place of these coverings, men often protected their heads with an end or fold of the himation or chlamys.

Bodies. The Ionic chiton, of wool or sturdy linen, was the usual masculine body garment. In earlier periods a long chiton was the dignified style for young men or old, but by the fifth century it had become outmoded for youth and was retained only by some conservative older men, those sacrificing to the gods, harp-players, and charioteers. With the last, it is said, the long skirt was useful as a protection for the legs. Fig. 7 shows the charioteer's chiton and the manner in which it was held close to the body: a narrow girdle or cord crossed the back of the neck, passed over the shoulders and under each

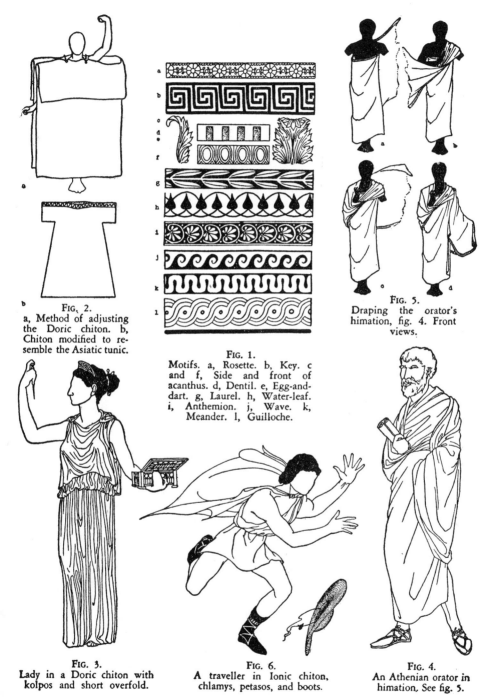

FIG. 2.
a, Method of adjusting the Doric chiton. b, Chiton modified to resemble the Asiatic tunic.

FIG. 1.
Motifs. a, Rosette. b, Key. c and f, Side and front of acanthus. d, Dentil. e, Egg-and-dart. g, Laurel. h, Water-leaf. i, Anthemion. j, Wave. k, Meander. l, Guilloche.

FIG. 5.
Draping the orator's himation, fig. 4. Front views.

FIG. 3.
Lady in a Doric chiton with kolpos and short overfold.

FIG. 6.
A traveller in Ionic chiton, chlamys, petasos, and boots.

FIG. 4.
An Athenian orator in himation. See fig. 5.

arm, linked into the back loop (see inset), and came around the waist to tie in front. A wider leather belt encircled the waist.

After the archaic period, the short chiton (fig. 6) was more generally used by all ages and classes. Its width was double the distance from elbow to elbow, its length approximately from collar-bone to knee; when the girdle had been adjusted and the garment bloused over, it was often shortened to mid-thigh. Frequently it was fastened only on the left shoulder either by a pin or by a knot, thus leaving the right arm and breast free. If the chiton were fastened on both shoulders, it was either pinned at intervals down the arm, as shown in fig. 7, or sewed to form the tops of sleeves. In the latter arrangement, a band of trimming often finished the top edge of the chiton (fig. 8). The arms emerged from the sides of the sewed chiton.

A variation of the pure Greek garment was the short Ionic chiton modified in the manner of the tunics worn by Assyrians and other Asiatics (Chap. II), i. e., from the original rectangle material was cut away under the arms, to leave sleeves of the " kimono " type (fig. 2b). A neck-opening was scooped out from the straight edge and a band of trimming sewed across, the effect being not much different from that in fig. 8. Notice that the typically Greek neck-line, shallow front and back, wide on the shoulders, distinguishes it from the Egyptian or Assyrian tunics (Chaps. I and II). With this shaped chiton was worn a belt about three inches wide.

Outer Garments. The himation was draped over the long or short chiton, or served as the only garment (fig. 4). One way of arranging the enveloping himation is as follows (fig. 5): Measurements: width, from armpit to instep, length, three and a half or four yards. Hold one end under the wearer's left armpit, cross the material in front, under right armpit and across the back diagonally to left shoulder (a). Bring the material down over left arm and turn it (b) as you cross the body. Draw it over right arm like a sling and over right shoulder (c). Cross the back again and drape the final end over the left arm (d and fig. 4).

This studied arrangement was the style, especially among orators and philosophers, in the fifth and fourth centuries. The archaic way of wearing the himation was like a shawl, the two ends hanging down over the arms in front. Later variations were to fasten it together on one shoulder (usually the left), and to wrap it around the body, throwing the final end over the shoulder, as shown in fig. 7, Chap. II.

The chlamys also could be worn without any other garment, but probably not so often in real life as in art (e. g., the well-known statue of the Apollo Belvedere, where it serves only as decoration). It is frequently represented over the short chiton (fig. 6). It was a favorite cloak for horsemen and was sometimes used in battle in lieu of a shield, for, fastened with a brooch on the right shoulder, it covered and protected the whole left side. A small chlamys, twisted, could serve as a girdle, as seen on the woman athlete in fig. 14.

Feet. In ordinary house or street occupations, men went barefoot or wore

sandals. At its simplest, the sandal was a sole with a leather thong between the great and second toes, connected with another thong going around the heel (fig. 12). In later centuries this style was nearly supplanted by others of greater com‑ plexity and more comfort (figs. 4 and 14). Boots, worn for support and protec‑ tion in the more arduous pursuits, reached to the calf or above. They were leather and were either laced up the front (fig. 20) or bound to the leg with leather straps (fig. 6). A curious boot worn in the archaic period had a sort of tongue curving out at the top (fig. 8). Men in simple dress wore a boot so soft, close-fitting and plain that it seems to be nothing more than a high sock. Sandals whose straps wrap around the leg to the calf give the effect of boots (fig. 9).

SOLDIERS

Warriors in early centuries fought naked save for the chlamys and a helmet, but later they dressed in the chiton and equipped themselves with helmet, cuirass, and greaves. Helmets varied in design (two styles are illustrated, figs. 9 and 10); their most distinguishing feature is the immense crest, or plume, of metal, horsehair, or feathers.

The cuirass at first consisted of a front and back piece of cast bronze (fig. 9), but afterwards it was of leather, plated with bronze in overlapping scales (fig. 10). It was worn over the stiff, pleated chiton mentioned on p. 50. The greaves or shin-guards (fig. 10) were of brass, bronze, and, later, iron.

In the earlier periods, shields were oval and convex (fig. 9), later they were round (fig. 10); they were often ornamented both inside and out. A sword-belt was worn over the cuirass, diagonally, right shoulder to left hip. The swords were short and thick (fig. 10) and sometimes curved (fig. 9). Other weapons were: the spear, about as long as the warrior was tall; the javelin, like that carried by the Assyrian in fig. 7, Chap. II; leather sling-shots for throwing pebbles or leaden balls; and bows and arrows. The arrow-shafts were about twenty-four inches long, with small, delicate heads of bronze or stone. Bows were of two kinds: (a) the more primitive sort, of one piece of wood, bent by the string; (b) the later style, of two curved pieces of horn or wood con‑ nected by a metallic band (fig. 8). Quivers were of leather or basket-work.

WOMEN

Heads. In the archaic period women's hair was worn hanging, arranged in carefully set snaky curls (fig. 15) generally held in place by a fillet or wreath. After the Persian wars, hair was commonly put up and confined in a variety of ways. The prevailing line is the one we associate with Greek women, *i. e.,* with a knot protruding at the back, so placed as to balance the nose in the profile view. Hair was often uncovered and unornamented, but it might be confined and adorned by a variety of kerchiefs, bags, or nets (figs. 11 and 12). A diadem worn over the brow (figs. 3 and 12) was as frequent as a support for the back hair, wide behind and narrow in front (fig. 13). One fillet (fig. 16),

two (fig. 17), or occasionally three (fig. 14) held the hair close to the head. However elaborate its ornament, the coiffure was not so built up as to distort the natural shape of the head, nor was the hair unduly curled or frizzed. Generally a veil or a fold of the over-drapery served for hood, though women as well as men wore the petasos (fig. 6) as a sun-hat.

Bodies. The pure Doric chiton (p. 51), made of wool, was the severely simple national garment favored by conservatives, especially in Sparta. It could be worn exactly as described and pictured in fig. 2a, ungirded and open on the right side; in any of the styles described below, the right side might equally well remain open or be seamed up. The chiton was originally fastened on the shoulders with long, ornamental stickpins (figs. 2a, 11, and 22a); later on, fibulæ (safety-pins, fig. 22e and f) were substituted, or the garment was sewed on the shoulders (fig. 13). While the chiton was usually lapped upon the shoulders back over front (fig. 2a), that method was sometimes reversed (fig. 12). The front and back pieces were so held that the material stretched tighter across the back than the front, making a high straight line in back, and a pointed fold in front, something like the style known to dressmakers as a " cowl " neck.

The overfold was an essential part of a Doric chiton (figs. 3, 11, 12). Its length varied greatly, from not much below the breast-line to below the hips. Even if the chiton were seamed up at the right side, the overfold might be left open.

The girdle was sometimes visible, sometimes hidden either by the overfold or the *kolpos* (the name for the bloused part made by pulling the chiton up over the girdle to make it the right length from the ground) (fig. 3). As represented in this sketch, the overfold was short enough to show the kolpos; often it was much longer, covering the rather small kolpos. In such arrangements the girdle was invisible. If a girdle (perhaps a second one) were tied on top of the overfold, the arrangement was called the " peplos of Athena " (fig. 13).

In the earlier centuries, the Doric chiton was sometimes scantier than the measurements given on p. 51, being not more than double the distance from mid-arm to mid-arm, and was closed at the right side. It had a short overfold, stopping above the waist-line, and little or no kolpos (fig. 11). The effect of this chiton, as it appears in the vase-paintings, is of a closed bolero jacket and a skirt. Yet our sketch was drawn from the living model dressed in a rectangular chiton of meager proportions. The neck often seems to have been shaped a little besides being bound with a decorated edging (fig. 11); in that case, the dress was sewed on one shoulder and adjusted with a pin on the other, the left shoulder-pin being merely an ornament. In some representations the neck-finish could be taken for a round collar, reminiscent of the Egyptian collar (Chap. I), though not so wide; such a collar would have been put on over the regular chiton neck. This narrow Doric chiton, as well as the one shown in fig. 13, must have formed its armholes from the sides; this would

FIG. 10.
A warrior in armor of over-
lapping plates.

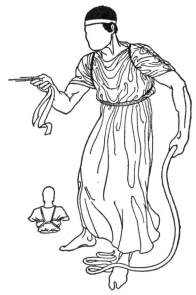

FIG. 7.
Charioteer in Ionic chiton. Inset
shows method of girding.

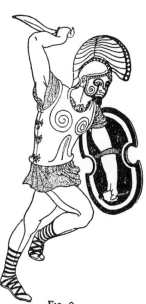

FIG. 9.
A warrior in bronze
armor of an early style.

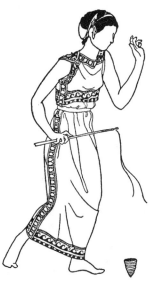

FIG. 11.
Girl in narrow Doric chiton.
This garment is made of a
rectangular piece of cloth, not
shaped by cutting.

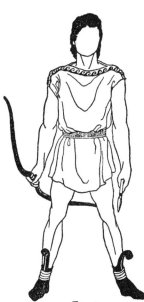

FIG. 8.
Archaic man in sewed
Ionic chiton.

necessitate opening the seam at the right side and cutting a slit to correspond to it on the left.

The Ionic chiton for women was ordinarily made of much thinner material than the Doric—commonly linen, sometimes silk—and was semi-transparent. Its measurements were: double the distance from wrist to wrist, by the wearer's height, or possibly a foot over, depending on how it was to be girded. It was adjusted essentially like the Doric chiton (fig. 2a), except that its great width necessitated pinning it from the neck-opening down each arm with about five pins or brooches, thus forming elbow-length sleeves. Since the Ionic chiton had no overfold and was of soft material, it lent itself to many varieties of girding. For instance, a long chiton might have two girdles, the one invisible, over which the kolpos was drawn up, blousing to the knees, the other visible, around the natural waist-line. The skirt would be no longer than to the knees and at that length is appropriate for Artemis or any huntress or girl-athlete (fig. 14). The same garment, pulled down long, would serve as a house-dress. The kolpos was also arranged to blouse over the girdle at the natural waist-line.

With or without a large kolpos drooping over the girdle, the Ionic chiton might be confined under the breast by a cord (fig. 16). Such a cord sometimes crossed at the front and linked into the back, in the arrangement shown on fig. 7. This binding served to keep the garment snug on the shoulders, for the weight at the sides tended to pull the neck awry.

Variations of the Ionic Chiton. The chiton could be much narrower than the measurements given above (fig. 14). It was sometimes arranged like the man's chiton in fig. 8, with a band of trimming around the neck and down the arms, the top permanently sewed, not pinned. Like the man's chiton shown in fig. 2b, the woman's dress could be cut out in sleeves, which were, moreover, sometimes wrist-length. (This is also the chiton or tunic worn by tragic actors.) Occasionally there was added to the Ionic chiton a false overfold, only in front, like a bib, pleated and sewed to the neck under a band. A short-sleeved tunic, cut like the Egyptian garment (Chap. I), but reaching only about to the knee, was put on over a narrow Ionic chiton, which showed at neck, sleeves, and skirt (fig. 17). The Ionic chiton, rightly an undergarment or decidedly a house-dress, was worn with the open Doric chiton on top, the soft, loose, transparent sleeves of the first emerging from the sleeveless shoulder of the second. Fig. 12 is taken from an Etruscan mirror-case. The mode was not typically Greek.

In the fifth century, such hybrid garments (especially those showing Asiatic influence) were not approved, and styles were more purely Greek, but again in Hellenistic times many oriental variations crept in, with the increasing use of soft imported silks.

Outer Garments. In the archaic period the himation was arranged in a puzzling way (fig. 15). Opinion now seems to be that it was the usual rectangle, put around the body and fastened on the right shoulder and down the right

arm with a series of brooches. According to Houston (see p. 69) the folds were made by pressing pleats in the side under the left arm, holding them while the rectangle was drawn tight up from left armpit to right shoulder and fastened there, and then pulling the pleats up and out in a frill above the tight diagonal line. It can be done this way, if you work with firm, rather adhesive material like flannelette, not with silk, which slips too much.

Such an elaborate arrangement went out of style by the fifth century, and the large himation was draped in various ways, as described for men. For women, as for men, one simple early arrangement was with the two ends falling in front, scarf-fashion. A charming practice often pictured in the later vase-painting, was to drape the first end at the left side, bring the rest around the back and over the right arm, and cross the body with the final end, draping it over the left arm (fig. 16). Another very simple method was to drape the himation under the right arm and across to the left shoulder leaving diagonal ends to fall both front and back, and fasten it with a fibula on the left shoulder.

To the fifth and fourth centuries especially belongs the beautiful fashion of enveloping the entire body and head in a very large himation, a mode which can be studied in the little terra cotta statuettes found at Tanagra. Fig. 18 shows the type and fig. 19 the steps by which it may be reproduced: *measurements*. About fifty inches wide (it does no harm to make it wider) by four or four and a half yards long.

Pin one corner to the right shoulder. Draw the scarf diagonally across the throat, pulling part of it down upon the arm, part over the head to the right side (a). Bring it around the right shoulder, across the breast and over the left shoulder and arm (b), again across the back and over the right shoulder (c). Now bring the last end across the body, around the left hip (under the earlier fold), and around to the right hip, when it is held in the right hand (fig. 18). The beauty of this himation lies in its flattering emphasis of the figure, and the way to get that effect is to pull the drapery tight as you go, especially across the back. The line is prettiest when, as shown in fig. 18, the wearer holds her right arm akimbo. The arrangement can of course be reversed, to leave the right hand free.

Women also wore the chlamys; sometimes it is difficult to determine what to call a large chlamys and what a small himation. The smaller drapery was worn as described for the himation and also in a charming and easy fashion (which was followed by men also): one end hung down the left side; the remainder of the chlamys was passed diagonally across the back, under the right arm, diagonally up across the chest and flung back over the left shoulder. A separate veil was sometimes draped over the head, and this may also be classed as a small chlamys. It was worn alone or in company with an himation. Sometimes such a head-covering was formed of the back overfold of a Doric chiton. Women's heads were covered for mourning and for performing sacrifices, e. g., Electra at the grave of Agamemnon.

Occasionally women, as mænads or possibly huntresses, wore the skins of

animals such as leopards draped across the body, or around the loins, or hung at the back like a cloak, the paws coming around the neck.

Feet. Women often went about the house barefoot. If shod, indoors as well as during their infrequent trips about the city, they wore soft sandals, cut like those of the men (figs. 12 and 14), but made in light or bright colors.

Amazons. Warrior women are represented in various masculine-style costumes: short Ionic chiton like the one on fig. 6 or fig. 14, or else Phrygian armor, Scythian or Persian trousers, and tunic. Our Amazon (fig. 20) wears scale armor in the Persian style, a short chiton, a chlamys, and a Scythian helmet. Her weapons are a battle-axe and a curved sword like the one shown in fig. 9.

CHILDREN

Infants were swaddled (*i. e.,* wrapped in long bands of linen, confining both arms and legs). After infancy boys went about quite naked for some years, even at school age being often clad only in the chlamys. It is said that a well-bred boy took care to keep his arms covered. Little girls, when they emerged from swaddling-clothes, were put into simple, narrow Ionic chitons, with narrow girdles crossed in front (fig. 21). After the twelfth year or sooner, boys and girls dressed like their elders. Athenian boys wore their hair longer than in the fashion for adults.

RELIGIOUS DRESS

Since there was no permanent priestly caste in Greece, there seem to have been no particular sacerdotal robes. Anyone, man or woman, who officiated at a religious rite, covered his head with himation or veil.

The gods themselves, however, enter Greek drama, and may therefore be considered for a moment. They were thought of as beautiful and heroic-sized men and women, dressed in the same style as their worshippers, except for special attributes. Many of these distinguishing details are familiar to us; all of them are to be found in the pages of Bullfinch, Gayley, or Frazer. Those most often needed on the stage are: the lion-skin and knotted club of Heracles; Athena's peplos (fig. 13) worn under the "ægis" (a short cuirass or gorget, sometimes of metal, sometimes of goatskin), and her helmet and round shield; and Hermes' winged petasos, winged sandals, and "caduceus" —a serpent-twined, wingéd staff. Apollo as the leader of the Muses wore a long Ionic chiton and long hair, like a woman; Artemis the huntress was dressed like the girl in fig. 14, carried bow and arrows, and sometimes wore the upturned crescent moon in her hair; Hera wore the crescent-shaped diadem shown in fig. 3; Aphrodite had no special costume, save that she was sometimes pictured nude, but her flowers were roses, and her bird the dove. Her sea-birth was remembered in attributes like shells and dolphins. Poseidon, clad in kingly garments and wearing a crown, had for attributes a trident and sometimes also a dolphin, a fish, or a horse.

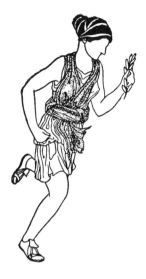

Fig. 14.
Woman athlete in narrow
Ionic chiton and chlamys.

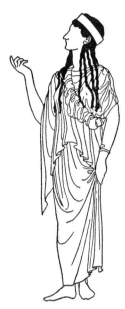

Fig. 15.
Archaic lady in an
elaborately draped
himation.

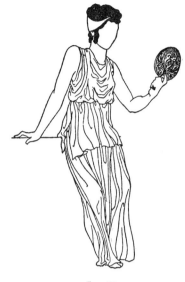

Fig. 13.
Narrow Doric chiton with arm-
openings at sides.

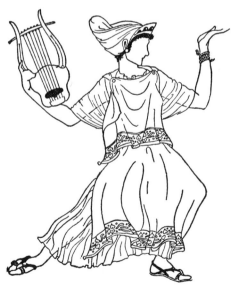

Fig. 12.
Woman with a lyre. She wears a
Doric chiton over an Ionic.

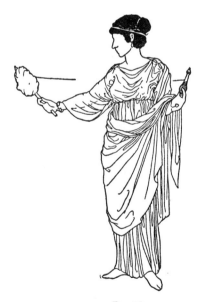

Fig. 16.
Matron in Ionic chiton and
himation.

JEWELRY

Greek men and women did not deck themselves with such an abundance of ornaments as did the Assyrians. The different articles were, however, large and might now be considered barbaric. Jewelry was usually of pure yellow-gold and, until the Hellenistic period, not often set with stones, but worked in beautiful and intricate designs, e. g., fig. 22c.

Although in the archaic period men appear to have worn gold ornaments in their hair, by the fifth century their jewelry was usually limited to one ring, engraved with a seal (fig. 22d).

Women wore necklaces, bracelets, rings, earrings (fig. 22c), and pins. They had long stilettos to keep the hair up (a and b), shorter stickpins, such as they used to fasten the Doric chiton (figs. 2a, 11), and *fibulæ* or safety-pins in great variety (fig. 22e and f, figs. 3 and 12). Their hair-ornaments, especially the diadems, were often gold, the hairpins gold or carved ivory.

ACCESSORIES

Ladies carried fans like the one sketched in fig. 23b and parasols (23a). Very likely an importation from Asia, these parasols are smaller than the Assyrian and Persian (fig. 13, Chap. II), and seem to have been held by ladies over their own heads as often as by their servants. Unlike the Asiatics, Greek men did not make use of parasols. They did, however, carry walking-sticks, which are pictured as about breast-high, with a T-shaped top.

The mistress of a house, her daughters, and her maid-servants prepared the cloth which they made into garments, spinning their yarn on hand-spindles (fig. 16) and weaving it on large, upright looms capable of holding a wide web. They made tapestry and embroidery upon hand-frames (fig. 17). In their less industrious moments they might amuse themselves at the toilet-table. Its equipment would have included a charmingly decorated jewel-box (fig. 3); bottles and jars, large or small, of metal, ivory, or alabaster, but all in pleasing shapes; and a hand-mirror of polished bronze (fig. 13). Upon the table there would doubtless have stood another bronze mirror, in a beautiful frame of intricate design (fig. 25e).

Greek vases, each type with its name and special function, are a study in themselves; fig. 25 (a, b, and d) shows only three of the shapes. Fig. 25c is the silhouette of a lamp, in which burned a wick floating in oil. Such a lamp might be carried about or set upon a stand intended for that purpose (fig. 15a, Chap. IV).

Professional musicians played the cithara (fig. 24c). The lyre (fig. 12) on the other hand was more commonly played. Indeed, lessons upon the lyre and the double flutes were part of the curriculum in boys' schools. A mouth-harness was often used in playing such flutes (fig. 24a). Shepherds especially played the syrinx or Pan-pipes, which were sometimes made in graduated lengths, as they are shown in fig. 24b, and sometimes all the same

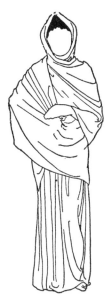

FIG. 18.
Himation draped in the style of the Tanagra figurines. See fig. 19.

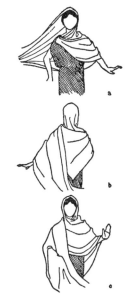

FIG. 19.
Draping the himation, fig. 18.

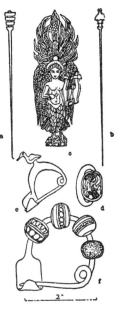

FIG. 22.
Jewelry. a and b, Hairpins or stick-pins, c, Earring, drawn from a gold earring in the Metropolitan Museum. d, Seal ring. e, f, Archaic fibulæ.

FIG. 21.
Little girl in Ionic chiton. Her toy is a terra cotta horse.

FIG. 20.
An Amazon wearing Persian scale armor, chiton, and chlamys in the Greek manner, and Scythian helmet.

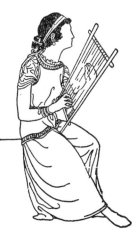

FIG. 17.
Lady weaving tapestry. She wears an Asiatic tunic over her Ionic chiton.

length. A simple sort of bagpipe was also known. Cymbals (fig. 30e, **Chap. II**), castanets, and sistrum (fig. 12, Chap. I) accompanied religious dances.

Wax tablets or rolls (fig. 17b and c, Chap. I), written on with a stylus, served the same purpose as our slates, but permanent writing was done with ink and reed pens upon papyrus or parchment. Books were inscribed upon scrolls, fastened on two sticks, rolled horizontally, and read from left to right (fig. 6, Chap. IV).

The whipping-top was a popular toy, and grown-up girls are pictured playing with it (fig. 11) as well as with knuckle-bones, with which one played a game like our jacks or else threw them like dice.

SOMETHING ABOUT THE SETTING

Temple architecture is of the horizontal type. There are no outer walls, but the flattened roof is supported by columns in single or double rows around all sides. The front shows a shallow pointed roof, the triangular space below, the pediment, filled with sculptural decoration. Fig. 26 shows the four "orders" of Greek capitals.

Private houses were built to look inward, not outward. They received light and air from the inner courtyard, open to the sky, with the rooms grouped around it. The court-ceiling was supported by pillars. The interior decorations of private houses were wall-paintings and, in the later centuries, mosaics.

Furniture, in shape not unlike the Egyptian, was made of bronze or wood. Stools were designed with straight legs and with curved ties, as in fig. 23c; chairs had curving backs and legs (fig. 23d) and sometimes arms; tables were small and low, beds narrow, with decorated head- and foot-boards. Couches (fig. 17, Chap. IV) were luxuriously equipped with mattresses and cushions. Men reclined upon these at banquets.

PRACTICAL REPRODUCTION

Materials. If you have chosen the right materials, you have solved half the problem of dressing a Greek play successfully. The drapery of the statues, revealing every line of the perfect bodies, and by its subtle curves contributing a beauty of its own to the design, is often the despair of the costumer, who "just can't seem to get it." When we turn to the vase-paintings we are confronted by another problem. In adapting their designs to the shapes and surfaces of pottery, the artists must have conventionalized drapery, so that there again exact imitation is difficult, if not impossible. The solution, it seems to me, is to abandon the effort to reproduce literally any particular statue or vase-painting. Instead, consider what qualities in real materials will produce the same types of drapery, and make the costumes of such materials, in the styles which approximate those depicted.

Material for Greek costumes must fall in "dead" folds, that is, it must not have any stiffness of its own which will hold it away from the body.

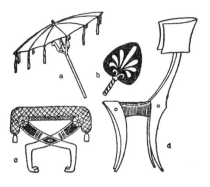

FIG. 23.
Accessories and furniture. **a,**
Parasol. b, Fan. c, Stool. **d,**
Chair.

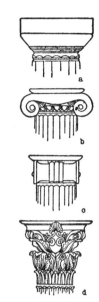

FIG. 26.
The Greek capitals. a, **Doric. b**
and c, Ionic. d, Corinthian.

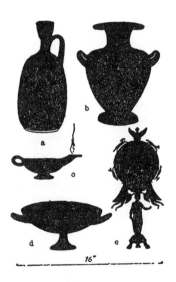

FIG. 25.
Accessories. a, Lekythos b,
Hydria. d, Kylix. c, Lamp. e,
Standing bronze mirror.

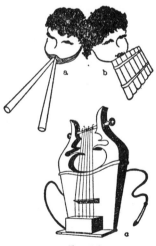

FIG. 24.
Music. a, Double pipe with
mouth harness. b, Syrinx or
pan-pipes. c, Cithara.

Chapter XX gives a list of materials which drape well; from that list we may select the following as especially adaptable to our purposes:

To represent heavy woolens, use various grades of flannelette, washed or dyed and rubbed to loosen the nap; for the finer woolens, a very cheap grade of unbleached muslin, well boiled (probably dyed) and dried smooth but not ironed. If you can afford real woolens, you will find a number of lovely soft weaves, among them balbriggan, wool crêpe, wool georgette, albatross, nun's veiling, viyella flannel, and Indian cashmere.

Imitate the heavier linens with Japanese crêpe, "baked" as described in Chap. I, or washed to remove the new look and dried straight but unironed. A slightly better quality of unbleached muslin than that mentioned above, laundered or dyed and used rough-dry, will also pass for linen. Inexpensive sateen, laundered to remove its stiffness and most of its sheen, substitutes for the better grades of linen.

Represent the still more diaphanous weaves by cheesecloth (Chap. XX, p. 573), cotton voile, pongee (especially satisfactory), mull, and washed silkaleen. You may also work in cotton and rayon mixed crêpes and various novelty weaves, if you will keep in mind when buying them that they must drape without stiffness and not be too shiny. Rayon materials sold for sash-curtains or, more opaque, for draperies, can be used to imitate those native silks woven with strands of beaten gold.

Help the effect of clinging drapery by judiciously placing weights along edges, invisibly, or quite openly as little balls at the corners of chiton or over-drapery (fig. 12).

Decorating. Materials of the right texture can almost never be bought in appropriate Greek designs—decoration will have to be applied in the workshop. Dyeing is the best process, for that does not affect the draping qualities. For methods of applying dye in patterns, see Chap. XX. Afterwards you can put on touches of gold with a brush, free-hand, but not enough to stiffen the garment. Remember that appliqué, while not quick to put on, is durable and satisfactory, especially on the heavier materials used for overdraperies.

Making the Garments. Cheap materials are seldom woven wider than thirty-six, sometimes only twenty-seven, inches, and one problem with draped garments is so to arrange the seams that the drapery is not marred. Two and a half widths of thirty-six inch material must go into the Doric chiton measuring double the distance from elbow to elbow, to be worn by an average figure, *i. e.,* size 34–36. The wide Ionic chiton (measuring double from wrist to wrist) takes three thirty-six inch widths for figures size 36–40.

Expensive woolens, fifty to seventy-two inches wide, should of course be put around in the authentic manner, *i. e.,* with the warp-thread running *across* and the selvages top and bottom, but if widths are pieced together the seams must run up and down. Crosswise seams spoil the drapery, and when they show, interfere with the long vertical line. (One of the virtues of cotton crêpe is that the seams are less evident than in smoother materials.) When you stitch

seams, do it with a loose thread, so that they will not draw. Stitch the overfold part of a Doric chiton on the *opposite side* from the rest, so that when it is turned over the seam is *inside*. Do not put hems in Greek garments. If you dislike raw edges, have them picoted, but see that the work is done with a loose thread, else it will pucker. Cut and seam the chitons before dyeing them, but be sure to allow from two to four inches for shrinkage—six is safer for cotton crêpe.

The shape of Greek garments and, in general, their adjustment, has been explained on pp. 51 and 54. It remains to consider how far it is wise to modify these historic methods for stage use. I believe that in most instances the draped rectangle can be retained, but that it can be permanently sewed in some places, after adjustment, so that the whole process need not be repeated for each wearing. For instance: adjust the man's short chiton, fastening it on one or both shoulders, and secure it with good firm stitches, but wrap the girdle and arrange the length each time it is put on. Do the same with a woman's long Doric chiton, and be sure to pin it to her brassière-straps when she puts it on. Both Doric and Ionic chitons fastened on both shoulders should be adjusted at the neck thus: hold the middle of the back half straight across the back of the neck, allowing ten or eleven inches (or the distance just inside the collar-bones) from pin to pin. Match twelve, thirteen or fourteen inches in front to this ten- or eleven-inch back opening, and pin them together, back over front (fig. 2a). The front will droop in a slight V, an effect that can be further accentuated by hanging a little weight in the middle, to drop inside, as is done with cowl-necked dresses. It is not satisfactory to sew this drooping part in permanent pleats, for it will not look the same the next time it is put on. Do not make the neck-opening too wide, or it will slip on the shoulder. It has been pointed out (p. 58) that in the Ionic chiton this tendency is counteracted by binding a cord over back and shoulders and under the arms (fig. 7).

Visible girding, around the waist, across the breast, or low on the hips, must be adjusted at each wearing, but for the girdle concealed by the *kolpos* (blousing) or an overfold you can substitute elastic run in a casing. For greater security, pin voluminous garments invisibly to the underwear at waist or hips.

A chlamys or himation must be adjusted at every wearing. Concealed pins as well as visible fibulæ may secure it, for the ease of the actor, not accustomed, like the Greeks, to taking care of draperies.

If you attempt the archaic pleated arrangement of the woman's himation (fig. 15 and p. 59), plan it out and adjust it on the wearer and then and there sew it to a strip of cloth or a wide tape, on the under side. The drapery on the shoulder and arm can be sewed to stay, and the round fibulæ simulated with buttons.

Insist that undergarments for both actors and actresses be reduced to a minimum, for the unhampered body should be outlined under the draperies. However, it is well to remember that these garments were opaque, that what

clothing the men did wear was of solid stuff, and that amongst women only a *hetera* or courtesan wore one single transparent garment.

Jewelry. Consult Chap. XX for construction or adaptation of jewelry. Do not use brilliants or any sparkling gem effects; " costume jewelry," recurrently popular (earrings, necklaces, and bracelets of yellow-gold), can often be used as it is.

Accessories. Suggestions for making various accessories of wire, papier-mâché, buckram, etc., as well as instructions for making armor, are given in Chap. XX. For making reed-pipes, scrolls, and instruments like the cithara, see Chap. II, p. 44.

The crest on top of a Greek helmet may represent metal like the helmet itself. If, however, it is to look like horsehair or feathers, use a soft dust-brush, a feather-duster, or a bunch of cock's-feathers. You can retain the back or socket of brush or duster, fastening it with nails, screws, and glue to the crown of the helmet.

Footwear. Sandals are not very easy to make satisfactorily. It is a comfort to remind yourself, therefore, that the Greeks often went barefoot in the house and even outdoors. If the actors must be shod there are ways to accomplish it. " Rehearsal sandals ". of soft seude, costing a dollar and a half or two dollars a pair, are very comfortable, and they can be cut out to more nearly resemble Greek styles, as shown in figs. 4 and 14. They come in gray or " white " (ecru), but can be over-dyed with suede dressing or the leather dyes procurable in ten-cent stores. Color them brown, black, and, for women, brighter colors such as red, blue, and green. If it costs too much to buy sandals for everybody, make some of heavy scenery muslin or upholstery canvas, sewed on a slipper-sole. Follow, in general, the diagram for a Roman sandal (fig. 11, Chap. IV) and the directions on p. 90. For the construction of boots, consult Chap. II. The soft boot described on p. 55 is the easiest to make and the most comfortable to wear, for it can be represented by a heavy sock, rolled at the top over an elastic and decorated as you wish.

Narrow girdles can be mere strips of the dress-material, in the same color or dyed darker if you want to emphasize the line of girding. Two-inch wide cotton tape is useful, too. Elastic is satisfactory for all concealed girdles, and wide elastic webbing, which may be gilded and decorated, makes good wide girdles or " zones."

Millinery. The construction of headdresses should present no difficulties. Most of them are made of ribbon or wider strips of cloth, wrapped around the head, or they are cloth caps made in two pieces with a seam down the middle, or felt caps like those of the Hebrews (Chap. II). Cheap " peanut-straw " hats can sometimes be bought in the shape of the petasos; any straw hat can be cut down, a piece of buckram can be painted straw-color and blocked on the head-mold (Chap. XX), or felt can be treated in the same way. The high support for the back hair (fig. 13) is made of a framework of thin wire, covered with metallic cloth, gilded net, or any other material.

The diadem over the brow (figs. 3 and 12) is easily made of buckram cut in a crescent shape, gilded or otherwise decorated, and held on by a narrow elastic concealed under the hair.

Adaptation to Type. Greek dress is more individual than any other. A style can be found to suit any type of figure (though obviously the more nearly ideal the figure the better it will look in this natural drapery), but each individual must be studied and the style of garment chosen especially for him or her. The principles of design which should govern the selection of any costume apply here. Remember in particular that strong horizontal lines shorten a figure, long unbroken lines lengthen it. The place of the girdle, the presence, absence, size, and place of the kolpos or the overfold, bareness of arms or drapery to the elbow, the nature of overdrapery, all make or mar the effect. A short, ungirded overfold is a mistake on a full-busted woman, but may look charming on a slender girl; a tall, willowy woman can wear the ample kolpos seen on the Erectheum maidens, but it is too bunchy for the short woman, even though she is slender.

The success of Greek costumes depends, finally, on the grace and poise with which they are worn—and that, unfortunately, is something which the costumer cannot sew in.

Suggested Reading List

Greek Dress—By Ethel B. Abrahams.
> A standard reference book, its authority based on a study of Greek texts as well as works of art. The reconstructions on living models are rather dowdy, but don't let them discourage you—your costumes need not look like that.

Histoire du Costume Antique—By Lèon A. Heuzey.
> An excellent book. It also has reconstructions on living models, a trifle more attractive than those of Abrahams, and proving convincingly that costumes can be made on his plans.

Greichische Kleidung—By Margarete Bieber.
> German text; line-drawings from vases, with diagrams; photographs of sculpture with accompanying reconstructions on models. The author has succeeded in making her models look very attractive.

Chapters on Greek Dress—By Lady Evans.
> A short book, but very sensible.

Ancient Greek, Roman and Byzantine Costume—By Mary G. Houston.
> Includes Cretan dress. Good text. Drawings from British Museum sources; sketches and diagrams of reconstructions.

Costume of the Ancients—By Thomas Hope.
> Line-drawings, mostly from vases. While it has been the fashion to disparage this book (published in 1875), it is valuable for its many and careful reproductions of the costumes, furniture, and accessories pictured on Greek vases.

A Guide to Greek and Roman Life—British Museum Handbook.

The Daily Life of the Greeks and Romans—Metropolitan Museum Handbook.

History of Art in Ancient Greece—Perrot and Chipiez.
> A standard book.

Social Life in Greece—Mahaffy.
 For the Greek background.

Everyday Life in Homeric Greece—By Marjorie and C. H. B. Quennell.
 Written for children, but of interest to anybody. Good pictures of costumes and accessories.

Ægean Archæology—By H. R. Hall.

The Palace of Minos at Knossos—By Sir Arthur Evans.

Alt Kreta—By Helmut von Bossert.
 This book, with the two immediately above, will give you a good idea of Cretan costume and accessories.

The Age of Fable—By Thomas Bullfinch.

The Golden Bough—By James Frazer.

Classic Myths—By Charles Mills Gayley.
 This book and the two preceding will give you further information about the gods and their attributes.

Where Further Illustrative Material May Be Found

There is a rich store of contemporary material from this great period, much of it familiar to almost everybody. It falls into the following classifications:

Sculpture: (a) architectural, (b) ideal statues, (c) realistic statues (including portraits), (d) relief sculpture, including architectural, grave-sculpture or " stele," and sarcophagi.

Painting: Practically the only survival is vase-painting, but this is a rich field, for the pictures include innumerable scenes from everyday life, showing articles of personal adornment, costumes, and household equipment.

Literature: The poets, from Homer on, have occasional references to costume throughout the texts. The historians, like Herodotus, have occasional references. The philosophical writers have occasional references.

The books suggested in the Reading List are illustrated with photographic or line reproductions of the various art works mentioned. These may also be seen in any standard art history, in textbooks of ancient history, and in inexpensive art prints. The most famous sculpture is reproduced in plaster casts, of the original size or smaller, and some of them may be seen in schools as well as museums throughout the country.

Sources of Sketches in This Chapter

We have drawn freely on the above sources for our sketches. We have studied the sculpture mostly in reproduction, casts or photographs, but have availed ourselves of the opportunity for first-hand study of vase-paintings, small bronzes, jewelry, terra cottas, and other articles in the Metropolitan Museum, supplemented by reproductions of similar examples in other collections. The earring (fig. 22c) is copied by permission of the Museum authorities from one in the Metropolitan, the fibulæ from two in the British Museum. The parasol is like one in a line-drawing by Hope (op. cit.), though we have seen parasols elsewhere, notably a much mutilated one carried by an Eros on the Parthenon frieze.

Chapter IV
ROMAN

DATES:

753 B. C. (the traditional founding of Rome) to
330 A. D. (Removal of the Capital to Byzantium.)

Some Important Events and Names

The Rule of The Kings, 753–500 B. C.
Horatio, Tarquin, Lucrece, celebrated in poetry.
The characters of the "Æneid," who, though presumably of an earlier time and more Greek than Roman, might be dressed like the preceding.

The Republic, 500–31 B. C.
Punic Wars, 264–146 B. C.
The Scipios, Elder and Younger.
Hannibal. (More Asiatic than Roman; see Chap. II.)
Cato.
Plautus and Terence, writers of Comedy.
The Gracchi.
Marius and Sulla.
The Conspiracy of Cataline.
Cicero.
The Triumvirate (Cæsar, Pompey, and Crassus).
The Gallic Wars, including the conquest of Britain.

The Empire, 31 B. C.–330 A. D.
Cæsar Augustus and the "Golden Age," 31 B. C.–14 A. D.
The poets Horace, Ovid, and Virgil.
The Life and Ministry of Jesus.
Nero, and the persecution of the Christians, 54–68 A. D.
Seneca, writer of Tragedy.
Tacitus, historian.
The destruction of Jerusalem by Titus, 70 A. D.
Destruction of Pompeii, 79 A. D. (See Bulwer-Lytton's "Last Days of Pompeii.")

Persecutions of the Christians continued from Nero, d. 68 A. D., to Diocletian, 284–305. This interval (250 years) is called "Early Christian."
Marcus Aurelius, the philosopher emperor, 121–180.
Christianity put on legal equality with other religions, 311.
Constantine removes his capital to Byzantium on the Bosphorus and renames it Constantinople, 330 A. D.

Some Plays to Be Costumed in the Period

The Kings:
Plays based on the "Æneid" and the "Lays of Ancient Rome," "Lucrece."

The Republic:
Shakspere's "Coriolanus."
Robert Sherwood's "The Road to Rome."
Shakspere's "Julius Cæsar" and "Antony and Cleopatra."
Shaw's "Cæsar and Cleopatra."
Masefield's "Tragedy of Pompey the Great."

The Empire:
Shakspere's "Cymbeline."
All the plays based on New Testament events.
Charles Rann Kennedy's "The Terrible Meek."
Masefield's "Good Friday."
Lew Wallace's "Ben Hur."
Shaw's "Androcles and the Lion."
Shakspere's "Titus Andronicus."

ROMAN

CONCERNING THE ROMANS

AUSTERITY marks the popularly accepted ideal of Republican Rome, an ideal still talked of in Cicero's day, though frequently belied by the actual life around him. Imperial Rome, on the other hand, is characterized by wealth, extravagance, ostentation, and a wholesale appropriation of the arts, literatures, manners, and religions of subject nations. The strongest influence, however, was always Greek. Ever since Etruscan times the inhabitants of Italy had looked to Greece for their culture, so that there was never such a marked difference between Italian and Greek art and costumes as between Greek and, for instance, Egyptian. In late Republican and Imperial times Roman thought reflected Greek, Roman artists copied Greek sculpture, Seneca modelled his tragedies, as did Plautus and Terence their comedies, on the Greek dramatists, and Virgil wrote the "Æneid" in a conscious effort to supply Rome with an Homeric national epic.

Rome was the bridge connecting the cultures of Greece and northern Europe, and so it remained until the Renaissance, when the first-hand study of Greek language and art was revived. The eighteenth century classic revival, which inspired the great furniture-designers and interior decorators, stemmed from Rome rather than from Greece, and it was Roman rather than Greek republicanism that the French sought to set up in place of their monarchy.

Rome, moreover, is still with us. We are surrounded by Roman eagles, mottoes, bank buildings, and railway stations. It may be that modern Americans really have an affinity for ancient Romans. Perhaps, as Booth Tarkington suggested in "The Plutocrat," the Successful Business Man of the U. S. A., striding masterfully through the Old World, is a veritable reincarnation of the Roman Imperialist, riding conqueror-wise through the streets of Athens and Alexandria.

GENERAL CHARACTERISTICS OF COSTUME

From the legendary first date till about 100 B. C., Roman costume, with the exception of the toga, is hardly to be distinguished from Greek dress of the same period. Etruscan influences are but little different, except that the Etruscans seem to have adopted the cut and fitted Asiatic styles more than did the Greeks. A reference to Chap. II will recall the Asiatic variations of tunic, skirt, and shawl. Roman austerity in the early Republican era inclined to the simplicity that characterized the same centuries (fifth and fourth) in Greece (Chap. III). There was, however, this slight difference in the construction

73

of garments: whereas the typical Greek *chiton* formed its sleeves from the *top* of the doubled rectangle (fig. 2, Chap. III), its Latin equivalents, the *tunica* and *stola,* usually opened at the sides for the armholes. At an early period, too, the Roman tunica habitually had sleeves about the length of those worn by the Assyrians (Chap. II), though the tunica was not tight like the Assyrian tunic, but draped (fig. 2). After 100 B. C., Greek and Roman dress showed more and more the effects of foreign influences, both Oriental and Western European; these united in changing the classic draped garments into cut, shaped, fitted dresses, depending for their beauty more and more on lavishly applied ornament and less and less on line. In the early Empire this change was not yet very evident, and so long as the toga kept its honorable position, (that is, till about 100 A. D.), the ordinary Roman citizen continued to look much like his Republican grandfather.

In costuming a play laid in the Roman world at any time during these thousand-odd years, we must first determine the correct size and shape of the toga. For the rest, we may make the following assumptions: if the period is early, the actors should look much like the Archaic Greeks (figs. 8, 9, 11, 15, Chap. III); if it is before the Punic wars, they should be simply clad in the best Greek tradition (figs. *passim,* Chap. III); if it is late Republican, the circumstances of the play and the characters represented will determine whether the actors are again draped with antique austerity or clad in garments which show the influences of Oriental luxury and Roman ostentation; if it is early Imperial, the dress of women, even the most sensible of them, should reflect something of the vogue for a stiff coiffure, covered arms, and lavish decoration; and if it is after the death of Nero (68 A. D.), men also should wear long and elaborate tunicas, to compensate for the absence of the out-moded toga. We may except from this statement country-folk and the poor generally, who continued to be merely covered by rough tunics.

<div align="center">MEN</div>

The Toga. The *toga* being the garment which distinguished Roman citizens from everybody else in the world, it is fitting that it should be dealt with first. At this point it will be named, characterized, and classified; later will come instructions for making it.

When the Romans emerge in semi-legendary history, both men and women are wearing a simple version of the toga, not unlike that *himation* worn by Greeks of the same period, which some writers believe was also rounded on two corners. During the two hundred and fifty years of the Kings, women may have continued to wear the toga, but after that they discarded it in favor of the *stola* and *palla;* only a woman who had shamed her honorable estate and was deprived of the right to wear the *stola* now donned the male toga, as a sign of her degradation.

The earliest recognized toga (of about the fifth century B. C.) was a segment of a circle, approximately sixteen feet along the straight edge (A-B) and six

feet across its widest part (fig. 1, I). If there were a band of trimming, it
followed the *curved* edge. At first this toga was the sole masculine garment,
save for a loincloth, and thus it continued till about 300 B. C., when the *tunica*
began to be used under it. The material was always wool. The toga was worn
by all male citizens, and banishment deprived them of the right to wear it.
(While indeed " foreigners " never had the privilege of the toga, it must be
remembered that the status of " citizen " was enjoyed by non-Italian provincials
under Roman rule. Thus St. Paul (who was Saul of Tarsus, in Cilicia) would
have had the right to be " togated.") Yet in the period of the Empire the toga
was actually seldom worn except for ceremonial occasions. From the third
century B. C. to the great days of the Empire, the toga underwent gradual
changes, always enlarging; then, after about 100 A. D., it grew narrower and
was always more and more closely folded, till it ended as a long narrow band,
which is described and pictured in Chap. V (frontispiece and p. 100).

The instructions given below for draping the togas are quoted, directly or
indirectly, from *The Roman Toga* (Wilson). The toga which has been
chosen for special attention and which is illustrated in figs. 1, 2, 3, and 4, is
the Large Imperial Toga, in fashion from the early Empire till Nero, and
therefore useful in a large number of plays, including the Passion Plays and
" Androcles and the Lion." It is the largest of the togas and, because of its
bulk, among the most difficult to drape; if you can drape this, you can manage
any of its predecessors. Diagrams and descriptions of these others may be
found in *The Roman Toga;* the following especially may prove useful to the
costumer: Toga of the Early Republic (diagram, fig. 7); Large Toga of the
Republic (diagram, fig. 16); Toga of the Ara Pacis (diagram, fig. 18) (the
toga you would use in " Julius Cæsar "); and the Late Form of the Toga
(figs. 62, 63, 67–68d, and 69) (a toga which you might need for a consul in
the time of Marcus Aurelius).

The toga must be carefully adapted to the size of the wearer; to accomplish
this Miss Wilson has evolved a system of individual measurement. By " unit "
is meant the measurement of the wearer from the base of the neck in front
to the floor, taken with shoes on. The " girth " measure is taken at the waist-
line. The dimensions AB (length) and cd (width) are the measurements
which must be most carefully taken, and if these do not differ more than
an inch or so for two actors (which is the same as saying that the two men
are nearly of a height and bulk) the toga can be worn by one or the other.

Large Imperial Toga—from " The Roman Toga " (Wilson), Schedule IV, p. 122

Extreme length (AB) girth plus	2 and $\frac{3}{7}$ units
Width of each end (Aa and Bb)	$\frac{1}{2}$ unit
Length of straight upper edge (EF)	$\frac{6}{7}$ unit
Length of straight lower edge (CD)	1 and $\frac{5}{7}$ units
Extreme width (cd)	2 and $\frac{5}{56}$ units
Width of sinus (cQ)	$2\frac{7}{28}$ unit
Width of lower section (dQ)	1 and $\frac{1}{8}$ units

Although these measurements may seem over-complicated, experiment in the costume workshop has shown that they work, and, moreover, Miss Wilson has proved that they work *better* than the segment-of-a-circle patterns that other writers advocate. The process of draping is explained on p. 92.

Either toga in fig. 1 could have a line of trimming two or three inches wide. While on the very early toga (I) the line is on the *curved lower* side, in II and III it is on the *upper* side, marked BEFA. This is the *sinus* side. The line stands for the purple band which marks it as a toga *prætexta* (see below). Figs. 1, III and 2 show an Imperial toga prætexta, with the sinus folded over ready for draping, and 2 demonstrates its size compared with the model, who stands in his tunica, waiting to be draped; figs. 3 and 4 show the same toga as it was worn, the one in ordinary occupations, the other in religious duties. The emperor himself, as Pontifex Maximus, wore this toga with the sinus over his head (fig. 4).

Besides varying in size from period to period, the toga had within any period several differences of decoration and color, which distinguished one class of wearer from another:

Toga *pura* or *virilis*, the ordinary dress of any Roman citizen, plain, of cream-white wool, and in all periods about six inches shorter than others in the current styles. This was the habitual costume of leisured persons, and it was donned by any citizen for formal occasions, though laid aside by artizans at their work.

Toga *prætexta* (figs. 2, 3, 4), the toga of public office, worn by consuls, prætors, censors, dictators, and other officials, and (strangely enough) by a young boy up to the age of fifteen or sixteen, at which time he ceremoniously assumed the toga *virilis*, which he continued to wear till he had earned the right to some other. Its distinguishing feature was, as has been said, the purple band, the color of which is described on p. 88.

Toga *candida*, the ordinary toga *pura*, made extra white by bleaching or treating with fuller's earth. It was assumed by those seeking office, hence the name " candidates."

Toga *pulla*, dark gray, brownish, or possibly black, used for mourning.

Toga *picta*, the triumphal toga, originally worn by victorious generals and the property of the state, later the official dress of the emperors and privately owned. It is believed to have been purple, embroidered with a pattern in gold thread.

Toga *trabea*, a parti-colored toga, purple-bordered (like the prætexta). The color apparently differed with the position of the wearer: (1) all-purple, for those consecrated to the gods, (2) purplish and white, for kings (in early times); and (3) striped in purple and scarlet, for augurs. A very specialized garment, you see, reserved for important people and occasions.

Some examples are given to make more concrete the use of the toga in its variations.

A consul of the third century would wear the style shown in Wilson, op. cit.,

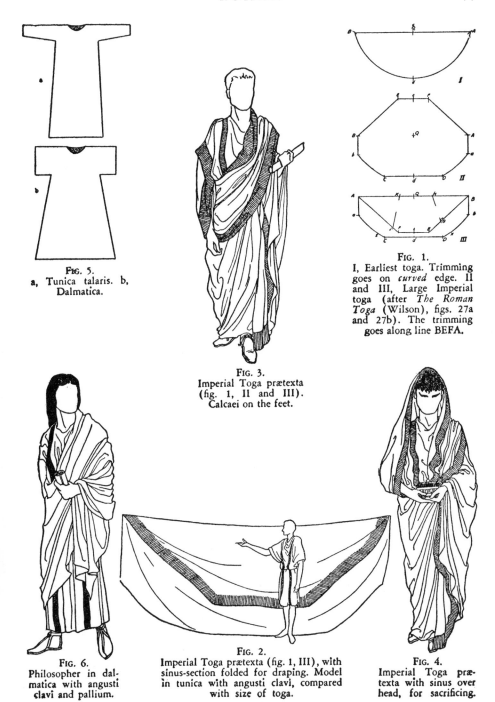

FIG. 5.
a, Tunica talaris. b, Dalmatica.

FIG. 1.
I, Earliest toga. Trimming goes on *curved* edge. II and III, Large Imperial toga (after *The Roman Toga* (Wilson), figs. 27a and 27b). The trimming goes along line BEFA.

FIG. 3.
Imperial Toga prætexta (fig. 1, II and III). Calcaei on the feet.

FIG. 6.
Philosopher in dalmatica with angusti clavi and pallium.

FIG. 2.
Imperial Toga prætexta (fig. 1, III), with sinus-section folded for draping. Model in tunica with angusti clavi, compared with size of toga.

FIG. 4.
Imperial Toga prætexta with sinus over head, for sacrificing.

diagram, fig. 7, with the purple stripe which proclaimed it a *prætexta*. A citizen in mourning during the period of the second Punic war would wear the toga *pulla* in the style shown in Wilson, op. cit., diagram, fig. 16 (Large Toga of the Republic). The conspirators who assassinated Cæsar would have worn the style shown in Wilson, op. cit., diagram, fig. 18 (the toga of the Ara Pacis), of perfectly plain cream-colored wool; but if one of their number had also happened to be announcing himself as a candidate for public office he might have appeared with the same toga made dazzlingly white. Pontius Pilate would have worn the Imperial toga described above, with a purple band, as it is shown in fig. 3, and if he had wished to sacrifice to the gods he would have pulled the sinus over his head, as shown in fig. 4. Nero could have been content with exactly the same toga, but it would have been within his rights to wear the Imperial toga as a toga *picta*, *i. e.*, made of purple cloth embroidered in gold, and the Nero of " Androcles and the Lion " would probably have done so, and displayed an extra amount of gold, too. And so on. Be sure that your characters have a right to the more colorful togas before you yield to the temptation to use them.

Wearing the toga was as much of an art as draping it. A toga worn too loose, or carelessly draped, was a reproach to the wearer; carried with an " air " and with a feeling of pride in that citizenship of which it was the badge, it must, by its very weight and voluminousness, have added to a man's self-respect. One cannot fancy a togated citizen being nagged by his wife, but when he came home and laid aside that dignity, appearing only in the tunica— was he not a different man? Not, perhaps, so devoid of dignity as he who in the chimney-corner removes coat, collar, and shoes, but no longer god-like. Let us look at this man, then, apart from his toga.

Heads. Hair was clipped all over the head, but fell in short locks on the forehead and at the nape of the neck (figs. 3 and 4), instead of being brushed back and neatly shaved, as in present-day styles.

From the second or third century B. C. to the middle of the first century A. D. men were smooth-shaven (always excepting some uncouth country-folk like the one whom Martial, in a neat epigram (XII, 59) calls a " shaggy farmer with a kiss like a he-goat's "). Occasionally during that time, to be sure, the short clipped beard would have a brief vogue; ordinarily, to let the beard grow was a sign of mourning. From the time of Hadrian (58–138 A. D.) it was fashionable to wear a clipped beard and moustache, like that familiar to us in the portraits of King Edward VII.

Hats were not a necessary part of costume, but they existed, in the same styles and used for the same purposes as among the Greeks (Chap. III).

Wreaths were awarded as prizes, very much as they were in Greece (p. 52); the laurel was the usual leaf. The special wreath or " corona triumphalis " worn by a victorious general during his triumph was originally made of real laurel and bay leaves, but was later imitated in gold. The " corona radiata " was the mark of divinity (gold, and as its name implies, made to suggest the

sun's rays) and Nero and subsequent emperors actually wore it during their lifetime, by virtue of the assumed divinity of the Cæsars.

Bodies. The *tunica,* corresponding to the Greek chiton, was of woolen material, usually natural-colored or white; it consisted of two pieces seamed together at the sides and sewed also at the top, leaving a space for the head at the top and spaces for the arms at the sides. This sleeveless tunica was the usual one for manual laborers, and was frequently worn slipped off the right shoulder, in the Greek manner. Sleeves to mid-arm (fig. 2) were also common. The tunica was worn girded, except for informal privacy. Its usual length, when girded, was to the knee in front and possibly three inches shorter in back. In the course of time the tunica sleeves became more definitely shaped and, gradually, somewhat longer; in the later Republican period these variations already existed. A tunica with sleeves to the wrist was called the *manicata,* that which had skirts to the ankle as well as long sleeves, the *talaris* (fig. 5a). Julius Cæsar is said to have worn a long-sleeved tunica and *he* was considered eccentric in his dress, but by Nero's time long sleeves were common. The tunica with shaped, wide sleeves developed wider and somewhat longer sleeves and in the second and third centuries A. D. became known as the *dalmatica* (fig. 5b). Till the end of the third century the decorations of the tunica were a matter of class distinction, and were generally no more than the *clavi.*

The *angustus clavus* was a stripe about one and a half inches wide, of purple like the prætexta band; it extended down each side of the tunica, front and back (figs. 2, 3, 6). This was the mark of the upper classes, strictly speaking only those of the rank of knight or above, though members of other selected groups, such as the *Camilli* (youths in the temple service), wore it also. After about 300 A. D. it lost its class significance and became purely decorative, appearing on feminine as well as masculine dress. The *latus clavus,* about which much controversy has raged, is concluded by the most careful investigators to have been only a wide version of the angustus clavus—probably measuring three inches or more—applied in the same way. In its original significance it was the mark of a senator, who, by the way, wore his tunica somewhat longer than the ordinary, and ungirded.

The tunica *palmata* was, originally, reserved for use with the toga picta. It was purple embroidered with gold, at first in a palm design; by Imperial times, however, no restriction was placed on the decorative motifs chosen. This tunica, originally worn only in a triumph, became the usual dress of the emperors from Nero onward, and was after a while adopted by others of the court. As a sleeved garment, with increasingly elaborate embroidery, it developed into the magnificent dress of the Byzantine court (Chap. V).

Feet. In the house a Roman might wear an informal kind of sandal called the *solea* (fig. 6 shows one style and fig. 11a and d the plan of another). Slaves were allowed no other footwear. Away from home the citizen wore shoes of different types, the most important being the *calcæus* (figs. 3 and 8),

which was forbidden to slaves. The ordinary color of the calcæus was leather-brown, but in the late Republican and early Imperial times there were color distinctions, especially that of black for senators and red for patricians.

Outer Garments. There were several kinds of rectangular cloak, distinguishable by name and size rather than by cut:—

(1) The *lacerna,* falling about six inches below the hip, rounded on the lower corners, fastened on the right shoulder by a *fibula* (or pin). It was usually of fine woolen material, and might be purple, scarlet, tawny, or any bright color. Sometimes it was of heavier, dark-colored material.

(2) The *sagum,* a practical cloak put on by the citizenry in war-time. It was of thick woolen stuff, in dark colors (but sometimes red), cut about square and pinned on the right shoulder.

(3) The *paludamentum,* larger than the sagum, but cut like it, the distinguishing cloak of military officers (fig. 7). It was of finer material than the sagum and often fringed. It was white, scarlet, purple, or some even darker color. It was worn over either armor or a tunica.

(4) The *pallium* (fig. 6), equivalent to the Greek himation. Scorned as foreign by the 100% Roman patriot, it was after a while regarded as the philosopher's cloak and as such adopted more and more by religious teachers, especially Christians, till it became, with a long-sleeved tunica or a dalmatica, the regular costume in which to represent Jesus and the Disciples. Religious art has preserved this convention down to our own day. During the time of the Empire the pallium had already become more popular than the toga for everyday wear and by the latter part of the second century it had superseded the toga as the dignified drapery of the ordinary citizen, the toga appearing only in the official dress of consuls.

(5) The *pænula,* a semicircular cloak, with or without an attached hood (*cucculus*) (fig. 8). The cucculus was worn also as a separate hood without the cloak. The pænula was used as a protection from the elements and therefore made of heavy material, even sometimes of leather. Though no longer called by its Latin name, this useful garment has never vanished from European dress, but may still be seen on foot-travellers, especially in mountainous districts. The South American *poncho* and the Arabian *bournous* are essentially the same garment. The Roman pænula varied from hip- to ankle-length and was either sewed all the way up the front, pulled on over the head, or left open, to be fastened by means of hooks, clasps, or buttons. It was the outer apparel of country-folk, slaves, and travellers (men or women), and, on occasion, of soldiers.

SOLDIERS

Roman helmets were made of iron; fig. 7 shows a style worn by officers, fig. 10 one suitable for a legionary. The crest, not as a rule so large as the Greek, was, like it, made of metal, horsehair, or plumes.

Under his armor the Roman soldier wore a rust-red tunica, a little shorter

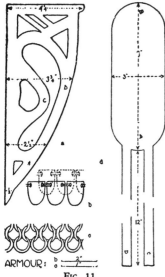

FIG. 11.
a, Pattern for solea size 10½ (cut it double). d, Tongue of solea. b, Bone scales for armor. c, Iron links for armor.

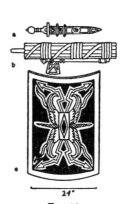

FIG. 12.
a, Roman short sword.
b, Fasces. c, Shield of a
Legionary.

FIG. 8.
Pænula with hood or cucculus. Calcaei.

FIG. 7.
An officer, wearing paludamentum, metal lorica, caligulæ.

FIG. 9.
Cope, a Christian church vestment. Diagram serves for pænula also.

FIG. 10.
Articulated lorica. Caligulæ.

than that of civilians. Above the neckline of metal appears, in the representa-
tions of soldiers, a roll of cloth apparently of the same material as the tunica,
which might indeed have been an extra, twisted piece designed to protect the
neck from chafing.

The *lorica* (another name for cuirass, p. 55) was of different kinds:

(1) Cast metal. The front and back were hinged and clasped under the
arms, and hinged shoulder-pieces clasped onto the front (fig. 7). This style
was worn only by officers and frequently not by them, being less comfortable
than the other kinds, all of which employed leather jackets, waist-length, as
a foundation.

(2) Overlapping scales (fig. 11b shows a detail).

(3) Chain (iron links) (fig. 11c shows a detail).

(4) Plates in sections. This is the armor depicted on the Column of Trajan
and is probably the best-known and most easily reproduced. It may be called
" articulated " and is seen in various styles. The armor sketched in fig. 10
(from a lorica made in the workshop) has a widish plate across the chest and
one like it in back, and below these, overlapping, five more horizontal plates.
Four overlapping plates in graduated sizes form the shoulder-strap.

Any lorica might have, as additional protection, a short petticoat of leather,
metal-tipped tabs, descending from the bottom of the lorica to hip or mid-
thigh, and the same sort of tabs around the armhole (fig. 7).

Greaves, like those of the Greeks (fig. 10, Chap. III), were occasionally, but
not often, included in the armor. *Bracchæ* (bracæ)—the word is an ancestor
of " breeches "—were adopted by soldiers for the campaigns in the north, as
a concession to the cold. They were rather like modern " shorts," though
sometimes narrower and occasionally longer, always, apparently, long enough
to show below the tunica. Romans scorned them as the garb of barbarians,
and the legionaries removed them before reëntering Rome. Nevertheless, they
became more and more popular in the later Empire, and in the next period
were an essential part of all men's dress (Chap. V).

On their feet soldiers wore the *caligula* (fig. 10) in various styles, all of
open construction and all coming up over the ankle; they were of brown
leather. The officer's caligula was more like the calcæus (fig. 7).

Accessories. The Roman shield, made of leather stretched on a metal frame,
was oblong, convex, and carried metal decorations, usually the insignia of a
man's legion (fig. 12c). The sword was short and thick, protected by an
ornamental scabbard (figs. 7, 10 and 12a). Short stocky daggers, worn at the
right of the belt, were often included in a soldier's equipment. A sword-belt,
when worn, was slung diagonally from shoulder to hip. Roman standards
displayed the badges of the companies; the legion standard was topped by a
gilt eagle with spread wings, holding a thunderbolt in its claws.

ECCLESIASTICAL VESTMENTS

In pagan ritual vestments played a minor part. The colorful toga trabea

(p. 76) marked some individuals as celebrants, others were only distinguished by the sinus of the toga drawn upon their heads (fig. 44). The complexities of Christian ecclesiastical dress grew, rather, out of Roman *civilian* apparel. The ordinary Roman garments of the first and second centuries A. D. went out of fashion for general use after about 300, but by that time they had crystallized in the vestments of the Christian Church. Without going into detail, let us note a few of the more important vestments and mark their sources.

The *cassock,* now a close-bodied, skirted garment, in cut more mediæval than antique, is probably a descendant of the tunica talaris (fig. 5a). At present the cassock is black, red or purple, and may be worn by choristers as well as by priests.

The *alb,* a white, sleeved garment which nowadays the priest wears immediately over his cassock and nearly as long as that garment, is a survival of the dalmatica (fig. 5b); so is the choir *surplice,* whose sleeves are now longer and pointed, like those of the Hebrew tunic shown in fig. 22b, Chap. II; and so is the *cotta,* cut straighter than the surplice and not so long as the alb, nor with such long sleeves. These last two are vestments worn by choristers as well as priests.

The *chasuble* (fig. 15, Chap. V) is probably a survival of the closed pænula, or possibly of the very wide *collobium* (a transitional garment) which is like the robe described for Egyptians and Persians (Chaps. I and II). In its early form the chasuble was a wide oval or even a circle (fig. 13c, Chap. V), but it decreased in width as it increased in stiffness, till in some modern versions it is fiddle-shaped front and back. The chasuble is worn only by a priest or bishop and since the early centuries has been a vestment reserved for the Communion Service, hence it is seldom appropriate for theatre costume.

The *cope* holds a better brief as a descendant of the pænula, for it is the half of a circle (fig. 9), as shown by this sketch drawn to the proportions of an ancient English cope, and is worn like the pænula. It has even the vestiges of the cucculus (hood) in a shield-shaped piece at the back. It is trimmed with wide embroidered strips (" orpheries ") all along the straight edge, and is held by a " morse," *i. e.,* an ornamental piece or a pair of clasps which hook across the breast. The cope is a vestment often called for on the stage, since it is part of a bishop's costume for any public function such as a coronation, a royal wedding, or a procession of ecclesiastics, and may be worn, indeed, in any church celebration, or outside the church.

The *stole* is said to be descended from the *orarium,* a large handkerchief originally used by anyone, but especially by deacons in handling vessels containing the consecrated elements. By the fourth century it had taken on its present shape of a narrow scarf, fringed at the ends, three or four inches wide and about two yards long. It is worn by priests and deacons in any ordinary church service, and by priests when reading the marriage, funeral, or baptismal service.

The *maniple* (not important for the stage, since it is part of the Communion

vestments) can be traced to a similar handkerchief, the *mappa*. It is now a narrow strip, fringed like the stole, worn by a priest on the left forearm.

In art, these specialized garments became conventionalized as the costume of sacred personages. We have noted the recognized garb of Jesus and the disciples (p. 80). Angels were represented in the vestments of deacons or priests, which after the second century consisted of the wide-sleeved *dalmatic* (the final *a* had early been dropped) (fig. 5b) with decorated neckline and the *angusti clavi* (p. 79), and the stole diagonally across the body (deacon), or crossed in front (priest) and bound to the body by a cord girdle. The cope, which for a long time was worn by both men and women as a ceremonial cloak, and not restricted to the use of bishops, was part of the dress of the Virgin Mary pictured as Queen of Heaven and also of the First Member of the Trinity.

WOMEN

Heads. Hairdressing followed, in general, the contemporary Greek styles (Chap. III). From the latter part of the Republican era, however, coiffures became increasingly elaborate and often unbeautiful. It is said that in late Republican and Imperial times Roman women bleached and dyed their hair and, moreover, wore false blond or red tresses taken from the heads of conquered northern barbarian women. Characteristics of the fashionable coiffures were: an excessive amount, frequently disposed in braids, intricately coiled; frizzing and curling in an elaboration that rivals the ancient Assyrians (Chap. II); and high dressing in the front, either with frizzed hair, in the manner that we know as " pompadour," or with decorations of the diadem sort. Fig. 13b is one version of the diadem arrangement. This sketch is from a portrait bust of the time of Trajan (A. D. 95–117). The upstanding row of thick petals appeared in that bust to be metallic, though in other similar coiffures hair in tight cylindrical ringlets forms the diadem. A fringe of frizzed hair conceals a narrow band and a " beau-catcher " curl curves in front of the ear. The coiled braids are arranged in a great cap at the crown of the head, and the hair curls naturally and prettily in the nape. This is one of the more attractive styles. Pretty, too, is fig. 13f, from a portrait bust of the third century. Here the parted hair is drawn back of the ears and looped low in the neck; all the long back-hair is braided and interlaced in a basket-weave and pinned up at the back. Fig. 14 takes its headdress from a Syrian portrait bust of the third century and shows its Egyptian and oriental influences in the low square line over the brows and the turban-like arrangement of the veil. A veil was added at will to any Roman coiffure. As in Greek practice, it was draped loosely over head and shoulders, not, as a rule, bound to the head with a ribbon or circlet, a style more properly associated with the middle ages (figs. 15 and 16, Chap. VI). Four more headdresses (fig. 13a, c, d, e), from coins, exemplify something of the variations in style during the survival of the Western Empire. Reminiscent of Imperial Rome was the familiar coiffure

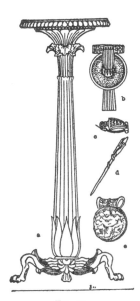

FIG. 15.
a, Lamp-stand. b, Fibula of the Empire. c, Enamelled fibula, late Empire. d, Ivory hairpin. e, Gold bulla.

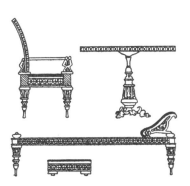

FIG. 17.
Furniture of ivory and inlay—chair, table, couch, stool.

FIG. 14.
Roman or Syrian lady, third century A. D., wearing long-sleeved tunica interior, over it a dalmatica, and over that a palla.

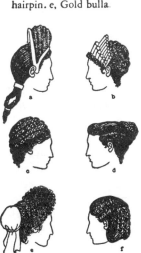

FIG. 13.
Headdresses of Roman ladies. a, b, Period of Trajan, end of first, beginning of second century A. D. c, Second century A. D. d, About 50 B. C. e, First century A. D. f, Third century A. D.

FIG. 16.
Coptic-woven designs for Roman textiles. a, Foliage. b, Laurel. c, Human figure motif. d, Human and animal figures. e, Abstract design.

of Alexandra, late Queen Dowager of England; in fact, as we shall see later, ladies of the 1870's and '80's definitely harked back to the hairdressing, though decidedly not to the dressmaking, of the Roman Empire.

Except with the veil and possibly, when travelling, with the *petasos* (sun-hat) (fig. 6, Chap. III) or the cucculus, Roman women did not cover their hair. The veil was used, as in Greece, as a ritual accessory.

Bodies. The Greek *chiton* (dress) described at length in Chap. III, was called the *stola* in Latin, and was the robe of the Roman matron. An under-garment called the *tunica interior,* also a chiton, was in general use from the Republican period. The underdress was of soft linen, the stola usually of wool; but as time went on the stola also was made of linen or even silk. The stola was always long, covering the instep. A distinguishing decoration worn by an honorable matron was the *institia.* Visible records of this trimming are lacking, since it is not imitated on sculpture and has apparently not been recognized in the surviving paintings. It is known to have been a narrow border around the bottom of the dress. Some investigators believe it to have been a flounce, though any such awkward divergence from the ordinary trimming of antique costume seems improbable; a flat band, woven, em-broidered, or appliquéd, is the more reasonable conjecture. The color is not specified.

Earlier it was stated that the Romans preferred to form tunica sleeves from the sides rather than the tops of rectangular garments. This method was not always followed in making the stola, for women often adjusted the Doric or Ionic chiton exactly as it was worn in Athens (Chap. III, pp. 56 and 58). But cut-out sleeves in the manner of the masculine tunica were also common. A combination of the cut-out sleeve with that distinguishing feature of the true Ionic chiton (fig. 16, Chap. III), a row of brooches along the upper arm, seems to be a peculiarly Roman style. The Etruscan-Greek mode of wear-ing an Ionic chiton for the interior garment, a Doric for the outer (fig. 12, Chap. III) was followed in Rome, but the reverse arrangement (*i. e.,* with the long-sleeved garment on top) was more common, especially in later cen-turies. The kolpos and the overfold (pp. 56 and 58), so important in Greek dress, were not as frequently seen in Rome; the girding, too, was rather simpler. The arrangement shown in fig. 16, Chap. III, one girdle, worn rather high-waisted, seems to have been a favorite; it is especially appropriate with the modified, sleeved chiton or stola. Indeed, as time went on, the Doric mode seems to have been entirely abandoned in favor of a modified Ionic, which finally developed into the scanter, sleeved, highly decorated garment of late Imperial (or " Early Christian ") times.

A version of this dress was the *dalmatica* (fig. 5b), worn by women as well as men. In the third century A. D. it was put on as shown in fig. 14, over a tunica interior which showed at the neck and again as three-quarter length sleeves under the wide sleeves of the dalmatica. Indeed covered arms were becoming more and more the style as the Empire grew older. The dalmatica

was not as a rule belted. It was frequently trimmed with the clavi (p. 79), narrow or wide, which by the third century had lost much of their class significance. It is in this dalmatica that the female saints are so often represented in Christian art.

Feet. Women, like men, wore soleæ (figs. 6 and 11a and d) in the house, calcei (fig. 3) outdoors. Shoes for women were of thinner leather than for men, and for fine ladies were made in colors—red, green, pale yellow, and, especially, white. Female slaves went barefoot or wore soleæ.

Outer Garments. The *palla,* which completed a woman's formal dress, was identical with the Greek *himation* and was draped in the same ways (Chap. III, figs. *passim* and p. 59). Fig. 14 shows the palla fastened on the left breast with a large fibula of the round type. This garment continued to be worn in the next period (Chap. V). It was usually made of wool, in different weights.

The pænula (p. 80, fig. 8) was donned by women travellers as well as men, for protection against the elements.

CHILDREN

Boys. Like his father, a young boy wore the tunica, with clavi if his rank permitted. Until the age of fifteen or sixteen he wore the toga prætexta (p. 76), but at that time he ceremoniously doffed the prætexta and assumed the plain, cream-colored toga virilis. During the coming-of-age ceremonies he wore a special tunica *recta,* which is said to have been of a thin, barred white material. At this time he also laid aside the locket or *bulla* (fig. 15e) which he had worn around his neck since infancy. The rich lad's bulla was gold, the poor boy's, leather. It was hollow and hinged, contained an amulet, and hung on a chain just below the hollow of the throat or a little lower.

Girls. A simple version of the tunica or Greek chiton (Chap. III, fig. 21) was the garment for little girls. A bride (who at her marriage became officially a woman) wore, for this occasion, the same type of white tunica recta (or *regilla*) as the boy's for his coming of age. The girdle confining her tunica terminated in a " knot of Hercules," *i. e.,* a metal clasp, one end of which was bent and slipped through a loop on the opposite side. Over the tunica she draped a palla, the color of which does not seem to have been fixed. Her hair was parted in the middle and drawn up upon the crown of her head. A double band of ribbon (the color is not specified) was bound around her forehead, and a flame-colored net covered her hair. Over this was a flame-colored veil (*flameum*), covering the forehead or resting on the top of the head, and bound by a wreath of flowers which had been picked by the bride herself.

MATERIALS

Woolen and linen were the staple fabrics in Republican and even in Imperial Rome. In the latter periods, silk was worn with increasing frequency—real silk, brought from China. It was very expensive and proportionately prized.

COLORS

There was probably more white and cream-color in the Roman than in the Greek scene, because of the togas and tunicas which until late Imperial times were usually white, with exceptions noted above. The recurring note in any assembly of men would have been the purple of the clavi and the prætexta border. The connection between the color called purple and superior rank is very old, and is economic in origin. Purple dye, made from a sea-creature, the *murex*, was rare, therefore expensive, therefore desirable. The manufacture of this dye had been from early times largely in the hands of the Phœnician city, Tyre, hence the color is called "Tyrian purple." The exact shade intended by this name has been a matter of some conjecture—the one pretty sure point being that it was *not* what we call "royal purple." It may have been crimson, but students are of the belief that it was usually a bluer red, a rich plum or garnet. The toga picta, tunica palmata, and toga trabea employed this color. During the second and third centuries A. D. men, especially those around the Imperial court, began to wear a greater diversity of colors. Even before that time the red shoes of patricians made an occasional gay accent in any assembly of important men.

The range of colors was always greater in women's dress. Except for the bridal convention of white and flame, colors seem not to have been fixed, though purple was probably restricted to the upper classes of women as well as men. Colors mentioned in contemporary texts include scarlet, violet, marigold yellow, crocus yellow, hyacinth-purple (which would be nearer our modern shade than the Tyrian), rust, sea-green or blue, and green. Probably the tints of the garments themselves were fairly light and bright (not what we understand by "pastel," but stronger) and designs were applied in deeper tones.

MOTIFS

Early Roman ornament followed the Greek model; in Republican times the decoration on men's dress was even more restricted than the Greek to borders, broad or narrow, and clavi, both of them purple and plain. Decoration on women's dresses was not so fixed by custom, and garments displayed such designs as are sketched in fig. 1, Chap. III. All-over patterns also followed the Greek model (p. 50). In the later Republican era and during the Empire, decoration on textiles reflected the influence of Egypt and the orient. Floral, geometric, animal, and human motifs appeared, in single all-over figures and in borders. Fig. 16 a–e, drawn from Coptic designs of about the fourth century A. D., at the very end of our period, show the way in which these were developed. Human and animal figures (c and d) became increasingly popular in the Christian era. They were arranged in realistic scenes (c) and included horseback riders. Animals like those in d were also arranged as units in an all-over pattern—rabbits being among the most popular beasts. The designs

based on Christian symbolism, enumerated in Chap. V, followed naturally from the pagan animals.

APPLICATION OF DECORATION

Fabrics were woven in patterns, or designs were embroidered on the completed fabric. As the Empire grew older, decoration on dress, as elsewhere, grew more florid, and gold was used with a lavish hand. The line down the top of the sleeve (fig. 8, Chap. III) was marked by a wider stripe. In the later years of this period the clavi, having lost their original significance, were embroidered in designs, which terminated above the hem in motifs round or wedge-shaped.

JEWELRY

Like other details of Roman life, jewelry was at first restrained in design and sparingly used, but later contributed to the general exuberant display. Women wore large earrings and bracelets of various types: heavy gold circlets, bangles of twisted gold, "snake" bracelets, and some of the same fashion with animal heads at the ends; and during the later centuries they wore bracelets one above another, as sketched in fig. 14. Men's adornment, in soberer times limited to the inevitable seal-ring, finally included many rings, on all fingers, even on upper joints, and large, elaborate fibulæ.

Women throughout the period and men in the latter part, had occasion for fibulæ to fasten the various outer draperies and, in the Greek manner, the sleeves of stolas and tunicas. The fibula of the Republican era was the safety-pin sort (fig. 22e and f, Chap. III), but in later centuries fibulæ more often took the form of round or long brooches (figs. 14 and 15b and c). Stickpins and hairpins resembled those used by the Greeks (fig. 22, Chap. III); fig. 15d shows a Roman hairpin of carved ivory.

Jewelry, which earlier derived its beauty from intricately-fashioned yellow-gold, was later enamelled or inlaid with bright colors and set with precious stones (not, however, cut or faceted like modern gems).

ACCESSORIES

The fasces (fig. 12b) was a bundle of rods enclosing an axe, the insignia borne by lictors before consuls and other magistrates as a symbol of power. Another official accessory was the ivory sceptre which a consul carried as his symbol of office (fig. 2, Chap. V). This he held in his left hand, and in his right the *mappa* or large handkerchief with which he gave the signal for the games to begin.

Other accessories of the toilet table, the study, and the music room were the same as we have described in Chap. III. Note the book-scrolls carried by the men in figs. 3 and 6.

SOMETHING ABOUT THE SETTING

In general construction Roman houses, or at any rate the country houses, were like the Greek (p. 64) but the interior decorations (as exemplified by those discovered in the ruins of dwellings which were overwhelmed by the Vesuvian eruption of 79 A. D.) show a very different sort of taste. Colored marbles, mosaics, and fresco-paintings divided the walls. These pictures were bright-colored and represented street-scenes in elaborate perspective as well as interiors and single figures. A characteristic design was a border of little cupids or " amorini," engaged in all sorts of everyday occupations. Mythological and legendary or historic scenes were also represented.

The colors used in room decoration are still strong and notable for abrupt contrasts of light with dark: red, for instance, with black figures, or black with light figures, or sky-blue with dark figures. Floors were laid in pictured mosaics or simpler geometric designs in black and white or colored marbles.

Furniture was made on the general lines of the Greek, though the ornamentation was often more florid. Fig. 15a shows a Roman lamp-stand, fig. 17, a chair, table, couch, and footstool of ivory with a colored inlay.

Public architecture combined Greek columns and triangular porticos with imposing domes. The favorite capital of Roman columns was the Corinthian (fig. 26d, Chap. III).

PRACTICAL REPRODUCTION

Materials. Use materials recommended for Greek costumes and apply designs in the same way (Chaps. III and XX). In plays supposed to take place after 100 B. C., " Antony and Cleopatra " or " Androcles and the Lion," for instance, it is permissible to represent lustrous silks (on appropriate characters), and this you may do with rayon weaves or sateen. Dyed pongee also looks rich and clings to the figure in the manner of the " thin-spun and clinging " silk garments in which, Lucan reports, Cleopatra appeared at a banquet.

Accessories. To make armor, follow the instructions given in Chap. XX, copying the sketches in this chapter. By convention, centurions in the Passion Plays are dressed in the articulated armor shown in fig. 10, although this style is not known to have been used till a somewhat later period. It has the advantage of being fairly easy to make and satisfactory when finished, and few in the audience will quibble about a fine point of dating.

Make shoes thus: Cut the solea from scenery or upholstery canvas, dyed the required color. Fig. 11a is a diagram of one half of the upper—lay the back on a fold and cut double; shellac the raw edges. Attach the tongue (11d), cut from the same material, to the upper, A to A. AB lies flat along the top of the foot until its straps (C and D) are laced through C and D of the upper and tied, when B falls forward to cover the lacings, like the tongue of a brogue (fig. 14, Chap. III). Sew the upper to a slipper-sole, bought at the ten-cent store. The measurements given are for a size 10½ shoe.

You may make the calcæus (figs. 3 and 8) upon the foundation of a leather or felt bedroom slipper or a "rehearsal sandal" (p. 68). Add four straps of matching material, long enough to wrap around the ankle several times (it will take a minimum of half a yard for each strap), cut them about three inches wide at the end attaching to the shoe, narrowed after about five inches to a width convenient for wrapping. Sew one pair to the shoe-sole under the ball of the foot, the other under the heel, and wrap them, crossing the instep and binding the ankle, as high as you wish. You may also make the calcæus with only one strap, under the instep, but this style requires a higher-tongued shoe as foundation. Elastic-sided shoes (like the old-fashioned "congress gaiters") are excellent to use for the calcæus, with the elastic siding removed (or concealed) and straps added.

The caligula, the soldier's short boot (figs. 7 and 10) can be successfully imitated with a brown sock sewed to a slipper-sole. Mark the pattern (following the sketches) with pencil or tailor's chalk while the stocking is *on* the model, then cut out carefully and finish the edges with shellac. Elastic in a hem at the top holds the sock up. You can also make this boot of felt or leather, seamed up the back, cut out and laced up the front. Get a cobbler to stitch upper to sole.

Hair. Some coiffures in the accompanying sketches require only an ordinary head of hair augmented by switches, but the frizzled-front types need a transformation if not a wig. You can make a transformation of crêpe hair basted on a piece of cotton net, further heightened by a pad. Pin this structure to the model's own hair. If you use a decorative head-band to cover the joining and to hold the transformation firm, you can construct an elaborate arrangement.

Garments. The stola and palla are cut like the chiton and himation (Chap. III); variations of the stola are described on p. 86. The man's tunica should be made of two rectangles, the front piece about six inches wider than the back, so that when they are laid together, outer edges matching, the front of the neck will hang slack. If the tunica is cut about two inches longer than it should be after belting, and that extra length is taken up in deep shoulder-seams, the neckline with the width turned in will have a pleasant soft finish, which will resemble that on sculptured figures.

The Toga. The following instructions for draping the togas are either adapted or quoted direct from *The Roman Toga* (Wilson). On p. 76 is given a brief list of some of the togas most useful to the costumer. The draping is basically the same for all, including the early (Roman-Etruscan) toga (fig. 1, I), *i. e.*, from left foot over left shoulder, across the back, under right arm and again over left shoulder. With such a mass of material as goes into the togas of the late Republic and early Empire more tricks than that must be employed. Quoted below, from *The Roman Toga*, pp. 68–69, are directions for draping one of them, the Imperial Toga, Wilson, figs. 27a and 27b, Schedule IV, p. 122 (our fig. III). This toga is chosen because its draping

can be followed for the two earlier styles and because it is appropriate for use in the majority of plays commonly produced. The sketches (figs. 2, 3, and 4) show it as a prætexta, because the presence of the dark band makes the lines of drapery easier to follow. These sketches were drawn from the model draped in a toga made according to the directions quoted. Miss Wilson advocates using a cheap grade of outing flannel which has been washed, rubbed and mangled, or cheap, soft unbleached muslin (Chap. XX), but this toga was satisfactorily made from medium-weight sateen, laundered; it was easily handled, it draped well, and was not as soft and adhesive as muslin.

The first step is to fold the toga, as shown in fig. 2 (the larger section, *not* the bordered part comes *next* to the model when you begin draping). With the purple border uppermost, arrange Aa between the feet, gather JK into folds resting on the left shoulder approximately at K. AK falls in ripples.

" The lower section of the toga is brought up and passes over the left forearm at about point Z. . . .

" Line KH is then brought diagonally across the back, passing under the right arm at about midway between the points K and H; the bordered edge of the sinus passes from the top of the left shoulder across the back of the neck, lies on top of the right shoulder and descends along the right upper arm. The sinus section at the back is therefore turned up on itself. . . . The remaining portion of KH is then brought diagonally across the breast. The sinus section is gathered into folds along the line HG and with it a portion of the undersection of the toga at H. . . . This second accumulation of folds, duplicating the one we have seen at point K, is then placed on the left shoulder. The lower section of the toga is then caught up and brought over the left forearm at about point X, so that the folds at X lie on the arm above folds at Z, already placed there. The remaining portion of the toga from points H and G to the end Bb is then arranged in the group of folds which hang down the left side of the back. These folds are not schematic, but in a general way they follow the diagonal line BG. Naturally, the fold BH is entirely abandoned in the folds hanging down from the left shoulder in the back. The purple-bordered edge may hang straight from the shoulder . . . or by a slightly different arrangement of the sinus it may form undulations. . . . The edge EFG surrounds the right side of the body and ascends the left side in front, forming the sinus." The fullness of edge AJ is drawn up to form the loop known as the *umbo* (fig. 3), used as a pocket.

These directions are less complicated to follow than to read, and indeed, with that great mass of material on your hands (fig. 2) you would feel very helpless without a guide. Two people assisted by the wearer are needed to drape the toga. Whatever the Romans may have done, the modern costumer will find it wise to use concealed safety-pins at strategic points, notably on the left shoulder and the right hip. It helps, too, to tuck the toga into the tunica belt as it goes around. More than one trial will be needed for a successful draping—not too tight, not too loose, long enough to cover the legs in back,

not so long as to trail in front. The tunica, however, is very simple to adjust, and an allowance of ten minutes to an actor should make the nightly proper togating of even " Julius Cæsar " possible for the run of the play.

A point to remember when costuming with a toga is that the actor has his responsibility. " The Roman devoted his left arm and sometimes his left hand as well to the support of his drapery. This is what . . . the togated character in a play must do." (Wilson, op. cit., p. 125.) It takes practice to wear the toga like a Roman gentleman, but the effect, when achieved, is unrivalled for dignity and impressiveness.

Suggested Reading List *

The Reading List for Chap. III can be used for this chapter also; Heuzey and Houston will be found especially helpful.

The Roman Toga—By Lillian Wilson.
 A detailed and careful treatise on this subject. Miss Wilson's conclusions are based on study and measurement of statues, the reconstruction of the togas from those measurements, and their draping on the living model.

The Ornaments of the Ministers—By Percy Dearmer.
 For a more detailed explanation of the Roman origin of Christian vestments.

Where Further Illustrative Material May Be Found

Information for Roman costume is drawn from the following sources:

Sculpture: Portrait busts (especially of the Imperial period), reliefs, sarcophagi, triumphal arches, ideal statuary.

Painting: On walls, especially at Pompeii, and portrait heads painted with colored wax, used on the outsides of mummy-cases and found at Fayum in Egypt.

Mosaics, especially for the period called " Early Christian."

Coins, which were struck with the relief heads not only of the Emperors but also of their wives and families.

Textiles, principally of the fourth and fifth centuries A. D., found in Egypto-Roman graves. The Victoria and Albert Museum in London has a fine collection, and in the United States the Metropolitan Museum and the Boston Museum of Fine Arts own enough pieces to give the student an excellent idea of the textiles and motifs.

Comments on dress by Roman writers.

Sources of Sketches in This Chapter

The quotations and diagram from *The Roman Toga* are made by permission of Miss Lillian Wilson and the Johns Hopkins Press.

The author of this book is indebted to her former pupil, Miss Lois Griffey, for the use of material assembled in her Master's thesis, University of Iowa, 1931, " Design of Costume for the Stage;—A Study Based on Characteristic Roman Costume." Figs. 2, 3, 4, and 10 are sketched from the model dressed in costumes made by Miss Griffey as the result of research. Fig. 11a and d is her pattern of the solea.

The other sketches are compiled from information gathered in the British Museum, the Victoria and Albert Museum (seen in reproduction), the Metropolitan Museum, the Boston Museum of Fine Arts, and the Fogg Museum of Harvard University (the last two in particular furnished originals for the headdress on fig. 14).

The textile designs are from photographic reproductions of Coptic fabrics, found in *Etoffes et Tapisseries Coptes*, H. Ernst, Editeur, Paris.

* The latest and best book, also by Lillian Wilson, was published after the first edition of the present work: *The Clothing of the Ancient Romans.*

Chapter V

BYZANTINE AND ROMANESQUE

$$\text{A. D. } 400-1200 \begin{cases} \text{Byzantine, } 400-1100 \\ \text{Romanesque, } 900-1200 \end{cases}$$

Some Important Events and Names

Sack of Rome by Alaric, 410.

Battle of Chalons (Huns repulsed), 451.

Fall of the Western Empire, 476.

Anglo-Saxon invasions of Britain, fifth century.

King Arthur (legend rather than history), who belongs to the period after the withdrawal of the Roman troops from Britain (early fifth century) and before the complete triumph of the Germanic invaders.

Pope Gregory I (Gregory the Great) sends St. Augustine as missionary to the English, 597–604 (but Christianity had existed among the Romanized Britons since 323).

The Hejira (flight of Mohammed from Mecca to Medina, marking the beginning of Mohammedanism), 622.

Battle of Tours (Charles Martel turns back the Mohammedans), 732.

Charlemagne crowned Emperor at Rome, 800.

Alfred the Great, 871–899.

Battle of Hastings (Norman Conquest of England), 1066.

The Crusades: the First, preached by Peter the Hermit, 1095; the Second, preached by St. Bernard, 1147; the Third (among the contestants were Richard the Lion-Hearted and Saladin), 1189–92.

St. Francis of Assisi, 1182–1226.

Some Plays to Be Costumed in the Period

We have no well-known dramatic literature about Byzantine characters. Pageantry, however, employs episodes from the history of the Eastern Empire, and some plays are localized at a period and in countries which would logically use the dress of Byzantium. Among them is Shakspere's " A Winter's Tale."

To the Roman-Briton or pre-Anglo-Saxon period (fourth and fifth centuries) belong the characters in a large group of plays, such as: Shakspere's " King Lear " ; plays derived from the Arthurian legends (see also p. 106) ; Maeterlinck's legendary plays like " Pelleas and Melisande " and " The Death of Tintagiles " ; the Wagnerian operas of " Tristan und Isolde " and " Parsifal " (frequently costumed in the style of the twelfth century, see p. 106).

Dramatizations of Irish folk stories like the pre-Christian " Deirdre " and " The Countess Cathleen " are perhaps best costumed in the style of about 500 to 800, Ireland's richest artistic period.

The Wagnerian operas based on German folk-lore of the Niebelungenlied may be costumed in a combination of Frankish and late Roman styles.

Edna St. Vincent Millay's " The King's Henchman " (tenth century) and Shakspere's " Macbeth " (historically, 1100) ; the dress should be of the ruder native sort, not influenced by Byzantium.

BYZANTINE AND ROMANESQUE

CONCERNING THE PERIOD

THIS eight hundred years saw the death of the old civilization of Greece and Rome in the gorgeous senescence of the Byzantine court, and side by side with that decay the development of the new civilization of western Europe, dependent at first upon the Roman tradition for its thin trickle of culture, upon the oriental tastes of Constantinople for its equally thin upper layer of luxury, but for the development of its social life, its organization, and its laws, upon its own sturdy northern genius.

From about 400 A. D., when the Imperial Roman ways of life had developed those Oriental traits which distinguish them as Byzantine, till about 1100, Constantinople (or Byzantium) was the fashion arbiter of Europe—the Paris of the feudal world. The names of the sixth century rulers, Justinian and Theodora, are associated in art history with the great church of Hagia Sophia and the churches in Ravenna. Byzantine influence on architecture can be traced in Italy and Sicily in buildings as late as the eleventh and twelfth centuries. Although the Eastern Empire continued in name until 1453, its importance as a center of refinement and luxury diminished after about 1100 with the Crusades, for then came direct to the stay-at-homes in France, Germany, and England, brought by the returning crusaders from Paynim lands, such prized luxuries as spices, perfumes, camphor, and silks, the last of greater variety and suppleness than ever Byzantium had yielded. The eventual heir to the arts of Constantinople was Russia. That country preserved them in her architecture, her religious paintings, in the state dress of her Imperial court, and in the peasant handicrafts.

In Britain and Gaul, even after the withdrawal of Roman protection, the Romanized Celts preserved for a time their Latin culture. This, however, was virtually annihilated by the Saxon and Frankish invaders. The result was that from about 400 to 1000 our Western civilization passed through what has been called the Dark Ages. It was a darkness not without its bright spots, notably the monasteries in Ireland and England, whence went out missionaries such as St. Patrick, St. Columba, and St. Aidan. In the ninth century the two men of vision who fostered an early renaissance were a Frank and a Saxon— Charlemagne and Alfred the Great. The English king deserves to be remembered not only as the defender of his country against the Danes but also as an educator of no mean intellectual force.

Four powerful factors distinguish this period: the growth of Papal authority, the development of monastic orders (their prototype the Benedictines,

founded in 526, at Monte Cassino in Italy), the rise and dominance of the Feudal system, and the birth (622) and astounding spread of Mohammed-anism. The twelfth century brought the ideals of chivalry and romantic love, whose object of worship was Woman, most perfectly exemplified by the Blesséd Virgin, and whose singers were the troubadours and trouvères of France. To this century belong the Chrêtien de Troyes version of the Arthurian cycle, the themes of the Robin Hood cycle and of other English and Scotch ballads. At the end of this period (before 1200) began the organization of students into universities, and from this time date the foundations of the universities of Paris, Bologna, and Oxford. Even before then (1100) Peter Abelard was drawing pupils about him in Paris; however, most of us remember him rather as the lover of Heloïse.

Romanesque architecture dates from the tenth to the thirteenth century, when it merged into Gothic. The church of St. Trophîme at Arles, the Abbaye aux Dames at Caen (built by Matilda, Queen of William the Conqueror), and many other monuments in France, Italy, Germany, and England testify to the impressiveness of the Romanesque style, owing but little to Byzantium, a great deal to Rome, and most of all to the native genius seeking to house and honor Christian worship. Northern and Western Europe, less a group of nations than a great collection of land-holders dominated by more powerful overlords, was culturally international. The manuscripts, the songs, the houses (inside and out), and the dress of the court circles were very much alike in France, Germany, and England. By the eleventh century France had already begun to assume the fashion dictatorship of Europe then passing from Byzantium, a dictatorship which she has continued to hold.

GENERAL CHARACTERISTICS OF COSTUME

It would be impossible to discuss eight hundred years and four or five nations in a single chapter, were it not that during that time and among those nations the actual cut of garments scarcely changed until the advent of the woman's *bliaut* in the twelfth century. From the meager information that we possess it would seem that the differences between Byzantine and Western dress from the sixth to the eleventh centuries are only differences of headdress, ornament, and length of particular garments. Garments for both men and women were developments of the sleeved tunics (*tunica, stola, dalmatica*) of Imperial Rome. Cloaks were rectangular (*pallium, sagum, paludamentum*) or semi-circular (*pænula*). These styles have been described in Chap. IV.

BYZANTINE

MEN

Heads. Hair was worn cropped, as in Imperial Rome, or bobbed, with a bang across the forehead (fig. 1). The beards and moustaches occasionally seen on figures are neatly trimmed. Hair was unadorned, confined by a simple fillet in the Roman manner (fig. 1), or by a gold circlet. The Imperial crown

of Justinian is such a band, enlarged to a width of perhaps five inches, flaring outward and upward from the head, and richly adorned with inset jewels and pendant pearls. A later crown in the Byzantine tradition is shown in the frontispiece. Other head-coverings, worn for service rather than for adornment, were the ancient *petasos* or sun-hat (fig. 6, Chap. III), the *cucculus* or hood (fig. 8, Chap. IV) and, possibly, the Phrygian cap (fig. 10).

Bodies. An undergarment or *chemise* with long tight sleeves was in general use. Indeed, from this time on men as well as women well-nigh abandoned the ancient Mediterranean custom of going bare-armed. The upper garment or tunic was cut like the late Roman *tunica manicata* or *talaris* (p. 79), the sleeves in one with the garment, or pieced on with a straight seam (fig. 5a, Chap. IV). The neckline was high and probably slit down a little distance to admit the head. The length of the tunic varied from a little below the knees (fig. 1) to the instep. Both the later Byzantine rulers and the Frankish kings are represented in the longer garment (frontispiece). It was usually belted. The *dalmatica* (fig. 5b, Chap. IV), the loose-sleeved tunic popular from Early Christian days, was at first worn over the tighter tunic by the laity, but soon became especially associated with official priestly and kingly costume (frontispiece).

Legs. Byzantine men are said to have worn the breeches or *braccæ* adopted by Roman soldiers from barbarian dress, but these are hidden by the tunic skirt. All men, apparently, wore hose. They were close-fitting and may have been knitted, like modern stockings, or cut from cloth and tailored to the leg, as was usual in Western Europe. As a rule the hose-tops are covered by the tunic skirt, but we may assume that they were gartered. The cross-gartering shown in fig. 1 is more frequent in Western than in strictly Byzantine modes.

Feet. Shoes were of soft material (probably leather as well as fabric), heelless, following the natural shape of the toes or slightly pointed (frontispiece and fig. 1). They were of different colors and elaborately ornamented with embroidery of silk, gold, and jewels.

Outer Garments. The cloak was an essential part of the costume, worn indoors as well as out. The rectangular drape of the ancients was still in use, especially for fighting men; its proportions seem usually to have been the length double the width, but its size varied according to its purpose. The more formal cloak was now the half-circular cape or *cope* (fig. 9, Chap. IV). This was worn draped across the body and fastened upon the shoulder with a large ornamental brooch (fig. 1). The square patch over the right breast is duplicated on the right shoulder-blade; the name " *tablion* " is given to this ornament, a distinctively Byzantine decoration. The semicircular *pænula* of the Romans (fig. 8, Chap. IV) remained, in two versions: the *chasuble,* a closed garment, round or oval, with a hole for the head, worn by the laity but also a part of church vestments; and a hooded raincoat, either closed up the front or split open and equipped with fastenings.

The Roman toga, though largely supplanted by the cope, did persist as an

official costume for consuls as late as the sixth century and is represented on the ivory diptychs of the time (fig. 2). Wilson (*The Roman Toga*) describes it thus (the quotations are direct and indirect, from the instructions on p. 113):

" The Toga of the Consular Diptych," Schedule XI, p. 124

Extreme length (AP)girth plus 2⅛ units
Width of long strip (Aa)......................... about 6 inches
Length of long strip to point where it begins to widen
 (line AM)................................. 1¼ units
Length of upper edge of drapery (EF)............... ½ unit
Width of end of drapery (Bb)...................... about 10 inches
Extreme width (cd) ¾ unit
Line OK.. about 10 inches
Line OM 5⁄14 unit

(For explanation of the unit measure see p. 75).

To drape (p. 113):

" The band (its end Aa just above the hem of the tunic) is placed on the front of the body and passed over the left shoulder; then it is brought diagonally across the back, under the right arm and across the breast. It is then brought again over the left shoulder and across the back." Secure it with a pin on the right shoulder. The rest of the drapery (the wide, apron-like part) is brought again under the right arm, across the middle of the figure and over the wearer's left wrist. Be sure to draw the lower edge AF tightly across the back, so that E will hang in a point in front.

This toga was made of richly brocaded, stiff material (woven probably, with flattened strips of gold) so that its draping was very stiff and formal, quite unlike that of the real toga. In its final version, the toga became the pallium. This pallium was not the Roman cloak of that name, but a band six or eight inches wide, of stiff material, lined, worn around the neck and hanging down or wrapped around the person in various ways. It was so used by kings of Byzantium and Western Europe as part of the robes of state (frontispiece) and became part of the Ecclesiastical vestments of the Eastern (Greek Orthodox) Church.

SOLDIERS

Till the middle of the ninth century or even later, soldiers of the Eastern Empire were clad like Roman warriors (figs. 7 and 10, Chap. IV). Helmets alone showed some change, having more brim and covering the head less deeply (fig. 12g).

WOMEN

Heads. Byzantine ladies wore their hair up, elaborately arranged according to the traditions of Imperial Rome (fig. 13, Chap. IV). Sometimes they concealed the hair in turban-like wrappings, a fashion perhaps borrowed from the Orient with which Byzantium traded. The mosaics of S. Vitale at Ravenna

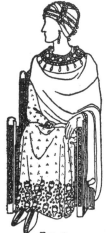

FIG. 3.
A Byzantine lady wearing a jewelled collar over her cloak. Note the chair.

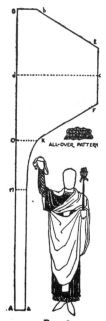

FIG. 2.
The Toga of the Consular Diptych— Sixth Century. Diagram after fig. 74. *The Roman Toga* (Wilson).

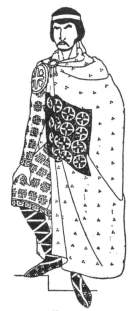

FIG. 1.
A Byzantine or a Frankish gentleman, about 500 to about 900 A. D.

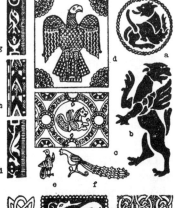

FIG. 5.
Byzantine, Teutonic and Celtic Motifs. a-i, Byzantine. j, k, l, Celtic. m, Teutonic.

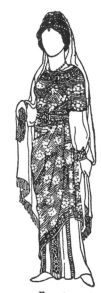

FIG. 4.
A Byzantine lady wearing her palla as a veil.

FIG. 6.
a, Byzantine Capital. b, Romanesque king's chair. c, Romanesque capital.

(usually reproduced in any discussion of Byzantine art) show both the stiff frizzed pompadour and the turban, also illustrated in fig. 3. The Empress Theodora wears, in addition to the turban, a crown something like that in the frontispiece, with double strings of pearls over each ear. Fig. 4 shows a pretty style, of coiled braids entwined with pearls. The braids were secured by stiletto-like hairpins with ornamental ivory or metal heads, like those used by the Greeks (fig. 22, Chap. III). Elaborate pendant earrings showed to advantage with the Byzantine coiffure (fig. 3). The large rectangular veil, which had also been worn by Roman women, was now frequently draped over the head, as shown in fig. 4, especially in church, in obedience to St. Paul's admonition (I Corinthians 11: 13).

Bodies. Like men, women wore the high-necked, long-sleeved chemise, which was sometimes visible under the upper tunic, at sleeves and skirt, as it is shown in fig. 4. Another type of tunic (fig. 3) has its own long tight sleeves and skirt to the floor. Sleeves were cut in one with the body, as explained for the men's tunics. The tunic shown in fig. 3 may not have been belted, since it was closer-fitting than that in fig. 4, where the girdle is a necessity. The position of the belt, when it was worn, varied from high (fig. 4), to the natural waistline or a little lower. The neckline was round, either as in fig. 4, cut fairly low, showing the chemise above, and richly trimmed, or, as in fig. 3, concealed by a collar; this collar was put on over both tunic and mantle. It is a typically Byzantine ornament, seldom seen in the West, and is curiously reminiscent of the Egyptian collar pictured and described in Chap. I.

Feet. Women's shoes resembled those of the men.

Outer Garments. A drapery of some sort was the usual addition to a complete costume. It was the rectangular veil or shawl shown in fig. 4, or the *chasuble* described above (under MEN), or the *cope*. Only the Empress seems to have had the right to wear her cope fastened on the right shoulder like a man's cope, and even she does not display the *tablion*. These draperies should not be regarded as protective garments—for that purpose there was the hooded cloak, described above (under MEN).

COMMON PEOPLE

Men. I have seen no contemporary representations of ordinary men and women, but common sense leads us to assume that they wore simple versions of the dress described above. Probably long breeches, bound to the leg with thongs, took the place of smooth stockings, and shoes of heavy leather replaced the soft, richly ornamented footgear of the nobility. It is the shepherd and the farmer who would have most need of sun-hat and hood, and of the large woolen cloak.

Women. The women undoubtedly coiled their hair very simply upon their heads, and veiled themselves modestly with their mantles in church. Over long-sleeved chemises of coarse linen they wore simple, loose tunics girded

with cords or leather belts. Probably their skirts were short enough for convenience, to the instep or even to the ankle, and their shoes sturdy and plain.

MATERIALS

The stuffs of which Byzantine court costumes were made must have been, judging not only from the mosaics, illuminated manuscripts, and carved ivories, but also from the fragments of actual textiles still in existence, almost overwhelmingly rich. The practice of weaving into a fabric flattened strips of pure gold, mentioned in the Bible, continued through this period, and this golden cloth was lavishly used by the nobility. More silk was worn than ever before, for the silkworm was introduced into Byzantium in the reign of Justinian, thus adding home-manufactured silk to those supplies still imported from the Orient. The art of weaving complicated patterns with colored threads was apparently still largely in the hands of the Egyptian Copts, who employed designs in the Byzantine taste for that trade. Simple all-over patterns, such as dots, stars, and circles, alone or in groups, continued in use. A silk called *samite,* strong and thick, was well adapted to the stiff grandeur of Byzantine dress. This was enriched with embroidery or with gold disks or jewels sewed on. There seems to be no doubt that pearls and precious stones were thus employed all over a costume, as well as in borders. Silk tissues were woven to use for veils. Linen, cotton, and wool in a variety of weaves served their customary purposes.

COLOR

Gold dominates the color-scheme of Byzantine court dress, gleaming in the high lights of stiff folds, incrusting the edges of lordly mantles. Next in importance comes purple, both violet and the official royal purple which was nearly red (p. 88). It is said that this last was exclusively reserved for the Emperor, and was acquired by others only by Imperial gift, and that in the tenth century it was not allowed to leave Byzantium and might be worn only by subjects of the Emperor. Besides these royal colors may be mentioned green (combined in the Coptic textiles with violet-purple), brown, blue, red, black, white, gray, and plum-color. These are to be seen on the Ravenna mosaics. Their color is not very vivid, but the pigment of even mosaics may have faded.

MOTIFS

Animal-forms, many of them related to Christian symbolism, some borrowed from Oriental design, and floral motifs, either surviving from antique art or having a Christian significance, appear in company with geometric and abstract forms. The illustrations in fig. 5 include a fanciful animal, part horse (c), a dog (a), a gryphon (b), an eagle (d), a dove (e), a peacock (f), a fish (g), and a vine (i). (d) to (i) are Christian symbols, to which category belong also the lamb and the pelican; (h) is a version of the chevron. Any of the single motifs might make part of an all-over pattern, or stand as a

large, separate motif. Typical is the method of enclosing a motif in an ornamental frame (a and c). The birds illustrated (e and f) usually appear in pairs, facing, sometimes divided by a floral or vine design. In addition to these motifs, human figures were employed decoratively, *e. g.,* upon the mantle of Theodora, in the Ravenna mosaics, a procession of the Magi in Phrygian dress.

APPLICATION OF DECORATION

A large roundel framing a single motif was frequently patched on the upper sleeve (fig. 1). A border finished the edges of neck, sleeves, and hem, the latter sometimes coming up high on the skirt, as in fig. 3. If, as in the frontispiece, the skirt was slit up, this opening was also defined. The Roman *clavi* (p. 79) persisted in this period, upon both masculine and feminine dress, in the form of embroidered bands at the sides of the tunic, front and back (fig. 4). Frequently these bands stop several inches above the hem, terminating in an elaborate motif. A wide ornamental band up the front may be considered a form of the *clavus,* also (fig. 4). The *angusti clavi* of ancient Rome in their original form, *i. e.,* two narrow purple stripes (p. 79) remained upon priestly dalmatics, as may be seen in the Ravenna mosaics.

JEWELRY

Yellow-gold, pearls and "uncut" (*i. e.,* unfaceted) precious stones were employed for the crowns, collars, earrings, finger rings, brooches, and girdles adorning these gorgeous people. We can also class as jewelry trimmings of gold thread embroidery and jewels, gold plaques, and pearls.

ACCESSORIES

Into the sixth century the *mappa* (the large handkerchief mentioned on p. 89) continued to be used by consuls (fig. 2) and other people also carried large kerchiefs (fig. 4). The consul carried a short sceptre with the Imperial eagle on it (fig. 2) and the Emperor had the orb and sceptre (frontispiece).

The scroll form of book, which had been in principal use throughout the ancient world (fig. 6, Chap. IV) was, in 400 A. D., rivalled by the *codex,* which was a book with covers and manuscript leaves bound together like a modern book. Even in the first century of our era the codex was known; on the other hand, the scroll continued in use till about 1000, but it was more and more relegated to the recording of official documents, a purpose it has continued to serve even to our day, in college diplomas. Parchment and its fine version, vellum, made the leaves; wooden boards covered with leather, stamped and gilded, or carved ivory made the covers. Rarely beautiful covers show veneer of beaten gold, encrusted with uncut gems. From the third century until the time of Charlemagne (800) men knew the art of dyeing vellum purple, and these purple pages were used for very precious words, which were inscribed in gold or silver.

SOMETHING ABOUT THE SETTING

The round arch and dome are typical of Byzantine architecture. The capital of a column (fig. 6a) suggests the intricate nature of architectural detail. House interiors were decorated with glowing mosaics (such as we may still see in the churches) and with rich wall-hangings. Furniture was in the classical tradition (fig. 17, Chap. IV and fig. 3b, this chapter).

BARBARIANS

Representations of the Teutonic people of Western Europe in the early centuries are infrequent, but there have been discovered, preserved in peat, in various parts of Germany, Denmark, and Holland, some actual garments which have been assigned to the first three hundred years of our era. From these, and from contemporary records, and those of two hundred years or so later, it is possible to attempt a description. Authenticity is not claimed for our two sketches (figs. 7 and 8); they only show the general style of barbarian garments, and in particular those details which contributed to the costumes of their Christian descendants. These may be considered as features which continued until Charlemagne's time, except as they were modified by contact either with the Romanized Celts of Britain and France or directly with the Eastern Empire.

MEN

Some of these people had long hair, which they braided, and some had beards, braided also. A heavy moustache was worn, without a beard, and a beard without a moustache. The cap-shaped helmet, brought to a point on top, was ornamented with horns or wings. Breeches were either short and worn in company with leg-bandages, or long and cross-gartered, as in fig. 7. Shoes were rude pieces of leather laced upon the foot. These men of the Northern woods frequently wrapped themselves in the skins of animals (tradition says that Charlemagne conserved this style in his hunting costume) but they had also large rectangular cloaks, woven in wide stripes of bright colors.

WOMEN

It is said that the women of the Saxons, the Franks, and the Allemani all wore their long hair loose upon their shoulders until after marriage (a practice continuing for brides even in the Renaissance), and that afterwards they braided it; but that married women of the North pinned theirs up. A skirt, made in the primitive fashion of running a draw-string through the top and with this adjusting the garment to the waist, formed one part of the dress; the other was either a tunic, sleeveless or with short sleeves, or a short blouse or jacket, such as the one sketched (fig. 8). Shoes, when worn, were like the men's. Women, on occasion, wrapped themselves in the cloaks described above.

MATERIALS

These early garments were made of dressed skins or of wool, which was apparently woven with some skill, in patterns such as stripes and simple geometric combinations. The swastika (see the brooch, fig. 9a) was an early symbol.

JEWELRY

Brooches or *fibulæ,* of the general shape of (a), fig. 9, appeared very early. This example is Anglo-Saxon of the sixth century. Twisted silver neck-ornaments called torques (fig. 7) and collars (fig. 8) also date from the early centuries. While the Teutons were still in the half-barbaric state and therefore preserving many of the dress characteristics mentioned above, they had jewelry such as that shown in fig. 9. The first (a) has been mentioned; (b) is a saucer-brooch, about three inches in diameter, (c) an armlet, (d) and (e) silver rings of the wrapped and spiral variety. All the foregoing are Anglo-Saxon of about the sixth century. Dating from the ninth century, but in a style seen earlier amongst the Norsemen, is the twisted armlet (f). To the seventh century have been assigned the Anglo-Saxon necklace and buckle-plate (h and i), the Frankish pin of colored enamel (g), and the Irish brooch, a copy of the Tara brooch (j).

MOTIFS

To the pre-Romanesque period belong such designs as those shown in fig. 5. (j) and (k) are Celtic, one from the sixth, the other from the seventh century; (l) and (m) show the Anglo-Saxon conventionalization of animal motifs.

Certain elements of the native style in dress and decoration persisted and were incorporated with the Roman-derived or Byzantine-inspired costumes of Western Europe:—the types of jewelry, the moustache for men, the long braids for women, wraps of animal skins, and breeches, which in some form have continued ever since. The Teutonic elements which disappeared from later mediæval dress are very long hair for men and bare arms for either men or women.

CELTIC

After considering the scant information available concerning Teutonic dress during the first eight centuries of our era, and the even scantier direct data about Irish clothing during the same period, the costumer may well ask, " How them *am* I to clothe Lear and his daughters, Isolde, Guinevere and Launcelot? " In the first place, you may take refuge in the fact that the familiar Arthurian stories were *written* in the twelfth century, and that the characters are figures not from the " dark ages " but from the dawn of chivalry, and you will therefore dress them in the fashions to be presently described—virtually

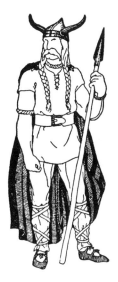

FIG. 7.
A Teutonic warrior, c.
100 A. D. to 800.

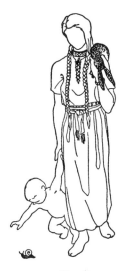

FIG. 8.
A Teutonic woman, c.
100 A. D. to 800.
Note the metallic col-
lar.

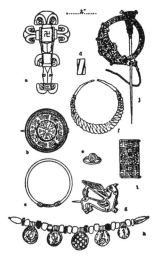

FIG. 9.
Early European jewelry, mostly
Anglo-Saxon, sixth to ninth
centuries. a, Fibula. b, Saucer
brooch. c, Armlet. d and e,
Rings. f, Armlet. g, Enamelled
pin (Merovingian). h, Neck-
lace. i, Buckle plate. j, Brooch
(Celtic).

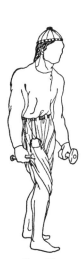

FIG. 11.
A French work-
ing-man, c. 10th
to 12th centuries.

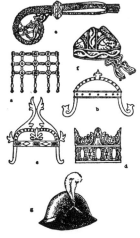

FIG. 12.
a to d, Crowns: a, Frankish,
7th century. b, Merovin-
gian, 9th century. c, Crown
of Charles the Bald, 9th
century. d, French 2nd half
12th century. e, Bishop's
crozier, Celtic. f, Bishop's
mitre, 12th century. g,
Frankish helmet, 9th cen-
tury.

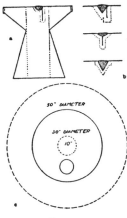

FIG. 13.
a, Romanesque tunic or
bliaut. b, Three neck-lines.
c, Diagram of the circular
cape or chasuble (Fr.
chape). Dotted lines show
outline of cape; solid of
hood.

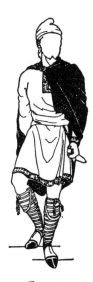

FIG. 10.
An Anglo-Saxon
of the upper
classes, c. 10th
century.

like the well-known Abbey pictures of the " Quest of the Grail " in the Boston Public Library and "King Lear" in the Metropolitan Museum. However, if you prefer sticking to the actual date (some time not long after 410) you will remember that the Celtic civilization was Roman, and therefore the dress would be in the style of the late Roman Empire (Chap. IV), which differed from that of Byzantium in only one important particular, *i. e.*, long sleeves were optional, not universal. Women's hair was pinned up, not worn in braids, men's hair was trimmed. Such magnificence as Rome and Byzantium knew would be very improbable, though important persons might have had a little of the precious silk.

The Irish plays are set at a time when Roman dress must have been well-nigh forgotten, and when Saxon influences must have made their impression on Ireland as well as on England. While by 500 the Continental Teutons were already under the modifying influence of Byzantium and while that influence is seen in Irish design, it is not likely to have affected the Island dress. Therefore the characters in Irish plays would wear their long hair loose or braided; their tunics would have short sleeves; their jewelry would be of the sort pictured in fig. 9; and the designs on their garments would be large: stripes, squares, circles, and simple geometric combinations, as well as more intricate interlaced patterns worked on borders. Material would be linen or wool—no silk.

ROMANESQUE

GENERAL CHARACTERISTICS

The first representations of Western European dress (extremely rare before the ninth century, after that increasingly numerous in church sculpture and manuscript painting) show that it was essentially the same as Byzantine, though usually lacking the extreme magnificence of the Eastern Court. By the tenth century, however, Western Europe had developed a style of its own which continued with few modifications until 1200.

MEN

Heads. Hair was short, or bobbed, or longish (frontispiece, figs. 10 and 11). Men were frequently clean-shaven, or if they were bearded, the beards were in one or two points (fig. 10) with or without trimmed, drooping moustaches (frontispiece).

Head-coverings were more popular in the West than in Byzantium and included: the Phrygian cap (fig. 10); a small skullcap cut in six or eight segments, finished by a button on top (fig. 11); and the bonnet or *coif* which fitted the head, covered the ears, and was tied under the chin—a head-covering which was a great favorite in the next century and is illustrated in fig. 6, Chap. VI. The fillet shown in fig. 1 may be seen also in a ninth century manuscript, but not so often in later representations. Chaplets of real flowers were worn throughout the period, on festive occasions, in the classic manner.

Royal crowns underwent various modifications, which are illustrated. In the seventh century the Byzantine influence was still strong (fig. 12a), as it was in the orientalized dress of Sicilian kings during the twelfth century (frontispiece). In the ninth century the Frankish crowns had foliated ornaments (fig. 12, b and c); amongst the English in the tenth century the foliations decorated a narrow circlet (fig. 15). In France by the end of the twelfth century, crowns had assumed the high foliated shape which characterized them until the Renaissance (fig. 12d).

Bodies. The Romanesque tunic of the upper classes (called in French the *bliaut*) was a neatly fitting garment, laced or sewed up one or both underarm seams each time of wearing (there were as yet no button or hook fastenings). The sleeves, cut in one with the body, or pieced with a straight seam at the shoulder or several inches below (fig. 13a), were sometimes, as in this diagram, wide at the top, sometimes closer-fitting. For the lower arm there were two styles: tight from elbow to wrist (adjusted to the arm by sewing or lacing each time it was worn (fig. 10), and open. The open sleeve was moderate in size (like a modern coat-sleeve, or at most no more than sixteen inches wide); about 1150 it was often very wide, in accord with feminine styles. When the sleeve was open, the chemise sleeve (or possibly the sleeve of another tunic) showed, fitting the arm neatly.

The *bliaut* skirt varied in length. Some men wore it above the knee, some below, even to the calf. The official royal robes were long-skirted (frontispiece); during the last half of the twelfth century the long-skirted mode was general amongst the upper classes. The *bliaut* skirt was sometimes slit, in front, in front and back both (especially convenient for horsemen), or on the sides. The dalmatic (frontispiece), part of the kingly as of the priestly dress, was generally slit and worn over the long white tunic or *alb* (p. 83). Necklines were cut high, and there was always a slit so that the head could go through. Fig. 13 (a) and (b) show possible variations in the neckline.

A belt held the bliaut in at the waist. The tight garment of the tenth and eleventh centuries, however, is represented (especially in Anglo-Saxon art) with no visible girdle, but with the fullness draped across the abdomen and bunched upon the hips. This curious effect can be reproduced thus: put on a tunic which is not skin-tight and has a skirt with gores (like that in the diagram, fig. 13a), pull the garment tight across the abdomen and hips and fold the surplus over in a big box-pleat at the back; tie a cord tight around the waist; adjust the tunic to blouse a little over the cord, front and back (fig. 10). This is the fashionable bliaut; probably when the fine gentleman had his bliaut carefully tailored and even laced to his figure, the laborer was still pulling his loose smock on over his head, as he continued to do for centuries and indeed still does in Russia and France (as, for instance, the railroad porters).

Legs. A man wore breeches under his tunic, usually short and therefore not visible. Men engaged in strenuous exercise, however, are represented without their tunics. In order to show the curious way the breeches were made (not

unknown, however, in other parts of the world, even today) we have sketched (fig. 11) a respectable working-man in his breeches. It will be seen that they are made on the principle of a baby's diaper, the back part drawn between the legs and up to the waist, where both back and front parts are held by means of a belt passing through straps. The sides are joined under strips of cloth or leather. Breeches for common people were also longer than this, cut like the Teutonic *bracchæ* (fig. 7) and like them frequently bandaged or cross-gartered.

(Ordinarily the man in fig. 11 would be naked above the waist, but we'll say that he is sensitive to sunburn, which gives us an opportunity to show a high-necked, long-sleeved chemise. Incidentally, not many men in his station would have such a neat cap.)

Stockings were an important part of costume. Even our working-man wore them when he was dressed up. For him they were of heavy cloth, clumsily made, and they wrinkled and fell forward at the top unless he bandaged them up. The nobleman had his stockings cut and fitted to his legs by an expert tailor. Sometimes the tops disappeared under the tunic hem, so that the gartering was not visible, sometimes the bare knee showed between gartered stocking and tunic. A simple cross-gartering holds up the stockings in fig. 1, one more complicated in fig. 10. This latter gartering is often depicted in Anglo-Saxon art. We have added one detail not visible in the originals, but without which the wrapping cannot be explained, *i. e.*, a straight piece running up the inside of the leg, underneath the wrapping. To produce this effect, grasp the tape at a point about one foot from the end (A) and hold it at the back of the knee. Pass the tape down the leg and under the instep and wrap around the leg in the manner shown. When you reach (A) knot the two ends. Pass the longer end around the leg again, letting it fall slack in front, and again knot in back. Finally bring both ends to the front and knot, as shown in the sketch. You will need two and a half or three yards of inch-wide tape for each leg. The manuscript paintings sometimes show these garters in gold, or in bright colors; they were probably strips of leather or wool. Stockings were of various colors, sometimes bright, like yellow or flame-color, often brown.

Shoes followed the fashions of Byzantium, but in the middle of the twelfth century more pointed toes were adopted, a style probably introduced from the Orient as one of the results of the Crusades.

Outer Garments. The rectangular cloak in various sizes continued to be the usual outer garment, fastened on the shoulder (left or right) with a large brooch or fibula (fig. 10). Brooches especially useful for pinning the heavy folds of the cloak could be, like the Irish example (fig. 9j), open circles which allowed the material to bulge through, or safety-pins with a high hump (fig. 9a) which could close over folds of cloth. The ceremonial cloak of the upper classes was still the cope. The original straight edge of the half-circle (fig. 9, Chap. IV), retained in the church vestment, seems now to have been modified for the laity by being scooped out a little where it touched the neck, so that it lay

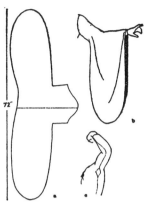

FIG. 18.
A lady of the late 12th century in cote, surcote, and wimple.

FIG. 20.
A is the pattern for the open sleeve of a bliaut. B is the sleeve upon an arm. C is a gusset set in to relieve the under-arm strain.

FIG. 14.
A French soldier, time of the Norman Conquest of England.

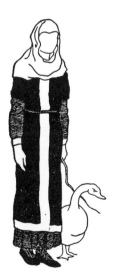

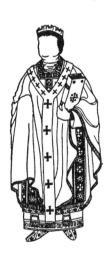

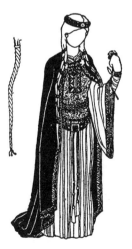

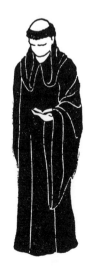

FIG. 19.
Country woman of the eleventh century and later.

FIG. 15.
A 10th century Anglo-Saxon bishop in full vestments.

FIG. 17.
French lady in court costume, bliaut and mantle (about 1150). (Inset) Braid wrapped in a silk casing with gold tassel.

FIG. 16.
A Benedictine Monk.

flat instead of standing up in the back. It was most often clasped upon one shoulder, as in fig. 1, but it might also be so adjusted as to open directly in front. The hooded raincoat mentioned above (Byzantine) was still a standard garment, especially among the lower classes.

<div align="center">SOLDIERS</div>

Till about the middle of the ninth century, soldiers of the Frankish court dressed in imitation of the Roman-style Byzantine soldiers, with such occasional variations as long tight sleeves on the tunic. By the tenth century another style began to displace this and by the time the Bayeux tapestry was made, soon after the Battle of Hastings in 1066, this other type seems to prevail (fig. 14). Helmets took the form of iron caps, coming to a point on top, frequently having a *nasal* or nose-guard and a curtain of chain mail completely covering the back of the head, ears, and neck. The chain shirt or hauberk could come down much longer than shown in the sketch, the sleeves of mail could reach the wrists, and the legs could be completely stockinged in mail. For horsemen, the scant skirt of the hauberk was slit as described for the tunic, above. The short-sleeved hauberk sketched, worn over cloth undergarments, with sturdy stockings or boots gartered to the leg, is another style frequently seen, and one which will be found practical to reproduce.

The short Roman sword gave place to the large two-edged sword of the crusader, its T-shaped guard foreshadowing the cruciform hilt of the next century. The sword in its scabbard was hung either on a belt or, as in the sketch, on a baldrick passing from right shoulder to left hip. The large kite-shaped shield bore the warrior's personal insignia (the beginning of the fashion for coats of arms).

Ordinary foot-soldiers did not necessarily wear chain mail, but might be clad in a sleeveless leather jacket over the cloth tunic, girded with a leather sword-belt; and no steel helmet, only a thick woolen cap.

<div align="center">CLERGY</div>

Heads. Fig. 16 shows a monk with the Roman tonsure, *i. e.*, the crown of the head shaved. This had been the style of tonsure in the Roman church since the early centuries and was followed also in Byzantium. By the seventh century it had been adopted also in the British Isles, where the practice in the pre-Augustinian church had been to shave the front of the head, leaving the back hair long. This last would probably be the correct tonsure for priests in the Celtic plays.

Early bishops did not always wear mitres—the bishop in our sketch (fig. 15), who is of royal blood, wears an Anglo-Saxon crown much like a crown on King Cnut in a manuscript of the early eleventh century. The first mitres were only low caps, with the points at the sides instead of front and back. By the end of the tenth century the low mitre shown in Fig. 12f was customary,

and was worn, as the mitre is now, by a bishop as part of his ceremonial costume.

Vestments. Fig. 16 shows the habit of Benedictine monks. It consisted of a white woolen cassock (a simple long tunic) and over it an ample black gown, to which was attached a loose black hood.

The tenth century Anglo-Saxon bishop of Fig. 15 wears (as English bishops after him continued to do until after the Reformation): boots (or hose) to the knee and sandals (the latter visible in the sketch); a tunic (seen at the wrist only); a second, white tunic called the *alb*, with a decorated hem; a *stole*, whose fringed ends are visible (this is held to the body by a girdle); the *tunicle* (which in the sketch is gray, with a decorated hem); the *dalmatic* of richly figured material; finally the *chasuble*, a large garment which in the tenth century still retained its primitive wide oval shape. At the wrists are visible the sleeves of the under tunic and of the alb, the shorter sleeves of the dalmatic being hidden by the chasuble. The alb is also visible at the neck. The ornamental collar is a *superhumeral*, from which hangs the *rationale*. Over this lies the *pallium*, a Y-shaped piece of purple woolen material, which was an accessory conferred as a special honor upon abbots, archbishops, and sometimes bishops. This is the Western version of the pallium shown in the frontispiece.

The chasuble was the vestment in which a bishop or priest celebrated the Mass, and is therefore not often to be used on the stage. It is, however, essentially the same garment as that worn by the laity for an outdoor wrap with or without a hood. The bishop's ceremonial dress for occasions such as processionals, coronations, and the opening of parliament (in the succeeding centuries) included principally the mitre and the cope (fig. 9, Chap. IV), richly ornamented with wide bands of embroidery and jewels, an embroidered hood, and *morses* or clasps of gold and jewels. With this the bishop could carry or have carried before him the *crozier*, which by now had assumed the well-known crook shape (fig. 12e). The book carried by the bishop sketched is probably a *missal* (service book) and its cover would be, doubtless, of stamped leather, red and gold.

Liturgical colors were at this time variable, different customs prevailing in different places. The alb was white; the other vestments were white (or its variant, gold) for festive seasons, black for penitential, and red for Passiontide. Yellow seems to have been considered a variant of green, blue of black.

WOMEN

Heads. Because of the scarcity of representations it is difficult to say just how long the Byzantine fashions in hairdressing persisted amongst the court ladies of Western Europe. The scant evidence of the ninth century is in favor of pinned-up tresses and turbans (figs. 3 and 4), as well as large veils and mantles over the head. A tenth century textile (probably of Byzantine manufacture) shows a Frankish princess with long braids. Certainly from 1000 to

1200 braids became the general mode. Very long hair seems to have been essential for the fashionable lady, and there is ample textual evidence that women had recourse to false hair when Nature's provision had been niggardly. The hair was parted in the middle and arranged in two long braids, falling sometimes as low as the knee. A variation from the ordinary braiding is shown in Fig. 17, where a ribbon is entwined with the hair. Some representations show an interlacing done thus: divide the hair in two strands (as is done in fig. 17) and bind with the ribbon, which passes around one, then both, then the other, and so alternately, to the end. A way to lengthen the braids was to put them in cases, attached sometimes as high as the neck (insert, fig. 17); these long cases were stuffed with tow or other filling. Both braids and cases were often finished at the ends with one or two ornamental metallic tassels, or a group of little pearl or gold drops. Upon the heads of court ladies there would probably be, as in fig. 17, a small gold crown or circlet, or a chaplet of real flowers, or flowers fashioned of gold and enamels. The head was frequently covered with the mantle or a veil, the latter often brought across the neck and over the shoulder. Fig. 18 shows one method of draping the veil (wimple) in use at the end of the twelfth century. It is folded around the head, folded and draped from the back around the throat, and the end is tucked into the head-drapery. During the very last part of the century, too, the braids were pinned up on the head and the veil wound turban-wise, leaving the throat uncovered.

The hood shown on the countrywoman (fig. 19) is here separate from the *chape* described below. The effect may be obtained by following the diagram (fig. 13c); the circle in solid line is the hood. If the hood is to be separate, as in fig. 19, the diameter should be larger, at least forty inches. The small circle in solid line indicates a hole cut for the face.

Necks. The separate round collar of the Byzantine lady (fig. 3) does not seem to have been popular in the West—the neck-finish on fig. 4 may be considered more probable for ninth century dresses. One of the invariable features of Romanesque women's dress is the high neckline; never was the neck exposed below the base of the throat. If the collar of the dress was cut somewhat lower, the neck of the chemise showed above it, as in fig. 17. This sketch shows the typical dress-neck of the eleventh and twelfth centuries, with a deep slit down the front, the whole opening widely edged with a band of gold-thread embroidery set with jewels. A large brooch fastened the dress at the neck. Variations of this neckline were: higher, so that the chemise was concealed, and slightly lower, revealing more chemise.

Bodies. The chemise was worn under all dresses, its cut adapted to the loose or snug fitting of the upper dress. The chemise had a long skirt (to the instep or the floor), a high neck, and long, close sleeves. At this point it is well to note the important fact that during the Middle Ages, *i. e.*, from Byzantine days to the seventeenth century, long sleeves were the only proper wear. A bare arm on a woman was a sign of shocking negligée. Any exceptions to this

rule which may be discovered in contemporary art will fall into one of three classes: 1, the representation of a woman at some work such as laundering, with sleeves turned back for convenience; 2, the representation of deliberate wantonness or undress in private; 3, occasional representations of mythological or fanciful characters, though it may be noted that even these usually have long sleeves, however fantastic the dress. The chemise was linen, and it is interesting to learn that, just as we add bluing to make our bleached linens extra white, so they added saffron to the rinsing water, both for its pleasant odor and for the creamy tint it imparted.

Over the chemise a woman wore a close tunic with tight sleeves, a somewhat shorter, looser tunic with looser, shorter sleeves (fig. 4), in which latter arrangement the chemise would be visible, or both. The countrywoman sketched in fig. 19 wears a rather crude version of the short tunic over the long one. Her chemise sleeves show at the wrists, like cuffs. Although the model for this sketch dates from the eleventh century, peasant women for two hundred years after her wore much the same dress, though it might be neater-fitting.

The dress associated in the popular mind with the Middle Ages, but actually by no means the only or most common one, is sketched in fig. 17. It was a formal court costume and was the mode only during the eleventh and twelfth centuries, reaching the full development of its special characteristics about 1150. This garment, like the nobleman's tunic described above, was called in French the *bliaut*. It had a very snug body, made, apparently, of a heavily crêped, a honeycombed, or a knitted, jersey-like material, which molded the figure. The skirt, set on at the hips, was of some soft, fine stuff, put on with a multitude of gathers or fine pleats, and was always long, touching the ground. The sleeves, of the skirt-material, fitted close at the shoulders and opened wide from above the elbow to the wrist. The width varied from about sixteen inches to a great size, big enough, in the most extreme examples, to trail on the ground. Such exaggeration led to the custom of knotting the ends, to keep them from the dirt. This custom, together with false hair and very tight bodices, was the subject of both sermons and lampoons. Like the man's, the woman's bliaut was laced up on one or both sides. Its girdle, made of silk cord, of cut leather, or of metallic disks, was put around the waist once or, as in fig. 17, twice (crossing in back). The waistline could be at the natural waist, above it, or at the hips.

Instead of this elaborate bliaut, a lady often wore the *cote,* a gown cut with the body and skirt in one, tight or more loosely-fitting according to her taste. If the sleeves were open, the chemise sleeves showed below, as they did with the bliaut, but the cote sleeves were often tight. All tight sleeves, of cote or chemise, were open to the elbow, to admit the hand, and at every wearing either sewed or laced together, as noted for the men (above). The skirt of the cote was long, over the instep, unless it was worn by a serving-woman or a busy housekeeper. The *chainse.* a dress made on the lines of the cote, was

apparently, intended for summer home wear, of washable white material, laid in fine pleats. Either of these dresses might be belted or not.

One more garment came into use at the end of the twelfth century: the *surcote*, worn, as its name implies, over the cote. In this, its early form, it was a loose gown with very deep arm-openings. Fig. 18 shows a surcote whose wide shoulders form a kind of sleeve. This garment is girded. Another type, cut away at the shoulder and ungirded, is shown in fig. 12, Chap. VI.

Outer Garments. A part of the court costume, worn with the bliaut, was the mantle, half-circular, like the men's (above). It was richly ornamented with a border all around, and fastened by means of jewelled metallic plaques, through which were laced silken cords or metal chains, which were adjusted to hold the mantle close or allow it to open across the chest. The mantle was lined with a contrasting material or with fur, and sometimes had a fur border. It was worn, as in fig. 17, open in front, or fastened upon one shoulder.

The mantle cannot be considered as an outdoor wrap. For that purpose the hooded semicircular cloak open up the front was worn by women as by men, and so was the closed *chape*, with or without a hood gathered onto the neck, the diagram of which is given in fig. 13c (the *broken* lines show the shape of the cloak-part). The rectangular shawl, described earlier, was still used, being sometimes large enough to envelop head and shoulders.

Feet. Women wore shoes like those described for men, and stockings gartered at the knees. Stockings seldom show, however, unless worn by working women with short dresses (fig. 19). Note the extreme simplicity of this shoe—a soft foot-covering rather like the modern ballet slipper. Many peasant women went barefoot. Raised heels, it may be well to insist, were never worn.

NUNS

In the Benedictine order nuns wore: a white undergarment or chemise and a black gown made very straight and plain, with moderate open sleeves; a white wimple wound around head and neck; and over that a black veil which covered head and shoulders.

MATERIALS

Woolen was manufactured domestically in France as far back as the Roman occupation, and was dyed red, blue, green, and yellow, and woven in stripes, plaids, and other simple designs. These early textiles, and those used for ordinary garments at a much later time, were heavy and coarse. The church of Notre Dame in Bruges preserves a piece of cloth which is said to have been a part of St. Bridget's gown. Whether or not it actually dates from the fifth century, it is a good example of early fabrics, being a dark mahogany-red woolen, of a texture very much like our burlap. Such fabrics, and not the finer wools and gorgeous silks imported into France and occasionally England, would have been the wear of the Scottish nobility of Macbeth's day, in the wilds of Caledonia.

Linen was domestically manufactured in the West, and was dyed in colors like the woolens. White linen of fine texture was available for wimples. Cotton was grown and spun in Italy after the twelfth century, and brought North. Earlier it was imported from Egypt and India via the ports of Asia Minor. It could be had in various weights, and was also woven in colored plaids and stripes. A cotton goods much spoken of in early texts was *fustian,* a useful fabric akin to our canvas, employed for interlinings as well as for the outside of garments. Crêped materials of linen, cotton, and silk were obtainable in the West by 1000 (see fig. 17).

If silk was precious in Byzantium, it was doubly so in Western countries; the wonder is then that the nobility managed to have as much of it as they did. Eleventh and twelfth century romances abound in descriptions of silken-robed ladies, such as those dressed in "vermilion samite, embroidered with gold flowers," "cloth of gold in birds, flowers, and crescents," "red-purple, tinselled with gold and trimmed in ermine," or "brown samite with little drops of gold"—all of which, at this date, they were importing from Byzantium or farther, and must have cost a pretty penny. In the twelfth century, after the Crusades began, silk was imported direct from the Orient as well as from Byzantium, and more varieties were available. Even from the time of Charlemagne, patterned silks had been used, a favorite from then till the twelfth century being a "powdering" of dots in groups of three (figs. 1 and 3). Oriental silks brought by returning crusaders inspired the native weavers, so that at Paris about the end of the Romanesque period they were skilled enough to weave silk and even damask. Velvet was imported at the end of the period. All the Byzantine weaves mentioned above, including silk tissues for veils, were available, at a price, to the Westerners.

One of the very special uses of these valuable textiles was for altar-hangings and priestly vestments, as may be seen in the richly patterned robes of the bishop in fig. 15. Kings and returning crusaders made gifts of silk to churches. Another enrichment of church furnishings was embroidery, for which the Anglo-Saxons were especially famed as early as the tenth century. Continental churches still preserve examples of this famous *opus anglicanum.* The bishop's cope afforded an especially good field for displaying this beautiful work.

Embroidery, unlike Oriental-woven fabrics, was within the reach of patient needlewomen at home, and was used to ornament garments otherwise, it might be, very plain. An interesting type of handwork mentioned in the texts is an appliqué of large motifs in an all-over design on the mantle, or conversely, a design cut out of the mantle-material, showing a contrasting color underneath, a type of ornamentation foreshadowing the decorative *slashings* so popular in the Renaissance.

MOTIFS

All the motifs enumerated above (p. 103) were employed also on Romanesque garments. To these were added, in the ninth century, vegetable motifs

such as the acanthus and the palmette (Chaps. II and III), a result of the classic revival under Charlemagne, and some of the freely rendered vine motifs typical of full-fledged Romanesque architectural details. In addition, Celtic and Teutonic art made use of interlacing (figs. 5j and k) and strangely conventionalized animal forms (figs. 5l and m, and 9g and 6c).

DISPOSITION OF ORNAMENT

The Byzantine custom of applying large single motifs in circles or squares upon sleeves and cloaks was not preserved in Romanesque dress. It is interesting to observe, however, that it did become part of the Byzantine inheritance of Slavic countries, and to this day appears on the peasant dress of those peoples. The Roman *clavus,* observed above as continuing in sixth century Byzantine costume, was still occasionally used in the form of a broad stripe up the front of a dress, as late as the eleventh century, after which it disappears. In the Romanesque practice, trimming was principally applied as a border around neck, sleeves, and hem; frequently a narrow strip of embroidery covered the seaming of sleeve to tunic, at the upper arm. These borders were often of the richest embroidery, in silk and gold threads, incorporating pearls and gems.

FUR

Unlike the Byzantine modes, those of Western Europe took account of fur, making a luxury of what was, in that climate, a necessity. Lingering a while, even on a summer's day, in the stone churches and ancient castles of Europe, the tourist will be convinced of the practical value of this mode. Almost any of the garments described above was, on occasion, fur-lined, and there were inside vest-like garments of fur, designed especially for extra warmth. Fur often lined the mantle and the outdoor hooded cape. It should be remarked that these garments were fur-lined rather than of fur with a lining. At the edges, however, the fur probably showed in wide bands, and applied fur borders were used even when the garment was not actually lined. As to the kinds, ermine and gray squirrel were most valuable and belonged to the nobility; marten, otter, and muskrat were displayed more commonly; and rabbit and sheepskin were the wear of humbler folk.

JEWELRY

The types of jewelry sketched in fig. 9 continued into the later centuries, though the workmanship became more refined. Articles were large, made of silver or gold and set with enamels, " uncut " gems, and pearls. Romanesque dress admitted of fewer detached ornaments than either Byzantine or barbaric costume; there was little place for earrings when the ears were covered, for bracelets when the arms were sleeved. Finger rings, crowns, circlets and chaplets, belts, belt-buckles and belt-ends, morses to fasten the cope at the neck, plaques for the ladies' mantles (fig. 17, and explained above), and brooches

make up the list. The *fibulæ* shown in figs. 9j, 10 and 17 were perhaps the most important accessories. They were large: four or five inches across for the cloak-fibulæ, at least three for the neck-brooches.

ACCESSORIES

At the end of the twelfth century purses like that shown on the working-man (fig. 11), or larger, were usual, either size worn at the belt. Knives dangled there, too, and sometimes other useful articles. Gloves of fur or leather, trimmed with fur or gold embroidery, were worn by the nobility; gloves constituted part of the official dress of kings and bishops. Stout cloth or leather gloves or mittens were used by the working classes as a protection from the weather or from briars.

The orb and sceptre shown in the frontispiece is in the style carried by Frankish kings. After the time of Charlemagne the sceptre of the Franks terminated in a fleur-de-lis.

SOMETHING ABOUT THE SETTING

Domestic architecture was fortress-like; as in churches, so in castles the low round arch prevailed. Supporting columns had highly decorated capitals, frequently carved in grotesque figures, as shown in fig. 6c (from the crypt of Canterbury Cathedral). Interiors of castles were stone, their cold gloom relieved by bright wall-hangings and murals. The master's seat was raised on a platform at one end of the great hall, and his table set there. By the end of the twelfth century, the earlier fireplace, built in the center of the hall, the smoke escaping through a hole in the roof, was replaced by a real fireplace, with a shallow hood, and a flue into a chimney in the wall.

Furniture was heavy and simple—benches, long tables, couches covered with furs or draperies—unless it was of the classic type imported from the East. Fig. 6b shows a type of royal chair suitable alike for Charlemagne, Alfred, or the French kings of a latter day.

PRACTICAL REPRODUCTION

A stiff and formal grandeur will be your goal in reconstructing Byzantine costume; in reproducing Romanesque dress a certain austerity will be your aim—simplicity of construction combined with barbaric touches in the heavy jewelry, the long hair, the furs, the gartered hose. Considering the dress of both Eastern and Western people you will take into account that new element, the Christian ideal of asceticism, which insisted on regarding the human body as something to be concealed. That is why you must make these costumes with long sleeves and high necks.

Materials. A wide range of materials can be employed in these costumes, if only you have a care that they be appropriate to the characters and their milieu, as has been explained above. In general, garments should be of pretty

heavy material, that is, not of voile, chiffon, cheesecloth, or paper cambric, or of crisp fabrics like organdie. Veils and wimples are the exception; the former *should* be of thin stuff, and the latter may be of batiste, precisely folded as in fig. 18.

Heavy unbleached muslin, covered with designs stencilled in paint and gold, will sometimes better represent the stiff Byzantine royal robes than will any more expensive modern material. Shop in the upholstery department for rayon drapery-stuffs to make the more flexible-appearing garments of Byzantium. Rayon satin, bought at the dress-goods counter, is another showy material and while it comes in plain colors and will not take dye, you may appliqué on it motifs and borders of painted muslin or single motifs cut from cretonne; for if you look around for patterns related to those pictured and described in the foregoing pages you will quite likely be rewarded. Remember, on Byzantine costumes you may use a lavish hand with the gold paint and you may employ cellophane gems (Chap. XX) and ten-cent store pearls to the limits of your patience and your purse. If there are gradations of grandeur in your Byzantine characters, dress the lesser nobility in sateen, patterned by spray-stencilling (Chap. XX). Both rayon satin and sateen should be lined with heavy unbleached muslin or worn over complete under-tunics of that material, in order to exhibit the necessary heavy richness.

For dressing very early Teutonic characters and many of the characters in the Irish plays, burlap will be found a most satisfactory substitute for the home-woven woolens actually used. With burlap (for both Irish plays and Arthurian legends) employ, as more luxurious material, flannelette, heavy muslin (prepared as described in Chap. XX, p. 574), and possibly sateen made up with the wrong (dull) side out. All these materials take dye well and may be stencilled or tied (Chap. XX). Remember that the range of colors was rather small (p. 116) and that the tones would all be deep and somewhat dull.

In the Romanesque plays you may use all the wool-resembling fabrics; fine cotton, or cotton voile, or georgette and chiffon (for veils), and sateen, rayon satin, and rayon drapery material, if your characters could have afforded such elegance. Japanese cotton crêpe and heavy silk or rayon-and-cotton crêpes can well be used for the bodice of the bliaut (fig. 17); knitted silk, rayon, or woolen sweaters also look like the material represented in sculpture. Finer soft cotton or rayon crêpes well represent the lighter material of skirt and sleeves. These are better than crêpe de chine, for they fall in softer, heavier folds. Fine textiles would be available to Matilda, wife of William the Conqueror, but probably unattainable by Lady Macbeth. Chiffon or georgette is appropriate for the veil or wimple of a noble French lady, but cheesecloth is more fitting for ordinary women.

About Accessories. The wide embroidered bands upon Romanesque garments can be made of muslin strips, patterned in oil-paint or tempera, and gold. Gold oilcloth, cut out in a pattern and glued to the muslin, is also effective.

Make the massive gold crown of papier-mâché on a wire screening foundation (Chap. XX). Thinner crowns can be cut from buckram and gilded, or even from cardboard (though cardboard, frankly, shows for what it is). For chain armor see directions in Chap. XX. For shoes you can use felt or leather heelless slippers, pullman slippers, and ballet slippers. Put on ornamental touches with oil-paint or tempera; the latter has the advantage of washing off if the slippers are not a permanent part of the theatre wardrobe. If the stockings are supposed to stop below the knee, use wool, heavy lisle, or ten-cent store cotton (*never silk*). Put an elastic in the top seam to hold the stocking up, whether or not you cross-garter it. Heavy cotton tape is satisfactory for the cross-gartering, and it can easily be dyed the desired color. If you dye it gold-color and put dots of gold paint at intervals you can give the effect of gold tape, whereas the metallic ribbons (especially lamé) are too slippery to stay up. In all costumes where the tops of stockings are concealed by the tunic, preferably use tights, because they stay up better, give a smoother leg, and require no other underwear. For ways of making jewelry, see Chap. XX.

To drape the wimple of fig. 18 (or any wimple to be covered by a large veil, such as that worn by nuns): take a rectangle of soft material about 72 inches by 40 inches, fold it diagonally and put it on the head, folded edge front, the two points about even. Throw one point across the throat and over the left shoulder; bring the other side down the left cheek, under the chin and up the right side and hold just above the ear while you bind the rest of that section across the forehead, around the back, and return to the point above the right ear; link the end with the part you have been holding and tie it, letting the final corner float, as in the sketch; keep the material in smooth folds on the head and cover the hair completely.

Cutting the Garments. Byzantine and Romanesque tunics were apparently made with the sleeve cut in one with the body in the manner of the *tunica talaris* (fig. 5a, Chap. IV), or set on straight to the body, as in the Persian tunic (fig. 22c, Chap. II). In the latter cut, the seam was covered by a band or roundel of trimming. Byzantine and Anglo-Saxon tunics frequently had sleeves fitting snugly into the armpit. If you make tunics of fairly elastic material, like cotton crêpe or even flannelette, you may cut them in with the body, taking the precaution to insert under the arms a square gusset (fig. 20c) to ease the strain. If your material is stiff, like heavy muslin, or easily frayed, like rayon, you may find it more satisfactory to use a pattern with a set-in sleeve, one set in with no fullness. A pajama coat pattern will do very well. For the bliaut with large sleeves (fig. 13a), a dolman or raglan sleeve pattern may prove useful if you can't cut from this diagram. Any of these sleeve patterns can be modified by narrowing it from elbow to wrist for the tight-cuffed styles (with which no undersleeve is needed), or by leaving it with a wide opening. With the latter style the bare forearm must be covered by a tight chemise sleeve—an effect best obtained by setting the undersleeves into a small guimpe to be worn under the tunic.

The body of any of these tunics can be cut by following the diagrams noted above (fig. 22c, Chap. II; fig. 5a, Chap. IV; or fig. 13a of this chapter) or by using a pajama coat pattern. Cut the pajama front in one instead of two pieces, and slit the neck opening in one of the styles shown (fig. 13b) or select a pajama pattern in the " Russian " style, or one with a V-neck. If the tunic skirts are to be short, the coat pattern as it is will have enough fullness; if it is to be longer, below the knee, a gore must be set in on each hip. If you want an elegant slimness, fit the body of the tunic close and hook it under one arm (or up the back, if you mask the opening carefully).

The pajama trouser pattern will be found useful to cut the breeches which sometimes appear just under the tunic and above the hose, or those which reach to the ankle and are cross-gartered (fig. 7). You will have to narrow the legs from the knees down, as described for the Persian trousers (p. 45). If the breeches are not to show (by intent, at any rate) get the actor to let you have a pair of his shorts, which you will dye more or less the color of his tunic, so that they may be unobtrusive whatever happens.

As to women's garments: the early tunic (dating from Byzantine days till about 1050) can be cut on the kimono nightgown pattern (Chap. XX), adding longer pieces to those short sleeves. In crêpe material this will be especially successful. Remember the little gusset mentioned above (fig. 20c). If a good deal of the undergown is to be visible at the lower arms, skirt and neck (as in fig. 4) make a complete garment, cutting it on the princess slip pattern (Chap. XX), adding set-in sleeves; but if it is to be seen only as under-sleeves, use a guimpe, as suggested for the men (above).

The bliaut should be made on the fitted lining pattern (Chap. XX) and to it attached, at the hip-line, a full gathered skirt. Put in at least three widths, even with heavy material, and four with the thin crêpes. Use the upper part of the pattern sleeve to cut the top of the open sleeve, enlarging it from above the elbow down, like the diagram (fig. 20a). Cut the sleeve either lengthwise or crosswise of the goods. A sleeve of these proportions takes two yards, and it descends only to the knees—make it as much longer as you wish. The bodice may be opened under the arm, as it actually was, but it is easier to get into opened up the back, and I advise this plan, if the back is covered by a veil. Also if there is concealing drapery, make the double girdle in fig. 17 in two pieces and fasten to the dress. You must hook the tight sleeves of the chemise or cote up the seam, as flat as possible, remembering that they were actually sewed or laced at each wearing. Therefore do not trim with buttons.

Suggested Reading List

Manuel d'Archæologie Française, tome III, Le Costume—By Camille Enlart.
 A very sound and scholarly volume, containing almost everything you could need to know about the Middle Ages. The French is not difficult and the illustrations are copious.

Ancient Greek, Roman and Byzantine Costume—By Mary G. Houston.
A good short survey of Byzantine costume, with a reflection on its influence in the Western World. Excellent pictures, some in color.

Women's Costume in French Texts of the Eleventh and Twelfth Centuries—By Eunice R. Goddard.
This is a philological treatise, but is very informative for the costumer, especially in its introduction, which summarizes the costume characteristics of the period.

British Costume During Nineteen Centuries—By Mrs. Charles Ashdown.
Illustrated by contemporary material.

Among the books which handle the subject in a less scholarly way, but are very pleasant reading, are:

English Costume—By Dion Clayton Calthrop.
Dress Design—By Talbot Hughes.
Costume and Fashion—By Herbert Norris.

Scenes and Characters of the Middle Ages—By E. L. Cutts.
This is a mine of information about monastic orders, the secular clergy, warfare, and special dress of various groups.

The Principal Weaving Ornaments Up to the Nineteenth Century—By Friedrich Fishbach.
Reproduces a large number of contemporary textile designs.

Where Further Illustrative Material May be Found

Mosaics, especially at Ravenna and Palermo; manuscript miniatures, textiles, mostly Coptic; a few actual garments, notably those treasured in Munich and Vienna; jewelry, discovered all over Europe and the British Isles and preserved in museums; sculpture, especially adorning the interiors of Romanesque churches. Reproductions of these are frequent in histories of art and architecture, or may be found in catalogues of collections such as that of the British Museum, the Cluny Museum, and the Metropolitan Museum. In the art museums of this country are plaster reproductions of the sculpture, and in some of them good collections of original jewelry of the period.

Sources of Sketches in This Chapter

Photographic reproductions of mosaics at Ravenna and Palermo; manuscripts in the British Museum, the Musée Condé at Chantilly, the Bodleian Library at Oxford (the last studied also at first hand); ivories and Anglo-Saxon jewelry in the British Museum (at first hand and from photographs); Field Museum photographs of Irish antiquities; sculptured figures from the Cathedral at Chartres (studied from the originals also); Byzantine Coptic fabrics (colored reproductions in *Etoffes et Tapisseries Coptes,* H. Ernst, Editeur, Paris, and *Das Fabrige Ornament,* Speltz, and some originals studied in the Metropolitan Museum; photographs of a capital at Santa Sophia and one at Canterbury.

Reproductions in Enlart, op. cit. fig. 12 (Munich Bliaut), figs. 406, 371 (manuscript at Durham); women's dresses in Goddard, op. cit. plates 1 and 11; Cutts, op. cit. fig. on p. 8 (manuscript in British Museum).

By special permission of Miss Lillian Wilson and the Johns Hopkins Press, the following are included in this chapter, from *The Roman Toga* (Wilson): Diagram of the Byzantine Toga, fig. 74, measurements applying to this diagram, being Schedule XI, p. 124, and instructions for draping this toga, p. 113.

Chapter VI
EARLY GOTHIC

DATES:

1200–1350

Some Important Events and Names

ENGLAND	FRANCE	GERMANY	ITALY
Richard Cœur de Lion, r. 1189–1199	Philippe Auguste, r. 1180–1223		Pope Innocent III, r. 1198–1216
John, r. 1199–1216 Magna Carta, 1215			Pope Gregory IX, r. 1227–1241 Inquisition instituted, heretics burned
	St. Louis (IX), r. 1226–1270	Frederick II, r. 1212–1250	
Roger Bacon, (humanist), d. 1294	Thomas Aquinas, (scholastic), d. 1274	Minnesingers, especially Walther von der Vogelweide, d. 1228	Franciscan and Dominican orders founded, 1214
	Philippe le Bel, r. 1285–1314		Cimabue, Florentine painter, 1240–1300 (?)
	Philippe VI, r. 1328–1350	" Parsifal " by Wolfram von Eschenbach, d. 1225	Marco Polo's voyages, 1260–1295
		House of Hapsburg first heard from	Dante, 1265–1321 Petrarch, 1304–1374
			Duccio (Sienese painter), d. 1320
			Giotto, Florentine painter, 1266–1337
			Orcagna (Florentine painter), d. 1368
			Pope Clement V, r. 1305–1314 Exile to Avignon, 1309–1377 Boccaccio, writer, b. 1313
Edward III, r. 1327–1377 Battle of Crécy, 1346: Gunpowder used, French fleur-de-lis added to English coat of arms. Order of the Garter, est. 1347(?)			Rise of Italian city-states Florence—Republic Venice—ruled by the Doges Milan, despotism Pisa, despotism

Some Plays to Be Costumed in the Period

d'Annunzio's " Francesca ⎫
 da Rimini " ⎬ Italian,
Stephen Phillip's " Paolo ⎰ circa 1275
 and Francesca " ⎭

Eugene O'Neill's " Marco Millions "
(concerning Marco Polo).

Josephine Preston P e a b o d y ' s " The
Piper " (circa 1300–1350).

Shakspere's " King John."

The Miracle Plays such as the Chester,
York and Coventry cycles, acted by
guilds soon after 1300.

Christopher Marlowe's " Edward II "
(Edward's dates are 1307–1327).

Any dramatization of " Aucassin and
Nicolette " (circa 1250).

Any plays whose date is vaguely " me-
diæval," and a good many plays based
on fairy stories may well be costumed
in this period, which is one of the
most beautiful in our history. And
the costumes are among the easiest to
make!

P a g e a n t r y frequently calls for early
Gothic costumes, as a glance at the
chronological table will show.

EARLY GOTHIC

CONCERNING THE PERIOD

THE architectural achievements in this and the following period are so remarkable that even in a costume history the style of building gives its name to the chapter—a name, as so often happens, bestowed in derision and worn with pride. " Gothic," seventeenth and eighteenth century devotees of the Classic Revival dubbed the artistic achievements of Northern Europe before the Renaissance; churches so different from Greek and Roman temples were to them barbaric, like the Goths who descended upon Rome. To us, who still seek to imitate, " Gothic " seems an expression of spiritual aspiration.

It was during this hundred and fifty years (1200–1350) that Gothic architecture developed from the Romanesque of thick walls, small high windows, massive pillars and rounded arches. While Early Gothic was still austere, perhaps even grim, its arches pricked toward Heaven, and its larger window-spaces began to glow with colored glass. Constantly the architects strove toward a more aspiring curve of arches, a more delicate forestry of supporting pillars, a greater expanse of traceried windows within the cathedrals and, without, a more daring flight of arrow-towers.

The common man, whose life was hard and drab enough, might at the cathedral get his fill of music and pageantry and color, for he had rich costumes of the gentlefolk to gaze at if his mind should wander from the drama of the Mass. Then too, he saw within the church other dramas, miracles and mysteries, the events of Easter and Christmas and the lives of saints. After 1300 the dramas moved out into the market place, and instead of choir-boys and priests as the angels and the three Maries he saw neighbor Tom as Noah and neighbor Hodge as Abraham and neighbor Dick as that terrifying but side-splitting character, Herod.

The Crusades ran their course, less and less holy, until the mid-thirteenth century, and served their purpose of diminishing the isolation of northern Europe, breaking up its provincialism, introducing to more and more people the arts and cultures of the Orient and of Southern Europe. Trade throve; so did domestic manufacturing of textiles.

With these changes, towns grew in importance and the class of townsmen began to have a voice in the world. This was particularly true of Italy. Although that unhappy country was not to be a nation for many centuries, from the second half of the thirteenth century it fostered within its city-states the great artists and poets who were the forerunners of the Renaissance.

Western Christendom was united in the form of worship established by Rome and regarded the Pope as its head. Nevertheless, even as early as 1214 the church structure could do with the buttressing it received from two new brotherhoods, Franciscans and Dominicans (known in England as Grayfriars and Blackfriars). In mid-century, moreover, it seemed necessary to institute the Inquisition and burn heretics. Thirteen hundred was a jubilee year, with pilgrims jostling each other in the Roman streets, but in 1305 a French king deported the Popes to Avignon, and there they stayed for seventy years—the " Babylonian Captivity."

Universities continued to be established; Cambridge dates from the thirteenth century, the University of Prague from 1348. Students were licensed to teach, to be called " doctors of Philosophy," but before they reached that desired goal must earn successively the title of " bachelor " and " master " of arts. Famous schoolmen delved in Aristotle or argued about angels dancing on a needle's point; at the end of the thirteenth century an English Franciscan called Roger Bacon suggested the idea of studying the world about us instead of old books, and so can go on record as the first mediæval humanist.

English and French claims to French and English thrones went merrily on, with the augmenting of blazonings on many knightly shields, till finally the battle of Crécy gave Edward III the excuse to quarter the fleur-de-lis with the English lions. This mighty triumph was the beginning of the Hundred Years War, which caused the death of countless English yeomen and the devastation of the peasant homes of France.

The cult of romantic chivalry continued. Minstrels spun long tales; of antique heroes, Æneas, Alexander, Pyramus; love-stories like the " cantefable " of " Aucassin and Nicolette,"

> " Of the pains the lover bore
> And the sorrows he outwore,
> For the goodness and the grace
> Of his love, so fair of face "—

she of whom it was said, " the daisy flowers that brake beneath her as she went tiptoe and that bent above her instep seemed black against her feet, so white was the maiden." While they listened to the story of Nicolette's bower in the woods, damsels wove chaplets of roses and violets, rue and marigold for their courtly lovers. Knights rode into combat proudly displaying their ladies' favors upon arm or helmet.

Romances, at first only sung, were now committed in manuscript to parchment (or the newer commodity, paper) and illustrated with miniatures painted in brilliant hues. About 1300 appeared " The Divine Comedy," that dramatic panorama of the middle ages.

In mid-century (1346–48) the Black Death swooped down upon warrior and lady, singer and peasant, alike in England, France, Germany, Spain, and Italy At a villa outside Florence a group of ladies and gentlemen, refugees

from the plague, told each other merry tales, which we may still read in a book called the " Decameron."

GENERAL CHARACTERISTICS OF COSTUME

The costumes of this one hundred and fifty years, simpler in cut than the twelfth-century court *bliaut* (fig. 17, Chap. V), were more elegant, more sophisticated, and less stuffy. Perhaps this impression is in part due to the superior skill of the manuscript limner, from whose art we learn so much of the period, and the increased technical ability of the sculptor. Earlier stone-workers, to be sure, knew how to render fine crêped material, but these later artists show us drapery following the lines of the body, almost as the Greeks did. The more general use of fine-woven fabrics, now that they were domestically manufactured, is probably another reason for the lighter, more graceful effect. Then, too, necklines were lower (not, at first, much lower, but even half an inch makes a difference) and the trimming was not so heavy, is not, indeed, visible in the sculpture and seldom in the miniatures. The heavy double-sleeve went out by 1200 and the shape of the forearm in its long tight sleeve was revealed, though from shoulder to elbow might depend various floating draperies, as will be seen.

In the thirteenth century, garments for both men and women were long. From 1200 to about 1270 even the shorter tunics for men came below the knee, and those of the leisure classes ordinarily fell to calf or ankle; even after 1300 the *cote-hardie* reached to the knee or a little above and it, too, might be longer. Women's dresses were invariably long.

The Crusades had introduced a simple system of distinguishing persons by means of emblems. Any crusader might wear the red cross on his breast; the Knights Templars (established in 1119 and abolished in the early fourteenth century) wore the red Maltese cross on a white ground. Soon personal emblems were adopted by pilgrim warriors, and from this custom developed the complications of heraldry. From being carried only by men and only on the surcote or shield, this blazonry came to be used first on men's civil dress and finally on women's also. After about 1250 this style had a firm hold on mediæval costume. In the period we are discussing, the blazonry was large, occupying the whole front of a man's garment from neck to hip, or a woman's gown, skirt, or bodice, or both. The nobility sometimes wore, instead of the blazonry, the chosen colors of their family. For a full hundred years this large heraldic decoration was an important part of costuming, and it gave way only to smaller devices, as will be explained in Chap. VII.

Somewhat analogous to this fashion is one (which came in about 1300) for parti-colored garments, in this first phase usually half-and-half. Some combinations mentioned in contemporary writings are: white and " rayed " (striped diagonally); yellow combined with blue-gray shot with vermilion; scarlet shot with yellow combined with peach-blossom; " rayed " combined with marigold yellow.

Though *necks* were not so well covered, *arms* were never bare, except, as
explained in Chap. V, for manual labor or in extreme negligée. Shoes were
heelless; pointed toes were very fashionable after 1300. Heads were covered
even more than in Romanesque times—men's as well as women's.

MEN

Heads. Hair was a pleasant and sensible length—bobbed to the jaw-line or
a little longer and usually cut with a bang across the forehead. Since we do
not see men represented with perfectly straight locks, and since, then as now,
there must have been a-many not born curly-headed, we may assume that the
hair was set artificially. It was sleekly brushed and the ends turned up in a
neat roll (figs. 1 and 2), or waved so that it curved gently over the ears
(fig. 3). It may be remarked, in passing, that throughout the Middle Ages
both ladies and gentlemen " preferred blondes," as witness this description of
Aucassin: " his hair was yellow, in little curls, his eyes blue and smiling."

Few beards are seen in representations of the thirteenth century *beau monde,*
but after 1300 some men may be discovered wearing small, neatly clipped
beards, often trimmed in *two* points, and clipped moustaches, and others with
still longer beards, as in fig. 5.

Circlets of metal, solid bands or linked pieces, set with jewels and enamel,
continued in fashion, as did chaplets of metallic and jewelled flowers. Wreaths
were made of feathers also, especially peacock tails. Wreaths of fresh flowers
were worn by the nobility only and were, as from antiquity, festive adorn-
ments. Lovers still exchanged flower-wreaths, May-day being an especial occa-
sion for giving and wearing such favors.

Caps were smaller than the Phrygian bonnet (fig. 10, Chap. V), which
had persisted till 1200. Some were of felt, covering the crown of the head,
with a little tail on top, like an inverted acorn cup (fig. 1). Occasionally caps
had earflaps (fig. 4) or a small brim cut in four pieces, any of which might
be turned up or down at will (as in fig. 4, Chap. VII). Cotton, wool, knitted
yarn, or even fur, as well as felt and (after 1300) beaver were made into caps.
From 1300 onward an increasingly popular cap for all classes was one which
looks like a baby-bonnet (figs. 5 and 6). Its vogue lasted till the end of the
fifteenth century, and it was preserved still longer as a scholar's cap, as part
of the headdress of the Doge of Venice (fig. 12, Chap. IX), and, finally, as
a nightcap. In the middle ages this bonnet or coif was usually tied under the
chin, and is most often represented as of white linen, though it might be of
black or dark silk.

The *chaperon* was a hood which covered the chin and neck and generally
had a cape attached. In its thirteenth century form it was fairly snug, but
roomy enough to slip over the head without unfastening (figs. 7 and 8e).
Later representations show it so close-fitting that it must have been buttoned
or laced up the front (fig. 8, Chap. VII). Originally it had no tail, as in
fig. 7, or only a short one (fig. 8e). Though the tail frequently fell at the

back of the head, as in fig. 8e, it sometimes pointed forward, a style crystallized later in the jester's cap (fig. 13, Chap. IX). About 1300 there was a fashion for stiffening the back-pointing tail with whalebone, so that it stuck out horizontally. The scalloped edge on the cape (figs. 7 and 8e) was a common decoration. Occasionally the cape and hood were made separate and either was worn without the other. Frequently, especially in the neat styles which arrived after 1300, the hood was slipped from the head and hung down the back, as shown in fig. 3. The tail was longer then, also, hanging in a small point to the waist or below. It is supposed that this chaperon, worn slipped off the head, is the origin of our various academic hoods.

The loose "capuchon" hood (that simple folded rectangle which was attached to the Roman *pænula*) (fig. 8, Chap. IV) was still popular as a protective covering, worn either attached to the semicircular waterproof cape, or alone.

A wide felt hat is a feature of the period (fig. 8a); it had a round shallow crown and, until about 1300, a button on top. Its brim varied in width from about two inches to several inches. This wide felt hat might be turned up in front (fig. 9) or back, and after 1300 was often turned or rolled at the sides, to form a sharp peak in front (fig. 2). During the thirteenth century black was the most ordinary color for felt hats; after 1300 both felt and beaver hats were dyed in various shades.

Another style of felt hat had a flat crown and a wide brim, with cords to hold the brim rolled toward the crown and strings to tie it under the chin. This hat was worn by the laity in the fourteenth century, but was at that time also adopted by cardinals (fig. 24, Chap. VIII), to whom the hat still pertains, and later by ordinary parish priests.

At this period straw hats were worn principally by countryfolk. They were coarse, braided sun-hats, shaped like the simple felts (fig. 8a). Peasants made hats of rushes, too, and the bark of the linden tree.

From 1200 fine gentlemen trimmed their caps and hats with gold or silver lace and from 1300 with knots of silk or metallic ribbon. Jewelled chaplets (such as that on the lady in fig. 17, Chap. V) encircled a man's hat, and jewelled pins fastened up the brim.

A curious and very prevalent custom was that of wearing a hat or cap on top of the chaperon or bonnet (fig. 5).

The kingly crown was a low, simple, foliated band (fig. 8d).

Bodies. The chemise, which still showed sometimes at neck and wrists, was fairly short (mid-thigh) and slit up front and back. Working-men might wear only chemise and drawers, with a belt around the waist and the chemise tails tucked into it (fig. 6).

During the thirteenth century men of leisure wore long tunics (called *cote, cotte,* or *coat*) reaching to below the knee, to the calf, ankle or instep (fig. 1). The long garment was especially fashionable during the second half of the century. The cote was a graceful garment, with sleeves cut in one with the

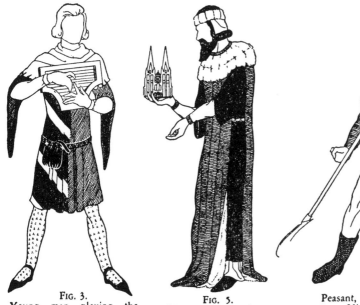

FIG. 3.
Young man playing the psaltery, 1300-1350. Chaperon and cote-hardie.

FIG. 5.
Nobleman, donor of a cathedral, 1300 to about 1350. His outer robe, fur-lined, may be classed as a peliçon.

FIG. 6.
Peasant, 13th or 14th century. His bonnet or "coif" was common to all ages, sexes, and classes.

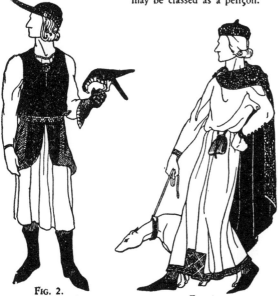

FIG. 2.
Gentleman in hunting dress, c. 1300. Note falconer's glove and turn-up surcote skirts.

FIG. 1.
Gentleman, c. 1250, wearing cote and mantle. Note his purse.

FIG. 4.
Scholarly gentleman—1300 to about 1350. Dante wore such a cap.

body, often wide at the top, in the style we call "dolman" (fig. 13a, Chap. V). The skirt was not very full, though allowing a good stride. The cote was belted immediately above the hips, and the upper part bloused a little over the belt (fig. 1). From the elbow down the sleeves were tight, and fastened up the outside of the arm with a row of buttons. The neckline was rather lower than in the past, a little below the collarbone. Though it must always have been slit to admit the head, such an opening is frequently not shown in representations, and when it is visible is not so heavily bordered as in Romanesque styles (fig. 10, Chap. V). The simple cote was the only indoor dress of ordinary folk and was, under the austere influence of St. Louis, worn alone by the nobility also.

The *surcote,* however, was frequently added. This garment, which seems to have begun as a protection or decorative covering for armor and to have been introduced into women's styles at the very end of the twelfth century (fig. 18, Chap. V), was now a part of masculine civilian dress. In its simplest form it was a sleeveless tunic with armholes wide enough to allow the free passage of loose-topped cote-sleeves (fig. 2). It was belted or unbelted at will, and its length varied from above the knees to the ankle. It was slit up the back, and sometimes up the front, for horsemen; for greater convenience, the two front corners might be tucked into the belt (fig. 2). Often it was made of rich material, fine woolen, samite, or other heavy silk, or even cloth of gold. Its neckline was like that of the cote, but the slit of the surcote was often richly trimmed and fastened with an elaborate brooch. Another, very usual, fashion was to leave the slit open and let the two corners fall back like revers, sometimes even rounding them out to make narrow lappets. Occasionally also a small round collar finished the neck, or a hood was attached to it. After 1300 the unbelted surcote was often furnished with two slits in front (fig. 14) which gave access to the purse on a belt underneath or admitted the hands as to a muff in cold weather. Occasionally a pocket was sewed inside the slit.

After about 1250 appeared various versions of the sleeved surcote. The garment itself was often wider than the cote, indeed more the shape of a chasuble or *chape* (figs. 13c and 15, Chap. V), and had slits for the arms, and sleeves. Fig. 4 represents one style, where the sleeves are little arm-capes. Worn as shown, unbelted and instep length, this surcote seems to have been especially popular in Italy and is the garment in which Dante is generally depicted. The scanter surcote, again, might have scanter sleeves set into its armhole. The man in fig. 4 may be wearing such a surcote, with half-sleeves and long skirt *over* his cote and *under* his loose black surcote. The sleeves were not always the color of the surcote, and it is probable that they were interchangeable and tied or pinned into the armhole. A surcote sleeve sometimes duplicated in shape the cote-sleeve, and was also buttoned from the elbow down, or else left unbuttoned and dangling. From this latter custom developed the style for a pointed piece or tail, sometimes called a "tippet," hanging from above the

elbow as a finish to the half-sleeve of the cote-hardie (fig. 3). The sleeve of an undergarment showed from elbow to wrist. Still another sleeve depicted is more truly only a floating drapery, attached to the armhole for only two or three inches at the shoulder. It is shown on a loose, unbelted surcote with rather small armholes.

After 1300 the vogue changed very decidedly. Whereas from earliest times the masculine dress of Europeans had been loose and easy, its tailoring never more intricate than that of a smock, now garments were form-fitting, even the skirts (often abbreviated to the knee) having no superfluous fullness. Such a mode demanded skilful tailoring, not only of the body-garment but also of the leg-coverings. The new garment was named the *cote-hardie.* It may sometimes have been worn directly over the washable chemise, sometimes over a garment corresponding to the earlier cote. The typical cote-hardie had a close-fitting, long-waisted body to which was attached a skirt, usually represented as without pleats or gathers, but full enough to allow free movement. We may suppose that it was either gored at the sides or cut partially circular. The joining of body and skirt was covered by a belt, often richly ornamented. The sleeves were scant and frequently displayed the appendage (tippet) noted above. Figs. 3 and 7 show the cote-hardie in two variations of cut and material. In both sketches the garment is accompanied by the chaperon, whose wide cape comes well over the shoulder. More often than not these two garments are represented together. However, when the neck of the cote-hardie *is* visible it is of a shallow " bateau " shape lower than the neck of the cote.

Short garments, such as the *doublet* and *jupe* were worn between chemise and cote-hardie. Being intended to furnish extra warmth, they were frequently quilted or lined with fur. Often sleeveless, they were on occasion sleeved. Before the end of the fourteenth century these very short garments (affording no covering to the legs) were seldom worn without a cote-hardie or a gown. Later, such a practice was not uncommon (fig. 1, Chap. VII).

Legs. Until the vogue for short garments (1300 and on) the rather bulky underdrawers sketched in fig. 11, Chap. V were a universal masculine garment. In fig. 6 they can be just glimpsed under the peasant's tucked-up chemise or cote. The hose of well-dressed men were neat-fitting even if their skirts were long; peasants went partially bare-legged, as in fig. 6, wore long drawers cross-gartered to the knee (in the old style shown in fig. 7, Chap. V), or bandaged their legs with straw and cloth strips. The straw afforded extra warmth in cold weather.

With the advent of short skirts, hose became very important to the well-dressed man. Probably most stockings were cut from strong but elastic cloth and fitted to the leg with seams. They were long separate stockings, *not* tights, *i. e.,* they were not joined in the crotch. They were not necessarily made with feet, but might be more like gaiters, with a strap under the foot; some undoubtedly had entire feet. Cloth hose were lined and possibly padded, when the shape of the leg needed improving. It is also supposed that knitted hose were

known. Though they were almost always of wool, very rarely they were silk. While the color of hose was a matter of choice, a serviceable gray-blue or slate color was perhaps most frequent. Hose decorated with an all-over pattern were fashionable toward the end of the period, clusters of spots (fig. 3), circles, and other little geometric patterns being popular; the fashion for parti-colored garments included hose in the divided arrangement. As the stockings grew longer the under-drawers grew shorter and scanter. While there are instances of garters around the knee, long hose were usually attached by straps to the belt or drawstring of the drawers.

Feet. Soles fastened on the bottom of hose-feet sometimes took the place of shoes. Shoes were still highly ornamental, and were made of leather, heavy silk, or velvet and decorated with embroidery and even jewels (fig. 4). Simple shoes (fig. 1) and equally plain slippers (figs. 3 and 5) were worn by well-dressed men, also, and are usually represented as black. Soft, close-fitting boots (fig. 2), probably of black leather, were worn by gentlemen in outdoor pursuits, and much the same style in heavy calf by peasants (fig. 6). Even in 1250 pointed toes had become fairly exaggerated (fig. 1), and between 1300 and 1350 they went to greater extremes, though there were always plenty of men who had only little points, or none, on their shoes.

Outer Garments. The circular or semicircular cape or mantle continued as a dignified outer garment (worn indoors to complete the costumes, as well as outdoors for a wrap). As shown in fig. 1, it was pinned, buttoned or laced on the right shoulder; arranged thus, it might also have a slit for the left arm; or it might be put on with the opening directly in front. The pilgrim in fig. 9 wears his simple cape thus.

Fig. 5 shows a garment somewhat akin to the mantle or, perhaps better, the *chape* (fig. 13c, Chap. VI). It covers the wearer front and back, but is open up the sides. A loose garment like this, fur-lined, seems to be suitably classed as a peliçon. The shoulder-cape shown on fig. 5 was worn with the mantle also, and was sometimes a part of kingly costume.

The chape with its loose hood or capuchon continued to be the favorite garment for rain or cold. Sometimes it was split up one side, and occasionally it had long loose sleeves.

SOLDIERS

From about 1200, while foot-soldiers continued to wear hoods (like the chaperon) entirely of linked mail, knights enclosed their heads in steel helmets, square-cornered or round, with complete visors or face-coverings having apertures for seeing and breathing. On top sprouted a crest. Later, at the beginning of the fourteenth century, a more comfortable head-covering came in, a short-pointed, cap-shaped steel helmet, put on over the chain-mail hood (fig. 10). In the early 1300's appeared (also worn over the chain hood and neck-covering) an iron hat closely resembling the A.E.F. trench helmets of the World War. These were intended for bowmen rather than knights.

The hauberk, or shirt of mail, reached to the knees; below it, legs and feet were clad in hose of chain-mail. A rather full surcote, to the knee or longer, was crossed by the diagonal sword-belt, and was, probably, additionally belted. This was in general the style till 1300—the style with which the closed helmet mentioned above would be worn. The warrior sketched in fig. 10 dates from 1325 and his equipment well shows the transition from chain to plate armor. His hauberk is as described above, the outer arms and the shoulders being further protected with plate. Over his chain-mail hose go jointed plates protecting the front of the legs and feet only. Spurs are fastened on over the steel plates at the ankle. The peculiar form of this man's surcote (some writers call it a " cyclas ") reveals his other garments very clearly. They are, from inside outward, as follows: cote (dark and plain); hacqueton (scalloped), a tight garment, probably quilted; hauberk (chain-mail); gambeson (scalloped), a tight-fitting sleeveless tunic; and surcote or cyclas, in this case shorter in front than in back. A narrow belt girds his surcote, a sword-belt rests on his hips. The only garment necessary to show besides the hauberk is the surcote or (for a period about 1350 to 1375 or 1400) the close gambeson. However, if you were representing a warrior just out of his armor you would probably dress him in a heavy, quilted hacqueton. Armorial bearings might be embroidered on the surcote or the gambeson.

Shields were of much the same triangular shape as that in fig. 14, Chap. V, but not quite so large. The coat of arms was blazoned on the shield, and appeared also on the shoulder-guards over the hauberk (fig. 10). Swords were lighter than those fashionable at the Battle of Hastings and had hilts more definitely cruciform; and a sword-belt, instead of swinging around the hips, might cross the body, right shoulder to left hip. Members of the nobility were entitled to wear white belts as well as golden spurs. While the old long-bow was still the Englishman's favorite weapon (as it had been at Hastings), the cross-bow (fig. 13, Chap. VII) had already come into use. The buckler, a small round shield held at arm's length to parry blows (fig. 9, Chap. IX), had already made its appearance (Ormsby Psalter, 1295). It was used in single combat rather than in battle.

CLERGY

By 1300 the bishop's mitre was usually taller than in earlier centuries (fig. 8b). The chasuble (fig. 15, Chap. V) had narrowed a little at the sides, but was still flowing and graceful. The cope (fig. 9, Chap. IV) had not altered and with mitre and alb now constituted the parliamentary dress of an English bishop. Though fig. 8c was drawn from a fifteenth century manuscript painting, there is evidence that from 1316 the papal tiara had three crowns. The year 1245 is said to be the date upon which the red hat (of the style described on p. 132) was first given to cardinals as a special distinction, and at that time also began the custom of dressing cardinals entirely in red. Others of the clergy wore the same hat, but not red. Different ranks of ecclesiastics were

further distinguished by the number of tassels on the hat strings: one to each string for a priest, three for a bishop, seven for a cardinal.

PILGRIMS

No particularly different costume set pilgrims apart from ordinary travellers, except that when they returned from a pilgrimage they sported souvenirs of the shrines they had visited. The pilgrim in fig. 9 is returning from the shrine of St. James of Compostella, whose badge was the cockle (or scallop) shell. Pilgrims, male or female, wore gowns (not always long) of sturdy wool, and ample capes to protect them from the elements. A hood was usually added, but even if that were omitted, the pilgrim wore a shoulder-cape, a custom so universal that this type of cape came to be called a " pelerine," a name still used in the nineteenth century to describe the short capes fashionable in women's dress. A wide felt hat, turned up as desired, was about as necessary as a cloak. The *scrip* or large pocket hung on a bandolier or baldrick and the tall staff with a knob on the top also became identified with pilgrim costume, though the scrip was equally popular with shepherds and farmers. From the top of the staff there often hung a round gourd.

WOMEN

Heads. Queens and unmarried girls wore their hair loose upon the shoulders, a custom for long followed by brides. The flowing tresses were confined only by a circlet or chaplet (fig. 11). But in the middle ages loose and uncovered hair was frowned upon for married women except royalty. There was something too seductive about hair. As late as the sixteenth century a moralist could compare flowing blond hair to the flames of Hell; girls were warned against exhibiting their hair (when they grew up, presumably); King David was considered to have fallen from grace after gazing upon the un-bound blond tresses of Bathsheba; and the mediæval artist was fond of depict-ing that arch-seductress, the siren, perpetually combing her golden hair. So the modest woman braided and twisted up her locks and covered them with cap or veil.

From 1200 until nearly 1300 the hair, still parted in the middle and braided, was drawn back and criss-crossed into a bun usually rather low on the nape; after 1250 this was covered with a colored net. When the hair had been ar-ranged thus, a piece of white linen was brought from under the chin to the top of the head and there pinned; then a band of stiff linen was pinned around the head. Instead of a band, there might be a complete cap, like a bell-hop's (fig. 12). A veil was sometimes put over this headdress, either falling free on the shoulders or draped around the neck like a gorget.

In the latter part of the thirteenth century, while the bun at the *nape* was still being worn, there arose another style, which massed the hair in two buns at the *sides* of the face, and this fashion had superseded the other by about 1300. The chin-strap and stiff band continued in favor for a while but by

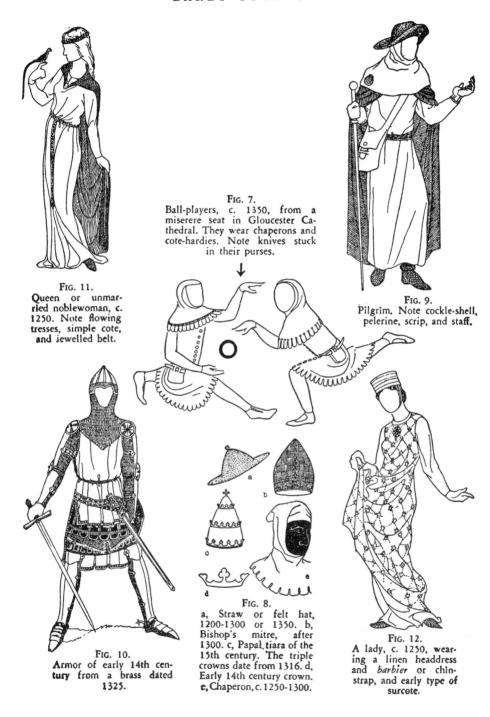

FIG. 11.
Queen or unmarried noblewoman, c. 1250. Note flowing tresses, simple cote, and jewelled belt.

FIG. 7.
Ball-players, c. 1350, from a miserere seat in Gloucester Cathedral. They wear chaperons and cote-hardies. Note knives stuck in their purses.

FIG. 9.
Pilgrim. Note cockle-shell, pelerine, scrip, and staff.

FIG. 10.
Armor of early 14th century from a brass dated 1325.

FIG. 8.
a, Straw or felt hat, 1200-1300 or 1350. b, Bishop's mitre, after 1300. c, Papal tiara of the 15th century. The triple crowns date from 1316. d, Early 14th century crown. e, Chaperon, c. 1250-1300.

FIG. 12.
A lady, c. 1250, wearing a linen headdress and *barbier* or chin-strap, and early type of surcote.

about 1330 was abandoned in favor of a band, circlet, or wreath, shaped to fit the wide coiffure (fig. 13). During the same time, some women enveloped their heads in silk bags with coarse nets over them. Others, especially young women, wore simply the large buns of braided hair over their ears, as some women wear it still (fig. 14).

A gorget enveloping chin, throat, and neck, pinned to the hair and worn without a veil (fig. 13) is a style belonging, particularly, to about the second quarter of the fourteenth century (though some women wore it before and some after that time). Over a longer period many women covered their heads and necks both; it might be, as in the twelfth century, with a long scarf twisted and tied (fig. 18, Chap. V) or, more frequently as time went on, with a separate gorget and wimple or head veil. Figs. 15 and 16 show two ways of arranging the gorget and wimple. The gorget seems to have been a kerchief folded bias, so that it fitted close when brought around the neck and pinned in back. An extra piece covering the forehead was sometimes added, and the wimple draped over that. The face was thus completely framed, usually in white. The wimple was either light or dark, and was confined by a band or circlet, or left unbound. Gorget and wimple seem to have been worn principally by widows, *religieuses* (pious recluses, some *not* in orders), and older women; not for some time to come were they the exclusive wear of nuns.

The chaperon (fig. 7), the small bonnet (fig. 6), the capuchon (p. 132), and any of the brimmed hats, often put on over a bonnet or chaperon, were all worn by women, though the more strictly masculine styles seem to have been borrowed principally after 1300.

Bodies. Up to about 1300 the typical dress was the simple gown or *cote* (worn over the long-sleeved, high-necked chemise). The cote itself had a round neck, not much lower than in the twelfth century but much less heavily ornamented. It was slit a little way down the front and fastened with lacings or a brooch. Its long tight sleeves, not very large at the shoulder, were probably cut in one with the body, which was not shaped by darting or tight lacing under the arms, but clung to the bust and went into soft gathers at the waist. The long and ample skirt was cut in one with the body, and it may have had side-gores to account for its width. It was confined immediately above the hips by a belt with a buckle and a long tongue which hung to the knees (fig. 11).

The *surcote* (whose beginning, at the very end of the twelfth century, is shown in fig 18, Chap. V) went through very much the variations described for the man's garment (p. 134). Its vogue continued in feminine apparel long after it had been abandoned by men. The feminine surcote of about 1250 had snug armholes (fig. 12) which might be left sleeveless or supplied with sleeves so as to be virtually a second cote. The tight sleeve left open from the elbow and dangling was as popular as with men (fig. 14), but the other varieties of sleeved surcote (p. 134) are seldom to be seen on women. About 1250 began a vogue for leaving the side-seams open and buttoning

them all or part-way down. Fig. 15 shows such open seams on a loose-sleeved surcote dated as late as 1325. The feminine surcote was generally unbelted; the two front slits or pockets (fig. 14) were popular with women as with men. By about 1300 there was already a tendency to cut the surcote away under the arms to below the hips, thus displaying a tight-fitting cote and, frequently, a hip-belt (fig. 13). The cote or, more often, the surcote, was worn by fine ladies very long. It would have trailed in front as well as back if it had not been held up in one or both hands (figs. 12 and 13) or draped over one arm. If a lady had need of both her hands, she could tuck her train into her belt (if she were wearing a belt). Since the surcote was often lined with fur or rich silk, the effect was sumptuous.

After 1300 by far the most typical dress is the gown or cote (or possib the surcote), unbelted, fitting the body close, having a skirt full at the hem long tight sleeves, and a wide " bateau " neck (figs. 14 and 16). The décol-letage completely differentiates the fourteenth century from earlier periods; it was often lower than that shown in fig. 14, a tendency more marked as time went on. Italy especially favored the low-cut, ungirded " princesse " gown. Because, while clinging, it outlines an uncorseted figure, it gives a decidedly short-waisted appearance (fig. 16). Occasionally a narrow girdle placed directly under the breasts enhanced that effect.

Peasant women (fig. 17) wore long chemises and over them very simple cotes, which they might tuck up into the belt for greater convenience. The woman in fig. 17 wears a chaperon and a straw hat on top of it; she is help-ing with the harvest.

Feet. Women's shoes were like men's. Since dresses were always long we have little occasion to worry about stockings, except to remember that they were worn and, moreover, held up by garters which might have fancy buckles. Otherwise, so it is said, there would never have been instituted the Order of the Garter, with its well-known gentlemanly motto, *" Hont y soit qui mal y pense."*

Outer Garments. During the thirteenth century, as earlier, a mantle or semi-circular cape completed a lady's court costume (fig. 11). This convention continued even later and has survived in the coronation robes of queens.

The chape with capuchon (fig. 13c, Chap. V) was the principal outdoor wrap. Ladies wore the other versions of the closed or open cape, frequently fur-lined, that have been described above under MEN.

CHILDREN

Infants were swaddled, the bands which wrapped them being, sometimes, richly embroidered (fig. 18a). Older children wore replicas of the adult cote and surcote. Both boys and girls are represented in the close linen bonnet (fig. 6), from under which, in the case of a little girl, the hair floats free. The children in manuscript pictures usually seem to be very simply clad, but un-doubtedly wealth made display, as it did amongst their elders.

MATERIAL

This one hundred and fifty years saw the introduction into western Europe of a greater variety of textiles. In general, garments seem to have been made of materials not stiff but heavy, for they are represented as falling in soft but not light-weight folds.

Linen weaves included sheer lawn and batiste for fine wimples and veils as well as canvas for sturdy garments. Cotton in various weights, hues, and patterns was made into under and outer dresses.

Of woolens (the staple material for both masculine and feminine garments) there were many sorts. The northern countries imported some fine cloths, such as camel's hair from Cyprus and Syria and jersey from Italy. Camelot, a very fine woolen cloth, much admired, was at first imported, but later was woven in France. Also domestically woven were serge, flannel, a fine cloth apparently somewhat like our wool crêpe, a heavy double-faced woolen, and the material called " scarlet." This last was a soft, fine-thread wool, " dyed in the yarn " with cochineal. After weaving it might remain a clear bright red, or be top-dyed black or any dark tone. Thus we read of " black-scarlet." The practice of making warm undergarments of red-scarlet continued for a long time. The red flannel underwear which was a joke-smith's standby even into the twentieth century might be considered a relic of that custom.

Silk was woven domestically and therefore, while still very expensive, was available to more people than in earlier centuries. There were several luxurious sorts, among them *cendal,* a heavy but supple satin much employed for linings; another heavy dull-finished silk, brocaded or diapered, which was especially suitable for mantles; velvet, which increased in popularity; silk brocaded with gold threads as well as all-gold or silver cloth (prized for rich secular garments and church vestments); and thin tissues or chiffons used especially for veils.

Fur can be classed as a material, since it often formed a complete lining to a garment. Sable, gray squirrel, and ermine were used by the upper classes (ermine seems to have been reserved for the nobility) and lamb by less pretentious folk. The humble wore badger, rabbit, muskrat, and even cat (more frank about it than our modern coat-merchants).

COLOR

Vermillion is a constantly recurring note in manuscript miniatures, accompanied by other bright, gem-like hues. From these pictures and from descriptions in texts we may conclude that a thirteenth-fourteenth century gathering would have been vastly more lively and colorful than a modern one. After about 1300 a court assembly would have been especially striking because of the large heraldic devices on garments, and also because of the vogue for parti-colored dress. The scene must indeed have been a perfect kaleidoscope of color and black and white, in strong contrasts. Yet it must not be forgotten

that the ordinary man or woman wore dark, serviceable hues such as dull brown and green, dark blue, gray, and the duller yellows, oranges, reds, and violets, colors to be extracted at home from barks, herbs, and iron-rust. Then, too, people wore their good clothes a long time, so that often the brilliance which has survived unimpaired on the pages of romances would have faded to mellower tones in actual fabrics.

MOTIFS

In the thirteenth century, when design was still applied in borders, it was principally composed of rather elaborate geometric arrangements (figs. 1 and 12). Patterned fabrics employed the same class of motifs, as well as the earlier bird-and-animal designs and some charming adaptations of the vine. The general nature of these designs did not change in the fourteenth century, but the border method of trimming was less popular than that of contrasting bold patterns and colors in blazonry or merely in striped effects. "Rayed" (wide striped) fabrics had been used since barbarian times. Plaids persisted also, and were made up not only into garments for men and women but also into draperies and bed-coverings. It seems probable that such stripes and plaids, which had for so long been home-woven, were the wear of respectable ordinary people, while elaborately-patterned materials decked the courtiers.

APPLICATION OF DECORATION

It has been noted in passing that the earlier practice of applying ornament in borders to neck, wrist, and skirt-hem continued in the thirteenth century, but in a lighter version. This type of trimming did not vanish completely, but it was overshadowed by the other and bolder designs introduced in the fourteenth century. A form of decoration which was to become very popular in the next period was the cutting of edges in scallops or tabs (figs. 3, 7, 10).

JEWELRY

Brooches, used by men and women to fasten capes and neck-openings, and by men as hat-ornaments, were of fine goldsmith work and set with jewels. (Gems were still "uncut," i. e., not faceted in the modern way.) Belts were often of equally elaborate materials (figs. 2 and 11), though they were also of plain leather, the ornamentation confined to an elaborate buckle and "mordant," or tip. Headbands or circlets were of gold, jewels, and enamel and were sometimes of plaques linked together, as were belts also (figs. 11 and 2). The circlet or coronet shaped to fit the wide-sided coiffure has been commented upon (p. 140) and is pictured in fig. 13. Gold and jewels were sometimes worked into dress-trimming, and frequently went into accessories such as sword and dagger hilts, purses, and the covers of devotional books.

About the middle of the fourteenth century began the use of "collars" or wide, flat necklaces, which were insignia marking the wearer as the member

of an "order" (such as the Garter) or the scion of some great house, or merely the follower of such a person. Indeed any piece of jewelry could bear the device, emblem, or motto of a man or of his feudal over-lord.

Neither bracelets nor earrings had much place in mediæval costume, but rings were popular with both men and women.

<div style="text-align:center">ACCESSORIES</div>

Royal. The French royal crown is sketched in fig. 8d. The orb and sceptre remained about the same as that shown in the frontispiece. From about 1200 the French kings held the " main de justice " (fig. 18b) when they gave judgment.

General. Almost everybody wore a purse (figs. 1, 3, 7, 9) hanging from his or her belt, often concealed, however, by the unbelted surcote. Travellers (shepherds, too) wore the large scrip or knapsack upon the hip, usually hung upon a bandolier (fig. 9). Upon a similar strap official messengers wore boxes, round or square and about six or eight inches in diameter.

Dangling from the belt were useful articles such as shears, keys, a sewing-kit, or a sheath knife. Another neat way to carry the knife or a dagger was to thrust it through a strap in the purse (fig. 7).

Gloves were worn more commonly than in the previous period. As then, laborers protected their hands with clumsy mittens or fingered gloves, and gentlemen and ladies wore well-made gloves with strong gauntlet cuffs, especially for the sport of hawking (fig. 2).

Musical. The musical instruments discussed in Chap. VII (p. 174) and sketched in figs. 11 and 20, Chap. VII, were being played by 1300; some, like the harp and the psaltery (fig. 3), earlier. The girl in fig. 14 is playing a four-stringed fiddle of the type called " rebeck." The young man in fig. 3 may be a professional minstrel (minstrels seem to have worn no distinctive costume, only to have dressed as sprucely as possible), but the damsel is not a member of any professional troupe. Women attached to parties of minstrels were usually dancers or contortionists and enjoyed no very savory reputation. No, this is a nice girl, and her father has permitted her to be taught the fiddle, for her own amusement and his.

<div style="text-align:center">SOMETHING ABOUT THE SETTING</div>

Domestic, like church architecture of the Early Gothic period, expressed itself in the vault and the pointed arch. Walls were of stone, with lancet windows, single or in groups. Large doorways were set in deep receding mouldings under pointed arches. Fireplaces, simple and shallow, were made in chimneys which projected from the wall. The cold stone walls of rooms were decorated with paintings or tapestries which told the stories of heroes and heroines of history and romance. Silk cushions and draperies upon couches or chairs added more color. Heraldic devices on banners and shields, hanging

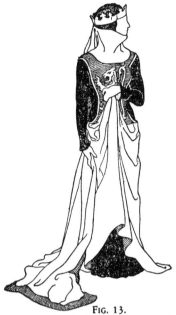

FIG. 13.
Lady of about the year 1330, wearing surcote with armorial bearings and gorget without wimple.

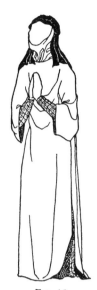

FIG. 15.
A middle-aged noblewoman, about 1325, wearing gorget and wimple, cote and open-sided surcote with sleeves.

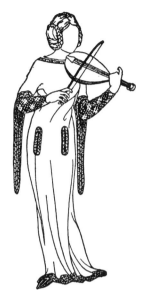

FIG. 14.
Young lady, c. 1350, playing violin or rebeck, wearing cote and surcote. Note the two slits in front.

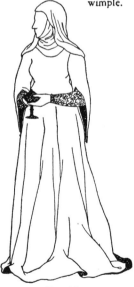

FIG. 16.
Lady, 1300-1350, wearing gorget and wimple, cote, and surcote.

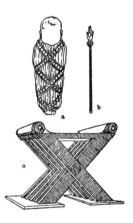

FIG. 18.
Infant in swaddling bands, 1200-1250. b, "Main de justice." c, Early Gothic stool.

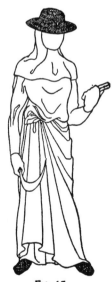

FIG. 17.
Peasant woman in a straw hat, 1200-1350. She wears a chaperon under the hat.

from beams or fastened upon the walls, proclaimed the importance of the householder.

Furniture was of heavy carved oak, often more Romanesque than Gothic in its lines. Great high-backed chairs with high arms were seats of importance. More common were stools of various sorts, of which a rather elaborate example is shown in fig. 18c. The French kings still sat, officially, on the "curule" type of chair shown in fig. 6b, Chap. V. Enormous, high-canopied beds and great carved chests furnished the sleeping-apartments. In the great hall of a feudal castle would be placed, upon a raised platform, a long, narrow dining table, covered with a richly embroidered or woven cloth and set with massive plate.

PRACTICAL REPRODUCTION

When you costume a play in this period—it is sure to be a romantic play— think of the type of feminine beauty you should try to reproduce: small sleek heads, high foreheads, long white necks, and sloping shoulders; long arms with tapering, gem-laden hands; small round breasts, slender waists, and long legs. Think of the ideal men as being tall and slender, graceful as well as strong and bold. The costumer has at her command, to create this illusion, long sheath-like garments, draperies falling from the shoulder, sweeping trains, and rippling capes. Along with this beautiful simplicity of line she will avail herself of brilliant colors, alone or in combinations, remembering in particular the excellent effect obtained with contrasting linings of mantles, cloaks, and surcotes.

There are enough headdresses to choose from in either the thirteenth or the early fourteenth century styles to find one becoming to any actress. Almost any woman looks the better for a close white wimple and gorget or chin-strap; gold and jewelled nets are immensely becoming to many. Be sure that you let only queens or maidens wear flowing locks.

Select the furs you use according to the rank of the wearer—don't put ermine on a tradesman's wife or on heralds, who are only servants. When you use heraldic devices as decoration, find out the correct blazoning if your character is historic, or, if fictitious, make up one that is plausible but not too near some authentic design. The book mentioned in the reading list, or others on the same subject, will help you.

Materials. From the list given in Chap. XX select those materials which have the quality of draping heavily and softly: flannelette and outing flannel to imitate soft woolens, rough-dried heavy muslin to suggest the harsher fabrics, and burlap for homespuns. Wool jersey or balbriggan gives exactly the right effect when used for dresses like the one shown in fig. 11, and neither is so very expensive, but if the pennies must be saved you will find that Japanese cotton crêpe gives an excellent effect, too, and it can be dyed in beautiful colors.

Both cotton rep and denim, while they are usually too stiff for women's

dresses, make up well into the close-fitting masculine cote-hardie shown in fig. 3. The material is so sturdy that you can even cut it out in scallops and leave a raw edge finished only with shellac. Use awning material cut on the bias for the horizontally " rayed " cote-hardie.

Use rayon satin to imitate the lustrous silks, rayon and cotton crêpe for the duller weaves. You can get good effects with sateen, too. Probably among upholstery or drapery fabrics you will be able to find a few appropriately patterned materials (p. 143); look especially for those woven with a metallic thread. For very sumptuous metallic fabrics, patronize theatrical supply houses (Chap. XX).

With the coarsest window-curtain net you can make good hair-nets. Gild it if you like, or simply dye it a bright color, and sew a pearl in every intersection. To imitate the smaller meshes which hold up the buns of hair at nape or sides, try at the ten-cent store for those colored silk nets that women use to hold water-wave combs in place.

Use good-grade cheesecloth, cotton (or silk) voile, marquisette, chiffon, or georgette for wimples and for diagonally-folded gorgets. For the chin-strap shown in fig. 12, employ crisper white, like batiste; for the headband of the same coiffure, still heavier white, starched and folded.

Accessories. Consult Chap. XX for ways to make jewelry; accessories of papier-mâché, plastic wood, and hardware; armor, shoes and, in general, millinery. Chaps. V and VII give suggestions about shoes useful for this period also. Study Chap. XX for methods of applying decoration, remembering that you must avoid anything that stiffens the fabric and interferes with its graceful draping.

Millinery. Consult Chap. XX.

If you need a flat stiff hat like that described on p. 132, look around for a felt or beaver " sailor hat " of the kind that women were wearing about 1910. A hat of much the same type is still a part of Spanish regional dress. Such hats can usually be rented from costumers under the title of " Spanish hats."

Block the little felt cap from an old hat-crown or make it of felt cut in four or six sections to fit the head (you can find a paper pattern among the " millinery " designs in pattern books).

Cut the close linen bonnet or coif (fig. 6) in two pieces with a seam up the middle of the back. You will have to take a dart just in front of the ear.

You can make the early chaperon (figs. 7 and 8e) by an " animal costume " pattern. Allow for the peak when you are cutting it. It will probably be loose enough to go over the head; if not, cut the neck wider. Use either the same pattern (made snugger with darts in the neck) or the hood on a " Mephistopheles " masquerade costume for the later, neater-fitting hood. If your pattern does not include a cape, cut your own, two rounded pieces front and back, fitted with seams on the shoulders and hooked or zippered up the front.

CUTTING THE GARMENTS

Men. The bliaut diagram (fig. 13a, Chap. V) is a good foundation for the cote (figs. 1, 2, 6). Make the sleeves smaller at the top if you wish and tight from elbow to wrist. Hook or zipper up the back of the forearm and add buttons (for decoration only unless you yearn to make buttonholes). If you make the sleeve snug at the top don't forget to insert the little gusset shown in fig. 20c, Chap. V.

Make the cote-hardie of fig. 3 with set-in sleeves. The top will probably be covered by a cape, anyway, and in stiff material it will be more comfortable. Use the vest-pattern of a " George Washington " or " Colonial " costume (Chap. XX) and set in a plain sleeve, or use the doublet pattern from the " Mephistopheles " costume, omitting the puffs from those sleeves. With either pattern you must cut a longer-waisted body. Set on to it at the hip-line, or even lower, a skirt. Cut the skirt straight with a few gathers eased in front and back; straight with side-gores; or as two halves of a circle, joined at both sides and with some of the extra fullness sloped off toward the waist at the sides. Cut a paper pattern first, using the " Mephistopheles " doublet peplum as a guide—though the skirt will have to be much longer than that peplum.

Cut the sleeveless surcote on the pattern of the bliaut, omitting the sleeves. Shape the armhole according to the picture you are following. The sleeved surcote must be cut like the cote it is supposed to go over. Or the under-garment may be simulated by false sleeves set in a guimpe, as explained on p. 121.

Cut the cape shown on figs. 1 and 11 by the plan for a cope (fig. 9, Chap. IV). If you want it fuller, cut three-quarters instead of half a circle. To imitate the mantle of fig. 5, seam the half-circular cope up the front and open it at the sides from shoulder to hem. Cut the surcote of fig. 4 the same way and seam it up the front, all but a slit to put the head through. Set the cape-like sleeves in thus: Put the garment on the wearer. Measure from the side of the neck-opening about five inches down or just to the point of the shoulder. Cut a ten-inch slit on the straight of the goods. Into the opening set a sleeve which is merely a segment of a circle, as deep as you wish, by twenty inches along the straight edge.

To represent the hanging surcote sleeve shown in figs. 3 and 14, cut a regular long sleeve and trim it off from the elbow down in a blunt-pointed wedge-shape; face back the part that shows; or else make an entire sleeve and leave it open. To make the hanging piece (tippet) which developed from this sleeve at the end of our period and later, take a band about three inches wide and a yard long and put it around the arm just above the elbow, like a bandage; sew it on the outside of the sleeve (the short end goes *underneath*) and let the long end dangle. This style of ornament can be of different material from the garment—even of fur.

Better not try to cut tights with fitted seams (but if you *insist,* look at the carefully measured pattern in Köhler and von Sichert's *History of Costume*). I think that what you gain in authenticity you lose in time and probable discomfort. Besides, many people believe that hose were sometimes knitted. With men's garments that are skirted to the calf you are probably safe in using long stockings, well-gartered. With skirts shorter than that, tights are essential. Make the actors wear braces (suspenders) and equip the tights with buttons. Use heavy cotton tights or stockings, not silk; modern silk stockings are much too thin. If you are set on representing silk hose get mercerized stockings or tights.

Women. Cut the early cote of fig. 11 by the men's bliaut pattern (fig. 13a, Chap. V) making the sleeve snugger at the shoulder, the skirt longer. Cut the top of the early surcote (fig. 12) on a kimono nightgown pattern (Chap. XX) as far as the hips (omitting the sleeves). At the hip-line set on a circular skirt, long enough to touch the ground when finished. Make the joining as inconspicuous as possible. For the surcote shown in fig. 14, use the kimono nightgown pattern, continuing the sleeves to the wrist and probably putting in gores at the sides of the skirt. Cut out the neck on the wearer till you get the desired depth.

The tighter-fitting dresses of the fourteenth century need a princesse slip pattern and set-in sleeves (Chap. XX). The undergarment of fig. 13 and the upper dress of fig. 16 are examples. In imitating the style of fig. 16, give the short-waisted effect by starting the skirt-part higher than the pattern indicates. Hold the pattern up on the wearer and mark the place to start at about the third from the bottom rib. Be sure to choose a pattern with many gores, or to add more gores, so that the skirt will be really full around the bottom.

To cut the surcote of fig. 13, use the lining pattern (Chap. XX). When you have fitted it smoothly and stitched the seams, put it on the wearer again and cut out under the arms as large an opening as you need. Attach to the body at the hip-line a very long circular or widely gored skirt (straight gathered is all right, if the material is soft).

Cut the various outer wraps as explained above under MEN.

Linings can be faked with wide facings, provided they do not make a bad line in the drapery and provided there is no danger of the unlined portions showing.

Accompany all dresses with a slip of heavy sheeting or unbleached muslin made on the general lines of the outer garment. This should be worn in *addition* to the skirt revealed under the lifted overdress in figs. 12 and 13.

Suggested Reading List

A Short History of Costume and Armour—Francis Kelly and Randolph Schwabe.
From 1066 to 1800. A very excellent book, copiously illustrated by contemporary material and written with authority. The preface is as well worth reading as the main text.

Mediæval Costume and Life—By Dorothy Hartley.
1100 to 1485. A very helpful book, having contemporary pictures side by side with photographs of modern actors in similar costumes, and diagrams for cutting the garments. Includes many hand-props. Discusses peasants and the professional classes rather than courtiers.

{ *Costume in England*—F. W. Fairholt.
{ *Dress and Habits of the People of England*—Joseph Strutt.
{ *English Costume*—George Clinch.
These are standard reference books.

English Costume—Dion Clayton Calthrop.
Agreeable reading.

Manuel d'Archæologie—Camille Enlart (tome III, le Costume).
(See list in Chap. V for comments.)

Le Costume Civile en France du XIIIe au XIX siècle—Camille Piton.
Very good pictures (sometimes wrongly dated), very poor text.

Ancient Armour and Weapons—John Hewitt.
A standard book.

Les Accessoires du Costume et du Mobilier—Henri Renée d'Allemagne.
11th to 19th centuries. 2 vols. Large pictures in great variety.

Heraldry for Craftsmen and Designers—W. H. St. John Hope.
An interesting and useful book.

Manual of Costume as Illustrated by Monumental Brasses—Herbert Druitt.
English. Valuable as source material.

History of Everyday Things in England—By Marjorie Quennell.

Scenes and Characters of the Middle Ages—E. L. Cutts.
(See list in Chap. V for comments).

Life On a Mediæval Barony—By William Stearns Davis.

Where Further Illustrative Material May be Found

Manuscript miniatures are probably the richest field. The larger museums and libraries contain original manuscripts, reproductions of which are numerous—most of the books listed above are illustrated largely with such reproductions. Unfortunately, the copies are seldom in color, and even then do not convey the beauty of the originals; so look at original manuscripts wherever you can, and study the photographs for details of the shapes of garments.

Statuary, as decoration on the exterior or interior of Gothic churches, and on tombs.

Smaller carvings, in wood, stone, or ivory.

Seals.

Paintings, mostly Italian, from the brushes of artists listed in the chronological paragraph and their contemporaries.

Stained glass—in European cathedrals.

All these sources are drawn on to illustrate the books recommended. They may also be found in books devoted to special topics like " glass " and in Histories of Art. Most art museums contain examples of some or all of these objects.

Brasses (the engraved brass plates upon English graves in the church floors), so fertile a source of costume and armor information, date from the fourteenth century. Examples may be found in reproduction in several books, including some of those recommended above, and in " A List of Rubbings of Brasses," Victoria and Albert Museum hand-

book. (Note: the cross-hatching which shows black in the rubbings indicates *white* on the actual garment.)

Sources of Sketches in This Chapter

For our sketches we have drawn upon all the sources mentioned above. Our manuscript studies are taken principally from the collections in the British Museum, the Bibliothèque Nationale, and the Bodleian Library. Examples from the first two have been conned in reproduction, but those in the Bodleian at first hand. Of the sculpture much on French and English cathedrals has been examined at first hand and later in reproduction. We have taken the entire armor on fig. 10 from a brass-rubbing (or rather a photograph of it in the Victoria and Albert handbook, op. cit.) of Sir J. de Creke, dated 1325, and fig. 7 from the wood carving on a miserere seat in Gloucester Cathedral. From a British Museum manuscript (Royal 2 B. VII), reproduced in Cutts (op. cit., p. 287) we took the musical instruments in figs. 3 and 14. Our debt to Enlart (op. cit.) is great, but from his many excellent reproductions of contemporary material we have taken nothing that can be called a direct copy. The sketches are (with the exceptions of figs. 10 and 7) entirely new figures dressed in garments whose originals we have found in the above sources.

The quotations from " Aucassin and Nicolette " are from Andrew Lang's translation of that story.

Chapter VII

LATE GOTHIC

DATES:

1350–1450

███

Some Important Events and Names

ENGLAND	FRANCE	ITALY

1350–1400

KINGS	KINGS	RULERS
Edward III, d. 1377.	Jean le Bon, r. 1350–1364.	A rule of city-states and the Roman Church.
Richard II, r. 1377–1399.	Charles V, r. 1364–1380.	The Popes were at Avignon till 1377, then back in Rome.
NAMES	NAMES	NAMES
Wycliffe, 1320–1384 (first Bible in English).	Froissart, the historian, 1338–1410.	Petrarch, d. 1374. Boccaccio ("Decameron," about 1350).
Chaucer, 1340–1400.		

1400–1450

KINGS	KINGS	RULERS
Henry IV, r. 1399–1413.	Charles VI, r. 1380–1422.	The Medici at the beginning of their power in Florence.
Henry V, r. 1413–1422.		The Popes.
Henry VI, r. 1422–1461.	Charles VII, r. 1422–1461.	NAMES—Painters. Masaccio, 1401–1429.
NAMES	NAMES	Uccello, 1397–1475.
Henry IV and V are among the most dramatic Englishmen of this time.	Jeanne d'Arc, Martyred, 1431. François Villon, 1431–1463 (?).	Fra Lippo Lippi, 1402–1469. Benozzo Gozzoli, 1420–1497. And others, for this is the beginning of the Renaissance in Italy.

There was also a Renaissance in the Netherlands (over which country the Dukes of Burgundy reigned), beginning with the brothers Van Eyck (Jan. d. 1426; Hubert, d. 1440).

Some Plays to Be Costumed in the Period

Percy MacKaye's "Canterbury Pilgrims." The religious dramas, Miracles and Mysteries, such as the "Second Shepherd's Play." They may also be costumed in the styles described in Chap. VI.

Shakspere's "Richard II" and "Henry IV."

Shakspere's "Henry V" and "Henry VI."

Shaw's "St. Joan."

Justin McCarthy's "If I Were King," a drama woven about an imaginary incident in the life of Villon.

Anatole France's "The Man Who Married a Dumb Wife."

LATE GOTHIC

CONCERNING THE PERIOD

THIS was a worldly period. The Age of Faith, which had found such marvellous expression in Early Gothic cathedrals, was nearly over. Church architecture, however, was not decadent, and this late Gothic period contributed beautiful examples of the Decorated and Perpendicular styles. Secular building was developing—castles, municipal and guild halls, and townhouses for the wealthy merchants. Life was growing easier, less hazardous, and there was more leisure as well as more wealth to devote to the arts of living. As may be judged from the few names listed above, literature flourished. In Italy and the Low Countries painting was well in the stride of the Renaissance. These countries (England and France as well) had many nameless painters illuminating manuscripts with a high degree of artistry. Anonymous writers were supplying England and France with drama: Miracle plays, based on the Biblical narrative, Mysteries, which set forth the lives of the saints (both in secular hands since about 1300), and Moralities, really more ethical than religious, which were flourishing before 1450.

The fourteenth century witnessed terrible plagues all over Europe. One result of this was the concentration of great wealth in the hands of surviving members of families and a consequent expansion in the luxuries of living, including dress.

Chivalry was still a living ideal, with all its conventions of Romantic Love and its pageantry of jousts and tourneys. The feudal system, however, was already weakening, making way for the new upspringing of national consciousness, which found its best expression in the achievements of Jeanne d'Arc. After the exploits of the Maid of Orleans, France struggled toward the end of the Hundred Years War. Through the later part of the fifteenth century England was rent by the Wars of the Roses, because of the rivalry of the houses of Lancaster and York.

While feudalism decayed, the great guilds and the merchant class grew more powerful. In every European country trade flourished, with every other and with the Orient.

GENERAL CHARACTERISTICS OF COSTUME

The arbitrary dates, 1350–1450, may be divided into fifty-year periods, 1350–1400, 1400–1450, standing for the early and late developments of certain eccentricities. The implication that a style stopped in the year 1400

155

and a new style usurped its place, is not intended. Fashions, especially the more sober and sensible, which flourished before 1400, were retained by conservatives well into the fifteenth century; on the other hand, you may find, before 1400, examples of most of the early fifteenth century characteristics, e. g., the exaggerated headdresses. It is a wise rule in costuming to be behind rather than ahead of your period, so that while some characters in " St. Joan " might wear costumes made for " Richard II," those in " Richard " could hardly be dressed satisfactorily in the " Joan " wardrobe.

The general spirit of the two periods seems to be expressed in their respective silhouettes: before 1400 modishness was still largely a matter of flowing draperies, after 1400, and more and more during the fifteenth and sixteenth centuries, smartness was synonymous with stiffness. " The well-dressed man " was becoming that tailor's joy which he has never entirely ceased to be.

The last of the fourteenth century was all a-flutter. The edge of anything which had an edge, from hats to shoe-tops, was likely to be scalloped, " dagged," or foliated. Veils still floated from ladies' heads and various trinkets, including occasionally bells, dangled from gentlemen's belts or baldricks. Extremes were the fashion. Low necks were *very* low, long skirts very long. A dandy could shock the preachers equally by the height of his collar (whaleboned far up the back of his head) or by the shortness of his jacket (its skirts sometimes not more than six inches below his belt). His sleeves, meanwhile, could have furnished material for two skirts. Moralists likewise hurled invectives against the long-skirted houppelande, which trailed in the mire (this soiling of good material was objected to for reasons of thrift rather than of hygiene).

In the fifteenth century the extremes were mostly in the upper silhouette. There were crisp pleats, tight belts, padded doublets, and the increasingly popular leg-o'-mutton sleeve, all these items foreshadowing the squareness of the next hundred years. The feminine décolletage was still a good text for preachers, better, in fact, since the V of the modish neckline joined the belt! Trains were even more exaggerated. The ideal might have been that of the lady in the " Keys of Canterbury," whose heart was won by the promise of a

<div style="text-align:center">

" 'broidered silken gownd,

With nine yards a-drooping and trailing on the ground."

</div>

The feminine coiffures, however—rolls and turbans, horns, crescents, and hennins—were the real " devil's insignia " of the century. In gowns cut-up edges were not so modish as wide facings of satin and, particularly, of fur.

The various names given to apparently similar garments are confusing and not necessary to consider in detail in this book. Part of the difficulty in identification arises from the practice of wearing many garments, one upon another. Briefly: men's close-fitting, short, often sleeved garments were named *pourpoint, corset, doublet, jupe,* or *cote-hardie;* their ampler dresses, with looser

sleeves and longer skirts, *gown, robe* or *houppelande.* The pourpoint, corset, or doublet was a very close-fitting garment, worn directly over the chemise and generally under another garment, either short and somewhat more ample, like the jupe or cote-hardie, or much more ample and frequently long, like the gown, robe, or houppelande. It will simplify matters to consider the scant garment as a doublet, the looser as either gown or houppelande. Corresponding to these masculine dresses are the feminine *corset* (French) (worn next the chemise), which is the *cote* of the preceding period, and the gown, worn above the *corset.* Tight or loose, these garments usually had sleeves, of which one pair fitted close around the wrists. *Bare arms were not displayed in public,* any more than they had been in the twelfth century (p. 114). A flowing sleeve, falling back, always revealed the tight sleeve under it.

MEN

Heads. Throughout the fourteenth century hair was "bobbed" and had a straight bang across the forehead. The neatly curled ends illustrated in figs. 1, 2, and 3, Chap. VI, continued in style, but straight locks were not unknown. Although many men were smooth-shaven, beards were in considerable favor, small and neatly clipped in one point or two (figs. 1, 2, 3) and accompanied by small turn-down moustaches. Some older men wore longer beards (fig. 4).

At the end of the fourteenth century and in the fifteenth a good many men had cropped heads, some almost in the modern manner, but more in a very ugly style which is occasionally inflicted on modern children: shaved half-way up the back, close-cut in front of the ears, lying cap-like on top of the head (figs. 5 and 6).

Into the fifteenth century men continued to wear, occasionally, the headband or chaplet described in the preceding chapters (pps. 108 and 132)—even the wreath of real flowers.

The *bonnet* or *coif* (fig. 6, Chap. VI and p. 131) was popular throughout this period. Usually of white linen, it was worn underneath almost any other hat. A gentleman is represented, for instance, carrying a chaperon and wearing a white coif. Older men wore the coif made of black velvet.

The *chaperon* went through curious changes at this time. In the first place, it was still retained in its ancient form, *i. e.,* a hood fitting the face and neck closely, with an attached shoulder-cape and a tail (fig. 8). Treatment around the face varied, the plain opening (fig. 8e, Chap. VI) sharing honors with turned-back facings, often of a contrasting color and frequently scalloped. The tail, called *liripipe,* grew and grew, till in the late fourteenth century it sometimes touched the floor and had to be tucked into the belt or thrown around the neck. In the latter part of the fourteenth century the chaperon began to be used in another way. The opening, originally surrounding the face, was put on the crown of the head, the cape-part with its scalloped edge arranged as a drapery or ornament at the side, and the liripipe twisted around the whole to bind it turban-wise on the head (fig. 2 shows the liripipe before wrapping).

There are many variations in the draping of this hat. Indeed, the chaperon itself had variations of cut, e. g., tail pointing front, two tails (front and back), two side peaks, a large blunt-ended bag instead of a tail, two such bags at the sides, like ears. When these chaperons were bunched up to make a hat each gave its own effect; individual taste had always much to do with the arrangement of folds. When men had gone through a period of draping the chaperon at each wearing, naturally enough they began to sew it into a permanent turban. At first it looked very much the same (I think the example in fig. 2 is permanently sewed); there evolved from it, in the fifteenth century, the roundel (fig. 5). The doughnut-shaped brim was attached to a skullcap, the trimming was a separate piece sewed on, and so was the liripipe, now frequently a flat strip, scalloped on the edges, as illustrated in fig. 8. Contemporary pictures show many variations of the roundel and its trimming. To the period of the sewed chaperon belongs the Van Eyck portrait (National Gallery) of a man in a large and intricately draped turban which may be the usual chaperon or only a large kerchief twisted around.

Of hats there were many styles, any of which was trimmed, at will, with fur, a jewelled circlet, brooches, medals, or feathers. Among them were:

The hat (or cap) with a high crown and no brim (figs. 9 and 11). This was sometimes even higher than those pictured and in that case must have been supported by wire or other stiffening. Felt or beaver was the material and black was perhaps the most popular color.

The bag-cap, brimless, but with an ornamented or furred band around the head. It was made of cloth or velvet in any color (fig. 3).

The hat with turn-up brim. One old style persisted, i. e., the hat with a fairly low, conical crown and a brim turned at back and sides, pointed in front (fig. 2, Chap. VI). So did the same hat turned up abruptly in front, like the pilgrim's hat (fig. 9, Chap. VI). A third type came in during the fourteenth century, though it was more widely popular in the fifteenth: a hat with a soft crown, sometimes gathered, and a widish brim split into four or six sections, some or all turned up. It was of felt or beaver and often had a fur-faced brim (fig. 4).

The wide hat (fig. 7). The one sketched looks rather like a cattleman's " ten-gallon hat." The crown was not always so tall, but on the other hand there *was* a crown for this type of wide-brimmed beaver which was even bigger—the bell-crown which you may see in the famous Van Eyck portrait of Arnolfini and his wife (National Gallery). The wide-brimmed hat was also made of straw or felt and in its less extreme sizes was popular with country-folk and travellers (fig. 12).

Bodies. The full, long-sleeved linen chemise, in length about to the thigh, was the undergarment. Next to it came one of the tight, short jackets, buttoned or laced up either the front or back, which may be classed as doublets. If the doublet were sleeveless it was usually worn for additional warmth under a second snug doublet or *pourpoint,* which had long tight sleeves. If, as in

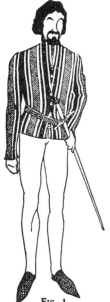

FIG. 1.
Man in a jupon or pourpoint, c. 1390-1400.

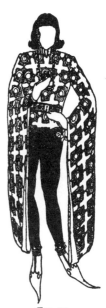

FIG. 10.
Young dandy, c. 1400, in a long-sleeved pourpoint.

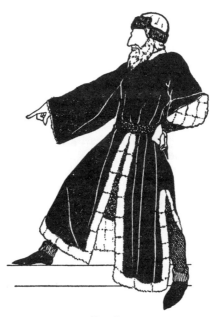

FIG. 4.
Man of c. 1450 in a furred gown, probably a peliçon,

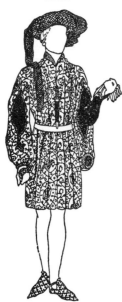

FIG. 5.
Gentleman, c. 1430, wearing a roundel.

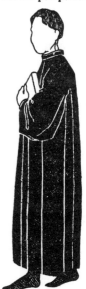

FIG. 6.
Young man (1440-50) in Italian-style gown.

fig. 1, the doublet served as an outer garment, it was carefully fitted and, in the fifteenth century, padded. The doublet worn inside often stopped at the waistline; that intended to be seen had a skirt, though sometimes very short (figs. 1 and 10).

The long-waisted and reasonably long-skirted cote-hardie (figs. 3 and 7, Chap. VI) was worn by unfashionable men throughout the late fourteenth and into the fifteenth century, after which it still persisted in the dress of court jesters (fig. 13, Chap. IX).

In the fifteenth century a short gown, as long as the calf, or stopping above the knee, took the place of the older cote-hardie. It had a good deal of fullness, which might be laid in pleats from shoulder or breast to hem, or pleated in the skirt-part only, and it was belted at the waistline or lower (figs. 5 and 11). It was worn over a doublet.

On top of his chemise the peasant wore a smock or *cote* of the old cut, put on over his head and held in at the waist by a leather belt (fig. 12).

Long Garments included the gown and the houppelande. The latter is especially distinctive of the end of the fourteenth century and the first half of the fifteenth. Other garments shared its characteristic features, *i. e.,* high collar, long skirts, huge flowing sleeves; but a garment showing all three may be classed as a houppelande. Properly it had a floor-length skirt, but two modifications were common: the skirt might be slit (fig. 3) to above the knee, for convenience in walking, or it might be shortened to the calf or knee and perhaps also slit (fig. 2). It fitted the body neatly (because it was either cut to the shape or laid in pressed pleats), but its skirt was full. At the height of its popularity (in the 1390's), it often had all its edges scalloped ("*dagged*"), *castellated* (fig. 2), or *foliated* (fig. 3) and faced back with a contrasting color, if not completely lined with it. By reason of its comparative looseness and its almost invariably large open sleeves, it was well adapted for an outdoor wrap, and it was often used as such, put on over a short doublet which might be worn uncovered in the house. Fur-lined, it became a winter coat. Sometimes the houppelande was unbelted, but it was more often held close to the body by a rich girdle.

The long, unbelted gown with moderate sleeves (figs. 6, 7 and 8) may be seen in a great many Italian pictures, where it was worn by any gentleman of importance. Eventually it became identified especially with soberer folk, scholars. It is not unlike the long gown discussed in Chap. VI.

The *surcote* was still to be met with in civilian as well as soldierly dress. An Italian version is shown in fig. 9, short, pleated, sideless, and worn over pourpoint and hose.

The *collar* was the newest feature of this period. Although it often graced the short garments (fig. 10), it is a distinguishing detail of the houppelande. It stood up well in the back of the neck and was buttoned up high under the chin also, or else cut away, leaving the throat free (fig. 3). In its exaggerated forms it sometimes rose to the middle of the back of the head and had to be

whaleboned up. The fashionable man must have his high collar; if he wore no houppelande, then on his doublet.

Arms. Arms were covered to the wrist with sleeves that were long and tight, except in the few instances when a sleeve bagged into a tight cuff. The snug sleeves often extended down as far as the knuckles and could be turned back in a cuff. The extra length was sometimes a circular flare which made a graceful frame for the hand (fig. 3).

The gown (fig. 8) and the peasant's tunic had sleeves of about the same length all the way down, which, if they fell back, revealed the sleeve of doublet or chemise.

To the houppelande belonged the huge flowing sleeve (fig. 3), but this was also affected by young dandies with a very short, tight doublet (fig. 10).

The end of the fourteenth century saw an innovation, the bellows-sleeve (fig. 5), later very popular. Though it was gathered into a cuff, through which the hand might pass in the ordinary way, it had also a long vertical slit, richly ornamented, on its outer side, through which the arm could be thrust. This is one of the first phases of the vogue for slashing which was to last a good two hundred years.

Toward the middle of the fifteenth century sleeves began to be wide at the top, either because they had large puffs added to the tight sleeve above the elbow or because they were cut in the leg-o'-mutton style (fig. 11).

Legs. Hose extended the entire length of the leg. Often they were really long stockings, tied to the upper garment with metal-tipped strings, called "points" (fig. 9) or made long enough on the outer side to fasten to the belt of the underdrawers. These underdrawers, worn with short garments, were now much abbreviated, to the size and general shape of an acrobat's trunks. With such skirtless garments as those sketched in figs. 1 and 10, however, the hose were made with a crotch, the effect being that of modern tights. Their difference from the modern garment is shown in fig. 2, Chap. VIII. Though generally shaped from cloth and fitted to the legs by means of well-placed seams, hose were sometimes knitted, it is believed, even at this period. Tailored hose often had no feet, but, like leggings, had straps under the instep. Others were made with complete stocking feet and still others, as in the previous period, were furnished with soles and worn without other shoes (fig. 3). The eccentricities of parti-colored hose are suggested by fig. 9. As to peasants, some still cross-gartered their long breeches in the ancient way, others protected their shins with cloth gaiters, gartered above the calf (fig. 12).

The pointed shoe (*Poulaine* *), already modish in 1350, reached the climax of exaggeration at the end of the century, when, it is said, tips were so long that they had to be held to the knee by chains. Such an extreme, however, is rarely met with. A tip six inches beyond the toe is, however, common enough (figs. 3 and 10). Such tips were held out, probably, by whalebone. Other less extreme points are illustrated in figs. 1, 2, 4, 5, 7 and 11. The vogue for sharp tips began to wane, and about 1450 feet looked natural for a little

* at *Cracow*, both names expressive of a Polish origin.

while (fig. 6) before the opposite exaggeration of the next period (Chap. VIII).

Very soft boots up to the calf were worn for outdoor occupations, and, for riding, longer boots pulled up above the knee. They were made of pliable leather and outlined the foot and leg like hose. Many representations show no fastenings; others indicate that the boots were laced up the inside or outside of the leg, or buckled at the sides or over the instep. The boots of country-people were rudely fashioned from cowhide. Wooden shoes or clogs were not restricted to peasant wear; the gentry, too, had a fashionably-shaped *patten* of wood, to protect their fine shoes from the miry streets (fig. 3).

Shoe materials included leather (from heavy hide to fine kid), cloth, felt, and velvet. The illustrations suggest how footwear was decorated. Leather was gilded and painted and fabric was sewed with ornaments. These shoes were all heelless, though they did sometimes have extra-heavy soles to increase the wearer's height.

Outer Garments. The houppelande, belted or unbelted, often served the purpose of an overcoat. The term *peliçon* seems to have been applied to any garment which was fur-lined (or possibly made of fur) but was not originally limited to any special cut. By the fourteenth century, however, the term may apply especially to an outer wrap and might be used to describe that sketched in fig. 4. A garment cut like the gown (fig. 6), opened up the front, fur-trimmed and furnished with a "capuchon" hood, served also as an overcoat. Any of these furred, loose coats was worn in the house, too, for extra protection in the winter. The cape or mantle, so long in use, still held its own and may be considered a part of formal court dress (though no longer an indispensable part). In regal dress the old style of opening up the front continued, but worn by other than a king, the mantle was fastened on the right shoulder with buttons, clasps, or pins (fig. 7). The short fur cape shown in fig. 5, Chap. VI, was worn with the royal mantle, as may be seen in the portrait of Richard II at Westminster Abbey. Such a cape of fur or fabric was also attached to the unbelted houppelande. The hooded cape, mentioned so often before and sketched in fig. 8, Chap. IV, was still worn as a protection against the weather.

SOLDIERS

There were several kinds of helmet, of which two are sketched in figs. 13 and 14. *Bascinet* is the name given to the style on the armored figure. The visor or *camail* was hinged and could be worn back from the face. Frequently an elaborate plumed crest towered at the peak of the bascinet. A steel hat, very much like those worn in the United States Army during the World War, was a common head-protection for bowmen.

Till after 1400 plate armor was still combined with chain. An early stage of the transition is sketched in fig. 10, Chap. VI, another phase, dated about 1400, in fig. 14. This armor, drawn from an Italian example in the Metro-

politan Museum, has plate protection for all exposed parts. It is worn over
a cloth undergarment (pourpoint), hose, leather gloves, and velvet shoes.
The body and arms are covered by a shirt of chain and the neck is protected by
a chain gorget. The plate body-protection was called a "brigandine"; 14a
and b show how it was hinged and buckled together. The brigandine sketched
is covered with red velvet fastened to the plates with brass studs. The outer
parts of legs and arms have steel protection. Two belts are worn with this
armor, a small leather belt around the waist and another, low on the hips,
of iron plates mounted on leather—the sword-belt.

Between 1350 and 1400 a cloth or silk covering, bearing the armorial
blazonry of the wearer, was generally put on over armor. At that time it was
a tight-fitting, usually sleeveless, *jupon* or *hacqueton* (Chap. VI). After 1400
knightly armor was almost entirely of plate, in transition toward the style
shown in fig. 11, Chap. VIII. Such was the armor worn by Jeanne d'Arc. The
style represented here (fig. 14) is that suitable for the "lists" scene in
"Richard II," and would not be inappropriate to use in "Henry IV" and
"Henry V."

Fifteenth century plate armor was sometimes worn with no covering, some-
times, as shown in Van Eyck's "Adoration of the Lamb," *over* a silken gar-
ment with open, fluttering sleeves. Frequently, however, it was protected by
a surcote, rather full and pleated, with or without sleeves. A military surcote
completely open on the sides resembles that shown on the civilian in fig. 9.
The *tabard,* familiar to us as the traditional dress of heralds, was likewise
worn by knights over armor; it was a short garment, stiffened with interlining,
open at the sides and furnished with square, wing-like extensions over the
shoulders. Armorial bearings were blazoned on the front.

A foot-soldier was not as a rule equipped with plate armor. Sometimes,
indeed, his only protection was the steel hat mentioned above. The cross-
bowman (*arbalistier*) was often better clad, as in fig. 13. Under his steel cap
he wears a hood of chain, whose cape covers his neck. His *jupon* or *hacqueton*
has wrist-length sleeves. Over it is a shirt of mail and over that a *gambeson*
made of heavy canvas or chamois-leather, interlined, quilted, and studded with
nail-heads. His legs and feet are given no unusual protection.

Although the old long-bow (the pride of English yeomen) was still in use,
the cross-bow or arbalest, a powerful weapon worked by ingenious machinery,
increased in favor (fig. 13). Shields, by the way, seem to have been largely
omitted from knightly equipment but retained for bowmen. They were rec-
tangular, convex, and about breast high. Propped up in front of the soldier
they protected him as he operated his weapon. The buckler, mentioned in
Chap. VI, pictured in Chap. IX, could be carried with a sword by any civilian
(cf. the "Prologue" of the "Canterbury Tales").

Swords had cruciform or cross-hilts. The sword belt was worn around the
hips (fig. 14) or as a baldrick diagonally across the body. It was customary
for the man in armor to hang a dagger in his belt at the right side, his sword

at the left. Swords were also worn without armor (fig. 1), and daggers were a usual accessory of civilian dress (figs. 3, 10, 11). They were a little lighter than the battle-dagger. Another still more slender style was given the expressive names of "misericorde" and "kidney-dagger," and was used as a "follow-up" weapon to give the decisive blow or "*coup-de-grace.*" Though the dagger was ordinarily worn on the belt, some dandies hung it around the neck (fig. 5) and even at the back, where it would seem to be more ornamental than useful.

<center>WOMEN</center>

Heads. Unmarried girls continued to wear their hair loose upon their shoulders. Prettiest is the old way, where the locks were confined by a chaplet or circlet (fig. 11, Chap. VI). But in the fifteenth century headdresses were often placed upon the flowing tresses. The heart-shaped headdress, described below and pictured in fig. 16, omitting the close cap over the ears, was poised upon the head, the hair hanging down the back. In early Italian pictures may be found maidens (apparently brides) wearing a turban or roundel, on the order of that shown in fig. 15c, but much larger, in fact a great cushion, balanced, it would seem rather precariously, on the head above loose hair. Another style, pictured in fig. 15a, is a veritable tricorne hat. Such a hat, exactly like those worn by eighteenth century Venetian ladies, is to be seen in a picture of the school of Fra Lippo Lippi (Ashmolean Museum) and represents a vestal virgin during the sack of ancient Rome!

Married women did their hair up. Unmarried older women were willy-nilly either *religieuses* or professed nuns, and therefore wore gorgets and wimples (figs. 15 and 16, Chap. VI). About 1350 the coiffure was often square, an effect obtained by pinning up braids over the ears and, a little later, by encasing the hair in an elaborate network or in ornamented metal tubes. Over this went the veil and on top of it the coronet, shaped to the coiffure, as in fig. 13, Chap. VI. The fashion for a gorget without the veil also continued for a while. As the century drew to a close, the square or cylindrical effect gave way to rounder protrusions again. As in fig. 14, Chap. VI, these might be of coiled hair; more and more generally, however, the hair was covered with netting or "reticulations" like round cages (fig. 17). With the reticulated headdress a veil was often worn but not invariably. No hair was visible, for both neck and forehead (where it showed below a headband) were shaved or plucked. Eyebrows, too, were plucked to faint lines, even, it is said, entirely removed. The reticulation was sometimes a wire netting enveloping the entire head; with this arrangement, too, hair was either covered or removed. Both reticulations were lined with colored silk, so that the amount of hair underneath was a matter of personal rather than public knowledge. In Italy, women were more reluctant to cover their heads, and their net bags and stiff reticulations exposed hair, pulled back to emphasize the fashionable high forehead, made higher by plucking. These comparatively low and simple coiffures, includ-

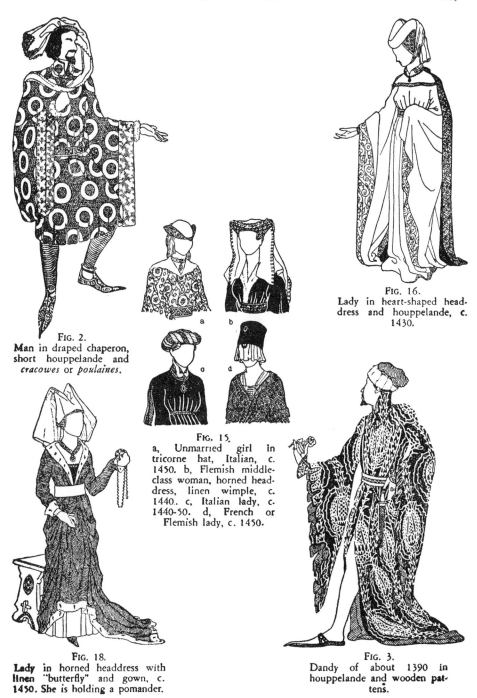

FIG. 2.
Man in draped chaperon, short houppelande and *cracowes* or *poulaines*.

FIG. 15.
a, Unmarried girl in tricorne hat, Italian, c. 1450. b, Flemish middle-class woman, horned head-dress, linen wimple, c. 1440. c, Italian lady, c. 1440-50. d, French or Flemish lady, c. 1450.

FIG. 16.
Lady in heart-shaped head-dress and houppelande, c. 1430.

FIG. 18.
Lady in horned headdress with linen "butterfly" and gown, c. 1450. She is holding a pomander.

FIG. 3.
Dandy of about 1390 in houppelande and wooden pattens.

ing the gorget and wimple for older women (like the duchesses of York and Gloucester), are those suitable for the few female characters in " Richard II " and " Henry IV."

The fifteenth century brought in the more fantastic headdresses. There were many variations of the general styles mentioned below, some which might be variously classified. All shared the characteristic of concealing the hair, usually allowing no wisp to escape (though it must be admitted that rare exceptions to this rule can be found). All exaggerated the size of the wearer's head and most of them increased her height.

From the side reticulations (fig. 17) developed pointed pieces, which finally became veritable horns over the temples (fig. 15b). These grew larger and more acutely pointed, till the headdress took on the appearance of a crescent moon. Akin to this crescent, but usually made in a different way, is the heart-shaped style. Still, in some examples it appears to be nothing but a roll, resting on the horns (15b); which may be a clue to its evolution. In many instances the roll dominated the structure, as shown in fig. 16. Then it was made like the masculine roundel (fig. 5), and must have had an inner support of wire, which could be bent into the heart shape pictured. A veil was a frequent addition, either draped across the top or, as in fig. 16, brought under the chin and pinned on top. This (incidentally) is the headdress which Tenniel put upon the Duchess in " Alice in Wonderland." That top-heavy affair is balanced on the over-large head without benefit of chin-veil.

A simpler coiffure was a brimless cap with a stovepipe crown and a transparent, stiffened veil half-covering the face (fig. 15d). The black loop over the forehead, which looks like a single curl, seems to have been, in reality, a flat piece of velvet. This feature was retained in the later hennins and indeed appears again in a slightly different form as late as the seventeenth century (fig. 10b, Chap. X). Somewhat akin to the nineteenth century stovepipe hat, and itself a forerunner of the hennin or steeple style, was a blunt or round-pointed high hat, like an old-fashioned sugar-loaf.

The real hennin (fig. 13h, Chap. VIII) is for some reason the headdress most popularly associated with the middle ages; as a matter of fact, examples of it can rarely be dated before 1450. An illustration of it is therefore included in Chap. VIII. The sharp-pointed cone was almost invariably accompanied by a turn-back frame for the face, usually of black velvet. A gauze was often wound around the cone and allowed to float from the tip. The early hennin (about 1450) was, like the cone, worn fairly upright on the head instead of slanting back, as in the later style pictured.

Toward the middle of the fifteenth century appeared a linen headdress (fig. 18) following in general the lines of the horned styles and frequently draped around the horned structure, the cone, or (especially later) the steeple. It was of fine, semi-transparent stuff, like lawn or batiste, and when, as sometimes happened, it was worn without the firmer hat, it probably had to be held out on a frame of whalebone or wire. This style, a very pretty and

becoming one, is sometimes named the "butterfly" and a version of it may still be seen in the coif of a certain order of Sisters of Charity.

Masculine hats were sometimes affected by women, the most commonly adopted being the chaperon of cloth or velvet, with some rather special features, such as a wide, turned-back facing. The peaked hat was put on over a chaperon or a close white bonnet. The wide felt and the straw in various widths (fig. 17, Chap. VI) were feminine hats as well as masculine. A cap, or a kerchief twisted like a small turban, was less formidable than the higher headdresses. The turban-roll, on the other hand, was an impressive style (fig. 15c). It resembled the masculine roundel, which was itself sometimes assumed by ladies in a form practically like that shown in fig. 5.

For older and soberer women the wimple was the accepted coif. It was still worn in the simple draped styles shown in figs. 15 and 16, Chap. VI, but was also arranged in elaborate flutings or neatly-fitting linen frames for the face, somewhat in the manner of fig. 13e, Chap. VIII and of the wimples of modern nuns.

Bodies. Over the chemise (which sometimes showed at neck and sleeves) (fig. 15b) was worn the *corset* (really the same garment that was called a *cote* in Chap. VI). It had a well-fitting body, a full skirt cut in one with it, and usually plain tight sleeves. In Italy women continued to wear the cote or beltless princesse dress (figs. 14 and 16, Chap. VI) alone, but in the northern countries it seems to have been regarded more as an undergarment or negligée. Apparently the cote or *corset* of the early 1300's was laced up the back, but representations made after 1350 show it with a front lacing, a style perpetuated during succeeding centuries and still existing in peasant dress. The *corset* had only to be made with the body separated from the skirt to become a "corset" in the more modern use of the word. Peasant women wore this front-lacing dress with no upper gown, and tucked its skirt up for greater freedom (fig. 22, Chap. VIII).

The sleeveless *surcote* lasted throughout this period and indeed into the Renaissance. Memling, who painted "The Marriage of St. Catherine" in 1479 and "The Shrine of St. Ursula" ten years later, dressed both his heroines in surcotes much like that shown in fig. 13, Chap. VI, but this was probably an effort to conventionalize the dress of an earlier period. The surcote sketched in fig. 17 in *this* chapter, however, *did* persist into the second half of the fifteenth century. As it developed from the earlier fashion, it was cut out more and more deeply under the arms, till it was not much more than a bib front and back, with a full skirt attached. For trimming it had deep bands of fur along the arm-openings, or, as in the sketch, a row of jewelled studs, brooches, or buttons down the front. A manuscript picture of a back-view shows the surcote laced from neck to hips. Since there is no practical necessity for fastening a garment with such deep neck and arm-apertures, it may be questioned whether in this instance the surcote is not merely simulated by a pinafore-like addition to the gown. Simulation would hardly have been possible, however, in dresses

which show a belt upon the hips of the *under* dress (fig. 17). A late version of the cut-out surcote body outlines a deep V over the abdomen and another (seen in a brass-rubbing) shows two such points, the first style, it would seem, a forerunner of the sixteenth century stomacher. To be classed as a surcote probably is the sleeveless or half-sleeved gown shown in fig. 15d, open in a V over the *corset*, having a fairly loose, unbelted body and an ample (presumably gored) skirt, lifted to show the skirt of the *corset*.

One apparently invariable characteristic of the over-dresses of every sort worn by ladies of fashion was their ample length. They always had to be held up or tucked into a belt in front, and frequently had additional length in back, for a train. A rich lining or facing of contrasting silk or fur was revealed when the skirt was lifted, and there were probably artful twists to display as much of it as possible.

At the end of the fourteenth century appeared the houppelande for women (fig. 16). The characteristic high collar was often greatly exaggerated (beyond that shown in fig. 15c). Women's houppelandes are pictured also with wide " sailor " collars (fig. 15a) of fur or embroidery, and with small round turn-over collars. The houppelande was worn either ungirded (when it was made close-fitting, more like the *corset*) or belted at a rather high waistline, with surplus fullness pleated in (fig. 16). The skirt was as usual full and long, and when lifted revealed the skirt of the *corset*. I have seen one instance of a lady's houppelande slit to the knee (in the manner shown in fig. 3), with her un-skirted leg showing under it, but this cannot be taken as a representative style.

The gown which came into fashion in the fourteen-hundreds and is more often seen than any other even after 1450 had a high-waisted bodice, either smoothly fitted or set in close-pressed pleats (fig. 18), long tight sleeves, and an immensely full skirt gathered on to the bodice. Its characteristic neck-finish was a wide shawl-collar rolled back from the bare neck. A wide belt enhanced the high-waisted effect. Sometimes the V-neck exposed the bosom to the belt-line, more often (as in fig. 18) part of the space was filled by the top of the *corset*. Fig. 15b gives an idea of how much the height of the décolletage might vary. In addition to the *corset*, the top of the white chemise might also be visible as in 15d. The sailor-collar of 15a is also to be seen on the gown. Fur was a very popular neck-finish, and lustrous satin rivalled fur. An interesting finish for the tight sleeve is shown in fig. 18 (possible also on the under-dress like that in fig. 17): the sleeve was made long enough to cover the knuckles, and flared a little at the bottom; it was faced back with another color and might be worn down or up, like a cuff.

Feet. Women's shoes show but little, their legs practically never; however, we may assume that they always wore stockings (the Wife of Bath had red hose), and we can see that their shoes resembled men's, though seldom reach-ing such exaggerated lengths.

Outer Garments. As with men, any of the looser upper-garments might be-come on occasion an outdoor wrap, especially if it were fur-lined. The mantle,

FIG. 13.
Soldier, 1450 and later, wearing hacqueton, chain hauberk, quilted gambeson. He is firing a cross-bow or arbalest.

FIG. 14
Italian armor, c. 1400. a, Back view, showing sections. b, How the brigandine fits together. c, Method of fastening arm-protection. After original in the Bashford Dean collection, Metropolitan Museum of Art.

FIG. 12.
Peasant in gaiters, c. 1400.

FIG. 7.
A knight of the Golden Fleece (c 1450). Note the collar of the order.

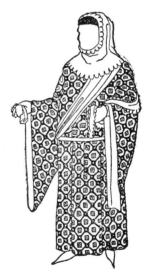

FIG. 8.
Man, c. 1350-80, in gown, baldrick and chaperon with long liripipe.

in its old form, was still the dignified accessory of court dress (fig. 16). The *chape*, or hooded, circular cloak so often described, continued to be worn as a general-utility cloak.

Riding Clothes. Women as well as men rode horseback both for travelling and hunting. They are occasionally represented sitting sidewise on a man's saddle, but more frequently riding astride. Their skirts do not appear to be divided, and indeed they were so full as not to afford any obstacle to a straddle. The only special riding garment seems to have been a foot-mantle, which appears to be a large cloth draped around each leg and tied in at the ankles. In the Ellesmere manuscript (Huntington Library) of the " Canterbury Tales " the Wife of Bath is represented in such a garment, and from that source Calthrop (*English Costume*) has made a charming sketch. The foot-mantle would not be useful for theatrical costuming unless the wearer were shown on horseback. Riding costume was otherwise whatever was stylish for ordinary dress: close veils, peaked hats, chaperons with wide hats above them, and gowns with or without cloaks.

CHILDREN

Infants continued to be imprisoned in swaddling-clothes (fig. 18a, Chap. VI). Children who could walk were dressed like their elders. Little girls wore their hair loose, but both girls and boys wore the close bonnet or coif of white linen (fig. 6, Chap. VI) till they were quite large. The children represented are not as a rule burdened with such long garments as their elders, nor with such elaborate headgear.

MATERIAL

The variety of beautiful materials mentioned in previous chapters became accessible to an increasingly larger number of people, the reason being that European textile workers were growing more skilful in imitating oriental stuffs. In addition to the linens, cottons, woolens, and silks described on pp. 117 and 142, there was taffeta and, particularly, velvet. Although this material was known in Europe from 1298 and figured, cut, and brocaded velvets in the fourteenth century, the real velvet age begins in the fifteenth century. *Samite* was an especially heavy and sumptuous silk, the name of which is so familiar largely because we encounter it in Tennyson's " The Passing of Arthur."

FURS

Ermine was reserved for the high nobility. As with us, the tails were generally added to the white ground. Gray squirrel was prized next highest, but in spite of its expense was lavishly used for collars, facings, and even linings of garments. Marten was popular and among the less expensive furs varieties of sheep and lamb, such as astrachan. Fox, muskrat, and rabbit satisfied the humbler sorts and helped to keep them warm. It is said that in this period fur was sometimes dyed unnatural colors such as red and green.

COLORS

The brilliancy of a court assembly of the fourteenth century was rivalled by that of the fifteenth. The taste for jewel-like hues had not abated, and the even more luxurious fabrics displayed them better. Contemporary inventories give the most entrancing names to colors, suggesting subtle variations. Paintings have preserved these lovely hues, and if time has mellowed the pigments, we may believe that something the same effect may have obtained in the actual fabrics, for clothes were expensive and could not have been discarded after a few months' wear. Rich men willed their garments to grateful heirs; a girl's trousseau saw her through some years of her married life. So the probability is that the reds, greens, blues, and golds were not garish, but soft, and in almost any scene were interspersed with duller tones, the brown, gray, and tan of humbler garments.

MOTIFS

While there were plenty of plain-colored fabrics, patterned materials were popular. Floral motifs abounded: a running vine (figs. 15, 16), stylized flowers in an all-over pattern (fig. 5). Various geometric arrangements, such as squares, lozenges, and circles, were often employed (figs. 2, 8, 10). A fabric might be "diapered" with small detached motifs, circles, squares, stars, or, very frequently, "powdered" with the owner's personal badge or monogram. Fig. 19d is an example of such a badge, Richard II's device of the crowned hart. In the fifteenth century the small badge or device on personal apparel was more fashionable than the large heraldic blazoning. After 1400 may be found examples of the large all-over patterns brocaded, damasked, and stamped or cut on velvet, which are especially associated with the Renaissance. The pineapple (fig. 3) is the best-known of these.

Stripes, both horizontal and diagonal, were still worn (fig. 1). Parti-colored garments increased in popularity and were arranged in all sorts of combinations: half and half (perpendicularly) or in balancing divisions of doublet, sleeve, hose, and boot. Sometimes only the hose displayed the parti-colored effect (fig. 9).

APPLICATION OF DECORATION

Design was applied to fabrics in all-over patterns more frequently than in wide borders. Edges cut in fantastic patterns and faced with bright colors were the most important characteristic of the late fourteenth century. Strangely enough, these fluttering hems seem to have been more popular with men than with women. Fur facings and edgings, the characteristic of the fifteenth century, were adopted equally by both sexes. Seams were edged with stitchery and neck-openings not fur-trimmed were embellished with it. Upon p. 161 is described a sleeve slashed to permit the passage of the arm. From such beginnings grew the slashing which was to dominate renaissance decoration.

JEWELRY

The kingly crowns were foliated and taller than in the earlier middle ages. Fig. 19a is in the style of Richard II's crown. Simple, low crowns were worn by the nobility (fig. 13, Chap. VI). Figs. 19b and c show the regal orb and sceptre as they were carried by Richard.

The " collar " or necklace of an " order " or chivalric organization was always worn by those who had the right. The collar of the Golden Fleece (fig. 19e) is representative of these ornaments. This order was founded in 1429–30. Men wore other chains, also, with jewelled pendants, and so did women (figs. *passim*).

The various fastenings of garments were often bits of jewelry: small sleeve-buttons (fig. 1, Chap. VI), larger buttons on a mantle (fig. 7), pins, especially large brooches, "morses" which still fastened the mantle (fig. 16), and studs (fig. 17). Sometimes, also, small metallic plaques were sewed all over a garment. Large rings set with " cut " or faceted gems were lavishly displayed. Belts were often made of linked gold plaques set with jewels; even leather belts displayed both buckle and tongue (mordant) of fine metal studded with jewels. Sword and dagger hilts and scabbards were often beautiful examples of the goldsmith's art.

ACCESSORIES

As we have noted above, almost any dress-accessory might be of precious metal, gem-encrusted. Oftener, of course, they were very simple and utilitarian —leather in place of rich fabric, iron in place of gold or silver.

Rich or poor habitually carried a purse at the belt. It was envelope-shaped, with a flap, and it could be large as the pilgrim's scrip (fig. 9, Chap. VI), or small as those in figs. 1 and 3, Chap. VI. The styles did not change appreciably from the fourteenth to the early fifteenth century. The shepherd in fig. 12 wears a scrip of a simple sort that would do for a traveller or any countryman.

The pomander (figs. 5 and 18) was an accessory popular with both men and women. It was a ball about the size of an apple or smaller. If it held a relique, it was of hollow metal, hinged in the middle, but it was more typically made of filigree and contained a sponge saturated in perfume. In an age of plagues this was regarded as a sanitary precaution; in an age of unpleasant smells it was doubtless a comfort.

The baldrick or bandolier, originally used to suspend something on (*e. g.,* a sword or a scrip, as in fig. 9, Chap. VI), was worn in the late fourteenth and the fifteenth centuries as an ornament also, by both men and women (fig. 8). It was often very ornate, of leather, silk, or metallic cloth, studded with jewels, cut with foliated edges, and even sometimes enlivened with bells.

Gloves look surprisingly like ours. They had either the stiff cuff shown on the huntsman in fig. 2, Chap. VI, or soft, fairly wide wrists. They were made from kid, chamois, and fabric; white was especially admired. Decoration was

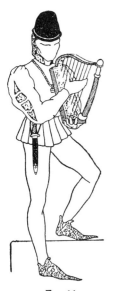

FIG. 11.
Frenchman, c. 1450,
playing a harp.

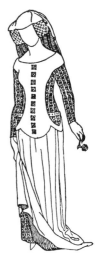

FIG. 17.
Lady in reticu-
lated headdress,
about 1390, and
a surcote.

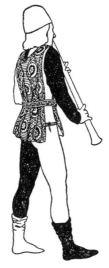

FIG 9
Italian boy, c. 1400,
playing a recorder or
English flute.

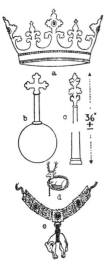

FIG. 19.
a, b, c, Crown, orb
and sceptre of Richard
II. d. Richard's badge
of the white hart. e,
The collar of the
Golden Fleece.

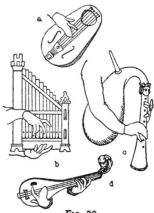

FIG. 20.
Mediæval musical instru-
ments. a, Guitar. b, Early
"portative" organ (bellows
are behind). c, Bagpipe. d
Mandore or citole.

applied in colored stitchery on the cuffs and backs of the hands. Some fine folk wore half-gloves or mitts; some had holes cut in the fingers to show their rings; others slipped their rings on outside their gloves. Laborers' gloves or mittens were of heavy hide or fabric.

Musical. A few of the many mediæval musical instruments are shown in this and the preceding chapter: in Chap. VI a psaltery (fig. 3) and a viol or rebeck (fig. 14); in this, a harp (fig. 11), a recorder or English flute (fig. 9), an early guitar (fig. 20a), a bagpipe (fig. 20c), a mandore or cithole (fig. 20d), and an early portable organ (fig. 20b). The " portative " of the later fifteenth century had a keyboard and a bellows in back, worked by the left hand. While there seem to be no pictures * showing how this simpler organ of ours was operated, it would be possible for a musician to hold the instrument as shown in the sketch while he pumped a small bellows by a string attached to his thumb. (The position of the hands is taken from a manuscript representation of this organ). " Positives " or small organs placed on a table were also popular instruments for a nobleman's hall.

SOMETHING ABOUT THE SETTING

Gothic architecture is the background for these costumes. Domestic interior decoration included oak-panelled walls; huge protruding fireplaces, ornately carved; tapestries; high-backed chairs carved in pointed arcades, in quatrefoils, foliage, and other Gothic architectural designs; carved stools (fig. 18); and long benches with or without high straight backs. Dining-tables were long, narrow, and covered with embroidered cloths.

PRACTICAL REPRODUCTION

Materials. The upholstery and drapery department is the place to start your shopping, since heavy materials are desirable. Some cretonnes and many brocades have genuine Renaissance patterns, both large and small. Rayon fabrics are made in appropriate stripes and small all-over designs. Cotton rep and denim make up well for the plainer costumes. Velveteen, corduroy, heavy flannelette, and heavy muslin are appropriate. Rayon satin and taffeta and sateen are satisfactory silk-substitutes. See also the suggestions for Early Gothic, Chap. VI.

For applying designs to fabrics, consult Chap. XX.

Accessories. For general suggestions for making accessories and jewelry, consult Chap. XX. Since jewels were faceted (*i. e.,* cut to sparkle) from this period on, you may now avail yourself of the ten-cent store stock.

Make belts and the collars of orders with the help of various gadgets from the hardware store. Instead of an all-metal belt you may make one of felt, studded with metal. Interline it with a piece of belting and it will hold a dagger or even a sword. Make bandoliers and baldricks the same way. Make purses of any desired material and line them with buckram. A pomander can be made with a tennis-ball as a foundation. Build it up to the desired size with

* Since the first edition of this work I have encountered a number of XV century representations of the portable, showing the mechanics of the bellows, on the same principle as described above. Fig. 20b is from a XIV century drawing: Brit. Mus. MS. Add. 10, 293.

plastic wood, imbed a hook in one end and to it attach some brass chain terminating in a big hook to fasten it to the belt. Gild the ball and pick out a filigree design with black paint.

Armor. For details of making armor, see Chap. XX. If you copy the brigandine (fig. 14), the shell of the body-part need not be metallized, but the velvet or cloth may be pasted directly on, simulating the nail-heads with spots of metallic paint. If you are imitating complete plate armor, include a surcote in the costume and you will not have to do so much work on the body-part. Unless the actor is shown on the fighting field (as in the " lists " scene in " Richard II ") see if you cannot put him into part of his armor only, or let him appear in the quilted gambeson, which may be made of the quilted material used for dining-table or bed-pads, dyed gray or tan and touched with drops of metallic paint to suggest metal studs. Armor suitable for use in " St. Joan " can be rented from the larger costuming establishments. Do not despair, however, of making a suit or two even of that style, and do not hesitate to attempt the armor shown in fig. 14, which is more appropriate for " Richard II " than the kind you can rent.

Shoes. Whenever possible, construct shoes by modifying ready-made slippers. It is better to forego the exaggeratedly long toes unless you can make some in which the actor will feel comfortable. They may be effective with short garments, but with a long-skirted houppelande they are likely to get in the way. Use ballet-slippers and felt or soft kid bedroom slippers. Add long tips made of felt (or leather). Along the seams stitch wire, which will hold the tips out. To make the soft boots, add felt leggings to felt slippers. Shape them in two pieces, with seams back and front, and lace them at front or sides. Heavy socks, dyed leather-color, with elastics run at the tops, make acceptable soft boots, also.

Millinery. For the construction of millinery in general, see Chap. XX. For making the chaperon, see Chap. VI, p. 147. If you intend to drape the chaperon on the head, either use the real hood as described, or make one thus: cut two large ovals with tails at one end, scalloped pieces at the other. Make one oval about an inch larger than the other all around. In the smaller oval cut a round big enough to fit on the head. Sew the two pieces together, leaving the scalloped ends open and faced back, if you wish, with a contrasting color. Put the hat on the head with the round hole fitting over the head like any cap. Arrange the scalloped part to stick up or hang down as you wish, and bind the whole to the head with the tail. You can also make the chaperon upon a small skullcap foundation, sewing it in the draped arrangement. Make the roundel (fig. 5) with a foundation of iron wire, pad it to the required thickness and cover it with a cylindrical case of cloth or silk; add the scalloped frill and the tail. Sew it all to a skullcap of the material.

Patterns for a six- or four-piece skullcap and for a soft hat with full crown and turn-back brim may be found among the millinery designs in standard pattern books.

Women's head-coverings seem more formidable to make than men's, but after all they are not so very difficult. For the cylindrical netted effects, use copper screening, cut, bound with stout tape, and bent in the right shape and secured with strong thread. Attach the cylinders to a headband and adjust them over the ears. The circular reticulations are easier to make because you can buy wire sieves the right size. Take away the handles, punch holes through which you may sew the sieves to a decorated headband, gild, and paint over the wire a latticework in a much coarser mesh; make jewels with blobs of tempera or sealing-wax, or sew glass beads at the intersections. This headdress adjusts over the ears and is very comfortable and becoming, especially with the addition of a light veil. You can make the large round reticulated cap either with a coarse-meshed wire basket, lined with silk, or with those copper-metal pot-scrapers which come in doubled squares. Open them up and shirr them on wire at the bottom, elastic at the top. The headdress in the Italian mode, which covers the back-hair only, is easily made in this way, the top elastic, gilded, going across the forehead. The hair, which will show in front and at the top, should be brushed smoothly back from the face.

A close-fitting bonnet or close hat-crown of buckram forms the basis for any of the towering fifteenth century headdresses. Upon such a cap sew the sugar-loaf or hennin (a cone of buckram), the horned (two cones), and the heart-shaped. An easy way to make the latter is to take a roll with a wire core, such as you have made for the roundel, tack it to the tight cap front and back (at forehead and nape), and bend it to the heart shape, narrow or wide as you wish. Cover sides and top with tight-stretched bias pieces of your chosen material, taking darts over the ears as required and tacking it to the under-cap. A chin-strap helps to keep this hat on, and it may be concealed by the veil as in fig. 16.

Make the pretty " butterfly " bonnets of tarlatan, in double or even triple thickness. The dressing is usually stiff enough to hold it up without other support, even if it is not made over one of the buckram shapes. If the white is used alone, start with a tight muslin bonnet, take a large doubled piece of tarlatan, pin the middle to the center of the cap and arrange the rest to your taste with pins and stitches.

CUTTING THE GARMENTS

Men. For the body of any snug-fitting garment use, as a cutting guide: the man's own vest, the vest of a " George Washington " or " Continental " fancy dress pattern, or the doublet of a " Mephistopheles " or " devil " costume. With any of these you will have to make the waistline lower. You can use the peplum of the " devil " suit as the guide in cutting any of the flaring skirts; the full pleated types you may make of straight widths.

For the body of a looser garment, gown, pleated houppelande, pleated short gown, use as a guide a man's nightshirt pattern (add side gores), pajama pattern with V neck (which can be modified in various ways), a " pierrot "

pattern found among fancy-dress costumes, or a " domino " pattern. Pleat the
garment in neatly and sew to an inside belting, not relying on the outer belt
alone to hold the pleats in place. Hold up the high collars with the little twisted
wire pieces sold for that purpose at the notion counter. For the sleeve use the
pattern sleeve as a guide. To make it fuller at the top, add extra material in
a fold down the middle while you are cutting; to narrow from elbow
to wrist, take off on both inside and outside seams. A real leg-o'-mutton
sleeve may be found among women's patterns, and will be a good guide
by which to recut your sleeve. Cut the extra long open sleeve on the
plan of that shown in fig. 20, Chap. V. Use any standard pattern for the
" bellows " sleeve, cutting it fuller from above the elbow down and consider-
ably longer; gather the end into a cuff; slit the sleeve down the outside. For the
flaring cuff (fig. 3) cut two circular pieces (the lining piece of a color to
contrast with the sleeve) and an interlining of crinoline; cut an inside circle
to fit the wrist. Slit the cuff to match the wrist-opening and fasten with a snap
at the outside edge. When tight sleeves are to be shown under open sleeves
(fig. 3), set the former on an underwaist or guimpe. If the same garment is
supposed to show at the throat, put a collar on the guimpe.

Tights are a necessity to wear with short garments, even those of knee-
length. With calf- or ankle-length gowns it is safe to wear long stockings.
Usually the costumer is content to provide stockingette tights of heavy cotton
or mercerized thread. If, however, you wish to be very authentic, you will
find hose-patterns in *History of Costume* by Köhler and von Sichert and easier
patterns in *Jeanne d'Arc, ses Costumes, son Armure,* by Adrien Harmand. The
latter author also gives excellent boot-patterns—in fact, patterns for several
garments of the period he discusses.

To dye tights half-and-half: carefully separate the tights down the crotch,
first running two lines of machine-stitching or close hand-stitching, one on
either side of the division, to stop ravelling; dye them and sew them together
again. When the tights are to be worn with a knee-length skirt, you can risk
dyeing without ripping apart, if you wrap a string very firmly for about an
inch along the division-line. That part will stay the original color, but it will
not show.

The only way to make the fancifully cut edges on a permanent costume, or
a costume to be seen at close range, is to face them, a method which allows
you to introduce the added touch of contrasting color so typical of the period.
Cut a paper pattern of the desired edge (remember that it is more effective and
much easier to make if it is simple). After basting the edge of the garment
and a strip of facing right sides together, mark the pattern on the smoother
material with pencil or tailor's chalk. Baste along the marks, stitch, cut out
close to the stitching, turn, and catch-stitch the facing back to the garment.
For long-distance pageantry, with a garment made of cheap material, simply
cut out the design on the raw edge.

Women. Cut the close-fitting dresses on a princesse slip pattern, adding much

fullness in the skirt. Cut the surcote top of fig. 17 by a fitted lining pattern; fit and stitch, then cut it away as shown in the sketch. It will look much better if it is made up with an interlining of heavy muslin (this is a statement that may be applied to all the tight-fitting "bodies" for men or women). The surcote may also be faked as a kind of pinafore on a sleeved bodice of another color. The full skirt will be made from the material of the pinafore. This surcote skirt may be made either straight and gathered or pleated on at the hip-line, or circular. There must also be an underskirt which will show when the upper one is lifted.

Cut the pleated houppelande on the "domino" pattern. Add gores at the sides from the waist down. Pleat the waist in and sew to an inside belt—put the ornamental belt on the outside. You can cut the top of the short-waisted gown (fig. 18) on the same pattern or on any blouse-pattern with set-in sleeves. Sew it to a belt as above. Or else make either gown or houppelande over a fitted lining. The skirt of the gown should be full as well as very long. It must be *at least* four yards around, not counting the extra width if there is a train. Gather or pleat it into the belt. If you cannot get all that bulk in, gore the seams off a little, but remember you want it to bulge around the waist and give a high-stomached effect. Cut sleeves as suggested for men's garments.

In addition to the underdress (which may have to be a complete princesse dress with sleeves if it is to show in several areas) all costumes must have a petticoat or slip of sturdy unbleached muslin or sheeting, to give the proper heavy effect. It need not be as full as the upper skirt. Do not skimp the amount of material in the upper skirt, either around or up and down. The grander the lady, the larger, as a rule, the yardage.

Do not let your actresses wear heels, unless they *must* increase their height; it spoils the characteristic posture of the period. Since skirts are always very long except for peasants (the *under*skirt should cover the instep when walking), shoes are not much of a problem; the ever-useful ballet-slipper or soft pullman slipper suffices. Decorate them if it seems worth while.

Suggested Reading List
(See the reading lists in Chaps. V and VI.)

Calthrop (English Costume) has an especially charming chapter on the "Canterbury Pilgrims."

Jeanne d'Arc, ses Costumes, son Armure—By Adrien Harmand.
 A very careful and minute study of the clothes probably worn by the Maid, with illustrations from contemporary sources, patterns for making each garment, and, finally, a sketch reconstructing the Maid in each of her types of costume. An invaluable book for anyone costuming "St. Joan." The French is not difficult.

Where Further Illustrative Material May be Found
(See also this paragraph in Chap. VI.)

Italian and Flemish paintings are among our best sources of information. The Flemings, especially, were meticulous in their rendering of details. The portraits and to some

extent the religious paintings of the brothers Van Eyck are particularly worth studying. Miniatures of the fifteenth century are also realistic in rendering and show many " genre " scenes, with people in workaday dress.

The " Canterbury Tales " and inventories of royal wardrobes are valuable sources, especially for the names of garments and textiles.

Sources of Sketches in This Chapter

We have drawn upon all the types of source-material listed here and in Chap. VI.

The musical instruments have been studied in manuscripts, in the figures of angel minstrels at Exeter and Gloucester Cathedrals, and particularly in Cutts, op. cit., pp. 267 and 295 (British Museum manuscripts). The guitar (fig. 20a) is taken from Schultz, *Hofische Leben zur Seite der Minnesingers.*

The " Wilton Dyptich " and the Westminster portrait of Richard II furnished the originals for the badge of the white hart and the crown, orb, and sceptre.

The shoes are from photographs of originals in the London Museum and the Victoria and Albert Museum and from various manuscript representations.

The group of statuettes by Jacques de Guerin (made c. 1430) in the Riyksmuseum, Amsterdam, furnished many details incorporated in several of the sketches.

The armor in fig. 14 is copied entire from a suit in the Bashford Dean Collection in the Metropolitan Museum of Arts, by courtesy of the Metropolitan Museum. The cross-bowman in fig. 13 is partly from a figure in Cutts, op. cit., p. 442, partly from other sources, such as some actual quilted body-garments in the Metropolitan Museum and cross-bows there and in other museums.

Chapter VIII

RENAISSANCE

DATES:

1450–1550

Some Important Events and Names

ENGLAND	FRANCE	GERMANY	SPAIN	ITALY
Edward IV, d. 1483.	Louis XI, d. 1483.	Printing, 1456.		Florence, Cosimo de Medici, from 1434. Machiavelli, 1469–1527.
Wars of the Roses, 1455–1485.				
			Columbus, America, 1492	Lorenzo de Medici, " the
Richard III, d. 1485.	Charles VIII, d. 1498.		Ferdinand, d. 1516	Magnificent," d. 1492.
Henry VII, d. 1509.	Louis XII, d. 1515, m. Anne of Brittany and Mary Tudor.	Emperor Maximilian, d. 1519.	Isabella, d. 1504.	Savonarola, d. 1498.
			d. 1547.	Popes Alexander VI,
Henry VIII, d. 1547.	François I, d. 1547.	Emperor Charles V, d. 1558.	Charles V also	Julius II, Leo X.
Field of the Cloth of Gold, 1520.				Sack of Rome, 1527.
Cardinal Wolsey, d. 1529.	John Calvin, d. 1564.	Martin Luther, Excommuni- cated, 1520 d. 1546.		PAINTERS Botticelli, 1444–1510.
				Ghirlandaio, 1449–1494.
		PAINTERS (Netherlands) Hans Memling, d. 1495. Pieter Breughel the Elder, 1525–1569.		Carpaccio, c. 1500.
	PAINTERS The Clouets:			Leonardo da Vinci, 1452–1519.
PAINTERS Hans Holbein the Younger, Court painter, 1536–1543.	Jean Clouet, Court painter under François I, d. 1541.	Albrecht Dürer, d. 1528. Lucas Cranach, d. 1553.		Raphael, d. 1520. Michael Angelo, 1475–1564.
				Titian, 1477–1576.

Some Plays to Be Costumed in the Period

"Pierre Patelin," the French farce (1465).

"Everyman," the English morality (1529).

Shakspere's "Richard III" and "Henry VIII."

Christopher Marlowe's "Doctor Faustus."

Some directors prefer to costume certain plays of Shakspere in the Italian styles of this period: "Two Gentlemen of Verona," "Merchant of Venice," "Romeo and Juliet."

RENAISSANCE

CONCERNING THE PERIOD

THIS hundred years, the second half of the fifteenth century, and the first of the sixteenth, saw the full flowering of art, whose burgeoning we have noted in the thirteenth and fourteenth centuries. Italy was the most luxuriant garden, probably because Italy had the closest bond with Antiquity, the recovery of which was an important part of the Renaissance. But in the Netherlands also a succession of painters continued the work begun by the Van Eycks (Chap. VII); in Germany Dürer and in England the German Holbein drew and painted immortally, and in France portraiture was splendidly represented by the Clouets.

Other and even more momentous happenings mark this as the age of rebirth: first, the beginning of printing; second, the discoveries in the New World; and third, the religious Reformation. The efforts of the kindly humanist and internationalist, Erasmus, to bring about reforms within the Church failed to stem the tide of change, and under Luther and Calvin the way was prepared for the bloody religious and social wars of the next centuries.

Although this was a period of absolute monarchs, during which the cry of the Wonderland Queen of Hearts, " Off with his head! " resounded frequently and effectually, the middle class increased steadily in wealth and power, and even peasants and common people were beginning to assert themselves. Cities, and especially the seaports of the Mediterranean, North Sea, and English Channel, did a flourishing trade, and the townhouses of burghers were filled with beautiful and useful articles from every corner of Europe and the East.

While in Italy the Renaissance type of architecture, with its arcades, straight-topped window and door-frames, and pilasters inherited from Rome, superseded the older style, in France high-pitched roofs showed a blending of Gothic with the newer inspiration, and in England the last flowering of Gothic resulted in some of its most beautiful details, such as the fan-vaulting of the Henry VII chapel at Westminster Abbey. In England, too, the perpendicular style of Gothic gave the " linen-fold " motif to decorative detail and, depressing the sharp Gothic point, resulted in the typical " Tudor arch." This was a period of château building in the North, resulting in such impressive piles as François I's château of Fontainebleau and Cardinal Wolsey's palace at Hampton Court. The most notable buildings were not ecclesiastical, but secular, typical of the changed emphasis of men's minds.

GENERAL CHARACTERISTICS OF COSTUME

The second half of the fifteenth century (or, to set an English date, from the beginning of the Wars of the Roses, 1455, to the end, at Bosworth field, in 1485, when Richard III was slain and the Tudor dynasty began with Henry VII) can be considered the last of mediæval costume, as it was of Gothic architecture. Dress was in a transitional stage, partaking of the characteristics described for such a play as " St. Joan ": for men, high shoulders, long pleated gowns, pointed-toed shoes; for women, hennins (fig. 13h), high-waisted dresses with V-collars and long trains, skirts gathered full over the abdomen. At the same time appeared details which may be characterized as sixteenth century: wide square shoulders, short gowns, square-toed shoes for men; lower head-dresses, square or round décolletage, longer waists for women. A play about Louis XI in his heyday would probably incorporate the older features; " Richard III " would display many of the new.

The arbitrary date 1490 (when Columbus was preparing to sail upon his momentous voyage) may be set as the beginning of the dress described in this chapter, the dress represented successively in the paintings of Memling, Ghirlandaio, Carpaccio, Raphael, Dürer and Holbein, and their contemporaries. Holbein, in his office as court-painter to Henry VIII, produced such a portrait-gallery of the times, of Henry, five of his wives, Sir Thomas More, Erasmus, court ladies and gentlemen, citizens and their wives, that we can scarcely think of the period save in terms of Holbein. Yet if we would costume a play about the Borgias, for instance, we should do better to consult Italian pictures of the contemporary scene; if " Faust," pictures by Dürer or Cranach and their compatriots. For at this time, more definitely than before, different nations expressed the prevailing mode in characteristically different ways. Everywhere, to be sure, there appeared an excess of ornament, stiff and magnificent fabrics, an exuberant display of jewels, and a flaunting of varicolored garments; and from South to North the slashing of material and puffing of other material through it.

Italians, however, did not distort the natural figure so absurdly as Northerners did, and Spaniards followed, in general, Italian modes. Neither doublet nor hose were distended with padding; sleeves, though large and elaborate, were not unduly stiff; shoes were not always exaggeratedly splay-footed. Till about 1510 Italian influence was strong in France and England, consorting well with the last of the softer mediæval fashions. The accompanying sketches suggest the differences in the development of Northern and Southern modes after that date.

Germans went to the greatest extremes, imagination running riot in " improvements " on the natural silhouette. From crown to toes they burst forth in hideous silken excrescences: large puffs, like melons, at head, shoulder, thigh; small puffs, like boils, over chest, back, arms, legs, and feet. Feathers sprayed from wide-brimmed hats, ribbons floated from shoulders, elbows, and knees.

The earlier fashion for parti-colored hose continued, not only in half-and-half arrangements, but in quarterings, with different designs on upper and lower legs. Fig. 5, our most Teutonic sketch, is a mild example of what might be done.

The English mode was soberer than the German, less graceful than the Italian. Henry VII had been a niggardly man, not given to display in dress, and his magnificent son, though he covered his great body with scarlet, yellow, cloth of gold, and jewelled brocades, did not resort to the Teutonic exaggerations. Perhaps his huge frame was impressive enough without the help of fantasy. At any rate, the Englishmen painted by Holbein during the second quarter of the sixteenth century are attired in rich, stiff, but dignified garments. Englishwomen, likewise, displayed a kind of austerity in richness. They wore their black velvet, red silk, gold brocade with poise and sobriety. There was an architectural quality to the costume, epitomized in the square " pedimental " headdress.

The Low Countries resembled Germany in a fondness for stiff linen head-tires, England in employing simple masses of rich fabric. France shared the more informal feminine coiffure of the Italians and their softer draperies, but affected also, at will, the formal English grandeur. French taste was not badly contaminated by German extravagances. Each country borrowed fashions from the other, and returning travellers were remarked for their cosmopolitan wardrobes. Thus an Englishman might display a shapely leg in tight Italian upper-stocks and a skirtless jerkin, or a French lady frame her face in an English " kennel " headtire.

The permanent characteristics in all countries for the years between about 1510 and 1550 may be summarized thus: rich heavy materials, in voluminous amount, large sleeves, close body-garments, large hip-clothing, wide-toed, heel-less shoes, and covered heads, both masculine and feminine. This is a good place to remark that, differing from modern custom, head-covering was not necessarily a part of *outdoor* as distinct from *indoor* dress. The feminine coiffures of this and earlier as well as later periods were not confined to the house, nor exchanged for hats outdoors (though, as we have noted, hats were sometimes added to flat coifs). Men wore their hats indoors in the presence of their peers and inferiors, and did not go bareheaded in a lady's company. Only before the king (and the Deity) did noblemen remain uncovered and only by royal permission might they cover their heads in the Presence. The king himself habitually wore a cap or hat, indoors and out indifferently. This statement holds good for the entire middle ages and the seventeenth century.

Fashions of the period survive to this day in special costumes. The Swiss Guards in the Vatican, for instance, wear the uniforms designed for them by Michael Angelo. The Yeomen of the Guard dress practically as they did when Anne Boleyn looked upon them on the day she was beheaded. Undergraduates at Oxford are still obliged to wear (in the University town) the same short, black gown that was an everyday garment of their predecessors when Cardinal

Wolsey founded Christ (or Cardinal) College. The gown in which you go up to get your B. A. is descended from the long gowns of Renaissance scholars and statesmen. When Protestant preachers substitute this academic gown for the older Catholic vestments, they are dressing substantially like Luther and Calvin. The academic "mortarboard" is a form of the Renaissance square cap, and another is the biretta worn by priests (fig. 14, Chap. IX)—the same with which some Anglican churches cap that anomaly, the choir-girl. Lastly, the origin of many details of peasant dress (especially feminine) can be traced to the early sixteenth century: the "corset" bodice in all its variations, the linen blouse with shirred neck and large embroidered sleeves, the full gathered skirt. In Italian costume, that familiar headdress of a stiff flat piece of cloth on top of the head, with an unstiffened fold hanging down the back, is preserved intact from headdresses of Renaissance ladies (French as well as Italian). In the Abruzzi, when a peasant woman puts on the traditional dress, she ties an ornamental sleeve into the armseye of her bodice, letting her white blouse puff between the ties, exactly as did the ladies who sat for their portraits to Raphael and Titian (fig. 15a).

MEN

Heads. During the earlier years of the period hair was as a rule " bobbed." Much, however, depended upon individual taste, and you may find in contemporary pictures almost any length. The waves and neatly curled ends fashionable in the middle ages are seldom seen; hair seems to have hung straight or curled, according to its nature. The Italian boys who wore girlishly long tresses (fig. 2) came under the disapproval of Savonarola. As the sixteenth century advanced, short hair (almost in the modern style) became more and more general. During the latter part of the fifteenth century beards were not fashionable, and they were by no means universal from 1500 to 1550; but since the two most picturesque monarchs of the time both affected a clipped chin-beard and small turn-down moustache, there were, naturally, plenty of imitators of that mode (figs. 1b, 4 and 6).

Almost all hats were variations of the low-crowned, brimmed cap which had appeared before 1450 (figs. 1a, 7, 10). Exceptions to this rule are the brimless cap, especially popular in Italy before 1500 (fig. 2), to be seen in the paintings of Carpaccio, Botticelli and their contemporaries, and the bonnet with earflaps, which held over from previous periods (fig. 6, Chap. VI). In the transition years this bonnet continued to be made very often of white linen. Louis XI is represented more than once in such a coif. As formerly, it was often retained *under* a hat or cap (fig. 12). As time went on, this cap became recognized as a scholar's or elderly gentleman's headgear, and was generally made of black velvet. The flaps were shorter and no longer tied under the chin. Ear-pieces appeared also on shaped felt or velvet caps, both those which fitted the head closely (fig. 3) and those which puffed out (fig. 14, Chap. IX).

The brimmed cap had many variations, of which a few are illustrated.

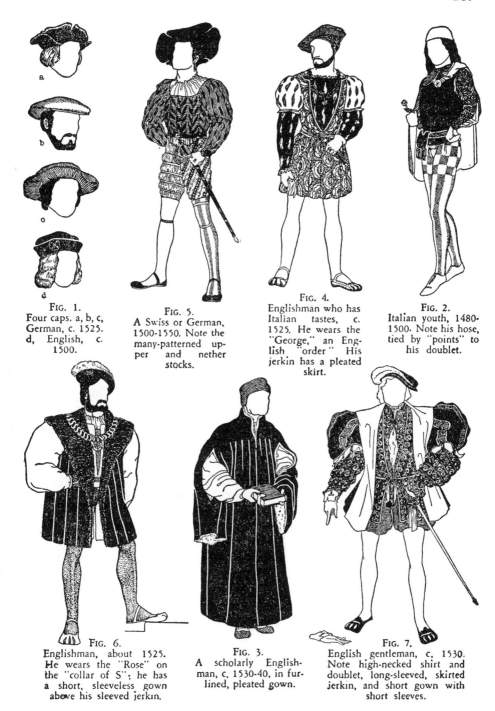

FIG. 1.
Four caps. a, b, c, German, c. 1525. d, English, c. 1500.

FIG. 5.
A Swiss or German, 1500-1550. Note the many-patterned upper and nether stocks.

FIG. 4.
Englishman who has Italian tastes, c. 1525. He wears the "George," an English "order." His jerkin has a pleated skirt.

FIG. 2.
Italian youth, 1480-1500. Note his hose, tied by "points" to his doublet.

FIG. 6.
Englishman, about 1525. He wears the "Rose" on the "collar of S"; he has a short, sleeveless gown above his sleeved jerkin.

FIG. 3.
A scholarly Englishman, c. 1530-40, in fur-lined, pleated gown.

FIG. 7.
English gentleman, c. 1530. Note high-necked shirt and doublet, long-sleeved, skirted jerkin, and short gown with short sleeves.

Often it was turned up all around (fig. 1d). Equally often the brim was cut in sections which could be fastened up or allowed to droop (figs. 1a and 4). Such a brim was sometimes wider and stiffer (figs. 1c and 5). The small, wide-crowned, narrow-brimmed cap, worn very much to one side, was popular with kings, courtiers, and citizens, and continued in style during the reign of Edward VI (fig. 6).

All these hats, of felt, beaver, or velvet, were ornamented with jewels sewed on in designs, with jewelled brooches, or with curled ostrich tips. Trimming was horizontal or drooping, and even in the fantastic Teutonic examples seldom stuck up in air. The flat cap (fig. 9, Chap. IX), made of dark-hued felt, without ornament, was worn by ordinary folk and the soberer gentry (fig. 1b).

Necks. In the transitional period, the high collar went out of style, and the fashionable neckline came first at the base of the throat (fig. 2), then lower, showing the shirred heading of the chemise or *shirt,* as we can now call it (figs. 5 and 6). This style rapidly developed into a real décolletage, especially popular in Italy and France, a fashion which gave some concern to the moralists. The youthful François I portrayed by Clouet affected this low neckline, but even older men followed the fashion. Fig. 4 represents the general style. Frequently, but not invariably, the shirt-frill showed above the doublet neck. After 1525 the shirt often rose higher above the low-cut doublet, till it encircled the base of the throat, with the heading forming a tiny frill (fig. 5). There was a slit down the front of the shirt to admit the head, and cords to hold the band together at the neck. A small turn-over collar appeared after 1525 and was well established by 1550. At the end of the period the neckband rose again into a real collar (almost as high as that on the lady in fig. 21), a style which continued into the next period.

Bodies. The *shirt* had large full sleeves, gathered into a band or ruffle at the wrist. Both this ruffle and the heading (or sometimes band) at the neck were embroidered in red, blue, black, or gold. The shirt was not invariably of linen, nor always white, but might be silk, white or colored. Changeable taffeta is mentioned as a shirt material. In that connection it is interesting to learn that English travellers to Italy were advised to wear taffeta-lined doublets, as a discouragement to fleas.

The *doublet,* worn next to the shirt, was the prototype of the modern waistcoat. Like the waistcoat, it was as a rule not worn alone. Often it had sleeves, usually not very ample, and made to tie into the armseye. The lower part of these sleeves and the front of the doublet are ordinarily visible in pictures. This garment was as a rule skirtless (fig. 5). Though it did sometimes open in front, apparently it was more frequently opened in back (fig. 9). The front could have a variety of arrangements. It spread flat across the chest, high or low-necked (figs. 4 and 5); it was open in a deep V and laced over the shirt; it showed the shirt (or the material of an intermediate garment) through slashes (fig. 4). It is possible that the material seen under a jerkin did not

always represent a whole doublet, but only a V-shaped false front or " stomacher." In the later years of this period doublet as well as jerkin was cut high and either fastened over the shirt (fig. 7) or left partly or wholly open; in the latter arrangement its corners often turned back like revers.

The *jerkin* came next over the doublet, corresponding to the modern suitcoat. It was frequently sleeved and opened in front, often to the waistline, displaying the doublet (fig. 4). A favorite addition was a collar with wide revers, sometimes of fur; other necklines were also fashionable: high (fig. 10), round (fig. 4), square (fig. 6), and long V (fig. 7). The jerkin had a skirt, sometimes only hip-length (fig. 2), but more often longer, either to the knee (fig. 4) or a little above (figs. 6 and 7). Often the knee-length skirt was laid in pressed pleats (fig. 4). Another style of skirt (fig. 7) had unpressed pleats with vertical trimming on the folds. Around the waist went a metal belt, a sash, or a ribbon girdle knotted in front, from which, at the left side, hung a dagger (fig. 4).

Arms. Doublet sleeves were sometimes sewed into the armseye, sometimes tied in by means of " points," *i. e.,* metal-tipped ribbons or lacings, sewed in corresponding pairs to sleeves and armseye. Figs. 5 and 10 show doublet sleeves cut in one with the shoulder; fig. 2 a pair tied in, revealing the shirt through the opening. From first to last the doublet sleeve seems to have been long and fitted snugly at the wrist, even though when made of heavy material it was often bulky and wrinkled. Fig. 2 illustrates the early sleeve, as worn in Italy. The shirt puffs through the doublet sleeve in two places, the outer forearm and the inner crook of the elbow; the slashes are tied or " bridged " together. This is an example of early styles in slashing. Another doublet sleeve is larger and looser (fig. 5), but this doublet is worn without a jerkin. It is through the slashes of the doublet sleeve that the shirt-sleeve puffs (figs. 2 and 4).

The jerkin sleeve was larger. Frequently it was not long, but, after puffing hugely at the shoulder, stopped above the elbow. It was sometimes loose to the elbow, or immensely puffed all the way down and into a cuff at the wrist (figs. 6 and 7). It might still, as in an earlier fashion (fig. 5, Chap. VII), have a slit in the outer seam through which the arm passed instead of through a cuff. Occasionally, as in the Italian style of fig. 4, the jerkin sleeve was small, not much more than a cap. In this period began the practice, later so general, of extending the breadth of the shoulder and concealing the joining of sleeve and armseye by an epaulet (Chap. IX, figs. *passim*).

Legs. The hose, sometimes visible to the waistline, sometimes partly concealed by the skirts of the jerkin, were, till after about 1510, all in one (fig. 2), though sometimes, as in this picture, made of variously-patterned material; after that time the legs were covered by separate garments, *upper* and *nether* hose or *" stocks."* The upperstocks (*haut-de-chausse* in French) were virtually breeches, either as small and tight as trunks (fig. 9) or longer and fuller in various degrees (figs. 5, 7, 10). German taste went to great extremes in puffing the upperstocks, often decorating one leg unlike the other (fig. 5).

Even with a skirted jerkin the upperstocks were frequently visible (fig. 7), sometimes reaching below the knee. *Netherstocks* were, as the name suggests, practically stockings (the French word "bas" is also a derivative of *their* word for this garment, "*bas-de-chausse*"). Fig. 5 is an example of how netherstocks also might contrast with the upperstocks and with each other. While some hose were still cut from cloth and shaped to the leg as in earlier times, the more comfortable knitted hose increased in popularity. The codpiece was nearly always visible (figs. 2, 5, 6, 7, 10)—a pouch-like appendage, made from the same material as jerkin or upperstocks and fastened by ties or buckles. Garters were an important accessory of hose. They were worn below the knee and sometimes also above it (fig. 5), for the practical purpose of keeping the stocking smooth, or for ornament, or both. The garter of the Order (fig. 5, Chap. IX) was usually worn by Garter knights, somewhat as nowadays a man wears his Masonic pin or his Phi Beta Kappa key.

The typical shoe of this period is completely heelless and very square-toed. Even before 1500 this style was well established, though in Italy the exaggeration was not so great (fig. 2) and it continued in splay-footed ugliness until about 1540, when the whim of fashion turned to a more reasonable, round toe. Figs. 3, 4, 5, 6, 7, 10 give an idea of the types of shoes and the method of decoration with slashes and puffs. Figs. 4, 5, 6, 7 show the exaggeratedly low cut. An ankle-strap seems needed to keep such a shoe on, though it is frequently not present in pictures. Shoes were made of leather, velvet, and heavy silk, and the ornamentation included—besides silken puffs—jewels and jewelled buckles and embroidery. Ordinary folk wore leather shoes, cut on the fashionable lines but unornamented (fig. 8). Boots, worn in outdoor pursuits, were soft and wrinkled (fig. 9).

Outer Garments. The gown was not, strictly speaking, so much an overcoat as a garment completing a man's costume, indoors as well as out. It was put on over doublet and jerkin or, possibly, over jerkin alone. In the transitional styles still occasionally worn long by young men, later it was, fashionably, short (figs. 6 and 7). The long gown (fig. 3) was then relegated to elderly statesmen and scholars, like Sir Thomas More and Erasmus. One outstanding feature of the gown is the large collar, square in back, wide on the shoulders, tapering toward the hem (figs. 6 and 7); yet such a collar was not invariably present (fig. 3). The gown was open up the front and often pleated into a short yoke front and back, a treatment that has survived in the modern academic gown. It had various types of sleeve. Sometimes, as in fig. 6, sleeveless, in other versions the gown had wide-open armholes with trimming around the openings. Sometimes, as in fig. 3, the large open sleeve was slit to afford an arm-passage. Sometimes, finally, the gown was provided with large puffed sleeves, as in fig. 7. Fur was the favorite trimming for the wide collar, and often for sleeves, which were in addition lined with fur, as in the middle ages (fig. 3). This garment was occasionally belted, but usually fell loose, displaying the front of the skirted jerkin (fig. 6).

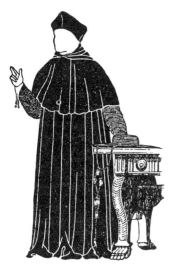

FIG. 24.
A cardinal in ordinary official dress. His hat is beside him, he wears a biretta. Note the seven tassels on the cardinal's hat.

FIG. 9.
Countryman (Italian), c. 1500, in doublet, upper-stocks and soft boots.

FIG. 12.
The Doge of Venice in the early 16th century.

FIG. 10.
Arquebusier, 1500-1550. Note three pairs of sleeves; under-doublet, doublet, and jerkin.

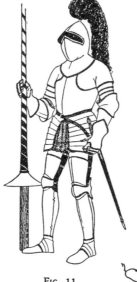

FIG. 11.
Tilting armor, 1500-1550, Austrian style. Note jerkin skirt.

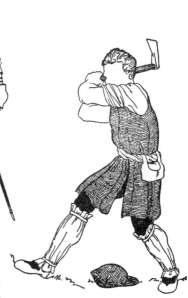

FIG. 8.
Flemish peasant, 1450-1550 and later. Specifically, 1525. Sleeveless jerkin over shirt. Cloth gaiters.

Cloaks were more peculiar to the transitional and early periods than to the years when Holbein painted. They were loose wraps for outdoors, and were circular or rectangular and sleeveless, in the styles described in earlier chapters. Fig. 2 shows a short circular cape modish in Italy.

PEASANTS

A tunic or jerkin worn over the old-style long chemise, sometimes slit in front for greater freedom, sleeveless or with moderately full sleeves tight at the wrist; roughly-cut hose reaching up to the thigh, and over them other hose, gaiters, or clumsy leather shoes; hooded capes, bonnets, close caps, or wide-brimmed felts or straws,—these details distinguish the early sixteenth century peasant but little from his predecessors (fig. 8). A more prosperous peasant might wear plain shoes of the fashionable cut and discard his smock in favor of a jerkin of cloth or leather. The Italian in fig. 9 is a plain man who has reduced his garments to shirt, doublet, tight drawers, and boots.

SOLDIERS

The second quarter of the sixteenth century (before 1550) is considered to be the high moment in the armorer's art. Tilting armor, such as that pictured in fig. 11, was entirely of plate. From his visored and crested helmet to his toes the knight was metal-encased. The tabard described on p. 163 seems not to have been worn generally in active combat, though still used on parade.

Swords wielded by men in armor were still heavy and made with the cruciform hilt. The tilting-lance had a large guard at its grasping-end, to protect the hand and arm (fig. 11).

Foot-soldiers fought without armor (fig. 10) or protected by padded garments like that shown in fig. 13, Chap. VII, or by hauberks of chain under their jerkins. The helmet in that same picture continued to be worn by bowmen. The cross-bow was still an important weapon, even though the arquebuse (fig. 10) had been known since 1446. Virtually the only shields were those described on p. 163, used by cross-bowmen, or the small round "buckler" pictured in fig. 9, Chap. IX, held at arm's length to ward off a blow, and popular with foot-soldiers and the middle-class generally, as it had been since the thirteenth century.

CLERGY

The chasuble (fig. 15, Chap. V) was greatly changed from its primitive shape, being now much cut away at the sides, to make a garment fiddle-shaped back and front, as it may be seen in modern Roman Catholic vestments. The cope and mitre remained as they had been (fig. 9, Chap. IV, fig. 8, Chap. VI). The habitual dress of cardinals such as Wolsey is shown in fig. 24; it was all red. The cap is a *biretta* and his cardinal's hat (which was a symbol of office, but *not* an article of attire) is beside him.

The English Reformation discouraged the use of the traditional Catholic vestments. Reformed bishops (for instance, Cranmer) dressed practically like an Elizabethan bishop (fig. 14, Chap. IX). Cutts (see p. 205) says that in England the Reformed clergy abandoned the tonsure and habitually wore the current academic costume, which included an older-style (long) cassock and a gown, also long (fig. 3) if they could afford it, otherwise short. They dressed in dark colors or black and wore a close hood with earflaps or a square cap of the biretta type (fig. 3).

<p style="text-align:center">SPECIAL COSTUME</p>

The Duke or Doge of Venice (fig. 12), whose costume is called for in more than one of the Elizabethan dramas, preserved in his official robes the garments of an earlier day. For the centuries during which the Doge governed Venice this costume did not change: the stiff, pointed cap (shaped on a block) worn over a white linen coif, and the long cape, fastened with huge gold buttons. Red and gold are the prevailing colors, but the design on the fabric changed with the years. The design sketched is appropriate for sixteenth century doges. Undergarments changed with the current modes.

<p style="text-align:center">WOMEN</p>

Heads. Maidens still wore flowing locks, and a good deal of a point was made of brides appearing thus. Francis Hackett in " Henry VIII " mentions that Catherine of Aragon went to her coronation in white satin, " her hair loose in token of her virginity," a matter of political importance, since it was claimed that her former marriage to Henry's brother Arthur had not been consummated.

Italian styles displayed the hair, entirely or partially. Italian women seem never to have taken kindly to the enveloping headdresses popular in the North, and even during the sixteenth century, they managed to display their hair, decorated rather than covered by silken caps and cauls. It might be loose, confined only by a narrow band or ribbon, from which depended a jewel; or arranged in elaborate coils and braids, hanging (fig. 13j) or pinned up (fig. 13g). Caps or nets, covering either the back or top of the head (fig. 15), displayed the hair parted in the middle and drawn over the ears (fig. 14). Italian modes of the sixteenth century included the large turban (fig. 16). Rarely one finds a lady, her hair otherwise unbonneted, wearing a man's style of hat, as in fig. 13g (Spanish).

French women took kindly to the Italian modes on the one hand, to Flemish styles on the other. In Flanders women liked a more enveloping bonnet, its style derived from fifteenth century headdresses. The Germans draped up elaborate structures of stiff white linen; the English specialized on the architectural style, which covered the hair. With any of these coifs the hair was worn either pinned up or hanging down the back, loose, as in fig. 14, or in a thick braid. Two transitional styles are sketched: the hennin, as it was worn up

to the death of Richard III (fig. 13h) and the black velvet frontlet without the hennin (fig. 17), belonging to about the same period. Fig. 13l shows how, also in the transitional period (before 1500), the linen cap was worn with a rich piece of material laid over it and a scarf covering the back of the head. From this style and the hennin evolved the kennel headdress.

The *kennel*, *gable* or *pedimental* headdress, familiar to us in the Holbein portraits, took its name from its shape, which resembles in outline the pediment of a Greek temple (fig. 18). Its essentials are: the piece which goes over the front part of the head and covers the ears and the veil or bag-cap covering the rest of the head. With the formal type of this headdress no hair was visible, that at the forehead being covered with rolls or folds of cloth. There were, however, linen coifs shaped in the same outline which left the parted hair visible on the forehead (fig. 19). The front roll was of diagonally striped material or black velvet. The kennel consisted of a stiff frame covered with rich material, pieces of which extended down the sides and might be pinned back upon themselves. The cap at the back, joining the kennel, was like a short-pointed chaperon (p. 157) or a bag with a square bottom. One side was turned back and pinned to the other at the back of the head. The bag was generally black velvet. A frontal of gold and jewels sometimes outlined the shape of the kennel; again, the outline was emphasized by a fold of transparent linen. Besides the imitation of this cap shown in fig. 19 there was a much simpler version worn by middle-class women and even the peasantry. It was merely the close cap shown in fig. 20, with longer side-pieces, turned up and pinned on the sides. Peasant caps, in Brittany for instance, still keep alive this style.

There were many versions of the cap made of linen or cloth and linen. In Germany and the Netherlands gentlewomen wore such head-coverings and often enveloped chin as well as head in stiff linen folds. Figs. 13a and b are examples of this mode. Fig. 13c is an especially " conventual " version, and so is fig. 13e, the gorget and wimple worn by a widow—practically identical with the coif of a modern nun.

Peculiar to Germany was the half-dome structure, entirely of stiff linen (fig. 13a), or of rich material stretched over a stiff foundation. Fig. 13f shows the dome in conjunction with a transparent linen bonnet.

One of the prettiest of the headdresses, popular, too, in England, was the crescent or horseshoe (fig. 13k). It was a piece of stiff material like buckram or cardboard, covered with velvet or brocade, copiously ornamented with gold and jewels. Occasionally, as here, a white fluting faced it next to the hair. Usually the back of the hair was covered with a cap like that worn with the kennel or smaller, but the front hair was always visible, parted in the middle and drawn down over the ears.

In both French and Flemish art may be seen examples of the headdress whose style is shown in fig. 13i, a piece of material laid upon the head and

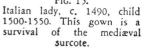

FIG. 14.
Italian girl, c. 1490-1500.
Her sleeves are fastened to
the armseye by brooches,
and her chemise puffs
through.

FIG. 13.
a, b, c, German, c. 1500 d, English,
c. 1530-40. e, Flemish, widow's
coif, c. 1500. f, German, c. 1500.

FIG. 15.
Italian lady, c. 1490, child
1500-1550. This gown is a
survival of the mediæval
surcote.

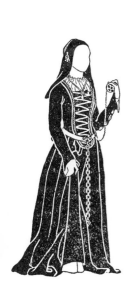

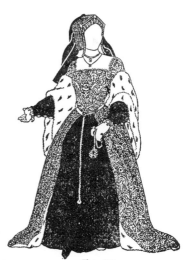

FIG. 17.
Flemish lady, c. 1480.
A transitional style.

FIG. 13.
g, Spanish, c. 1540-50. h,
French, hennin, 1450-1480. i,
Flemish, c. 1525. j, Italian,
before 1500. k, Kennel,
English, c. 1540. l, Flemish-
English, c. 1480-90.

FIG. 18.
English lady, 1525-1550. The full
fledged "Holbein" style. She wears
a kennel headdress.

hanging down the back. In this example it is worn over a close cap **with** turn-up lappets. Its simplest form has survived in *Italian* folk-dress.

The cap in fig. 21 belongs to the latter part of this period, and is one whose general style persisted for a century,—as a widow's bonnet it has returned to fashion more than once. It will be recognized as a version of the cap affected by Mary of Scotland.

Bodies. For a while, indeed up to 1485, the short-waisted dress with V-neck and wide belt (fig. 18, Chap. VII) was retained, but at the same time appeared another style, frequently found in Flemish pictures, which had a tight-fitting bodice generally laced up the front over an underdress. This was sometimes short-waisted, that is to the natural waistline, and sometimes joined to the skirt at the hips, with a deep U-shaped dip over the abdomen (fig. 17). A girdle of links or flexible woven or braided gold with a long front pendant was the typical finish for this bodice. At this time (*i. e.,* the period of Richard III and Henry VII) the skirt of the gown was not as a rule open over an underskirt, though it was long enough so that it might have to be lifted up to show such a skirt, and it frequently trained behind. The sleeve worn with this early dress was usually plain and close-fitting, as in the preceding mode, but sometimes it displayed the same tendencies observed in men's dress, being, as in fig. 17, slit up the back to show the chemise, or shortened to a half-sleeve above the long full sleeve of an underdress. The chemise showed at the arms-eye where the sleeve was tied in. Occasionally the wide-mouthed over-sleeve (fig. 20, Chap. V), typical of an earlier costume as well as of the dress worn later in this period, appeared with the long-waisted gown.

The transitional styles in Italy retained both long and short-waisted dresses. The lady in fig. 15 wears a gown cut like a fifteenth century surcote, worn over an underdress or *corset* laced in front over a chemise. Sleeves of another material are tied into the upper gown and display an early type of slashing. Fig. 14, a short-waisted gown, has no visible underdress. Its moderate sleeves, also tied into the bodice, proclaim it of an early style. The chemise shows at neck, armseye, and wrist. The little girl in fig. 15b is dressed in a style somewhat later than that of the lady.

After 1510 women's dress shared in general the trend of masculine styles, that is, toward a wide, square top and big sleeves and a wide lower silhouette.

The long V opening over a low-necked underdress developed by a natural transition into a square neck, a style very general by the time the bodice-and-skirt fashions were fully established. At the same time a wide round décolletage came into favor, especially in Italy. The sketches show some of the possible variations in the square neck. The one most often pictured by Holbein in England is that shown in figs. 18 and 19—a square wider at the lower corners than at the shoulder and arching upward over the bosom.

The chemise (the body-garment corresponding to the masculine shirt) was almost always visible at neck, sleeves, or both (figs. *passim*). Its importance

increased in the way described under MEN. The feminine décolletage was naturally lower than the masculine. A high-collared dress with the chemise-frill showing around the throat appeared in a feminine version about 1550 (fig. 21).

Arms. In Italy and frequently in France sleeves were voluminously puffed, especially at the top. In England, Germany, and the Netherlands they were set into the armseye comparatively tight, but from just above the elbow expanded, to narrow again into a wrist-fitting cuff (fig. 19). These sleeves usually appear to be part of the underdress (fig. 18), which shows also, very often, in the front of the skirt. The undersleeves were covered to the elbow by the wide sleeves of the upper gown, turned back to display a facing of rich brocade or fur. The middle-class dress sketched in fig. 20 has a gown with cap-sleeves, put on over a sleeveless underdress (black) which shows the full white chemise-sleeves.

Skirts. During the first twenty-five years of the sixteenth century the skirt of the gown was usually closed all around (fig. 17) even if the laced bodice revealed an underdress. Later, the reverse was more often the arrangement—the gown-skirt falling apart to expose the underdress or " petticoat," while the back-laced bodice fitted smoothly across the breast (fig. 18). Our sketches show that after about 1510 skirts of upper gowns were cut separate from bodices and attached at the waistline. The voluminous bell-shape was obtained not by hoops, but by a multiplication of heavy gathers or pleats, one skirt on top of another. Skirts of fine ladies were always long, the upper sometimes trailing in back (figs. 18 and 19). Even working-women wore skirts to the instep or floor, but kilted them up in various ways (figs. 20 and 22).

Outer Garments. Women's outdoor wraps were, as formerly, large cloaks, often hooded. The little shoulder cape sketched in fig. 21 is a part of the costume, not necessarily intended for outdoor wear. It continued into the next period.

PEASANTS

Working-women wore the simple " cote " or dress of an earlier period, with long scant sleeves which they turned back for work, showing the chemise sleeves. The bodice was laced over the chemise. Fig. 22 shows a slightly more dressy arrangement of a V-shaped piece or " stomacher" inserted between lacing and chemise. A handkerchief or collar, white or dark, was occasionally placed around the neck in somewhat the fashion associated with later Puritans. A large white apron tied around the waist formed part of the costume, as did a linen bonnet. Outdoors, peasant women put hats on top of their bonnets —the old-style peaked hat, or some version of the wide straw sun-hat. Shoes were made in the prevailing mode. The clog shown in fig. 22 is an interesting form of the wooden shoe still an important part of peasant dress; this example is Flemish.

CHILDREN

As in earlier times, children's dress reproduced that of their elders. Yet in the charming child-portraits so frequent from this period on we see some attempt at simplifying the contemporary grandeur to childish comfort. Fig. 16 (its source is a Christ Child by Pinturricchio) shows the little chemise, prettily embroidered, in which we hope any child might have been allowed to play in the nursery. In northern countries, little tight bonnets seemed necessary for infants and continued to be worn by girl-children (fig. 15) until they assumed more formal coifs, a promotion which, apparently, happened at about the age of ten. Little boys discarded the bonnet after babyhood. A Holbein portrait of the Prince of Wales (afterwards Edward VI) at about the age of two shows him wearing the close bonnet or coif tied under his chin. On top of it is a flat cap with a feather, exactly of the style worn by his father. A later picture, made when he was six or seven, shows him with hair cropped above his ears and straight across his forehead and a very plain flat-cap, like the cap in fig. 10, Chap. IX.

MATERIAL

Rich, heavy silks, metallic cloths, satins, taffetas, and particularly velvets, dressed the grand folk. During the Renaissance brocaded, pressed, and cut velvets were fashionable. Various thin silks, such as chiffons, crêpes, and stiffened gauzes were employed for scarves, veils, and parts of coiffures. Wide-meshed nets of silk or metallic thread were used for the cauls so popular in Italy (figs. 14 and 15).

Woolens were employed about as they had been in the middle ages (p. 116). Fine cloth was esteemed for gentlefolk's apparel; coarser homespuns must content the lower classes. Countryfolk wore materials locally woven and dyed, the colors therefore limited to those procurable from native vegetable and mineral sources.

Linen and cotton (less common) included most of the varieties with which we are familiar.

COLOR

This is a period of strong, often dark, colors. Black velvet was a constantly recurring element of costume, appearing especially in headdresses, under-sleeves, and underskirts. White linen furnished another almost certain accent in women's coifs and men's and women's neck-and-wrist ruffles. Red, deep blue, wine-color, gold brocade were all fashionable. It is recorded that when Catherine of Aragon died, Henry had the bad taste to dress himself entirely in yellow to celebrate the occasion.

MOTIFS

The Renaissance motifs first used in the fifteenth century dominated the decorative scheme of the sixteenth. While rich unpatterned fabrics made a part

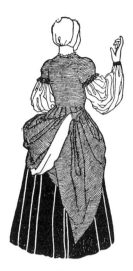

FIG. 20.
Flemish burgher's wife,
1525-50, wearing
chemise, sleeveless
under-dress, and gown
with cap-sleeves.

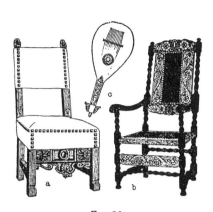

FIG. 23
a, Chair about 1500. b, Chair
somewhat later. c, Lute.

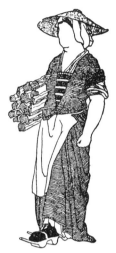

FIG 22.
Flemish peasant
woman, 1525-1550.
Note her wooden
clogs.

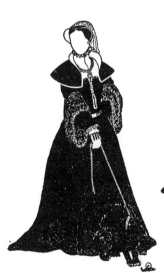

FIG. 21.
Flemish bourgeoise, 1550. Her
cap and collar are in transition
toward Elizabethan modes.

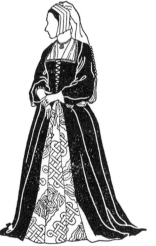

FIG. 19.
English lady, 1530-50. Her
coif is a linen version of
the "kennel" of fig. 18.

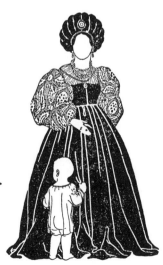

FIG. 16.
Italian lady, 1500-1550.

of almost any costume, patterned textiles were combined with them. There is no rule, large areas were plain, with smaller sections, like collar, stomacher, or undersleeve patterned, or the reverse. Fabrics of different patterns were also included in one costume. Upon a large-patterned fabric was applied design in passementerie, narrow braid, or gold galloon, in borders, latticework, or stripes. However applied, design might be either abstract (often interlaced or " strap-work ") or a conventionalized flower, fruit, or leaf-form. The pineapple (figs. 12 and 18), the rose (fig. 19), the pomegranate (fig. 4), the leaf (fig. 2) are a few of the many motifs. Personal emblems, used singly or in an all-over arrangement like the floral motifs, included the well-known crowned salamander of François I and initial letters or interlaced monograms, such as the HR–AB with which Henry adorned his possessions during the ascendency of Anne Boleyn (and changed to other initials for subsequent wives). Large heraldic blazonry was now restricted to military tabards (or those worn by heralds), servants' liveries, pennants, banners, and wall-hangings.

APPLICATION OF DECORATION

Slashing predominated in decoration. The slashes might be long, e. g., from shoulder to elbow (a style begun early in the fifteenth century), shorter and crosswise, as shown in the sleeves of figs. 2 and 15, or small and all-over or arranged in groups (a style increasingly popular toward the mid-century: figs. 4, 5, 10). The doublet was the garment most often slashed, on its body and sleeves. Theoretically, the shirt showed through the slashes, but probably, with the many small incisions, puffs of contrasting material were sewed into the openings. Especially in German styles, hose also were elaborately slashed and puffed (figs. 5 and 10). Not only the upper but also the netherstocks were so ornamented, occasionally below as well as above the knee. One pair of legs could display slashings up-and-down and across, short and long. While the incisions might be merely stitched back (if the garment were of leather, not even that was necessary), in more sumptuous apparel each slash was edged with silk or metallic braid and even beaded with jewels. Imagination ran riot to the limit of the pocketbook.

A type of trimming allied to slashing in its effect was the appliquéing of material on other material. Such appliquéd pieces were edged with trimming, as if they were slashes. The long perpendicular stripes on upperstocks and sleeves (fig. 7) or on the whole front of a lady's bodice were managed thus. " Bridges " which held long slashes together and " points," which tied sleeves into " bodies " and hose to doublets (fig. 2), have been mentioned above. The metallic tips on " points " were like the tips on modern shoe-laces, except that they were often graceful examples of the metalworker's art.

Large areas of trimming, such as collars and cuffs, were of satin, velvet, or fur (figs. 3, 6, 7, 18, 21). Of the furs, ermine held its own for formal wear by royalty; gray squirrel yielded a little in favor to marten and sable; less

sumptuous furs, mentioned in earlier chapters (pp. 142 and 170) contented the lower orders.

JEWELRY

Jewels, especially pearls, were strewn upon garments; included in all-over designs, in the braids which edged necklines, cuffs, slashings, and head-dresses; arranged as trimming on hats; even included in shoe-decoration (figs. *passim*). Though sometimes the pearls may have been false, records attest that real pearls as well as gems were employed in astonishing profusion.

Men wore as accessory jewels: hat-brooches, sleeve-brooches, drop earrings (fig. 5), rings (on every finger, the thumb, and first joints of fingers), and chains. Often such chains were the collars of orders such as the Fleece (fig. 19, Chap. VII), the Rose on the collar of S (fig. 6), and the "George" (fig. 4). Girdles were frequently fashioned of gold and jewels, and the sheaths and hilts of daggers were set with gems.

Women's jewelry included: earrings if the style of headdress permitted (fig. 16), jewelled circlets, or a single pendant jewel on a ribbon in the middle of the forehead (fig. 15), jewelled frontlets to the kennel or crescent head-dress (figs. 13k and 18), brooches, necklaces both long and short, sometimes two or three at a time (figs. 14 and 16), and rings. Pendants in the shapes of medallions or crosses were hung from either long or short chains. With any of the dresses described above ladies wore, at will, gold-linked and jewelled girdles (figs. 17 and 18). From such girdles dangled various acces-sories in silver or gold: keys, needle-cases, scissors, pomanders (fig. 18), or rosaries.

ACCESSORIES

Men wore daggers, sometimes, as in the middle ages, thrust through a strap on the purse, more often hung on a chain at the girdle (fig. 4). After about 1510 dress-swords began to be worn. These were lighter than those used with armor. Hilts were at first cruciform, but after about 1520 often had a guard curved from hilt to pommel, called "knuckle bow" (figs. 5, 7, 10).

Purses (still worn at the girdle) did not differ materially from those of earlier times (fig. 2). Like other articles, they were elaborately decorated for the use of fine folk. Men carried canes, fairly tall sticks with knobs. Gloves, sometimes worn, more often carried, by both men and women, introduced the prevalent slashing, through which rings were visible (fig. 19). Gloves for falconry remained as in previous centuries (fig. 2, Chap. VI); other gloves had variously decorated gauntlets or cuffs and embroidered backs (figs. 7 and 21).

Musical instruments illustrated in Chap. VII continued in use, and others, like the pipe and tabor (fig. 15f, Chap. IX), were already familiar in Henry VIII's time. The lute (fig. 23c) was a favorite instrument for accompanying the voice.

SOMETHING ABOUT THE SETTING

In Italy, palace interiors were decorated with fresco-painted walls and ceilings, marble floors in patterns, statuary recovered from antiquity or made by great contemporary artists, rugs and hangings from the Orient, tapestries made after the designs of artists, and massive gold and silver plate designed by goldsmith-artists. The shape of columns, door- and window-frames, and details of their decoration showed the influence of the ancients, but included opulent details foreign to the Greek ideal. Furniture, made of oak, was square, massive, heavily carved. Chair-backs and seats were upholstered in leather (carved or pressed and gilded), as well as satin or velvet (fig. 23). Beds were canopied and often placed on raised platforms.

In France an Italian influence combined with the last of the Gothic to produce the style seen in the châteaux of Fontainebleau, Blois, Amboise, and others. High-pitched roofs with clustering chimneys recalled the Gothic, as did enormous and elaborate fireplaces with projecting hoods. Townhouses of the bourgeoisie in the rich merchant cities of Germany and the Netherlands were built with the characteristic " step-roofs."

English interior decoration showed particularly the depressed Gothic arch known as the "Tudor arch," on window- and door-frames as well as on panels. English oak furniture preserved more Gothic details than did Italian. As in the South, rich and colorful hangings contributed greatly to the luxury of living.

PRACTICAL REPRODUCTION

Materials. Fortunately, upholstery and window-draping materials are still made in Renaissance designs and in many colors appropriate for these costumes. Their stiffness, too, makes them appear more authentic than ordinary dress-materials. Shop first in the upholstery department for your grandest costumes. Next look for velveteens, either among the upholsteries or the dress-goods; if velveteen is beyond your budget, buy corduroy. Look at all the rayon weaves, both in upholstery and dress-materials; shiny satins, taffetas, and brocades are all appropriate. Try among lining-materials for brocaded patterns in rayon or sateen.

Cheaper, and yet effective, is sateen stencilled in an all-over pattern (Chap. XX). Even unbleached muslin, dyed and stencilled, produces a good effect. Dashes of gold paint in the stencil give a rich glint and do not stiffen the material unduly. Occasionally you may find cretonne in appropriate patterns. Use this for showy, not modest, costumes. Combine it, not with shiny rayon, but with corduroy, flannelette, velveteen, fur or fur fabric, cotton rep, or any woolen material. Touch it with gold paint and sew pearls on it as you wish.

Dress characters not supposed to be of the court or the wealthy merchant-class in flannelette, dyed, rough-dry muslin, and burlap, denim, khaki, or cotton rep.

Gold and silver lamé braid (obtained at small cost from theatrical supply houses, Chap. XX) is showy in the lavish trimming described above. It is, however, rather difficult to sew on, crumples easily, and frays badly; hence it is not satisfactory for permanent costumes. Gold soutache or wider gold braid bought in the trimming department, or the gold braids and edgings ("gimp") used in lamp-shade making are more durable and not much more expensive. If you are hurried and if the costume is not planned to go into a permanent wardrobe, save time and money by decorating with gold paint. Trim with fur wherever you are able to.

For methods of making accessories and jewelry, see Chap. XX. Since "cut" gems are now appropriate, you may buy diamonds, rubies, emeralds, and sapphires at the ten-cent store and use them in your ornaments. To make a pomander, see p. 174.

Millinery. For making millinery in general, see Chap. XX. You can utilize a modern beret as a basis for a number of the masculine caps. Make the stiff flat-cap by reblocking an old felt hat or by cutting a crown and brim from felt. Make the velvet hats with a circular crown shirred on to a crinoline under-cap, and a round brim stiffened with buckram interlining. Patterns for several caps of this type may be found among the millinery designs in standard pattern books. Old hats can frequently be utilized with but little change.

Make the crescent headdress on a framework of wire, with muslin stretched over it and painted, or of buckram, cut and sewed in the right shape and covered with fabric. Use the same type of inner structure for the kennel. It should be about an inch thick, made to fit about four inches back on the head, and covered with velvet or brocade, long tabs of which, doubled but not stiffened, hang down at the sides and are pinned back on the kennel. Under the kennel, a scarf should be wrapped turban-wise around the head. Attach the bag-cap to the back of the kennel.

Make the white coifs of large pieces of doubled tarlatan or starched batiste. For a foundation use a close white cap with a chin-strap. Sew the middle of the stiff stuff to the crown of the cap and, on the model's own head or on the head-block, arrange the folds according to your design and tack to the bonnet. Make the dome-shaped caps of buckram, cut and shaped upon the head-block and covered as you desire. For the large-netted cauls, buy sash-curtain net in the coarsest mesh, dye or gild it, edge it with milliner's wire, bend to the required shape, and sew pearl beads in the intersections.

Shoes. Make men's shoes from felt bedroom slippers, cutting small slits over the toes and filling with colored puffings; or sew on a new felt front, as splay-footed as you please. For making the soft boots see Chap. XX and p. 175. Women can wear any flat-heeled slippers, ballet-slippers, even "re-hearsal sandals," since feet are usually but little seen. If shoes are to be featured, use felt, satin, or quilted slippers, and sew decorations on them. *Do not let your actresses wear heels.* For making armor, consult Chap. XX. Get out of using it if you can, or make excuses for showing warriors in only

part armor, such as the body-part or the helmet, which can be managed very satisfactorily.

CUTTING THE GARMENTS

Men. Unless there is some reason to show the undergarments, they may be simulated, the only complete articles being the hose, jerkin, and gown. You may set sleeves double into the jerkin armseye, or arrange an upper half to overlap the lower, like two sleeves; sew pieces of white in full puffs under slashes to represent the shirt, whose appearance at wrists and neck need take the form only of ruffles or gathered tucker. Set a V-shaped piece in front of the jerkin to stand for the doublet. Preferably use tights to represent the hose, even if they are supposed to be netherstocks only; they stay up better, especially if they are held up from the shoulder with suspenders. If the jerkin is skirted, there need not necessarily be any upperstocks. When upperstocks are a feature of the costume, cut them from either a pattern for shorts or one for knee-breeches (" George Washington " or " Continental " pattern), adapting it to your design. To represent the slashing of hose, appliqué on them puckers of material edged with braid. Slashes made in leather or felt garments need only to be edged with gold paint. For stage use the cod-piece is frequently omitted.

Cut the body of the doublet or jerkin by the actor's own vest, the waistcoat of the " George Washington " pattern, or the doublet of a " Mephistopheles " or " devil " pattern. To enlarge any sleeve, divide the pattern down the exact middle and add as much fullness as needed at that point. Distribute the gathers along the top of the arm, in the usual way. Although you may buy good puffed-sleeve patterns (among the women's patterns), even these are not full enough, for you will need from one to three yards at the top of any of these sleeves. Cut the jerkin skirts circular, gored, or in straight lengths gathered or pleated to the body.

Use a nightshirt pattern for the scanter type of gown, adding ·gores at the side: or a " domino " pattern. For the full pleated gown, short or long, use the pattern for a smock with yoke. Allow about half again as much fullness across both front and back. The effect will be like an academic gown.

Women. Either a fitted lining or the bodice of the " Martha Washington " or " Colonial " costume (Chap. XX) is the foundation pattern for these bodice dresses. Cut it long- or short-waisted according to your design, and set on a skirt. For the early or " transition " type of dress, make a gored skirt (add extra gores if you use a modern pattern), but for all the other styles, make a straight skirt, gathered or pleated onto a waistband and attached to the bodice. Open the bodice up in front or back according to your design. You may suggest the underdress with a V in the front of the bodice, a false front on the underpetticoat, or double sleeves. However, if the underdress shows in all these places and if the gown is to have the tight upper sleeves of figs. 18, 19, and 21 you had better make a whole underdress of lining-muslin. Set in elbow sleeves

of muslin and add the large sleeves from there to the wrist. Put a width or more of good material in the front of the underdress, if the overskirt is open.

Do not actually tie in the attached sleeves, but sew them in and add the " points " or jewelled brooches as trimming. Make the large oversleeves of figs. 18 and 21 on the general plan of the sleeve in fig. 20, Chap. V, using the sleeve-pattern that fits your bodice to cut the upper part and making the large lower portion as long and wide as you need it. Face, turn back, and tack to the upper part of the sleeve.

In general, the thing to remember in making both masculine and feminine costumes for this period is that they must look voluminous and heavy. Make all the body-garments on a lining of the heaviest sheeting or even scenery-muslin and interline the full sleeves with muslin, tailor's canvas, or crinoline. Interline the doubled material in the hanging sleeves. Unless you are using firm material like rep or velveteen, line the skirts of jerkins and gowns likewise. Rayon satin especially needs to be lined in order to look heavy enough.

For every skirt provide a petticoat of heavy muslin, straight widths (unless worn with a gored skirt) and at least eight yards around (with gathered skirts). The outside skirt should be ten yards around if it is sateen or rayon satin, and even in heavier materials that much may well be used. It will be very full over the hips, the bodice will be very tight-fitting and the waist will, consequently, look small. Bone the bodice in front, under the arms, and a short way up the back seams.

Suggested Reading List

Manuel d'Archæologie (tome III, le Costume)—By Camille Enlart.
 This is the last period covered by this thorough book.

Scenes and Characters of the Middle Ages—By E. L. Cutts.
 The last period covered by this book also. Especially useful for pictures and quoted contemporary descriptions of armed men, chivalric combat, and musicians.

Historic Costume
A Short History of Costume and Armour } By Francis M. Kelly and Randolph Schwabe.
 Two very excellent books, covering their field (in England particularly) from 1066 to 1800. Copiously illustrated with reproductions (some colored) of contemporary pictures and line-drawings of many more.

History of Fashion in France—By Challamel (trans.)

Histoire du Costume en France—By Quicherat (in French).
 Both good references for French costume.

Costume Ancien et Moderne—By Cesare Vecellio.
 (In the original Italian and also in a French text.) This was a Renaissance book about costume, and while it is not reliable for earlier periods, it is a good reference for contemporary dress.

Where Further Illustrative Material May Be Found

There is a wealth of material by whose help we can reconstruct this sumptuous period. Renaissance painters executed many portraits and also, like the earlier artists, dressed

the characters in their Biblical or legendary pictures in contemporary styles. Thus the figures in Carpaccio's " Legend of St. Ursula " and some of those in Ghirlandaio's " Birth of the Virgin " are veritable fashion plates. You cannot, to be sure, rely on all pictures, or all the figures in a picture, for a literal transcription of the modes. Certain religious figures had costumes fixed by convention; Biblical characters were often represented in pseudo-oriental garb which is not realistic for any time or place; most of Botticelli's ethereal beings (except those in portraits) are in " fancy dress " ; and the few authentic creations of Leonardo da Vinci are costumed in an artistic simplification of the mode.

Italian pictures, then, when they are portraits or can be recognized as realistic, are good references, not only for the cut of garments, but for details of textiles, colors, trimming, and jewelry. German painting is even better, since it went in for detail with rather painful meticulousness. French painting, being largely portraiture, is reliable. The Netherland painters combined photographic accuracy with good technique. They have left us story pictures crowded with actors of all classes in contemporary dress, as well as many professed portraits. Pieter Breughel, painting toward the middle of the sixteenth century, made a specialty of peasant scenes. Holbein is, of course, the most important chronicler of upper-class English dress and manners in the early days of the Reformation.

Manuscript miniatures, particularly Flemish, afford accurate information, and to that form of illustration there can now be added wood-cuts and engravings for the new printed books. Statuary, especially funeral effigies, and English memorial brasses, represent the dress of their subjects with minute detail.

Contemporary literature which adds to our knowledge of dress as well as other details of splendid living includes: stories, morality plays, and descriptions of such gorgeous pageantry as the meeting of Henry VIII and François I on the Field of the Cloth of Gold.

Sources of Sketches in This Chapter

The various sources enumerated above have been freely drawn upon for the sketches in this chapter, though in no instance have we copied any single picture.

Either at first hand or in reproduction we have studied pictures in the collections of: The National Gallery, National Portrait Gallery, Hampton Court, The Ashmolean Museum, Windsor Palace, The Louvre, the Pitti Palace, the Uffizi Gallery, the Metropolitan Museum, the Chicago Art Institute, the Detroit Institute of Art, and various private collections. In particular detail and at first hand we have studied some Flemish tapestries (c. 1525) and the sixteenth century armor in the Metropolitan Museum. The manuscripts consulted (in reproduction) were from the British Museum collection.

Enlart, op. cit. (figs. 96, 98, 250), and Cutts, op. cit. (figs. on pp. 454, 457 and 459), have furnished us with copies of original pictures from which we have drawn many details.

Chapter IX

ELIZABETHAN

Some Important Events and Names

ENGLAND	FRANCE	SPAIN	HOLLAND	ITALY	AMERICA
Edward VI, r. 1547–1553	Henri II, r. 1547–1559 (Married Catherine de Medici)		William the Silent, d. 1584.	The Catholic Counter-Reformation, from 1545	Jamestown, 1607
Mary, r. 1553–1558	(Mistress, Diane de Poitiers)	Philip II, r. 1556–1598 (Married Mary of England)	The struggles for independence from Spain	PAINTERS Bronzino, 1502–1572	Landing of the Pilgrims, 1620
Elizabeth I, r. 1558–1603	François II, r. 1559–1560 (Married Mary of Scotland)		PAINTER Marcus Gheeraerts, 1561–1635	Moroni, 1525–1578 Tintoretto, 1518–1594	Pocahontas, during the reign of James I
Execution of Mary Stuart, 1587	Charles IX, r. 1560–1574	Philip III, r. 1598–1621 The Religious Persecutions		Veronese, 1528–1588 Caravaggio, 1565–1609	
Destruction of the Spanish Armada, 1588	(Massacre of St. Bartholomew's Eve, 1572)	PAINTER El Greco, 1548–1614		Guido Reni, 1575–1642	
James I, (Stuart) r. 1603–1625	Henri III, r. 1574–1589		ENGLAND (*Continued*)		
MARINERS Francis Drake, 1540–1596	Henri IV, of Navarre, 1589–1610 (Married Marguerite of Valois)		DRAMATISTS Thomas Kyd, 1558–1594		
Humphrey Gilbert, 1539–1583			Christopher Marlowe, 1564–1593		
John Hawkins, 1532–1595	The Edict of Nantes, 1598		William Shakspere, 1564–1616		
Richard Grenville, 1541–1591					
Walter Raleigh, 1552–1618		Cervantes, 1547–1616 "Don Quixote"	Francis Beaumont, 1584–1616 John Fletcher, 1579–1625		
WRITERS Philip Sidney, 1554–1586			Ben Jonson, 1573(?)–1637		
Francis Bacon, 1561–1626					

Some Plays to Be Costumed in the Period

"Gammer Gurton's Needle," William Stevenson, first acted at Christ's College, Cambridge, soon after 1550.

Kyd's "Spanish Tragedy."

SHAKSPERE

All of the Shakspere plays may be costumed in the English fashions contemporaneous with their writing. Some directors, convinced that the spirit of all the plays is Elizabethan, dress even "Julius Cæsar," "A Midsummer Night's Dream" and the historical plays thus. However, the plays which are by common consent costumed in "Elizabethan" style are:

"Twelfth Night" (excepting Viola, Sebastian, and the Sailors, traditionally dressed rather like modern Greek peasants)

"Much Ado About Nothing"

"Love's Labour's Lost"

"The Taming of the Shrew"

The plays which have Italian plots are often costumed in the Renaissance styles described in Chap. VIII, or in the Italian versions of late sixteenth century modes, but they, also, may be thoroughly English in appearance:

"Two Gentlemen of Verona"

"Romeo and Juliet"

"The Merchant of Venice"

"All's Well That Ends Well"

"Measure for Measure"

"Othello"

"As You Like It" should be dressed in contemporary English (or French) fashions.

PLAYS OF OTHER ELIZABETHAN DRAMATISTS

Ben Jonson's "Silent Woman," "Volpone," "Every Man in His Humour."

Beaumont and Fletcher's "The Knight of the Burning Pestle."

PLAYS DEALING WITH PEOPLE AND EVENTS OF ELIZABETH'S AND JAMES'S REIGNS, SUCH AS:

Shaw's "The Dark Lady of the Sonnets."

Clemence Dane's "Will Shakspere."

Maxwell Anderson's "Elizabeth the Queen" and "Mary of Scotland."

Eugene O'Neill's "The Fountain" (about Ponce de Leon).

ELIZABETHAN

To us of the English literary inheritance, the years after the death of Henry VIII and through the reign of James I are principally identified with that remarkable woman, Elizabeth Tudor. Her predecessors, the boy Edward (whose councilors made his short reign a continuation of his father's) and Mary (who attempted to turn back the religious clock and restore England to the spiritual control of Rome) and her successor, the Scottish James, are overshadowed by her personality and the great events of her reign. Under her England expanded from an island appendage of Europe into a maritime power to be reckoned with. Under her occurred the first step in the transference of authority in the New World from Spaniards to Englishmen: the defeat of the Invincible Armada by the God of Storms and the Mariners of England. This victory resulted in an upflaming of patriotic zeal and of fidelity to Elizabeth as the personification of England.

It was in the second half of the sixteenth century and the first years of the seventeenth that England experienced the full tide of the Renaissance. English genius expressed itself middling well in painting, sculpture, and architecture, but gloriously in literature, and very brilliantly in vocal music.

Italy was already in the ebb of her Renaissance; under the rule of petty princes (after the Peace of Augsburg in 1555) Germany sat uncreative; France was torn by religious wars and dynastic changes; Spain was wasting her energy in the fanaticism of the Inquisition; and Holland still writhed under the heel of Spain. England alone had the happy experience of uniting religious freedom (at least for the majority) with national solidarity and youthful exuberance.

At this point in our history, America enters. The costume of American aborigines is outside the province of this book. For the rest we must remind ourselves that among the adventurers and pioneers, Spanish, French, Dutch, and English, were men of all ranks, from gentlemen to indentured servants, from grave and beruffed crown governors to tough old soldiers and sea dogs, adventurers all. There were women among the Pilgrims who came to New England in 1620 and a few women joined the Virginia settlement during the first quarter of the seventeenth century. While James I reigned, our native princess, Pocahontas, "The Lady Rebekah," with her husband, John Rolfe, visited the English court, dressed in gowns suitable to such an appearance.

In England and on the continent the middle classes (merchants, tradesmen,

artisans, and farmers) were independent, self-respecting, and had a voice in affairs. They figure importantly in contemporary literature, including drama.

GENERAL CHARACTERISTICS OF COSTUME

Sumptuous materials, plain-colored and brocaded, continued throughout this period, and the exuberant use of jewels increased, real gems and pearls being worked into the all-over designs upon doublets, sleeves, and skirts as well as upon girdles, sword-belts, and other accessories. The square silhouette acquired by massing in gathers huge quantities of heavy material, was gradually superseded by one much slenderer, in which the natural figure was masked by smooth upholstery. Long waists, long legs, small long heads were the ideal. Width at the hips threw into greater contrast small waists. Ruffs and other elaborate neck-ornaments increased in size and intricacy during the first quarter of the seventeenth century, and lace, as the most admired material for them, assumed more and more importance.

It is English costume primarily that this chapter will consider, but the Elizabethans had eclectic tastes. Moreover, court dress in different countries was more cosmopolitan than during the previous period. The Italians dressed most gracefully: the slim black elegance of Venetian gentlemen was outstanding among other men's gaudy apparel; Spaniards developed a stiff and forbidding grandeur which English, French, and Dutch tried to imitate, especially the women, who caged themselves in Spanish hoops over a period of seventy-five years. Though certainly not a graceful costume period, the Elizabethan *has* style, " chic," and a distinct charm when, nowadays, we reproduce it upon the stage.

MEN

Heads. As a rule hair was short, though there was more latitude in that detail than there is now, for in the beginning of the period some older men continued to wear the longer locks of Henry's reign; during the latter years of James some dandies had already adopted the typical seventeenth century curls; and throughout the period a fop would sometimes be seen sporting ringlets, or perhaps, after 1600, a single love-lock over the shoulder. For most men the hair was cut very much as it is now, though not trimmed so close, especially in back. It was brushed up from the forehead without a part (fig. 4) and was sometimes trained into a roll or curl away from the brow—a womanish effect (fig. 3).

Beards were very commonly worn even by young men. As a rule the beard was a small, neatly-trimmed point (figs. 2, 3, 5), but it was sometimes larger, whether square or pointed (figs. 1 and 6). Moustaches, small as a rule, accompanied beards. During the entire period there were always some smooth-shaven faces.

Hats. The flat-topped, beret style of cap, still worn by courtiers in the reign of Edward (fig. 8), went out of court fashions about 1565, when it was rele-

gated to the use of the middle classes from merchants to apprentices and servants (figs. 9 and 10) and known as the " city flat-cap." It was made of felt or knitted from black woolen yarn. Elderly scholars wore this type of cap, with earflaps (fig. 3, Chap. VIII), and so did the clergy. The close bonnet or coif mentioned in previous chapters was also a scholar's head-covering, worn alone or with the flat-cap. An embroidered dome-shaped cap was worn somewhat informally by men (fig. 6), women, and children.

The first hat to come into favor had a narrow but stiff brim and a gathered crown which, in this fashion, was set rather high on the head at a jaunty angle (fig. 5); its height increased with the years. It was especially popular in Italy and Spain. It was trimmed with a band of metallic braid or braid and ribbon twisted together; with rosettes of gold and jewels; or with feathers (ostrich tip, osprey plume, or something stiffer) affixed by a brooch.

Hats made of stiff felt and beaver had narrow brims and low " stovepipe " crowns (fig. 1) or wider, swooping brims and higher crowns of the same type (fig. 2). A hat which came in toward the end of the century and continued into the reign of Charles had an even wider brim, like a sombrero, which was turned up according to taste (fig. 7). Different types of trimming are shown in the sketches. Under the Valois (i. e., up to 1590) French taste favored a hat with a small rolled brim and bulbous crown as much as eight inches high, with elaborate osprey and ostrich trimming riding even higher, straight up the front (fig. 3).

Velvet, as well as felt and beaver, was made into hats, the color being a matter of choice, though black was common.

As explained in Chap. VIII, hats completed an indoor as well as an outdoor costume and (except in the presence of royalty) were doffed less frequently than is our modern custom.

Necks. The shirt, whose importance was explained in Chap. VIII, was now often equipped with a collar in lieu of the earlier shirred heading. In various forms this turnover collar (" band " or " fall ") continued at the same time with the more pretentious, expensive, and uncomfortable ruff, and it survived the ruff's popularity. Figs. 7, 9, 10, 12 show versions of this collar, from the very narrow to the wide, lace-trimmed " falling band." A *double* collar of fine, stiff muslin is among the attractive variants of the mode. The collar was often worn by men of importance, and generally by simpler folk such as artisans, apprentices, clerks, small country clergy like Sir Oliver Martext, and minor town officials like Dogberry.

The ruff, that especially distinguishing feature of the period, appeared in many versions. Very narrow (fig. 5), it rose from the top of a high neckband; when it was left open in front or tied with tasselled strings (often invisible). Wider, it was separate from the shirt, had a band which slipped inside the collar of the doublet, and was fastened close all around (figs. 2, 3, 8, 11). Very wide, as it was worn by some people from about 1580 till the end of the starched ruff mode (about 1625), it stood out six and a half, seven, or even nine

inches from the neck (figs. 3 and 16c). The medium ruff (four inches wide) was as a rule rather thick (three inches) as shown in figs. 2, 6, 8, 11. The wide, thin ruff (fig. 3) was supported by an " underpropper " or " supportasso," a structure of wire, wood, or cardboard which rested on the shoulders like a yoke and rose up at the back of the neck. Those made of wood or cardboard were solid, shaped structures, covered with satin. The underpropper sketched (figs. 16b and c) had for model one made in the workshop from descriptions of Elizabethan structures. It is this type, made in a series of tabs, which some writers consider a " piccadil "—in itself a rather ornamental affair. Supported by such a structure, the ruff tipped up behind, forming a frame for the face. One more variation of the mode, pictured in two versions in figs. 1 and 26b, displayed several layers of ruffs, one upon another.

The material of ruffs was either fine linen, wide lace, or linen edged with lace (white, colored, metallic, or black for mourning), stiffly starched and set with fluting or " poking " irons. The size of the flutings varied greatly; edges were often held stiff and close like a honeycomb; equally often they made large open curves. The ruff was not always pleated into the neckband, being occasionally gathered on informally.

Starch was usually white, but there is record of ruffs starched in color: red, blue, purple, green, and yellow. Toward the end of James's reign people began to wear their ruffs unstarched, this style of " falling ruff " being a transition to the collars of the next period.

After 1610 appeared the fan-shaped, wired-out collar or " whisk," the nearest masculine approach to the wide, open collars worn by women (fig. 4).

Bodies. In a complete costume the presence of a shirt is revealed only by the collar and cuffs. The shirt was like that of the preceding period, a full blouse gathered on a shallow yoke or shirred into a neckband. It had very full sleeves gathered into armseye and cuff—much like the peasant shirts of today. Such a shirt (made of coarse linen, not fine cambric) would be revealed when (in " Love's Labour's Lost ") Costard takes off his doublet to fight with Don Armado, the impecunious Spanish gentleman who confesses to having no shirt under *his* doublet.

Next above the shirt a man often wore a waistcoat, an unstiffened jacket with or without sleeves. It was not visible except in informal half-dress. It is said that the Earl of Essex was executed in a scarlet waistcoat.

Over the shirt or waistcoat went the doublet, a jacket ordinarily opening up the front (though there are instances of back-openings). It had a standing neckband and, typically, a skirt or shaped peplum, though the latter was often lacking (figs. 1, 2, 3). The waistband came just above the hips and was pointed in front, a characteristic exaggerated during the last half of the period. Doublet sleeves were often detachable, and sometimes made of material different from the body. The " points " by which they were tied in to the armseye (p. 189) were seldom visible, for the whole shoulder-seam was covered by a " wing " or crescent-shaped roll (figs. *passim*).

The Italian doublet was a sensible enough garment, made of heavy material, to be sure, and interlined, but following the natural shape of the body (fig. 8). Some Italians adopted the stiff Northern style; on the other hand, plenty of German, Spanish, French, and English conservatives among the upper classes were of the Italian taste in doublets, and in any country working people, having to consider both comfort and economy, wore unstiffened garments. The typical doublet affected by the fashionable world outside Italy was stiffened and stuffed, making a man to conform, in defiance of nature, to the fashionable ideal—wasp-waisted, pigeon-breasted. It seems surprising that such valiant fighters as Sir Philip Sidney, Raleigh, Essex, and Drake should have fancied themselves in this effeminate mode, yet so they are portrayed. The height of absurdity was reached at the end of the century with the " peascod-bellied " doublets (fig. 3). Much greater exaggerations than our example are recorded, where the point of the doublet actually hooked down to the crotch. This absurd style is perpetuated in the traditional costume of Mr. Punch, whose beaked nose is repeated in the curve of his peascod.

The unnatural figure (figs. 2, 3, 4, 5) was produced by the aid of a stiff tight under-lining to pinch in the waist, buckram to make the protruding shape, and " bombast " (padding) to hold it out. During James's reign the more exaggerated shapes declined in favor.

The doublet was often worn alone or with a looser gown or a cape; with almost equal frequency it was covered by the jerkin, smoothly shaped to fit over it. Like the doublet, the jerkin could be either skirtless or skirted (figs. 1, 2, 7, 8). Sleeves, when it had them, were open, even hanging, and did not conceal the doublet sleeves. Wings and shoulder-rolls generally appeared on jerkins (figs. 2, 7, 8, 12). The jerkin could be fastened all the way up with ornamental buttons (figs. 1, 7 and 8), buttoned at the top only (fig. 2) or left entirely open. When long-skirted (a style that came in during James's reign), its identity merges with that of the gown (fig. 2). Jerkins of leather or " buff-jerkins " may be classified as " sports-jackets," for they were worn by huntsmen, soldiers, and sailors. They were laced up the front or under the arm (fig. 12).

Arms. Throughout the period sleeves were of a reasonable size. Conservative gentlefolk and the lower classes wore them no bigger than the modern coat-sleeve. Elizabethan sleeves, however, all tapered somewhat from gathered shoulder to slim wrist. Along with the exaggeratedly small waist appeared the leg-o'-mutton sleeve, which soon widened to large proportions, especially in French fashions. To obtain the smooth effect desired even in a puffed sleeve, it was held out with buckram or with whalebone frames, or it was " bombasted," *i. e.,* padded as one might a bed-quilt. One style more; this was sleeves arranged in puffs to the elbow or over (fig. 3). The hanging sleeve of the jerkin (fig. 2) is a survival of the mediæval bellows sleeve (fig. 5, Chap. VII). Variations in the sleeve roll or crescent may be remarked in the various sketches. Wrists were finished with white. As a rule, turned-back cuffs accompanied the turnover collar, ruffles (or separate wrist-ruffs) the neck-ruff (figs.

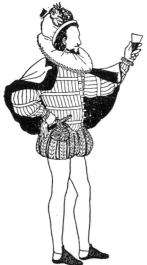

FIG. 3.
A Frenchman of the court of
the Valois, c. 1580-90, wear-
ing round hose and a peasecod-
bellied doublet.

FIG. 2.
Man (1600-1625) in
doublet with em-
b r o i d e r e d sleeves,
long-skirted jerkin,
heeled shoes.

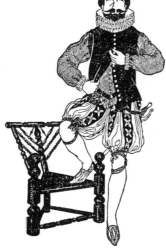

FIG. 1.
Man in doublet and jerkin,
triple ruff, "paned" upper
stocks and cross-garters.

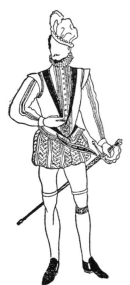

FIG. 5.
Gentleman, c. 1590-1605,
wearing "canions" and
the Garter of the Order.

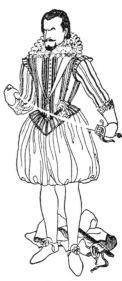

FIG. 4.
Gentleman, c. 1600-1625,
wearing a wired whisk and
small shoe-roses.

1, 3, 6, 11); but that was not invariably the case, and handsome, lace-trimmed cuffs from two to four inches wide could accompany any neck-finish (figs. 2, 5, 7).

Legs. Parti-colored hose went out of fashion. The division of hose into upper-and-nether stocks was complete, though the netherstocks were as long as the old-style long hose when they were worn with the very short French " round " or " melon " hose, for these were sometimes no longer than the trunks worn now by circus acrobats. Fig. 3 represents a conservative pair of French hose. The very short puffs were, however, frequently worn over another pair of upperstocks, called " canions," virtually tight knee-breeches (fig. 5). The lower edges of these were covered by the netherstocks or stockings, usually rolled above the knee and secured by garters. The gentleman in fig. 5 wears the garter of the Order, and is probably one of those who prided themselves on such good calves and well-fitting stockings that they needed no ribbons to insure unwrinkled hose. If he had not this confidence, he might wear elaborately fringed ribbons tied in large bows at the sides of his knees (fig. 8) or resort to the cross-gartering adopted by Malvolio (fig. 1). In this style, the ribbon, placed *below* the knee, is interlaced at the back, brought forward and knotted *above* the knee at front or side. Stockings, though sometimes still cut from cloth and carefully tailored, were very frequently knitted, occasionally of silk. In the second half of the period began the custom of embroidering them with clocks in silk or metallic thread.

To return to breeches: the melon-shaped trunk-hose varied in length from the shortest possible (figs. 3, 5, 11) to a length a little above the knee. They were padded out, sometimes to ridiculous proportions, and frequently " paned." This means that the upper material was cut in vertical bands, which were trimmed on the edges with braid; between the bands showed the padded lining (fig. 3). Another method of trimming in " panes " (which looks about the same) was to make the padded breeches, then trim them with vertical strips, caught in at the top and bottom (fig. 5). A German variant of this style had an inner part not stiff with padding, but very voluminous, which was allowed to hang in puffs between the vertical strips (fig. 1).

" Venetians " were longer breeches, fastened below the knee, with the stockings generally rolled over them. They varied from scant, like the breeches fashionable in the eighteenth century (fig. 8) to about the width of modern riding-breeches, and they were padded to a smooth pear-shape. Larger and unpadded, rather like modern knickerbockers, they appeared with many types of costume (figs. 2, 12, 25).

A long, extra-full type of " melon " or " trunk-hose " had a band above the knee and bloused over that band in a full puff to the knee or below (fig. 4). It had a great deal of fullness, and when made of velvet and unpadded, in the Italian style, looked almost like a skirt, or, more exactly, like the gymnasium bloomers formerly worn by girls. Any large, unpadded breeches may be classified as " slops."

There were two kinds of breeches loose at the knee. One variety can perhaps be identified as "galligaskins" : breeches almost as wide as those shown in fig. 4 but loose and flapping over the knee; they were favorites with sailors. The other type was scanter and stiffer, like a loose and clumsy version of modern trousers cut off above the knee, or like the " short pants " that little boys wore in the 1890's and early 1900's (fig. 7).

Feet. Up to 1600 shoes remained heelless, but the soles were often very thick, sometimes decreasing in thickness from heel to toe, so as to throw the foot forward as with actual heels (fig. 7). After 1600 veritable heels were introduced and immediately became popular (figs. 2 and 5). They were not very high (no higher than the modern masculine heel) and were often painted red. A medium round toe prevailed till the end of James's reign, when it began to be squared off a little (fig. 5). The shoe came up well over the instep (like a modern house slipper) but was sometimes cut out deeply at the sides (figs. 4 and 5). In the earlier years especially it often slipped on without fastenings, again like a house slipper (figs. 1, 7, 8, 9). Another shoe, increasingly popular, was fastened over the instep. At first it was secured by a simple thong or ribbon, the latchet (fig. 2), a method of fastening retained well through the seventeenth century. It was only at the end of the period that the fad for " roses," *i. e.,* large puffs of ribbon (fig. 4) came in. Shoes were made of leather, velvet, and satin, often in light colors. Fig. 1 shows how the style for slashed shoes persisted into this period.

Boots hugged the calf, but were loose enough from below the knee to turn over and up again, as in fig. 12. Often they remained up, reaching high on the upper leg and held there by means of straps fastened to the doublet (somewhat in the manner of the earlier hose attached to the doublet). For ordinary use boots were russet or black; for dress-display they were made in pale gray or even white and handsomely decorated with punch-work.

Fig. 3 illustrates a pair of *pantofles* or mules, put on to protect fine shoes from the dirt. Mules were also worn for bedroom slippers, as nowadays.

Outer Garments. Though gentlemen appeared frequently without anything over the doublet (figs. 4 and 5), a complete costume consisted of doublet and hose with another garment above. The jerkin described earlier was such a garment. Another was the "mandillion," affected somewhat more by military men than by courtiers. Fig. 16a shows a mandillion which is unseamed under the arms and put on over the head, so that its shape is not unlike the military tabard described on p. 163. Mandillions could open up the front instead, but unlike the jerkin they were all loose from the body and generally rather stiffly interlined and heavily braided.

The open jerkin with hanging sleeves and knee-length skirts (fig. 2), differed little from the short gown, since that also sometimes fitted the body snugly. Another short gown, like that shown in fig. 7, Chap. VIII, though not so full, was in favor with young fashionables early in the period, but by the time Shakspere's plays were produced it had gone out of style. Made of unpre-

tentious, dark material, it was still worn by poor curates and impecunious scholars like Holofernes in " Love's Labour's Lost." The long gown, however, was the garb of more important scholars, of statesmen, solid " city " merchants, and the like. The gown might be, as in the earlier fashion, gathered full on a yoke, or cut with a close-fitting body and skirt in one, like the fitted coats worn by modern women. It hung to the floor or at least the ankle. Its sleeves were generally long and open, either all the way from the shoulder, as in fig. 6, or with a short sleeve-cap and a hanging lower part. The square collar with revers, so popular in the last period, was retained, especially with the gown which remained open down the front. With a collar hidden by the ruff, it often was fastened only at the throat, to fall apart from there down (fig. 6); or it was fastened as far as the waist by means of hooks or frogs. Occasionally it was drawn in at the waist by a narrow belt. Wings or rolls finished the shoulders of this as of other garments.

Capes were both long and short, both draped and stiff. Some had armholes, some even hanging sleeves. The smartest cape, that worn with a wide-sleeved doublet and short French hose or slender Venetians, was not more than hip-length (fig. 3). As in this sketch, such capes were often collarless, to be worn with a wide ruff. Yet a stiff, high-rolling collar was a favorite feature of the short cape, another neck-finish being a cowl, rather like an academic hood. There were various ways of wearing capes, the short, stiff version either straight across the shoulders or diagonally across the back, the large, soft kind in any way to suit the wearer.

Related to the gown was the plain " coat " worn by servants and the pensioners of various institutions; it was put on over a close doublet and scant hose. It had a neatly-fitting body joined to a straight gathered or pleated skirt which reached to the calf and fell open in front. The coat was fastened from neck to waist by pewter buttons. At neck and wrists were modest bands of white linen. A leather belt encircled the waist. With this costume was worn the flat-cap (fig. 10). As a rule the coat was blue, bright or dark, so that the men and boys who wore them were often called " blue-coats." Orange-yellow stockings and plain black shoes completed the costume. Such liveries were made also in other colors, such as gray, and the stockings, too, could be of different colors. Upon the sleeve of the blue-coat or upon a doublet-sleeve (fig. 9) a servant wore his master's device. The chevrons and company emblems upon modern military uniforms are a survival of this custom. Boys at Christ's Hospital and other endowed schools in England still wear the blue-coat uniform, unchanged save for slight later innovations in neckwear and shoes.

SOLDIERS

Plate composed the armor of this, as of the previous period (fig. 11). The decoration on such a suit as that sketched was often very fine, of gold and enamel inlaid on the steel. Real " practicable " armor, worn by the heroes of England's sea and land victories, was not necessarily so complete or cumber-

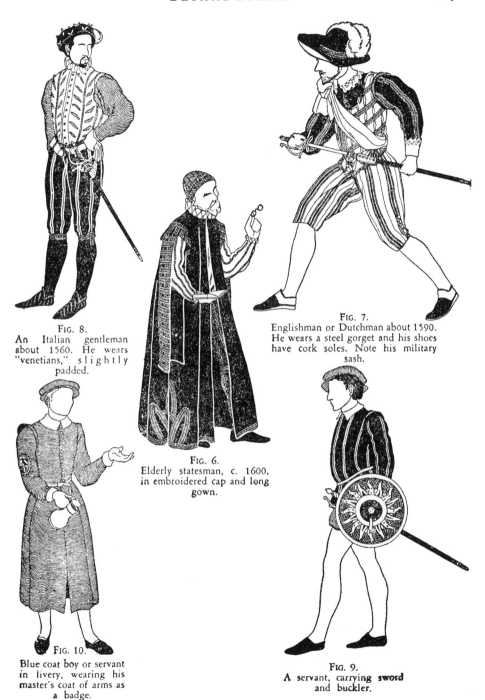

FIG. 8.
An Italian gentleman
about 1560. He wears
"venetians," slightly
padded.

FIG. 7.
Englishman or Dutchman about 1590.
He wears a steel gorget and his shoes
have cork soles. Note his military
sash.

FIG. 6.
Elderly statesman, c. 1600,
in embroidered cap and long
gown.

FIG. 10.
Blue coat boy or servant
in livery, wearing his
master's coat of arms as
a badge.

FIG. 9.
A servant, carrying sword
and buckler.

some. It often consisted only of breast and back-plate and a " morion," the brimmed helmet pictured in fig. 11. Men are portrayed also with only a steel gorget, or neckguard, over the doublet (fig. 7). Indeed, with the steady improvement in firearms, the usefulness of armor decreased. " Buff-jerkins," sometimes reinforced with steel plates, or canvas jerkins heavily quilted (like the gambeson (fig. 13, Chap. VII), were worn by foot-soldiers, with a morion or burgonet (fig. 12).

Cruciform hilts were still seen on swords, but the " knuckle-bow " type was more in the mode (figs. *passim*). Swords were worn in holders attached to the belts (figs. 4, 11 and 12); the blades were thin rapiers. The rapier was a very usual accompaniment of civilian dress as well as of armor (figs. *passim*); daggers, too, alone or in addition to the sword, were worn by gentlemen thrust into the belt at the right side (fig. 3). If a gentleman went abroad without his sword, he equipped his servant with one, as well as with a " buckler" or shield (fig. 9). This buckler, which had been used by the middle class and servants since the thirteenth century, was held at arm's length and used to parry blows. It was rarely more than two feet in diameter, twelve to eighteen inches being the common size. A spike in the center, from four to as much as ten inches long, made the buckler an offensive weapon as well as a shield.

At this time firearms actually ousted the cross-bow as the weapon of foot-soldiers. Fig. 12 illustrates an Elizabethan or Jacobean *arquebuse* and a gun rest. A " wheel-lock " pistol was in use also by 1600.

CLERGY

The Church of England clergy of Elizabeth's and James's day were required to wear the scholar's gown described on p. 190 when they went " abroad." If a man could not afford a long gown, the shorter was permitted him, but it was to be of sober color and not ornamented. In his own home the clergyman might wear what he wished, provided also it were not fanciful or extravagant. Black does not seem to have been expressly enjoined, except for the cap, which was to be silk or cloth, according to the wearer's means—either the close coif with earflaps or the biretta sketched in fig. 14. The preaching vestments, worn also when christening, marrying, and burying, were the cassock (a garment like the " blue-coat," but longer and black), surplice, and stole, practically those worn now. The neck-finish was a turnover collar or a ruff, as in lay dress. Bishops (fig. 14) wore as their ordinary dress (1) the long cassock, (2) the rochet, a white gown with fairly full sleeves, (3) the chimere, a sleeveless black gown, open up the front, and (4) the tippet of black fur. Bishops often wore ruffs. A biretta completed the costume. The ceremonial dress, worn also in parliament, was: cassock, rochet, cope, mitre (see pp. 83 and 137).

CLOWNS AND JESTERS

Shaksperian " clowns " are frequently no more than country bumpkins, who

would be dressed like the lad in fig. 9, except that their garments would be made of rough homespun and clumsily tailored. A comic constable like Dogberry would wear the same sort of dress, and in addition a gown of rough cloth, cut like those described on p. 218 (fig. 6). A clown like Launcelot Gobbo is a servant and would wear his master's livery (like the boys in figs. 9 and 10), smart or shabby as the text called for. The term "clown" is also applied to a jester. This person, of whom Touchstone and Feste are examples, had his own livery. It is supposed that this sometimes included a long-skirted jerkin or a gown like the "blue-coat" of fig. 10. Just as often, however, the Elizabethan jester wore a short-skirted costume, its style preserved from the fourteenth century: "chaperon" or hood, "cote-hardie" or doublet, and hose, all in "motley" or parti-color. "Cap and bells" proclaimed the jester, the cap assuming different forms: (1) with ass's ears and a forward-curving peak (fig. 13); (2) without ears and, in place of the peak, an uprearing crest or "cockscomb"; and (3) with two horn-like peaks at the sides of the head. Bells were ordinarily added to the peak of the cap and the tips of the dangling sleeves. A pouch at the belt was part of the jester's equipment; so was the "bauble" or "zany," a doll's head on the end of a stick; and often a bladder, like a tough-skinned balloon on a wand, made into a rattle by putting dried pease inside it.

In addition to the usual bells the jester in fig. 13 wears a set of "morris bells" on his legs. In Tudor England morris dancing was a popular accomplishment. Of late years it has been revived and taught in America as well as England and is often and appropriately included in plays and pageants of English life. Men performed morris dances and jigs in their ordinary dress enlivened with gewgaws and ribbons, except when they were representing characters in the May-day revels, such as Robin Hood, Maid Marian, and the Hobby Horse, but they always added the bells, worn on ribbon-trimmed garters just below the knee. Ribbons tied around the hat and shirt sleeves and floral hat-trimmings were and are purely fantastic costume touches; bells, on the other hand, are really part of the dance-equipment, their rhythmic jingling adding an accent to the music.

Another and more elaborate arrangement of the morris bells, upon a legging or shin-guard, appears in a contemporary woodcut illustrating Will Kemp's account of his nine days' morris from London to Norwich. Since the style is popular with modern morris dancers, it should be described in detail. The legging is made in a latticework of cut-out leather, strips of cloth, tape, or ribbon, long enough to extend from just below the knee to just above the ankle, wide enough to go around the leg. Bells and ribbon streamers are attached. Leather was probably the material in Elizabeth's day, as it may be now. Cut twelve-inch squares of leather into a latticework of four strips across and four up and down. Stitch strong, inch-wide red tape across top and bottom, a yard each; these are to fasten the leggings to the leg, wrapping and tying. Provide twenty-four bells for each pair of leggings. Iron bells make the most

noise and they are durable; you can buy them from shops which sell dog harness. The disadvantage is that if iron bells come off in the dance and are stepped on they may cause serious injury; for that reason the lighter brass bells procurable from theatrical supply houses (Chap. XX) may be better. Cut red and blue ribbons about eight inches long, six of each color to a leg. Get a cobbler to clamp bells and ribbons together on the leggings thus: bells at each intersection *except* the four which will go up the inside of the leg (because bells there might hit together in the dance); pairs of ribbons, doubled, to make four-inch streamers, fastened with the bells on the top and next-to-the-bottom rows. Instead of leather you may use ribbon-encased elastic garters for the top and bottom of the leggings, plain ribbon for the rest of the lattice-work.

A pair of handkerchiefs (or a stick, depending on the dance) was (and is) also a part of morris-dance equipment.

WOMEN

Heads. Hair, during the first years of this period still parted in the middle, was later drawn away from the ears and fluffed out at the temples. It was arranged thus under the caps which remained as a transition from earlier styles. Soon, however, hair was brushed straight back from the forehead and ears in the style we call "pompadour." A point on the forehead ("widow's peak") and arches above the temples were admired features (figs. 19, 22, 26a), though sometimes the line was softened by a fringe of curls (fig. 26b). Before long the natural, drawn-back hair was puffed and dressed over a support (figs. 21 and 22), the coiffure growing higher as the years advanced; but in the latter part of James's reign a wider, flatter style, with frizzed locks at the sides and a lower forehead-line made its appearance, a transition toward the coiffure of Charles I (fig. 23). During the vogue for the high roll, especially in Elizabeth's later years, false hair and even complete wigs ("periwigs") were resorted to, blond and red hair being especially popular. Make-up was in ordinary use at court, too, scandalizing the Puritans.

There was one headdress which continued in favor at the English court until the vogue for high pompadours superseded it, lasted among Dutch burghers' wives for a longer time, and during the whole period was an appropriate coif for widows. This was the cap which dipped to a point in front and curved in wings over the temples, displaying the hair (fig. 18). Tradition associates this bonnet particularly with Mary Stuart, the Scottish Queen, though the style was anything but peculiar to her. It was made of different materials, from velvet with jewels to lace or batiste, and it had numerous variations, *e. g.*: (1) it was worn over another, close cap (baby, fig. 25); (2) it could be placed well over the forehead or back on the crown; (3) it had strings; (4) it had wide wings, little wings, double wings. Individual becomingness probably dictated the style chosen. Of the older crescent headdress there remained also a small version, set much farther back on the head (fig. 26b). The later, high

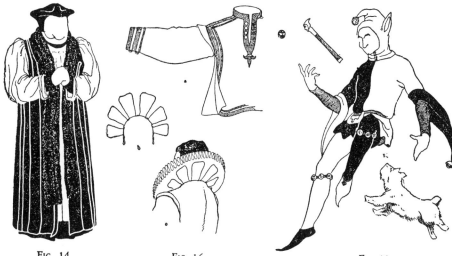

FIG. 14.
English bishop of the Reformed Church, c. 1575.

FIG. 16.
a, A mandillion, or jacket, open under the arms. b, An underpropper. c, The same, supporting a ruff.

FIG. 13.
A jester (Elizabethan and earlier) wearing morris bells.

FIG. 11.
Armor, English, 1590. Note "Morion" helmet, earring, round hose.

FIG. 12.
Arquebusier with gun and gun-rest, 1600 to 1625, and later. "Burgonet" helmet. Breeches are "slops."

FIG. 15.
Musical instruments: a, b, c, d, A set of recorders, c 1600. e, Virginals, c. 1575. f, Pipe and tabor.

coiffure was dressed with loops of gems, with pear-shaped pearl drops (fig. 22) and with sprays of osprey and jewels.

In the meantime, ordinary women were modestly covering their simply-dressed hair with plain caps. One style is sketched in fig. 24, another, which Americans think of in connection with New England Puritans, appears on fig. 20, Chap. VIII.

Feminine hats were copies of masculine. Women even wore the tall, tapering " sugar-loaf " with widish brim, and countrywomen put it on over a white bonnet (fig. 24). Welsh peasant dress preserves this feature even yet. Fashionable women particularly affected the small hat perched jauntily on their stiffly dressed hair (figs. 19 and 20).

Necks. All the styles of neck-ruff described under MEN were worn by women. The small ruff or fluted ruffle at the top of a high collar (fig. 19) was a favorite, the collar often being left unfastened to the base of the throat (fig. 18). There were varieties of standing ruffs, outlining the low décolletage at back and sides or only in back. These ruffs were either pleated fan-wise (fig. 26a) or made flat (fig. 21) and were supported by some version of the underpropper (p. 213). Pictures of Elizabeth show a further structure of wire, lace and jewels, rising back of head and shoulders in a trefoil shape (fig. 22). Closed neck-ruffs of varying widths were worn with low-cut dresses, and sometimes small ruffs in addition to the open collar (fig. 21). In earlier years the décolletage, still square and arching in the middle, was often filled in up to the neckband with material different from that of the bodice. Fig. 20 shows such a guimpe (or " partlet ") with an inverted V in front displaying the bare neck. Often the bodice was simply cut high-necked, as in fig. 24. With such a high-necked dress women, like men, wore turnover collar or ruff.

Bodies. The under chemise now rarely showed except at neck or wrists. But, as in other periods, when women turned back their sleeves for household work, the white chemise sleeve showed, probably pushed up to the elbow.

Bodice and skirt, while frequently of the same material, were cut separately and may be considered as two articles. The fashionable bodice was tight, flat across the chest, long-waisted, with a point in front which increased in length until well into the reign of James, after which time it began to shorten again (fig. 23). The methods used to produce the wasp-waist seem nowadays like torture, for we learn of bodices or corsets stayed with strips of steel and hard wood and even some made entirely of pierced steel.

If an undergown were worn, this would often be visible down the front of bodice and skirt. The bodice (corresponding to the man's doublet) was occasionally of material different from both skirt and upper gown, and was visible in the front and on the arms. A rather looser bodice or jacket, examples of which may be seen in the Victoria and Albert Museum and may be recognized in portraits, was of linen heavily embroidered (fig. 23). If the outer gown were closed all the way up the front, only the sleeves of the underbodice would show; if only the bodice of the upper gown were fastened, the under-

gown was revealed at sleeves and skirt (fig. 20). However, the costumes of the latter part of Elizabeth's reign and of James's frequently omitted the upper gown and consisted of bodice and skirt of the same (or different) material (figs. 21 and 22). The pointed boc ice was frequently accentuated by the use of a stomacher, a triangular or shield-shaped piece with its broad end at the low décolletage, its point resting on the skirt. This was a separate, extra-stiff piece and frequently differed in material and trimming from the rest of the costume. Fig. 22 shows an exaggerated point on the bodice itself; the stomacher was often as long as this point. Ordinary women wore dresses and sometimes upper gowns with bodice and skirt of the same material (fig. 24 and fig. 20, Chap. VIII), though the sleeves might be of different stuff; according to their tastes and abilities, they aped the court fashion of tight, long waists.

Arms. Sleeves, on the whole, resembled those described under MEN, though women were fonder of puffs, and often held in the full, leg-o'-mutton sleeves by ribbons in a series of puffs from shoulder to wrist (fig. 21). There was a feminine trick, too, of wearing a short puff on the upper arm, a tight sleeve from there to the wrist, and veiling the tight sleeve in a second puff of crisp gauze. Turn-back cuffs and wrist-ruffs were equally popular. At the end of James's reign began the fashion for slightly shorter sleeves (not quite to the wrists) with wide lace cuffs (fig. 23)—a style to be developed later. The wings or rolls appeared on feminine dress almost as often as on masculine.

Legs. Throughout the period, women wore distended skirts, whether the effect was achieved by many layers of stiff material only or by some form of hoop. In the first half of the period, the skirt was bell-shaped and smooth, and sometimes spread almost unwrinkled over a frame whose arching hips were less wide than the hem (figs. 19 and 20). To produce that effect, hoops of graduated size were inserted in a petticoat. This hoop-skirt was a Spanish innovation (though popular everywh re) and was called in England a *verdingale* or *farthingale* (there were many spellings). In the period of Shakspere's plays the first (bell-shaped) farthingale vied for popularity with another, especially French shape in which the maximum width was at the hips, where it might assume a huge span, as much as a yard and a quarter from side to side and twenty or twenty-four inches from front to back (figs. 21 and 22). This effect could be achieved, apparently, by three different methods: (1) two wide, arching structures of wire resting on the hips (fig. 10, Chap. XII), upon which was draped the very long skirt and with which the long pointed bodice could best be worn; (2) a huge padded roll or bolster (fig. 17a and b) of equal size all around, over which the immensely full gathered skirt was draped and often looped up, as in fig. 22; and (3) a cartwheel or flat hoop which gave a shelf-like top with sharp edges (figs. 21 and 17c). This last farthingale was often accompanied by a pleated ruffle extending from the waistband to the edge of the farthingale. Any of these huge skirts might be of the same material all around, or be opened to display a petticoat or the skirt of a gown. In general skirts were still long, though with the French (cartwheel) farthingale

they needed to be shortened to instep-length, and during a brief time about the middle of the reign of James they were, fashionably, ankle-length. Real trains with hoop-skirts were comparative rarities.

Before 1625 women had begun to discard the hoop (fig. 23); it had never been usual with the middle class and peasants, though most women did their best to emulate the fashionable wide hip, by means of very full skirts gathered into a waistband, a multiplicity of petticoats, and the looping up of the outer skirt into bunches.

Feet. Shoes followed in general the styles described under MEN. Fashionable women owned shoes made of rich brocaded cloth ornamented with pearls. When heels were introduced, women took to them eagerly as a means of improving a low stature. These heels are, to our eyes, wide and clumsy and of no great height. Thick cork soles provided another way to add inches; *chopines* (which Hamlet mentions) were other elevating devices, pedestal-like pieces arranged on a sole to support both heel and ball of the foot. Chopines were a Venetian mode and seldom seen in England.

Outer Garments. While the upper gown was more fashionable in the earlier than in the later years of this period, it continued to be worn during the entire time. Like the men's gown it might be cut with a fitted top (fig. 18), or to hang in back from stitched pleats or a yoke. It was made (1) sleeveless, (2) with short sleeves (cap or puffed) (fig. 18), or (3) with hanging sleeves. In front it was arranged variously: (1) open all the way up; (2) fastened at the neck as in fig. 18; (3) fitted and fastened up like a second gown. A high collar with a ruff or a fluted ruffle (fig. 18) shared honors with various open collars in the masculine modes, including one heavily furred. Indeed the whole gown could be of fur or fur-lined. The sleeveless open jacket or jerkin, about as loose as the masculine " mandillion " (fig. 16a), was another outer garment, a useful and pretty addition to a lady's cos ume (fig. 23).

CHILDREN

Portraits of noblemen's children and the children of the upper middle class are numerous and bear out in general the statement made in earlier chapters, that children's dress did not differ materially from adult (fig. 25). The unfortunate mites were even subjected to the discomfort of starched collars or ruffs, and hoops (fig. 25). However, their bodices and doublets were not always nipped in at the waist, their hair was simply arranged, and their shoes were soft.

Boys wore conservative versions of the round hose or else " slops," and doublets with ruffs or turnover collars. Up to the age of three or four they wore long skirts, like girls, and caps. Girls kept the long skirts and discarded the caps later. These caps were made like the bonnets that babies still wear, and they sometimes had strings. They were often embroidered, like that on the elderly gentleman in fig. 6. Infants and older girls wore aprons, long straight pieces of fine muslin and lace. On top of the bonnet, or directly on

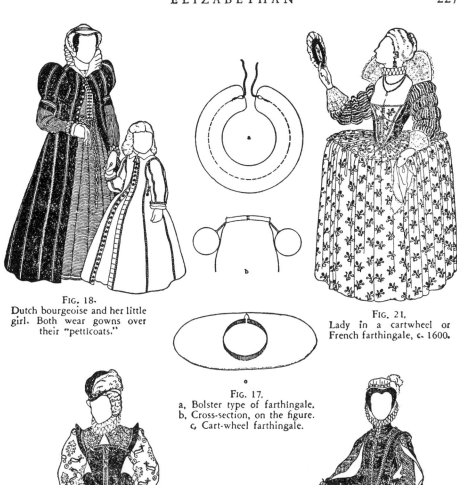

FIG. 18.
Dutch bourgeoise and her little girl. Both wear gowns over their "petticoats."

FIG. 21,
Lady in a cartwheel or French farthingale, c. 1600.

FIG. 17.
a, Bolster type of farthingale.
b, Cross-section, on the figure.
c, Cart-wheel farthingale.

FIG. 20.
Lady in Spanish farthingale, c. 1560-75. Her bosom is covered by an embroidered partlet.

FIG. 19,
Spanish lady and her dwarf, c. 1575. She wears the early bell-shaped type of farthingale.

the hair, both boys and girls perched caps and hats in the styles affected by their elders.

MATERIALS

Silk, satin, taffeta, brocaded damask, metallic cloth, and velvet plain and figured were all used for the sumptuous court costumes. Woolen cloth in fine and coarser weaves, " scarlet " (p. 142), which was often over-dyed black, striped or " rayed " cloth, worsteds, and frieze went into soberer garments and warm cloaks. Fustian, a heavy, canvas-like cotton material, was used for both linings and the outside of garments, and heavy linen was the basis of others that were embroidered. Silk gauzes were used for veils.

Some elaborate ruffs and cuffs were made entirely of lace, others of lawn, lace-edged or plain. Lace was dyed various colors (blue is especially mentioned) and was also made of colored silk and gold or silver thread. Such laces edged ruffs and took the place of braid in trimming.

COLORS

An extremely wide range of colors was drawn upon for Elizabethan costume, as freely by men as by women. Black and white, black and gold, black and red were admired combinations. Full tones of red, green, and blue, and bright hues like orange-tawny and flame-color, shared popularity with the paler tones like yellow-green, saffron and light (" watchet ") blue. This blue, and white, were equally popular at the court of James I, especially in satin. Though neck and sleeve-ruffs were occasionally colored, as a rule they furnished the white accents in any costume. Gold-color and the milky white of pearls appeared in almost every elaborate *ensemble.*

MOTIFS

The motifs described for Rennaissance costumes (p. 198) continued to be popular, supplemented by naturalistic flower-designs, applied as all-over embroidery to caps, jackets, and sleeves.

APPLICATION OF DECORATION

The Elizabethan has been called a period of braiding. While " pinking," slashing, and the resultant puffs continued as decorative features, they were on the whole smaller than formerly and subordinate in interest to the braid which outlined them or made designs on its own account. Braid or lace (black, white, colored, and metallic) " guarded " or covered all the important seams of tight-fitting doublet or bodice, and edged neckbands, wristbands and shoulder-wings; it appeared in horizontal or perpendicular arrangements on bodice, sleeves, and upperstocks or in a strap-work design upon any surface. The herringbone braiding shown in fig. 7 is among the simplest of these designs.

The English had been famous for their needlework ever since the tenth century (p. 117). Till the Reformation this art had been principally lavished

on church furnishings and vestments; after that event, embroidery was more often used to beautify lay dress and household furnishings. Examples of garments so decorated still exist, as well as portraits showing how they were worn. Figs. 6 (cap), 2 (sleeves and purse), 3 (purse) and 23 (bodice) are representative of such stitchery. The all-over embroidery, of silk and metallic threads, couched, fagotted, or satin-stitched, sometimes incorporated pearls and other gems (fig. 22). In fact, upon court costumes, hardly an area was suffered to remain plain; goods already figured was further embellished with embroidery, braiding, and jewels. Even plain folk must have braiding (fig. 9) and modest needlework, such as black edging on white chemises, quilting, and smocking or honeycombing.

Ribbon bows (fig. 19), rosettes, and metal and jewelled buttons (figs. 3 and 18) were other bits of decoration. "Points" (p. 189) finished the ends of ribbon bows and lacings (fig. 19). These bits of metal, in common with other minute but useful articles of apparel, show a beauty of craftsmanship lost to our shoe-lace tips, their descendents.

JEWELRY

Chains, earrings, brooches, and finger rings were worn in astonishing profusion by both men and women (figs. *passim*). The George (fig. 5), the Fleece (fig. 19, Chap. VII), the Rose (fig. 6, Chap. VIII), the badge of the order of St. Michael, the cross of the Knights of Malta (fig. 2), and other orders were worn by those who had the right (men only, except for women sovereigns like Elizabeth). The "collar" of linked metallic ornaments spread wide across the chest and worn over the topmost garment was now sometimes replaced by a broad ribbon. A new order, even more important later, in the seventeenth century (fig. 4, Chap. X), was instituted by Henri III in 1578, the Order of the St. Esprit. A gentleman's "follower" or retainer wore the badge of his service on a ribbon, and members of guilds wore their badges (struck in lesser metal like pewter) on chains. In addition to these official ornaments, purely decorative chains were worn by men as well as women.

Brooches set with large jewels or cameos were pinned anywhere on the costume, even on hats. Earrings were oftenest pear-shaped pearl drops, and men wore them in one ear only (figs. 2, 3, 7, 11). Mariners affected small gold hoops, though some of them (soldiers, too) wore instead of a hoop a black silk cord put through the lobe and tied in a knot in front. Any finger and the thumb could carry rings. Women's hair-jewels have been described earlier. Women's girdles were often jewelled (fig. 20) and from them dangled various articles, such as a small mirror on a handle, a pomander (fig. 20), or a fan. The early fans were rigid, in shape round, oval, or oblong; they were edged with feathers, down, or other trimming, and sometimes set with a small mirror (fig. 21); another rigid fan was just a cluster of feathers on a handle (fig. 22). In the latter part of the period these fans vied in favor with the folding type familiar to modern eyes.

ACCESSORIES

Men's belts fitted neatly and followed the line of the doublet; belts were almost always present, and were useful in a pocketless costume. Into the belt a man tucked his gloves, a handkerchief, a soft bag-purse (fig. 20), or a letter. From the belt hung the sword or dagger and the pocket or purse (figs. *passim*). Men's and women's gloves had gauntlet cuffs, often stiff and heavily embroidered and fringed; they were of leather in a variety of colors.

Men wore embroidered baldricks and sometimes sashes tied in large bows on the right shoulder (fig. 7).

Aprons, as noted under CHILDREN, had come into style. Fine ladies now began to take over this work-woman's accessory, turning it into a frivolous adornment of lawn and costly lace.

Women carried muffs, which were usually small and made of luxurious fabrics.

MUSICAL

The lute (fig. 23a, Chap. VIII), the pipe and tabor (fig. 15f), and the viol were instruments popular at dances. Figs. 15a, b, c, and d show a set of recorders. Four performers with these flutes should enter when Hamlet cries, " Some music, come, the recorders." Although four was the usual number, seven or even nine men sometimes played in concert. The recorder was a vertical flute, controlled by eight stops, six in front, one at the back, one at the side. The extra brass piece sketched in 15d was added only to the large bass instrument. The recorder was a popular accompaniment of the singing voice; it remained in favor, under this name, till the end of the seventeenth century. The " virginals " (fig. 15e), a very early type of piano, was small and light enough to be carried about and placed on any convenient table.

SOMETHING ABOUT THE SETTING

English furniture was made of oak, heavy and rather clumsy. Fig. 1 shows a type of " turned " chair made in England and brought over to America by early settlers. The straight-backed Renaissance chair with upholstered or embossed leather back (fig. 23, Chap. VIII) continued in use. Other oak pieces included carved chests, cupboards, stools, side-chairs, and heavy tables with bulbous " melon " legs. The high-backed seat upon a raised dais was still often the seat of the lord of the manor. Canopied and set in front of a tapestry it was grand enough to seat Elizabeth herself during her progresses through her kingdom.

PRACTICAL REPRODUCTION

Materials. In copying Elizabethan garments you are seeking to imitate heavy materials, many rich and some with a high lustre. First search the upholstery departments for suitable fabrics, such as rayon brocades and damasks (they

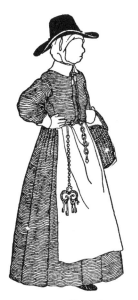

FIG. 24.
Country-woman, c. 1600.

FIG. 25,
Little boy and his sister,
English or Dutch, c. 1600. The
boy wears "slops."

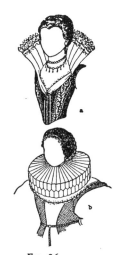

FIG. 26.
a, Standing ruff, c. 1600. b,
Double ruff and frill. Dutch,
c. 1600.

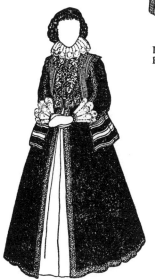

FIG 23.
Lady about 1625, in falling
ruff, embroidered bodice and
loose jacket or jerkin. Tran-
sitional to "Charles I" styles

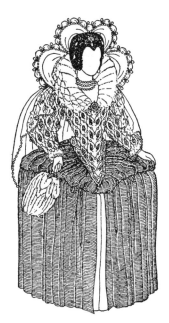

FIG. 22.
Lady in a French bolster
farthingale, standing ruff and
a second wired ruff (c. 1575-
80).

may be found with Renaissance patterns), cotton rep (to imitate woolen) and denim (for "fustian"). Look for velveteen and corduroy among the dress-goods. In the materials sold for bathrobes you can sometimes find heavy figured flannelette (which gives, under lights, a rich effect like cut velvet) and figured Terry cloth (which does about the same thing). Rayon satins and taffetas and the brocaded rayons sold for coat-linings are sumptuous and make beautiful backgrounds for trimmings. The heavier sateens, made up in their plain color or ornamented with a stencilled pattern (Chap. XX) are inexpensive and look fairly grand. Silver and gold lamé cloth (purchased from theatrical supply houses) (Chap. XX) gives very gorgeous effects and should be sparingly used, only upon the important person in a scene.

Use tarlatan, white and (rarely) colored, for ruffs and collars, which you can also make of muslin, batiste, or organdie. When you buy lace for ruffs, get a coarse kind, like "torchon," which shows up well on the stage; you will have to starch it.

For the chemisettes which fill in low necks use soft silks and silkaleens or even crêpe de chine or georgette if you shirr it.

For linings you will need the heaviest scenery-muslin, upholstery canvas, or "marine duck," buckram, crinoline, and cotton batting (bought in packages of from one to five pounds).

Flannelette or outing flannel makes rather handsome cloth suits, and may be dyed in beautiful colors. Burlap sacking (Chap. XX) is the best material for rustic clothes; because of its loose weave you will have to make it up on a self-toned lining.

Trimmings. Seam-binding or cotton tape in a contrasting color is a very satisfactory trimming for plain garments. For grander, buy all you can afford of gold and silver braid, soutache, and gold galloon. Look for the latter among lamp-shade supplies. Colored braids other than metallic will also make effective trimmings.

You may simulate embroidery on material like heavy muslin with tempera paint and metallic paint, but the area must be one which is not exposed to rubbing or wrinkling. Be as prodigal as purse and time will allow with cheap pearls, glass beads, and ten-cent store gems; it is almost impossible to exceed the authentic limits in ornamentation.

Accessories. For ways of making over shoes see Chap. XX and suggestions for Renaissance shoes (p. 203). For women's shoes you may employ modern slippers (*not* patent leather), with moderately high heels ("baby French" or Cuban); brocaded or metallic slippers go especially well with rich court costumes. Countrywomen may wear flat felt bedroom slippers or even low-heeled russet or black oxfords (if the dresses are kept at instep-length). They may also wear low-heeled strap-slippers or "Mary Janes." If the dress is made ankle-length, the felt slippers will be the safest, and care must be taken to supply the actress with woolen or coarse cotton stockings, since silk would be incongruous. Ladies may wear heavy silk stockings.

While shoe-roses (p. 217) were a late development and not very common at any time during this period, they are the usual resort of the costumer with limited budget and time, for they serve to mask the modern shoe so that it is not offensively anachronistic. Put them preferably on thin-soled dress-shoes or pumps (*not* patent leather). The rose (in its simplest form a strip of ribbon or hemmed material gathered along one edge and drawn up) should be big enough to cover the shoe-laces. Sew the back of a safety-pin on the wrong side and with it pin the rose securely into the laces, using extra pins if necessary.

You can convert any gloves, kid or fabric, into the Elizabethan gauntlet by stitching on a cuff of similar material, interlined with buckram. Sew on ornaments or paint a design in tempera.

Make the rigid fan out of a wire frame over which is stretched the desired material, and a wooden handle; sew feathers on the wire edge.

To make jewelry, armor, and hats, see Chap. XX.

A ruff has, as a beginning, a neckband of white belting three inches wide for most ruffs. The material for the ruff itself may be starched muslin, lace, or organdie, but tarlatan is the easiest to work with. Unless the ruff is of the open sort (in which case it will probably be basted inside the neckband), it will be fastened in back and the band must be equipped with hooks and eyes. Every time the ruff is put on the outer ends must be fastened together with a snap or a tiny safety-pin.

Cut the tarlatan crosswise (not bias) of the goods. To insure accuracy it is well to draw two measured straight lines on a long table, thumb-tack the tarlatan to the table and cut over the lines with a razor-blade. It will take five widths of tarlatan to make a ruff from four to six inches deep and three inches wide, more for a very large one, less for a very small one. For a ruff whose depth is to be six inches finished, cut strips thirteen inches wide. Stitch the widths together, trimming off most of the thick selvage. Fold the long strip so that it is six and a half inches wide. Now pleat this doubled strip like the folds of a fan, the exact width of the neckband, using a piece of cardboard as a gauge and truing each fold by it. Divide the neckband into four equal parts, marked with pencil-checks. Hook the band together and stand it on a table. Stand your pleated tarlatan around it, *raw edges next the band,* and arrange it evenly according to your marked sections. A half inch has been allowed for lapping on the band; pin this at the top of every pleat to the top of the band, keeping the pleats upright, not slanting. Gently turn the whole thing over and pin the other side in the same way. Now whip the pleats to the band, top and bottom. In order to hold the pleats in a neat cartwheel, take fine thread and tack the outside of each pleat to its neighbor (keep a running thread—it will not show six feet away). You may now open the pleats in the pretty S-curve by running a curling-iron inside each sharp edge, first dampening the tarlatan slightly with a paint-brush. You will need to repeat this curling process after almost every performance; it restores the ruffs admirably. If you wish a lace edge on the ruff, stitch starched lace on the folded edge of the tarlatan before pleating.

To give the effect of gold, silver, or colored trimming, you may simply touch the fluted edges of the finished ruff with paint (but this paint has an unpleasant effect on the curling-iron). Tarlatan ruffs will not, of course, launder, and can be satisfactorily dry-cleaned only once.

The open ruffs are made of lace, put on a frame of the heaviest milliner's wire or iron wire bound with ribbon. You will need both upright and crosswise wire supports to hold the frame in position. Sew the ruff to the back of the bodice-neck. Very large closed ruffs and sometimes standing ruffs need an underpropper. Fig. 16b and c show an underpropper (made in the studio by Miss Florence Drake, p. 238) which proved very satisfactory. It is of heavy iron wire. Bend the first end of the wire to the shape of the wearer's neck and continue with the same piece of wire in the graduated petal-shapes shown, ending at the side, making one joining. Hold the bent wire to the curved section with twists of thinner wire. Gild the wire. Attach it to the wearer's shoulders with strong safety-pins. The flaring high-neck open collar or " whisk " (fig. 4) must be stiffly starched and also edged with fine milliner's wire.

CUTTING THE GARMENTS

Men. The foundation of a man's costume should be a close-fitting body and breeches of heavy muslin or even canvas. Cut the doublet from the actor's own vest or on the pattern for the " Mephistopheles " costume; the round hose on the " Mephistopheles " trunks, the " Venetians " and " slops " on the " George Washington " or " Continental " pattern, altering for width and length as needed.

If the doublet is to be soft, it may be cut like the lining and stitched with it; if it is to be of the stiff, padded, pigeon-breasted sort you will have to make a buckram front. While it is true that the stiff as well as the soft doublet was apparently opened up the front, a back opening is easier to manage in the stiff one, concealing the back fastening as carefully as possible and simulating the front opening with braiding and buttons. If you do this, you may make the stiffening with a single piece of buckram, wider than the actor's chest. Match this to shoulders, front of armseye, underarm seam, and neck and trim to the shapes of these places. Slit part way up, part way down, the front and lap the superfluous width to make the desired projection; trim and sew flat. Take lapped-over darts on shoulders, near waistline, and under the arms as needed. Pad between lining and buckram with cotton wadding. Do not finish the job without trying the doublet on the actor, for if too much wadding is used he cannot move, if too little, the buckram front will crack. Finally, cover front and back (working on the actor or on a dress-form) with the costume-material. Do not pad or stiffen the back of the doublet. For less exaggerated fronts, pad with layers of sheet wadding till you attain the desired rotundity.

Start the upperstocks on the foundation of lining-material mentioned above. Put the breeches on the actor and pad out with layers of wadding to make the desired shape, tacking it as you go. Even the slim Venetians need a layer of

padding to give them a smooth appearance, and the French hose need a good deal. Before you complete the job by covering with the costume-material, be sure that the actor can sit down in the breeches. An alternative device for distending round hose (if you are not particular to have them smooth) is to use an interlining of " marine duck " of the same size as the outer material. For Venetians you may cut the outside on the same pattern as the lining, allowing more fullness as needed, and shape with darts around the knee. Simulate the effect of " panes " by sewing together two materials in alternate stripes, braiding the stripes that represent the outside; or by putting braided strips over the finished breeches, fastening the strips to the waistband and to the *inside* of the lining at the lower edges.

Use the same tight lining for the very full breeches of fig. 4. Make the outer part actually a full gathered or pleated skirt, but cut out a shallow crotch. Sew the top part to the waistband of the lining and the bottom edges to the bottom of the legs, on the *under* side, so that they may blouse over.

Tight canions need no padding and require only enough material to cover the lining between the trunk-hose and the knee.

With Venetians, canions, and long full breeches, stockings may take the place of tights (though the latter are more comfortable and make for a smoother leg), but with any of the shorter hose tights are a necessity. Hold both tights and breeches up by suspenders, either a pair for each, or one pair with a double set of buttons or some strong safety-pins. If the stocking is to be rolled over the breeches at the knee, put a narrow elastic in the top to help out the fancy garter worn below the knee (which you will make of elastic, bought in the desired color or dyed). Although fine gentlemen did wear silk stockings, you must remember that these were much heavier than most of the long hose we can buy nowadays, and you will probably find it more satisfactory to use mercerized cotton, or to put a cotton pair under the silk.

Sleeves. For ways of enlarging sleeve-patterns, see p. 204. Interline the full sleeves with crinoline. Cut the hanging sleeves like any others at the top, but make them extra-long and slit them on the outside.

Shoulder-wings are crescents cut from buckram, covered, lined, and attached to the upper part of the armseye. The roll can be made with a piece of wire, curved to fit the shoulder, wound with cotton wadding till it looks like a crescent, then covered with bias material and ornamented with braid as desired; or you can cut two crescents, stitch together, turn, and stuff.

Women. Like the doublet, the fitted bodice must be lined with heavy muslin or canvas. Use the fitted lining pattern or the " Martha Washington " or " Colonial " pattern. Recut the sleeves according to your model. Exaggerate the point in front. Bone with heavy featherbone in center-front, side-front, underarms, and side-backs. If a separate material is to fill in the décolletage, cut the lining high-necked for a foundation and sew that material over it. The extra stomacher must be shaped from buckram and will have to be boned from side to side as well as up and down. Sew one side of it to the bodice and when the

costume is put on adjust the other side with pins, bastings, or hooks. To the inside of the waistband sew large hooks, two in back, one under each arm, two in front, which will meet eyes on the skirtband. Without this hooking the bodice and heavy skirt will part company. You may even have to supplement with pins or bastings when the costume is put on.

The bell-skirt is put on over a hoop made as directed in Chap. XX. The outer skirt is straight-gathered or gored, according to the effect desired. If gored, it must be at least three yards around the bottom, probably more. A petticoat of heavy muslin of size and cut corresponding to the skirt must come between it and the hoop, and it is well also to wear a narrower petticoat *under* the hoop.

The farthingale wide at the hips can be made in two ways, for two different effects. Both methods start with a snug waistband of two-inch belting equipped with hooks and eyes, and both employ wire.

For the first or "bolster" farthingale, twist iron wire into a hoop open at the ends and large enough to stand out about six inches from the waist. Pad this with many layers of cotton wadding till it is fat enough to rest upon the hips (about eight inches thick). Encase the roll in muslin and attach by very firmly sewed tapes to the belt at the underarms. Sew tapes to the open ends and tie them together when the bolster is on (fig. 17a and b). The skirt to go over this bolster is made in straight lengths, its entire fullness gathered into the waistband; it must be at least eight yards around, more if the material is as soft as sateen. The petticoat may be made with a yoke fitted over the bolster, the straight widths gathered on the yoke.

Make the flat-topped, sharp-edged farthingale of fig. 21 and fig. 17c thus: Cut No. 14 steel wire and have it electric-welded into a hoop. Cut a paper oval of the shape you want the hoop to assume. The largest farthingale you are likely to use measures thirty-six inches from side to side and eighteen or possibly twenty inches from front to back, and you will probably make it smaller. Lay the pattern on an old soft-wood table and outline the edge by driving in nails in pairs every few inches. Fit the wire hoop over this oval; lay on it heavy muslin which has been cut roughly to the pattern and pin it as tight as a drumhead to the wire between the pairs of nails. Lift it out, complete the pinning, baste firmly, and either whip it down with carpet-thread or, if your machine will take it, stitch. In the precise center of the drumhead draw a circle whose circumference equals the wearer's exact waist-measure. Upon this circle pin and baste the belting, equipped with hooks and eyes on sufficiently overlapping ends. Inside the circle formed by the belting slit the muslin (fig. 17c) and sew it back to the inside of the belt, very securely, both top and bottom; trim. Slit the stretched muslin from the belt-opening to nearly the wire edge (it should be open on a long side) and overcast or bind. The muslin petticoat (in length from the wearer's hips to about two inches above her instep, plus a hem, and in width seven yards for the largest hoop) is gathered to the wire edge. Over it is then gathered the outside skirt, a yard wider than

the underskirt and two inches longer. Turn up the hems on the wearer. Such a skirt cannot be managed longer than instep length, and a trifle shorter is permissible. From the waist to about two inches over the wire edge, place a flounce, either straight and fan-pleated into the waistband or cut the shape of the top, but larger. Tack it occasionally to the edge. This garment is not so appalling to get around in as might be imagined, and it is very charming, especially when worn in the more artificial comedies.

For the way to make the side-pannier type of dress-support, see Chap. XII.

Suggested Reading List *

(See also Reading List for Chap. VIII.)

Dress Design—By Talbot Hughes.
> Has photographs of some of the costumes in the Victoria and Albert Museum. The analysis of Elizabethan costume decoration is helpful.

English Costume—By Dion Clayton Calthrop.
> Charming reading. He quotes Shakspere on costume.

Elizabethan Pageantry—By H. K. Morse.
> An unusual gallery of Elizabethan portraits, accompanied by illuminating excerpts from contemporary texts and followed by an excellent glossary and bibliography.

{ *English Costume*—By George Clinch.
{ *Costume in England*—By E. W. Fairholt.
> Standard books.

{ *Historic Dress in America*—By Elizabeth McClellan.
{ *Two Centuries of Costume in America*—By Alice Morse Earle.
{ *Early American Costume*—By Warwick and Pitz.
> Good books on American dress.

The Heritage of Dress—By W. M. Webb.
> Tells you more about the Bluecoats and other interesting survivals in costume.

For General Reading about Customs, Costumes and Setting

History of Everyday Things in England—By Marjorie Quennell.
> Intended for children, but interesting to anybody.

Social England—Edited by H. D. Traill.

Shakspere's England—Chapter on Costume.

Life in Elizabethan England—By Wm. Stearns Davis.

An Elizabethan Journal—By George Bagshawe Harrison.
> Put together from contemporary texts (1591–1594).

Where Further Illustrative Material May Be Found

There are many portraits for this period, the painters including most of those listed in the section " Some Important Events and Names," as well as others not named here. Copies of such portraits are to be seen in many libraries, illustrating art histories, general histories, and biographical studies. Most of the books suggested above are illustrated with photographs of contemporary material.

In addition to portraits, there are funerary effigies, English memorial brasses, and

* Since the first edition of this work, two important books on Elizabethan costume have appeared: *Shakespearian Costume for the Stage and Screen*, F. M. Kelly; *Costume in the Drama of Shakespeare and His Contemporaries*, M. Channing Linthicum. There are several charts of XVI century costumes in *Period Patterns*, by Doris Edson and Lucy Barton.

miniatures (small portraits painted on ivory). Some of these are to be seen in photographic reproduction in the books mentioned above, and original examples of others are in larger art museums. A good many garments of the period have survived and are preserved in museums.

Among the contemporary textual sources may be mentioned the plays of Shakspere, Ben Jonson, and other dramatists, and Stowe's "Annals."

Sources of Sketches in This Chapter

From the wealth of material offered to a student of this period we have accumulated in our sketches as great a diversity of cut and ornamentation as there was room for. We have looked at pictures (or their reproductions) in the Metropolitan Museum, the National Gallery, the National Portrait Gallery, the Ashmolean Museum, the Rijksmuseum, the Louvre, Hampton Court, and private collections. Also at contemporary woodcuts and brass-rubbings as well as at actual costumes in the Victoria and Albert Museum and the London Museum. The armor we have studied principally in the Metropolitan Museum. A small statue of a jester in the British Museum, reproduced in *Manuel d'Archæologie Française*, tome III, le Costume, by Camille Enlart (fig. 388) and the reproduction of a woodcarving in an English parish church (Temp. Henry VIII), have been our principal sources for the jester's costume. The author is indebted to the Master's thesis written by her former pupil, Miss Florence Marie Drake, "Design of Costumes for Characters in Elizabethan Plays," State University of Iowa, 1931, for the record of studio experiments in Elizabethan costume and for an excellent bibliography. The cover design, "German players of 1574 in a market," has for its source a contemporary woodcut. This woodcut has been reproduced in *Theatre Arts Monthly* and our adaptation is used by kind permission of the editor, Mrs. Edith J. R. Isaacs.

Chapter X

CHARLES I AND COMMONWEALTH

DATES:

1625–1660

━━

Some Important Events and Names

ENGLAND	FRANCE	SPAIN	NETHERLANDS	AMERICA
Charles I, r. 1625–1649 m. Henrietta Maria of France	Louis XIII, r. 1610–1643 m. Anne of Austria	Philip III, r. 1598–1621	Period of Dutch Independence, Separation of Holland and Belgium	Myles Standish, 1584–1656
Commonwealth, 1649–1660	Richelieu, Cardinal, 1624–1642	Philip IV, r. 1621–1665		Dutch colonization of New Netherlands, 1623
Oliver Cromwell, 1599–1658	Louis XIV, r. 1643–	DRAMATIST Calderon de la Barca, 1600–1681	PAINTERS Rembrandt van Rijn, 1607–1669	Peter Stuyvesant, 1602(?)–1672 Governor of New Amsterdam, 1647–1664
John Milton, 1608–1674 "Areopagitica," 1644	Cardinal Mazarin, Minister, 1643–1661	PAINTERS Velasquez, 1599–1660	Franz Hals, 1580–1666	Maryland colonized under Cecil Calvert, Lord Baltimore, The "Ark" and the "Dove," 1633
OTHER POETS George Wither, 1588–1667	Cyrano de Bergerac, 1620–1655 DRAMATISTS	Ribéra, 1588–1656	Peter Paul Rubens, 1577–1640 David Teniers, Elder, 1582–1649 Younger, 1610–1690	
Robert Herrick, 1591–1674	Pierre Corneille, 1606–1684 "Le Cid," 1637	Zurbaran, 1598–1662		
John Suckling, 1609–1642	Jean Racine, 1639–1699	Murillo, 1618–1682	Adriaen Brouwer, 1606–1638	
Richard Lovelace, 1618–1658	Molière (Jean Baptiste Poquelin) 1622–1673		Adriaen van Ostade, 1610–1685	
Court Painter, Anthony Van Dyck (Dutch) 1599–1641	"Les Precieuses Ridicules," 1659		Terborch, 1608–1681	
Inigo Jones, Architect and Stage Designer, 1573–1652	French Academy, founded by Richelieu, 1635		FRANCE (Continued) PAINTERS Philippe de Champaigne, 1602–1674	
Wenceslaus Hollar, 1607–1677 Bohemian Engraver, worked in England			Pierre Mignard, 1610–1695	
Theatres closed, 1642			Charles le Brun, 1619–1690	
			Abraham Bosse, Engraver, 1602–	

Some Plays to Be Costumed in the Period

Edmond Rostand's "Cyrano de Bergerac."

Calderon's "Life's a Dream" (written, c. 1636).

Bulwer-Lytton's "Richelieu."

Beulah Marie Dix's "Alison's Lad."

Victor Hugo's "Ruy Blas."

Molière's "Les Precieuses Ridicules" (1659).

CHARLES I AND COMMONWEALTH

THE Thirty Years War, that European struggle which lasted from 1618 to the Peace of Westphalia in 1648, expressed the disrupted condition of Europe at the end of the Renaissance—a Europe torn by religious dissensions for which sincere men gave their lives, and which the diplomats used to forward their own national ends. From Bohemia to Sweden, from Italy to Holland, from Germany to Spain, the nations fought.

The British Isles, comparatively withdrawn from the continental struggle, were the theatre for another of their own—partly, indeed, religious, but more especially a battle between old and new ideas concerning the relative importance of king and people, the privileged, frivolous minority and the industrious, pedestrian middle class, all those opposing forces summarized in the epithets, " Cavalier " and " Roundhead." Charles I, son of James Stuart, reigned for twenty-four years in increasing impotence. Then (in 1649) the English people found, perhaps to their own surprise, certainly to the regret of many, that they (or their parliament) had killed their anointed king and given themselves a kingless government, a bishopless church, and an official Puritan morality. They tried it for eleven years; then cheered a returning Stuart. In the meantime, however, Charles the First's wife, Henrietta Maria of France, had taken her children (those pretty children whom Van Dyck had painted in such a charming group) back to Paris, where Mazarin, acting for the young Louis XIV, doled them out the scanty charity accorded to poor relations; and there they awaited the restoration of their rights.

The English theatres were officially closed in 1642; even before that time drama was on the wane. English literature was more truly represented by vigorous controversial prose, by metaphysical writing in both prose and poetry, and by the lyrics of the Cavalier poets, those polished writers of worldly verse.

Still ruled as part of the domains of the powerful house of Hapsburg, still enriched by the wealth wrested from the New World, Spain was nevertheless sadly weakened by the loss of the Netherlands, and from that time onward lived partly in retrospect, with a pomp and formality which the rest of seventeenth century Europe was rapidly forgetting. From Italy the leadership in Latin painting passed to Spain, where artists produced religious pictures, to be sure, in keeping with the teachings of the Jesuits, but also realistic portraits and *genre* studies.

241

Protestant Holland, now fully established in independence, entered into a golden age of middle-class peace and prosperity, which was recorded by a multitude of brilliant painters so enamored of their dearly-bought home that they constantly reproduced it, down to the last shining copper kettle upon the humblest tidy hearth. The Catholic Netherlands, also, had its great painters, but these, like Van Dyck and Rubens, won their fame as much abroad as at home.

The strong French King, Henri IV, had a weak successor, Louis XIII, whose reign was a struggle for power among his mother, Marie de Medici, his wife, Anne of Austria, and his minister, Cardinal Richelieu. It was the latter who finally ruled, to be succeeded, upon his death and that of the king by Anne as Regent and Cardinal Mazarin, whose joint power lasted during the minority of Louis XIV, that is till about 1661. These historic characters are, however, to young romantics of few or many years, only the background for D'Artagnan, Athos, Porthos, and Aramis and that semi-legendary personage, Cyrano de Bergerac.

To a disunited and war-torn Europe, increasingly and fiercely nationalistic, the New World offered opportunity: as a source of increased revenue; as a broader theatre for national warfare; as a dumping-ground for surplus and undesirable population; and finally as a refuge for religious dissenters. So it came about that while Spain sent royal governors and priests to grab the gold and save the souls of the Southern and Western aborigines, and France (not very enthusiastically) sent intrepid explorers and devoted priests into the North and West, the Dutch and English slowly and unspectacularly colonized the middle Atlantic seaboard. Puritans in New England, Cavaliers (by that name is meant the party, not necessarily the class) in the South, and between them, in the New Netherlands, Dutch burghers and their wives, trading in New Amsterdam and Fort Orange and farming their immense land grants up the Hudson—all of them were there to stay, to make homes and found families, to become, in fact, Americans.

GENERAL CHARACTERISTICS OF COSTUME

The first ten years of this period witnessed the gradual change from that extreme stiffness which characterized the costumes of James's reign (as of Elizabeth's) to the elegance and relative comfort with which we are familiar in the somewhat idealized dress of the Van Dyck portraits.

In the transition period first to go were "bombasting" or padding from men's doublets and breeches and "farthingales" or hoops from women's skirts; last to stay was the starched ruff, retained by older, conservative men and women well through the reign of the first Charles. Portraits of American Colonial governors throughout the century display this dignified accessory, together with the long "councillor's cloak" (fig. 6, Chap. IX). In more fashionable dress, even at the beginning of the period, starch came out of ruffs. and the multiple-pleated lace fell limp from a high neckband.

The next change, soon evident, was in the direction of simplicity. Excess of ornamentation, so usual in Elizabeth's and James's reigns, went out of fashion; though indeed to modern eyes both ladies and gentlemen still seem over-decorated and overclad. Long vertical slashes on sleeves, returning to favor, ousted short all-over slashes, and trimming was now largely confined to the edges of garments.

Rich textiles (notably velvet and satin), arranged in natural folds, soft, deep hues and clear, light tints, decoration of wide lace, narrow gold braid, and buttons—these are outstanding features of dress in the best years of the period, i. e., from about 1630 to 1650. In France during the next decade ornament again became over-profuse, and there began that craze for ribbons which distinguishes court dress in the later seventeenth century. In England, on the other hand, under the Commonwealth, Puritan taste produced a severity which only succeeded in depriving "cavalier" fashions of their charm. This austerity distinguished sober religionists everywhere: in England, France, Holland, and, notably, in the Massachusetts Bay Colony. It was not, then, actually different garments, rather plainer versions of the same, that set these people apart from their more worldly and extravagant contemporaries.

<div style="text-align:center">MEN</div>

Heads. As long as ruffs still retained their stiffness, hair was of necessity fairly short, the style most favored by fashionable men being a bob of reasonable length (not shingled). Cropped hair, as it appears on various figures in Chap. IX, was by no means uncommon in the earlier years, nor peculiar to puritanical persons (fig. 3). As the pleated falling ruff (fig. 1) was displaced by a scanter collar, hair was allowed to grow longer. At first it was fashionable to brush it straight back, preserving the high forehead admired by Elizabethans (though this did not preclude a side or center parting); later men followed the lead of the ladies and adopted a fringe across the forehead, either straight and thick or arranged in ringlets. Some dandies (including Charles himself) arranged their hair asymmetrically, i. e., with one side square-cut, the other in a long, beribboned love-lock; but from about 1630 to 1660, most men let their unbound hair fall on the shoulders, often in waves, but not arranged in set curls. While Cavaliers cherished their flowing locks, Round-heads made a virtue of cropped hair (fig. 3).

Beards and moustaches, already, in 1625 small and neat diminished still more during the succeeding years. The moustache, brushed away from the lips, bristled out at the sides (fig. 6) or curved upward (figs. 1, 2, 4, 5). The typical beard of the earlier years was that which we name "Van Dyck" (figs. 1, 5, 8). Later it was less fashionable than a small tuft on the chin (the style known as "Imperial," figs. 2, 4, 6, 9). By 1660 many men wore smaller moustaches *without* beards, and many others were clean-shaven. Older men naturally conserved the earlier fashions, and some even kept to long beards of the mid-sixteenth century cut.

Hats. Some conservative men (particularly Puritans) held to the stiff-brimmed and high-crowned headgear of James's reign (fig. 3), a style which was to become fashionable again before the end of the period; but in the thirties and forties court circles in England, France, and the South wore low-crowned hats. Moderately large brims were likely to be stiff (fig. 1), wider brims were softer and cocked up according to taste at front, back, or side (figs. 2, 4, 5, 7). While Puritans and men of humble class limited hat trimming to a plain band and austere buckle (fig. 3), fashionables made much of their hats. Some spent money on jewelled hatbands, others affected the elegance of a completely untrimmed hat, but most went in for ostrich plumes. These were long and varicolored and disposed according to the wearer's taste, sometimes piled in profusion on the hat, generally drooping from the brim or curling around the crown, rather than standing upright (figs. 1, 4, 5, 7). At the last of the period, large loops of ribbon rivalled plumes in popularity. The hats themselves, of felt or beaver, were more often black or dark than light, as in fig. 7.

Necks. Already by 1625 the small starched ruff had become the mark of the ultra-conservative; it remained during this period the accompaniment of official and clerical dress (fig. 9). The ruff has survived in a few costumes, such as the uniform of the Yeomen of the Guard, the choir dress of choristers at Salisbury Cathedral, and the pulpit dress of Norwegian Lutheran clergymen. The wide pleated ruff and the one which measured seven or nine inches from the neck were deprived of their starch and allowed to droop from a high neckband to the shoulders (fig. 1), a style popular till about 1630. After that date it was abandoned by the fashionable world in favor of a wide collar. Actually this "band" was no new thing, having been the wear of humble men and unostentatious gentlefolk for a hundred years. But now it was converted by the more frivolous into a wide and elegant affair, which spread in lacy expensiveness under the flowing locks of a cavalier (figs. 2, 4, 6). Plainer, though not necessarily less wide, it finished the necks of scholars, priests (fig. 8), working and serving men, and anyone of austere tastes (fig. 3). Plain linen collars which stood up and curved away from the face, somewhat like the earlier and wider "whisk" (fig. 5 and cf. fig. 4, Chap. IX), were especially popular with Spanish gentlemen, though not unknown in other countries. The cords with which collars were tied are visible in contemporary paintings (figs. 3 and 8), though not so often with the wide, lace-trimmed variety as with plainer styles. Collars were worn *outside* armor (figs. 5 and 6), cloaks (figs. 1 and 4), and gowns (fig. 8).

Bodies. The doublet of 1625–30 was still rather stiff, though no longer padded. It had a middling short waist, a distinctly pointed front, and a peplum which flared at the hips (fig. 1). Around the waistline appeared a series of ribbon bows with metal-tipped ends, which held doublet and breeches together. After 1630 the typical doublet was even shorter-waisted and not so stiff. In some doublets the body and the fairly long gored shirt were cut in one; thus

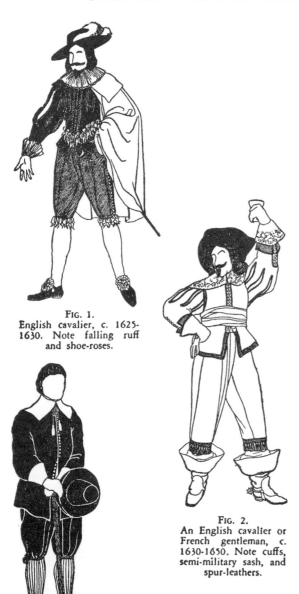

FIG. 1.
English cavalier, c. 1625-1630. Note falling ruff and shoe-roses.

FIG. 2.
An English cavalier or French gentleman, c. 1630-1650. Note cuffs, semi-military sash, and spur-leathers.

FIG. 3.
Roundhead or serv-ingman. Note the ratchets of his shoes.

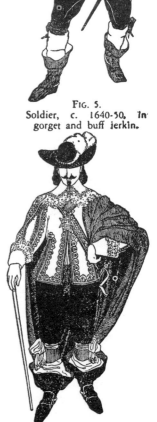

FIG. 5.
Soldier, c. 1640-50. In gorget and buff jerkin.

FIG. 4.
French courtier, wearing the cordon bleu, c. 1630-40. Note unbelted doublet and soft boot-hose.

the waistline was not defined (fig. 3). Others, also unbelted, were deeply slit at the sides (fig. 4); still others had peplums made of overlapping panels, in the manner of the women's bodices (fig. 13). Long vertical slashes (two or more in front and one or two in back) permitted great freedom of motion. Through the openings showed the white shirt. Often, also, the doublet was left unbuttoned from the breast down (fig. 4).

The jerkin, which in James's reign had been a part of nearly every formal costume, was now more often to be classed as a separate utility jacket. It was especially in favor as a soldiering garment and was frequently made of leather (the " buff jerkin "). It could be laced, buttoned, or fastened with frogs either on the sides or, as in fig. 5, up the front. Before 1650 jerkins had long skirts, as shown in fig. 5, later they were curtailed to about the length of a modern vest (fig. 3, Chap. XI). The jerkin worn by such old campaigners as Myles Standish was, as a rule, sleeveless, worn over a sleeved doublet. Speaking of sleeves, it is difficult sometimes to decide whether a jerkin is really sleeveless or equipped with sleeves of different material; both styles were known. The jerkin illustrated probably has its own sleeves, this type with horizontal rows of braid being a favorite with soldiers. The sleeved jerkin frequently took the place of a doublet; other jerkins, even those with hanging sleeves, required a doublet underneath. Leather jerkins worn by military leaders were sometimes embellished with elaborate all-over embroidery.

Arms. It is presumed that, as in earlier periods, sleeves were tied into the doublet with metal-tipped ribbons or " points " under the wing or " crescent " (fig. 1). Moderation was the rule for sleeves, all following in general a " leg-o'-mutton " shape, *i. e.,* wide at the top, diminishing from elbow to wrist. They were almost always slashed, except in the soberest of costumes (fig. 3). Earlier sleeves were decorated with slashes on the upper arm only, several of them all around (figs. 1 and 2). The later styles were more likely to have one long slash on the front of the arm, extending from armseye to cuff and trimmed with buttons and loops which could be actually buttoned if desired (figs. 4 and 6). Through the slashes showed the fine cambric shirt sleeves or sometimes, in the case of short openings, a puffy lining of different-colored silk.

Wrists were finished with wide cuffs, ordinarily white. An accompaniment of the pleated falling neck-ruff was a similarly pleated wrist-ruff (fig. 1). As a rule, cuffs matched collars, both in material and style (figs. 3, 4, 6). An innovation in this period, interesting as a precursor of the coat-cuff so important during the next hundred years, was an extra long sleeve with a different-colored lining or facing, unbuttoned for about six inches and turned back from the wrist like a cuff (figs. 2 and 5). Frequently a lace cuff was added, an effect reproduced in fig. 2, and one which may be studied also in the well-known " Laughing Cavalier " of Franz Hals. The small white ruffles in fig. 5 are continuations of the shirt sleeves, but wider cuffs were apparently separate articles.

Legs. During the reign of Charles I round trunks (French or melon hose)

(Chap. IX, figs. *passim*) went out of fashion, though retained in pages' liveries as pointed out by Kelly and Schwabe (*Historic Costume,* p. 125). Till about 1630 the modish leg-covering was a pair of moderate-sized knee-breeches or " slops " (see Chap. IX). They covered the stocking-tops, stopped just above the knee, and were finished by rows of ribbon bows with " points " (fig. 1) or by wide ribbon garters with large bows at the sides (fig. 6). Later on breeches were narrower, garter-bows or rosettes even larger (fig. 4). Plain breeches were plainly, even meagerly, gartered (fig. 3). Breeches as a rule repeated the long slash of the sleeve, fastened together entirely or partway with close-set buttons and loops (figs. 1 and 6). If left unfastened a little way up from the bottom, the slash displayed a white puff underneath, to match the sleeve-puffs.

After the thirties a rival to knee-breeches appeared in the form of tubular trousers, cut fairly full at the top and narrowing only a little toward the bottom, which was about six inches below the knee (fig. 2). The lower edge, which hung free from the leg, was often finished, as in the sketch, with fringe.

Feet. Stockings (stout yarn for every day, heavy silk for dress) were lighter-toned than breeches and frequently wrinkled on the leg (figs. 1 and 6).

Shoes had long vamps and round tips (fig. 1) which were displaced about the middle of the period by square tips (figs. 3 and 6). Heels were moderately high and often painted red. Tongues were high, with side-pieces fastened over them, meeting on the instep and secured by latchets of leather or ribbon (figs. 3 and 6). On early shoes the latchet was often covered by a shoe-rose (fig. 1); later, shoes were tied with big ribbon bows.

Boots were popular for most outdoor occasions and frequently for indoors as well. Spurs upon heavy spur-leathers were their usual accompaniment, even when the wearer was not intending to ride. Some of these boots were very long, tight as far as the knee, and so loose from there up that they fell back, displaying the lining (figs. 5 and 7). Others, not so high, were wider and turned over half-way up the lower leg (figs. 2 and 4). This gave an opportunity to show the colored, lace-edged, or embroidered lining or the top of the boot-hose (a second pair of hose, ungartered, which came between boot and stocking). Boots shared with shoes the long, squared-off tips.

Outer Garments. A semicircular cape was the principal outdoor wrap, a cape not so stiff as that fashionable in James's reign. If it had a wide collar (fig. 1), that also dropped limp upon the shoulders, whereas Elizabethan collars had flared outward. Capes were short or long according to their purpose but were all draped in picturesque ways, some of which are suggested in figs. 1, 4, and 7. Fig. 7 represents the typical disguise cape for a villain in a " cloak and sword " drama, an extra-long, completely circular cloak. To the inner side of the cape-collar (or to the neckband, if, as sometimes happened, the collar was omitted) long cords were attached, and with these the cape was secured to the body, as demonstrated in fig. 1.

Clergymen, scholars, and statesmen still wore long gowns of the style shown

in fig. 6, Chap. IX; undergraduates and poorer clergy continued to make shift with shorter gowns, much like those compulsory at Oxford to this day.

SOLDIERS

It may be difficult to realize that the daredevil Musketeers of France and the Cavaliers who fell defending their King at Naseby were tricked out in plumes, lace, silk, and ribbons, and that no particular uniform distinguished one army from the other on the battlefield. Old campaigners *did* favor the sturdy buff jerkin described above (fig. 5) and defended themselves for the thick of the fight with part armor: a cuirass, as sketched in fig. 6, or only a gorget, shown in fig. 5. Helmets, too, were still considered useful as a protection against bullets. Morions (illustrated in fig. 11, Chap. IX) continued to be popular, but not more so than the " lobster-tailed " helmet shown in fig. 6, with ear-pieces and articulated protection for the back of the neck. Just as often men fought in their plumed hats. Full plate armor, virtually like that sketched in fig. 11, Chap. IX, was worn rather as parade dress than as a costume for actual combat.

War-swords were long, heavy, and provided with projecting pieces at the hilt, of which two styles are illustrated in figs. 5 and 6. Dress-swords (figs. 1 and 4) were somewhat lighter, with knuckle-bowed hilts. The arquebuse and gun rest illustrated in fig. 12, Chap. IX, were still used, though the musket (which was also a match-lock gun) was so improved during the century that the gun rest could be dispensed with. Cartridge-belts were like bandoliers and swung from left shoulder to right hip. As a rule swords were hung on baldricks (figs. 4 and 5) though narrow sword-belts were fairly common (figs. 1 and 6). A broad military sash was often worn passed across the body, right shoulder to left hip, where it was tied in a large bow (fig. 6); just as often it was tied around the waist (fig. 2).

CLERGY

In England the lawmakers of the Established Church instructed its clergy to wear at home the ordinary dress of a sober gentleman, but outside the house a long gown or " cassock " and an academic robe with large sleeves. The " choir " or church costume consisted of the black cassock, a white surplice, and a black tippet; the dress when celebrating the Communion Service (again, as in pre-Reformation usage) included alb and chasuble (fig. 15, Chap. V). (This return to mediæval practice was abruptly stopped when, in 1644, a Puritan Parliament made the English National Church Presbyterian.)

Upon ceremonial occasions a bishop wore his cope and mitre, but his ordinary choir costume was practically the same as it is in the Episcopal Church today (fig. 9): black cassock; over it a *rochet* (a white surplice with large, full sleeves gathered into black wristbands); and over that again a *chimere*, a black silk, sleeveless gown, open in front. Laid across his shoulders and hanging down the front was the *tippet*, which was still sometimes of fur but

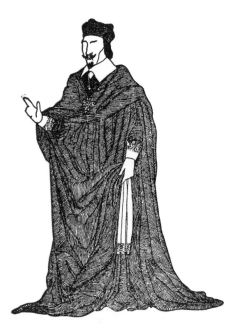

FIG. 8.
A French cardinal, wearing the
cordon bleu.

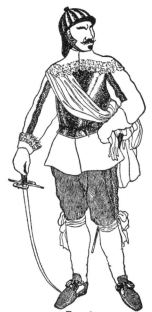

FIG. 6.
Soldier in "lobstertail" hel-
met, 1625-1650. Note steel
cuirass and military sash.

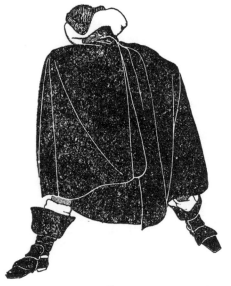

FIG. 7.
Bravo in disguise cape,
1625-1650. He is masked.

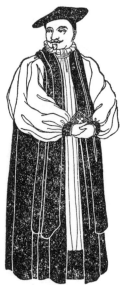

FIG. 9.
Bishop of the Church
of England.

frequently of silk. He might wear his University hood hanging down his back. Unlike a modern bishop, this prelate wore a neck-ruff, small and conservative. A bishop (a priest also) habitually covered his head with the biretta or " square cap," worn by anybody during the High Renaissance, but since Elizabeth's day the distinguishing mark of a scholar.

French Roman Catholic clerics dressed not unlike English churchmen, sober contemporary garments being the only habit prescribed. Priests wore hair and beard in the style affected by laymen. Cardinal Richelieu is the churchly character most likely to be introduced into plays about this period. In portraits he wears a " choir costume " like that sketched in fig. 8: cassock with choir-train, *cappa magna* (also trailing) and biretta, all of these red; surplice or cotta and cuffs of fine, lace-trimmed white linen; plain linen collar. There is no valid objection to dressing him thus in any scene.

Dissenting ministers dressed like members of their flocks, in sober colors and black.

WOMEN

Heads. Even before Charles came to the throne, the high-dressed coiffure affected by Anne of Denmark had gone out of style (fig. 23, Chap. IX), and by 1630 fashionable heads, instead of being long and oval, were wide and squarish (figs. 10a and 11). Side locks were cut rather short and curled to a frizzy mop; back hair, left long, was coiled in a bun. The front hair, except what was in a fringe on the forehead (figs. *passim*), was drawn straight back from the face. During earlier years the fringe was rather thick, but after 1650 it was thinned to a sparse row of curls. After mid-century locks were somewhat longer and ringlets made their appearance (fig. 18). The back knot, braided or twisted (fig. 13), was disposed at any becoming angle and supported ornaments: a comb (fig. 11), strands of pearls (fig. 14), a set bouquet (fig. 13), or a feather. In Spain, where court dress always leaned toward formality, coiffures were stiff. In fig. 17 is sketched a Spanish style of arranging long hair, a union of sixteenth century stiffness and seventeenth century width. The familiar Velasquez portraits of the Infanta show how Spaniards sometimes exaggerated this width.

Modish English and Continental ladies no longer wore caps. To be sure, dowagers clung to the older fashion and widows donned that coif which succeeding generations have identified with Mary Queen of Scots (fig. 10a): a graceful cap, pointed on the forehead, arching over the temples. Black was proper for this widow's coif. Very much the same cap in sheer white was worn by Dutch burghers' wives. Another Dutch bonnet, sketched in fig. 10b, is a good deal like fig. 10a, except that the cap fits close to the head and the point is lower on the forehead (cf. fig. 15d, Chap. VII). The third headdress (fig. 10c) was also much affected by the Dutch bourgeoisie. The front piece is a rounded disk, presumably made of cardboard or light wood, covered with black silk, with a black silk pompon sticking out of the middle. It is attached

to an ample black veil by means of a black band. " Cap " and veil, poised at front and back of the head, balance each other.

Middle-class and peasant women in England, France, Germany, and Holland wore white caps, many of which still form a part of regional costumes. Caps like those illustrated in figs. 15 and 16 were worn by the wives of English merchants; such caps were also seen in France, Holland, New Amsterdam, New England, and Virginia.

Women's hats scarcely differed from men's. As yet a hat was not a necessity outdoors, and a lady might walk, ride, or even make a journey with uncovered hair. However, a court lady occasionally appropriated the cavalier hat made of velvet or beaver and abundantly decked with plumes. Less fashionable women went to market in wide-brimmed, steeple-crowned felts or beavers, discreetly ornamented with a steel buckle or a tasselled cord (fig. 15). They frequently clapped such hats on top of their white caps, a custom which persisted for a long time and is indeed still followed in the almost extinct national costume of Wales. Women's hats, like men's, were oftener dark than light.

The hood was a type of head-covering which served all classes. In its simplest form it was only a square of silk, woolen, or lace, folded diagonally and tied loosely under the chin. Most of these kerchiefs were black, though some lace ones were white. Almost as simple as the kerchief was a primitive bonnet made of a strip of cloth, the back edge puckered to fit the head, the front corners furnished with strings to tie under the chin (fig. 19). The woolen hoods were made in black and in colors, so often red that they were finally called " cardinals." Such hoods lasted, with variations in the shape, well through the eighteenth century (fig. 13, Chap. XII) and indeed survived into the nineteenth. As for the unshaped kerchief, it has never disappeared from peasant dress.

Necks. Till about 1630 high-necked costumes included a pleated neck-ruff with the starch omitted (figs. 10a and 11). It was a long time, however, before older women gave up the formal starched ruffs and longer still before such ruffs disappeared from the gala dress in some country districts. The square décolletage, very low in front, fashionable during James's reign, held its own into the thirties. The bare bosom was partially veiled by folds of lawn, plain or pleated lace edging, or even a " standing ruff," the so-called " Medici collar " (fan-pleated or plain) which had been worn since Elizabeth's day. The typically seventeenth century neckline was wider on the shoulders and somewhat higher in front. Long sloping necks became the mode, the effect enhanced by berthas of sheer lawn and lace which always dropped over the shoulder (fig. 13). In fact this was a period of collars.

Never has white linen been used in prettier ways to conceal or only veil the neck and bosom. The accompanying sketches show examples but do not pretend to exhaust the varieties. Fig. 12 has a double collar; fig. 14 a lawn vestee and bretelles. In fig. 15 you may see how a lady might combine conservatism with the display of a fine bust, for the collar, encircling the base of

the throat, spreads apart and is, besides, of transparent lawn. Fig. 18 is charming and modest, with a fairly high-cut bodice, a sheer pleated kerchief fastened in a high V, and a collar as high-necked as a man's. Fig. 16 represents a housewife of the middle class and of sober tastes, whose kerchief, folded diagonally and pinned close in her throat, is of thoroughly opaque linen. Puritan women wore such a kerchief, or a collar made like the one in fig. 15, of heavier linen, pinned together to cover the neck; not only pious dissenters, but any woman of the serving classes dressed thus.

Bodies. Up to about 1630 bodices retained a stiff corset shape and a long, pointed stomacher (fig. 11), but soon after that time they were less heavily boned and much shorter-waisted all around. When the stomacher of an undergown was visible, its sides were well concealed by the short-waisted body of the upper gown and its point lay on the petticoat (figs. 11, 14, 18). Through Charles I's reign the stomacher continued to be seen, often with the upper gown laced over it. In the later years of the Commonwealth in England and the minority of Louis XIV in France it returned to fashion. During the interim another type of bodice was more in favor, a short, big-waisted jacket, with a peplum usually consisting of tabs which varied in length from six or seven to eighteen inches below the belt. About six of these tabs, narrower at top than bottom and overlapping, made a continuous flaring peplum (figs. 12, 13, 18). Often the place of the front tab was taken by the blunt-pointed bodice front. Not all short-waisted bodices had peplums; some stopped at a round waistline and fitted over the skirt. Sober dresses, such as that in fig. 16, were as likely to be made with as without a peplum, either tabs or a shaped piece cut flaring. The woman in fig. 17 demonstrates again in the style of her bodice that formal and conservative interpretation of the mode so typical of the Spanish court; here the long, stiff, pointed waist is combined with a fashionable neckline and sleeves, and a peplum of ample length. A soft ribbon sash tied at the front or side-front (figs. 11, 12, 14, 18) was a fashionable accompaniment of seventeenth century bodices.

Arms. The seventeenth century differs from preceding Christian periods most radically in the matter of sleeves. For the first time in centuries women in formal dress displayed a portion of their arms. Already before 1625 this tendency had begun (fig. 23, Chap. IX), and from that time on, semi-short sleeves were the rule rather than the exception. Until about 1660 the elbow was always covered, and generally half of the forearm also. Long sleeves (fig. 17) were not entirely abandoned, of course. During the first few years of the period large sleeves remained in fashion, and they seem to have retained the stiffening which gave them a balloon shape, even when, as often happened, the fullness was divided by a ribbon into two puffs (fig. 11). Many small vertical slashes displayed an undersleeve of white or a color. In fig. 11 these slashed sleeves belong to an underdress and the small cap-sleeves to the overgown. Early dresses had shoulder-wings, but with the advent of wide collars and berthas these passed into disuse. After about 1630 sleeves were no longer

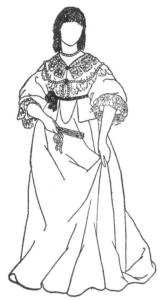

FIG. 12.
English lady, c. 1640-50.
Note her double lace
collar.

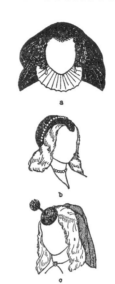

FIG. 10.
a, French, 1630-1640.
b, Dutch, 1600-1660.
c, Dutch burgher's
wife.

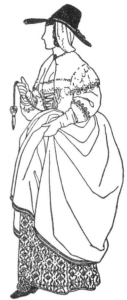

FIG. 15.
Wealthy bourgeoise,
French, English or
Dutch, 1640-50.

FIG. 14.
English court lady, 1630-
1649. Note the ruffled cuffs.

FIG. 11.
English court lady, c. 1625-30.
Hair, ruff, sleeve, and long
bodice mark this as a transi-
tion costume.

FIG. 13.
English court lady, c.
1640. Note the bouquet
in her hair.

very full, nor puffed, nor tied with ribbons. They were of moderate size, some even rather small (fig. 16) and almost the same width from armseye to cuff. Though sometimes trimmed with vertical strips of braid (fig. 18), they did not often follow the masculine fashion in slashing. A white finish was almost invariably added at the wrist. The much-pleated sleeve-ruff (fig. 11), while most popular in the 'twenties, was not entirely abandoned later, nor was the turned-back pleated cuff (figs. 17 and 18). Double-ruffled cuffs with extra ruffles turned down over the arm (fig. 14) were fairly common. More often than any others appeared turned-back cuffs like men's, plain or lace-edged. It is worth noticing that these cuffs were not very snug-fitting (figs. 15 and 16), for the whole sleeve was fairly heavy, indeed a little clumsy.

Legs. Only at the Spanish court was the farthingale still worn (fig. 17); there, the reputed place of its origin, it held on until the reappearance of hoops in the rest of Europe. Velasquez is our authority for the use of hoops more exaggerated even than those in Elizabeth's wardrobe. Everybody outside of Spain threw away their cages and let their under-petticoats, petticoats, and gowns fall about their legs in graceful, albeit heavy, folds. Except for being able to get through smaller doors and sit in narrower armchairs, ladies did not gain much freedom by this change of style, for it is really easier going if yards of material are held away from the legs instead of clinging around them. On the other hand, the new draperies were certainly pleasanter to look at.

During the time that over-gowns were still the rule, they were often open all the way up the front, displaying the skirt of the underdress (figs. 11 and 17). In mid-century the upper skirts were more frequently seamed up all around. Court ladies and the wealthier bourgeoisie wore these upper skirts very long, making it necessary to loop them up for walking and thus giving opportunity for the display of petticoats of considerable richness (figs. 13 and 15). Such bunched-up draperies were often simply held in the hand or thrown over one arm, but active women tucked them into the belt or pinned them back, leaving their hands free. During the last years of the period the upper skirt was again open in front and occasionally pinned back out of the way, forming panniers. This arrangement became more fashionable during the second half of the century.

Feet. Skirts were so long, even in the dress of middle-class women, that shoes seldom show in contemporary pictures. In general, they followed masculine styles, though the squared-off point was not so exaggerated. Large shoe-roses (fig. 15) were fashionable in the earlier years, and, later, ribbon latchets and highish tongues. Women's shoe heels were fairly high and, like men's, often painted red. Ordinary women wore heavy black shoes with broad low heels and latchets of thongs. Silk stockings were luxuries of the rich, home-knitted yarn hose, necessities of the poor.

Outer Garments. Women enveloped themselves in circular capes, like those described under MEN, when they desired either extra warmth or that anonymity

which is so often part of the plot in the " cloak and sword " drama. The cape or cloak illustrated in fig. 19 has large, loose sleeves and is belted at a high waistline—a type often represented in contemporary art.

CHILDREN

Still dressed in small replicas of adult costume, girls as well as boys profited by the relative comfort of these styles over Elizabethan (fig. 20). Until they were three or four years old, little boys wore girls' clothes, including aprons and the close bonnets illustrated in fig. 20, made familiar in the well-loved picture of " Baby Stuart."

MATERIALS

Velvet and satin are equally characteristic of the period, which is further distinguished from both the preceding and the following years by the popularity of unpatterned fabrics. Not that figured materials vanished (figs. 15 and 17) (for instance, brocaded satins hold an important place in the costumes painted by Van Dyck); but there seems to have been real appreciation and enjoyment of the high lights on plain silken folds (figs. 11 and 18).

Woolen, cotton, and linen fabrics were generally unpatterned, neither stripes nor plaids playing any important part in even unpretentious dress. Soft, fine woolens held their own in the costume of gentlefolk, while coarser homespuns continued to be the all-purpose materials for plainer garments.

Fine and heavier bleached linen was used in collars, cuffs, and aprons; linen of the type we call " crash " for jackets, underbodices, and petticoats (frequently embroidered); and fustian, that heavy, canvas-like cotton material, for whole suits as well as for linings.

The period made beautiful use of lace, mostly in collars, berthas, and cuffs. Venetian point and the bobbin laces of France and Belgium were equally prized.

COLORS

Dark, rich hues like Burgundy, sapphire-blue, crimson, purple, and brown (and of course black) were favorites for velvet, and it is to be remarked that young girls and even children were dressed in these dignified fabrics and colors. White, cream, sky-blue, almond-green, tan, rose, and gray were fashionable in plain and brocaded satin; they were made into masculine as well as feminine garments. Beautiful contrasts of dark and light resulted from the universal use of white collars and cuffs on velvet; the white or cream-color of patterned lace further enriched and softened pale-toned costumes.

Scarlet-dyed woolen (p. 142) was so generally employed for warm hoods, cloaks, and petticoats that red must be considered a frequently recurring note in any assemblage of middle-class people, even the most godly. It is a mistake when costuming Puritans of either England or the colonies to confine the color-scheme to black and gray. In addition to the scarlet just mentioned, ap-

propriate hues include rust-red, brown, leather-colored (" buff "), deep wine-color, maroon, dark blue, bottle-green, and violet, as well as light tones such as tan, pearl gray, and gray-blue.

MOTIFS

Renaissance patterns were still dominant in brocaded fabrics, though as a rule they were rather smaller than during the sixteenth century. Diapers, dots close together, small floral sprigs, and spiral designs (fig. 11) occur also, as well as close-set formalized floral motifs like those on the petticoats in figs. 15 and 17. Indeed, old motifs, "tightened" and formalized, rather than new motifs, characterize seventeenth century design.

APPLICATION OF DECORATION

While, as noted above, the age admired rich fabrics plain, needlewomen went on embellishing both satin and heavy linen with fine stitchery, as they had done in Elizabeth's day. Raised " satin-stitch " and quilting were equally popular, such work being applied to caps, jackets, doublets, stomachers, sleeves, baldricks, purses, boot-hose tops, gloves, and other fairly small articles of apparel.

Garments were trimmed along the edges: hems (fig. 13), fronts of gowns (figs. 11 and 18), bottoms of doublets (figs. *passim*), hems of oversleeves, and bodice-tops (fig. 11). Slashes were edged with gold braid (figs. 1 and 20), metallic lace, or gimp. Close-set buttons with matching loops (fig. 4) are a trimming especially to be remarked in this period; they might be practical or only decorative. Braiding applied all over an area was an especially military decoration (fig. 5).

White lace as trimming was almost entirely restricted to collars, berthas, and cuffs and to an occasional chemise front visible through bodice strings; the exception is ecclesiastical dress, where, as nowadays, lace was liberally applied at the hems of surplices and cottas (fig. 8).

JEWELRY

Men managed to introduce a good deal of jewelry into their dress. Hatbands and brooches, buttons, studs, pins, and rings were all included. Sword-hilts, too, were often fine examples of the goldsmith's art.

Yet the most important ornament of a courtier was the badge of the order to which he belonged. The Garter in England, the Fleece in the Low Countries, the Order of the Knights of Malta in Spain were still among the most distinguished honors to which a man might aspire. But in France all courtiers hoped to become members of the Order of the St. Esprit (Holy Ghost), which had been founded by Henri III, the last Valois king. Membership in this order was limited to one hundred, and most of the important Frenchmen in this and the succeeding period attained that honor. The badge (figs. 4 and 8) was a green cross with eight points, bearing upon its obverse a

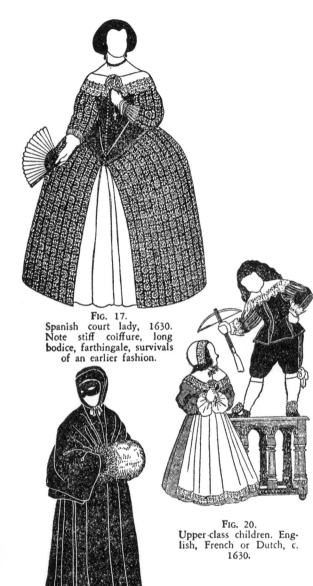

FIG. 17.
Spanish court lady, 1630.
Note stiff coiffure, long
bodice, farthingale, survivals
of an earlier fashion.

FIG. 16.
Middle-class housewife,
English. A dress suitable
for Puritans.

FIG. 20.
Upper-class children. Eng-
lish, French or Dutch, c.
1630.

FIG. 19.
Travelling costume. English
or French.

FIG. 18.
English court lady—travelling
or riding-dress, c. 1640. Note
her kerchief and collar.

dove turned downward, on its reverse the Archangel Michael. After the time of Henri IV its " collar " or chain was composed of the lilies of France alternating with the monogram H. In the seventeenth century, however, this order, in common with others, was often worn on a broad ribbon. The ribbon of the St. Esprit was blue, so that after a while the Order itself was known as the " cordon bleu " and, by implication, its members were referred to as " les cordons bleus " (for instance, by Mme. de Sévigné). The order was not dissolved till 1831.

Earrings for men were no longer very fashionable; though it is said that Charles I wore one to the scaffold. Seafaring men clung to their earrings for two hundred years and more; not only professional pirates, be it noted, but " respectable " sailors as well.

Women continued to place long, pear-shaped pearls in their ears; but earrings showed less with dangling side-curls than with the close-dressed hair of the preceding fashion.

A choker of large beads, oftenest pearls, but sometimes gold or semi-precious stones, like carnelian (figs. 12, 14, 17), was nearly always worn with low-cut dresses. A court lady frequently added a long pearl chain, festooned wide upon the bosom and held in the front by a large jewelled brooch (fig. 14). From that point the chain frequently fell in a loop over the bodice (fig. 12). Brooches were popular with all classes as clasps for the collar (fig. 15).

With the advent of short sleeves, bracelets became important ornaments. Double strands of pearls twisted around the arm (fig. 11), and golden bangles set with jewels are both to be seen in contemporary portraits.

Early coiffures permitted the use of wide combs topped by pearls (fig. 11). Later the long loose tresses were twined with strands of pearls (fig. 14). Little ornaments put in beside the knot of back-hair were sometimes of gold and jewels. Gold and precious stones were employed for buttons, studs, and indeed for a great variety of feminine dress-accessories.

ACCESSORIES

Men. The military sash described on p. 230 was adopted upon occasion by men not soldiers (fig. 2). It was often deeply fringed.

Daggers were no longer a common accompaniment of non-military costume, but swords were, as has been noted under SOLDIERS. Walking-sticks came into style: canes made of smooth wood, with simple, round knobs of wood or metal. Though often moderately short, as sketched in fig. 4, they were also of the height shown in fig. 1, Chap. XI.

Gloves (figs. 2 and 6) were still important items of masculine dress. They had gauntlet cuffs, some of which were embroidered as in the previous period, some plain and even unstiffened. The Elizabethan purse or " pocket " hung at a man's belt continued to be popular through Charles's reign. Purse and belt, when not visible, may be assumed to be present under the doublet or jerkin.

Men and Women. Two accessories already familiar in Shakspere's day now began to be more widely used, *i. e.,* the patch and the mask.

In "All's Well That Ends Well" the Clown says that Bertram has "a patch of velvet on's face: whether there be a scar on't or no, the velvet knows; but 'tis a goodly patch of velvet"; which points to a Renaissance use of this curious embellishment, and one reason for it. There are plenty of such references in Elizabethan texts. Yet the real vogue for patches began toward the middle of the seventeenth century. Though satirists of this and succeeding periods drew faces spotted with patches in the most grotesque profusion, and though it is said that a sort of sign language grew up about their use, serious portraits seldom show them, or at most only one modest circle or star (fig. 18).

Masks were worn, of course, as disguises by professional bravos, who lurked in dark corners to rid some well-paying patron of an inconvenient enemy (fig. 7). But masks had a more legitimate office in protecting the delicate complexions of ladies from the dust and sun of the public highway. Half-masks, such as that pictured in fig. 19, and others which covered the whole face, perhaps with a lace curtain for the lower half, were equally popular. The second function of this accessory in a lady's wardrobe was to preserve her anonymity and protect her reputation; an invaluable "prop" for Lady Thus-and-So when, in Act II, she comes to the old tavern to keep a rendezvous with the hero.

Muffs, mentioned in Elizabethan texts (I have not seen them in Elizabethan portraits), had by now become very popular. Women carried them so universally that the wonder is how they had ever gotten along without; carried them with warm wraps (fig. 19), with plain street clothes (fig. 16), and with low-necked dresses (fig. 14); carried them, actually, in company with fans (fig. 14). Men, too, made use of these comfortable accessories, though not nearly so often during the first half of the century as later. Muffs were of fur, cylindrical, not so tightly stuffed as they have been later, and of moderate size.

Women. The adoption of short sleeves brought in the fashion for elbow-length gloves, pulled smooth or allowed to wrinkle on the arm (figs. 15 and 18). With long sleeves the ladies drew on soft-wristed short gloves, stiff gauntlets having been discarded from feminine styles (fig. 17). White and light-colored kid, undecorated, was the fashionable material.

Although the apron was still excluded from formal court dress (unless for children, fig. 20), as a pretty, sheer white panel, occasionally lace-trimmed, it had become almost the badge of the wealthy bourgeoise. Fig. 16 shows a plain apron; the little girl in fig. 20 wears one ornamented with lace, as her mother might. Aprons made entirely of lace are to be seen in some portraits—costly accessories. Being stringless, the apron was tucked up under the bodice point.

The ribbon sash or girdle, so frequent an accessory in this period, made a convenient line from which to suspend various useful articles: *e. g.,* a purse (fig. 16), scissors (fig. 15), needle-case, keys, a mirror (fig. 18) or a fan (fig. 14).

Fans were still popular, rigid and folding types equally so. The small fan shown in fig. 11 is of an interesting shape.

SOMETHING ABOUT THE SETTING

Oak panelling, carved in the florid style of the late Renaissance, with Roman details, floral festoons, and a profusion of naked cherubs and realistic animals; plaster ceilings ornamented in strap-work and other designs—these are typical interior decorations of seventeenth century houses. Exteriors were of timber-and-plaster construction, sometimes with carved oak balconies overhanging the street.

Furniture followed the lead of architecture, with backs and legs arcaded (fig. 20) or carved in a " barley-sugar " twist, like the architectural columns. Elizabethan and Jacobean melon-bulged legs still appeared on tables, and the same ornament on four-poster beds.

The rich ate from heavy, elaborately-ornamented silver vessels, and drank from silver tankards; poor folk used pewter, horn, and wood for their plates, cups, and spoons.

No new musical instruments were added to those described in Chap. IX. Lutes were still popular; so, of course, were fiddles; virginals appear frequently in paintings of the period, and recorders are mentioned with admiration in contemporary literature.

PRACTICAL REPRODUCTION

Materials. Although seventeenth century costumes were vastly less stiff than those they replaced, the actual weight of materials was the same: velvets, satins, and brocades were heavy, and their folds stood out from the body. You will fail to suggest the elegance of the period if you copy these costumes in light-weight, sleazy material. Since modern fabrics (especially inexpensive sorts) are seldom heavy enough, the very first necessity is linings and petti-coats of unbleached muslin or sheeting.

Assuming, then, that you will reinforce most of them, you may use: sateen, thin satin-finished silk, and rayon satin; lining-brocades, drapery-brocades; vel-veteen and corduroy; rep, terry cloth, ratiné, denim, khaki cloth. You can probably buy material appropriately patterned to imitate brocades among draperies or lining-materials. Linen curtain-stuff is sometimes to be found woven in a raised floral pattern, resembling hand-embroidery of this period; occasionally, too, cretonne looks like it.

Heavy flannelette or outing flannel, dyed, resembles fine-woven wool and is appropriate even for a cardinal's robes (though you will probably use sateen or cotton poplin if you want the character to appear in silk, which he may equally well do). The mottled gray flannelette looks like coarse rather than fine cloth. Burlap, dyed and lined with self-color, is decidedly the most con-vincing cheap material with which to represent rough peasant homespun. Real woolens and cotton-and-wool mixtures are of course desirable and, wide as they

often are, occasionally prove as inexpensive as the cotton substitutes. Ratiné and terry cloth look like rather finer-woven frieze. For the soldierly buff jerkin use leather, suede, felt, or upholstery canvas dyed brown.

For collars, cuffs, and aprons like those in figs. 3 and 16, use longcloth, percale, or light muslin; for sheer neck-finishes, batiste. Consult Chap. IX for the process of making ruffs. Employ coarse laces in preference to delicate: honiton, cluny, machine-made filet (the kind used for table-runners), even battenberg. Starching is often helpful to make collars stay where you have arranged them.

Trimmings. Besides white or cream lace, you may use metallic, but only as a narrow edging. This, with gold or silver braid and gimp, can often be bought among lamp-shade materials. You can also gild or silver coarse lace, braid, tape, or rickrack trimming, but this you will have to do, carefully, after it is sewed on the garment. Buttons are important items in decorating these costumes, and you can use almost any fancy sort: brass, steel, silver, cut steel, brilliants. Bone or pewter buttons are appropriate on plain garments: you can silver bone buttons or wooden button-molds to simulate the pewter.

Accessories and Millinery. Chap. XX offers suggestions for making hats and making or faking jewelry. You may use sparkling gems and pearls from the ten-cent store. Modern kid or even fabric gloves may be worn by women; men's gauntlets can be made as explained in Chap. IX; so can hanging " pockets." To make metal tips on ribbons: cut small pieces from a tin cigarette-box and pinch on to the ribbon-ends with pliers. Masks sold for fancy-dress wear will do for seventeenth century masks; in strict accuracy, they should not be held to the head by elastic; so if they are to be adjusted on the stage, you had better substitute ribbons. Make the rigid fans as described in Chap. IX. For the folding sort, buy large fans made of plain paper and paint them in solid colors or designs like those on the petticoat in fig. 15, the gown in fig. 17, or other floral or geometric patterns; if you like, you may use cherubs and festoons of flowers, in the manner of contemporary wood-carvings.

Hats present no very difficult problem. If you have some old felts with the crown and brim in one piece, you can reblock them into the steeple-crowned hats sketched in figs. 3 and 15, following the directions in Chap. XX. You can also make hats from buckram covered with cloth. Patterns may be found among standard masquerade costumes, under the title of " witch " or " puritan "; but the felt hat is easier to make and more satisfactory when finished. You should be able to collect old velvet, felt, or, with luck, beaver " picture hats " that will easily work up into the sweeping cavalier hat shown in the sketches. There is no really adequate substitute for ostrich plumes, except in costuming long-distance plays or pageants; for such purposes you may make handsome feathers of shredded and curled paper (according to directions issued by the Dennison Company). Willow-plumes may often be begged or borrowed. Remember also that you *can* omit plumes in favor of jewelled hatbands, that you may use a cluster of cock's-feathers or quills, that with a cos-

tume of the 1650's you may substitute clusters of ribbon loops, and that you may give even a dressy character an untrimmed hat.

For making women's caps, see Chaps. VIII and IX.

Shoes. Square-tipped shoes are carried by a few theatrical costumers. Faking them is difficult and, dramatically speaking, hardly worth the trouble. Better to use the actor's own half-shoes with moderately pointed toes, and give them a touch of authenticity with huge shoe-roses, like those shown in fig. 1; make the rose of layers of gathered silk or ribbon, fastened on a buckram backing and attached to the shoe-laces by safety-pins. Paint the heels red with tempera, which will wash off later. If you prefer a shoe with a latchet, like those in figs. 3 and 6, take house slippers, either leather or felt, add a tongue and side-pieces of similar material, and tie them over the instep. Preferably use black, though dark brown is permissible.

Women's shoes show so little that modern styles may be worn without great offense to the stickler for authenticity. Choose long-vamped models with moderate Cuban heels; black kid oxfords are the best shape, though party-slippers of gold or figured brocade are right as to material. Add large shoe-roses, in the manner shown in fig. 15. Peasant women, whose dresses may be shortened to the instep, should wear heavy black, low-heeled oxfords, or house slippers remade as described above, or, for the matter of that, heelless felt bedroom slippers just as they are (minus any fancy pompoms). If peasant women's stockings show they *must* be cotton or woolen, not silk; if for any reason a lady is to show her stockings, see that they are heavy service-weight silk, not chiffon.

Costumers occasionally carry wide-topped cavalier boots, and if you can see them before renting and can afford the expense, it is wise to get them, bearing in mind the styles shown in the accompanying sketches. However, you can fake boots pretty successfully by adding leggings to heavy, square-toed shoes. Make the leggings of black or russet leather, leatherette, dull-finished oilcloth, or upholstery canvas dyed and made up double. Following your chosen model, make the leggings with front and back seams and elastics to go under the instep. Cut the leggings straight and rather loose to go up the leg as far as you wish; then add the other, flaring, piece. Cut this a complete circle with a hole in the middle to fit the top of the legging; then take it up in darts at front, back, and sides till it has the desired flare. Line the entire legging with canvas. The lower part will need it for stiffening, and the upper part for the contrasting color; line that part again, if you wish, with lace-edged muslin.

Make the spur-leather of another interlined piece which you will put on separately and fasten with an elastic under the foot and a strap and buckle behind. It is very useful to cover discrepancies between legging and shoe. For the campaign-boots sketched in fig. 5, you can start with army-boots, adding only the extra top which flares moderately, and the spur-leather. Spurs (fig. 7) are so like the modern kind that you may use the latter without incurring criticism save from an expert. If such spurs are not available make your own of plastic wood built up on a foundation of iron wire (Chap. XX) and treated

with shellac and graphite, as described under *Armor* in Chap. XX. Twist loops at the end of the side-pieces and sew these with carpet thread very firmly to the leathers. It is a good plan to use for the rowel the wheel-part of a dressmaker's tracing-wheel, imbedded at the end while the material is soft. You can also cut spurs from sheet-lead, but they must be worn carefully, for lead bends.

CUTTING THE GARMENTS

Men. Cut the body part of a man's doublet or jerkin by the " Mephistopheles " pattern. Following one of the sketches, make the doublet shorter-waisted and add a peplum of overlapping tabs or one of the flaring peplums (for which you can use the pattern as a guide) (figs. 1, 2, 6). Even with the garment apparently cut all in one (figs. 3 and 5) it is really better to cut the skirt separate and seam it on as inconspicuously as possible (as tailors do with modern cutaway coats). The peplum of the pattern is a good cutting-guide for such skirts also. To cut sleeves use a leg-o'-mutton pattern (Chap. XX) or the sleeve of the " Mephistopheles " doublet; with the latter extend the upper part in a wide curve to the cuff instead of making it tight from the elbow down. Fill in short slashes with puffs of contrasting material; under long vertical slashes provide a complete sleeve of lighter color or white.

Cut the bellows-breeches on a pattern for women's knickers or the " George Washington " or " Continental " pattern (Chap. XX); they should be fairly full at the top. For the open-legged trousers sketched in fig. 2 use a pajama pattern, cutting the legs off shorter and tapering them a little if necessary. With both types of trousers supply suspenders and the necessary buttons.

Use mercerized stockings in preference to silk, which are difficult to get heavy enough. Always provide thick cotton or woolen stockings for plain costumes—unpatterned stockings, of course.

Women. Cut all bodices on the fitted lining pattern (Chap. XX), changing the shape of the neck. If the dress is to be worn with a plain high collar, follow the high neckline indicated in the pattern. Cut off at the waistline in imitation of the sketch. Seam up the outside and lining together and bone the bodice at front, side-seams, side-fronts, and back. Add tabs and stomacher as called for. The stomacher needs a buckram interlining and boning at the sides and probably across. Use the sleeve-pattern provided, adding fullness as needed on the outside of the arm (straight of the goods). To give the proper effect in copying fig. 11, interline the sleeves with crinoline. Finish the bodice at the bottom if you do not have a peplum, and in any case provide it with heavy hooks at front, back, and sides, to meet eyes on the skirtband.

Make all skirts straight and gathered into a waistband. Eight yards is the minimum width needed in any material, ten in goods as soft as sateen. Every dress must be worn over at least one petticoat eight yards wide. To get the best effect with rayon satin, make it on an interlining (paper cambric will do) in *addition* to putting it over the petticoat. If a gown is supposed to open over a

fancy petticoat you may fake the latter with about two widths of material sewed on the front breadths of the petticoat.

Cloaks. Semicircular capes have been described more than once. The " Mephistopheles " pattern includes a small cape which may be used as a guide for cutting a larger one. The large, truly circular cape must have a diameter twice the distance from neck to hem, probably three yards, which will take nine yards of material a yard wide. Sew the widths together to make a square and cut a true circle. Cut out a small circle the circumference of the wearer's neck; split the cape up the front. The " Mephistopheles " pattern has a cape collar if you need one, which you may modify at its outer edge as you wish.

Cut the woman's cloak pictured in fig. 19 as three-quarters of a circle (very long). Cut side-slits for the arms to go through thus: start at the top of the arm and cut a place about ten inches long, on the straight of the goods; face or bind. Next take a rectangle of material about three yards long and a yard and a half or two yards wide. (The measurements will depend on the wearer: for the length estimate once and a half the distance from neck to wrist, doubled; for the width, the distance from neck to about six inches below waist, doubled.) At a point midway of the length cut the rectangle half-way across its width (this will be the open front). Round out a neckline to correspond to the neck of the cape. Sew the two necks together, seam inside; finish all raw edges. Put the garment on like a coat with cape sleeves; confine the cloak with a belt, high-waisted, *under* the top drapery in back, *over* it in front, and pleat in the drapery as shown in fig. 19. Having adjusted and pinned the belt on the wearer, tack it permanently.

To make the hood shown in fig. 19, take a piece of material about a yard square. Put it on the wearer's head and adjust it on a gathering-thread to fit neatly at the nape of the neck; sew ribbons on the front corners and tie under the chin.

Suggested Reading List

All the costume books listed in Chap. IX and some of those in Chap. VIII can be profitably consulted for this period also. Most useful of them all are the two books by Kelly and Schwabe (see Chap. VIII) because of the number of excellent pictures (carefully dated), the brief but well-organized and informative text, and the excellent bibliography. Calthrop (see Chap. VIII) reproduces some of Hollar's engravings from the *Ornatus Mulierbris Anglicanum;* McClellan (see Chap. IX) others, larger. Warwick and Pitz (see Chap. IX) include among their illustrations portraits of colonial governors and divines and their wives.

A book which has a few pictures from earlier periods, but is more valuable as a reference for the seventeenth and eighteenth centuries, is *Four Hundred Years of Children's Costume,* by Percy McQuoid. These are color-reproductions of child pictures by famous artists. A page of text with each picture gives its date and some information about the sitter.

Where Further Illustrative Material May Be Found

In the pictures by artists listed on p. 240 and their contemporaries, both painters **and**

engravers, can be found a wealth of information on the costumes of this period. The larger art galleries in Europe and America contain works of these artists and so do many small civic galleries and private collections. Reproductions, besides those contained in the books listed above, are accessible in histories of art, biographies of artists, and other books dealing with the period, and in collections of art prints. Magazines like *The Connoisseur, L'Illustration, Art and Archæology, The Burlington Magazine* and other art journals; current publications like the *Illustrated London News,* and the picture sections of Sunday papers should all be searched for reproductions of pictures. Look out, too, for illustrated catalogues of exhibitions and sales.

Of seventeenth century artists, none is more valuable to the costumer than Hollar, the Bohemian engraver who worked most of his life in England and the Netherlands. Such another in France is Abraham Bosse. These two pictured life as they saw it about them, with probably even less concession to Art (as contrasted with reality) than was made by the Dutch *genre* painters. Van Dyck painted English court ladies and gentlemen as they wished to see themselves; Philippe de Champaigne and Pierre Mignard did the same in France; Hollar and Bosse drew the well-to-do and respectable townspeople as they actually looked in their comings and goings, their dances and banquets. These two artists clung to the habit of realism, even when their subject chanced to be a court scene. How fortunate for us that they left such a complete record of bourgeois activities and costume just at the moment when the middle class was becoming influential in shaping the destinies of nations, certainly those of the future United States of America.

Sources of Sketches in This Chapter

All the sources mentioned above have been drawn upon for the accompanying sketches. They have been studied mostly in photographic reproduction, though some, especially in the Metropolitan Museum and the Chicago Art Institute, from the originals also. The British Museum, the Louvre, the National Gallery, the National Portrait Gallery, the Rijksmuseum in Amsterdam, and smaller collections in Europe and America house those pictures we have particularly followed. The artists include: Velasquez, Van Dyck, Daniel Mytens, Paulus Moreelse, Teniers, Justus Sustermans, Jamesone, Philippe de Champaigne, Jacob Cuyp, Rembrandt, Franz Hals, Van der Helst, Claas Dyst van Voorhout, Adriaen Brouwer.

Actual costumes in the Victoria and Albert Museum (studied in the original, and later verified from photographs in the official " Guide to the Collection of Costumes ") furnished various details, so did the reproductions of contemporary portraits in McClellan op. cit. and Warwick and Pitz op. cit. It is obvious that to the engravings by Hollar and Bosse our debt is great, though we have never copied an entire picture.

" Trachten, Kunstwerke und Gerätschaften des 17th u. 18th Jahrhunderts," von I. H. von Hefner-Alteneck, a collection of colored reproductions of rather unusual contemporary pictures, also furnished us with a number of details, particularly the headdress in fig. 10c.

Chapter XI

RESTORATION

DATES:

1660–1700

Some Important Events and Names

ENGLAND	FRANCE	HOLLAND	AMERICA
Charles II, r. 1660–1685 m. Catherine of Braganza	Louis XIV, r. 1643–1661 (minority) r. 1661–1715 (actually) m. Maria Theresa, Infanta of Spain	William, Prince of Orange, m. Mary Stuart, daughter of James II	New Amsterdam surrendered to England, 1664
MISTRESSES Lucy Walter Lady Castlemaine Louise de la Querouaille Nell Gwyn	MISTRESSES Louise de la Vallière Mme. de Montespan Mme. de Maintenon (m. 1684)	Reigned as William III of England	New Jersey, formerly Dutch settlements, controlled by England, 1664
James II, 1685–1688 (deposed) m. 1. Anne Hyde 2. Mary of Modena	Revocation of the Edict of Nantes, 1685	PAINTERS Pieter de Hooch, 1630–1677 Vermeer, 1632–1675	Carolinas colonized by England, 1663 Hudson Bay Company, chartered, 1670 (English in Canada)
William and Mary, 1689–1702	DRAMATISTS Corneille, d. 1684 Racine, d. 1699 Molière, d. 1673 (all the plays between 1659 and 1672)	Gerard Terborch, 1617–1681 Jan Steen, 1626–1679	Pennsylvania, colonized, 1682
Great Plague, 1665 Great Fire, 1666		Van der Helst, 1613–1670	Huguenot immigrations after 1685
James, duke of Monmouth, plot to succeed Charles, 1685	WRITER La Fontaine, 1621–1695 " Fables," 1668	Jordaens, 1593–1678	
Judge Jeffreys of the " Bloody Assizes "	PAINTERS Mignard, d. 1695		ENGLAND (*Continued*) WRITERS
Battle of the Boyne, 1690 (defeat of James II by William of Orange)	Le Brun, d. 1690 Nicolas Largillière, 1656–1746		Milton, d. 1674 " Paradise Lost," 1667 John Bunyan, 1628–1688 " Pilgrim's Progress," 1678
DIARISTS Samuel Pepys, diary, 1660–1669	Hyacinthe Rigaud, 1659–1743		DRAMATISTS John Dryden, 1631–1700
Sir John Evelyn, diary, 1641–1697	CABINETMAKER André Charles Boulle, 1642–1732		William Wycherly, 1640–1685
ARCHITECT Sir Christopher Wren, 1632–1723			Thomas Otway, 1622–1685
WOOD-CARVER Grinling Gibbons, 1648–1721			George Farquhar, 1678–1707
PAINTERS Sir Peter Lely, 1618–1680			William Congreve, 1670–1729
Sir Godfrey Kneller, 1646–1723			Mrs. Aphra Behn, 1640–1689

Some Plays to Be Costumed in the Period

Paul Kester's "Sweet Nell of Old Drury" (about Nell Gwyn).

Anthony Hope's "English Nell" (about Nell Gwyn).

James Fagan's "And So To Bed" (about Samuel Pepys).

Molière's Comedies. All produced between 1659 and 1672, they may be costumed in the earlier styles of this period, or in styles later than the date of first production; indeed the second plan is usually followed.

Wycherly's "The Country Wife" (1672–3) and "The Plain Dealer" (1674).

Congreve's "The Way Of The World" (1700).

Farquhar's "The Recruiting Officer" and "The Beaux Stratagem" (classed as Restoration plays) were produced in 1706 and 1707, and their costumes belong rightly to the period of Queen Anne, described in Chap. XII.

Edward Knoblock's "My Lady's Dress." The play contains one scene, ⌐ Dutch comedy, dated 1660.

RESTORATION

EUROPE continued to squabble and intrigue. An ambitious young man in search of adventure could almost always find a war to get mixed up in; generally in the Low Countries, for England and France picked fights with Holland and the powers were always disputing about the Spanish Netherlands.

Holland held her own; Spain, under the feeble rule of the last Spanish Hapsburg, Charles II, presented but the shadow of her former commanding self; the Scandinavian countries were building up solid national fronts; and among the German principalities and kingdoms, Prussia was stepping to the fore.

France under Louis XIV (le Roi Soleil, le Grand Monarque) was the most imposing of the powers. She had achieved a centralized government in that her erstwhile independent feudal noblemen were all held at the capital under the constant surveillance of their overlord, the king. At Versailles Louis had decreed a palace filled with works of art designed especially to celebrate his own magnificence. An army of architects and landscape gardeners created for him; for him the Gobelin factories wove eulogistic tapestries, designed by his courtier-painters. Everything was on a magnificent scale, everywhere money flowed.

Under the patronage of the court, masque and spectacle flourished, richly mounted and costumed. The commercial theatre also received royal encouragement. Corneille and Racine composed stately dramas which adhered faithfully to the Greek unities of time, place, and action. Molière, after a long period of touring the provinces in his own plays (entertainment only a step removed from the old improvisations modelled on the Italian Commedia del'Arte), produced at Paris during thirteen or fourteen years that series of brilliant comedies which are still read and acted with gusto in France and foreign countries.

Those of the king's subjects who had least reason to be happy were the Protestants, who under Henri IV, by the Edict of Nantes, had been granted the right to practice their religion and pursue their business without molestation. Gradually their rights were infringed upon, gradually more and more compulsion was put on them to forsake their faith, till finally with the revocation of the Edict in 1685 they became once more hunted victims of religious persecution. The Huguenots left the country in large numbers; the sober, in-

dustrious merchants and skilled craftsmen thus lost to France were gained by Holland, England, and the English colonies.

Louis was old; he had married a severe and pious wife; he himself became pious, and all the sparkle and gorgeousness went out of Versailles, leaving only a dull pomposity to usher in the new century.

Meanwhile in England the experiment of a kingless government had petered out. Amid general rejoicing Charles II appeared at Whitehall on May 29, 1660. He reigned twenty-five years, died still King of England, and seems to have had a very good time out of it. Though his private life was scandalous and his statesmanship apparently not of a high order, he was, on the whole, popular. Conforming outwardly to the Established Church, Episcopal again, not Presbyterian, he was tolerant toward Dissenters and sympathetic to the Church of Rome, in whose bosom he is believed to have died. England on the whole was extraordinarily touchy on religious questions and very much afraid of " Papish plots." Therefore, when it became clear that Charles would have no legitimate heir and that the throne would pass to his brother James, an avowed Romanist, much talk arose of putting James aside in favor of the Duke of Monmouth, Charles's eldest illegitimate son. Nevertheless James II was crowned and reigned three years, after which he was deposed in favor of his Protestant daughter Mary and her husband, William of Orange.

Truly England had a busy time of it, for in 1665 London suffered from the Plague, and in 1666 it was swept by the Great Fire. During the rest of the century a new London rose on the ashes of the mediæval city, a London eventually dominated by the spires of Christopher Wren's parish churches and the dome of St. Paul's, his greatest monument. Milton lived on in blindness, to produce " Paradise Lost," that light-suffused epic of Lucifer the Fallen Angel. Bunyan, prison-bound, progressed with his Pilgrim through the Slough of Despond and the tinsel temptations of Vanity Fair out upon the Delectable Mountains. And in those years lived Lorna Doone and John Ridd, lovers who are to Devon every bit as real as Bunyan, Milton, King Charles, and King James.

With the return of Charles the English theatre woke up; and very wide-awake it was, what with all the clever young men, not to speak of Mrs. Aphra Behn, writing comedies, and women acting in them (the first time the English professional stage had been trodden by feminine foot). And none more pop-ular than the erstwhile orange-girl, Nell Gwyn, who brought the town (and the King) to her feet as she swaggered through her performances of *Sir Harry Wildair* and other " breeches parts."

Upon the stage of the New World England was the leading actor. Holland withdrew from New York and New Jersey (though the Dutch stayed); the French dug into the soil of Quebec, to remain even when France relinquished her hold; the Spaniards were firmly entrenched in the South and penetrating West; but here stood England, solidly planted along the Atlantic seaboard. One by one the thirteen colonies came into being, till by 1700 they were all

established but Georgia, and all English-ruled. Yet it must not be forgotten that in 1700 Germans, Swedes, Dutch, Walloons, French, and Jews were also domiciled here, contributing their share to the making of Americans.

GENERAL CHARACTERISTICS OF COSTUME

With Charles II's restoration to the English throne the Puritan lid blew off and the frivolities of courtiers, suppressed for eleven years, popped up; in the same year Louis XIV emerged from the guardianship of Mazarin and began his own magnificent career. Costume on both sides of the Channel reflected these events, and the two courts appear to have scintillated partly with the idea of dazzling each other.

From 1660 to nearly 1680, including the period when the Molière plays were first presented, men and women, both French and English, displayed in their dress an exuberance almost equal to that of Germany during the Renaissance (Chap. VIII). Curls, ribbons, puffs, flounces, and feathers appeared wherever they could find clinging-space. A general loosening, a " studied negligence," became the fashion. The hankering to indulge in this sartorial abandon found an outlet in the mode for symbolic art. My lady So-and-So, posing for Sir Peter Lely, court painter, had only to loosen the bodice-strings over her delicate chemise, which slipped a bit wantonly down her white shoulder, and catch up her satin mantle just in time over her ripe bosom, to become Diana or, indifferently, St. Catherine.

It was not very long before both masculine and feminine dress began to take on again that stiffness, smart elegance, and artificiality which in another form had been abandoned soon after the death of James I. While the second James ran his brief course as the last Stuart king, this style was becoming firmly established; under Dutch William it settled into a sufficiently respectable formality. This was in keeping not only with the dull rigidity of the English court but also with the pietistic atmosphere surrounding the later years of Louis XIV. As Lely and Mignard had been the painters of the earlier costume, so Kneller and Largillière recorded these later fashions.

MEN

Heads. Though plain folk still wore uncurled locks falling about their necks (figs. 2 and 3) and though an occasional man of fashion may actually have grown the curls that fell upon his shoulders in such profusion, certainly by 1660 the greater number of up-to-date gentlemen were wearing wigs. Before long these made no pretense to naturalness but were an impressive feature of costume, in the interest of which heads were close-cropped or shaved. These wigs were made in the colors of natural hair, very seldom in the artificial white adopted during the eighteenth century, though some few instances of powdered locks might be found even before 1700. The " full-bottomed " or periwig continued in almost undisputed sway until Anne's reign, even though before that time soldiers, sportsmen, and travellers began to confine the flow-

ing ends with ties at the back (fig. 10). When (about 1690) the stiff, wide neck-bow came into style, to accommodate it curls were pushed back from the sides of the face (fig. 8). The high peaks of hair rising from a middle part (fig. 9) were fashionable only from about 1695 to 1715.

Traces of beard and moustache lingered till 1680. The tiny fleck under the lower lip disappeared first; then the thread of moustache; and the fashionable world entered upon a century of smooth-shaven faces.

Hats. The cavalier hat with low crown and many plumes was succeeded by one higher-crowned, stiffer, and a little narrower-brimmed (figs. 1 and 5); and that again, early in the period, by a low-crowned hat, somewhat wider, turned or " cocked " up a little on one or two sides (fig. 2). For a good while less fashionable folk, including both serving-men and Puritans, kept to steeple crowns (fig. 3), while other soberly-clad gentlemen, *e. g.,* priests and Quakers, donned the wide, unornamented hat illustrated in fig. 4, familiar to Americans in representations of William Penn. By the nineties modish men cocked their wide hats on three sides, and this tricorne hat was established as *the* fashion for the next hundred years (figs. 8, 9, and 10). So long as hats had wide straight brims they continued to be decorated with plumes (fig. 5) or large clusters of ribbon loops; but when the brim was turned up all 'round, trimming was confined to the edge. At first of ostrich fronds (fig. 8), before the end of the century this decoration had given place to metallic lace or braid (figs. 9 and 10), which held its own nearly as long as the tricorne itself endured. Hats were made of felt or beaver, and almost always black. After the adoption of wigs, gentlemen frequently carried rather than wore their hats, outdoors or in, regarding them as drawing-room accessories like ladies' fans. It was etiquette to tuck the hat under one's arm, earning it the name of " chapeau bras." Nevertheless the traditional significance attached to wearing headgear was not forgotten; permission to cover in the Presence was still a sign of kingly favor. For instance, Mr. Pepys recorded of Charles II's coronation that as soon as the king had put on his crown, his lords put on their caps.

Caps had an important function for private, informal wear, *i. e.,* to protect the close-cropped head when the wig was laid aside. " Nightcaps," like that illustrated in fig. 6, Chap. IX, were worn for this purpose, as well as other, larger caps, sometimes fur-trimmed. Still other nightcaps were put on for bed (again to keep drafts from cropped polls), and these were white and soft, either made like the coif which had been an important part of costume in the middle ages (fig. 6, Chap. VI) or like the tasselled stocking cap still familiar as a part of some regional costumes. It is this soft bed cap that should be worn by M. Jourdain of " Le Bourgeois Gentilhomme," when the stage directions call for a nightcap.

Necks. After 1660 the wide collar or " falling band " (fig. 1) was narrowed somewhat on the shoulders (fig. 5) and often arranged in a box-pleat in front. As long as the doublet in any style lingered, *i. e.,* until about 1670, this collar

accompanied it; and, narrower, it lasted much longer in conservative dress (fig. 4). Indeed, reduced to a pair of small tabs (often called " Geneva Bands ") this collar may still be seen as part of clerical dress and the uniforms of English " bluecoat boys." The collar sketched in fig. 3, wide, square across, fastened by tasselled cords, persisted among the common people, unchanged from the previous period, until about 1680 it was superseded by a neck-cloth.

By 1670 men of fashion had given up bands in favor of cravats. The earliest type of cravat, to be seen in pictures painted even by 1660 (fig. 2), was a piece of lawn, folded and wrapped around the throat, its two ends tied together in front with a narrow black or colored ribbon. The second style (dat-ing from about 1670) was merely a long strip of lace or lawn passed around the wearer's neck from back to front and there turned one end over the other. An early version of this cravat is shown in fig. 6. It is made of lace and has wide ends. The lace strip is probably attached to the upper edge of a plain linen neckband, the two ends left hanging in front, one to be turned over the other. This is the construction of the cravat on Charles II's wax effigy, which was photographed in 1933 when the costume was removed for cleaning. The cravat pictured in fig. 7 continued to be worn for a long time, indeed well into the next century. A variation in the manner of wearing the neckcloth was called the steinkirk (fig. 9). This twist was originally a military trick, named for the battle of Steinkirk (1692), where, the story goes, soldiers, dressing hurriedly upon a sudden alarm, put on their cravats thus; soon after that the style was adopted in civilian dress also.

From 1690 to 1700 the neck-arrangement shown in fig. 8 enjoyed a con-siderable vogue. Here a big, stiff ribbon-bow (light or dark) was placed *under* the cravat-ends. The neckcloth shown in fig. 10, which is wrapped around the neck and has no hanging ends, is not a common style at this date, but being well adapted for wear with a cuirass, had a certain early popularity among soldiers.

Bodies. Between 1650 and 1660 or '70 the doublet of Charles I's reign was sometimes lengthened almost to the knee (fig. 2). Like its predecessor it could be worn either beltless or belted, but, following the new trend, it had a lower waistline; its skirts flared slightly. Fairholt (*Costume in England,* Vol. I, Glossary) calls this type of garment a " cassock." Except for length, it is essentially like the modern clerical cassock, as may be seen even more clearly in fig. 4, which represents a short cassock on a priest. Notice that, in its turn, it differs little from the " coat " of the Elizabethan servitor or pen-sioner (fig. 10, Chap. IX), save, again, in the length. Soldiers also wore gar-ments described as cassocks (fig. 5), a good deal like the sleeved jerkin pic-tured in fig. 5, Chap. X. In this sense, as well as to describe a loose outer coat and the clerical garment, the word was already used in Elizabeth's reign. All three cassocks pictured in this chapter differ from similar, earlier garments in the matter of their sleeves, which now were shortened to a point half-

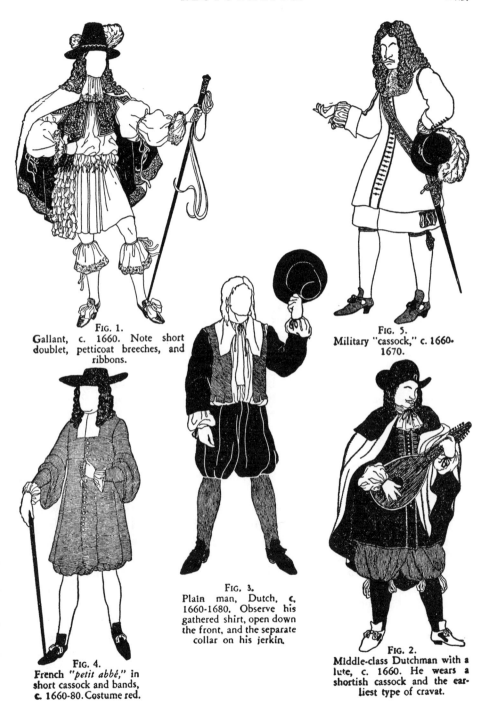

FIG. 1.
Gallant, c. 1660. Note short doublet, petticoat breeches, and ribbons.

FIG. 5.
Military "cassock," c. 1660-1670.

FIG. 3.
Plain man, Dutch, c. 1660-1680. Observe his gathered shirt, open down the front, and the separate collar on his jerkin.

FIG. 4.
French "petit abbé," in short cassock and bands, c. 1660-80. Costume red.

FIG. 2.
Middle-class Dutchman with a lute, c. 1660. He wears a shortish cassock and the earliest type of cravat.

way up the forearm. The cassock, then, was worn as a plain garment up to about 1670 and by conservatives like clergymen and Quakers considerably later.

Another so-called doublet or jerkin worn informally during this period was a loose leather jacket put on directly over the white shirt (fig. 3). It was nearly as short as a modern vest, though its tabs were occasionally rather long. Sleeves of another material were sewed, pinned, or tied in at will. This is the garment in which men of various European countries performed their daily labors, and we may assume that it was equally popular in the colonies. Common soldiers and sailors wore it, too.

Structurally akin to this plebeian jacket is the doublet illustrated in fig. 1, *the* fashionable court garment during the first years of the Restoration. It was no more than a bolero jacket, a mere topping to the voluminous, fine cambric shirt which bloused below it over the breeches and in great puffs from under its rudimentary sleeves. Its neckline was concealed by the spreading collar, but all other edges were richly trimmed with metallic lace or braid. Sailors seem to have had a fondness for this short jacket, and continued to wear it after it had gone out of style among landsmen. They liked shirts with turnover collars open at the throat and often knotted bright-patterned kerchiefs about their throats; they wore close caps, sometimes with " stocking " tops, like the nightcaps described above; in short, their dress was the original for the conventionalized " pirate " costume so popular nowadays at fancy dress balls.

Attempts have been made to trace to Persia the origin of the coat which about 1670 ousted the short doublet from fashionable wardrobes. It is true that the first coats (fig. 6) closely resembled the contemporary Persian garment, which in its turn had not changed much from the ancient Persian coat described and pictured in Chap. II. It is true also that Sir John Evelyn returned from Persia in 1666 enthusiastic about the native costume. (Pepys made an entry about it in that year.) Nevertheless it was four years after that date when the new garment actually replaced the short doublet at both French and English courts, and a comparison of fig. 6 with figs. 4 and 5 will show its equal resemblance to the long-established cassock. Be that as it may, here was a coat, and the history of masculine dress from that day to this is largely a record of the changes rung upon that essentially unchanged garment.

The first coat was collarless and had a very slightly flaring skirt cut in one with the body. It was no longer than the doublet or cassock pictured in fig. 2, but its successors *were* longer (by 1680 as long as those shown in figs. 6 and 7), and at that length the coat stayed throughout the period. From the beginning these coats had close-set buttons with buttonholes from neck to hem, often left partly unbuttoned. During the next ten years the body of the coat grew snugger-fitting, and at the same time its skirts acquired a more decided flare; about 1690 pleats were introduced at the side-back and stiff interlining for skirts, so that they stood out smartly (figs. 8, 9, and 10). After about 1680 many coats were slit at the back and over each hip from waist to hem for

convenience in riding, and after 1690 to accommodate the sword (figs. 9 and 10). The slits were equipped with "practicable" buttons and buttonholes. Tops of pleats were also finished with buttons, which remained reminiscently on men's coats long after they had ceased to be of any use.

Pockets appeared in nearly all coats, in the early examples placed within a few inches of the hem (fig. 6). Experiments were made with diagonal and vertical pockets, but the horizontal style became the standard. The position of pockets varied a good deal; about 1690 they were rather high (in fig. 8 they are just concealed by the arm, hat, and muff); then just a trifle lower, as in fig. 9; then lower still, as in fig. 10—but it seems to have been a matter of personal taste as well as current fashion. They were inside pockets not patched pockets and they all had outer flaps which could be buttoned down; figs. 6, 9, and 10 show the progressive widening of flaps. One pocket (not illustrated) was crescent-shaped, cut diagonally on the coat and buttoned without a flap.

Waistcoats were seemingly not worn under the very first coats, and in many instances the omission was of no importance, since the long skirts would have concealed them. The early vests were only about as long as the jerkin shown in fig. 3, but soon they were lengthened to a few inches above the coat hem (figs. 9 and 10), a length which they retained well into the new century.

Under all doublets, cassocks, or coats was worn a white shirt, varying in fineness according to the wearer's means, but invariably full in both body and sleeves. As sketched in fig. 3, the shirt was opened up the front and gathered close to the neck by a drawing-string; often it was fulled into a neckband, wide enough to turn over in a small collar or, upright, to support a cravat. Wide collars were detachable.

Arms. The most distinctive thing about "Restoration" sleeves is their shortness. Early doublets (fig. 2), military cassocks (fig. 5), clerical cassocks (fig. 4), working-men's leather jackets, the short loose doublets of the sixties (fig. 1), and all later coats had sleeves varying in length from only a few inches below the shoulder to a few inches above the wrist. The doublet of which fig. 1 is an example had the most impractical sleeve of any; at its shortest nothing more than a shoulder-wing, at its longest a wide sleeve turned back in a big cuff above the elbow, or occasionally, like the doublet-sleeves of the previous period, slit from the armseye down.

All coat sleeves were much alike at the top, fitting with practically no fullness into the armseye; at the bottom they expanded into cuffs, originally formed, like those pictured in fig. 5, by turning back the sleeve itself. From 1680 to 1700 the length of sleeves varied considerably. On the whole it may be said that they were shortest at the beginning of the mode and grew longer, as can be seen by looking in succession at figures 6 to 10. Observe that even in fig. 10 the cuff does not come all the way to the wrist; and that cuffs grew wider as well as longer and were buttoned back on the sleeves (figs. 8 and 10). Coat-sleeves, like the cassock-sleeves of fig. 5, were often opened up the back seam; also like the cassock-sleeve, these early coat-sleeves had buttons

and buttonholes part way up, so that they might be fastened if desired. Such buttons survived as ornament after they had ceased to be of use, and have remained down to modern times.

Vests often had sleeves. It is supposedly the brocaded vest-sleeve that is turned back over the coat-cuff in figs. 6 and 9; though the sleeve might well have been simulated with a facing. Other vests had tight sleeves down to the wrists, like those visible below the cassock-sleeve in fig. 4. Here only the ruffles of shirt-sleeves show.

From under all outer sleeves puffed a white lawn shirt, its superfluous fullness sometimes held above the elbow with ribbons (fig. 1). Ruffles finished the wrists of all but the plainest shirts, and even those had ribbons to hold them close (figs. 2, 3, 5). Some ruffles fell directly over the hands (figs. 4 and 7), others turned back from a wristband (figs. 6, 8, 9), with or without a ribbon finish.

Legs. During the time that short, elaborate, open doublets were in style, *i. e.,* from about 1660 to 1670, men wore with them either the semi-long, tubular breeches pictured in fig. 2, Chap. X, or a new style, called " petticoat breeches " (figs. 1, 5, and 21). Sometimes these were divided skirts, though often they were, as in figs. 1 and 5, actually petticoats. A full kilt-pleated skirt was perhaps the most fashionable. As pictured in fig. 1, petticoat breeches were lavishly ornamented with bunches of ribbon loops, and similar ribbons with " points " or metallic tips drooped from the waistband also, clustering especially in front. Plainer petticoats were worn with a simple doublet, like the child's in fig. 21, or with a military cassock (fig. 5), and even these had their share of ribbons. Under the petticoat could generally be glimpsed snug breeches covering the knee (fig. 1), or full gathered bloomers, like the older-style feminine " gym bloomers." These were descendants of the Elizabethan " slops " (Chap. IX). Bloomers were retained for wear with the earlier coats (fig. 6), with cassocks like that sketched in fig. 4, and with shorter cassocks (fig. 2) and short jerkins (fig. 3). (Sailors clung to slops far into the eighteenth century, and they may still be seen in regional costume in various parts of Europe.) Ruffles of self-material or of lace often decorated the bottoms of breeches, scant or full (fig. 1).

After 1690 all manner of full and long trousers went out of style, and everybody who pretended to the mode wore close breeches of the " knicker " type, fastened at the side with buttons or a buckled band.

The ornamental topped stocking or " boot hose," which in the previous period had fallen over the wide boot-top, was still worn, though boots themselves had gone out of style for formal dress. Often the tops of these extra stockings were pulled up over the breeches (fig. 8) and secured to the waistband by means of eyelets and points in something the manner of Renaissance hose (Chap. VIII); with such an arrangement the fancy top was seldom visible. If, however, an under-stocking was first donned, pulled well up on the leg over the breeches and secured there, and then the boot hose was drawn on

FIG. 6.
English courtier in early style coat, 1681. Note wired shoe-ribbons.

FIG. 7.
English gentleman in military coat, c. 1680.

FIG. 8.
French or English gentleman, 1690-1700. Notice the elaborate cravat, the *chapeau-bras*, the stocking-purse, and the shoe-buckles.

FIG. 10.
Military leader: French, English, German, c. 1690-1700.

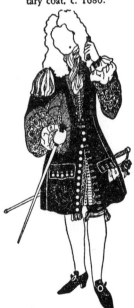

FIG. 9.
English or French gentleman wearing a steinkirk cravat, 1692-1700.

over it and gartered below the knee, the lace-trimmed top of the boot hose fell over the garter, giving the effect shown in fig. 1. Indeed, it is difficult to say whether this is not always the explanation of the apparent tight breeches with flounces. Another device which produced the same effect was the " cannon," *i. e.,* a lace flounce attached just below the knee to the same stocking which was drawn up over the breeches. Perhaps this cannon is really the ornamental top of the boot hose worn minus the hose. Bunches of ribbon at both outside and inside of the leg finished the garters worn with full bloomers (figs. 2, 5, and 6). Occasionally the tight knee-breeches of the nineties had similar decoration, which showed when the stockings were tucked inside the breeches (fig. 9).

Feet. Up to about 1690 all shoes, heavy or light-weight, had long, squared-off toes, high tongues, and more or less open sides which met on the instep and were fastened by latchets (figs. 1 to 6). They were generally black—occasionally brown—and had heels varying from the width and height usual on modern men's shoes to slenderer, higher heels, more like present-day feminine styles (fig. 5). Shoe-roses went out of fashion almost immediately, their place being taken by ribbon bows (figs. 3, 4, and 5), sometimes wired to stand out several inches on either side of the foot (fig. 6). Big loops of wide or narrow ribbon tied a dandy's shoes (figs. 6 and 1); little loops those of ordinary people (figs. 2, 3, 4, 5). After about 1690, while the shoe retained its long, squared toe and high red heel, it discarded the very high tongue, the open sides, and the ribbon latchet, substituting for the last a square or round buckle (figs. 8 and 9). Fig. 8 shows a red shoe-tongue cut in a scallop like a cupid's bow, curving down over the instep.

Outer Garments. Men still wore capes for outer wraps (figs. 1 and 2), but with the advent of coats these ceased to rouse much interest as fashionable dress-accessories. But as yet overcoats were not worn, and collared, circular capes were necessary for warmth; undoubtedly, too, they still served the secondary purpose of disguise.

SOLDIERS

Between 1660 and 1670 the military cassock (fig. 5) described above, or a shorter buff jerkin, was a soldier's costume; after that a heavily-braided coat was substituted for it. The differences between military coats of 1680 and 1690–1700 are illustrated in figs. 7 and 10. Sashes were retained as military accessories, though no longer a part of civilian dress; they were wound around the waist now rather than draped across the body. Until the last years of the century the sword continued to be worn on a broad, elaborately decorated baldrick (figs. 5 and 7). After that the heavy cavalry sword as well as the small dress-sword (fig. 9) was swung upon a hanger attached to a belt underneath the coat, which had slits at side and back to allow the hilt and sheath to protrude. From about 1660 to 1670 military swords still had cross-guarded hilts (fig. 5); after that sabers as well as dress-swords had knuckle-bow hilts

(figs. 7 and 10). Although armor fell more and more into disuse, some men still wore a steel gorget or even a cuirass (fig. 10) under the coat. Steel helmets were virtually abandoned, and most men fought in the hat modish at the moment (figs. 5 and 10).

Soldiers and other horsemen wore a heavy leather "jack boot," usually black, though occasionally brown (fig. 7). It was tight up to the knee, where it flared in a high, wide cuff, split up the front and flopping over, or fastened up on the thigh. It was equipped with spurs on heavy spur-leathers, even larger than those of the previous period. At the end of the century cavalrymen sometimes substituted for these boots leather leggings worn over shoes (fig. 10). The leggings were held snug over the knee by straps behind; spur-leathers covered the instep, where leggings joined shoes.

CLERGY

The dress of Anglican bishops and the church costume of Protestant clergymen remained about as described in Chap. X, except that both ruff and wide collar were abandoned in favor of the "bands" pictured in fig. 4, a neck-finish worn from that time on by some clergymen of the Roman Catholic Church, the Church of England, and dissenting sects.

The street attire of English clergymen included the cassock (according to Fairholt (op. cit.) not always long), the academic gown, the tippet (fig. 9, Chap. X), white cuffs and bands, and a wide hat on top of the fashionable periwig—virtually the costume shown in fig. 4. This, however, is the picture of a French "petit abbé" and would be red. Percy Dearmer (*The Ornaments of the Ministers*) states that the Anglican clergyman's cassock was *long,* and that to distinguish Roman priests from Anglican, the former in England were ordered by the Church to wear a *short* cassock in the street. But "Papist" priests being unpopular there, the question is, did they want to be distinguished?

SPECIAL CHARACTER

The physician's costume assumed by Sganarelle in Molière's *The Doctor in Spite of Himself* consisted of (1) a black steeple hat like that on fig. 3, very narrow of brim and high of crown (about a head and a half tall); and (2) a long black gown open or buttoned from neck to hem, with large flowing sleeves like those of modern academic gowns. He put these garments on over his own wood-chopper's dress.

WOMEN

Heads. Until about 1690, fashions in hairdressing showed no very marked change from the styles of Charles I and Louis XIII (figs. 12, 13, and 15). The difference lay principally in greater naturalness. Now ringlets clustered in the back, and smaller tendrils waved about the face, replacing the earlier dense frizzle (cf. figs. 10a and 11, Chap. X). Even when curls were wired to stand away from the face (fig. 14), they were not thickly massed. In court

circles careful negligence was the keynote, never better exemplified than in the short hair affected by Nell Gwyn—a mop of curls parted in the middle, springing apparently helter-skelter from her gay Irish head.

The tight little nosegay tucked in beside the bun, so popular in the 1640's, was replaced by a cluster of ribbon loops, in keeping with the current passion for ribbons (fig. 12). Strands of pearls were still woven into the coiffure.

The well-to-do bourgeoisie as well as court ladies followed these fashions, which were copied also by wives of Colonial governors, as may be seen in domestically-produced American portraits. Women of simpler lives, in both the Old World and the New, continued to wear caps like those pictured in figs. 15 and 16, Chap. X, and the French, Dutch, and German caps shown in figs. 20, 11, and 16. In any Colonial scene there would probably have been a goodly percentage of caps, since the greater number of women who arrived during the seventeenth century were of middle-class and peasant rather than aristocratic origin. In particular, the plain-living Quakeresses of Penn's colony, the Puritans of Massachusetts, and the Dutch women of New York wore caps rather than ringlets. In Quebec, too, French women from Normandy and Brittany clung to their regional headdresses.

After 1690 the fashionable coiffure took a decided turn away from the picturesque Lely ringlets in favor of a formal arrangement in which the front hair, severely waved, was built up high and away from the forehead, in one peak or two (like the masculine periwig pictured in fig. 9, or even higher). During the last decade of the century such a coiffure was topped, more often than not, by a " tower," " fontange," or " commode " (three names for one cap); for caps suddenly reappeared in court circles.

This fontange had for foundation a close cap of lawn or lace, often with long side-lappets which were pinned up upon the cap or hung down the wearer's back; so far not different from the various caps recorded earlier. The unique feature of the fontange was the front, a high structure of lace, lawn, or both, stiffly starched, fluted, and if necessary also wired (figs. 17 and 18). Two or more graduated tiers went into the fontange; the highest tier might be either in back or front, but the greatest height was in the middle and the whole tower inclined at a slight angle *forward* over the face. In place of (or in addition to) lappets, appeared black ribbons, with ends floating at the sides (fig. 18) or back, and a smart wired bow behind the tower.

The kerchief described in Chap. X, which had not ceased to be popular, was adapted in size to the height of the fontange (fig. 17). So was the hood, which now was often made in the familiar " Red Ridinghood " style, *i. e.*, a circular piece gathered around the face and into the neck of a cape. Occasionally, too, women covered their heads with part of a great shawl which served also as a wrap, as pictured in fig. 16.

Necks. High-necked collars differed from the styles sketched in Chap. X principally in being much wider over the shoulders, making a characteristic horizontal line across the chest (fig. 21). The older, diagonally-folded kerchief

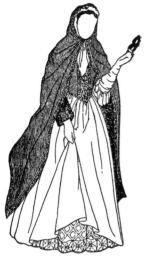

FIG. 16.
German Bürgerin, c. 1675-1700. Note the tiny fur muff on her arm, and her quilted petticoat.

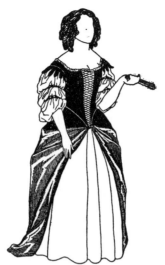

FIG. 14.
Dutch, French, English lady, c. 1660. Her curls are wired to stand away from her face.

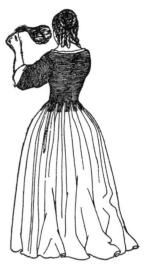

FIG. 13.
Bourgeoise, Dutch, French, English, c. 1660. Note that her chemise is visible at neck and cuffs.

FIG. 15.
Middle-class Dutch woman —1650 to c. 1680, lacing up her dress over her chemise. She wears the popular "Dutch jacket."

FIG. 12.
Court lady, English or French, c. 1650-1670. A knot of ribbon in her hair replaces the older-fashioned nosegay.

FIG. 11.
Dutch peasant woman, 1650-1680. Note her embroidered cap and her earrings.

sketched in fig. 16, Chap. X, still appeared upon simple dresses. With other equally plain and modest garments, the low-cut bodice neck was filled by a folded kerchief tucked inside (figs. 15 and 22) or by the high, clumsy neck of a chemise (fig. 11). Fig. 13 shows, back view, a variation of this style in a much better-made garment with a lower but still conservative neck.

The ladies whom Lely painted showed their chemises, too, above their bodice-tops, but much, much lower down (figs. 12 and 14). Lely must be taken with a grain of salt; still, comparing him with French court painters and the always realistic Dutch, one must admit that the fashionable décolletage was indeed low. Often a soft scarf veiled or partially veiled the breast (fig. 12).

Pictures painted after 1690 by Kneller of English court ladies and by Largillière of French show either of two necklines worn with the new, formalized modes: a low, wide, drop shoulder outlined by a lace bertha, not gathered but carefully fitted (fig. 18); and a deep but fairly narrow décolletage formed by an over-dress opening in a wide V over the low-cut underbodice (fig. 17). Frequently, as in the sketch, the white ruffle of the chemise softened the front. These two styles continued side by side during the first years of the eighteenth century, the square neck finally triumphing.

Bodies. A comparison of the sketches in this chapter with those of Chap. X will reveal the great contrast in the length of the waistline. Even peasants (fig. 11) and housewives (fig. 15) lowered the bottom edge of their bodices and pointed them a little in front. Tabs remained in style for a few years, all around as in fig. 13, or only one or two at the back (a fashion which recurred during the next century). A short peplum was often added to a simple woman's bodice (fig. 11). Made without tabs or peplum the bodice was likely to be pointed in back as well as in front (fig. 18). The exaggerated point shown in figs. 12 and 14 belongs to the first twenty years of the period; after that a more reasonable line (fig. 16) was the rule. The especially long stomacher (fig. 14) lying out on the skirt (probably a relic of late sixteenth century modes) seems to have been popular principally in Holland. While, as usual, the bodices of active women were fairly comfortable, those worn by women of any pretense to fashion were stiffly boned and snugly laced. Bodices were fastened in front, usually by means of lacings, widespread (figs. 14 and 15) or close-drawn (fig. 11), but sometimes by a series of ornamental brooches or ribbon bows (fig. 12). In this as well as the succeeding period there were also plenty of back-laced bodices, smooth across the front.

Many women wore underdresses with another garment on top. Such a dress, its bodice and skirt attached, may be seen in fig. 15 under a jacket, and glimpsed in fig. 14 under a whole gown. On the other hand, even a rather dressy costume often consisted of one garment (fig. 12). Simpler dresses frequently had skirts and bodices of different colors (figs. 13 and 16). The bodice of fig. 16 shows a strip of different material up the front (in the manner of the old-time stomacher) rather than the material of an underbodice.

Two garments in the nature of jackets, yet not properly to be classed as outer wraps, are sketched in figs. 15 and 20. The fur-trimmed velvet jacket was particularly popular in Holland, and is represented in many Dutch paintings. It was a comfortable, loose-fitting garment, sometimes a little shorter, sometimes longer than that sketched, with sleeves three-quarter length or just over the elbow. Warmly lined and widely fur-edged (around the bottom, too, in many instances), it was a most comfortable thing to wear in a draughty house, and was adopted by all classes. Outside of Holland, where it was also appreciated, it was called a " Dutch jacket." Black velvet and white rabbit fur are the materials in which it is oftenest represented.

Fig. 20 illustrates a so-called " night-rail." This was a pretty little shoulder-cape, made of muslin and lace, sometimes a trifle longer than the one sketched, like the " combing jackets " that fastidious ladies not so long ago used to put on while they arranged their long hair. The night-rail had originated, indeed, long before as a bed or boudoir jacket, but about 1670 it suddenly became popular among the younger bourgeoisie of Paris and elsewhere as an informal street-wrap worn over a dress. Here was a fad somewhat analogous to the modern promotion of pajamas from bedroom to beach. The practice agitated moralists, who inveighed against it with the usual results.

Arms. Middle-class and peasant women wore sleeves of the same material as their bodices, rather large, set with gathers or pleats into a slightly dropped armseye; pleated or gathered also at the other end, where the fullness had to be fitted into a semi-tight band or simple cuff (figs. 11 and 13). Frequently, as in these sketches, the chemise-sleeve was turned back over the cuff. In fig. 21 the sleeve-cuff is wide enough to afford a glimpse of the chemise-sleeve under it.

Court dress of the Lely period is notable for the delicacy of its white chemise-sleeves, often entirely revealed, emerging from a sleeveless gown, as in fig. 12, or from a gown with nothing more than cap-sleeves (fig. 14). Chemise-sleeves were tied or pinned up in a variety of picturesque ways (fig. 14). Fig. 20 represents a simple chemise-sleeve worn with a sleeveless bodice.

While the full sleeve, partly or entirely white, did not disappear even with the dawn of the new century, it was rivalled after 1690 by the sleeve sketched in figs. 17 and 18: a style modelled on the masculine coat sleeve, though scanter and shorter. It was elbow-length and finished either with a white ruffle (figs. 17 and 16) or a cuff, wider upon the outside than the inside of the arm (fig. 18). This new sleeve was to remain fashionable during the greater part of the eighteenth century.

Legs. The everyday skirt of an active woman was straight and gathered full into a band, its top concealed by the bottom of the bodice (figs. 11, 13, and 15). Peasant women shortened their skirts to the instep, but women higher up in the social scale let theirs touch the floor, or at most reveal the shoe-tip (fig. 20). Observe, in fig. 11, how the clumsily-arranged placket at the left side has gaped open. The skirt in fig. 15, with a front opening, and that in fig. 13

are neatly closed. For housework the woman in fig. 15 would be very likely to turn her skirt up in front, like the little rich girl in fig. 22, revealing, like her, a simply trimmed petticoat; often a red woolen petticoat. When fashionable women wore a dress without an over-gown the skirt was generally closed all around (fig. 12), but lifted it would have revealed a petticoat as dressy as the quilted example in fig. 16, or the flowered in fig. 20.

During the entire period the over-gown, a usual part of court costume, was opened up the front and turned back, showing both its own interlining and the material of the underdress. Though simpler gowns like that in fig. 20 cleared the ground when they were draped back, in formal dress skirts trailed, a tendency more marked during the last decade (figs. 17 and 18). At first the draping was simple, just a matter of turning back the front edges of the skirt and securing them to each other and to the back breadth. After 1690 more ingenuity was expended on draping, the skirt being piled up in the back like a bustle and supplied with an under-support to assist the effect. The ribbon suspended from the shoulders of fig. 18 holds up a separate breadth of the train, making a bustle silhouette without complicated drapery. Notice that the skirt is held back by a brooch.

Aprons entered upon their period of greatest importance and so may be classed with skirts rather than with mere accessories. A humble apron of heavy cotton cloth, more often blue, brown, or gray than white (fig. 11), kept the worst soil from a peasant's rough skirt; a sturdy white linen apron protected the housewife's finer cloth dress (fig. 21); a narrow, straight panel of lace-edged lawn enhanced the charm of a bourgeoise's pretty costume (fig. 20); and the same type of garment protected the finery of even royal children (fig. 20, Chap. X). Finally, in the last decade of the century, ladies of the court added quite non-utilitarian aprons to their costumes (fig. 17): knee-length or even shorter, made of all-over lace, silk and lace, or colored silk with metallic trimming.

Feet. Shoes, seldom visible except in peasant dress, followed the variations in style described under MEN. The heels of women's shoes were higher, and shoe materials included, besides leather of varying weights, satin, brocade, and embroidered silk. Mules (which we have already encountered in Chap. IX) were popular for house wear. They had raised heels like other slippers.

Outer Garments. Capes like men's, capes with a capuchon (like Red Riding-hood's), and great shawls (fig. 16) were the usual outdoor wraps.

EQUESTRIENNE

As we have noted from time to time, women, though they had always ridden horseback, had made little effort to provide a distinctive dress for that necessary exercise. When any garment *was* donned especially for riding, it was either a protective skirt or something adapted from masculine dress, usually hat and gloves. Thus, during the reign of Charles I, women wore cavalier hats with their ordinary cloth or velvet dresses (fig. 18, Chap. X). Now, after the

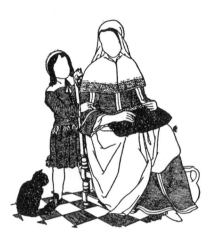

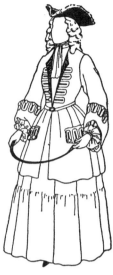

FIG. 21.
Dutch Bourgeoise and her son,
c. 1660. Note the very deep
collar. She is making pillow-
lace.

FIG. 20.
Parisian Bourgeoise in "night-
rail," c. 1670. She wears a
gown with sleeveless bodice
over her chemise.

FIG. 19.
English lady in riding
habit, c. 1690-1700.

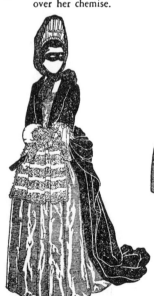

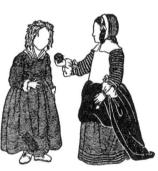

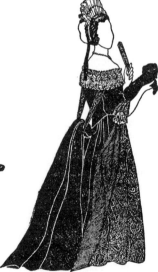

FIG. 22.
Dutch child of wealthy
middle class and poor
child, c. 1660.

FIG. 17.
French or English court lady,
c. 1675-1690. Her kerchief is
extra big, to drape over her
fontange. Note tiny muff, lace
gloves, and elaborate apron.

FIG. 18.
French, English, or Ger-
man court lady, c. 1675-
1700. Note her fontange
and the ribbon which holds
up her panel train.

Restoration, began the custom never afterwards entirely forsaken of wearing a feminine imitation of male riding dress. Mr. Pepys was shocked at the innovation, but that in no wise deterred the ladies, who found that they had never looked more charmingly feminine than in the mock-severity of their new habits. Fig. 19 shows a horsewoman at the end of the century. Her costume, even to the wig, imitates that of a man rider, except that her smaller waist is emphasized by a neat belt, and the skirt of her coat is gathered on to the body in order to fall prettily over her well-petticoated skirt. This is unusual among skirts of the period in being made with a flounce, and it is a little shorter than her house dresses. Her feet are shod in ordinary shoes, not boots.

CHILDREN

The little boy in fig. 21 wears a simple version of doublet and petticoat breeches, which sets his date as not later than 1680. He is a Dutch child, but other lads in France, England, and the Colonies might well have dressed the same. Like the girl in fig. 22, he wears a cap, a common feature in pictures of children as old as these.

The benevolent little girl (fig. 22) belongs also to the earlier years of the period, as may be seen from her collar and long sleeves, under which appear the puffs of her chemise sleeves. The unfortunate child to whom she is presenting the apple is wearing a dilapidated version of the grown-up style shown in fig. 15.

With the change in adult fashions children's styles changed also, and as usual differed very little from them. There is, for instance, a picture by Largillière of the small son of James II (the boy who grew up to be the Old Pretender) and his sister, in which they are dressed almost precisely like the man in fig. 8 and woman in fig. 18.

MATERIALS

Materials for ordinary dress did not differ from those of the preceding period. In court costume, also, there was no great change until about 1690, when interest revived in patterned fabrics of diverse colors as well as in gold and silver brocade. Velvet and satin were combined with these showy stuffs or worn alone. Lace of the kinds enumerated in Chap. X appeared even more lavishly than before, and white linen showed in every costume.

Printed calicos were introduced into France during the period and became very popular. In the early years they were imported and necessarily costly, but in the last decade of the century the art of block printing was matured in France and then introduced into England by a French Protestant refugee, after which cotton and linen prints were accessible to nearly everybody. Patterns upon the imported fabrics were Oriental, and included the familiar " Persian palm " and exotic birds and flowers, but domestic prints employed European motifs also, e. g., conventionalized roses and other flowers and foliage.

COLORS

The Restoration in England and the outburst of magnificence at the French court were accompanied by an exuberance of color. Less often were costumes made of deep-toned velvet, more often of light-colored satin. Moreover, a number of colors were combined in one costume. After about 1690 the court at Versailles was, to be sure, rather subdued; but in London a nobility well launched in frivolity was not to be deterred by a stodgy Dutch King, and there, as well as in the uplooking German courts, French circles not immediately under the eye of the King, and the small aristocratic groups in the Colonies, bright-hued garments prevailed. Colors were not very subtle; primitive tones like red, blue, yellow, and green were popular and fearlessly combined. In such a costume as that sketched in fig. 18, for instance, the petticoat might have been of brocade in three colors and gold, the gown of green satin faced with yellow, and if the apron from fig. 17 were added, that might have been sky-blue silk with white lace. Men's coats were often red; so were women's petticoats; flowered silks were as popular for one as the other. At first breeches material matched coats (fig. 6); later, breeches were oftenest of black velvet, whatever the coat color. Hats and shoes were almost always black, stockings white or light-colored.

MOTIFS

No especial change occurred in the type of motifs. Stylized flowers were much used, either in an all-over pattern covering the ground (cuffs, figs. 6 and 9) or in a sprinkling of single sprays (figs. 20 and 6). Renaissance motifs (Chap. VIII) still appeared in patterned fabrics (fig. 18). Designs were on the whole larger than in the previous period.

APPLICATION OF DECORATION

From 1660 to 1680 ribbons dominated the decorative scheme (fig. 1). Petticoat breeches were even made entirely of ribbon loops; fronts of bodices were filled in with clusters of ribbons. Ribbons appeared wherever there was a place to tie or fasten them: hair-knots, shoe-knots, garter-knots, sleeve-ribbons, ribbons on walking-sticks and fans. But after the advent of the coat, men's dress speedily shed most of its fluttering ends, the last to go being sword-knots, shoulder-knots, and knee-ribbons (fig. 9).

Before the advent of the coat, lace was added to masculine dress almost as profusely as ribbon: in addition to being a neck and wrist finish it showed at the knee in garter-ends and ruffles or cannons and combined with ribbon in the shoe-roses of the earlier years of the period. After 1680 lace was severely restricted to cravats, sleeve-ruffles and handkerchiefs. In women's dress, on the contrary, opportunities for displaying the precious fabric increased during the later years with the return to style of caps and the vogue for white night-rails, elaborate aprons, deep sleeve-ruffles, and white above the décolletage. Lace made its appearance on stomachers and petticoats, too.

Small areas like cuffs and pocket flaps were trimmed with velvet, and wide cuffs were made of figured brocade (as noted above, actually the cuffs of a sleeved vest). Buttons, not so important in the ribbon era, returned to favor with the coat and were applied as illustrated in figs. 6, 7, 8, and 9. Braiding gave a military character to coats like those sketched in figs. 7 and 10, gold braid and lace also appeared together with buttons on many court costumes and finally ousted feather trimming from the edges of tricorne hats. Fringe and tassels decorated the ends of military sashes and, occasionally, sword-hilts and canes.

Hand-embroidery was as important as ever, ornamenting jackets, caps, and small areas of garments. Quilting (fig. 16) began its long period of popularity, petticoats especially being worked with this stitchery.

JEWELRY

The character of jewelry did not change much from the previous period. Watches on chains may occasionally be remarked in representations of both men and women. (Watches were not new, of course; wearing them as orna-ments was the innovation.) Men sometimes wore their "orders" on broad ribbons across the chest, left shoulder to right hip. Most women, even peasants, had dangling earrings of some sort (fig. 11), the fashionable drop being, as formerly, a pear-shaped pearl. Pearl chokers were pretty generally worn, but the long necklaces popular in the last period (fig. 12, Chap. X) were no longer modish. Jewelled brooches were pinned here and there upon feminine dress. With the advent of the fontange the graceful custom of twining strands of pearls in the hair fell into temporary disuse.

ACCESSORIES

Men. Great wigs brought with them a fad for combing the hair in public (fig. 9). About the time when the coat was securely established in the mode, snuff-taking came in, bringing with it the equipment of snuff-box and hand-kerchief (fig. 6), both carried, when not in use, in coat pockets (fig. 9). Early in the period men in general took to carrying muffs (fig. 8), which they continued to do well into the eighteenth century. Unlike women, men sensibly kept their hands free by hanging the muff on a ribbon around the neck, as sketched, or upon a sash or belt around the waist. Round, well-pad-ded, fairly good-sized, these muffs were made of cloth or silk almost as often as fur and were frequently decorated with the ubiquitous ribbon knots. The "pocket" attached to the belt, so long an accessory, vanished with the advent of coats and their set-in pockets; then both men and women began to carry stocking-purses (fig. 8) netted of silk, with a slit in the middle and a movable ring to secure the money at one end or the other.

Tall walking-sticks ornamented with ribbon or tassels (fig. 1) and shorter sticks (figs. 8 and 9) were equally popular in the petticoat breeches period; later only the short canes were modish. At the end of the century a slender

dress-sword became a regular part of court costume, and was conveniently carried on a sword-belt and hanger under the coat (as explained in Chap. X) rather than on the early baldrick. Gloves were no longer a fashionable accessory of masculine dress; rather they were limited to the use of soldiers and horsemen (figs. 7 and 10); they had limp wrists and no embroidery. Men about the court made up their faces quite as openly as women and as frequently wore patches.

Women. Fans were still important feminine accessories; occasionally they were ostrich-feather whisks (fig. 13), but as a rule folding fans (figs. 14, 17, 18). Muffs, remaining in high favor, were absurdly small and often worn pushed up on the wrist, as in fig. 16. Women employed masks as in the previous period (Chap. X) and both make-up and patches even more lavishly. Elbow-length gloves, wrinkled on the arm, were necessary outdoor accessories and often appeared with formal indoor costume also. They were light-colored, made of glacé kid or silk (fig. 16) and at the end of the century even of lace (fig. 17).

SOMETHING ABOUT THE SETTING

In France the decoration and furnishings of palaces and wealthy private houses was grandiose. The " baroque " style included carved and gilded wood, gilded plaster, and a lavish use of the shell motif. Often a shell-shaped niche formed the background for a statue. Painted walls, painted ceilings, and huge tapestries were filled with mythological or allegorical pictures, many referring to Louis himself, the sun-king, in the character of Apollo. Furniture, made of oak or walnut, was large and ornately carved with the popular semi-Roman, semi-Renaissance motifs and often gilded; it was upholstered in damask or needlepoint covered with large floral designs.

English and Dutch and consequently American Colonial walls were panelled in dark wood; furniture, too, was dark (fig. 12), the carved pieces being of oak. American colonists made soft wood, like pine, into turned chairs and tables. The low chair shown in fig. 21, actually drawn from a Dutch picture, had (and has) its counterpart in many an American cottage. The high-backed carved chair in fig. 12 might have been seen in an English or Dutch house of some importance, and its like was brought overseas to the new homes of the richer colonists. Oak side-chairs had wooden and, toward the end of the period, caned seats; cottage chairs had rush seats. Armchairs had carved backs or else both backs and seats were upholstered in velvet, brocade, or needlepoint. Home-made Colonial furniture was frequently decorated with incised geometric patterns; English craftsmen, led by Grinling Gibbons, lavished elaborate carving on both furniture and woodwork: classical motifs, realistic flower and fruit festoons, and cupids. Tiles were a feature of Dutch fireplaces, a detail often imported to the Colonies.

Accessories of the ordinary seventeenth century domestic interior are familiar to us now, having been brought out of many an attic to grace the

living-room, *e. g.,* brass and copper warming-pans, kettles, candlesticks, and iron cranes. It is possible to study both kitchens and formal apartments in Dutch paintings and to find their replicas in the admirably arranged rooms of the Metropolitan Museum American Wing and similar exhibitions in other museums. Wine-glasses and jugs (fig. 11), pewter plates, silver porringers, and other accessories of daily life are part of the American as well as the Old World heritage.

An especially Dutch accessory is illustrated in fig. 21: a lace-pillow with bobbins and lace upon it. As it is recorded in seventeenth century Dutch pictures, it may still be seen in the laps of old women at innumerable Belgian doorways.

Among musical instruments lutes were still popular and so were recorders (Mr. Pepys learned to play the latter, being enchanted with their sweet tone). Spinets and harpsichords, members of the piano family, took the place of the older virginals (Chap. IX).

PRACTICAL REPRODUCTION

Materials. Consult Chap. X for appropriate materials for these costumes, not overlooking the advice about lining them. You will find a number of cretonne patterns appropriate to the late style of costuming Restoration and Molière comedies. It is possible to touch the floral designs with dashes of gold paint (after the costume has been sewed) which will suggest a gold-shot fabric. Look among theatrical materials (Chap. XX) for lamé cloths stamped with colored patterns; these are not extremely expensive and may be used to advantage even on small areas like cuffs. Face the turned-back fronts of gowns with sateen or rayon sateen. Plan to use a good deal of light-toned, unpatterned, shiny material for costumes dated before 1680, and plenty of patterned goods in bright colors combined with a fair amount of dark tones for those of the later years.

Trimmings. Consult Chap. X for types of trimming. You can buy quilted material intended for table and bed-pads to dye and use for petticoats; this serves a double purpose, being both decorative and stiff. But since self-toned stitching does not show up very well on the stage, a faked quilting will prove more effective. Dye and iron heavy muslin (Chap. XX) and draw an appropriate pattern on it in a narrow broken line, with black oil-paint or india ink.

Accessories. Consult Chap. X for advice about masks and fans. You can transform almost any small hinged box into a snuff-box; an average size is shown in fig. 6. Gild, silver, or paint it in oils to resemble enamels. Use the leg of a stocking for the purse (fig. 8), which should be about twelve inches long; gather each end and finish with an ornamental button or a tassel. Open the seam midway for three or four inches. Take a little bone or brass ring only big enough to push the stocking through and slip it on the purse, bringing it close over the end that contains stage money. Any small coarse-toothed white, silver, or gilt comb will do for that gentlemanly accessory of a Restora-

tion gallant. Women may wear modern long gloves of glacé kid, silk, fabric, or lace and in almost any color; men, too, may wear women's long-wristed gloves in black or brown.

Millinery. Patterns for "George Washington" or "Colonial" costumes include a tricorne hat, which you may use if you wish, covering it with black flannelette, duvetyn, serge, or any dull-finished material in preference to sateen; yet it is simpler and more satisfactory to adapt a felt hat (fig. 4). Old hats of the correct shape may be found, and you can reblock others as explained in Chap. XX. To turn up the sides: dampen the brim, roll it on three thick round sticks, and dry; keep the sides up if necessary by means of black carpet-thread, caught into crown and brim, then drawn up as close as desired. You can buy ostrich-feather fringe to edge hats; it is not extremely expensive, though somewhat dearer than the gold gimp which is generally as appropriate.

It is difficult to make periwigs which will be acceptable in realistic indoor plays; as a rule you will probably rent the excellent wigs which professional costumers can provide. For pageants, or highly stylized plays, you can make a wig with yarn sewed in layers upon a well-fitted skullcap (Chap. I); yet even such a wig is not inexpensive; renting will probably prove to be the best procedure.

As a foundation for the fontange make a close "baby bonnet," with long lappets over the ears if you wish. Prepare two or more pieces of batiste and lace or tarlatan and lace, deeper in the middle than at the ends and three times as long as the finished frill will be; have it knife-pleated or pleat it yourself; support it on a frame of milliner's wire. Put the cap on the hat-block and adjust the two pleated pieces, inclining them slightly forward over the face.

Shoes. For remaking boots and shoes, see Chap. X. Cut the curved tongue shown in fig. 8 from red leather or felt and sew it on a wide piece of buckram, which may be slipped over the instep inside the shoe; the red tongue will fall forward. Cut high tongues from black leatherette, leather, or oilcloth; back with buckram, and secure in the shoe by the same means. To make the stiff shoe-bows represented in fig. 6, stitch a backing of black buckram edged with milliner's wire on black ribbon or in a black sateen casing. You can buy small oval or rectangular steel buckles, or rent them from a costumer; you can also cut them from cardboard, thin wood, or several layers of buckram stitched together and cover them with heavy tinfoil. Sew the buckle to a piece of black buckram the right size to mask the shoe-laces and secure this to the foot by wide elastic slipped under the instep. If an actor is representing a dandy, he really should wear women's shoes with moderate Cuban heels; but if you cannot fit him, try to have extra lifts put on the actor's own light-weight black oxfords.

Women may wear modern "Colonial" oxfords (of black kid, *not* patent leather) with high Cuban heels, also brocaded party-slippers, as high-vamped as possible. Actually the French heels of the period were not so high and

narrow as those on modern slippers, but they will probably show very little, and the stilted walk produced by our heels is correct enough.

To make armor, see Chap. XX.

CUTTING THE GARMENTS

Men. Any bolero jacket pattern may be used to reproduce the curtailed doublet of fig. 1 and the longer style of fig. 3. Alter the sleeve according to the sketches. Make the petticoat breeches like any straight skirt, pleated (fig. 1) or gathered (fig. 5). Under them the actor may wear tights to which you have sewed the ruffles or " cannons " described under MEN; adjust them on the wearer and baste securely, then sew with firm but not tight hand stitches. If you prefer, make very snug breeches just covering the knee and add the ruffles.

A pattern for a " domino," shortened, can be used to cut the upper garments of figs. 2, 4, 5, and even that early coat shown in figs. 6 and 7. Or you may use a cassock pattern, also shortened (Chap. XX). Fit the domino a little closer in the back and under the arms. Enlarge the sleeves and turn them back in the cuff represented, facing to simulate the vest sleeves (p. 278). To cut the full breeches worn with these cassocks or coats, use a bloomer pattern. To represent the sleeved vest indicated in fig. 4, set a pair of tight sleeves on a guimpe to be worn under the cassock.

The " George Washington " or " Continental " pattern may be used to cut both coat and vest of figs. 7, 8, 9, and 10. Leaving the back as it is, cut the front of the pattern off at the waistline and replace by straight skirts, pleated or both gored and pleated over the hips. Leave the seam open in the middle of the back and at the sides, to accommodate the sword. Enlarge the sleeves and make the cuffs as much wider as the sketch indicates; lengthen the waist-coat. (Face the wide cuffs to suggest the turnover undersleeves.) If you wish to show a sleeved vest, set straight, rather snug sleeves in the same vest and finish with a frill to indicate the shirt frill.

If the shirt is to be partially covered, you can make it satisfactorily on a shallow yoke, and for this you may use as a guide the top of a modern shirt-pattern, the top of the domino pattern, or any pattern that has a neckband. Upon the yoke both front and back gather a width of thirty-six inch material, making the shirt two yards around. Cut out an armseye and set in a sleeve at least a yard in width. As always in enlarging a sleeve, add all the extra material in the middle of the pattern, and distribute it around the armseye except where it comes under the arm. Open the shirt in front, put on a neckband wide enough to stand up well under a cravat or turn over to make a small collar. Gather the sleeve into a wristband, with or without a heading or a turned-back ruffle. If you want a shirt with fullness gathered into a neckband, follow the directions described below under *Women,* but cut the neck-opening pretty high.

Use the George Washington pattern (above) to cut the scanter breeches,

but for these seventeenth century costumes do not make them very snug. All breeches should rely on suspenders, not belts or drawing-strings; this means that you must not fail to sew buttons on the waistbands.

If you roll stockings *over* breeches (fig. 8) put elastics at the top of the stockings to hold them up, if breeches cover stocking-tops (fig. 9), you *may* use well-gartered stockings, but tights with suspenders will insure a smoother leg. If you wish to use silk stockings, put them on over a pair of cotton or mercerized, unless you have unusually heavy silk, for the ordinary silk hose are much too thin.

Women. The feminine chemise, so often an important part of the costume, must be as full as the masculine shirt described above, and always pulled up on a drawstring. Instead of using a pattern, you can take a doubled piece of thirty-six inch material long enough to extend from the neck to below the hips and cut out a neck-opening (working on the wearer or on a dress-form) big enough to spread wide on the shoulders. Roll or hem the edge and put a casing as far from the edge as you wish your heading to be deep. Run in a tape and draw up to the desired height. With the garment still on the model, cut slits for the arms, beginning just at the point of the shoulder and cutting on the straight of the goods. Now shape an armseye and cut out a sleeve to correspond, making it as described above under *Men,* and as long as you wish, allowing extra length if you are tying it in puffs.

For any of the bodices sketched in this chapter, follow the directions given in Chap. X. Cut these bodices, however, with long pointed waists. Shape the tops according to your chosen sketch and vary the sleeves as described, following the directions given in Chap. X.

Make all skirts and petticoats straight and gathered into a band. A skirt of the early period (figs. 11 to 16, and 21) must measure at least eight yards around, and nearly an equal width must be allowed for an underpetticoat. The skirts shown in figs. 17, 18, and 20 need be only six or seven yards around, but they must also have good heavy petticoats of nearly equal width, and the overskirts must be as wide as the underdresses, besides being at least a yard longer. To imitate fig. 17, put a bustle (see Chap. XVII) under the petticoat in back. To imitate fig. 18, add the train as an extra breadth lying on top of the overskirt and gathered in with it, the loose breadth to be looped up through the ribbon as pictured. If the material is as soft as sateen the loose breadth should be lined with heavy material the same color as the turned-back facing in front. For the skirt of the riding-habit (fig. 19) use four breadths gathered into the waistband and eight or more in the flounce. Cut the coat on the bodice pattern (above), opened up the front and faced back as pictured; add a gathered skirt or peplum. Cut the sleeves by the sleeve of the bodice pattern, making them a trifle fuller and shaping them from the elbow down, as explained under *Men* (above).

Cut the loose jacket (fig. 15) on any semi-fitting jacket pattern, adding side gores for extra fullness. Set sleeves in a wide armseye; have no extra fullness

at the top. Cut the night-rail (fig. 20) like a shallow yoke with a straight, slightly gathered flounce, or else by a cape-pattern with darts on the shoulder.

Suggested Reading List

See the notes under this section in Chap. X.

Where Further Illustrative Material May Be Found

Of the artists enumerated in the beginning of this chapter you will probably encounter Lely most often and find him the most baffling because of his habit of portraying his fair sitters in fancy dress. Yet undoubtedly his beauties are the early Restoration ideal, just as, about 1905, the Christy Girl was the ideal in America. Study Lely, therefore, for the spirit of Restoration costume, his contemporaries for the detail. Mignard is rather more believable than Lely, but the Dutch painters are still better. To them we may confidently go for handsome gowns, decent but sober dresses, and the clumsy garb of peasants. Largillière's portraits of French men and women, and Kneller's of English are undoubtedly realistic, exaggerated perhaps on the score of personal comeliness, but perfectly believable on the score of costume construction. A few portraits of American worthies and their spouses, to be found in museums and college halls, are also valuable sources.

Contemporary wood-cuts illustrating books and pamphlets are excellent references; so, too, are the cuts and engravings of court functions and garden parties at Versailles. The reign of Louis XIV was rich in elaborate masques, and the costume designs and stage sets are full of information for the modern costumer, showing as they do how the designer's conception of mythological and fantastic dress was influenced by current fashions.

Representative works of contemporary painters may be seen in galleries throughout Europe and America; copies of them in art prints, art journals, histories of art, and biographies of the period; and many of them in the costume books suggested in the reading list. Engravings and costume designs are not so often reproduced, but may be spotted by an alert eye.

Sources of Sketches in This Chapter

Of the contemporary material listed above, we have followed in particular certain pictures by Lely, Kneller, Mignard, Largillière, Philippe de Champaigne (d. 1674), Pieter de Hooch, Terborch, Van Tilborgh, Netscher, Jan Steen, Van Oost, and Le Nain. These were studied mostly in reproduction, the originals being in the National Gallery, Chicago Art Institute, Brussels Museum, the Wallace Collection, and the Kaiser Friedrich Museum; the garments on the peasant in fig. 3 follow details in the color-reproduction of a Jan Steen in the collection of Lord Berestead in London; the lady in a riding habit (fig. 19), those in a Kneller in the collection at Ham House, Petersham (reproduced in the International Studio, May, 1931).

We have studied, both at first hand and from photographs, actual garments in the Victoria and Albert Museum, and on the wax effigy of Charles II at Westminster Abbey, and from these reproduced certain details, notably the early coats sketched in figs. 6 and 7.

Trachten, Kunstwerke und Gerätschaften des 17th u. 18th Jahrhunderts, von I. H. von Hefner-Alteneck, a collection of colored reproductions of rather unusual contemporary pictures, furnished us with a number of details, especially those reproduced in figs. 5, 17, and 18.

Chapter XII

EARLY GEORGIAN

DATES:

1700–1750

═══

Some Important Events and Names

ENGLAND	FRANCE	AUSTRIA	GERMANY	RUSSIA	AMERICA
Anne, r. 1702–1714 m. Prince George of Denmark	Louis XIV, d. 1715	Empress Maria Theresa, Archduchess of Austria, 1740–1780	Frederick the Great of Prussia, r. 1740–1786	Peter the Great, r. 1689–1725	Georgia, colonized under James Oglethorpe, 1733
George I, r. 1714–1727 m. Sophia Dorothea of Zell	Louis XV, r. 1715–1774 (Regency of Duc d'Orleans, 1715–1723) m. Marie Lezczynska of Poland			Catherine the Great, r. 1762–1796	Wesleys as missionaries, 1735
					New Orleans, founded, 1718
George II, r. 1727–1760 m. Caroline of Anspach	*Maîtresse en titre,* Mm. de Pompadour, 1745–1764				Benjamin Franklin, b. 1706
The Young Pretender. Jacobite Uprising, 1745. Flora McDonald	War of the Spanish Succession, 1701–1714 (Henceforth Spanish Kings are Bourbons)				George Washington, b. 1732
STATESMEN Sir Robert Walpole, 1676–1745	WRITERS Voltaire, 1694–1778				
Wm. Pitt, Earl of Chatham, 1708–1778	Jean Jacques Rousseau, 1712–1778				
PREACHERS John Wesley, 1703–1791					
Charles Wesley, 1708–1788					
PAINTERS Kneller, d. 1723					
William Hogarth, 1697–1764					

DATES:

1700–1750

··

Some Important Events and Names

ENGLAND
(*Continued*)

ARCHITECT, ETC.
Wren, d. 1723
Gibbons,
d. 1720

Thomas
Chippendale,
1718–1779

MUSICIAN
Handel,
1685–1759

WRITERS
Joseph Addison,
1672–1719

Richard Steele,
1672–1729

"The Tatler,"
1709–1711
"The Specta-
tor," 1711–1712

Jonathan Swift,
1667–1745
"Gulliver's
Travels,"
1726

Daniel De Foe,
1660–1731
"Robinson
Crusoe," 1719

Alexander Pope,
1688–1744

Samuel Johnson,
1709–1784

Laurence Sterne,
1713–1768
"Tristram
Shandy," 1759

Thomas Gray,
1716–1771
"Elegy," 1751

DRAMATISTS
John Gay,
1685–1732
"Beggar's
Opera," 1728

Colley Cibber,
1671–1757

ACTORS
Nance Oldfield,
1683–1730
David Garrick,
1717–1779
Peg Woffington,
1714(?)–1760

FRANCE
(*Continued*)

PAINTERS
Largillière,
d. 1746
Rigaud, d. 1743

Antoine
Watteau,
1684–1721

Nicolas Lancret,
1660–1743

Jean-Marc
Nattier,
1685–1766

François
Boucher,
1703–1770

Quentin LaTour,
1704–1788

J. E. Liotard,
1702–1789

Jean Chardin,
1699–1779

CABINETMAKER
André Charles
Boulle,
d. 1732

Some Plays to Be Costumed in the Period

Farquhar's "The Recruiting Officer" (1706)
and "The Beaux' Stratagem" (1707).
John Gay's "The Beggar's Opera" (1728), and
"Polly."

G. Lillo's "The London Merchant; or George
Barnwell" (1731).
Tom Robertson's "David Garrick."

EARLY GEORGIAN

L OUIS QUINZE and Georgian, an age of contrasts if there ever was one! Madame de Pompadour spending the revenues of the French monarchy, and Voltaire shaping the minds of the French intellectuals; bewigged Church of England clergymen droning dull sermons to sleeping congregations, and the Wesleys preaching new hope and spiritual life to awakening miners; ribbons, laces, perfumes, minuets, and fêtes champêtres for the rich, and dirt, rags, stinks, gallows dances, and enforced soldiering for the poor,—here stood the early eighteenth century, midway between an old and a new economic world, retaining something of the gloom and glamour from mediævalism the while it took on the fierce beauty and ugliness of modernity.

Wars followed each other, involving all the principal European nations, whose people gave their lives for causes which concerned them very remotely, as witness these high-sounding names: the War of the Spanish Succession, the War of the Austrian Succession. Battles were fixed in popular memory in curious ways; for instance, the great Duke of Marlborough's country house was named " Blenheim," a new wig, " Ramillies."

A semi-Oriental empire went Occidental when Peter the Great forcibly turned the face of Russia toward Paris. A closer neighbor also made Paris its cultural model when Frederick the Great of Prussia launched his kingdom as a European power. Three women rulers qualified for headlines in history: Anne, the last of the Stuarts, whose short reign gives its name to that group of writers, actors, and statesmen who so brilliantly ushered in the Georgian Era; Catherine the Great, who carried on an amorous life that would have constituted a full-time occupation for most women, as a side-line to the real business of being Empress of Russia, an obligation which she ably discharged; and the Empress Maria Theresa, Archduchess of Austria, who combined administrative abilities in no way inferior to Catherine's with unimpeachable morals. Two important thrones changed dynasties: Spain shifted from Hapsburgs to Bourbons; England shelved the Stuarts of Scotland for the Guelphs of Brunswick.

Not without some protest, however, was the German house established in Britain. There was a " Jacobite" uprising in favor of the Old Pretender (" James III ") in 1708 and another in 1715 just after Anne's death. Neither of these is as well remembered as " The Forty-five," the last uprising, led in person by the Young Pretender. The effort failed, but left a heritage of legends and poignant songs all centered about the endearing personality of

300

Charles Edward Stuart, "Bonny Prince Charlie," "The Young Chevalier," henceforth to share with his ancestress Mary the retrospective loyalty of those who love romantic youth and lost causes.

In the New World France held to Canada and Louisiana, and Spain sent Jesuit missionaries from Mexico into California, forerunners of a later flourishing colonization. England already had twelve sturdy colonies on the Atlantic coast and now added a thirteenth, Georgia. No longer pioneering experiments, these colonies enjoyed a settled and independent life and considerable wealth, enabling them to adopt the comfort and gracious charm of Georgian domestic furnishings. Moreover they had an ever-increasing confidence in their own strength, which was being tried out in perpetual skirmishes with the French and Indians, unconsciously preparing the colonists for their later struggle with the parent country.

GENERAL CHARACTERISTICS OF COSTUME

The first fifteen years of the century, embracing the reign of Queen Anne and the last period of Louis XIV's life, show no marked changes in the character of either men's or women's costume. The taste of both these monarchs was in conformity with the rather stuffy formality of periwigs, fontanges, and bustle-like draperies.

But with the boy Louis's accession to the throne of France began that elegant, delicate, and essentially feminine type of costume, "Rococo." The period of the Regency marked the transition to this exquisitely artificial mode; the next fifty or sixty years, its development. France was the undoubted dictator of style; even the English, while affecting scorn of French character and conduct, did not hesitate to adopt French fashions. At the same time the English upper classes were beginning to acknowledge a taste for the country which they displayed by a certain rustic simplicity, or affectation of it, in dress: e. g., shade hats, kerchiefs, and short skirts. While these bucolic touches had a kind of parallel in the purely imaginary pastoral scenes of French painters, actual court dress was as yet little affected.

Wigs and powdered hair, with porcelain-tinted complexions and artful patches; long, slender bodices and distended skirts; wide coat-tails, clocked silk stockings, and red-heeled shoes; flowers, ribbons, and lace,—with an exquisite sense of proportion designers combined these charming details, displaying a restraint in lavishness which checked frivolity on the brink of foolishness. During the third quarter of the century the fatal step was too often taken and the charm went out of Rococo.

MEN

Heads. Until about 1715 the large full periwig pictured in Chap. XI was worn in fashionable circles; after 1700 it was characterized by a further exaggeration of the two peaks shown in fig. 9, Chap. XI. Powder was used more often than before, making the wig not always white, but gray; many wigs were

still natural colored. After 1700 the voluminous curls of the periwig were modi-
fied in various ways, all with the purpose of taking the hair away from the front.
Fig. 1c shows the ends of the wig curled, figs. 4, 7, and 9, slightly different
versions of the peruke, *i. e.*, a wig shortened but unconfined. By 1730 wigs
which spread upon the shoulders were worn almost exclusively by old-fashioned
gentlemen and representatives of the learned professions (in England judges
still wear full-bottomed wigs). Younger men and fashionable folk had all
adopted the soldier's expedient (fig. 10, Chap. XI): some version of the " tie "
wig. The term simply means that the curls of any wig were confined at the
back of the neck.

Some wigs were merely tied with a black ribbon, the curls hanging free
from the nape (fig. 3). Military men (others also after about 1740) adopted the
custom of wearing long braided queues, tied with a small ribbon bow at both
top and bottom (fig. 8). This is, apparently, the " Ramillies wig," so called
because soldiers at the battle of Ramillies (1706) were said to have had their
hair braided thus. This is the wig that Tristram Shandy's Uncle Toby, that old
campaigner, took out of his trunk when he dressed up to go a-courting the
widow. Subsequently some men arranged the Ramillies in two braids instead
of one. The pigtail was another arrangement adopted to keep the hair away
from the neck: the back hair was wound with a spiral of black ribbon, the
end either left free like a paint-brush or clubbed up, the ribbon tied in a bow
at the top in either case, though not necessarily up to the nape. (Pigtails con-
tinued to be worn by British sailors till the mid-nineteenth century.) A very
popular way to dispose of the back-hair was to bundle it into a black silk
bag drawn up on a string and fastened with the usual bow (fig. 2).

As soon as the very large periwig went out of style, the front of the wig,
(the *toupet*) was drawn straight back from the forehead and arranged full
above the ears. Till 1740 the side hair generally covered or half-covered the
ears, either with rows of curls (figs. 3 and 5) or with what were called
" pigeon's wings," *i. e.*, frizzed side hair brushed forward from the ears in
a puff (fig. 2). As the century progressed, curls were tighter and scanter, dis-
playing the ear (figs. 1a and 8).

Not all men wore wigs. In the beginning of the century a few unpretentious
persons even let their own hair fall loose about their necks in the old seven-
teenth century manner (fig. 1b). After the immense periwig went out, plenty
of men wore their own hair gathered into a tie, bag, or queue and generally
powdered. The man in fig. 6 has his hair in curlers; when they are removed
it will be brushed in such neat rolls as are shown in fig. 5.

All western Europeans with the slightest pretentions to good grooming
were clean-shaven. At the same time white-wigged gentlemen of Poland,
Rumania, and other easterly lands are shown with moustaches.

Hats. Practically all hats save those of the clergy, Quakers, and some other
unfashionable folk, who continued to wear styles like that sketched in fig. 4,
Chap. XI, were stiffly tricorne. Until about 1715 they looked much as they

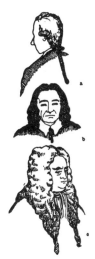

FIG. 1.
a, Toupet with
side-curls; pig-
tail, c. 1750. b,
A servant, c-
1700-1725. c,
Periwig, c. 1700-
1725.

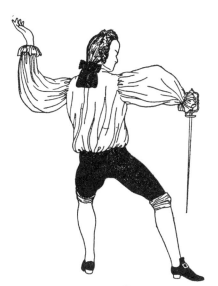

FIG. 2.
Toupet with "pigeon's"
wings," a wig-bag,
ordinary style of shirt,
c. 1725-40.

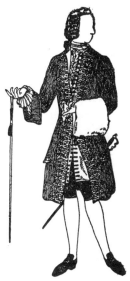

FIG. 3.
Tie-wig with side curls, c.
1740-50. Note cane and
sword, jabot, and shoes
with moderately low
tongues.

FIG. 4.
Peruke. Star and rib-
bon of the Garter,
1700-1725.

FIG. 5.
Toupet, "Solitaire" tie,
1720-50. Note the
double-strand garters.

FIG. 6.
Hair curlers, a sleeved
waistcoat, Queen Anne
chair, c. 1720.

had in the previous period; later they were somewhat higher-crowned (fig. 7). Wide gold braid or gilt lace edged the brims (fig. 5). Occasionally a plume was added, and rather frequently a ribbon bow or other ornament. Cockades in different colors and sizes decorated civilian hats as well as military (fig. 8). Turbans or other caps (fig. 6, Chap. XIII) were worn by men in negligée dress as a substitute for the wig.

Necks. The long neckcloth described in Chap. XI, arranged in the manner shown either in fig. 7 or fig. 9 of that chapter, continued to be worn by many people throughout the eighteenth century (figs. 1c, 6, and 7). But after the first twenty-five years it yielded fashion supremacy to the stock, a plain muslin band put around the neck and fastened in back (fig. 3). Sometimes a narrower black band encircled the throat outside the stock (fig. 4). A favorite variation was a broad black ribbon attached to the wig-bag in back, brought around the neck to the front, and there fastened with a buckle or a spreading bow (figs. 5 and 8). This arrangement was called the " solitaire." Shirts were decorated with a *jabot, i. e.,* a double frill running down the front (figs. 3 and 4). In the early part of the century men of plain habit were still to be found wearing the old-fashioned " band " or turnover collar (fig. 2b).

Bodies. Shirts (made of heavy muslin or fine cambric according to a man's means) were still very full (fig. 2) and finished around the neck with a band which served also as a small turnover collar. Such a collar was sometimes visible in negligée costume if the wearer did not, like the man in fig. 6, wear a neckcloth. Shirt-sleeves were extremely full and finished with wide ruffles of cambric or lace, almost always visible below the coat cuff.

Coats developed along the lines explained in Chap. XI, remaining during this period skirted to the knee or a trifle below. Up to 1720 the skirts were usually not remarkably wide (figs. 3 and 4), but from then until 1750 many of them had a decided flare (fig. 5). About 1700 pockets moved up nearly to the waistline (fig. 4) but later went down again (fig. 3). The position of pockets and the width of skirts shifted rapidly during the period and even, apparently, followed individual taste. Coats were high in the neck, collarless, and equipped with buttons and buttonholes all the way down the front, though seldom were all the buttons fastened; and for that matter, buttonholes were sometimes entirely omitted; fads developed during which now one and now another section was left open (figs. 3, 4, and 5).

Vests were a trifle shorter than in the last century, but never more than a few inches above the coat hem (except in some cavalry uniforms and a few sport suits). Vests often had pockets, placed in positions to correspond to the coat pockets. In this period the vest sometimes matched the coat (fig. 7), though it was perhaps more often made of a lighter color, or of flowered stuff (figs. 3, 4, and 5). During the very early years of the period some men had the bottoms of their vests trimmed with fringe.

A garment which may be classified either as a sleeved vest or a house-jacket is sketched in fig. 6. This particular jacket is velvet and has a flat fur collar,

a touch which began to be added to informal garments early in the period. Long dressing-gowns were often made of sumptuous materials and turned back all the way down the front in a long rolling collar, to show a contrasting lining (fig. 6, Chap. XIII). As in the last period, dressing-gowns were also made of India calico or of domestically printed cotton goods.

Arms. The cut of coat-sleeves from armseye to elbow changed but little. Cuffs were often very wide as in fig. 5, and as in figs. 4 and 5, slit up the backs; they were sometimes considerably narrower (figs. 3 and 8). Almost always they were furnished, as formerly, with three or more buttons by which they were (or were supposed to be) fastened back on the sleeves. Usually sleeves were shorter than wrist-length and therefore allowed a glimpse of shirt puffs as well as ruffles; but as the century progressed, they were made longer (figs. 3 and 8). Sleeves in vests resembled those shown in fig. 6.

Legs. Breeches were oftenest black velvet (figs. *passim*) though lighter satin breeches were fashionable too. They were still rather roomy at the top but fitted neatly over the knee. While stockings were usually rolled outside the breeches (figs. 2, 4, 5, and 6), some were carried up underneath (fig. 3). Occasionally garters almost like the Elizabethan cross-garters held up the stockings (cf. fig. 5 with fig. 1, Chap. IX), but more often no garters were visible. Breeches were finished at the knee by a modest row of buttons or a buckle. A gentleman's stockings for dress were of heavy silk in some light color, often clocked in black; hose for all ordinary purposes were woolen.

Feet. By 1720 the squared-off toes of shoes (described in Chap. XI) went out of style, yielding place to a rounded, though still long, point (figs. *passim*). Tongues grew shorter, buckles larger (fig. 5). Shoes were black, heels often red and fairly high.

The heavy jackboots pictured in fig. 7, Chap. XI, were now relegated to the use of postillions and hostlers; a gentleman's riding-gear included instead the top boot, fitted over the knee and cut out at the back (fig. 8). White woolen boot hose were still often worn between boots and stockings and were occasionally visible above the tops of boots. After the first few years gaiters, not so high or cumbersome as the leather leggings shown in fig. 10, Chap. XI, were occasionally worn in lieu of boots, a detail adopted especially by infantrymen.

Outer Garments. Although capes were not discarded, for many purposes their place was taken by greatcoats resembling suit-coats, but longer and more voluminous (fig. 7). They preserved the older details, such as large pocket flaps, very full skirts, and wide cuffs. The overcoat illustrated is collarless, though already some had velvet collars.

SOLDIERS

Although in the middle of the seventeenth century, with the establishment of standing armies, a beginning had been made toward uniforms, they were not systematized till the eighteenth. From the first half of the century dates

the modern custom of dressing one army to distinguish it from another, one regiment from its fellow regiment. While, as today, the cut of garments was in general like that of contemporary civilian dress, certain colors were adopted, which stamped a group as soldiers of a particular allegiance. An outstanding and early example is the red coats of the British regulars, assumed, it is said, by the Parliamentary army in 1645. Regiments were distinguished one from another by the color of their coat facings; companies by minor trimming details; officers by insignia peculiar to their rank. An easily discerned ornament was the hat cockade (fig. 8), henceforth to play an important part in national uniforms.

Early in the century military men began to button back the skirts of their coats for greater freedom. By 1750 this arrangement of the coat, which was scanter by then, produced a " clawhammer " effect (fig. 8). Soldiers' waistcoats were shorter than civilians'; cuffs were narrower; wrist-ruffles were omitted, and by the end of the period military dress in general was acquiring a trimness which was soon to be taken up by men everywhere.

Under his coat and over his waistcoat an eighteenth century officer sometimes wore a steel cuirass like that of the warrior sketched in fig. 10, Chap. XI; but armor was as a rule reduced to the formal vestige of a steel gorget shown in fig. 7, Chap. XIII, a distinctive badge of officers in more than one army. Good-sized military swords with knuckle-bow hilts were suspended on hangers fastened under the waistcoat.

CLERGY

Catholic clergy on the continent retained the costume shown in fig. 4, Chap. XI. Fairholt (*Costume in England,* Vol. II, Glossary) says that a long cassock was included in the street costume of the Anglican clergy until the reign of George II. After that date an English clergyman dressed practically like the Presbyterian minister pictured in fig. 8, Chap. XIII, with a hat, if not tricorne, wide brimmed like that of fig. 4, Chap. XI. Percy Dearmer (*The Ornaments of the Ministers*) states that the Anglican clergy also wore, in the street, academic gowns. They wore wigs in the prevailing fashion. Anglican church vestments included as now: long cassock, surplice, tippet or stole, academic hood, and the Communion vestments prescribed in the reign of Edward VI (Chap. VIII). Bishops looked then in church practically as they do now (fig. 9) except for the wigs and the wide " bands," which latter have given place to round clerical collars. Note the sleeves on fig. 9, much larger than they were during the seventeenth century and finished with ruffles (cf. fig. 9, Chap. X).

WOMEN

Heads. The high fontange of the late seventeenth century (figs. 17 and 18, Chap. XI) was not modish after the first few years of the eighteenth. Through the reign of Anne and the last years of Louis XIV the hair (or wig) was still

FIG. 12.
Young French court
lady, c. 1730-40. Her
skirt has a hoop
under it.

FIG. 10.
Panniers, worn from 1735
to c. 1785.

FIG. 11.
French court lady, c.
1720-1730. Note the
early type of sleeve.

FIG. 8.
Cavalry officer, c. 1740-50
in Ramillies wig. (Worn
after 1706.)

FIG. 9.
Anglican bishop in church
dress, wearing peruke, c.
1700-1730 or later.

FIG. 7
Peruke and greatcoat,
c. 1725.

often dressed in somewhat the fashion of the masculine periwig (figs. 8 and 9, Chap. XI); the double peaks were frequently exaggerated. The hair upon the shoulders, not so dense as in men's styles, was trained into ringlets. Such coiffures, with possibly a fontange or so, would be appropriate in costuming "The Beaux' Stratagem."

Nearly coincident with the accessions of the first George in England and Louis XV in France appeared a lower and more natural coiffure. Fig. 11 shows a fairly early arrangement, one which remained popular throughout the period; figs. 12 and 17 others, slightly different, in vogue up to about 1750; and figs. 22 and 24 suggest the later high front dressing which was carried to such extremes in the next period. We are accustomed to class all these arrangements under the general name of "Pompadour," after the lady who dictated the fashions of the French court from about 1745 to 1764 and who in common with everybody else dressed her hair thus. This graceful and generally becoming mode, by drawing back the hair from forehead and ears with Greek simplicity, made the most of a well-shaped head and good features, and on the other hand softened defects with judiciously placed ringlets and waves. Especially in formal coiffures, curls long or short often escaped from the back-hair to stray down the back of the neck or over the shoulder (figs. 11 and 24), and the nape was softened with delicate tendrils (figs. 14, 15, and 18). To formal coiffures were added delightful ornaments: small bunches of delicate artificial flowers (figs. 24 and 22), little wreaths (fig. 12), and strings of pearls combined with flowers (fig. 11). Becomingness guided the placing of ornaments, though they generally adorned the front of the hair rather than the back.

Although, with the fontange outmoded, caps again ceased to hold a place in formal costume, they enjoyed great popularity even in court circles as accessories to house dress, and were habitually worn by the middle class and by widows and elderly ladies. No cap had the formidable proportions of the fontange; all were fairly small, often mere wisps of lawn and lace. Figs. 14, 16, 18, 20, and 21 give examples but do not exhaust the types. The mob-cap (fig. 18) entered the fashion early and held its place for a century, lingering even longer as a dust cap as well as the headdress in various regional costumes. Showing from under the hat in fig. 12, Chap. XIII, is a variation of the mobcap which includes frilled lappets meeting under the chin. Some of these caps, such as the early style illustrated in fig. 14, which may perhaps be considered as a depressed fontange, have been preserved in the headdresses of waitresses.

The popular hat, often put on over a frilly cap (a long-lived custom, cf. Chaps. VI, IX, and X), was a simple, low-crowned, wide-brimmed affair (fig. 19). The hat illustrated is black beaver, but its shape is the same as that of the straw hats so popular from this time on (fig. 12, Chap. XIII). Long a part of countryfolk's attire (cf. fig. 22, Chap. VIII), the straw hat was suddenly taken up by the fashionable world, a fad which reflects that hankering after

the simple life mentioned earlier; indeed the hat was spoken of either as a
" shepherdess " or a " gypsy " straw. But while the peasant's hat was plaited
of straw, rushes, or even pliable bark, fashionable millinery was made of fine
yellow straw manufactured in Leghorn. Even in the earliest years hats were
often held down by broad ribbons tied under the chin (fig. 12, Chap. XIII),
making them prototypes of the later poke bonnets.

From about seventeen hundred and throughout the century, the hood shown
back view in fig. 13 was worn by women of all classes; though later, when
immense headdresses were the rule, it was not often seen on fashionable ladies.
Such a hood might be made of soft silk, taffeta, or woolen material. This, with
the capuchon hood attached to a cloak (fig. 19), was the principal outdoor
headgear aside from the hat.

Venetian ladies wore the unique headdress pictured in fig. 23, a masculine
tricorne from which depended a black lace mantilla arranged almost like a
mediæval gorget. Pietro Longhi, the Venetian genre painter (1735–1750), has
recorded this curious but charming local fashion. In other parts of Europe
ladies wore the tricorne hat only as part of a riding habit or sports dress
(cf. fig. 19, Chap. XI).

Necks. The two typical low necklines discussed in the last chapter continued
side by side throughout this period. Figs. 11, 12, 20, 22, and 24 show the
widely open round neck, either with or without an upper gown; figs. 14, 15,
and 17 illustrate the square neck formed by a gown opening over a low-cut
underbodice. As a rule the top was softened by some pretty finish: a flower
wreath (figs. 12 and 24), a pinked ruffle, or the upstanding lace or lawn
ruffle of the chemise (figs. 11, 15, 21 and 22). In less formal costume the
décolletage of essentially the same cut was filled in by one of several collars.
The sheer fichu represented in fig. 18 was popular throughout the period, as
may be seen in pictures of French, English, and American women as diverse
as the good housewife in Chardin's " La Bénédicité " ; the first Polly Peachum
in " The Beggar's Opera," and an extremely respectable lady whose portrait
hangs in the Fogg Museum at Harvard University. The ruffle shown in fig. 16
may also be considered as a form of fichu; but the twining neck decoration in
fig. 17 (made of wide passementerie) is more properly a combination of
neck-ruff and scarf. Soft neck-ruffs, small versions of the Elizabethan ruff, were
deservedly popular, for they were almost always becoming. Fig. 24 shows a
ruff of shirred ribbon. Others were made of white or colored dotted tulle or
of point d'esprit; still others of flowers. The American lady noted above wears
a small sheer ruff as well as her lawn fichu. The gauze cape in fig. 20 might
be called either a collar or a pelerine (a garment very popular later, in the
nineteenth century). It was sometimes a little wider than this and edged with
passementerie or fur, but it was worn, apparently, more for coquetry than
warmth.

Bodies. Bodices were all made on the " corset " shape. They were, ideally,
very slim, tight, and long-waisted. Not always pointed in back, as shown in

fig. 13 (a rather early style), bodices almost invariably had exaggeratedly pointed fronts, which were sometimes further emphasized by a line of trimming (fig. 12). More rarely the long front had a U shape (fig. 17) or a round line (fig. 21). Whether a costume consisted of but one dress or of a gown over bodice and petticoat, the front of the bodice was commonly trimmed to emphasize the narrow effect. Fig. 11 shows a style called "échelle," as its name implies, a " ladder " of horizontal trimming: braid, lace, or ribbon. A series of ribbon bows was another popular type of decoration; still another a plastron, of passementerie appliquéd in a design (fig. 12) or of embroidered flowers (fig. 24). Gowns open over under-bodices might be laced across (fig. 20) or left open to show ruffles of lawn or lace (fig. 21). Over-gowns were usually open in front (figs. 13, 14, 15, 17, 20); dresses worn without gowns were as often laced up the back (figs. 11 and 18). Skirts open up the front over petticoats might be worn with back-laced bodices (figs. 16 and 23). Notice that the bodice in fig. 16 retains across the front four tabs, relic of an earlier peplum. Dresses of the first years occasionally included a peplum almost long enough to pass for a little skirt or drapery laid out upon the wide hips (fig. 11). In this example the peplum is draped; in others it is a shaped piece more like those seen in the seventeenth century.

Arms. During almost all the first half of the century, but especially in the first quarter, many sleeves were still puffed or ruffled up to the top in various graceful and elaborate ways, of which two examples are sketched in figs. 11 and 12. Fig. 11 has cap-sleeves of the bodice material and a series of double lace ruffles from there down; the sleeves of fig. 12 are all white, emerging from the armseye of a silk bodice. Such sleeves may be looked upon as the descendants of the seventeenth century chemise sleeves, even though they may not actually belong to an undergarment. Peasant women did frequently wear a sleeveless corset bodice which showed the chemise at the top, between the front lacings, and in the full elbow sleeves, an arrangement perpetuated in various regional costumes. Side by side with the full sleeve flourished that type which had come into fashion later in the seventeenth century, a fairly slender elbow-sleeve, from under which emerged a white ruffle. Early gowns had on the whole rather wider sleeves, which almost always terminated in a turn-back cuff of generous proportions, inspired by the masculine coat-sleeves (figs. 14, 15, and 17). In such an early example as fig. 14 it is pretty clear that the cuff is actually formed by turning back the sleeve itself, and in the little girl's costume in the same picture the chemise sleeve is probably turned up over the outer sleeve to make the white finish. Figs. 18, 20, and 23 show smaller, neater cuffs. It is not possible to state that all wide cuffs belong to early dresses, all narrow cuffs to late, for examples of each may be seen in pictures dated in both quarters of the half century.

It was during only about the last ten years of that time that cuffs were omitted from elbow sleeves, their place being taken by ruffles of self-material usually supplemented by lace or lawn ruffles (figs. 21, 22, and 24). **Fig. 22**

FIG. 16.
An early parasol, a
quilted petticoat, c. 1735-
40. Note the watch.

FIG. 15.
Boy, c. 1730. Lady in sack-backed
dress, 1735-50.

FIG. 13.
Middle-class woman wear-
ing a hood popular after
1700.

FIG. 14.
Early type sack-backed gown, c.
1720-1725. Child same date.

shows a ruffle abruptly lengthening on the outside of the arm, and a double-ruffled finish; the ruffle on fig. 24 points upward. The sketches give some idea of the variations in the filmy lawn or lace ruffles which fell over the forearm so flatteringly.

Long sleeves were not entirely absent from eighteenth century dress, albeit the elbow sleeve may be considered typical. Fig. 16 shows one long tight sleeve, simple but not lacking in charm, and fig. 13 another on a plain dress, a sleeve which probably terminates in either a small ruffle or a narrow turn-over cuff.

Legs. In 1710 hoops returned to fashion and were important enough and fetched a good enough price to be considered worth stealing by the rascals in " The Beggar's Opera." Many women did not wear hoops, still trusting to a number of stiff petticoats to give them the fashionably expanded skirts (figs. 13 and 14); others wore hoops of reasonable dimensions (fig. 16); but many donned huge round hoops, making of their skirts widely distended bells (figs. 11, 12, 15, 17, 18, 20, and 21). Note, in fig. 21, how the petticoat and gown were worn *over* the hoop and another, slim skirt, *under* it. The hoop was actually a stiff petticoat with rows of whalebone from hem to hips; however, the effect is the same and the comfort greater if, on the stage, the flexible steel framework described in Chap. XX is substituted.

About 1735 or '40 the bell-shaped hoop was largely superseded by panniers (fig. 10) which held out the skirts enormously at the sides but allowed a slim silhouette from front to back, somewhat in the manner of certain Elizabethan farthingales (Chap. IX) but more exaggerated. It was possible for the width from hip to hip to be as much as three feet four inches, from front to back no more than twelve inches (fig. 23). While skirts were sometimes simply hung to fall over the panniers in full gathers (figs. 14 and 22), a less cumbersome skirt was made with a seam down the top of the pannier (fig. 15); if much fullness was desired, the skirt was arranged as in fig. 23, with straight breadths pleated into the top seam.

The length of skirts varied considerably. As a rule they touched the ground or were shortened only enough to clear the instep. Sometimes, however, dance-frocks came nearly to the ankle (figs. 12 and 24) and toward 1750 street dresses were also shortened a little (fig. 19). Throughout the period formal costumes and sometimes also informal house dresses had trains. On the matter of opening skirts up the front, opinion was apparently divided. Some dresses even without over-gowns were split to show ornamental petticoats (figs. 16, 22, and 23), others were closed in front (figs. 11, 12, 18, and 20); some over-gowns were closed in front (fig. 17), many others open (figs. 24, 15, 19, and 21). Looped up overskirts in the styles fashionable either in the preceding or in the succeeding period were seldom seen.

The sack-backed gown must be considered by itself, combining, as it did, bodice and skirt in one garment. It made its appearance about 1720 and became immensely popular, its vogue lasting up to 1780, after which it was still

retained as a formal court dress until the drastic changes of the French Revolution had swept all monarchical styles into the discard. The popular name for the sack-back (which has frequently been revived) is "Watteau pleat," a loose term, since Antoine Watteau died before this style of dress had more than begun its career. Fig. 14, taken from an early picture, shows the very loose garment worn from about 1720 to 1725 or 1730. As may be seen, the full width of the material appearing at the hem is pleated into the neckline, the garment being shaped loosely into an armhole and underarm seam. These early robes were often sleeveless, to be worn over a sleeved bodice. In front they were open to the waistline or lower (fig. 17) or even all the way down. There is an analogy between this garment and the mediæval surcote of the fifteenth and early sixteenth centuries (cf. fig. 15d, Chap. VII and fig. 15, Chap. VIII), the difference being that the garment of the middle ages and Renaissance had no back pleats. Although this loose robe continued to be worn as a negligée or dressing-gown put on directly over the night shift, by 1725 it was succeeded for public appearances by a neater garment (fig. 15) in which all the extra fullness is laid in a box pleat at the neck, whence it descends to merge with the fullness of the skirt. The gown was fitted neatly under the arms and was often made over a tight "body." After a while the pleats were sewed to the back of the underbody, sometimes as far down as the waist. Even the later gown did not always have its own sleeves, as it has in fig. 15. The *robe à la française,* as the English named it, had a train and in its later version opened over a petticoat or a whole dress, though with a tight body it needed no underbodice.

The night-rail (fig. 20, Chap. XI) was restored to its proper position as a boudoir garment, as it is represented in the Countess's dressing-room scene of Hagarth's "Marriage à la Mode." Another fairly informal garment was the short "sack" or jacket illustrated in fig. 12, Chap. XIII; an example may be seen in the same series of paintings.

Feet. Shoes had high "spindle" or, as we say, "French" heels which, like men's, were often painted red, if they were not covered with brocade like the shoes. Toes were pointed, vamps long. Fig. 12 shows a shoe which has long side pieces crossed over the instep; fig. 24 a pair with a buckle set so high on the instep that the skirt just covers it (this lady, by the way, is just sinking in a curtsey, which accounts for the position of her feet). Shoes were often made of satin in plain colors, and both these and brocade shoes were further embellished with gold braid. Everyday shoes were of course not so dressy, being of the types shown in figs. 11 and 13, Chap. XIII, or like the little black boy's in fig. 11. Mules (fig. 21) resembled modern types except that, like the shoes, they had longer vamps; they were very popular for house wear. "Clogs" were extra soles, fastened over the insteps and fitted with pieces which filled in the arch from the ball of the foot to the bottom of the high heel, thus making a flat surface upon the ground, like a heelless shoe. Anyone who has attempted to walk with high-heeled shoes on the cobblestones of old European

city streets will appreciate the practical value of this device. Clogs also pro-
tected delicate shoes from the mud, though they seem ill adapted for the
purpose, being so often made of satin and brocade to match the shoe. The
Victoria and Albert Museum possesses clogs, one of which is illustrated in the
official " Guide to the Collection of Costumes." Since clogs are unlikely to be
needed as a stage accessory, we have not burdened any of our figures with them.

Outer Garments. The cloak illustrated in fig. 19 was popular during this
period as well as later. It was not always hooded, nor did it always have arm-
slits; on the other hand it sometimes *had* wide loose sleeves. Women also
wore longer capes, like those for men. The cape-like garment attached to the
shoulders in fig. 11 is a formal court train, akin to the mediæval court mantle.
The wearer is a lady of royalty or high nobility.

EQUESTRIENNE

Riding habits aped mannish styles according to the practice begun in the
preceding period. Except for the long, full skirt they followed masculine dress
in all details, even to a wig in a black bag. For " le Sport," in that day prin-
cipally hunting, the costume was the same (cf. fig. 19, Chap. XI and fig. 20,
Chap. XIII).

CHILDREN

As may be seen in figs. 14 and 15, children's dress followed adult fashions.
Both the boy and girl in the sketches are simply dressed and their costumes
are adapted a little to their age: the girl is not tightly laced, the boy wears
his own hair, unpowdered. This was not always the case with the unfortunate
children of the nobility, who had their portraits painted, at any rate, in gar-
ments every whit as restricting as their elders'.

The small black boy illustrated in fig. 11 might almost be classed as an
accessory, so much was he part of the great lady's *entourage,* so little did he
count as a human being. These negro children were dressed in fantastic varia-
tions of the current modes, usually with oriental touches reflecting the general
interest in the East. Sometimes, instead of the little coat and breeches, such a
child wore a Turkish costume consisting, besides the turban, of tunic, sash,
and full trousers.

MATERIALS

Although figured materials were so very popular, plain colored satin was
still made up into handsome dresses, especially during the first quarter of the
century; and taffeta also, being of a texture adapted to the bouffant skirts of
the period. In addition to these silks lutestring,* a ribbed weave, was often
employed in both men's and women's dress. Men's coats as well as breeches
were of velvet, which was frequently used for ladies' capes and especially for
court mantles, though it was not very popular for dresses. Brocade and damask,
both frequently woven with some metallic threads were in the forefront of the

* or lustring, corrupted from the French *lustrine,* a glossy silk fabric.

FIG. 18.
Middle-class lady, 1725-40.
Mobcap, fichu, apron.

FIG. 19.
Walking dress worn over panniers
(fig. 10), 1735-1750. Note the
beaver hat over a cap.

FIG. 17.
An English dowager, 1730-1750.
Note the passementerie trimming
around her neck.

FIG. 20.
Middle-class English lady, c.
1730-40. Note the transparent
cape.

mode. Silk gauzes were in considerable demand for little scarves and various other neck decorations.

Men's outer wraps including greatcoats were woolen, as were also their plainer suit-coats and women's simple dresses, cloaks, and hoods.

Cotton and linen goods were frequently used for dresses. The printed India calico mentioned in Chap. XI continued to be popular, particularly for men's dressing-gowns and women's negligées and house dresses. From the end of the seventeenth century domestic block-printed cottons and linens patterned in gay designs were available in France, Germany, and England and were inexpensive enough to warrant making into everyday garments. White linen, muslin, or lawn, in varying degrees of fineness, appeared on almost every costume.

COLORS

To think of Rococo is to think of delicate, flowerlike colors. Roses, carnations, and other blossoms in pale green, pink, blue, lavender, maize, and primrose strewn upon lighter backgrounds abounded in the dress of these dainty ladies and elegant gentlemen. Yet there was a goodly mixture of stronger colors also: black backgrounds with flowers in crimson and green, gold-color and purple, colored backgrounds worked in gold and black. Men wore velvet, satin, and fine woolen in deep tones such as black, brown, burgundy, and dark blue. The red coats of British officers appeared in almost every sizable English gathering; for the matter of that, civilians wore red too, e. g., the " pink " coats of fox-hunters which have persisted even into our own day. Working-women and others of sober tastes often wore plain dark dresses.

MOTIFS

Later generations gave the name of Pompadour to the flower-strewn silks of this period. In addition to these flowers, not always so large as those of the late seventeenth century (fig. 5) yet not so tiny as they were later, appeared the characteristic ribbon motif, showing ribbons in bows and loops, often in connection with baskets of flowers. Bands of ribbon woven alternately with nosegays of flowers foreshadowed the great vogue for stripes in the latter part of the century. Already in the second quarter both wide and narrow stripes were fairly common in silks and cottons. Woven checks and small plaids were also worn for work-clothes (fig. 13, Chap. XIII).

The passion for " Chinoiserie " (things Chinese) which had already begun in the latter years of the seventeenth century and which raged highest during the first half of the eighteenth expressed itself to some extent in dress-materials; indeed Chinese art subtly influenced all design, though the actual patterns on fabrics were not often replicas of Chinese scenes or motifs.

APPLICATION OF DECORATION

The embroiderer's art was never more assiduously practiced than during the

eighteenth century; beautifully executed designs ornamented coats and waist-coats (fig. 5), bodice fronts, petticoats, and indeed entire dresses (fig. 24). Quilted petticoats were more popular than ever (fig. 16). Appliqué and passementerie work likewise enriched costumes with happy effect. Artificial flowers, appliquéd upon a surface or festooned over it, lent a pastoral grace to ladies' dress (figs. 12 and 14). Ribbon bows added another charming frivolous note (figs. 12, 17, and 22). Braid, gold and silver lace, or gimp were introduced on practically every masculine coat, either in plain strips (figs. 4 and 8) or in elaborate patterns (figs. 3 and 5). Coats were trimmed around the collarless neck and down the front edges, around the cuffs, and on pockets. All but the plainest hats had at least a narrow edge of gold braid or lace. Buttons and buttonholes were both useful and ornamental; in addition to fastening the coat up the front they also held cuffs back on sleeves and pocket flaps down on coats. Velvet was utilized for the small turnover collars of smoking vests and sometimes the collars of greatcoats; fur could be sub-stituted for velvet on the jackets (fig. 6). Fur on women's apparel seems to have been limited, usually, to muffs and the trimming on outdoor cloaks or capes (fig. 19), though very sumptuous garments might be fur-trimmed. Men infrequently added lace to their cravat ends or jabots, but often to wrist-ruffles and handkerchief hems; women employed it profusely: at the top of the bodice, in the front V, on the elaborate sleeve-ruffles, on skirts and petticoats, and on caps. Aprons even for children (if they were of the nobility) were sometimes entirely of lace.

JEWELRY

A man's jewelry was reduced to a ring, the badge of an order, and any elaborate goldsmith work or embellishment of gems that he might have had applied to his snuff-box and sword-hilt. The watch, good-sized and very thick, with a chain dangling from it, was worn in the fob pocket at top of the breeches. Watches are not often visible in contemporary pictures because of the long waistcoat and coat, but they were nevertheless all too accessible to the pickpocket; Peachum, the rascally gaoler in " The Beggar's Opera," reckons five gold and seven silver watches among the day's takings of his light-fingered associates. The " Order " now began to be pinned on the left breast of the coat, while its ribbon was put across the body left shoulder to right hip, in the manner of the earlier military sash (fig. 4). Not but that on official occasions the whole collar of the order was worn, as it may be seen, for instance, on Queen Anne's effigy in Westminster Abbey (a reigning queen is entitled to wear the decorations ordinarily reserved to men).

Considering that hairdressing exposed the ears, it is remarkable how few women wore earrings, or at any rate had their portraits painted in them. Not that there are lacking instances of the great pearl drops so popular during the preceding two hundred years (to cite Queen Anne again, there is a large pair on her effigy), but they were by no means universal. Jewelry was worn with

much more restraint than had been the style since before the Renaissance. The garniture in the hair might be of gold and diamonds; there might be jewelled pins in the bodice, in fact all the way up the front; and almost any accessory might be set with gems; but the day had passed when a lady loaded her fingers with rings, her arms with bracelets, and her neck with chains. Anne's effigy is, to be sure, bedizened in the good old way with all the paste jewels possible, copied from the originals in the royal treasure. Yet one of the most charming features of the period is the beautiful bosom and throat rising unadorned from a delicate froth of lace. Women wore watches like men's (as they had occasionally in the last period also). They were hung upon longish chains from the waist, as shown in fig. 16.

ACCESSORIES

Men. The dress-sword was an invariable accompaniment of a gentleman's formal costume (figs. 2, 3, and 5). This sword was a rapier, lighter than the soldier's sword (fig. 8) and, like it, worn on a hanger swung from the belt underneath coat and waistcoat in such a way that the sword protruded through slits in the coat. Hilts were often silver or gold and set with gems. Men carried canes, sometimes in addition to swords (fig. 3); they had round heads, finished with nothing more elaborate than a metal knob. The cane sketched here is a small stick, for show rather than use, and is adorned with a tassel, as in earlier fashions. The stick in fig. 7 is sturdy, intended actually to aid the footsteps of the bearer.

Snuff-boxes were as omnipresent as ever (fig. 4). They were sometimes rather large, as much as four and a quarter inches long and three and a quarter deep. They were made in a variety of materials, *e. g.,* tortoise-shell and silver, gold or silver enamelled and set with jewels, inlaid wood, and Chinese lacquer. Many men smoked pipes of the shape illustrated in fig. 6, about the same that had been used since Raleigh introduced pipe-smoking to Queen Elizabeth. Handkerchiefs were valuable enough to be enumerated along with snuff-boxes, silver-hilted swords, and silk stockings in the takings of Peachum's thieves, and it is interesting to note that the lace edging was sometimes colored. The hat was still considered an indoor accessory, as described in Chap. XI. Throughout the period men carried muffs (fig. 3). Gloves were regarded as utilitarian rather than dressy accessories, as explained in Chap. XI.

Women. Folding fans were an almost invariable accessory of ladies' dress costumes; in this period they reached their highest point of beauty. They were made of silk stretched on delicate ivory or shell sticks and exquisitely painted by the most famous artists, in landscapes, figure groups, and all manner of charming compositions. Ladies still carried pomanders which were like those pictured in figs. 5 and 18, Chap. VII, but much smaller (fig. 11). Long gloves were a necessary outdoor accessory and were sometimes worn also for indoor occasions (figs. 19 and 23). Mitts were almost equally popular, being made either of lace or kid, the latter sometimes with embroidered backs. The size

FIG. 24.
Young lady at a dance, c. 1750.
Note her hair, dressed over a
pad.

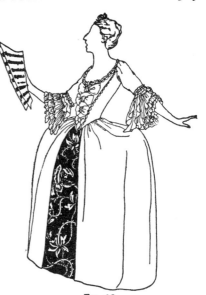

FIG 22.
French or English lady
wearing panniers (see fig.
10), c. 1740-1750.

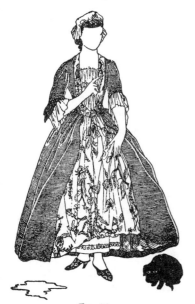

FIG. 21.
Lady in house dress over round
hoop, wearing mules, c. 1735-
1740.

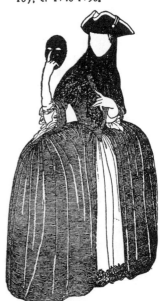

FIG. 23.
Venetian lady in street dress, c.
1740-50. Note the manner in
which her dress is pleated to
fit her panniers (fig. 10).

and shape of muffs remained about the same as in the last period (fig. 19). Parasols, though not unknown in earlier centuries (having never lost their importance in the Orient), now began to come into their own. Perhaps their vogue may be traced to the Chinese influence mentioned above; indeed these early parasols look rather Chinesy (fig. 16). A lady might carry her own parasol as in the sketch, though it was often held over her by the little black boy who may be considered almost as much of a necessity to the lady of fashion as her monkey or her parrakeet.

During Queen Anne's reign aprons held the fashionable position they had attained at the end of the previous century, but after about 1720 the interest in them as garnishments of court costumes languished, and they were relegated to the position of dainty, sometimes expensive, but still utilitarian accessories of house dresses (fig. 18). Masks were worn as explained in Chaps. X and XI and were often made to cover the whole face (fig. 23). Patches continued to be worn by both men and women.

SOMETHING ABOUT THE SETTING

In France the grandiose Baroque style of Louis XIV gave place to the feminine daintiness of Rococo. Even during the Regency this tendency expressed itself in more delicate furniture, in which caning played a considerable part. After Louis XV actually began to reign, the style quickly reached perfection. Woodwork was enamelled in white or cream, and wall spaces were filled with brocaded silk, tapestry from the factories at Aubusson, or painted panels. To the baskets of flowers and the ribbons already mentioned was added a motif of musical instruments, viol or guitar, flute, and bagpipes:— part of the equipment of imaginary pastoral life. Furniture was still generously proportioned, though light and graceful in design. It was made of walnut and other light-colored woods, sometimes left in the natural gray-tan color, often enamelled or gilded. It was exquisitely carved, painted, and upholstered in satin or delicate Aubusson tapestry. Furniture in the " Boulle " fashion (decorated with wood marquetry, inlaid with shell or metal, or metal-mounted) continued also from the preceding period. In interior decoration the Chinese influence was direct, designs being actually copied from Chinese sources. Beautifully painted screens played a large part in eighteenth century interiors and incidentally in dramatic plots. Chinese lacquer was adopted and brought to a high degree of perfection by Martin, his special processes, in particular a green rubbed with gold, being still named " Vernis-Martin." Such lacquer was applied to various examples of cabinet work.

In England " Queen Anne " furniture was carved rather than painted, developing from the styles described in Chap. XI. A Queen Anne chair is illustrated in fig. 6. One of the period's most outstanding features is the upholstery of needlepoint, worked by the ladies of the family. Another detail by which a Queen Anne interior may be recognized is the broken pediment, often with an urn in the middle, applied architecturally over door-frames and

to large pieces of furniture like secretaries. Unlike French furniture, English was usually of dark wood, neither painted nor gilded. With the Georgian era appeared those graciously-proportioned, white-panelled interiors with which we in America are fortunately also familiar. The Adam brothers, those famous decorators, began their career before the period ended; so did Chippendale, who was making mahogany furniture before 1750.

Delicate porcelain imported from China revolutionized table-setting. Beautiful flat silver as well as large pieces of plate graced the tables of the well-to-do. Pious Queen Anne presented an astonishing number of silver Communion Services to American colonial churches.

Among musical instruments, spinets and harpsichords were popular, and so of course were violins and guitars; recorders or " English flutes " went out of fashion; instead people took up the transverse or " German flute."

PRACTICAL REPRODUCTION

Materials. You will have little trouble in finding materials appropriate to this period. If you look among curtain and upholstery goods, your search will be rewarded with cretonnes and chintzes in considerable variety. Some of them are printed in a ribbon as well as a flower motif, and some by their shaded stripes give an effect of satin. Shop with a definite picture in your mind, taken from the accompanying sketches and other examples. Correctly patterned silk is usually rather expensive and sometimes unprocurable because not in the current fashion. But floral patterned silk-and-cotton or silk-and-rayon brocades, intended for linings, appear in the shops year after year. They generally come in rather " old-lady " colors like purple-and-black, gray, and black-and-silver, which are excellent for your purposes. Use plain-colored rayon satin and taffeta as freely as you wish, and sateen also. If you would put time rather than money into a costume, you can apply designs on light sateen by means of spray-dying (see Chap. XX) though it is difficult to procure more than two tones by this process. By batiking (Chap. XX) you can manage several colors.

Among dress materials, inexpensive chintzes sometimes come in correctly large floral patterns; and percales in wide stripes. Old-fashioned checked gingham is appropriate for the dresses and aprons of servants; so are plain-colored gingham and blue denim. Denim and khaki cloth can be used also for workaday masculine garments.

Men's suits should be made of the flowered materials and satins enumerated above, of cotton duvetyn, velveteen, small-ribbed corduroy, any smooth-finished woolen goods, and heavy outing flannel, dyed. Breeches should generally be made of black velveteen, but if they are to be worn with coat and vest and will therefore show little, sateen will do. Make men's dressing-gowns of the same large-flowered cretonne or chintz that you use for women's dresses and line them with sateen. If you are using fur, get either rabbit, which comes by the yard, or one of the fur fabrics. When you make your estimate on the cost of women's dresses, allow for bodice linings and under-petticoats of heavy

muslin; include the same material, upholstery canvas, or tailor's canvas in your estimate for men's coats and waistcoats.

Trimmings. For trimmings consult this section in Chaps. X and XI. It is possible in a short time to put very effective embroidery on fairly small areas like waistcoat fronts (fig. 5) by working with coarse wool in a big loose over-and-over stitch. Draw the design on the material with pencil or chalk, embroider and, if you wish, outline it with black chain-stitching. Embroidery takes no longer than the process of batiking the same design. It is also effective to cut motifs from cretonne and appliqué them on the garment. They may even be glued on, but gluing is not very trustworthy for costumes to be used more than once.

Small artificial flowers such as you may buy in the ten-cent store are appropriate for this period; look at those sold for millinery, for table-decoration, and the sort made of ribbon and intended for trimmings. Crêpe-paper flowers do not come amiss, if they are to be seen at a little distance.

Accessories. Consult Chap. X for advice about masks and fans, Chap. XI for suggestions about snuff-boxes. You can buy the slender, long-stemmed clay pipes appropriate to this period (fig. 6). Follow the advice about gloves in Chap. XI.

If you may use a parasol that is never to be closed, you can make one of the shape shown in fig. 16, with a frame of heavy iron wire (see Chap. XX), stretching silk or glazed cambric over it. If the parasol must be opened and closed, look for a modern one as near the shape as possible and put it on a long handle.

Millinery. To make tricorne hats, consult Chap. XI. For the veil arrangement shown in fig. 23, take a piece of black Chantilly lace (if necessary, plain black net will do), run a gathering-string at the top edge, adjust the fullness evenly and fasten that edge to the inside of the hat-crown at back and as far as the ears in front. Put the hat on and fasten the drawing-string tight under the chin, adjusting at every wearing.

To make a mob-cap (fig. 18), cut a circle about twenty-six inches in diameter out of white lawn. On it mark a second circle about twenty inches in diameter, and upon that line sew a casing. Run a tape in and draw it up to fit the head. The measurements will depend on the individual head and upon how wide you want the frill, how puffy the crown. Plan it out in paper or waste material before cutting the good material. The other caps illustrated are either variations of the mob-cap (figs. 16, 20, and 21), or a series of over-lapping ruffles (fig. 14). For the hood (fig. 13) take a piece of cloth sixteen inches wide by about thirty or thirty-six long. Put it on the head, gather it up tight on the back edge, and sew the two ends together. Turn it away from the face enough to reveal the temples. You may line the hood with a contrasting color and turn it over to make an edging on the right side as shown in the picture. Make it of woolen goods, duvetyn, flannelette, or one of the silk materials in a plain color.

Rent wigs if possible. If renting is out of the question, make them of yarn as described in Chap. XI; or of crêpe hair over a foundation of cotton sewed on a skullcap. This latter method is most successful with a white wig. In making wigs, work always on the wearer's head or, better still, on a wig-block of the correct size.

Hoops. To make round hoops, see directions in Chap. XX. Make the panniers shown in fig. 10 thus: Use number 14 iron wire, double-twisted for the large ellipse, single for the two extra pieces. Make the main ellipse as wide across the hips as you wish (three feet, four inches is about the maximum that the actress can manage) and about twelve inches from front to back. Make two wire loops for each side as shown in the sketch, the first about thirteen inches deep, the other the same with two inches added for the elbow. Adjust these as you see them in the sketch and take the panniers to a forge or a plumber's shop, where you can have them soldered at all the joints. If it is at all possible to get the work done, have the side pieces, including the ends of the main ellipse, hinged. If this is done the wearer may lift up the sides of her dress in passing through narrow places, as women actually did. It is equally satisfactory to make the frame of strong wicker, which may be fastened together by raffia put through drilled holes, or hinged if you can manage it. The frame is attached to a waistband of tape (or to an accurately fitting band of belting equipped with hooks and eyes) by means of other tapes, as shown in the sketch. Where the tapes touch the frame, they will have to be soldered, riveted, or if you use wicker, tacked. Next to the body the actress should wear a scant petticoat as shown in fig. 21, then the hoops or panniers, then a full petticoat, and finally the outer skirt.

Shoes. For ways of adapting shoes or utilizing modern styles, see Chap. XI.

Renting. From the end of the seventeenth century down to the present, men's coats have been "tailored" in very much the modern sense, that is, artfully cut in a number of pieces, interlined, and judiciously padded. It is difficult for the dressmaker whose work has been entirely with women's frocks to turn out a coat that looks really professional. For this reason I advise that if finances permit, men's costumes from this period on be rented (with exceptions to be explained later). If there is one century that costumers know about, it is the eighteenth; if there is one costume they are likely to have in stock, it is the so-called "Colonial." Their costumes are as a rule well made and of materials reasonably accurate. Of course if you can personally select the costumes you will use, so much the better; if not, you must write careful descriptions and if possible, append sketches, in addition to filling out the measurement blanks the firm sends. Specify the preferred colors and give second choices. Even more important is to insist on the *kind* of coat you want; for this and the preceding period you must ask for "square cuts." When the costumes arrive, you may find that the sleeves are too long, but you can, without injuring the garment, take a tuck under the cuff. Be prepared to supply the necessary sleeve-puffs to go under the shortened cuffs; also any especial stock or neckcloth and the

proper ruffled shirt-front; these are easily made by copying the sketches. With the suit the costumer will provide hat, white cotton stockings, and shoe-buckles on elastics. Although you may be disappointed in details (the best of costumers will send you what he has on hand, even if it is not what you asked for), you will probably come out better than if you attempted to make the costumes; moreover, if you are planning to use the costumes in only one production, renting will be cheaper than making.

CUTTING THE GARMENTS

Men. However, if your costumes are to become part of a permanent wardrobe, it is worth while putting money and time into their construction. Follow the suggestions for cutting given in Chap. XI. Remember that you must line the waistcoat with heavy muslin or canvas and interline the coat throughout with the same canvas; a sateen lining is not enough. Haircloth, which costs about twenty cents a yard, may be used to give extra stiffness to the skirts. In making all garments remember to stitch accurately and press as you go along. If the coat is of wool, have it finally pressed by a tailor.

You should have no difficulty in cutting any waistcoat by the pattern suggested in Chap. XI. Use the coat pattern to cut the jacket shown in fig. 6, putting on scant skirts and adding a collar. Breeches cut by the "George Washington" pattern should present no difficulties.

To make the white shirt, see Chap. XI. No harm will be done if you use the shallow yoke, and the garment is not quite so bulky that way. Unless the coat is to be removed there is no real necessity for a shirt, for it may be faked with sleeve-puffs, a small guimpe or a dicky to take the frill, and a stock.

Women. In Chap. XI you will find directions for cutting women's bodices and skirts. The "Martha Washington" pattern also furnishes you with a good bodice. Do not follow the pattern for the width of skirts; a skirt to be worn over hoops should measure at least eight yards around and the overskirt as much or more.

To make the skirt fitted over panniers: Use one width of material for the front and another for the back and gather them on a waistband hooked in the back, arranging the gathers so that the pieces nearly meet under the arms. Put this on the wearer, over the panniers. Now add two more widths to each side, both front and back. Pleat this amount to fit the space over the hips (fig. 23) and seam together along the top. Round off at the top outer edge to fit the curve of the pannier and stitch together down the side. If you want a skirt with more fullness, add more material; if one with less (figs. 15 and 19), add only the width you need and round off the material to fit the panniers, easing it in as necessary with a few tucks at the corners. You will have to make the muslin petticoat thus as well as the upper skirt. If a decorative petticoat is to show in front, make a front width of the good material sewed on a similar width of muslin; omit the front width from the overskirt.

Cut the early sack-backed dress (fig. 14) by some pattern like an old-

fashioned nightgown (you can find one in any standard pattern book), put-
ting thirty-six inches into the back breadth and pleating it all in. Cut the skirt
of the gown longer than the pattern and in order to gain an extra two yards
around the bottom, insert at each side seam a triangle, the full width spread-
ing at the bottom, the apex joining the underarm seam at the waistline. For
the front, cut the gown without a yoke or collar and leave it open, as shown
in fig. 17.

The " Martha Washington " pattern provides for a pleated back like the
later sack (figs. 15 and 17); utilize it thus: cut the bodice including the back
pleat, making the latter both somewhat wider than the pattern, to allow for
a deeper pleat, and considerably longer, to provide for a train. If you wish
to give the effect of a separate bodice underneath, you may make the front
sections of a different material. Now take a second breadth of material like
the back and sides, long enough to extend from shoulders to floor in front.
Folding it in a pleat on each side, shape it to the shoulder and sew in with
the bodice. Split the front breadth part way or entirely down, according as you
are imitating fig. 15 or making an open gown. Now sew the under part of
the front pleats to the side front seams of the bodice. Fill in the sides of the
skirt with straight breadths at least two yards wide and gather them to the
bottom of the bodice. The sack-backed dress shown in fig. 15 may be made
by the pattern except that the side pieces of the skirt should be straight and
probably at least a yard wider on each side, and the whole skirt much longer.
The underpetticoat must also be much fuller. If the sack back is worn with
panniers, cut the back and front as described above, the sides as explained
under *panniers*.

Cut the cape (fig. 19) on the pattern of a modern cape with gored side
seams. Add the capuchon, which is cut like Little Red Ridinghood's hood, *i. e.*,
a circular piece about a yard in diameter, made like a mob-cap (above, p. 322)
but attached along one edge to the neck of the cape.*

Selected Reading List

Of the books enumerated in Chaps. X and XI those by the following authors will
be found useful for this period also:
Kelly and Schwabe, Calthrop, Clinch, Fairholt, McClellan, Warwick and Pitz, Earle,
Talbot Hughes, and McQuoid.
Satirical Songs and Poems on Costume, Thirteenth to Nineteenth Centuries—By Fairholt
(1849). Furnishes entertaining material on this and the succeeding periods.
The Quaker, A Study in Costume—By A. M. Gummere.
Gives information about the costumes of this particular group in the seventeenth,
eighteenth, and early nineteenth centuries.
The Eighteenth Century—By Paul LaCroix.
Is, like this author's other books, a reliable reference.
Histoire du Costume en France—By Quicherat.
Another standard book which will be useful in this period.

* In *Period Patterns* there are a number of authentic patterns charted from eighteenth century
garments.

Modes and Manners, Ornaments—By Max von Boehne.

Dealing with a number of accessories, has good-sized pictures of snuff-boxes and fans. The book is one of a series, all good, written in German, some of which have been translated.

Where Further Illustrative Material May Be Found

Hogarth is as useful an English reference for this period as Holbein is for the time of Henry VIII. Although the content of his pictures is satiric, except in frank caricatures he does not exaggerate the costumes. In caricatures, of which there are many from his pen and also from the pens of lesser artists, we may study those details so much in the public eye that they seemed worthy of ridicule. Pamphlets and broadsides published in France, England, and even America may be found in reproduction. Fairholt's collection (op. cit.) gives good examples; it is to be found upon the shelves of many libraries. These prints deal mostly with the seamier side of eighteenth century life.

The French painted (a) realistic, if sometimes flattering, portraits, (b) portraits in which the subject is dressed in imaginative costume, and (c) purely imaginary scenes in which ladies and gentlemen in contemporary dress mingle with shepherds and shepherdesses in costumes which are a combination of contemporary, " old-fashioned," and fantastic elements. From all these types of pictures information may be drawn, if one is able to separate the realistic from the imaginative.

In the early years of the century Kneller in England and Largillière and Rigaud in France were still painting, and their later portraits, like their earlier, are good costume references. During almost the whole of the period Nattier painted portraits. In the middle years of the century Boucher made charming portraits, besides painting the plump and rosy nudes and cherubs on pink clouds for which he is best known. Antoine Watteau died in 1721, hence his exquisite if vague costume pictures record only early costumes, though it is, strangely enough, his name more than any other painter's which we associate with the period. Lancret's equally charming scenes, contemporary yet unreal, furnish information for twenty years longer. Chardin painted genre pictures comparable to the Dutch paintings of the previous period and equally valuable as references for bourgeois costumes. Much information may be found in the works of the pastellist La Tour, and those of Liotard (who painted the well-known " La Petite Chocolatière "). The paintings of Longhi give us valuable details of contemporary Venetian dress. The efforts of native American portraitists also supply us with interesting details.

Pictures by the above artists are to be found in the galleries of Europe and America, and reproductions of them in collections of art prints, histories of art, biographies of the period, and in the costume books recommended above. Reproductions of the smaller objects of art such as fans and snuff-boxes may also be found in various art books. A good many costumes have survived from this period and may be seen in museums in various cities, e. g., the Victoria and Albert Museum, the London Museum, the Metropolitan Museum, the Museum of the City of New York. The first named issues an illustrated catalogue. Art and archæological magazines publish many excellent photographs of eighteenth century pictures and objects of art.

Sources of Sketches in This Chapter

Of the contemporary material listed above we have especially followed pictures by Kneller, Hogarth, Chardin, Nattier, Lancret, Boucher, and Longhi, and costumes in the Victoria and Albert, the Metropolitan, and the New York Museums. Other artists whose pictures have afforded us details are Van Loo, Perronneau, J. B. Pater, Alexis Belle, Knapton, F. Cotes, the anonymous artist who painted the portrait of Mme. Adelaïde, daughter of Louis XV, and another who painted a portrait of the Countess of Coventry,

reproduced in the *Connoisseur* for August, 1905. The wax effigies of Queen Anne and the Duchess of Richmond in Westminster Abbey have been studied, though no detail was copied, as were also some contemporary portraits of participants in the original " Beggar's Opera " production. The museums housing the originals of our sources are: National Gallery, National Gallery Millbank (Tate), Wallace Collection, Versailles, and one or two private collections. We have worked from photographic reproductions of these various sources though we have also studied the originals as well as others showing similar details.

To two books we are indebted for further details. Köhler and von Sichert's *A History of Costume* has the photograph of a velvet smoking jacket (fig. 409), which together with a contemporary portrait in a modern edition of the " Beggar's Opera " (of a Dr. Arne, by an anonymous painter) gave us the information for our sketch, fig. 6; (but the head is from Hogarth's " Marriage à la Mode "). McClellan's *Historic Dress in America*, Vol. I, has the picture of a hood (fig. 168) which was the principal source for our sketch, fig. 13.

Chapter XIII

LATE GEORGIAN

DATES:

1750–1790

••

Some Important Events and Names

ENGLAND	FRANCE	GERMANY	SPAIN	AMERICA
George II, d. 1760	Louis XV, d. 1774	Frederick the Great	Charles III,	French and Indian
George III,	Mme. du Barry,	of Prussia, d. 1786	r. 1759–1788	War, 1754–1763
r. 1760–1820	official mistress,			
m. Charlotte of	1764–1774	Maria Theresa of	Charles IV,	Stamp Act, 1765
Mecklenburg		Austria, d. 1780	r. 1788–1808	
	Louis XVI,			Revolution,
STATESMEN	r. 1774–1792	Seven Years War,	Jesuits expelled,	1775–1783
Pitt, the elder,	m. Marie An-	1756–1763	1767	
d. 1778	toinette of		(the Order sup-	Washington,
	Austria, 1770	MUSICIAN	pressed, 1773)	President,
		Mozart, 1756–1791		1789–1797
Edmund Burke,	Excavations at		PAINTER	d. 1799
1729–1797	Pompeii, 1755	POETS	Goya, 1746–1828	
"Conciliation,"		Schiller, 1759–1805		Franklin, d. 1790
1775	Fall of the Bastille,			Envoy to France,
	1789	Goethe, 1749–1832		1776–1785
WRITERS				
Dr. Johnson,	Lafayette,			Franciscan Missions
d. 1784	1757–1834			in California, 1769
	in America, 1777			
Thomas Chatter-				San Francisco, 1776
ton, 1752–1770	Mme. De Staël,			
	1766–1817			PAINTERS
Lord Chester-				John Trumbull,
field's Letters to	Voltaire, d. 1778			1756–1843
his Son, 1774	Rousseau, d. 1778			
				Gilbert Stuart,
Horace Walpole,	DRAMATIST			1755–1828
1717–1797	Beaumarchais,			
"Castle of	1732–1799			Charles Peale,
Otranto," 1765	"The Barber of			1741–1827
	Seville," 1755			
Robert Burns,	"The Marriage of			John Copley,
1759–1796	Figaro," 1778			1738–1815
DRAMATISTS	PAINTERS			
Oliver Goldsmith,	Nattier, d. 1766			
1728–1774				
"She Stoops to	Boucher, d. 1770			
Conquer," 1773				
	Chardin, d. 1779			
Richard Brinsley				
Sheridan,	La Tour, d. 1788			
1751–1816				
"The Rivals," 1775	Liotard, d. 1789			
"School for				
Scandal," 1777	Jean Honoré			
ACTORS	Fragonard,			
	1732–1806			
David Garrick,				
d. 1779	Jean Batiste Greuze,			
	1725–1805			
Mrs. Sarah Sid-				
dons, 1755–1831	Mme. Vigée-LeBrun,			
	1756–1842			

DATES:

1750–1790

███

Some Important Events and Names

ENGLAND
(*Continued*)

ARTISTS

Hogarth, d. 1764

Thomas
Gainsborough,
1727–1788

Sir Joshua Reyn-
olds, 1723–1792

Joseph R. Smith,
1752–1812

George Romney,
1734–1802

Adam Buck (Irish)
1759–1833

George Morland,
1763–1804

W. R. Bigg,
1755–1828

ARCHITECTS

Adam Brothers,
Robert, 1728–1792
in London, 1759

CABINETMAKERS

Chippendale,
d. 1779
" The Gentleman
and Cabinet-
Maker's Director,"
1754

George Hepple-
white, (?)–1786

Thomas Sheraton,
1751–1806
" Cabinetmaker
and Upholsterer's
Drawing Book,"
1791

Some Plays to Be Costumed in the Period

Goldsmith's " She Stoops to Conquer."
Sheridan's " The Rivals," " School for Scan-
dal," " The Duenna."

John Balderston's " Berkeley Square."
All plays and pageants about the American
Revolution.

LATE GEORGIAN

CONCERNING THE PERIOD

I F the forty years preceding the Fall of the Bastille was a continuation of the Age of Rococo, it was not less the Age of Reason.

Two major performances ran simultaneously in the theatre of the Western world. On the one hand, a ballet was being danced upon the crater's edge. Till 1774 the manager and *première danseuse* was Mme. Du Barry; after that until the final curtain, Marie Antoinette. The settings were, first Versailles with its salons and gardens in the Grand Manner, later the Petit Trianon and Rustic Village, arranged in the light classical and the " natural " or " Anglo-Chinese " styles, with a stage full of Greek pavilions, waterfalls, fake ruins, and thatched cottages. The *corps de ballet* was composed, in the beginning, of court ladies and gentlemen; later, of well-scrubbed shepherds with beribboned sheep and picturesque milkmaids with glossy cows which they milked into Sèvres vases. On the other hand appeared drama-with-a-purpose; not much of a hit in the beginning, but finally playing to crowded houses. Its expositors were Voltaire, Burke, Thomas Jefferson, and others; its leads the American Colonies and finally France. It had many settings: shabby city rooms, small country villas, the House of Commons, provincial taverns and assembly halls, the battlefields of rebellious America, and Paris. Its supporting cast included first a handful of intellectuals from here and there, then American backwoodsmen, farmers, and traders, and at last a mob of French *sans culottes,* whose performance overran the ballet stage and sent the dancers scurrying to England or Purgatory.

If you would feel the sentimental charm of Rococo, look at pictures by Fragonard and the English portraitists and read Austin Dobson's " Vignettes in Rhyme." If you prefer your Rococo with the spice of cynicism, see Sheridan's plays and " The Barber of Seville." If you want to learn the ideals of those who sought for justice and reason in a world of special privilege and topsy-turvy morality, read Burke's " Conciliation of the American Colonies " and the Declaration of Independence.

There were, in truth, three R's in the eighteenth century: Rococo, Reason, and Romanticism, the last fostered by Rousseau but flowering after his death in the poetry of Robert Burns and his successors. In art as in literature, the romantic element arrived somewhat late and lasted into the next century, during much of the time sharing interest with the classic. About 1755 the latter received a fresh stimulus from excavations at Pompeii and elsewhere in Italy. The Chinese influence was still strong until the eighties, when it

may be said to have merged with Romantic. A revival of interest in the Gothic was another phase of the Romantic movement, early expressed in literature by Horace Walpole's melodramatic novel, *The Castle of Otranto,* and in architecture by his unparalleled Gothic villa at Strawberry Hill; later in decoration by Chippendale's straight-backed chairs.

The period had its share of strong rulers and long wars. Two women, Catherine and Maria Theresa, and one man, Frederick, still dominated European politics; the Seven Years War involved Europe as usual and under the pseudonym of the French and Indian War lost Canada to France. But this maze of diplomatic intrigue is not for us to thread. More to our point are such items as these:—One of the really important people in Paris was Mme. Bertin, Marie Antoinette's dressmaker, a woman of the people whose word was law to fashionable ladies of Paris, London, and (when it got there) New York. The " Macaronis " were members of a London club which flourished in the seventies, part of whose ambition in life was to be " different," in the pursuit of which laudable intent they wore wigs a foot high, with extremely small tricorne hats perched slant-wise atop, bob-tailed coats, and striped stockings. Casanova, an Italian adventurer who was born in 1725 and lived till 1798, published the memoirs which have made his name a synonym for " rake " and " libertine." English resorts and watering-places assumed an important position in fashionable life; Vauxhall Gardens, Bath, Tunbridge Wells, Brighton, Scarborough, and other resorts were the haunts of the *beau monde* and the happy hunting grounds of adventurers. Bathtubs were scarce; musk and civet were favorite perfumes. Highway robbery flourished in England, and the " knights of the road " were often popular heroes; their eventual hangings were attended by large and enthusiastic audiences for whom the highwaymen dressed handsomely and put on a good show at the gallows.

GENERAL CHARACTERISTICS OF COSTUME

Costume history of this period divides rather sharply into two parts: the years 1750–1780 and 1780–1790. The first thirty years witnessed principally an exaggeration of the features described in Chap. XII; the last decade was a time of innovations, many of which held over after the Fall of the Bastille in 1789, a date which marks the termination of what may be properly considered eighteenth century costume.

(1) Up to 1780 men in their dress moved steadily in the direction of neatness and slenderness. Wigs were as small as they could be (except those of the afore-mentioned Macaronis, who may be set aside as freakish); coat-skirts narrowed to tails; waistcoats shortened; breeches were as tight as nature would permit; cuffs and pocket-flaps shrank. Women, on the other hand, went through one of their worst periods of inflation and managed to exaggerate their silhouettes both crosswise and upward with panniers bigger than ever and coiffures three feet high.

(2) After 1780 many men wore their hair unpowdered and some took the

step of discarding the tricorne hat in favor of the new-old steeple, of wearing high collars on their coats, and of cutting those coats straight across the front, all features to be illustrated in the " Empire " styles (Chap. XIV). In women's appearance the changes were considerably more radical and more general also. In the first place, panniers went out so that the full skirts fell straight in the front and swelled out at the back. Muslin became the rage and with it round waistlines, ribbon sashes, and cambric fichus puffing enormously over the bust. Hair changed abruptly from exaggerated height to a considerable, though not grotesque, width, and, like men's, frequently kept its natural color. This right-about-face among modish women can easily be traced to the Romantic movement already described, as well as to Marie Antoinette's make-believe rusticity and to that authentic love of the country, now a recognized feature of English life.

Naturalness returned first to children's dress, from which it should never have been absent. As early as 1770 English artists were painting little girls in baby-waisted, sashed muslins with skirts above the ankles, and during the decade before the fall of the Bourbons the French royal children and consequently others were dressed with the new " English " simplicity. It was, incidentally, the Frenchman Rousseau who had worked for this along with other educational reforms. In the childish costume of the seventies and eighties may be seen a foreshadowing of the adult dress, male and female, which is called " Empire."

MEN

Heads. Wigs did not change radically from those fashionable in the forties. Hair was brushed away from the forehead and frequently revealed the ears. One or two rows of curls were arranged either just at the sides (figs. 1 and 5) or all the way around (fig. 3), and the back hair was brushed down to terminate in a cluster of curls, a bag, a pigtail, or a queue, as pictured and described in Chap. XII. In the seventies modish gentlemen followed the feminine lead and dressed their hair or wigs rather high in front, a fashion much exaggerated by the Macaronis. There was, too, a " bob " wig, either bushy or set in curls all around.

After 1780 a wig which was very bushy all over the top of the head and over the ears came into style. This wig was not always tied up in back, but sometimes lay upon the neck in several carefully-disposed curls. Fig. 4 shows a very conservative variation of the style, where the man's own unpowdered hair is puffed over his ears and tied in back. There had always been men who wore their own hair instead of a wig, and now the fashion became more general, along with a liking for unpowdered heads (figs. 4 and 5). Unfashionable fellows even let their straggling locks hang around their necks untied (fig. 2).

Heads which were shaved to accommodate a wig needed some sort of head-

covering when the wig was laid aside. In the second part of the eighteenth
century this generally took the form of a turban (fig. 6).

Only smooth-shaven faces were fashionable in Western Europe and the
Colonies. Eccentrics, or rustics unmindful of appearances would be the only
men likely to go bearded or even moustached.

Hats. (1) The fairly large tricorne discussed in Chap. XII remained about
the same throughout the years (fig. 7). But from about 1770–1776 ultra-modish
men adopted also a smaller, flatter type, cocked higher in back than front, a
hat which the Macaronis exaggerated in minuteness, in cockiness, and in the
slant at which it was worn. (2) The years after 1780 saw three innovations:
(a) an uncocked beaver (fig. 5), (b) a hat cocked in two places only, *i. e.,*
front and back or both sides, and (c) a hat with a narrow, stiff brim and
high, tapering crown, reminiscent of the seventeenth century Puritan hat (fig.
3, Chap. X); these last two are illustrated in Chap. XIV, as belonging more
properly to the " Empire " period.

Necks. (1) Stocks and jabots (figs. 1, 3, 4, and 7) continued as the usual
neck-finish, with the old-fashioned cravat or neckcloth still suitable for negligent
dress (figs. 2 and 6). (2) After 1780 there were occasional indications of
the next style, a collar showing above the cravat, the latter, as illustrated in
figs. 5 and 20, sometimes tied in a bow in front. Rarely one might see a man's
shirt open in front, like the little boy's in fig. 21, but only under extremely
informal circumstances.

(1) After about 1770 moderately high collars were put on coats. Figs. 3 and
7 are the types usually seen up to 1780; (2) fig. 4 and the overcoat collar of fig.
5 are the newer styles, which remained during the succeeding period. Notice
that the waistcoat of fig. 4 has lapels, also a style to become more popular
later. The rough coat on fig. 2 has a small turnover collar reminiscent of that
shown on the smoking-jacket in fig. 6, Chap. XII. The collar on the dressing-
gown (fig. 6) is nothing but the coat itself turned back to show the lining.

Bodies. (1) After 1750 only old-fashioned people wore a really full-skirted
coat. The clerical coat in fig. 8 and the suit dated about 1760 (fig. 1) show
the transitional garment whose skirts could actually be buttoned all the way
down the front, though they seldom were; figs. 3 and 4, the newer cutaway
coats which predominated after 1770. (2) After 1780 a still newer fashion
came in along with these sloping tails: a coat high-collared, short-waisted,
double-breasted, cut square across the front with the skirt commencing only at
the hips,—the ancestor, indeed, of our " tail coat." This type is illustrated in
Chap. XIV, to which period it more properly belongs; though it is foreshadowed
in fig. 7. (1 and 2) The informal, bob-tailed jacket pictured in fig. 2 is not a
stylish garment; it may better be classed as a rough version of the sleeved
waistcoat shown in fig. 6, Chap. XII. Though, as has been said, the Macaronis
affected skirtless coats, these were close-fitting and sloped away from the front.

(1) In the seventies pockets were placed higher than in the sixties (figs. 1
and 3), and their flaps diminished in size more and more. Buttons, important

in everyday costume because on occasion the coat was actually fastened, were sometimes omitted from dress coats, which did not even meet over the chest (fig. 3).

Waistcoats grew shorter and shorter. (1) Figs. 1 and 6 show the usual length worn between 1750 and 1770; (2) figs. 2, 3, and 7 the later styles. (1) In 1750 the waistcoats on military uniforms were already short. The sketches show three ways in which the bottom line was adapted to the shape of the coat. (2) With the latest tail coat the waistcoat was cut square across the stomach, often somewhat longer than the coat. The double-breasted waistcoat with lapels shown in fig. 4 is a forerunner of later styles, when not only lapels but also standing collars became a feature.

Arms. All sleeves were wrist-length and usually revealed lace or cambric shirt-ruffles. These were generally not extravagantly wide, and at the end of the period were often reduced to two-inch frills (fig. 4). Cuffs narrowed; (1) from 1750 to 1760 they still resembled the original cuff formed by a turned-back sleeve, in that they preserved the three buttons and buttonholes which had once fastened them back (figs. 1 and 5). Such buttons, though obviously no longer of practical use, were still retained on the dress coats of the seventies and later. In the next decade the cuff was sometimes completely omitted and the close sleeve was buttoned up the back perpendicularly (fig. 4). These survive on modern coat sleeves, as decoration merely. Unconventional garments like those shown in figs. 2 and 6 as well as clerical dress and uniforms displayed this feature earlier (fig. 7).

Legs. After about 1760 breeches were always fitted over stockings and were just about long enough to cover the kneecap (though at times a trifle longer). Occasionally, as in fig. 3, finished with embroidered bands, they were more often plain, fastened with from three to five buttons or both buttons and a buckle. The material of breeches was, as earlier, black velvet or satin, cloth or satin lighter than the coat and waistcoat, or fabric which matched waistcoat, coat, or both (fig. 1). With the advent of short waistcoats the fit of breeches became important, and it was increasingly modish to wear them very smooth and tight. In the 1770's riding-breeches of doeskin were adopted and (as on Alfred Noyes' Highwayman) "they fitted with never a wrinkle," a phenomenon which may still be observed on the famous Horse Guards at Buckingham Palace.

Gentlemen wore well-gartered, heavy silk stockings in white or light colors and frequently clocked; others put on dark home-knitted woolen hose (figs. 2 and 8).

Feet. Men's shoes were lower-heeled than formerly and while still long-vamped, had, as a rule, shorter tongues, though the unfashionable and the conservative often clung to high tongues (figs. 2 and 8). Top boots were worn by civilians as well as military officers and gaiters by countryfolk as well as the infantry.

Outer Garments. Capes were not by any means discarded; they had a mili-

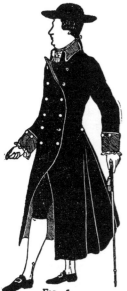

FIG. 5.
Overcoat, c. 1780. A new style of hat and cravat, also.

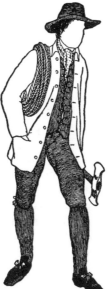

FIG. 2.
Countryman, 1770 and later. Note his sack-like coat with a small collar, his carelessly shaped hat, his neck-cloth.

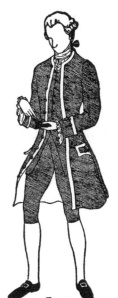

FIG. 1.
Transitional type of coat and waistcoat, c. 1760.

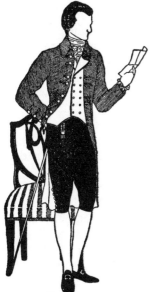

FIG. 4.
Gentleman, c. 1780-1790. Hepplewhite style chair. Note collar, waistcoat with lapels, watch-fob.

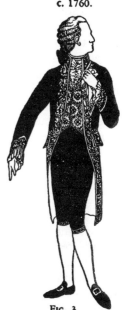

FIG. 3.
Court costume, 1775-1790. An example of the beautiful embroidery of the period.

tary look, being frequently a part of the equipment of army officers (witness the well-known picture of Washington crossing the Delaware). Long capes had turnover collars, but another semicircular, half-length cape had a hood, quite in the manner of the ancient " pænula " (Chap. IV).

Overcoats were popular with the general run of men. (1) Early in the second half of the century they looked about like that shown in fig. 7, Chap. XII. (2) After 1780 a neat-fitting, double-breasted garment with a standing collar and long skirts (fig. 5) came into style. In addition to this collar, the greatcoat sometimes had double or even triple capes, like those shown on the lady in fig. 19, a coat which became even more popular in the next period (fig. 6, Chap. XIV).

SOLDIERS

Fig. 7 shows the type of officer's uniform worn in the British army during the French and Indian War. With variations in the color of coat and facings, in the application of braid, and in hat-trimmings, such a uniform was also worn by officers of other national armies. Note how it foreshadowed later civilian styles in its short, collared waistcoat, double-breasted coat with lapels faced with another color and turned back, skirt cut off in front and square-tailed behind, and narrow cuffs with a perpendicular row of buttons. By the time of the American Revolution some changes had crept in, among them the substitution of an applied facing for *bona fide* lapels; you will recognize that feature as also part of the uniform supplied by the Continental Congress to its soldiers. Notice that this British officer wears a miniature steel gorget on a chain around his neck. This is the last relic of plate armor, for though men did occasionally have their portraits painted in a cuirass, they no longer wore plate in actual combat. This vestigial gorget lingered in some officers' uniforms throughout the century. Note that the military sash was still a feature of an officer's costume.

Infantrymen wore coats on the order of that shown in fig. 8, Chap. XII, and were further distinguished by white gaiters buttoned over their shoes, in place of boots. Most soldiers wore variations of the tricorne hat, but Grenadiers wore a helmet with a mitre-like piece in front.

If you are costuming a Revolutionary play which includes soldiers, it will be well to consult the specialized books suggested in the Reading List, for besides the familiar blue and buff of the Continental army and the red of British regulars, there were many other variations, in color as well as in minor matters of cut and trimming. For example: white or red took the place of buff on the facings of some blue coats; the Green Mountain Boys' dress uniforms consisted of the regular woodsmen's brown buckskin trousers and fringed shirt. In the British forces, Johnson's Royal Greens wore white breeches and waistcoats, green coats, brown leggings, and black hats faced with white, and Butler's Rangers had their green coats faced with red. If you are staging one of the early battles of the Revolution, remember that plenty of " rebels "

fought in their everyday dress: buckskins, homespun jacket with its waistcoat and breeches and a coarse shirt, or even a long-skirted, belted smock or " farm frock," on the order of the English smock pictured in fig. 8, Chap. XV.

CLERGY

The Protestant clergy dressed like their parishioners, except that they habitually wore black of a simple and conservative cut and that they continued to wear the " bands " described in previous chapters instead of any more modern neck-covering. Anglican clergymen dressed, outside the church, like the Presbyterian in fig. 8, and during services, in cassock and surplice, as they do nowadays. Dissenting ministers either put on academic gowns for the pulpit or preached in their ordinary dress. Clerical hairdressing followed the prevailing styles, though sometimes laggingly. Hats were small plain tricornes or flat-crowned, wide-rimmed felts much like that shown on fig. 4, Chap. XI.

WOMEN

Heads. (1) 1750–1780. Smooth, low-dressed hair went out of fashion at the French court and in circles whose members aped French styles. Still, it must not be thought that all women or any women on all occasions adopted the absurdities chronicled below. The hair shown on fig. 11 and that covered by a hat in fig. 12 are typical of many women of good position. The extreme style of which figs. 9 and 10 are mild examples lasted about twenty years, that is from 1760–1780, and its worst phase occurred during the last five years, while the American Revolution was a-fighting and when " The Rivals " and " School for Scandal " were first produced. " She Stoops to Conquer " appeared in 1773, and Miss Hardcastle, masquerading as a servant, might well have worn her hair as in fig. 11. So might Olivia, heroine of " The Vicar of Wakefield," and Lady Teazle before she came up to London, for Sir Peter remembers her thus: " Recollect, Lady Teazle, when first I saw you sitting at your tambour, in a pretty figured linen gown, a bunch of keys at your side, your hair combed smooth over a roll ——" So would the heroines of Revolutionary dramas arrange their hair, with the addition, perhaps, of a curl or two at the neck; and they might take a walk in cap and hat, like the lady in fig. 12.

But if the Colonial young lady is city-bred and goes to balls, if she figures in the gay doings attendant on the British occupation of New York, she will probably have her hair dressed as high as that on fig. 10 or even fig. 9, and she will leave it in its natural color or powder it as she chooses. Lady Teazle and her friends would go to the extremes of fig. 9 or farther, and so would Mrs. Malaprop, but the character of Lydia Languish suggests a lower and more romantic style, like that shown in fig. 18.

If you wish to fit out your actresses with even more extreme coiffures you have good authority for building as high as your stage set will permit. Not only are there innumerable satirical pictures, showing the hairdresser at his work mounted on a ladder, sedan chairs unroofed so that the lady's head may

rise a foot or so above the side, and such-like witticisms; but there are also sober records of houses remodelled with high-arched doorways to accommodate the mistress's head, and of those mistresses kneeling on the floors of their coaches to make room for their hair at the top; and finally, measurements are given of actual headdresses from eighteen to thirty-six inches high, with added inches of ornaments.

Miscellaneous materials were used for stuffing such a great mound and the whole mass was plastered together with pomade and finally powdered, not always dead white, but sometimes lightly, tempering raven locks to gray and fair tresses to ash-blonde. After the labor and expense involved in its erection, the coiffure was left untouched for a startling length of time, the wearer accommodating herself to sleep as best she could. Commentators dwell with mingled repugnance and fascination on the effects of lapse of time upon the assorted ingredients. " In summer," says a contemporary, " two weeks is the longest a head can go without being opened." Fortunately, nowadays, an actress needs merely clap an admirably sanitary wig upon her head and remove it at the end of the performance.

Stiff rolls of hair placed at the top and one or more equally stiff curls at the sides further embellished the coiffure; and to crown all the inspired hair-dresser placed ornaments whose topical names were no more absurd or ir-relevant than the objects themselves: miniature gardens, baskets of fruit, houses, full rigged ships, to mention only a few. The waving plumes shown in fig. 9 are a rather late conceit of Marie Antoinette and others.

(2) 1780–1790. By the year 1780, hairdressers having built to the extreme height abandoned those tactics and went in for a relatively natural head that was notable for width and curliness. Fig. 17 gives an example of this newer style, fig. 18 another, which retains height at the back but develops width at the sides, and fig. 15 a third, which shows a high front along with side full-ness. Figs. 16 and 19 indicate how, after about 1785, naturalness reigned again. The English portraitists painted many examples of this new style with its picturesque variations. While hair was still occasionally grayed with a touch of powder, and while many conservative women held to a high-dressed, white coiffure for formal occasions, it became more and more the thing to wear one's natural-colored hair in the new styles.

Millinery. CAPS. (1) 1750–1780. As in the earlier years of the century, caps were habitually worn by unpretentious women and by the fashionable for semi-negligée. If a woman's coiffure were low, the cap did not differ much from one of the styles shown in Chap. XII. Fig. 11 shows a small mob-cap with a stiffened lace frill and a smart bow in front, fig. 12 a mob-cap with lappets fastened under the chin. Fig. 13 shows an interesting variant of the simple cap, *i. e.,* a strip of lawn edged with a pleated frill and put bandage-wise around the head. This, or a good-sized mob-cap with a bow in front, or a plain little cap of the " baby-bonnet " variety, was worn by serving-maids. A lady of fashion whose hair was dressed high must wear a cap large enough to accom-

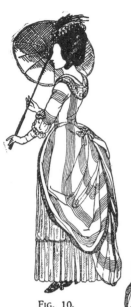

FIG. 10.
Conservative English
lady, 1770-1780,
wearing a polonaise.

FIG. 9.
Exaggerated style of the
French Court, 1760-1780.
"Lady Teazle" might wear
such a costume.

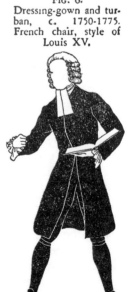

FIG. 6.
Dressing-gown and tur-
ban, c. 1750-1775.
French chair, style of
Louis XV.

FIG. 7.
Officer in British army, c.
1750-1770. The stepped
back coattails foreshadow
later styles.

FIG. 8.
Presbyterian minister, 1750-
1800. He wears "Geneva
bands."

modate it, and the elaborate structure of fluted lawn shown in fig. 14 was popular among fine folk during the decade before 1780. (2) 1780–1790. After that date mob-caps, made very large to frame the newly fashionable wide hair, took on a vogue which survived the Revolution. The lady in fig. 17 wears a turban, a type of headdress accompanying formal costume which took such a firm hold on feminine fancy that in one style or another it lasted far into the nineteenth century.

HATS. (1) 1750–1780. The picturesque "shepherdess" or "gypsy" hat of leghorn straw continued to be worn by some women straight through the period; it was often put on over a frilly cap, as it is shown in fig. 12. Such a hat was not appropriate on immensely high coiffures, for which there were devised all manner of fancy millinery, made of straw, velvet, or shirred silk and elaborately trimmed with plumes, feathers, ribbon bows, and wreaths of flowers. Hats were usually far too small to cover the immense coiffures, and they nearly always slanted forward toward the nose. Fig. 10 shows a rather conservative hat, modish in the seventies.

(2) 1780–1790. With the advent of lower and wider hairdressing returned the low-crowned, wide picture hat made of velvet, beaver, or straw. Fig. 19 shows a very simple "young girl" hat of this type. The same sort of hat was often much larger, profusely trimmed with ostrich plumes, and perched far to one side on hair dressed like that of the lady in fig. 17, in short the "Gainsborough" hat, familiar from the well-known portrait of the Duchess of Devonshire. The forward-tilting hat (fig. 18) still topped a coiffure of clustering curls. About 1780 came in a feminized version of the new masculine steeple-crowned hat, trimmed sometimes with only a band and buckle, sometimes, as in fig. 16, with ribbons and feathers. At about the same time milliners invented an enormous mushroom-shaped hat with a high wide crown of puffed silk as well as trimmings of ribbon-bows, lawn ruffles, and feathers; frequently the frill of a mobcap could be discerned beneath the brim. This hat was revived in a chastened form no longer ago than 1910 (fig. 15, Chap. XIX). Men's fashions were aped with tricorne riding hats and with new-style cocked hats (fig. 20) trimmed with a perky cockade or, as pictured, a cluster of feathers.

(1 and 2) When neither indoor cap nor outdoor hat was appropriate, there was still need of a head-covering to take the place of the earlier kerchief or hood of the forms described in Chaps. X, XI, and XII. While a woman whose hair was dressed as in fig. 11 might still wear the simple and sober camlet or silk hood shown in fig. 17, Chap. XI, this would never do for the fashionable big coiffure, either high or wide, and for such there was devised the *calash* (fig. 15), a structure of silk, often green, shirred on hoops hinged so that they could be collapsed like the hood of a carriage. Indeed it was named for the *calèche* or light carriage which had such a top. Transparent material such as lace, net, or gauze was also used for this type of head-covering, and then the frame would be of fine wire or small whalebone.

Necks. (1) 1750–1780. Low-necked dresses worn before 1780 and many after that time continued to display the characteristic square cut, fairly high in back and often extremely low in front, typical of the corset bodice dress and particularly of the costume composed of an under "body" and an upper gown (figs. 9, 11 and 12). In the seventies a surplice bodice, *i. e.,* with one side folding over the other, making a V-neck, was occasionally worn, but it is not a typical style. (2) 1780–1790. After 1780 there was an increasing vogue for the dress cut with a round neck, very low and drooping off the shoulders, as it had done in the seventeenth century; also for a neck fairly high at back and shoulders, deep in front (fig. 17); and for a "bateau" neck surrounded by some form of ruffle (fig. 19).

(1) 1750–1780. The fichu never lost its popularity; it may be seen tucked into the bodice or the apron-bib (fig. 13), draped around the neck with a V in back and a knot in front (fig. 10), or high over back and shoulders, tucked into the bodice in front (fig. 17). (2) 1780–1790. After 1780 the fichu became the principal neck-finish and ran to extremes of puffiness (figs. 15 and 16). Fig. 16 shows the customary way of disposing of the voluminous folded lawn, fig. 17 a way to drape a more delicate piece of gauze and lace.

(1) 1750–1780. Ruffles, presumably belonging to the chemise, still showed at the top of a low-cut "body" (figs. 9 and 11). Sometimes the entire square décolletage was outlined by starched and pleated lace which stood up all around, higher in back than front. (2) 1780–1790. Wide frills of lace or lawn fell back over the shoulders (fig. 14) or edged the neck in a double ruffle (fig. 19). The imitation of mannish styles in the eighties produced a white lawn shirt gathered into a band at the throat, with a lawn stock tied as in figs. 18 or 20.

Bodies. (1) 1750–1780. Throughout the period bodices were still tight and well-boned. If, as in the sack-backed dress or the short sacque (fig. 12), the outer garment was fairly loose, the "body" under it was still tight. Until about 1780 the waist was long and more or less pointed in front, as in the earlier mode (figs. 9, 10, 11, and 12). If, as frequently happened, the gown revealed an underbodice, the latter was: (a) smooth across, proving indisputably that the "body" was laced up the back (fig. 11); (b) ornamented with crosswise trimming (fig. 12), or ruffles and ribbon (fig. 9); or (c) laced up over a chemise (a style which, without an over-dress, may still be seen in regional costume). An over-gown or *polonaise* like that shown in fig. 10 was often fastened up the front, concealing the "body." (2) 1780–1790. After 1780 all dresses but the most formal (which still retained the pointed front) were made with round waists, and sashes came back into favor (figs. 16, 17, and 19).

The over-gown held its own, appearing in several versions (figs. 9, 10, 11, 14, 15, 16). (1) 1750–1780. The *robe à la française,* as explained and pictured in Chap. XI, fig. 15, continued to be worn upon important formal occasions. The same sack-back might be seen up to 1780 on a more informal

looped-up dress (fig. 11) and on a *sacque* (fig. 12). During the seventies there was no garment more popular than the *polonaise* (fig. 10), an over-gown with fitted back and front and a draped skirt. (2) 1780–1790. After 1780 its place was taken by another gown with long, undraped skirt, sometimes called a *levite* (figs. 15, 16, 17). Yet simple frocks without over-gowns were fully as popular (fig. 19).

Arms. As late as 1790 many elbow-sleeves were still made like those de-scribed in Chap. XII. Some were even finished with cuffs, usually narrower on the inside of the arm than the outside. (1) 1750–1780. Yet after 1750 or '60 most short sleeves were finished in such ways as are shown in figs. 10, 11, 12, 13, and 14. Note that in fig. 11 the lace ruffle has been supplanted by one of the dress material, lined like the skirt with a contrasting color. Fig. 9 shows a fussy little sleeve after the older fashions described in Chap. XII.

(2) 1780–1790. The new styles decidedly favored wrist-length sleeves, most of them on the order of those sketched in figs. 15, 16, 17, 18, and 19. They were almost invariably finished with white ruffles, and if the garment were of a " mannish " cut, as in figs. 18 and 20, they aped the gentleman's cuff. Long sleeves set in below short full sleeves were to be seen even in the eighties, though the style was more popular later (fig. 12, Chap. XV).

Legs. (1) 1750–1780. Hoops were less inevitable in the second half of the eighteenth century than in the first. With elaborate, formal costumes, to be sure, the panniers described in Chap. XII were retained, and some dresses like those in figs. 11 and 12 may have been held out by conservative whaleboned petticoats, but frequently the silhouette was comparatively slim (fig. 10). (2) 1780–1790. After 1780 panniers were definitely given up, save by older women for formal occasions; any distending apparatus under the skirts was placed at the back only, and it is probable that this often consisted merely of heavy petticoats thickly gathered in back.

(1) 1750–1780. During the seventies in particular the skirt of either sack-backed gown or polonaise was draped. In many instances this draping was accomplished as it had been earlier, *i. e.,* by turning back the skirts to show a lining (fig. 11); in the typical polonaise, however, the skirt was looped up at the sides and back, so that it fell in festoons over the petticoat (fig. 10). In-visible tapes held the draperies in place, or else shirring-strings ran in cases on the under side or, for further decoration, on the outside. Bows of ribbon were sometimes arranged as though they tied the festoons in place. Such an elab-orate drapery as that shown in fig. 9 must have been cut, draped up, and sewed to a supporting lining shaped like itself. Simpler polonaises also were sometimes cut in scallops to imitate the line of earlier drapery. (2) 1780–1790. After 1780 all this drapery went out of fashion and again the overskirt fell straight down over the petticoat or at most was pushed back to emphasize the " bustle " silhouette (figs. 14 and 15).

(1) 1750–1780. Petticoats were profusely trimmed. The simplest were often quilted and the most elaborate decorated with deep flounces (figs. 10 and 14),

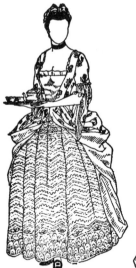

FIG. 11.
Middle class lady or
upper servant, c. 1770-80.
"Miss Hardcastle" might
wear this dress.

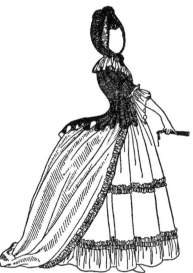

FIG. 14.
Lady in house costume,
1770-1780.

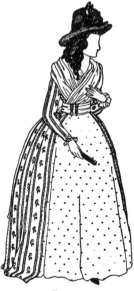

FIG. 16.
Lady in "levite," c. 1780-
90. Note her *two* watch-
fobs.

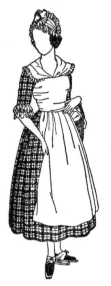

FIG. 13.
A servant-girl, c.
1770 and later. Note
the pattens.

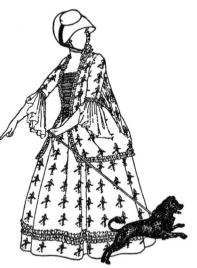

FIG. 12.
Shepherdess hat and "sacque,"
house or informal street dress,
c. 1760-80. Note the frilled
bonnet under her leghorn hat.

FIG. 15.
Lady in calash and man-
telet, c. 1780.

rows of lace, quillings (figs. 10 and 14), horizontal insets of contrasting ma-
terial, flower-festoons, ribbon loops, bows interspersed with tassels (fig. 9),
and embroidered or appliquéd designs. In one fashion-plate wide ribbons
puckered at intervals with gold cords and tassels finished the two sides of the
upper skirt. Sometimes the front edges and even the bottom of a gown or
polonaise were trimmed with shirred lace, ribbon, and gold cord.

(1) 1750–1780. In the sixties and seventies all except formal dresses were
generally short, reaching only to the instep or ankle (figs. 10 and 11) or
even higher (fig. 13). (2) 1780–1790. With the new styles of the eighties,
skirts again descended to the floor or nearly, and even street dresses had trains.

Feet. Shoes changed very little from the previous period. Fig. 11 illustrates
a pair to be worn on ordinary occasions, fig. 10 a pair for dress. Fig. 13 shows
a girl wearing pattens, a species of overshoes worn to protect the feet from
damp and dirt. They were wooden soles raised on a pedestal and held to the
feet by wide leather bands. Although women's shoes were commonly low-cut,
high-laced kid boots rather more than covering the ankle, were worn for
riding (fig. 20). Small ribbon bows sometimes decorated shoes like those of
fig. 11, in lieu of the older buckles.

Outer Garments. (1) 1750–1780. Capes proved to be the most convenient
wraps to wear over voluminous dresses (fig. 19, Chap. XII). Some were
simply enveloping semicircular capes, some had arm-slits, some actual loose
sleeves; many had hoods. (2) 1780–1790. During the last quarter of the century
the scarf or shawl returned to fashion as a wrap, a position it was to retain
for nearly a century. Fig. 15 shows an early version of such a wrap, the
mantelet, a scarf of taffeta or other silk, wide at the back and narrow in the
front. As shown in the sketch, its ends were often crossed fichu-wise at the
waistline; sometimes, if long enough, they were carried around to the back
again. Such mantelets are generally represented as black or a dark color, in
pleasing contrast to the light garments beneath.

(2) The mannish styles which had been followed in riding costume for some
time now extended also to street dress and resulted in the *redingote,* a caped
overcoat (fig. 18). Worn over a white shirt and a waistcoat, it amounted to
a "coat dress." The mannish style of the garment did not prevent wearing
with it any variety of feminine hat. The short jacket shown in fig. 14 over
petticoat and dress is a house garment, and generally pictured in connec-
tion with a cap.

EQUESTRIENNE

(2) Fig. 20 shows a riding-habit taken from a fashion design of the year
1785. It incorporates features from the latest masculine modes, *i. e.,* hat cocked
front and back, cravat tied in a bow, coat with turned-back revers, waistcoat
with both collar and revers turned over the coat, and small close coat-cuffs.
The skirts of the jacket, cut away from the front in the fashionable line, are
given extra fullness in order to set gracefully over the full, many-petticoated

skirt, only short enough to reveal the high laced boots described above. Notice that the lady's hair, while fashionably wide over the ears, is dressed in a neat club at the back, as a concession to the tailored effect. Habits were made in various bright colors. The costume illustrated had a king's blue cloth skirt, a dark blue jacket whose white lining shows in lapels and a little in the skirt, a red cloth waistcoat edged with gold braid, and a black hat with white plumes. The kid shoes are white.

CHILDREN

Figs. 21 and 22 illustrate the difference between children's dress before 1770 and after 1780. The decade was a transition time, during which parents gradually became convinced of the superiority of the new styles. One Frenchman could recall to the very year when the change came in his family (*Memoirs of Baron de Frenilly, 1768–1828.* Published by Heinemann, London, 1909). In 1778, when he was ten years old, he was sent to call on the aged Voltaire. He was dressed for the occasion in green and pink satin coat and breeches; his hair was done up in a triple row of curls and powdered, and he wore a small sword. The Girardin children with whom he played were already being costumed " in the dress of English sailors," *i. e.,* round hat, waistcoat without skirts, and trousers. Soon after the famous visit (between 1778 and 1780) young Frenilly's father decided to put his children also into " English dress " and to his great joy the lad was allowed to discard silk, curl-papers, curling-irons, and pomade, and to play cropped-headed in nankeen and muslin. The children in fig. 21 are dressed in simpler garments than they would have been wearing to a party, yet it will be seen that even these are only adult styles fitted to childish bodies; the boy and girl in fig. 22 wear clothes designed for their age. By 1785 most French boys, including the Dauphin, were given the freedom of jackets and pantaloons. Girls fared as well as boys. Muslin chemise dresses with round necks and high sashed waists left bodies unhampered. Often sleeves were short instead of long, as they are sketched in fig. 22; skirts, too, were often shorter, almost to the knee. Once established, juvenile dress changed very little for a good many years. Boys wore their hair cut short, or hanging in natural locks over their ears; girls wore ringlets and often thick bangs across the forehead. After infancy, neither boys nor girls kept the close baby-bonnet which had been so long a feature of children's costume; both wore wide beaver hats trimmed only with a ribbon band. Girls, like women, tied on gypsy straw hats, sometimes with ruffled caps under them. Children wore heelless shoes while their elders were still mincing about in high heels. Latchet ribbons, shown on our boy in fig. 22, were varied by buckles or bows, as in earlier fashions.

MATERIALS

(1) 1750–1780. Up to 1780 the materials described in Chap. XII prevailed, though even before that time fine cloth began to be favored for gentlemen's

suits. Yet, throughout the period, even *after* 1780, satin and particularly velvet were the materials considered suitable for such court costumes as those shown in fig. 3.

(1) 1750–1780. Satin, taffeta, brocaded silks, lutestring, and other rich textiles for dress; chintzes, India calicos, domestic block-printed linens (fig. 11), and cotton woven in plaids, checks, and stripes (fig. 13); and the usual array of woolens, ranging from fine camlet to coarse linsey-woolsey, all contributed their share to the diversified feminine attire.

(2) 1780–1790. After 1780 two changes took place. First, there was among fashionable men a much greater vogue for broadcloth, replacing silken fabrics till they were to be seen only in court dress. Second, and more momentous, muslin took the entire feminine world by storm; by 1790 diaphanous muslin (white, colored, or embroidered in silk or metallic threads) had almost driven out the more stately silk materials. Paradoxically enough velvet returned to favor, and was employed in over-dresses (fig. 17) and in turbans as well as in wraps, rather charmingly contrasting with muslins and silk gauzes. Mannish feminine styles called for woolen materials (figs. 18 and 20).

COLORS

(1) 1750–1780. What has been said about colors in Chap. XII applies to this period also. (2) 1780–1790. After 1780, more men than ever were wearing dark plain coats. Women, on the contrary, favored even lighter shades than before, relieved by colored ribbon sashes, *à l'enfance*. Yet (fig. 17) on occasion women as well as men wore dark tones. We read of bottle-green, king's blue, claret-color, and russet, of mulberry, scarlet, cardinal, and cherry, of snuff-color (a brownish gray), and especially of "puce," a purplish brown which had been very popular with men even in the seventies.

MOTIFS

(1) 1750–1780. After the discoveries at Pompeii in 1755 textiles reflected the influence of late Roman decoration in smaller and more delicate floral designs (figs. 11, 12, and 16), in small all-over motifs like dots and circles, and in stripes, often as in fig. 16 alternating with a small sprig. Figs. 10, 15, 18, and 21 show other variations of the omnipresent stripe, which was woven in self-colored satin on silk or in a contrasting color on silk or satin as well as in cotton and linen. Checks or plaids (fig. 13) were not fashionable patterns, but were used for workaday dresses and aprons.

APPLICATION OF DECORATION

Besides patterns woven in or printed on fabrics, motifs were applied to garments with the needle (fig. 3). Quilting was still a popular form of stitchery (fig. 11). Braid was usually applied to even plain coats and waistcoats and, in imitation of these, to mannish feminine coats (figs. 1, 4, 5, 7, 8, and 20), the decorated areas being collars, front edges, cuffs, and pocket-flaps.

FIG. 20.
Riding-habit, 1785.
Note the high shoes.

FIG. 21:
Children old-style, 1750-1780.

FIG. 19.
Muslin frock, childish fashion, 1785-1790.

FIG. 18.
Travelling costume—the "Redingote," 1785-90. Note watch-fob and miser purse.

FIG. 22.
Children new-style, 1780-1790. (and later).

FIG. 17,
The new turban and a velvet gown, French, 1785-90. The lady wears a cameo bracelet.

A narrow metallic or white braid often edged tricorne hats. Women's hats, as already explained, were profusely trimmed with flowers, ribbons, ruchings of lace or lawn, and above all, feathers. In fact, ostrich plumes were in high favor with women from about 1775 until after the beginning of the new era.

(1) 1750–1780. Between 1760 and 1780 while men's costume was being pruned of adornment, women's dress was often badly overdecorated. Both skirts and bodices were bedizened, as may be seen by studying the sketches. Fig. 9 illustrates the tendency to treat a woman as something to be upholstered. Lace ruchings, puffs of silk, panniers, festoons of ribbon, ribbon bows, drapery, and cords and tassels all contributed their share to the bewilderment of ornament. Even simple dresses were trimmed with quillings (fig. 12) and flounces (figs. 10 and 14). Lace played a part in most costumes, both masculine and feminine, or if not lace, cambric, adding a touch of white to neck and sleeves.

(2) 1780–1790. The greatest extremes of ornament disappeared after 1780, attention being concentrated after that on hats, fichus, and ribbon sashes.

JEWELRY

Men wore a ring or two and silver, sometimes gold, occasionally " paste," shoe-buckles and knee-buckles, and some of them snuff-boxes, elaborate articles of gold and enamel. Otherwise men's only chance for adornment lay in watches and fob-seals. The watches themselves were heavy, thick " turnips," and the seals ponderous affairs of gold and semi-precious stones. Fig. 4 shows a seal, and the watch worn in the fob-pocket of the trousers. It became the fashion also to wear watches in pairs, usually in a pocket at either side of the breeches. Often only one fob had a watch attached, the other watch being a dummy or *fausse montre.*

Women had as usual more opportunity than men to display jewelry, and with the return of overdecoration in dress many women took advantage of it. Upon their coiffures sparkled diamonds set in little circles, in chains festooned on the hair, or in ornaments thrust in here and there. Brooches fastened the fichu or any other detachable part of the dress, and so did diamond-headed pins. Rings, bracelets, and even shoe-buckles were set with jewels. Some women wore earrings, the familiar pendants of pearl or of gold studded with diamonds. It is well known that " the affair of the diamond necklace" made one more item in the list of popular grievances that sent Marie Antoinette to the guillotine. Even so, most portraits of the period show reticence in adornment, in pleasant contrast to Renaissance and seventeenth century pictures.

Cameos were again in fashion; they were set in brooches and also in rigid wrist-bracelets (fig. 17), a style destined to be very popular during the nineteenth century. Many middle-class women possessed strings of smallish gold beads, worn at the base of the throat, still to be seen among American heirlooms. Housewives also wore a " chatelaine," silver, gold or even jewel-studded (Queen Charlotte had one encrusted with diamonds) thus: A stout hook was attached to the bodice or waistband and from it depended on chains various

articles such as an étui ("housewife" or needle-and-thimble case), scissors, and a watch. Such a contrivance was also made merely to hold housekeeping keys. Women, like men, wore watches on fobs. If a waistcoat were included in the costume, the fob depended from under it (fig. 18); if there were a sash, the watch was tucked into that so that the fob (or fobs) fell over it (fig. 16).

ACCESSORIES

Men. Canes began to take the place of dress-swords, for after the seventies the latter were less and less common. Such canes were usually of the length shown in figs. 4 and 5 and had knobs and tassels. While some men still carried muffs, the fashion was going by. Snuff-boxes and lace handkerchiefs, both as described in Chap. XII, were still very usual accessories.

Women. Parasols had somewhat shorter handles (compare fig. 10, this chapter, with fig. 16, Chap. XII) and were not quite so dome-shaped as in the earlier part of the century. During the seventies their popularity spread from France to England. The appearance of fans and gloves and their use remained as related in the preceding chapter (figs. 9, 10, and 12). Muffs were no less popular with women than formerly (fig. 15). "Miser purses," described in Chap. XI, were still carried by both men and women (fig. 18). Ladies affected tall canes with their walking dresses (fig. 18).

A black velvet band around the throat (fig. 11) and sometimes also at the wrists, was a popular ornament. Gaily striped sashes like that shown in fig. 18 are unexpected additions to mannish costume, giving a slight military tinge to the ensemble (fig. 7).

Servants wore large enveloping aprons with ample bibs (fig. 13), as often made of checked or dark-colored gingham as of white goods. Ladies still wore frivolous little aprons, which were often short and full (cf. fig. 17, Chap. XI) and elaborately decorated.

SOMETHING ABOUT THE SETTING

Soon after the excavations at Pompeii (or at any rate by 1770) French interior decoration and furniture were following antique models. The "Louis XVI" style was more delicate in scale, less ornate in detail, than the "Louis XV" (fig. 6). Straight legs, straight or oval-shaped backs, carving and inlay in Greco-Roman designs, and upholstery of delicate-toned satin and grosgrain stripes are some of the distinguishing features of this furniture. Walls were panelled in natural-colored or enamelled woods, but parts of them were also papered in small designs of flowers, classical motifs, or, especially in the earlier years, little Chinese scenes. Chinese lacquer and Vernis-Martin lacquer (Chap. XII, p. 320) continued to be admired. Inlay and marquetry, painted panels, and porcelain medallions, were all used as decoration on furniture which was painted, gilded, or left in the natural color of some pale wood such as satinwood.

Like French, English interior decoration followed the inspiration of Rome,

principally under the guidance of the Adam brothers, especially after 1759, when Robert established himself in London. Chippendale, who died in 1779, had little to do with the antique, remaining always closer to the Rococo. The typical " Adam " interior, rather small-scale, rather austere, light in tone and delicate in line, was appropriately furnished either with the designer's own cabinet work (which closely resembled " Louis XVI " styles) or with pieces created by Sheraton. The latter's work, usually in mahogany, was characterized by its straight legs, rectangular chair-backs, and inlay. The third great English cabinetmaker, Hepplewhite, designed his chairs in shield shapes or with interlacing hearts or " Prince of Wales " feathers. Fig. 4 shows a chair of this type, upholstered in the omnipresent stripes. Old American houses have many rooms decorated in the Adam style, furnished with pieces made by native craftsmen working under the influence of the great Englishmen as well as the French.

Along with furniture went very beautiful silverware, glass, and porcelain. Never have household furnishings and decoration large and small been more beautiful or better adapted to harmonious living; therefore we still surround ourselves with original eighteenth century articles, or with modern reproductions. It is for this reason fairly easy to find correct furnishings for a play of this period.

PRACTICAL REPRODUCTION

Materials. Appropriate materials are silk if you can afford it, printed in small floral designs and in stripes, rayon taffeta and satin, velveteen or small-ribbed corduroy. Shop in the upholstery and lining departments. Look for figured sateen also among materials intended for draperies and bedspreads.

Heavy outing-flannel, dyed, will serve well for some of the woolen garments. Cotton duvetyn, ratiné and terry cloth may also represent woolens. Burlap may be used for the coarsest of homespuns.

Striped ticking makes excellent petticoats for working-women and plain blue or gray denim and khaki cloth are appropriate for making simple gowns, jackets, and breeches.

Checked gingham, striped percale, flowered dimities, small-patterned chintz and cretonne, sprigged calico, and flowered dimity may all be used for women's cotton dresses. Flowered mull, dotted swiss, and white or pale colored marquisette in small dots or circles, batiste, organdie, and point d'esprit are all appropriate materials for the late style dresses. Various striped and flowered gauzes, especially if they are stiffish, are excellent to use for turbans.

Remember that suits and dresses must all have interlinings and full petticoats like those described in Chap. XII.

Trimmings. For trimmings consult this section in Chaps. X, XI, and XII. Look for gold cord and tassels in the lamp shade making department.

Accessories. See this section in Chap. XII.

Millinery. See this section in Chap. XII.

The cocked hat is easily made by turning up the front and back of any wide

brimmed hat. The various small sloping hats (figs. 10 and 18) can be made by taking a straw or velvet hat, cutting its crown over so that it is very shallow, and putting a wide bandeau at the back (unless the wig is so tall that the hat can just be pinned on the slope).

If you have occasion to use a calash like that illustrated in fig. 15, try first to borrow a real one; many still exist. If you would make your own, use the clock-wire recommended for hoop skirts (Chap. XX). Cut five pieces, the longest for the middle, the shortest for the back. Have holes drilled at the ends. Cut an oval of material about three times the length of the steels; stitch casings on the under side, the first at the front edge, the last about six inches in from the back edge. Run in the steels. Join the five steels at either end on a pivot. Gather the bonnet close to the back of the neck, with a ruffled heading. Add bonnet-strings. You can make the bonnet with featherbone also, but it will not be collapsible.

Wigs are essential for men. If you must have very high headdresses for the women, rent wigs if possible. See this section, Chap. XII, for home-made wigs. Often women need not wear extremely high headdresses, and the actress's own hair, brushed over a pad and augmented by a switch and a curl or two, will suffice. It can be powdered if you wish.

Hoops. See this section, Chap. XII, and directions for making hoop skirts, Chap. XX. The necessary fullness can often be produced with full starched petticoats. A small bustle (fig. 21a or b, Chap. XVII) helps the silhouette of dresses fashionable about 1780.

Shoes. See this section, Chap. XI. Light kid shoes dating from about 1905 · 1910 will pass for the riding shoes (fig. 20), with the addition of bows. Both men's and women's black oxfords can be satisfactorily used for ordinary shoes, with the addition of large buckles to cover the lacings.

Renting. See this section, Chap. XII. In ordering these costumes specify *cutaway* coats. Most costumers have on hand a supply of authentic suits of Revolutionary uniforms, both Continental and British, both officers and privates. If you want any very special uniforms, such as those described under SOLDIERS, you will probably have to make them yourself, or at least be prepared to put facings and trimmings of the right color on the red or blue uniforms you rent.

CUTTING THE GARMENTS

Men. See this section, Chaps. XI and XII. It is clear that you can cut uniforms as well as civilian suits from the "Continental" pattern, which can be used about as it is for many of these costumes. It is not difficult to modify the shape of the coat-skirts or the length and shape of the waistcoat, or to put on an extra stand-up or turnover collar. Collars and lapels on the waistcoat, the size of cuffs and pocket-flaps can all be changed to copy the sketches.

Women. See this section, Chaps. XI and XII. The "Martha Washington" pattern can be followed unchanged in reproducing figs. 10 and 12, except that

for fig. 12, a sacque, you must shorten the skirts of the over-gown. To make the dress in fig. 11, follow the directions for the later sack-backed dress given in Chap. XII. Take the advice given in the instruction sheet about tying up the side draperies with tapes, but place them to suit the picture you are imitating. You will almost always need to make the petticoat fuller than the pattern allows.

For a dress like fig. 9, make the bodice by the same pattern omitting the pleat; make a full petticoat (and under-petticoat) to fit over the panniers shown in fig. 10, Chap. XII. Put panniers and petticoat on the dress-form. Make a slip-cover of paper cambric to fit over the petticoated panniers, a cover fitted smoothly with seams and darts, such as you might make for a piece of furniture, and cut it off in approximately the line you will want at the bottom of the overdrapery. Now attach to the bodice a gathered upper skirt, open in front, and drape, pin, and tack it to the cambric slip, adding loops of ribbon, cord, tassels, etc. The sketch merely suggests what may be done.

For the dresses sketched in figs. 13 and 19 make a tight bodice on the fitted lining pattern (Chap. XX) (which includes long tight sleeves), and a full-gathered skirt with an overskirt if necessary. Put from six to eight widths in both skirt and petticoat and the same amount in the overskirt. The skirt of the redingote (fig. 18) need not be so full. Simulate the waistcoat of the redingote with false pieces stitched to the sides of the bodice front; hook the garment up the middle of the waistcoat. You can cut both the jacket of fig. 14 and the jacket of fig. 20 by the same pattern, adding a gathered peplum on fig. 14 and a peplum with side godets and a back pleat on fig. 20.

Cut the mantelet (fig. 15) in a triangle, about two yards across the base and about a yard from base to apex. Make it of rayon taffeta or other crisp material, edge with a double ruffle of the same or a lace ruffle, and put it on with the apex of the triangle down.

You can cut the fichus of figs. 10, 13, and 17 by the piece included in the paper pattern; those for figs. 15 and 16 may be of the same general shape but must be much larger. The collar of fig. 19, which should be finished in front with a pin or bow, consists of an organdie ruffle across the shoulders topped by a bias velvet band with another, double, ruffle above it. The double ruffle may be narrower in front.

Make the apron of fig. 13 full, and gathered on a waistband far enough around to cover the back of the hips. Make the bib of a straight piece brought tight around the body like a bandage and lapped over and pinned or hooked in back. Attach it to the apron band, which needs no strings.

Make the little girl's dress (fig. 22) like a full nightgown, with either kimono or set-in sleeves. Put a drawstring in the neck and another at a high waistline. Almost any straight jacket pattern will do to cut the boy's coat, and a pattern for " shorts " to cut the trousers; extend it to the proper length and narrow the legs as required. As for the children in fig. 21, you may buy child-sized " Colonial " patterns and make such variations as the sketch suggests.

Selected Reading List

See this section in Chap. XII.

Gallerie des Modes et Costumes Français, 1778–1787, Extraits de l'Art Pour Tous.
Four large portfolios of contemporary fashion-plates, colored, including stage styles,
with brief and charming text in French explaining each plate. An excellent contemporary reference for this nine years.

Les Elégances de la Toilette, 1780–1825—By Grand-Carteret.
Good pictures.

UNIFORMS

American: McClellan (op. cit.).
 The Army and Navy of the United States—Wm. Walton, Boston, 1895.

English: *A History of the Dress of the British Soldier, From the Earliest Time to the
 Present Day*—By John Huard, London, 1852.

French: *L'Armée depuis le Moyen-Age jusqu' au Révolution*—By Paul LaCroix.
 L'Epopée du Costume Militaire Français—By Henri Buchot, Paris, 1899.

German: *Geschichte de sächsischen Armee*—By Ferdinand Hauthal (Seven Years War
 to 1859). Leipsig, 1859.

Where Further Illustrative Material May Be Found

The portraitists mentioned in the beginning of the chapter, whose works may be seen
in the larger art galleries and in many smaller collections, are all excellent references for
this period. Native American portraits are to be found in various art galleries, in private
houses, college refectories and chapels, state houses, and the rooms of historical societies.
Many are reproduced in McClellan (op. cit.) and Warwick and Pitz (op. cit.).

Pamphlets and broadsides of a satirical nature were illustrated with woodcuts which
prove illuminating though sometimes vulgar sources of costume information. Engravings
of pictures abounded and so did illustrations. All these are still sometimes to be found in
second-hand bookshops and are often reproduced in modern books and in current art
publications. Beginning with this period we have fashion-plates (see bibliography) for
our information.

The American Wing at the Metropolitan Museum in New York and similar collections in other cities furnish a complete course in American interior decoration. Illustrated
catalogues of these make excellent text-books.

Actual costumes of the period are numerous and may be seen in the museums of
Europe and America.

Sources of the Sketches in This Chapter

Of the contemporary material listed above we have followed more particularly pictures
by: Morland, Romney, Gainsborough, Reynolds, Zoffany, Hudson, Walton, Le Brun,
Greuze, Read, Gilbert Stuart, and Charles Peale, hanging in the National Gallery, National Gallery Millbank (Tate), National Portrait Gallery, Wallace Collection, British
Museum, Museum of Versailles, and at Washington and Lee University (the last, seen
in reproduction only, Peale's portrait of Washington as a Colonel of Militia).

We have followed also engravings from Morland and from Wheatley's " Cries of
London " and some French engravings after Deboucourt, Moreau, and others. Figs. 18,
19, and 20 were inspired by fashion-plates in *Gallerie des Modes*, op. cit.; McClellan,
op. cit., furnished some details; so did *Trachten, Kunstwerke und Gerätschaften des
17th u. 18th Jahrhunderts*, by I. H. von Hefner-Alteneck. Many others are taken from
actual costumes seen in the Victoria and Albert Museum, the London Museum, the
Metropolitan Museum, and the Museum of the City of New York.

Chapter **XIV**
DIRECTOIRE AND FIRST EMPIRE

Some Important Events and Names

ENGLAND	FRANCE	AMERICA
George III, d. 1820 Regency of the Prince of Wales, 1811	Louis XVI, d. 1793 The Terror, 1793–1795	PRESIDENTS Washington, 1789–1797 John Adams, 1797–1801
STATESMEN Wm. Pitt the Younger, 1759–1806	REVOLUTIONARY LEADERS Mirabeau, d. 1791 Danton, d. 1794	Jefferson, 1801–1809
George Canning, 1770–1827	Marat (assassinated by Charlotte Corday), d. 1793	Madison, 1809–1817 EVENTS
Wars with France, 1793–1815	Robespierre, d. 1794 The Directory,	Louisiana Purchase, 1803 Second War with
MILITARY LEADERS Duke of Wellington, 1769–1852	1795–1799 The Consulate, 1799	England, 1812–1814 ARTISTS
Admiral Nelson, 1758–1805	Napoleon First Consul for life, 1802	Copley, d. 1815 Charles Peale, d. 1827
Battle of Trafalgar, 1805	EVENTS First Empire, 1804–1814	Gilbert Stuart, d. 1828 Trumbull, d. 1843
Fashion Arbiter from 1800 to 1816, George Bryan (" Beau ") Brummel.	Restoration, Louis XVIII, 1814–1824 The " Hundred Days," March 1, 1815, to	CABINETMAKER Duncan Phyfe, 1768–1851 In New York from 1790
POETS Robert Burns, d. 1796 Wm. Blake, 1757–1827	Battle of Waterloo, June 18, 1815	
Wm. Wordsworth, 1770–1850	WOMEN Mme. de Staël, d. 1817	
S. T. Coleridge, 1772–1834	Mme. Roland, 1754–1793 Mme. Récamier,	
Byron, 1788–1824 Shelley, 1792–1822 Keats, 1795–1821	1777–1849 Josephine Beauharnais, 1763–1814, wife of	
PROSE WRITERS Charles Lamb, 1775–1834	Napoleon, divorced, 1809 Marie Louise of Austria m. Emperor Napoleon,	
Sir Walter Scott, 1771–1832	1810 Napoleon's son, the	
Jane Austen, 1775–1817	King of Rome, called later the Duke of Reichstadt,	
ACTORS John Philip Kemble, 1757–1823 Mrs. Siddons, d. 1831	nicknamed "l'Aiglon," 1811–1832	

Some Important Events and Names

ENGLAND (*Continued*)	FRANCE (*Continued*)
ARTISTS	ARTISTS
Romney, d. 1802	Greuze, d. 1805
Adam Buck, d. 1833	
W. R. Bigg, d. 1828	Mme. Le Brun, d. 1842
Morland, d. 1804	
Joseph R. Smith, d. 1812	Louis David, 1748–1825
Zoffany, 1733–1810	Louis Boilly, 1761–1830
Henry Raeburn, 1756–1823	François Gérard, 1770–1837
John Hoppner, 1758–1810	J. B. Isabey, 1767–1855
John Opie, 1761–1807	Baron Gros, 1771–1835
Thomas Lawrence, 1769–1830	
Wm. Beechey, 1753–1839	
Francis Wheatley, 1747–1801	

CABINETMAKER
Sheraton, d. 1806

Some Plays to Be Costumed in the Period

Dramatizations of "Pride and Prejudice" (written in 1796–97, usually costumed in styles of "Empire," about 1800–1815).

Langdon Mitchell's "Becky Sharp," a dramatization of Thackeray's "Vanity Fair" (first part takes place before Waterloo).

Louise N. Parker's "Pomander Walk."

Shaw's "The Man of Destiny" ("Directoire" styles).

J. M. Barrie's "Quality Street" (Act I, 1805, Acts II, III and IV, 1815).

DIRECTOIRE AND FIRST EMPIRE

CONCERNING THE PERIOD

THE French Revolution dominated the thought of the world, whether you liked what was going on, as some onlookers did immediately after the Fall of the Bastille and during Napoleon's empire, or hated it, as everybody did during the Terror and many during the Empire also. Willy-nilly, the affairs of France involved all Europe and changed its map, its manners, and its modes.

The Napoleonic rule produced a new Paris, that Paris which is said to be the place where all good Americans go when they die: a city of boulevards, parks, and monuments, fit setting in which to display all the luxuries that the world comes to buy; an environment in which one may forget that other, mediæval Paris, the cool dim aisles of Notre Dame and the ardent tranquillity of the Sainte Chapelle. And the Sainte Chapelle seems to have forgotten that next door in the Conciergerie the Terror ruled red-handed; the Cathedral of Our Lady has perhaps forgiven that once before the high altar a harlot was enthroned as the Goddess of Reason.

The Napoleonic Wars gave Britannia, Bonaparte's arch-enemy, (1) the leadership of the allied nations, (2) the rule of the waves, (3) two epic heroes, Wellington of Waterloo and Nelson of Trafalgar, and (4) after many years, Landseer's lions of the Nelson monument, those charming animals beloved of children. Besides these blessings, the new century brought England world leadership in manufacturing and, as a consequence of modern inventions, the Industrial Revolution. British ownership of Canada and control of India almost compensated for the loss of the American colonies and the annoyance occasioned by those pestiferous Yankee sailors.

Creatively, England had never shone more brightly. The years between 1770 and 1830 embrace the great period of pictorial achievement, when the portraitists from Reynolds to Lawrence painted both prolifically and brilliantly. The new romantic school of poetry, first inspired by Burns, flowered in the work of the Lake poets and the young genius of Shelley and Keats. The novel, that pride of the nineteenth century, was represented during its first years by Scott's historical tales, full of Gothic chivalry and deeds of derring-do, and Jane Austen's everyday stories, full of fancy-work, county assemblies, petty matchmaking, and delicately barbed irony.

This is the "Federalist Period" in America, when the colonies, having wrenched themselves free from the leading-strings of England, and having

taken eager but uncertain steps in the direction of national unity, became actually a federation of sovereign states under the leadership of a president. He presided first in Philadelphia, then in that remote and raw new city, Washington. This was a controversial, a self-assertive, a "spread-eagle" period. Its artistic relics, both pictorial and decorative, embody those qualities, commemorating battles and heroes of the great struggle in narrative pictures, portraits, and patriotic emblems on canvases, furniture, wall-paper, chintzes, glass, and porcelain, the latter made for the American trade in China or England. The War of 1812 brought forth a new upsurging of patriotism and heroes such as Andrew Jackson and Commodores Hull (the *Constitution*) and Perry ("Don't give up the ship"). It demonstrated the excellence of "Yankee" seamanship. It produced "The Star Spangled Banner."

While cannon roared and nations were remade, enter the waltz, over which eighteenth century die-hards shook their white heads and vowed that the younger generation was going to the dogs in three-four time.

GENERAL CHARACTERISTICS OF COSTUME

With the French Revolution a great change occurred in costume throughout Europe and the United States. Seldom has the end of one century and the beginning of another witnessed such a decided break between the old and the new. Not that the change was actually accomplished overnight. Even the Revolution was unable to break down entirely the conservatism of the eighteenth century. On the other hand, even before 1790 (as has been explained in Chap. XIII) the stiff formalism of the mid-century had been modified by the gradual return to natural-looking hair, by the discarding of immense panniers, and by the increasing popularity of simple cotton materials for women's dresses and woolen fabrics for men's suits. All these reforms, together with simplicity in childish dress, had been gaining popularity in England and gradually became fashionable in France also, side by side with conservative formality. With the overthrow of the French monarchy, English aping of French styles was for a time halted and English dress continued independently along the lines begun in the eighties, simple but modest. The sympathies of the United States were not all with France, and during the nineties American women's dress reflected more of the English "baby" waists and ample petticoats and less of the Franco-Roman split tunics and bare legs. It is to Republican France that the student must turn for the most extreme examples of that neo-classicism whose influence dominated European styles until 1815 and lingered in some details for ten years more.

In the mad, self-conscious days of the early Republic and the Directory, the dress of French women expressed their creed of freedom to almost the literal extreme. More naked than any respectable Greek woman would have showed herself in public, these exponents of liberty promenaded the Paris streets and gardens in transparent muslin arranged in what they fondly imagined was the antique manner over pink silk tights, their bare feet shod in flat-heeled sandals

and their heads (O marvellous incongruity!) covered by enormous poke bonnets.

In England, and generally in America, simple muslin was the mode also, but the skirts which fell from high waistlines were provided with opaque under-petticoats and the necks were no lower than modesty approved. The girls in " Pride and Prejudice " followed one of the prettiest, most maidenly fashions ever arrived at by the often absurdly clad feminine portion of mankind.

After about 1800, when the extremes of the French fancy had abated, there was no great difference between the dress of French, German, English, or American women. By 1804 the fashion had reached the prettiest point in its development, for with the establishment of the Empire court etiquette again imposed a rigid formalism upon French fashions. In other countries, too, the simple " childish " dresses were gradually pushed aside in favor of tighter gowns in richer materials. After fifteen years the antique origin of " Empire " dresses was almost forgotten (fig. 22).

In the meantime men, even in France, resisted the attempt to clothe them in chitons and sandals. During the last years of the century, indeed, they merely exchanged the bondage of wigs and ruffles for the equally galling restrictions of choker cravats and skin-tight pantaloons. Yet more comfortable apparel was on its way, and already a man could be well-dressed and at the same time efficient. During the Revolution and the subsequent Napoleonic wars, the dictatorship of men's fashions passed from Paris to London. Beau Brummel, preaching cleanliness, neatness, and sobriety in masculine dress, was the sartorial leader of Europe from about 1800 till his eclipse in 1812, and ever since his day the supremacy of English tailoring has been acknowledged by Europe and America.

MEN

Heads. A few men continued to wear wigs or to powder their own hair, which was tied back in a queue (hair-powder was advertised in New York newspapers as late as the first decade of the new century). Yet among those who changed their appearance with the changing times, hair was worn in its natural state, unpowdered and frequently unconfined. It was sometimes cut rather short (fig. 3), sometimes allowed to hang longer, as it is shown in portraits of the young Bonaparte. Often it was held back in an informal queue, with short locks escaping at the sides. Some men still curled the side-hair in the fashion of the eighties. There was a good deal of latitude in arranging the front; middle partings, side partings and unparted " pompadours " were equally popular.

By about 1800 a fairly uniform style had been adopted, the style which was continued with few changes through the first quarter of the nineteenth century. The hair was clipped in the back to the contour of the head, but left long enough upon the crown to set in ringlets or the studied confusion of " wind-blown " locks over the forehead (figs. *passim*). It was a fashion directly

imitating the portrait busts of Roman emperors. A hint of returning whiskers (absent from fashionable visages for a hundred years) could be discerned in small sideburns, not much more than slight prolongations of the front locks (figs. 1, 5, and 6). Indeed, sometimes these front locks themselves, grown long and brushed forward in a style called " dog-eared," took the place of whiskers (figs. 2, 4, and 8).

Hats. The three-cornered hat was definitely "out," though some old-fashioned gentlemen still clung to the style. Its place was taken by the top-hat and the cocked hat. During the Directory both were worn by people of fashion, though the cocked hat was the dressier of the two (figs. 7 and 8). After 1800 the latter, while it remained a regulation part of court costume and of some uniforms, was not so popular as the top-hat. The cocked hat was black and either entirely plain or trimmed with feathers, a cockade, or an ornament like that on the uniform hat shown in fig. 8. After 1800 the front, which had originally risen nearly straight across (fig. 2), was pinched back (fig. 8). The top hat of the Directory was made with a narrow, slightly rolling brim and a high crown, smaller at the top than around the head (figs. 1 and 6). A narrow band encircled the base of the crown and a buckle frequently ornamented the front. After 1800, though the brim remained practically the same, the crown tapered less, and the buckle went out of fashion (fig. 5). These hats were made of well-brushed beaver and in this period were more often black than lighter-toned, as in fig. 1. Servants in livery and some of the clergy retained the small, flat-crowned tricorne of the eighteenth century. Quakers and a few other conservatives still clung to a wide, low-crowned hat whose brim was rolled a little at the sides, substantially the hat illustrated in fig. 4, Chap. XI.

Necks. Many men still wore a white stock either with or without a narrow black band on top and with the shirt-frill just visible below (Chap. XIII). Napoleon ordained this neck-finish for court dress, adding a lace fall in place of the ordinary cambric frill (fig. 7). Up-to-date gentlemen wound the cravat around the neck and tied it in a bow in front (figs. 1, 2, 4, and 5). During the nineties many extremists wrapped their huge white neckcloths very high, sometimes over their chins (fig. 2). Frequently even with the highest cravats the stiff points of the shirt collar stood up over the jowls (figs. 2, 4, 6, 8). After about 1800 a wide black or white cravat was fastened in back and had no bow in front (fig. 8). Almost invariably there showed above the cravat the edge of a white band, or the collar points (figs. 4, 6, and 8); occasionally such points turned down over the collar instead of standing up from it. As a rule, a bit of cambric frill showed between cravat and waistcoat.

Coat collars stood high. In civilian dress the main difference between the Directory and the Empire was that in the Directory the collar stood up just around the neck and turned over abruptly with a deep notch separating it from the very large rever (figs. 1, 2, and 3), while in the Empire it was still high, but turned over with a longer roll and was separated by a notch from a

smaller rever (figs. 4 and 5). Court coats, like military uniforms, had high standing collars which did not turn over (fig. 7).

Bodies. The tail coat cut away abruptly in front, already introduced before the Fall of the Bastille, was the well-nigh universal wear under the Directory and Empire (figs. 2, 3, 4, and 5). The other type of coat, which sloped gradually from a high waistline to a place somewhat below the knee and buttoned up single-breasted, was in the seventeen-hundreds an outdoor coat, part of the riding-habit (fig. 1). The peculiar strap-fastenings help to distinguish it as for the saddle rather than the drawing-room.

The square-across tail coat was at first single-breasted, with large revers (fig. 2); later it was more often double-breasted. The coat popular just before the Empire was adjustable, that is, the front could either be folded high and buttoned across the chest with from four to seven large buttons (fig. 3), or fastened by only two buttons, the open part turned back to form revers. Often, too, a man left his coat entirely unbuttoned, to display his waistcoat with shirt frill above.

In the nineties the square coat-tails were sometimes very long, to the calf at least, a style affected by the " Incroyables," those extremists of the Revolutionary era. After 1800 tails stopped at the knee or a trifle below. Pleats were set in on either side of the center back, with a button at the top of each pleat. Pockets (not very large, with narrow flaps) were placed high, sometimes actually at the waistline, and far back (figs. 1, 2, 3, and 4). A single-breasted bobtailed coat was not unknown. Fig. 5 shows this informal type of jacket, recorded by an observant traveller in the States just before 1815. The statement that in some countries modish gentlemen wore tailless coats, while not verified in contemporary pictures, receives support from the presence of such a short jacket, which might be a survival, in Spanish regional costume and in bellhops' liveries.

After 1800 the coat adopted for court costume was cut away from a point at the breast, sloping in one sweeping line to the end of the tails, which were about knee-length (fig. 7). The French Emperor Napoleon wore a uniform of such a cut, and so did the English Admiral Nelson. What distinguishes this Empire dress coat from the cutaway coat of the eighteenth century (cf. fig. 3, Chap. XIII) is the high point at which it is fastened (caught by a hook, not buttoned over) and begins to slope. This is in general the type of dress coat worn by officers during the War of 1812. During the nineteenth century the same coat might still be seen in the liveries of footmen.

Waistcoats varied a little in length. When worn with square-front coats they usually stopped at the waistline, though sometimes they were longer, so that a bit was visible even when the coat was buttoned (figs. 4 and 5). To be worn with the cutaway coat the waistcoat was often shaped in a blunt inverted V or in two V's a short distance over the breeches-top (fig. 7). Double-breasted waistcoats could at will be buttoned nearly to the chin or left open for some distance and turned back in lapels over the coat. A single-breasted

FIG. 1.
Riding clothes, c. 1790-
1800. Note bow tie,
strap fasteners.

FIG. 6.
Top hat and caped
overcoat, English style,
1795-1815.

FIG. 2.
An "Incroyable," time
of the Directory, 1795-
1799.

FIG. 3.
Gentleman of the
Directory, c. 1795-
1804. This coat can
be worn open, mak-
ing wide revers.

FIG. 5.
Young American, c. 1810-
1815. This "bobtailed" coat
was an informal garment.

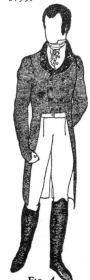

FIG. 4.
English or French
gentleman, in rid-
ing boots, c. 1815.
Note slight gathers
at top of sleeve.

waistcoat often had a standing collar, visible inside the coat-collar (figs. 3 and 4). Shallow pockets with narrow flaps were often added to waistcoats.

Arms. Until after 1800, sleeves were set plain into a snug armseye, a style which persisted in dress-clothes and uniforms. In the early years of the new century a little more fullness was introduced, concentrated in the top of the sleeve (figs. 4 and 5). Sleeves fitted the arm snugly. While the cuff lingered during the nineties (figs. 2, 3, and 7) and was continued still later in informal types of coat, after 1800 it was somewhat less modish than a plain wrist fastened with two buttons (figs. 4 and 5). Often the buttons were left unfastened, the white shirt-sleeve or wristband showing underneath. A narrow cambric ruffle sometimes showed below the cuff (fig. 2) in the eighteenth century manner. Long lace wrist-ruffles were revived for the Empire court costume (fig. 7).

Legs. During the twenty-five years under consideration knee-breeches remained a part of all formal dress (figs. 3 and 7), but pantaloons were increasingly popular for general wear. Breeches were extremely tight; they covered the knee and were commonly finished with nothing fancier than three or more buttons up the side, though occasionally a little braid might be added (fig. 3). In the early nineties knee-ribbons sometimes took the place of buttons or buckles, upon those breeches which were still occasionally worn with riding-boots. The first pantaloons were calf-length and even tighter than breeches, being made of elastic knitted fabric (figs. 1 and 2). By 1800 pantaloons, still tight, were full length; in 1810 they were ankle length and sometimes a little looser. For riding and occasionally for other uses such trousers were strapped under the foot. Both breeches and pantaloons opened with two slits at the side-fronts (figs. 1, 4, and 8). Small fob-pockets for the watches were placed at either side, nearly at the waistband.

Feet. With knee-breeches were worn white stockings (silk with dress-clothes) generally clocked in black, and black kid pumps, heelless or with very flat heels. The distinguishing feature of these pumps is their rather short vamps, short tongues and plain buckles. Stockings and pumps were also worn with the calf-length pantaloons of the nineties. Stockings were not always white, the colored stripes shown in fig. 2 being especially favored by dandies. Gaiters, which had been and still remained a part of infantrymen's uniform, were taken up by civilians and worn with breeches (fig. 3), and with pantaloons as well. Out-of-doors boots were considered correct, nor were they thought incongruous in the drawing-room. The civilian boot of the nineties was short, only about as high as the calf (fig. 1). About 1800 another, higher boot came in also; it was finished at the top with a wide band of lighter-colored leather. While it resembled the late eighteenth century boot which also had a turnover top (fig. 7, Chap. XIII), the cuff of this boot was so snug-fitting that it may be considered rather as an extra piece attached on the outside (fig. 6). A high boot worn alike by civilian horsemen and soldiers is illustrated in fig. 4. The boot illustrated in fig. 8, ascending nearly to the knee

in front, curving down to hug the calf in back, was likewise appropriate for both civil and military dress, even the ornamental binding and tassels being used with either costume. Ordinarily these boots were black, the facings buff, the decorations gold.

Outer Garments. Capes did not vanish from masculine apparel, but fashion interest was concentrated rather on overcoats. The old-style greatcoat (figs. 7, Chap. XII and 5, Chap. XIII) was modified to suit the changed styles, its skirts shortened, its cuffs diminished. The newest overcoat was furnished with a multiplicity of capes (fig. 6). Such a coat offered excellent protection against the weather, and being, besides, loose-fitting, could be adapted to many purposes. Coachmen, particularly, favored it, and indeed clung to it when it had been dropped from ordinary wardrobes.

MILITARY

Military uniforms reflected the fashions of the times, therefore differing from army to army and within each army from regiment to regiment less in cut than in color and decoration. While the common soldier conserved the style of the eighteenth century in many details, officers had their coats cut with fashionable high standing collars, which sometimes were very high indeed, and tails in the styles of the moment. Some were shaped like the dress coat in fig. 7, many like the tail coat in fig. 3. The uniform sketched in fig. 8 has such tails, but they are far around at the back and are short and curved off to a blunt point, a style still preserved in the uniforms of West Point cadets. In the nineties the high uniform collars sometimes turned over, and the double-breasted coat could be turned back in wide revers; it was in fact, a coat like that shown in fig. 3. The cutaway type of coat often had those appliquéd revers described in this section of Chap. XIII (a detail which may be studied in the best-known portraits of Napoleon). During the Napoleonic wars coats were buttoned straight up to the high-standing collar (fig. 8). The ornate gold braiding was another feature of officers' coats. Toward the latter part of the time coats frequently had scant skirts all around in the style shown a little later by civilians as the " frock coat," a fashion which has persisted in dress uniforms.

Soldiers wore either knee-breeches or longer tight pantaloons (fig. 8) and either high or low boots (figs. 4 and 8). In 1793 the French National Guard was already outfitted in looser ankle-length pantaloons, of the kind familiar to us on the traditional figure of Uncle Sam.

Officers wore light dress-swords (fig. 7) (which had been largely given up by civilians) sometimes attached to, or at any rate worn at the same time with, a baldrick. In action they carried heavier sabres, swung from a hanger at the waist (fig. 8). Epaulettes had the importance and the significance we attach to them. Sashes were still worn with uniforms, generally wrapped around the waist. Elaborate braiding extended over not only the coat but the breeches as well.

Dress uniforms were accompanied by cocked hats, but the high " shako," still to be seen on West Point cadets was adopted in many regiments for the ranks.

CLERGY

Clergymen dressed practically like the man pictured in fig. 8, Chap. XIII, except that they followed the layman's fashions in hairdressing. While the Anglican clergy had given up the cassock as street attire, it was still worn by continental priests. In England, bishops preserved a reminder of the cassock in the apron which covered their legs about to the knee, and many of the clergy wore long black gaiters. Apron and gaiters are still retained in the dress of a Church of England bishop.

WOMEN

Heads. Until the last years of the Empire hair was arranged with the simplicity which distinguished dress, though women's ideas differed widely in the interpretation of that simplicity. From the nineties it was fashionable to have short locks, loosely curled and arranged in studied confusion (figs. 11, 13, and 23). At the same time various coiffures of long hair modelled after the antique, both Greek and Roman, were worn by the neo-Greeks of Paris and even London (fig. 9a). Often the back hair was arranged in a simple knot, while short curls waved upon the forehead and in the nape (figs. 14, 15, and 17). The familiar portrait of Mme. Récamier shows a version of this style. Before 1815 the middle-part and topknot so universally worn during the next period had made their appearance (figs. 16 and 20) and a few high, elaborate coiffures also (fig. 22).

Fashionable women did not wear caps very often in society, though French women of the Directory did appear on the street in large and lacy versions of the mob-cap. Such a cap survives in the dress of some French provincials. Conservative married women and older women generally still wore house-caps, of which fig. 9c is an example. A large but simple form of mob-cap was often worn by servants. Turbans, on the other hand, were extremely modish' for evening coiffures and appeared in many versions, of which fig. 17 shows one example.

For street wear over the new small hairdressing there were many bonnets and caps. The absurdly exaggerated poke illustrated in fig. 11 seems to have been affected principally by the " Merveilleuses," the feminine counterparts of the " Incroyables," but other types of the poke were plentiful enough. There was, for instance, a bonnet which was fashionable in the nineties, a simple affair, all brim (fig. 12); the upright feather is a very typical trimming. About 1804, and later, too, a quite different type was fashionable, with a round stiff crown at the back of the head and a flaring brim (fig. 19). Finally there was the scoop shape illustrated in fig. 21, included in the fashions for 1807, but preserved long after as a " Quaker " bonnet. Indeed variations of

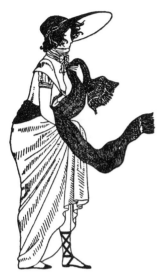

FIG. 11.
A Merveilleuse, period of the Directory, 1795-1800. Note very low décolletage and very high neckcloth.

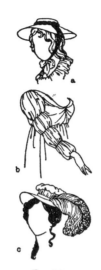

FIG. 10.
A little girl's hat, c. 1812. A sleeve, c. 1810-15. An English hat, c. 1815.

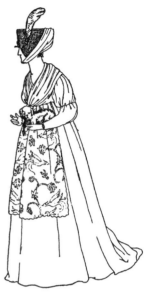

FIG. 12.
An English lady, c. 1790-1800. The upright feather was a popular touch.

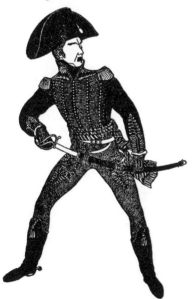

FIG. 8.
Officer in the Napoleonic wars. Note military sash and tasselled boots.

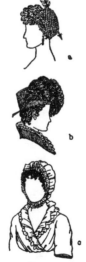

FIG. 9.
A neo-Roman French coiffure, 1804. An English hat, c. 1800, and an English bonnet and ruffled neck-finish. 1810-1815.

FIG. 7.
Dress uniform for the French or English court, 1804-1815.

these and other types may still be encountered in the dress of various religious communities in Pennsylvania and elsewhere.

Styles in hats leaped from one fancy to another. It is not possible to illustrate more than a few. In the earlier years mushroom brims and puffy crowns were still to be seen, and sometimes the crowns without any brims. About 1800 high crowns and small brims were favored, with copious plumes rising in the front (fig. 9b). High crowns with small rolling brims were popular in the early years of the new century (fig. 14). The trimming was generally placed upright in front, and if the hat happened to be beaver, not straw as it is here represented, the edge might be fur-trimmed. The Napoleonic wars imparted a strong military cast to millinery, as witness the riding-hat (fig. 23), almost a direct copy of the soldier's shako. A curious little hat, dated 1815 or a trifle earlier, had a small puffed crown, a widish brim, and plumes (fig. 10c). The " shepherdess " hat of the eighteenth century had not gone out of style. Often it was tied down with ribbons, as shown in fig. 10a. Another shade hat, flat or mushroom shaped, had ribbon streamers on top and under the brim trimming such as flowers and white frills; or it could be put on over a ruffled mob-cap in the old way.

While ribbons and flowers, ruchings and lace were all popular trimmings, nothing was in greater favor than ostrich plumes, particularly in the last years of the eighteenth century, when a plume or two rose straight up above a lady's forehead, whether it was attached to a hat or merely pinned into her evening coiffure. The nodding plumes shown in fig. 18 are typical of an English court headdress; this custom is still retained in the three plumes obligatory in presentation costume at the English court.

Necks. With the advent of Greek fashions the extremely puffy fichu was much reduced, though that type of neck-finish was retained along with the short-waisted dress and never ceased to be worn by conservative women, especially with simple dresses (fig. 12). Akin to it is the surplice neck with a ruffled finish (fig. 9c), which was to be seen on some dresses during the whole period. However, after the first few years most women were wearing bodices with low round necks. The depth of the décolletage varied greatly: some dresses revealed more of the bosom than is generally considered decent (figs. 11 and 13); others almost covered the collarbone. Though the chemise neck gathered up on a drawing-string continued throughout the period (fig. 13), it shared popularity even from the beginning with a neck cut down square, finished with a binding or other decoration (figs. 11 and 17), and with a neck slightly pointed (fig. 16). Surplice necks (fig. 9c) and various open necks with ruffled collars finished simple informal dresses (fig. 10a). After 1804 the modish feminine world, following the lead of the French court, had its formal dresses made with bodices cut extremely low in front and fairly high in back to support the stand-up lace collars revived from Renaissance styles (fig. 18). Although one saw even street-dresses low-cut (fig. 15). after 1800 necks even higher than the ruffled style of fig. 10a were also

fashionable. The triple-rowed ruching which fills in the neck of fig. 19 would probably come together in a V in front, leaving the throat free, but it is not as often to be found after 1810 as the high ruff over a snug neckband (fig. 21). The ridiculous combination of an extremely low bodice and an extremely high wrapped cravat, illustrated in fig. 11, was a French fad not often followed in other countries, but a mannish cravat with a riding-habit was, as usual, not uncommon. After 1800 the military inspiration was traceable in standing collars and bodices braided across the front.

Bodies. After two centuries of bodice-and-skirt dresses, women returned for a while to the frock cut all in one, i. e., the chemise dress or tunic, in its simplest version actually gathered on strings at the neck and under the breasts. For twenty years or so little girls had been clad thus, and it was a short step for women to adopt the style. Almost immediately this too-simple gown was modified to follow the figure on more sophisticated lines, and bodices and skirts were again cut separately, though joined to make a one-piece dress. The front of such a bodice was smooth and snug-fitting and very short (figs. 18, 20, 21, 22). The front piece extended a little way under the arm, where it met the side back piece in an underarm seam. It also extended a little way over the shoulder, where it met the curving center-back pieces (for this bodice buttoned up the back) (fig. 17). Most dresses of the "Empire" and even of the Directory period were made upon patterns of this general type. The "shirt-bosom" front (fig. 21) is no exception, nor is the gathered bodice shown in fig. 16, for the front piece was made separate and attached to the fitted underbodice.

In the exuberance of escape from the old formalities, stays had been discarded. For young, lithe figures (ideally all Revolutionary figures were as young and lithe as those painted by David) no restraint was needed under the pseudo-Greek tunics. However, when smooth, tight bodices and sheath-like gored skirts returned, corsets returned with them. High-busted, long-hipped, these were nearer in ideal to the foundation garments of the 1930's than to the wasp-waisted corsets of the 1830's.

Arms. The short puff is a characteristic sleeve of this period (figs. 11, 17, 18, 20, 21, 22) but not the only one. A shorter, draped sleeve was one accompaniment of the Greek tunic, another sleeve was short and straight, with a crenelated or vandyked edge (fig. 14). Still another had two puffs instead of one. Another imitated the Roman imitation of the Greek Ionic chiton (cf. Chaps. III and IV) with short sleeves caught along the top by brooches (fig. 13). There were also plenty of long sleeves, often in low-necked dresses, and they had a variety of forms: (1) long and tight, flaring over the knuckles (fig. 15), (2) arranged in puffs from shoulder to wrist (fig. 10b), (3) not very full, simply gathered into a ruffle at the hand, and (4) the same sleeve held in by a ribbon just above the elbow (fig. 12).

Legs. The skirt of a true chemise dress was fairly full, with the gathers distributed pretty evenly around the body (figs. 13 and 14); in the nineties,

skirts, even when attached to separate bodices, were equally full all around (figs. 11 and 12), but later, with fitted bodices, they had a rather scant front and fullness concentrated in the back (figs. 17, 18, 20). During the nineties skirts were both long and full, though being made of light materials they seemed scanty after the huge structures which had preceded them (fig. 12). After 1800 a certain number of tight, form-fitting skirts (fig. 15) were accepted, and with the establishment of the Empire, skirts fitting smoothly across the front and gathered in the back took the lead (figs. 17, 18, 20). Soon there was a bit of a flare at the bottom; horizontal trimming helped the effect (fig. 20). Finally a smooth gored skirt with a stiffened hem line marked the transition from the natural silhouette to the "bell shape" of the nineteenth century (fig. 22).

In the nineties skirts were long, often trailing. Fig. 11 shows a fashionable trick which had its parallel in the middle ages, that of throwing the superflous length of skirt over the arm; but there is this essential difference: Mediæval ladies were well petticoated, whereas the silk-stockinged or bare leg of the Merveilleuse was uncovered nearly to the knee. Most skirts were set on at a high waistline (the longer line shown in fig. 11 harks back to the eighties), but the fashion-plates of 1815 include some intimations of the coming "natural" waistline. After about 1800 there were a good many varieties of length to choose from. Formal dresses continued to have trains (fig. 18) and touched the floor in front. Many others, both for day and evening wear, were also long (figs. 12, 17, and 20); but an ankle length was increasingly popular (figs. 15, 16, 19, and 21) and before the period ended many young women danced in still shorter skirts (fig. 22). Fashion notes for the year 1813 include an even shorter dress, really calf-length, worn with high gaiters.

The tunic or over-dress, covering in part both body and legs, was a classical touch which survived throughout the period. Fig. 13 shows a costume fairly approximating the real Greek chiton, fig. 14 another in which the Greek original has been nearly lost sight of, except, perhaps, in the girdle crossing the body after the old Ionic manner (Chap. III). The robe or court mantle (fig. 18) was in reality a train attached to the dress at the high waist. It was made of rich material, often velvet, in contrast to the delicate muslin or gauze frock. Fig. 15 shows well the formalization which so quickly overtook the neoclassic style when it was subjected to the Imperial influence.

Feet. Heels were completely out of style. Devotees of the Greek revival wore bright-colored sandals with ribbon straps up the leg (fig. 11), put on over the bare skin or flesh-colored silk stockings. More popular still were thin, flat, low-sided slippers (figs. *passim*), generally finished with no more than a tiny bow near the tip. The shoes were often homemade, from satin, silk, or soft kid in white and delicate colors as well as black. Sometimes they were embroidered at the tip. Roundish toes prevailed in the earlier years of the new styles, but by 1813 the fashion illustrations once more show points.

FIG. 14.
French neo-classic gown, with
a pelerine, 1804. Note tiny
parasol.

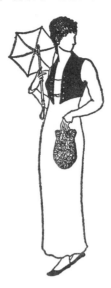

FIG. 15.
English neo-classic
dress and spencer, c.
1800-1805.

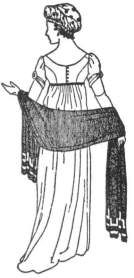

FIG 17.
"Empire" dress and
turban, c. 1804-1810 or
'15.

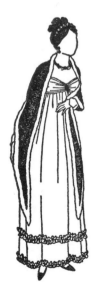

FIG. 16.
English "Empire"
dress and mantel-
ette, c. 1804-15.
Note the matched
ornaments.

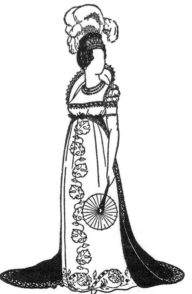

FIG. 18.
Court costume including Eng-
lish plumed headdress, c.
1804-15. Note the wheel fan.

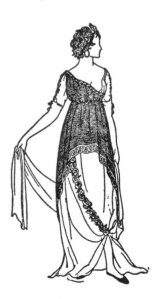

FIG. 13.
French neo-classic style, 1802.
Note the sleeves imitating the
Ionic chiton (Chap. III)

After 1800 slippers often had cross ties (fig. 21), a fashion more general later.

Outer Garments. The *spencer,* a neat little jacket, usually of darker material than the dress underneath, was worn both indoors and out. It was often sleeveless (fig. 15), but when sleeves were added they were long and rather tight. Whether the spencer was left open, as in the sketch, or buttoned up to the pit of the throat, it usually had the same type of turnover collar; yet sometimes it was finished with a ruff of the sort shown in fig. 21. Its back had the peculiar diamond shape illustrated in fig. 19. In winter, fur lining gave it extra warmth. It was, in fact, such another useful garment as the seventeenth century Dutch jacket and the twentieth century sweater, and after its introduction about 1800 remained deservedly popular for many years.

The *pelisse* was a complete coat dress opening up the front over a lighter dress and worn either in the house or on the street; though a pelisse generally had long sleeves, its cut was similar to the dress pictured in fig. 21. Other long coats, somewhat looser and shorter than the pelisse, were used entirely as outdoor garments (fig. 19). Large raglan sleeves and the curious, narrow, diamond-shaped back are distinguishing features, as well as the narrow fur edging. The *redingote* was another long coat, cut on fashionable feminine lines and caped like a man's overcoat (fig. 6). Fur-edged circular capes were still worn as evening wraps and the old-fashioned caped cloak like Little Red Ridinghood's continued as a utility garment among the less fashionable.

There were a variety of smaller wraps, of which the most omnipresent was the scarf, a long rectangle, like the Greek chlamys (Chap. III), draped as the wearer pleased (figs. 11, 13, 17, and 20). Though worn as an accessory to a street costume, the scarf was particularly a part of the evening toilette. Akin to it was the *mantelette,* a scarf pointed in back, wide over the arms, narrow in front (fig. 16). It was made of velvet with a fur edge (a style shown in the fashions for 1808) or of taffeta with a ruffled lace edging. Included among the fashions for 1807 was a long thin fur boa, knotted around the neck like a fichu and hanging down the front of the skirt (cf. fig. 18, Chap. XV). A *pelerine* was a small shoulder-cape which had its name from the cape worn by pilgrims in the middle ages. Fig. 14 shows one style; another was somewhat longer, covering about half of the upper arm, and rounded front and back. Among the styles of 1808 and later years is a little silk cape fitting neatly just over the point of the shoulder and trimmed all around with puffed silk.

EQUESTRIENNE

As usual, a woman's riding-habit was an adaptation of masculine modes. The military influence expressed in the hat of fig. 23 showed also in a coat with a standing collar and elaborate braiding across the front, in the style of fig. 8, which was equally as popular as the riding coat shown in fig. 23. Skirts were both long and full and held out with starched petticoats. Ladies rode in slippers or ankle boots (shoes).

CHILDREN

Little boys' clothes remained very much as they had been just before the Revolution. The larger boy pictured in fig. 24 is typical, in the cut of his jacket and pantaloons, of the Dauphin as well as of boys as late as the twenties. A variation from this style is nearer that earlier suit shown in fig. 22, Chap. XIII, *i. e.,* white shirt with ruffled collar open in a V and a short jacket, but the jacket worn after 1800 was somewhat longer and round about, not cut away from the front. Small boys and girls dressed alike, with baby-waisted frocks, low necks, and short puffed sleeves (fig. 24). The small child illustrated in fig. 24 is a boy, for it was boys who first put on long pantalettes under their dresses. This lad is dressed after a representation of Napoleon's little son in 1814 (see p. 387), except that the King of Rome is wearing, in that picture, a dark velvet dress instead of white muslin.

Little girls wore wide sun-hats tied under their chins (fig. 10a), boys wore either wide round beavers or caps with a visor, jockey caps.

MATERIAL

Through the nineties men still wore some silk fabrics, as witness the striped silk coat of fig. 2 and the velvet suit of fig. 3, but woolen was more and more popular:—fine broadcloth for gentlemen, coarser woolens for common folk. Cotton and linen were also much used, nankeen being the material for summer suits in the tropics and in those states whose climate was hot.

Waistcoats were made of silk, satin, lutestring, and fine cashmere. Breeches continued to be made of satin, or else of the same material as the coat, but the skin-tight pantaloons (fig. 2) were of fine elastic material, wool, or occasionally silk jersey. After about 1810 some trousers were made looser-fitting and therefore demanded firmer materials, such as nankeen, twill, and fine-ribbed corduroy or velveteen called " moleskin."

During the nineties, when France, which had manufactured the most and the best silks, was in too chaotic a state to attend to weaving, the vogue for muslin and all cotton fabrics reached its height. Very beautiful effects were obtained with these diaphanous materials, whose popularity continued even after the return of silk to less than prohibitive prices. At best, silk was not, any more than it had been, within the reach of every woman for all occasions; that phenomenon was reserved for the twentieth century.

After about 1800, and especially after the Napoleonic court had re-introduced formality in dress, satin and velvet returned to favor, often combined with gossamer muslin over silk slips (fig. 18). All-over lace dresses appeared also at the French court, in accordance with the Emperor's encouragement of native lace-makers; but they were very costly. The average woman wore printed linen, sprigged muslin, flowered chintz, checked linen or cotton, and tiny-figured calico in summer ; and fine or coarse cloth, from cashmere to linsey-woolsey, in winter. Stockinette, plain or decorated in small dots, was a fabric

used for such dresses as fig. 15 (drawn from an actual garment of the period). The effect is very modern.

COLORS

Men. Except for the stripes mentioned as a fad of the nineties, men's coats were generally plain-colored, trimmed, if at all, with darker velvet or, in the case of uniforms and official court dress, with gold embroidery or braiding. If waistcoats were not of the same material as coats, they were lighter colored; frequently they were patterned (most often in stripes) or embroidered. Both breeches and pantaloons were generally somewhat lighter than coats, though the very early stockinette pantaloons were black (fig. 2). For coats, favorite colors were brown, snuff-color, burgundy, plum, bottle-green, black, and especially a very bright strong blue; for waistcoats, white and light shades, sprigged, dotted, checked, striped; for breeches, black, white, dark gray, buff, tan, fawn-color. The red coats of the military or of huntsmen stood out in nearly every English scene.

Women. Up to about 1810 women's dresses were predominately light-colored. A great many were white, with touches of color, perhaps, in sash and hair-ribbons. Such accents were often strong, including black embroidered edges and the bright colors found in oriental designs, usually on scarves. White embroidered with metallic threads, either silver or gold, was popular throughout the period.

With the return of more sumptuous materials, heavier colors came back: black, Pompeian red, various shades of green (especially a very bright tone), strong yellow, violet, lilac, heliotrope, and " king's blue " (these colors being particularly popular for redingotes, pelisses, and spencers, along with the still darker shades enumerated above under *Men.*) For muslin dresses the " pastel " shades and white held their own.

Fur, both white and brown, was effectively applied to light-colored wraps.

MOTIFS

Throughout the period the classical influence was strong. All the designs listed or illustrated in Chap. III are suitable upon costumes described in this chapter (*e. g.,* figs. 13 and 14). The place of naturalistic flowers (so omnipresent in eighteenth century design) was taken by circles, dots, squares, and lozenges, or small sprigs. After the Egyptian campaign, *i. e.,* in the late nineties, an oriental element joined the Greco-Roman, apparently because of the shawls and scarves that returning campaigners brought to their women-folk, and thus there is a hint of the Persian palm, exotic birds (fig. 12) and other Eastern patterns. Of direct motifs from ancient Egypt there is little trace in dress, though they were freely adopted in furniture design. After the establishment of the Empire, the delicate Greek patterns were somewhat pushed aside by the more ostentatious Roman versions of the same motifs (fig. 18).

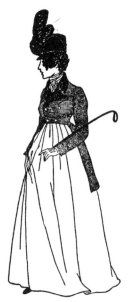

FIG. 23.
A riding-habit, 1807-15.
Note the military hat.

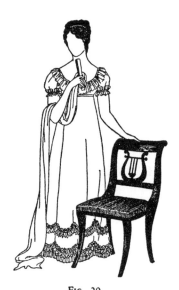

FIG. 20.
"Empire" dress, American.
Duncan Phyfe chair, c,
1810-14.

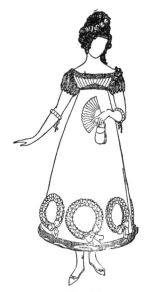

FIG. 22.
French dancing dress,
1813. An advanced
style.

FIG. 24.
Two little boys, c. 1814. An early
appearance of pantalettes.

FIG. 19.
A coat and a poke bon-
net, 1804. Note very
large muff.

FIG. 21.
English lady in
walking dress, c.
1810-15.

After about 1810 the antique began to be combined with Renaissance features. For example, in neck-finishes (figs. 9b, 18, 19, 21), hats (fig. 10c), puffed sleeves (fig. 10b), and slashed or " paned " decoration (fig. 22). The corset-bodice with a shirred chemise top returned too, now very high-waisted, like other dresses. Altogether nineteenth century costume was very eclectic, but it was women's and children's dress which borrowed from the past; masculine garments developed steadily on the new lines, to meet increasingly utilitarian demands of a dawning industrial age.

APPLICATION OF DECORATION

Thanks to Greek models, Directoire and earlier Empire dresses were decorated chiefly upon the edges, around neck and sleeves, dress-hems and tunic-borders (figs. *passim*). In a fashion perhaps reminiscent of the late Roman *clavus* (Chap. V), decoration also extended up the front (fig. 18). A delicate tracery of colored silk or metallic threads was the stitchery employed for the daintiest designs, but later ornament in the florid Empire taste was applied in raised embroidery (fig. 18).

From about 1800 women's dress re-introduced the un-Greek trimmings of ruffles, shirrings, puffs, and flounces. These were applied to hats, necks, and the lower portion of skirts (figs. 16, 20, and 21). The materials were lace, fluted or pleated cambric, or the material of the dress. As the first decade of the nineteenth century ended, a multitude of frilly collars, capelets, shoulder-bretelles, and sleeve-ruffles arrived on the scene, followed by flounces and horizontal trimmings, all giving a widened effect to the bottom of the skirt (fig. 22); and at the same time appliquéd ornament reached almost the elaborateness of the eighteenth century. (Compare fig. 22, this chapter with fig. 12, Chap. XII.)

A man's suit was trimmed only with a dark velvet collar, bright buttons (made of brass, silver, gold, or mother-of-pearl), modest ruffles at throat and wrists, and a little embroidery upon the waistcoat. Only upon uniforms (figs. 7 and 8) gold braid and embroidery still flourished, together with fringed and tasselled epaulettes, decorated boot-tops, and sashes. Even knee-ribbons, popular for a few years of the nineties, were soon discarded, and shoe-buckles became plainer and plainer.

JEWELRY

Men. Dress-swords occasionally had highly ornamented hilts (the Emperor's was encrusted with diamonds); orders (upon a short ribbon around the neck, or pinned upon the breast) sparkled with gems. Otherwise, save in an occasional ring and possibly a pin stuck in the shirt-frill, there was no place for gems on masculine dress. Heavy gold watches, with their fobs and seals, dangled singly or in pairs from under the waistcoat (figs. 1 and 3).

Women. Hair-ornaments were often jewelled or at least of gold. They took the form of ropes of pearl (fig. 20), golden arrows (fig. 9a), combs, fillets

(fig. 22), small tiaras (fig. 16), and even coronets (the last worn by the high nobility, fig. 18). Many decorations were borrowed directly from Greek and Roman designs, *e. g.,* gold laurel wreaths and diadems (cf. Chap. III). Jewelled ornaments secured the turbans or fastened the nodding plumes. Necklaces of pearls, diamonds, or other stones, at first copied from the Greek, later even more delicate (fig. 16), finally became heavier under the influence of Imperial ostentation (fig. 18). With bare arms bracelets were favorite ornaments, among them the rigid type already mentioned in Chap. XIII, which remained popular throughout the nineteenth century. Earrings were again in style (figs. 9a, 13, and 16) and often copied from Greek or Roman models.

This period saw the beginning of another nineteenth century fancy, *i. e.,* a matching set of jewelry: tiara, earrings, brooch, necklace, and perhaps bracelets. The set which served as a model for fig. 16 was made of cut steel, very fashionable at the time; it sparkled handsomely and was considered dressy enough to wear to parties. Matching sets in silver or gold, the latter (it might be) encrusted with precious stones, were popular also.

ACCESSORIES

Men. Though snuff-taking had not yet gone out of fashion, cigar-smoking was now introduced from Spanish-America into the States, and Europe also (fig. 5). Quizzing-glasses (fig. 7) were affected by the beaux, and canes were very popular. Dress-swords were virtually abandoned, but some canes were swordsticks, *i. e.,* they carried blades sheathed in the hollow cane, which was smooth, slender, with a round or crutch-handle. The gnarled stick affected by the Incroyable (fig. 2) was a real weapon of defence, useful in the troublous days of the Revolution. Gloves were again articles of fashionable male dress, and were made of fine, delicately-colored kid; riding-gloves, of heavy stitched leather, with fairly short wrists, were usually made in more serviceable colors.

Women. Some women carried canes (fig. 18, Chap. XIII), but parasols were more popular. They were small, sometimes covered with glazed paper, more often with a watered, striped, or embroidered silk. The tiny parasol shown in fig. 14 was fashionable in 1804 and later; the adjustable type illustrated in fig. 15 was first used about 1800, and maintained its popularity during most of the century; fig. 21 shows a style of 1812. About 1807 the fashion books were illustrating another parasol which recurred through the century, one which could be carried by a ring in the ferrule instead of by the handle; during that year the parasol was short, only about a third the length of the bearer.

Fans were small and most often of the ordinary folding type (figs. 20 and 22), though a folding wheel-fan appeared also (fig. 18). Enormous muffs (fig. 19) were made of fur or alternate rows of fur and shirred silk. Gloves were omnipresent; they were short and often brightly colored, with long sleeves; long, glacé, generally white, with short sleeves (figs. 13, 14, 17, 18, and 21). During most of the period gloves were long enough to meet the short

sleeves, or to miss them by only an inch or two, but toward the end they began to shorten (fig. 22). Occasionally, as in the sketch, the tops were ornamented. The backs, too, were sometimes embroidered. Ladies wore kid or silk mitts, (*i. e.,* half-fingered gloves) thoughout the period.

Handbags or reticules were important items in a lady's costume, taking the place of the " pockets " which had formerly hung from the girdle. Figs. 15, 19, and 22 suggest the variety in size, shape, and material. " Miser " or " stocking " purses were also carried by ladies as well as gentlemen (cf. fig. 8, Chap. XI and fig. 18, Chap. XIII).

Lace-bordered veils were draped on hats and bonnets (fig. 19). Wreaths of artificial flowers ornamented hair and gown (figs. 13 and 22). Workers donned big bibbed aprons of white or checked cotton (fig. 13, Chap. XIII). Ladies protected their house dresses with dainty versions of those useful garments. The apron illustrated in fig. 12 is of muslin embroidered in white.

SOMETHING ABOUT THE SETTING

The delicate and almost austere type of furniture and decoration produced in England and France during the last years of the Monarchy was succeeded by another copied more directly from Greek models. Antique influence prevailed in French furniture of the Directory, in English pieces of Sheraton's last style (d. 1806), and in American-made pieces of the " Federalist " period (fig. 20). In the latter, a spread eagle was frequently substituted for the urns or flower designs of European originals, mirrors, clocks, fenders, and andirons as well as chair backs displaying this emblem. Under the influence of the French imperial court, furniture as well as the smaller articles, took on a heavier and more pompous classicism, reflecting Imperial Rome and Egypt (fig. 7).

In the first and second decades of the new century, draperies and upholstery materials were heavier than formerly, alike in texture and color. Chairs were upholstered in silk, brocade, velvet, leather, and haircloth, black or colored. At windows, over white sash curtains, hung draperies of damask, taffeta, and copperplate printed linen, including the famous French *toiles de Jouy.* Designs were narrative, scenic, and symbolic in character, and in those fabrics printed especially for the American trade were again " Federalist," *i. e.,* patriotic. China manufactured abroad for use in the United States was decorated with similar patterns.

Scenic wallpaper, printed either in monotone or in several colors, was a feature of the period. Each unit of the design covered a considerable space and could therefore set forth in panorama a whole scene, classical or contemporary.

A feature in the drawing-room was the lady's harp, or if that happened not to be her instrument, a harpsichord or a spinet. Musically inclined gentlemen favored a flageolet, a transverse flute.

PRACTICAL REPRODUCTION

Materials. To represent the woolen materials from which men's garments

were so often made, real woolen is naturally best. Look for bargains in serge, twill, and even in wool and cotton mixtures. The latter will do excellently for homespuns. Velveteen and fine-ribbed corduroy will serve many purposes in men's suits and pantaloons, and women's outdoor garments. Heavy outing-flannel, dyed a rich color, makes about the best substitute for broadcloth. Other cotton fabrics suitable for masculine dress are cotton rep, cotton drill, khaki cloth, and denim. To represent the pantaloons shown in fig. 2, use tights with the feet cut off, firmly faced with straight binding, with an elastic added at the bottom; or make very tight breeches from cotton or rayon stockinette. For the tight pantaloons worn with boots, simply use tights as they are. Sateen is appropriate for waistcoats, court breeches, and coat linings.

Almost any kind of thin cotton material, even a good grade of cheesecloth, is suitable for women's dresses. Marquisette, net, lawn, organdie, dotted muslin, checked gingham, calico, chambray, and percale, are all appropriate. Buy only small patterns, such as dots and circles or other geometric figures or flower sprigs on a light ground. To represent silk, use sateen, silkaleen, mercerized silk mull, thin crêpe de chine, and (for a dress like fig. 22) rayon satin. For the court train, spencers, and coats, use the velvet or woolen substitutes mentioned above. Jersey, balbriggan, or any elastic fabric is suitable for a clinging dress like fig. 15.

Trimmings. Use metallic braid for military designs on military and court costumes (figs. 7 and 8) and cotton or woolen braid on the plainer suits. It is possible to apply a design like the one on fig. 7 with oil paint or tempera, or coarse wool embroidery, as explained in this section, Chap. XI. Make ruffles and ruchings of batiste, organdie, or tarlatan; the lady's standing collar (fig. 18) of starched net held up by a fine silk-covered wire. Use brass, jet, gilt, silver, steel, or mother-of-pearl buttons on men's suits. In the lamp shade making section look for ready-made, flower-like trimming for such dresses as those sketched in figs. 13 and 22.

Jewelry and Accessories. At the ten-cent store you can buy pieces of jewelry that will be appropriate to this period. Use all the imitation diamonds you wish; also cameos. If you have access to an old-fashioned button-bag you will probably find treasures there which you can convert into brooches, necklaces, and watch-seals.

Make the various reticules as you would modern workbags. To make the miser-purse, see this section, Chapter XI. Look there also for notes about snuff-boxes. Twist the quizzing-glass from a piece of heavy wire; it need not have a glass in it. See if you can't borrow a wheel-fan (fig. 18). They were popular in the latter part of the nineteenth century and later. See also if you can find small parasols; they were used quite late in the century and are still to be discovered in many attics; such things are difficult to make.

Any gnarled stick will do for the Incroyable (fig. 2) to carry, and a modern light cane for other men. You may use modern slip-on gloves of leather or kid for both men and women.

Millinery. Suggestions for making hats will be found in Chap. XX. If you have a very wide-brimmed felt or beaver hat, you can easily cock it up in the shapes shown in figs. 7 and 8; if you have to make the entire hat of covered buckram, use dull-finished cloth in preference to sateen. It is easier for inexperienced milliners to reblock men's felt hats (as explained in Chap. XX) into top hats, than to make them of buckram.

Mob-caps have been explained in this section, Chap. XII; add a ruffled chin-strap and you have the style shown in fig. 9c. To make the turban, fig. 17, start with a skullcap. Over it sew a circular piece large enough to bag a little. Make a roll padded with cotton, wider in the middle than at the ends, wrap it with bias folds of the material, and sew it to the edge of the turban; cover the joining with a band of trimming.

Make all the pokes of buckram covered with material. Fig. 12 needs no crown other than the bias scarf stretched across the back and over the chin. Fig. 11 must have a small buckram crown; the buckram crown of fig. 19 is shaped like a drumhead and covered smoothly, but the brim has shirred silk over it and is faced with a light-colored silk or lace. It has strings to tie under the chin. Make the shovel-bonnet (fig. 21) like a sunbonnet (you can buy a pattern), with a soft, gathered crown.

To make the narrow-brimmed hat (fig. 14), reblock a felt hat. To make the riding-hat (fig. 23), buy a very cheap cotton cap with a visor; upon that foundation build a buckram crown covered with black velveteen. Paint the visor black.

If you will warn the actors not to have their hair cut for a few weeks before the performance, it can be brushed to give the proper effect. Curl it if you wish. Add sideburns of crêpe hair.

Almost any bobbed hair can be arranged in the short feminine styles pictured. Add a large switch of braided hair for the effect shown in fig. 9a. The arrow can be made of a quill trimmed and gilded or a meat-skewer with additions of buckram, also gilded. Curls and switches can be used to make the long-haired coiffures. You might need a wig to represent fig. 23, which is a style that a good wig-dresser would imitate beautifully.

Shoes. See Chaps. X and XI for the construction of boots and Chap. X for suggestions about spurs. Black leather (not patent) dress-pumps are appropriate for all occasions where boots are not used. Add small steel buckles (or buckles cut from triple buckram, stitched together and silvered). If pumps are not available, you can use ballet-slippers or black felt slippers. You can make gaiters of heavy black socks. Cut away heels and toes, bind the edges, put buttons up the sides and a line of tape beside them to simulate the opening. Put an elastic in the hem to hold them up.

Ballet-slippers are most satisfactory to use for women's shoes, though flat-heeled kid or felt bedroom slippers will do also. Add small bows or cross-ties. To make the sandals (fig. 11) cut down bedroom slippers to only a toe-cap and heel and add wide cotton tape to wrap around the ankle. Canvas sandals will

do, also, or the soft suede " rehearsal sandals." Avoid high heels, for they are alien to the spirit of the period and will spoil the characteristic gliding walk.

Renting. If you can afford to rent the men's costumes it will probably pay to do so, for the reasons explained in Chap. XII. However, if you do not select the costumes in person you must be prepared to be put off with types more suitable to the next period. You will probably be most successful in getting dress coats like figs. 7 and 8, and a suit like fig. 4.

<div align="center">CUTTING THE GARMENTS</div>

Men. If you are assembling a permanent wardrobe and wish to make the men's suits, remember to buy as good material as you can afford, to interline all coats with tailor's canvas or heavy muslin, and to baste carefully and press frequently. Have all cloth coats pressed by a tailor when they are finished.

To cut the coats pictured in figs. 1 and 7, use the " Continental " pattern described in Chaps. XI, XII and XIII, altering the shape of the tails and collars by the sketches. The tails of fig. 7 are " claw-hammer " shaped, slit up the back, the left side folded over the right. The tails of fig. 1 are fuller, square across; they are not only slit up the back and folded over, but also laid in a pleat at each side of the slit, each pleat finished with a button.

To cut the coats shown in figs. 2, 3, 4, 5 and 8 use an " Uncle Sam " pattern, modifying the length of waist, the collar, revers, and tails, to resemble the sketch. The tails of fig. 8 begin far around, indeed just back of the hips; they are only long enough to cover the buttocks, and they are cut like those of fig. 7 (above).

Heavy cotton or mercerized tights are the best and easiest substitute for the tight breeches shown in figs. 1, 2, 4, 6, and 8. As explained under *Materials* you need to cut them off only for the style shown in fig. 2. It is more work and probably fully as expensive to make them from jersey cloth. But it is possible to use underwear drawers, if you can change the front opening to two side-front slits, removing all the bulkiness of facing and buttons, for the breeches are visible right up to the waistline. For the breeches shown in fig. 5, use the " Uncle Sam " pattern; cut them scanter at the top and a little fuller just at the ankles, and omit the straps. Use the " Continental " pattern to cut the breeches shown in figs. 3 and 7, fitting them tighter over the knee and actually fastening them with hooks and eyes or zipper, and trimming with buttons. Do not fail to provide suspenders with all breeches and pantaloons.

Cut waistcoats on either the " Uncle Sam " or the " Continental " pattern, changing the lower edge and adding collar and revers as indicated. Use a modern collar as a pattern for the standing collar, changing the angle of the points to frame the chin; make it of doubled muslin, starch it stiff, and iron it flat. Shape the cravat to the neck, hook it at the back, and support back and sides with whalebone (figs. 3, 6, and 8). For figs. 1, 2, 4, and 5, add tie-ends at the back, slip one through the other in the manner of a riding-stock, bring around to the front, and tie. Make the stock shown in fig. 7 of white

lawn and add in front a doubled lace ruffle. If a costume requires the display of a ruffled shirt-bosom, put a lawn double ruffle on a small " dicky " attached to the front of the stock. If a character has occasion to take off his coat, give him a fine muslin or cheesecloth shirt buttoned up the front, with a double ruffle running down about six inches from the neckband (the latter should have the pointed collar described above attached to it). Make the sleeves about half a yard wide and gather them into a normal-sized armseye upon a slightly dropped shoulder. Finish the wrists with a band and ruffled heading about two inches wide.

Cut the overcoat on the " domino " pattern (Chap. XX), shortening the skirts and making the sleeves smaller. Set an inverted pleat from waist to hem at each side of the back and split it up the middle. Put a button at the top of each pleat. Or use the cassock pattern. Cut the capes by a pattern that has a dart on the shoulder and sew them one above the other at the neck; add the turnover collar. Notice the tab-fastenings on this overcoat as well as on the riding coat, fig. 1.

Women. To cut the waists shown in figs. 9c, 10b, 12, and 14 use any blouse pattern with a little fullness in the front. Attach to it a full gathered skirt opened inconspicuously in the front, like the blouse. Set in sleeves. Cut the dress of fig. 13 all in one piece, sleeves in with the body. Put a gathering string in the neck and another at the high waistline. Split the sleeves along the top and fasten together with ornaments. Make the tunic on the wearer: a width front and back, scooped out for an armhole on one side, on the other sloped from shoulder nearly to the waist. Sew up the side-seams, shape the skirt in front as indicated, put a gathering-string at the waistline. Make the trimming at the top tight enough to hold in place over the bust, and fasten at the shoulder with a large brooch. Drape with the flower-festoon. The under wear should be very scant; but if the dress is of transparent material a short silk slip must be worn, unless the actress prefers to wear pink tights. If she wears a chemise and no tights she may go bare-legged.

Cut the upper tunic of fig. 14 with the top and skirt in one, as for fig. 1 (above), and hold it down by means of a ribbon girdle bound across the front and back and around the waist. Make the underskirt amply full, with more gathers in back than front. If the material is opaque, no slip need be worn; if it is transparent, provide a long, scant slip of soft material. Cut the jersey dress shown in fig. 15 on a modern one-piece dress-pattern with set-in sleeve. Make the slight fullness in the skirt with gores or godets, not pleats. Put a belt around at a high waistline.

Cut the bodices of figs. 11, 17, 18, 20, 21, 22, and 23 by the fitted lining pattern (Chap. XX), modifying the sleeves, neckline, and length of waist according to the sketch. If you wish to be more authentic, cut out a pattern on the wearer, in imitation of the bodice whose back is shown in fig. 17. The front is in one piece, fitted with darts under the breasts. It extends over the shoulders and around the sides to an underarm seam. There it is joined by the

side-back pieces, which in turn join the two narrow pieces which make the Y-shaped back, and they join the front section just below the shoulder.

The bodice of fig. 16 will be cut like the others, but has, in addition, a straight piece about the depth of the waist, shirred up the middle and attached to the bodice at the center and the sides. Attach it to the front and shape to armseye and underarm seam before you seam the bodice together. Make the shirt bosom shown in fig. 21 separate also, tucked and trimmed with braid, then attached to the bodice. All bodices of thin material must be made on an interlining.

Gore the skirts of figs. 17, 18, and 20, but allow a full straight breadth to be gathered into the back. Cut the skirt of fig. 22 with four gores. Hold it out at the bottom by means of heavy featherbone, padded with sheet cotton to a roll about three inches thick, covered with a casing of silk or sateen and attached to the bottom of the skirt. Provide ample petticoats under the skirts of figs. 12, 19, 21, 22, and 23, none at all under those reproduced in figs. 11 and 13; and scant slips under the clinging skirt of fig. 15 and under the moderately full skirts like figs. 14, 16, 17, and 18.

Cut the spencer on the fitted lining pattern; if you want sleeves, use those in the same pattern; then make flaring cuffs, as shown in figs. 4, 5, or 15. Cutting the collar as in the sketch, you may button the garment up the front to the pit of the throat. To give the effect of the diamond-shaped back which a spencer often had in common with coats, appliqué on it a square whose top and bottom points are cut off an inch or two by the collar and hem, while the side points merge into the armhole.

The effect of the coat (fig. 19) may be obtained thus: First make a fitted lining. Using the pattern for a raglan-sleeved coat or dress, cut sleeves and body-part (short-waisted). Put it on the wearer over the lining, fit it by means of darts and snug seams under the arms (fasten it up the front as far as the breast); tack it to the lining. Make a square as described above, of the size shown in the picture, and stitch on at the back, through lining and all. Make a straight skirt with two pleats in back, as shown, and attach it with an inside seam to the body. Or cut your own pattern, following the picture. Put the fur trimming all around the skirt, up the two fronts, and around the neck. Fasten the coat with frogs or merely with hooks concealed under the fur.

Make the pelerine (fig. 14) with seams on the shoulder, a pointed back, an open pointed front, and a standing collar fastened with a ribbon bow. Cut the mantelet (fig. 16) as a segment of a circle, approximately two yards and a half along the straight edge and a yard or less at the widest place. Make it of velvet or taffeta and trim with fur or gathered lace.

For the court train or "mantle":—make a fitted girdle of belting, boned at sides and front, six inches or more deep in back, very narrow in front. To this attach the train, made of two widths of velveteen or satin, lined with contrasting color and rounded on the lower corners. To be effective it should trail on the floor at least a yard, probably more. Pleat the material on the belt with

a heading about an inch deep; make it scant in front and fullest in back with an inverted pleat in the middle. Stitch firmly to the belt and put it on over the gown, hooking it in front under an ornament or brooch. You may also make the mantle to reach only to the front of the hips, but in that case you must stitch it on the dress at the waistline.

For children's costumes, see this section, Chap. XIII.

Suggested Reading List *

Historic Dress in America—By Elizabeth McClellan.
Vol. I describes costumes up to 1800; vol. II those of the earlier nineteenth century. Many of the illustrations are photographs of actual garments.

Dress Design—By Talbot Hughes.
Illustrated with photographs of costumes as well as with line drawings.

History of Costume—By Köhler and von Sichert.
Has a number of photographs of actual costumes belonging to this period.

Dame Fashion—By Julius M. Price.
Begins in 1786. Good pictures, many of them reproductions of contemporary fashion-plates.

Fashion in Paris—By Octave Uzanne.
Very pleasant, gossipy text and lovely colored pictures, mostly of women. Begins 1797.

Les Elégances de la Toilette—By Grand-Carteret.
Goes to 1825.

Die Mode, Menschen und Moden in Neunzehnten Jahrhundert—By Fischel and von Boehn.
Illustrated with many pictures, some colored: reproductions of fashion-plates, con temporary portraits, and topical sketches.

Histoire du Costume. Les Modes au XIXième Siècle—By André Blum.
Illustrated with many contemporary pictures.

Le Luxe Français, Vol. I, " L'Empire "—By Henri Buchot.
Illustrated with excellent pictures.

L'Armée en France et à l'Etranger—By Louis Auguste Picard.
Military.

Where Further Illustrative Material May Be Found

The artists, English, French, and American, mentioned at the beginning of this chapter are generally excellent references, though sometimes their costumes are vague or fanciful. Examples of these artists' work may be seen in all the larger galleries and private collections of Europe and America. Reproductions are numerous, in books, magazines, art-prints, and postcards. Broadsides, story-books, and magazines were illustrated with engravings, which may still be bought. By the year 1780 fashion-plates had appeared in France, and England had magazines devoted wholly or in part to the modes. In the bibliography are listed names and publication dates of a number of these. Leaves from some of them may be found not only on French and English bookstalls, but even in America. Many libraries contain scrap-book collections of early fashion-sheets, if not files of the complete magazines. Most of the books recommended above are illustrated with

* In 1937 appeared English Women's Dress of the Nineteenth Century, by C. W. Cunnington, most valuable year by year account and representation of the material discussed. Period Patterns in cludes many charts for the nineteenth century.

reproductions of the above sources, or with reproductions of actual costumes, of which there are many in various museums.

Sources of Sketches in This Chapter

Out of the wealth of contemporary material, we have taken details for our sketches directly from the following:

Pictures by Beechey, Hoppner, Opie, Lawrence, LeBrun, Gérard, Greuze, Isabey, Le Gros, and Goya, the originals of which are in the Museum of Versailles, the Louvre, the Wallace Collection, the National Gallery, the National Portrait Gallery, and various private collections. The pantalettes on the smaller boy in fig. 24 we have dated from a picture of Napoleon entrusting the Empress and the little King of Rome to the National Guard; the picture is in the John Wykoff Collection, Rutgers University. We have not reproduced the costume in detail. The bob-tailed coat and the cigar are based on some textual authority and on the graphic evidence of a sketch-book made by Paul Svinin, whose sketches, edited by Avrahm Yarmolinsky under the title of *Picturesque United States of America, 1811, 1812, 1813* were published by Wm. Edward Rudge, New York, 1930. We have not copied the sketch. Fashion drawings by Vernet and Debucourt, many fashion-plates from the magazines listed in the bibliography, and contemporary portraits and illustrations from *The Lady's Magazine* also furnished details. Actual costumes in the Victoria and Albert Museum, the Metropolitan Museum, and the Museum of the City of New York, the wax effigy of Nelson in Westminster Abbey, furniture in the Metropolitan Museum, and a chair in a portrait of Napoleon contributed further points. A caped overcoat photographed and reproduced in Köhler and von Sichert (op. cit.) was one source of information for fig. 6, but a portrait of Andrew Jackson (now at the "Hermitage," Nashville) was another; the back view of a bodice (fig. 17) is from McClellan (op. cit.) but the figure is not. Other source material has been studied and may also have contributed a share, for the details were encountered over and over again. Though most of the above sources have been seen in the original, the sketches were nearly all made from photographs.

Chapter XV

ROMANTIC

DATES:

1815–1840

═══

Some Important Events and Names

ENGLAND	FRANCE	GERMANY AND AUSTRIA	AMERICA
George III, d. 1820	Louis XVIII, r. 1814–1824	Frederick William III of Prussia, r. 1797–1840	PRESIDENTS Madison, –1817
George IV, regent, 1811–1820 r. 1820–1830 m. Caroline of Brunswick	Charles X, r. 1824–1830 July Revolution, 1830	Francis I of Austria, r. 1768–1835 Metternich, 1773–1859 Congress of Vienna, 1814–1815	Monroe, 1817–1825 John Quincy Adams, 1825–1829
William IV, r. 1830–1837 m. Adelaide of Saxe-Meiningen	Louis Philippe, r. 1830–1848 Lafayette, d. 1834	The Holy Alliance (Russia, Prussia, and Austria), 1815	Andrew Jackson, 1829–1837 Van Buren, 1837–1841
Victoria, r. 1837–1901 m. Albert of Saxe-Coburg-Gotha	WRITERS Chateaubriand, 1768–1848 Balzac, 1799–1850	WRITERS Goethe, d. 1832 Heine, 1797–1856	Spain cedes Florida to United States, 1819 Missouri Compromise, 1820
STATESMEN Castlereagh, d. 1822 Canning, Prime Minister 1827	Victor Hugo, 1802–1885 "Hernani," 1830 Alexandre Dumas, Père, 1802–1870	Jacob Grimm, 1785–1863 William Grimm, 1786–1859 (Folklore)	Independence of Spanish America: Bolivia, Mexico, Peru, Brazil, 1820–1824
Duke of Wellington, Prime Minister, 1828–1830 Catholic Emancipation, 1829	George Sand, 1804–1876 Alfred de Musset, 1810–1857	MUSICIANS Beethoven, 1770–1827 Liszt (Hungarian) 1811–1886	Monroe Doctrine, 1823 Lafayette Revisits America, 1824–1825
Parliamentary Reform, 1832 First Passenger Railroad, 1825	Baudelaire, 1821–1856 DRAMATIST A. E. Scribe, 1791–1861	Chopin (Polish) 1810–1849 Schubert, 1797–1828 Schumann, 1810–1856	Panic of 1837 WRITER Washington Irving, 1783–1859 "Sketch Book," 1819–1820
POETS Keats, d. 1821 Shelley, d. 1822 Byron, d. 1824 Blake, d. 1827 Coleridge, d. 1834 Wordsworth, d. 1850	"Valerie," 1822, Théâtre Français PAINTERS David, d. 1825		PAINTERS Charles Peale, d. 1827 Gilbert Stuart, d. 1828
ESSAYIST Charles Lamb, d. 1834	Gros, d. 1835 LeBrun, d. 1842 Isabey, d. 1855		Trumbull, d. 1843 Thomas Sully, 1783–1872

DATES

1815–1840

==

Some Important Events and Names

ENGLAND
(*Continued*)

NOVELISTS	ACTORS
Jane Austen, d. 1817	John Philip Kemble, d. 1823
Scott, d. 1832	Mrs. Siddons, d. 1831
Bulwer–Lytton, 1803–1873 "Pelham," 1828	Charles Kemble, 1775–1854
Benjamin Disraeli, 1804–1881 "Vivian Gray," 1826	Fanny Kemble, 1809–1893 début, 1829
Charles Dickens 1812–1870 (Childhood scenes in "David Copperfield," c. 1822) "Pickwick Papers," 1837 "Oliver Twist," 1838 "Nicholas Nickleby," 1839 "Barnaby Rudge," 1840	Edmund Kean, 1787–1833 Mme. Vestris (dancer) 1797–1856

ARTISTS
Raeburn, d. 1823
Beechey, d. 1839
Lawrence, d. 1830
Adam Buck, d. 1833
George Cruikshank, 1792–1878

William Makepeace Thackeray, 1811–1863 "Yellowplush Papers," 1838

FRANCE
(*Continued*)

Horace Vernet, 1789–1863

Ingres, 1780–1867

Delacroix, 1799–1863

Daguerreotypes, after 1839 Invented by Louis Daguerre, 1789–1851

Some Plays to Be Costumed in the Period

Rostand's " L'Aiglon " (c. 1831).
Henri Murger's " La Vie de Bohême," which is Puccini's Opera, " La Bohême " (c. 1830–1840).
DuMaurier's " Peter Ibbetson," first part.
Langdon Mitchell's " Becky Sharp," last act.

Dion Boucicault's " The Streets of New York," prologue, panic of 1837.
Dramatizations of " Oliver Twist " and " David Copperfield."
Dramatizations of Mrs. Gaskell's " Cranford."

ROMANTIC

Both the French Revolutionists and Bonaparte were suppressed at last. The Treaty of Paris restored the Bourbons to the French throne; the Congress of Vienna brought other rulers out from hiding. The Holy Alliance, Metternich of Austria its brains, led the forces of reaction, backed by the hereditary aristocracy whose interests lay in a return to the *status quo*. Yet, although in different countries and for a few years absolute monarchy and an antiquated feudal system did prevail, the spirit of the century was not to be gainsaid. Censored press, regimented universities, persecuted Jews, overtaxed and unrepresented common people bubbled and seethed under the diplomatic lid, here and there bobbing up in revolt.

There were signs that Europe had not forgotten July 4th, 1776, nor July 14th, 1789. Such were the Greek struggles for independence from the Turk, a cause which enlisted the enthusiasm of liberals like the aged Lafayette and the poet Chateaubriand and for which Byron gave his life; the successful revolt of South American countries against Spain, encouraged by Canning and backed by the Monroe Doctrine; the July Revolution, France's repudiation of the old-fashioned Bourbonism of Charles X; the Industrial Revolution in England, with its attendant violence and suffering, and (on the other hand) Catholic Emancipation and Parliamentary Reform.

The physical world changed faster than the political. In the first decade of the new century Napoleon's rule had installed illuminating gas in some continental public buildings, and in 1812 a London company announced itself as prepared to furnish gas to city householders. By 1830 gas-light was the accepted illumination in urban theatres, greatly increasing the scope of stage effects. (Though to be sure, the great Crummles, with whose company Nicholas Nickleby toured the provinces, still played by candle footlights.) The telegraph was experimented with and by 1835 had taken its present place as the servant of mankind.

The age of steam had begun in 1807 when Robert Fulton's steamboat, the *Clermont*, travelled from New York to Albany in thirty-two hours. It took a second stride in 1814 when George Stephenson made his first steam locomotive. In 1830 the *Rocket* made thirty miles an hour at the opening of the Liverpool and Manchester Railroad, and in 1838 the *Great Western* steamship crossed from Bristol to New York in fifteen days. Steam began to turn the wheels of industry, and invention followed upon the heels of invention, upsetting the world for handworkers, whose services were no longer needed.

Artistically, this is the peak of the Romantic era, which had had its beginnings in the seventeen-eighties. Gothic, Oriental, and sentimental modern subjects shared popularity with the antique as the painters' inspiration. Writers in France were turning from Revolutionary subjects to the themes of yesteryear or to somewhat painfully frank self-revelation. In Germany, Goethe wrote of the Sorrows of Werther and the metaphysical adventures of Faust, Heine penned lyrics as tuneful as those that Burns had sung. Although English poets turned for their themes to Nature, the middle ages, the Orient, and the Land of Faërie, the light which glowed through these colorful vessels was the flame of individualism, the poet's personal response to Beauty and his whole-hearted belief in the rights of his fellow-men. The novel was well launched as the major literary form of the nineteenth century. The year 1837 is memorable not only for Victoria's accession but also for the publication of *Pickwick*. *Oliver Twist* followed, first in a line of English social reform novels. Washington Irving stepped forth as the first literary American to be recognized in England.

What diverse pictures are to be found in the pre-Victorian album!—George Sand and Chopin on the island of Majorca; the ladies of Cranford at tea with the Honorable Mrs. Jamison; Mimi and Rodolphe in the Bohemia of Paris; little David Copperfield toiling in the London bottle factory; Lafayette revisiting, as an old man, the nation for whose birth he had fought as a lad; young Benjamin D'Israeli making the Grand Tour; and, on " Old Hickory's " inaugural day, his backwoods constituents clambering with muddy boots upon the White House satin.

GENERAL CHARACTERISTICS OF COSTUME

The dress of the later Romantics expressed them excellently well. In place of a natural or "Greek" figure, which may be said to have epitomized women's revolt against all the corseted formalism of the eighteenth century, there arrived by one stage after another the hour-glass form, in its fragile artificiality suiting well a generation of clinging vines, those gentle Amelias who had the vapors, adored Byron (though blushingly), netted purses and worked samplers, went into declines, and died of broken hearts.

At the Restoration of the Bourbons, Parisian women were still presenting the appearance of cylinders, only slightly wider at the bottom than at the top; upon the abdication of Charles X they looked like capital X's or double equilateral triangles, the tops of their leg-o'-mutton sleeves as wide as the hems of their short skirts, their tiny waists the meeting of the two apexes. Soon after 1830 the extreme of this shape, as also of the attendant fantastic coiffures, waned, and the feminine figure assumed that graceful bell shape which it retained for the next twenty years.

During the same twenty-five years (1815–1840) men's clothes passed from the picturesque modes of the Empire into the frock-coated, trousered fashions exemplified by Albert, the Prince Consort (whose name, in America, clung to the coat as long as the last conservative wore one). As late as 1830 a man

might wear a flowered waistcoat and even a bright-hued coat. His buttons presented possibilities for gaiety, too, and so did the lining of his coat, permissibly of red velvet. In the next decade these flights were more and more frowned upon. The broadcloth coat was darker, or at any rate duller, the black cravat narrower. Throughout the period masculine dress reflected feminine in the matter of a nipped-in-waist and outspreading hips, making gentlemen of a very lady-like appearance, at variance with their recorded conduct.

The nineteenth century was as eclectic in costume as in decoration. Thus, while Greek tunics and Greek motifs still lingered in feminine dress, a Renaissance influence was evident in such details as closed or open ruffs, puffs and slashes, hanging sleeves, corset bodices and gathered chemises, full-crowned berets, and shoulder-rolls, all of which reappeared more than once during the century. The " Gothic " revival was probably responsible for this interest in the fifteenth and sixteenth centuries, and certainly for the newest styles in jewelry, plainly inspired by mediæval architectural details. The Napoleonic wars furnished a whole generation of ladies with military touches, which they applied especially to riding-dress. Sympathy for the cause of Greece brought out details copied from Macedonian peasant costume, notably short jackets for children and tasselled caps (fig. 7).

The dates to which this chapter is limited are more than usually arbitrary, for many of the details enumerated began before 1815, many others lasted after 1840. Some people eagerly adopted novelties, others clung to the good old ways. Changes were effected less rapidly and less completely than nowadays; many women in remote districts might go almost all their lives through without knowing that the styles had altered. The decade following 1830 was a transitional time, when the extremes in women's dress represented in figs. 17, 18, and 19 were gradually modified, and when the coiffures shown in figs. 9b and 17 were tempered to the more credible shapes of figs. 9a and 12, Chap. XVI.

MEN

Heads. The style of masculine hairdressing established about 1800 continued through this period, with considerable variations to allow for individual taste. Hair was worn longer than in modern fashions, luxuriant on top and at the sides, brushed forward more often than backward, and parted, if at all, slightly to one side (figs. 1–4). Many men went smooth-shaven, others grew small sideburns (figs. 2 and 3). By 1828 they sometimes added small moustaches (fig. 2).

For men of fashion, the top hat was the only wear. It altered comparatively little from 1815 to 1830 having, in general, a rather narrow brim, rolled at the sides and drooping a trifle over the face. As to the crown, up to 1830 it was oftenest bell-shaped, but after that date sometimes high and tapering (fig. 5). The variations are made clear in figs. 1 to 6, 5 and 6 showing the latest styles, which lasted till the forties. In 1830 or 1832 one might have remarked on the same stagecoach well-dressed men wearing examples of each. Simul-

taneously there would have been seen, most often on countryfolk, but occasionally on the more fashionable, a flatter-crowned, broader-brimmed hat (figs. 4 and 8). In America, and especially in the South and West, the wider version (fig. 8), new and neatly shaped, was popular even with well-dressed men.

About 1820 the cap, which had for some time been worn primarily by little boys (fig. 20), jockeys, and sometimes coachmen, was taken up by gentlemen as a travelling and to some extent a sports cap.

As before, clergymen wore a shallow-crowned " shovel hat," or, with formal dress, a tricorne.

High hats were made of beaver, in gray, fawn-color, and white as well as black; caps, of cloth, in colors to match the coats; and countrymen's hats, of straw or felt, not always black.

Necks. The neckcloth was still wrapped high around the throat and often, though not invariably, showed the stiff points of a collar above it. With evening dress the neckcloth was white (and often with daytime costumes as well), made of muslin starched, ironed, and folded to the required width. Though black was most popular for daytime, colors were permissible. In 1828 fashion writers took account of a plaid cravat to wear with sporting dress (fig. 2) and another of sky-blue to grace a riding-habit.

Often, especially in evening dress, a section of pleated white shirt and a pleated or fluted white ruffle were visible between collar and waistcoat (figs. 1 and 3). Mention may be made here of the " Byron " collar, affected by that volcanic poet, other poets, and their imitators; it was an unstarched shirt-collar, left unfastened at the throat or held together loosely by a silk scarf, negligently knotted (fig. 7).

One type of cravat, shaped and whaleboned to stand up high around the neck, had no ends to tie in front (fig. 3). This was a neck-finish popular in the early twenties as well as during the First Empire. Another black cravat had ends long enough to be tied once and then puffed out to fill the entire space above the waistcoat; still another was knotted in a large full bow with fairly long ends, a style rather common from 1820 to '30 and even later. A perennial stand-by was the white neckcloth knotted in front (fig. 5). A cravat favored for riding was folded over flat, filling the space above the vest, and concealing the shirt (fig. 4). About 1820 the ends of a white cravat were sometimes tied in a very small bow under the chin. A variant of this stock was recommended by the *Gentleman's Magazine* for 1828; it was an evening cravat of muslin (starched or soft, with or without a whalebone stiffening), tied in front in a double or triple knot, the ends then carried around behind and fastened at the back of the neck. Fig. 1 reproduces another evening tie pictured in the May, 1828, number of the same fashion book; it has two stiffened points projecting from under the knot, but no bow loops. This issue of the magazine also reports that at the moment few dandies were wearing frills to their shirts, but rather a pleated bosom fastened with two buttons of coral or enamelled gold.

Usually the collars of coats were rolled high in the back of the neck, a peculiarity of tailoring which lingered until after 1830 (figs. 1, 3, and 4). Sometimes, particularly on frock coats, the tailor put a wider, flatter collar, foreshadowing later styles (fig. 6). Throughout the period riding coats were just as frequently finished with a high standing collar, after the military usage (fig. 2). Any coat might have a black velvet collar, though perhaps more often dressy tail coats than the less formal frock coats. Collars, if not velvet, were of the material of the coat.

Bodies. At first, coats followed pretty much the style established during the Empire. That cutaway dress coat which had been the formal court costume up to Waterloo (fig. 7, Chap. XIV) gradually went out of fashion in favor of the tail coat for evening as well as daytime (figs. 1 and 4). This coat was no longer short-waisted; the waistline had, in fact, reached very much the place it kept during the rest of the century. The tails curved back well over the hips and descended to a few inches above the knee, where they were cut off square. During the decade of 1820–'30, when women's dresses were growing smaller-waisted and wider-hipped, men's coat-tails kept them company by flaring out from the waist (figs. 1 and 2), an effect achieved by cutting body and tails in separate pieces and inserting pleats at the back of the waistline. The tails were cleverly interlined, too, to assist the flare. Corsets were by no means unknown to men of fashion, since a womanish figure was the ideal. Some men, while professing scorn of the feminine method of producing a slender middle, nevertheless had recourse to waistcoats with lacings in the back, drawn as tight as desired. The male silhouette also showed that other characteristic of the ideal feminine shape, sloping shoulders. Tail coats were double-breasted (fig. 4) or if not actually so, at least simulated the effect with two rows of buttons, three or four on a side (fig. 1). Much of the time the coat was left open, displaying the waistcoat. Then as now, the man who followed the fashions knew just which buttons to leave unfastened, and on what occasions.

The frock coat became increasingly popular for morning and sports wear. Although usually single-breasted and supplied with about six large buttons and buttonholes (fig. 2), it was sometimes made double-breasted, with four or five buttons on a side, which might be fastened up to the squared-off lapels. It was modish to leave the single-breasted frock coat unbuttoned, or to fasten only the last two buttons. Coat skirts stopped just above the knee; they were scant across the front, flaring from hips to hem, and pleated at the back on either side of the central slit (fig. 6). A riding frock coat (figs. 2 and 3) differed from the pedestrian's (fig. 6) only in being rather scanter across the front (not always buttoned up), possibly a trifle shorter, and sometimes finished with a standing collar as mentioned above. So long as the carriage age lasted, this type of coat with the addition of a leather belt was the correct livery for grooms (top hat and all).

A bob-tailed coat was at this time an informal garment intended for young boys and adults of inferior position, and, occasionally, for sportsmen. It was

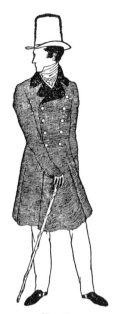

FIG. 5.
Overcoat, 1830-1835.

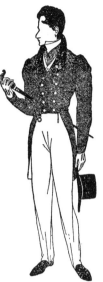

FIG. 4.
Morning dress, 1828.

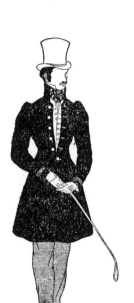

FIG. 2.
Riding frock coat,
1828.

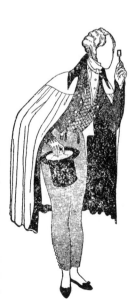

FIG. 1.
A gentleman in evening
dress, 1828.

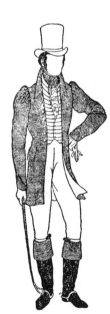

FIG. 3.
Riding frock coat and
"smalls," 1828.

single-breasted, slightly cutaway in front, and finished with a modestly rolling collar, the ancestor of the sack coat ubiquitous in modern dress.

Waistcoats gave gentlemen the opportunity to indulge individual tastes, for they were often lighter than the coat, being of figured material, or pale-toned satin or cashmere embroidered along the edges. Evening waistcoats were very often white, though not uniformly so; in 1828 a stylish material was black cut velvet, as in fig. 1. White Marseilles was a waistcoat material considered appropriate with riding-coats (fig. 2). For the daytime, color was quite permissible; so were patterns, such as all-over crosses and vine leaves, plaids, and the still popular stripes (fig. 3). Although the best taste frowned upon loud patterns and colors, plenty of men indulged in them and were not thought eccentric. Waistcoats were cut at the lower edge: (1) square across the front (fig. 1); (2) with only a slight dip; (3) with one or two small points; (4) with a shallow curve away from the center (fig. 3). Occasionally in evening dress the waistcoat extended an inch or so *below* the front of the coat, but as a rule the bodies of the two garments were about of a length. With a frock coat the waistcoat was visible chiefly when the coat was left unbuttoned. Double-breasted waistcoats were still to be seen, though toward the thirties single-breasted were commoner. Most waistcoats had some sort of collar, either standing (fig. 3) or rolled. Frequently a man wore an inner waistcoat, visible at both top and bottom of the outer or only at the top (fig. 4); it was white or light-colored, and it followed the lines of the upper waistcoat.

Arms. Coat-sleeves were very moderately leg-o'-mutton in shape, the fullness concentrated on the top of the arm. From the elbow down they fitted snugly. Oftenest they had no set-on cuffs, but instead a continuation of the sleeve carried over the wrist and flaring around the hand, sometimes as far as the knuckles (figs. 1 and 6). The tight sleeve was necessarily left unseamed for a little distance above the wrist, and fastened by one or two buttons. Sometimes the slit was left open a little way up, to show the white shirt-sleeve (fig. 1). Riding-coats often had small cuffs, either round or pointed (figs. 2, 3, and 4) and so did short jackets.

Wrist-ruffles gradually went out, so that in 1828 the fashion reporter already quoted remarked (as though it were something unusual) that he had seen six-inch lace ruffles at the wrists of the young men in the train of Mme. Vestris, the famous dancer.

Legs. Knee-breeches were worn no more except by those attending at court (where they were obligatory) and by some countryfolk and conservative older men. At evening functions, in place of breeches men wore pantaloons which were not very long, *i. e.*, well above the ankles (fig. 1). They were fairly full at the top, very tight from the knee down, and made of elastic material, wool or (occasionally) silk. These tight pantaloons were open-seamed from the calf down and fastened with four or five gold buttons. Those men who rode in high boots wore "riding smalls" (fig. 3), which were wide at the hip and

tight from the knee down; they were just long enough to meet the boots. Smalls were made of doeskin or of cloth such as drill or "moleskin" (velveteen or fine ribbed corduroy). Men did not always ride in these breeches; just as often they put on pantaloons over their short boots (fig. 2). Such pantaloons were also light in color, and made of drill, corduroy, or twill. They were fairly narrow at the bottom, and always strapped tight under the boot (figs. 4, 5, 6). Other pantaloons were loose, indeed baggy, but were tapered to a narrow width at the instep and strapped (fig. 2)—a slender version of the exaggerated "peg-top" trousers which recurred at intervals during the nineteenth century. In the late twenties one might have seen also the reverse of the peg-top, *i. e.,* trousers fairly tight at the top, bell-mouthed at the bottom, a shape then, as now, popular with sailors. These wide trousers also were usually strapped.

Feet. For evenings stockings were white, gray, or transparent black silk. Occasionally striped stockings were worn in the daytime. Evening pumps were black, low-heeled, short-vamped, finished with small black bows or small buckles (fig. 1). The ankle-high shoes or the short boots nearly covered by trousers were black, with blunt-pointed toes and low square heels. It was no longer the thing to wear boots outside trousers in the city; boots were now relegated to sports wear. They were made of black leather and came about to the calf; here they were finished by a turnover cuff of buff or brown leather or cloth (fig. 2). Shorter boots (Wellingtons) of the sort often covered by trousers, could also be pulled on outside. Hessian boots, in the style of those shown in fig. 4, Chap. XIV, were still popular. During the earlier years of the century a gentleman of fashion might put on gaiters when he was in the country. After a while that fad went out, and gaiters were again restored to their centuries-old place as an adjunct to rural or menial dress (and strangely enough, to the costume of Anglican bishops and deans). They were worn by peasants with their smocks (fig. 8) and by hostlers. Yet a country gentleman might wear them, or indeed any city man who felt that comfort was more important than style.

Outer Garments. The many-caped overcoat shown in fig. 6, Chap. XIV, continued to be worn by travellers, though by 1830 it was being appropriated to the use of coachmen in particular, and was not so strictly in the mode. Fig. 5 shows the other overcoat, popular for city wear. It was of cloth in dark blue, brown, or green, with black velvet collar. It had full skirts and was buttoned up snugly, double-breasted. Its pockets were in slits, either vertical or diagonal, outlined with braid. For evening men wore picturesque capes of blue broadcloth made with a contrasting lining, a velvet collar, and cord fastenings (fig. 1).

Special Costumes. Military uniforms of the Napoleonic era were perpetuated in many regiments and armies. More and more the tail coats (described and pictured in Chap. XIV, fig. 8) were replaced by frock coats (a style which persisted through the century), and breeches by pantaloons or trousers.

Clerical dress underwent the changes described for lay costume, in the matter of hairdressing and the cut of coats. Many Protestant ministers wore white neckcloths with their black suits, though some, notably in the English Church, clung to the old-style " bands " (fig. 8, Chap. XIII).

Lounging costume afforded an outlet for masculine love of the picturesque. Fig. 7 shows a dressing-gown fashionable in the late twenties and later, made of chintz, with loose pantaloons to match and yellow morocco slippers "à la Chinese" (sic). A small handkerchief of India printed silk, rolled and knotted carelessly around the neck over the open shirt-collar, and a " Greek " or stocking cap of varicolored knitted silk completed the costume.

Almost to the end of the nineteenth century there really was a peasant dress in England, the smock-frock (fig. 8). It was, of course, not a new garment, and the name, " smock," had long been applied to a woman's chemise. In the middle ages working-men had worn the same loose shirt along with a pair of breeches; in many countries, especially of eastern Europe, it still kept the ancient shape. France had it (still has) in the Renaissance style, i. e., gathered full upon a yoke, with big sleeves; England's version shows traces of the same ancestry. English pictures of the peasantry during the centuries from Elizabeth to George II neglect the smock, but it reappears in eighteenth century representations. The Anglo-American farmers, called out hastily at Lexington, fought in their " farm frocks." What distinguishes the English peasant smock from others is its unique and beautiful honeycomb stitchery, so identified with the garment that it has been named " smocking." While in the matter of color this work does not compete with Slavic peasant embroideries, in design and execution it is worthy to uphold the ancient prestige of English needlework. The smock in fig. 8 is copied from a Sussex example in the Victoria and Albert Museum. These comfortable and picturesque blouses have finally disappeared from the English countryside and may be seen now, in a debased version, only upon painters and the attendants in " arty " shops and tearooms.

After the autumn of 1829 a familiar figure in London streets was the policeman, familiarly called " Peeler " or " Bobby," because he was the creation of Sir Robert Peel, Home Secretary. His uniform was not very different from ordinary dress; it consisted of: a black hat, high and straight-sided, as illustrated in fig. 6, but with the narrow brim turned down rather than up; a blue cloth coat, cut away sharply like the morning coat in fig. 4 and fastened up the front with six or seven brass buttons; and pantaloons strapped under the foot. In summer these last were of white wash material. The coat collar was high and standing, as illustrated in fig. 2, and had the policeman's number in gold embroidery on the left side. Above it showed the wings of a white collar (figs. *passim*). Upon the cuffs were three rows of gold braid. From the beginning the Peeler carried no weapon, not even a truncheon.

WOMEN

Heads. During the years between 1815 and 1820 more and more women

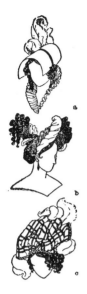

FIG. 9.
a, Bonnet, 1816. b,
Turban, 1828-31. c,
Toque or "beret,"
1828-31.

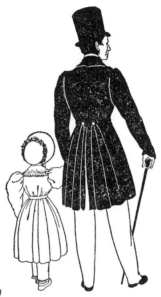

FIG. 6.
Little girl and her father,
1830-1835. Note the back
pleats, finished with buttons.

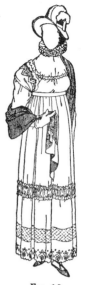

FIG. 10.
Lady at the time of
the Bourbon Res-
toration, c. 1815-20.

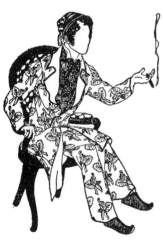

FIG. 7.
Dressing-gown, cap in the
Greek style, shoes "à la
Chinese," c. 1825-'35.

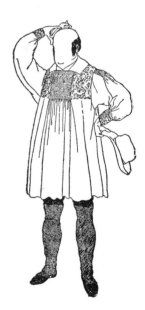

FIG. 8.
English countryman, 1800-
1840 or 1850.

began to arrange their hair smooth over the brow, often parted in the middle, with ringlets, puffs, or loops at the sides, a type of coiffure especially associated with nineteenth century femininity. Yet some remained loyal to the short curls or the wind-blown locks pictured in Chap. XIV. In the early twenties the back hair began to be piled higher on top (fig. 16), and during the next ten years the coiffure gradually assumed that extreme height which culminated in the absurdities of the year 1830 (fig. 17). A man reporter of the period characterizes the style as " à la giraffe " and devoutly hopes it will soon go out; though indeed it was several years before his wish was realized. But by 1836 the worst was over, and the mode was all for a low coiffure with curls or loops over the ears (fig. 9b, Chap. XVI).

It is pleasant to contemplate the comparatively natural ringlets which surrounded a lady's face about the year 1820 (fig. 15), though sometimes even at that date the knot or sheaf of curls towered rather ambitiously; pleasanter certainly than to study (in fashion-plates of 1828 to 1830 or '32) the masses of sausage-curls tumbling over the eyes of foolish virgins and matrons, the almost incredible loops, wings, and urn-shaped topknots (fig. 17), and the equally monstrous bonnets which were called upon to shelter such structures (figs. 9b and c).

Caps were a regular part of house dress for matrons, young as well as old, and spinsters of a " certain age." They had the example of Royalty; her Most Gracious Majesty, Queen Charlotte, had her portrait taken, sometime about 1818, in a mob-cap of the type illustrated in fig. 11. In those earlier years one might have seen other conservative caps akin to the eighteenth century styles pictured in preceding chapters. Later, caps went flighty along with hair; fig. 19 suggests the fanciful shapes created by capmakers in the late twenties and early thirties. Imagine gentle Miss Mattie of Cranford in such a concoction, the type for which she yearned and which Mary refused to bring her from the city.

With evening costume fashionable women still wore turbans, which conformed to the styles of coiffures. Fig. 14 represents a turban of about 1820, fig. 9b another of 1828 or '30.

For outdoor wear there was a choice of bonnets or hats; at times it is a little difficult to distinguish between them, since the former were sometimes very open and the latter often had strings. Generally speaking, a bonnet was wider in front than in back, a hat about the same size all the way around.

Poke bonnets, whose vogue had commenced in the last century, continued to be popular. Fig. 9a shows a version (1816) of the " Quaker " type; it is very frivolous, though, with its nodding plumes, ribbon bows, and short-sided brim. From 1815 to 1820 deep crowns, set well back on the head, and deep but open brims were fashionable (fig. 12). Later, during the twenties and early thirties, the brim flared still wider, showing bobbing curls upon the wearer's temples. Such a bonnet was sometimes worn over a frilled cap; or muslin and lace frills were sewed into the bonnet (fig. 18).

From 1815 to 1830 hats had high crowns, made necessary by the increasing height of the topknot (fig. 10). Fig. 13 was sketched from a real hat bought in 1818, made of leghorn straw and trimmed with taffeta ribbon. A wide lace veil such as this, worn with either hat or bonnet, occurs in fashion-plates throughout the whole period. The simple ribbon trimming (fig. 13) was often augmented by plumes which sprayed and curled over the hat, ears of wheat, field-flowers, and branches of roses, made of gauze, crêpe, cambric, muslin, or straw. The bonnet in fig. 18 and the headdress in fig. 17 will suffice to show the extremes to which trimming could be carried. The strings dangling from hats were more often than not left untied, or tied only loosely.

The toque or *beret* was simply a cap with a huge crown and no brim, made of silk or velvet to be worn outdoors (fig. 9c).

The materials used for hats, bonnets, turbans, and toques were straw, satin, silk, and plush. The plaid of fig. 9c is one of the few examples of patterned fabrics in millinery, though the bonnet-strings were not always plain.

Necks. In simple, conservative dress the fichu maintained a place (fig. 11). The prettiest daytime neck-finish (especially popular from about 1815 to 1820, though worn both before and after) was the ruff upon an open V or a high neck (figs. 9a and 10). It belongs especially to that transition period when sleeves were neither very large nor set very low on the shoulders. It was frequently accompanied by bretelles with deeply indented edges. After 1820, the " swan-neck " ideal being well established, high-necked dresses had fichus and turnover collars more often than ruffs. Yet in a way this pretty trimming was not lost but was put in the form of a ruching or a fluted collar at the top of guimpe or tucker (fig. 19). Fig. 18 illustrates one collar (fashionable from the early twenties into the thirties) described by its French sponsor either as *pelerine* or *canezou*. The terms are confusing, both being applied also to somewhat different articles; for the pelerine was a short separate cape deriving its name from the shoulder cape of the mediæval pilgrim (fig. 12), while the canazou was a sleeveless guimpe or large, shaped fichu, often of transparent muslin, worn *over* the bodice.

There were many low necks, following the lines fashionable during the First Empire. They were about equally low front and back, and (whether rounded, square, or slightly V-shaped in front) they all tended to drop over the point of the shoulder (figs. 12, 16, 17, 19). The taste of the times (at any rate among the upper classes) ran a little to extreme openness. In 1831 Fulke Greville ("Memoirs") says: "The Queen [Adelaide] is a prude, and will not let the ladies come *décolletées* to her parties. George IV, who liked ample expanses of that sort, would not let them be covered."

Fig. 14 shows a low neck with a lingering touch of Greek influence, elsewhere well-nigh lost—the bodice with a loose pleat in front, obviously inspired by the natural front fold of a *chiton* (Chap. III). The bodice sketched was taken from a fashion-plate of 1822, but the style may be traced over a period of several years. Fig. 17 shows a typical moderate décolletage of 1830,

when the bottle neck was nearly always emphasized by a bertha or ruffle extending over the shoulder.

Low-cut necks were not restricted to evening wear, day-gowns exposing the shoulders and bosom quite as often. With no sense of incongruity a long-sleeved dress would be made with very low neck (fig. 16). Sometimes an otherwise low neck was filled in by a tucker (fig. 15), a style to be traced, perhaps, to the Renaissance influence already mentioned. Fig. 15 shows one aspect of the revival in the corset and chemise bodice, pictured on a lady of the early twenties.

Bodies. Before 1825 not only corsets, but nipped-in corsets returned. The change was quickly effected. *Parisiennes* assembled to hail the Restoration of the Bourbons in 1815 still had short waists, not so much smaller than their busts and hips (figs. 10, 11, 13). Five years afterwards their round belts had dropped to nearly normal (figs. 12 and 14), and by 1824 the longish, slim, round waist, emphasized by a belt with a large buckle, was well established for the next five or nearly ten years (fig. 16). By 1830 the prestige of the round waistline was threatened by an occasional return to a pointed bodice, which was actually adopted in the late thirties.

Throughout the period the bodice was drop-shouldered and rather narrow-backed, made on a pattern which had two back-pieces (it opened in back), two underarm pieces at each side, two front pieces with a seam up the middle and a pair of darts at the side-fronts. This smooth-fitting bodice was sometimes left plain, its structural lines perhaps emphasized by cording (fig. 17); sometimes it was masked in part or wholly by a ruffle, bertha, or collar, and sometimes it was covered by an overdrapery across the front, shirred in the middle and puffed over the breasts (fig. 19). This last style may be seen in illustrations dating from 1820 to 1830, and is indeed only a development of the shirred bodice shown in fig. 16, Chap. XIV. In the late twenties another method of adding fullness came in, *i. e.*, with folds or pleats extending from the dropped shoulder line to a V at the belt, both front and back.

Until 1825 and sometimes later if skirt and bodice were in different colors, the *bodice* was the darker; but occasionally after 1825 one wore a white or light bodice with a dark skirt—a combination thought especially appropriate for seaside excursions.

Arms. From 1815 to 1820 short sleeves were puffed at the top (figs. 14 and 15) and not unduly large; long sleeves were either tubular (figs. 11 and 13), of a smallish leg-o'-mutton shape (fig. 10), or else made with a puff and a long extension of the same or contrasting material (fig. 12). Between 1820 and 1830 the dropped shoulder was increasingly emphasized, and the sleeves, expanding from a point at the biceps, grew more and more balloon-like. Of course even as late as 1830 plenty of women still wore the small puff and extension (fig. 16) or the moderate leg-o'-mutton (fig. 19), but the modish went in for width. Often the sleeve was held in graduated puffs, ending in a tight and rather wide cuff; again it sloped smoothly down to a cuff finished

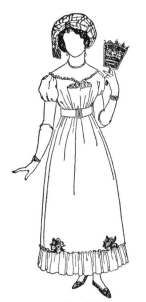

FIG. 14.
Dress with a "Greek"
neck; an evening turban,
1822-23.

FIG. 12.
Lady in spencer and
pelerine, 1818-1825.

FIG. 15.
Evening dress of Renais-
sance inspiration, 1820-
1825.

FIG. 11.
An English housewife,
about 1816 to 1820.

FIG. 13.
A pelisse and leghorn hat.
1818-1820.

with some rows of trimming over the hand (fig. 18). Sleeves for evening were puffed and extended about half-way down the upper arm, to be finished by simple bands or small frills. Long sleeves with evening frocks sometimes consisted of a puff of the dress material veiled by full, long gauze sleeves gathered in at the wrists. Again, the silk puff was continued by medium-sized transparent sleeves.

Legs. By 1815 skirts had already begun to be definitely wider at bottom than at top, the fullness obtained sometimes by gathers, sometimes by gores (fig. 22, Chap. XIV). Although during the succeeding years fairly scant skirts were still to be seen (figs. 10 and 13), on the whole the width increased. In 1820 the skirt was fairly small over the hips but expanded at the hem to a circumference of about two and a half yards (figs. 12 and 14); by 1830 its width was half again as great (figs. 16 and 17). With the increasing width, some fullness was introduced at the waistline, pretty largely concentrated at the back, though the skirt was still gored to preserve a top scant compared to the wide hem (figs. 16 and 17). Quilted cotton petticoats, heavily starched, with other petticoats on top, held out the fullness.

Not since primitive times had so many European women worn short skirts: ladies, too, not menials. Almost nobody's dress touched the floor, day-gowns fluctuated between instep and ankle length, and dance-dresses were often shorter (fig. 22, Chap. XIV). By some extremists the wide skirts of 1828-'30 were shortened to the calf, and a very ugly silhouette resulted. The only trailing garment was the court-train or mantle, still obligatory for presentations; it was put on separate, over the ball-dress, as explained in Chap. XIV.

During the entire period the principal trimming on skirts was placed below the knees, though sometimes it went up the front also. At first taking the form of fairly flat appliquéd bands, wreaths, festoons, small ruchings, or shirred strips (fig. 10), it soon went into real flounces, one or two from the hem up, which broke the short skirt into horizontal lines, thus adding to the apparent width (figs. 14, 15, 16, 17).

Feet. Flat heels were still omnipresent. House slippers, the tiny, soft affairs described in Chap. XIV, were made (sometimes at home) of kid, silk, or satin, in black, white, and colors. Their toes, before 1820 usually pointed (fig. 14), later were often round or even square (fig. 15). Slippers had, for ornament, tiny bows at the top and sometimes embroidery (fig. 15), and for service, ribbons to tie around the ankle (figs. 10, 16, and 17).

After about 1820 ankle-boots or shoes became popular for outdoors. They were nearly as soft as the slippers and were fastened by lacings up the *inside* of the ankle. A strip of kid went up the instep, and the toe and heel were sometimes of the same kid, darker than the upper, cloth part (fig. 18). Stockings were invariably white or light-colored.

Outer Garments. The spencer, that little jacket described in Chap. XIV, continued to be popular. One might classify it with bodices, except that it was always put on over a dress, often for outdoors. As a rule it was darker than

the dress. Fig. 12 shows the shape of these jackets during the period under discussion. Many were high-necked (fig. 15, Chap. XIV); some, even though cut low, were worn on the street with a pelerine of fur or silk (fig. 12). The pelerine was, as may be seen, a tiny shoulder cape, often, though not necessarily, of fur. Ermine, by the way, was a fashionable pelt; since the mediæval class distinctions no longer held, any woman wore it who could afford the expense.

The shaped scarf or *mantelette* shown in fig. 16, Chap. XIV, was still popular, grown wider on the shoulders as the style demanded. It covered the back almost like a jacket and descended to the knees in front, being sloped off narrow from the shoulders down. It came in all sorts of materials, from muslin or silk with lace flounces to fur.

The *pelisse* was a long cloth or silk coat, almost a second dress, save that it was open up the front (figs. 13 and 18). Among other enveloping wraps were large capes falling to a little below the knee; they were often topped by additional shoulder-capes or pelerines, the whole garment edged with fur.

The long, thin fur boa, noted but not pictured in Chap. XIV, is often illustrated in the fashion notes of 1830 and thereabouts. It was made up with an animal's tail at one end, a head at the other, the jaws clasping the tail for fastening. It was as much as three yards long and worn as pictured (fig. 18).

Long, fairly narrow scarves were still draped over any sort of dress (figs. 10 and 19), but their popularity was already shared by a larger shawl (fig. 13, Chap. XVI). Still, this large, diagonally-folded square enveloping the shoulders could not be displayed at its best until the fifties, when big sleeves no longer interfered with the draping. Long or square, the shawls were mostly decorated in oriental designs, which had been modish since the beginning of the century and were now to be had at less trouble and somewhat less expense. In 1820 factories at Paisley, Scotland (as well as others in France), began to turn out shawls in the designs which we still designate as " Paisley " (fig. 11, Chap. XVI).

EQUESTRIENNE

Riding-habits still combined the current fashions in masculine and feminine dress. The fad for military braiding which held over from Waterloo till about 1818 found excellent scope in the tailored habit. In 1817, for instance, a fashionable model consisted of a high-waisted, gored but still full skirt, with a bodice braided all across the front, and over that a plain-sleeved, tailless, tight jacket, also braided, with high military collar and epaulettes. With it went a mannish neckcloth. Pumps with bows were worn with this habit, and a high-crowned cap with plumes rising high in front, like the cap shown in fig. 23, Chap. XIV. This was named the " Glengarry " habit, for its hat was covered with a tartan plaid.

About ten years after, in 1828–30, the ladies' magazines were recommending another habit. This costume of " Clarence Blue " (a bright, strong color) had

a close-fitting bodice, but no jacket, a ruff, a narrow-brimmed top hat, and a veil. Its waistline was lower and much tighter, its skirt full around the hips and very long, its sleeves leg-o'-mutton in the mode. Colors suggested for riding-habits were rather like those for men's coats, though brighter tones were also fashionable. Purple was one of the popular hues at this period as well as later.

CHILDREN

Till 1825 or thereabouts children dressed a good deal as they had done earlier (fig. 24, Chap. XIV). Pantalettes, mostly tubular, sometimes tied in and ruffled at the ankle, were now worn by little girls as well as boys (Chap. XIV) under the skirts of their knee- or calf-length frocks. Girls of ten or over were put into longer skirts with no visible pantalettes. Older boys went into pantaloons, fairly tight, ankle-length, *not* strapped under the foot; and upper garments like a girl's bodice (frilled or wide-collared). Some boys wore short jackets, either double or single-breasted, often left unbuttoned. Such jackets were worn over a shirt with wide collar. The long waist of the " bodice " in fig. 19 proclaims the costume to be of the later twenties or even as late as 1830.

From 1825 to 1840 taste in children's dress, as in their elders', degenerated. Little girls were done up to resemble their mothers, in wide-skirted, fussy frocks. Their skirts were shortened to the calf, and from there tubular pantalettes covered the legs to the ankles (fig. 6). Their bonnets and hats were trimmed with ribbons and flowers in a profusion imitating the atrocities of adult millinery.

By the thirties many younger boys were wearing that tunic which continued for a long time to be the standard garment for lads up to seven or eight years of age (fig. 20), a costume familiar to readers of " Strewelpeter " (" Slovenly Peter "). The boy in fig. 20 has on a fashionable velvet beret or tam-o'-shanter reminiscent of early sixteenth century hats (Chap. VIII).

Somewhat older boys often wore instead of the tunic suits much like older people's, with the important exception of the jacket, which was as short as that pictured in fig. 20, or even shorter, after the style we name " Eton," because ever since then it has been part of an Etonian's uniform. Boys might wrap their throats up in stocks and high collars, but they might also follow the more comfortable fashion of open shirt-collars. The visored cap pictured in fig. 20 was a boy's everyday head-covering, but when he was really dressed up, like his father he donned a high hat (again, a style continued at Eton).

MATERIAL

Men. In masculine dress fur was favored by some of the luxuriously inclined. Not only overcoats, but occasionally tail coats, too, were trimmed with sable or some less precious pelt, upon the collar, the cuffs, and even upon the front edges. Velvet collars were put upon both dress coats and overcoats; cut-velvet was made up into evening waistcoats. Waistcoats were even more fre-

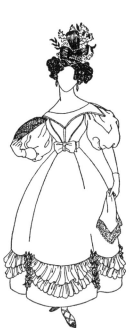
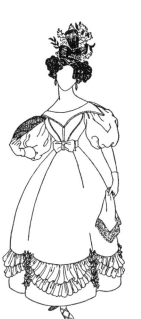

FIG. 16.
A "half-dress," 1826-1828.
Note the comb in the lady's
hair.

FIG. 18.
Bonnet and pelisse, c.
1830. Note the narrow
fur boa, stylish also dur-
ing the preceding period.

FIG. 17.
A ball costume, 1828-1830.
This type of headdress may
be seen on portrait minia-
tures of the period.

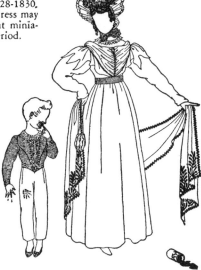

FIG. 20.
Brothers, 1830-1840. The smaller boy
wears a beret of the period.

FIG. 19.
Morning-dress and cap, c. 1830.

quently made of figured and embroidered satin, or striped, flowered, or plaided silk, if they were not cashmere or white marseilles.

Coats were ordinarily made of broadcloth, though sports coats were of rougher fabrics. Common folk wore homespun woolens and " linsey-woolsey," a mixed goods. In hot climates entire suits were made of white linen or nankeen, a cotton material originally imported from China.

Pantaloons were of nankeen, drill, " cord," or " moleskin," (see glossary) a common enough material, which in darker colors was worn by the lower classes as well as the gentry. Until after 1830 evening pantaloons, being nearly skin-tight, were fashioned of wool or silk jersey or " kerseymere."

Men's top hats were usually beaver, their lower-crowned hats felt, and their caps, cloth. The beaver was rather long-haired and fuzzy, quite unlike the later glossy brushed beaver; it was more often light-colored than black.

Women. A great number of women's dresses were made of light-weight cotton fabrics such as muslin, chintz, and calico for house dresses and gauze over silk slips for party-frocks. At the same time, heavier materials were not lacking, and silk, satin, taffeta, and even velvet were made up into entire dresses as well as coats, capes, spencers, pelisses, and mantelettes. " Half-dress " (not party costumes, but still slightly formal) was frequently made up in merino (a fine woolen, rather like wool-crêpe) or cashmere, if not in some darker-toned silk. Outer coats and riding-habits were most often of woolen goods.

Hats were of straw (fine leghorn or Milan, in the natural tan or yellow), gauze, crêpe, sarsanet (cambric), muslin, velvet, plush, satin; they were trimmed with flowers of similar materials, with chenille, ribbons (taffeta or satin), or with ostrich plumes, sometimes curled, sometimes straight.

Children. Small children of either sex as well as older girls wore muslin, with woolen extras for warmth; boys wore woolens and a good deal of nankeen in its natural buff-color.

COLORS

Men. The colors of men's coats included black, brown, blue (both deep and bright or " king's blue "), bottle-green, olive-green, " sea-pine " green, plum, chestnut, " London smoke " and gray-brown. The smartest color for evening coats was blue, with brown running a close second, and green allowed; but as late as the later twenties at summer soirées coats were light-toned, in such charming pale shades as sky-blue and spring-bud green.

For evening, pantaloons were dark gray or black (with blue coats) but for daytime they were usually light: white, cream, tan, fawn, buff, and light or dark gray. Waistcoats and cravats, other than black or white, were cream, jonquil-yellow, buff, " bread "-brown, sky-blue, " flora " blue, and royal blue.

Women. In the light materials favorite colors included rose, celestial and lapis blue, cream, buff, yellow, pale green, dove-gray and lavender-gray; in heavier fabrics, made up for " half-dress " and outdoor wraps, nut-brown, bottle-green, gray-lilac, and " amaranth " (purple). During the thirties and a

little earlier rather violent color combinations, such as yellow piped with green, and black flowers on a red ground, were considered smart.

Children. Girls and small children were still dressed principally in white and " pastel " shades, enlivened by brighter sashes and shoulder knots. Older boys wore darker colors, in imitation of their fathers.

MOTIFS

The influence of Antiquity lingered in the motifs applied to women's costume; long after the Greek tunic dress was outmoded the " Greek key " would recur, often incongruously in company with realistic flowers. Patterned fabrics were on the whole less in demand than plain; still, there were plenty of all-over designs to choose from. Floral motifs and leaf-forms were popular. " Pompadour " patterns, *i. e.,* realistic roses, were woven on ribbons for hats and sashes. Cottons were dotted with flower, leaf, or abstract (usually Persian) motifs, often so tiny that at a short distance the pattern merges into one tone. About 1825 larger patterns began to be printed on dress goods. The beautiful oriental designs woven in Paisley shawls were large, also. Throughout the periods stripes were worn in cotton and silk, and from the twenties plaids began to be popular, for both dresses and toques. The pantaloons shown in fig. 20 are a forerunner of many plaid trousers on Victorian boys and their fathers, too.

APPLICATION OF DECORATION

In men's dress, decoration was limited to a restrained edge of embroidery upon the waistcoat, to velvet collars, and to the buttons which appeared on coat, waistcoat, and the ankles of tight pantaloons (fig. 1). Such buttons were large on coats, small on waistcoats and pantaloons; brass for ordinary folk, gold for dandies (or on coat and waistcoat, mother-of-pearl).

Upon women's costumes ornamentation was lavishly applied. Ball dresses were embellished with appliquéd leaves, flowers, ribbons, " cupid's wings," roses, and tuberoses, cut from plush or silk and arranged in rows, festoons, or wreaths upon the lower halves of skirts. Circles and festoons were made of silk puffings (fig. 22, Chap. XIV), and bands around the skirt of the same puffing, but wider. Flounces were arranged either in festoons (fig. 17) or straight around; they might be narrow or wide, and put on singly or in groups of two or three. Toward the latter part of the time clusters of tucks were added to the flounces. Much of this trimming was of the dress material in the same or a contrasting color. With muslin dresses went sashes and belts of silk, satin, or taffeta. Upon broad belts of grosgrain ribbon designs were sometimes embroidered in fine cross-stitch or needlepoint. Such belts were clasped with large buckles of steel, silver, or even gold and jewels.

Trimming upon bodices resembled that upon skirts. Braiding in the military style was also popular, especially in the earlier years of the period. It was applied to high standing collars, to cuffs, and across the fronts of smooth bodices.

Black upon a light background was the customary combination. Berthas and fichus were, as usual, dainty white affairs of fine muslin and lace. A deeply indented edge, admired throughout the period for collars and bretelles, was sometimes of lace, sometimes cut out of the muslin collar and buttonhole-stitched. Berthas and pleated edges inside the décolletage, made entirely of lace, were becoming as well as fashionable. The caps illustrated were concocted from muslin, lace, and flowers. Artificial flowers adorned elaborate evening coiffures as well as caps, hats, and sometimes dresses.

JEWELRY

Men displayed rings, watches with heavy seals (but now singly more often than in pairs), shirt-studs of gold or coral, and occasionally a diamond pin stuck in the shirt frill. Official decorations like the ribbon and badge of an order followed the fashions described in Chaps. XIII and XIV.

Women's jewelry was often profuse and usually heavy. Long drop earrings (fig. 9b) were favorites with some; others preferred lighter drops or even ear-studs. Long chains were looped around the throat; from them occasionally hung crosses, apparently with no religious significance (fig. 16), an ornament which returns to style from time to time. Watches upon the ends of long chains were pinned at the belt. About this time cameos began to be more accessible to women of modest means, being cut from shell as well as from the more precious and difficult stone. They were especially popular in brooches, for a brooch was a trinket possessed by nearly every woman and almost constantly employed to fasten collars at the throat (fig. 19) or to ornament the fronts of low-cut bodices. Some women possessed cameos in sets, earrings, brooch, and perhaps a pair of bracelets. Bracelets had never been more popular. Women put them on over the wrists of long sleeves and outside long gloves (fig. 14). (Some also displayed their rings outside their evening gloves.) Jewelled ornaments, including combs, pins, and diadems, graced a lady's evening coiffure. Various accessories of wealthy women were jewelled.

ACCESSORIES

Men. Among a gentleman's accessories the quizzing-glass (fig. 1) was now as omnipresent as the snuff-box formerly. A rectangular shape was popular, in a fairly large size, *i. e.,* about two and a half inches by one inch, on a six-inch handle; this size made it possible to stare through the glass held at arm's length (a fashionable gesture), instead of investigating the subject closely, as our gentleman happens to be doing. The boutonnière, often a rosebud, was another very important touch to a dandy's costume. When wrist-ruffs went out, gloves returned to style ; gentlemen wore them always for walking and riding, and in what seem very unsuitable colors, such as lilac and yellow.

Women. Gloves were even more indispensable to the ladies, short gloves with long sleeves, longer gloves with short sleeves. White was preferred, though with street dress pale colors were permissible. Occasionally the tops of

evening gloves were ornamented (fig. 22, Chap. XIV), but they were more often left plain. After about 1812 the gloves worn with short sleeves began to be shorter (fig. 22, Chap. XIV). The length illustrated, or a trifle shorter, which is called three-quarter, remained modish till the end of the thirties. The materials for gloves (or the equally popular half-gloves or mitts, fig. 15) were kid, silk, and lace. Especially during the twenties women were so devoted to their gloves or mitts that they retained them even at dinner and while playing the harp.

Almost equally necessary in an evening toilette was the fan. Though the small folding type (fig. 15) was common, rigid varieties were also in evidence, that shown in fig. 14 being a fashionable choice in 1823.

Muffs continued to be very large (fig. 19, Chap. XIV) until 1830, when suddenly they grew much smaller and round.

Parasols, at this time carried right side up, i. e., by the handle, had longer handles and also longer points (fig. 13). But fashions changed from year to year: this long type belongs to the year 1825, another (fig. 12), dated a few years earlier, harks back to eighteenth century shapes; toward the thirties, while long handles were still in vogue, parasols themselves were much smaller in span. At that time, also, came up the recurrent fad for animal heads on handles; this time a small head at the end of a crook. Many women undoubtedly used the same sunshade till it wore out, regardless of the fluctuations of fashion.

Reticules were everywhere, and made in almost every conceivable style. For example: one bag of about 1816 had a rigid handle; another, carried in 1818, was stiff and circular, with a flounce around the bottom, a tassel on the under edge (fig. 12). A large reticule of the thirties was very like a modern purse, with a flap and a lock; another of the same years was netted and pulled up on a drawstring, and still another was just a large bag (fig. 13). Many women carried small netted miser-purses (fig. 18, Chap XIII) in their hands or tucked into their belts. In "bandboxes," small or large according to necessity, ladies carried their caps to parties, putting them on when they took off their bonnets.

SOMETHING ABOUT THE SETTING

In interior decoration the heavy taste of the Napoleonic court continued to rule the period of the Restoration in France and the corresponding "Regency" period in England. After 1820 particularly the eclectic character of nineteenth century art was evident in its furniture. So was an increasing desire for comfort, which was particularly recognized and catered to in Germany during the early eighteen-twenties. The style then crystallized is known as "Biedermeier," distinguished by such details as heavy, festooned draperies, dark and heavy table-covers, and amply proportioned padded furniture, upholstered in tufted satin and protected by antimacassars. In English designs the new Gothic contended with copies from the antique. Little harmoniums like the seraphina survived in many households; to others came the "cottage organ," enriching the

artistic life of the home circle. Grant that rooms of the Romantic and Bieder-meier period were more than a bit stuffy, with unnecessarily heavy draperies and too much furniture; nevertheless they were homelike, and as to the fur-niture, it was honestly made of solid, handsome wood, and much that survives is charming.

Architecture preserved a Georgian flavor, especially in America, where in smaller towns and cities well-designed houses and public buildings remind us pleasantly of the early years of our national life.

PRACTICAL REPRODUCTION

Materials. See this section, Chap. XIV. Men's clothes, with the exception of garments supposed to be worn in hot climates, should be of wool. Add rich-ness as you wish with velvet collars and silk waistcoats.

Of the fabrics enumerated as suitable for women's dresses you may use rather more sturdy and opaque sorts than you would in costuming the previous period. You may put in some chintzes of larger patterns, as well as small sprigged dimities. Be on the lookout for old-fashioned calico in dark blue and a kind of liver-color, spotted with tiny flowers; both the colors and the texture are excellent for simple dresses. To represent merino or cashmere use cheap, loose-woven unbleached muslin, dyed and rough-dried. If real fur is not avail-able for trimming you can do very well with fur-fabric or plush. To make ermine, sew tails of black velveteen about two inches long upon white plush, leaving the ends loose.

Trimmings. See this section, Chap. XIV.

JEWELRY AND ACCESSORIES

Men. See this section, Chap. XIV. Make the cravat of fig. 1 with the usual band fastening at the back, to which add, in front, a loop holding in place a diamond-shaped piece of doubled, heavily starched muslin, or muslin interlined with buckram. Bone the cravats of figs. 2, 3, and 4 at sides and back. Interline the second, folded-over cravat of fig. 4 with muslin or crinoline, shape it nar-rower at back than front, and adjust by simply folding one end over the other.

Women. Try to borrow a long-handled parasol or umbrella like that shown in fig. 13; they were common enough fifteen or twenty years ago. If you cannot find a pagoda-shaped parasol (fig. 12), see Chap. XII for the way to imitate it; the style has been revived in recent years. Make the fan shown in fig. 14 of a wire frame covered with paper or silk and paint a design on it. If you take from a large sieve its detachable handle and frame, you can easily bend the frame to the right shape.

MILLINERY

Men. To make top hats, see this section, Chap. XIV. For the type shown in fig. 1 you can use a modern or somewhat out-of-date silk hat; those sketched in figs. 3, 4, 5, and 6 you can reblock from felt (Chap. XX). To imitate the

style shown in fig. 2, follow the directions which come with an " Uncle Sam " pattern, but cover with dull-finished cloth, *not* sateen. As to that, you can probably rent hats of the styles shown in figs. 2, 3, and 5.

Women. To make a mob-cap, see this section, Chap. XII; to make bonnets and hats, Chap. XIV. For the elaborate structure shown in fig. 19, start with a baby-bonnet as a foundation, make the upstanding part of lace-edged batiste or even pinked tarlatan, pleated, and trim it with pleated ribbon. Use a skull-cap as foundation for the turbans (figs. 9b and 14) and the berets (figs. 9c and 20). If you put a crinoline interlining in the berets, the puffs will stay up. For 9c twist the cloth over a roll of cotton-covered wire and hold up the top-knot on more wire with curls in the middle and a braided switch around, as pictured. The length of the wearer's own hair does not matter, so it be parted in the middle. Extra switches or curls will take care of the other coiffures. If you can afford it, rent a wig to imitate the elaborate coiffure shown in fig. 17; good wig-makers do this sort of thing well. However, if you must manage it yourself, dress the actress's hair in sausage curls at the sides and if her hair is long pull the back part up and pin it on top. Dress a switch over loops of silk-covered wire, hold it together securely with elastic bands, and add the decorations. Pin the whole structure firmly to the topknot. If the actress has short hair, put a ribbon around her head under the curls and pin the false hair to that. As a matter of fact, though the historian must record this headdress as having indisputably existed, the stage costumer will consider carefully before she sends an actress on the boards in such an unusual top-knot.

SHOES

See Chaps. XX and XI for constructing boots and Chap. XIV for adapting pumps and slippers. Trim pumps with small ribbon bows, not buckles. If you choose, you may hold ladies' slippers on with elastic straps across the instep, instead of with crossed ribbons. Black elastic-sided house-slippers are best for men to wear with strapped trousers; but if you must use laced shoes bring the trousers as far over the insteps as possible. Represent the lady's high shoes (fig. 18) thus: cut away felt or kid bedroom slippers, leaving heel, toe-cap, and about an inch at the sides. Put them on over heavy cotton socks and sew securely along the edges of the slipper. Sew a line of material matching the slipper up the front and around the top (where it will cover an elastic used to hold the sock up). The sock may be white, light-colored, or dark, the slipper black or dark brown. Persuade the actresses to wear something heelless, otherwise the whole effect of the costume will be spoiled.

RENTING

See this section, Chap. XII, for opinions about renting the men's suits. For this period costumers can do pretty well by you, especially with garments of the type shown in figs. 1 and 4, and with hats, as noted above. It is, as always, more satisfactory to make a personal selection.

CUTTING THE GARMENTS

Men. It is possible to fake coats like those of figs. 1 and 4 with modern tail coats, if you can be content with black. You will have to sacrifice the gathered sleeve, but you can manage to put on a higher velvet collar and bright buttons. Though not really accurate, it will pass. A bright waistcoat and proper pantaloons will help.

See this section Chap. XIV for making coats and trousers. Use the " Uncle Sam " pattern to cut the coats of figs. 1 and 4, the " Continental " for those of figs. 2, 3, 5, and 6, adding proper lapels and collars, modified from the " Uncle Sam," and cutting the skirts fuller and longer as the sketches indicate. In following either pattern, you will have to change the sleeve a little, by inserting fullness in the center (fold on the straight of the goods) and by cutting the top curve higher. You will also find it necessary to shape the coat closer, by taking in at the underarm seams and by making darts at side-fronts and side-backs.

For the pantaloons represented in figs. 1 and 3, use tights (see Chap. XIV). To simulate the smalls (fig. 3) put a narrow braid around the legs of the tights below the knee and a row of buttons above the braid up the outside of the leg. To cut the other pantaloons follow the " Uncle Sam " pattern, adding fullness for fig. 2. Use wide elastic for straps. Be sure to provide suspenders and buttons with all trousers.

Use a modern dressing-gown pattern for the coat of fig. 7, pajama pattern for the trousers. Use either the " Uncle Sam " or the " Continental " pattern to cut the waistcoats, changing the collars and the lower edges. Cut the cape (fig. 1) thus: make a deep yoke with a seam on the shoulder, upon which gather straight widths of material; add a high rolling collar, interlined with crinoline.

Make the smock (fig. 8) on a modern smock pattern with a yoke, but allow extra material in the width of both sleeves and body. It is not necessary to smock it, but you must hold down the fullness with machine-shirring, to the depth pictured. Cut the gaiters of canvas, dyed leather-color. Make a seam front and back and hook or zipper up the outside, adding plain black buttons to simulate the original fastening.

Women. See Chap. XIV for cutting women's bodices, coats, and spencers. Backs should be narrow, but the diamond shape is no longer necessary. It is satisfactory enough to make all these tight bodies by the fitted lining pattern (Chap. XX), and to simulate the curved front and back seams (fig. 17) with pipings or bias bands. To reproduce the bodice shown in fig. 14, cut a tight front as usual; then cut a second front made of a straight piece shaped into the armseye and underarm seam; fold this in a box-pleat in front, gather it into the waistline, and fasten to the fitted bodice. Tack it to the bodice under the box-pleat. To represent the style shown in fig. 19, make a circular bertha about the same depth front and back, cut pointed over the shoulders; attach

to the top of the tight bodice. Take a straight piece deep enough to wrinkle and stitch it with an inside seam to the neckline of the bodice, over the bertha. Shirr up on the shoulders and in center front and back and put a line of trimming over the shirring. Open it in back under the trimming. Put the same trimming on the loose lower edge if you wish. Cut the bodice of fig. 15 like a little corset, boned, and laced over a full blouse with a drawstring in the neck. For figs. 10 and 18, fill in above the décolletage by a guimpe with fluted collar.

The sleeves of figs. 11 and 13 can be cut by the pattern that comes with the fitted bodice, if a little more fullness is allowed. Use the same pattern for figs. 12 and 16 and put puffed sleeves on top. For figs. 10, 18, and 19 use a leg-o'-mutton pattern, cutting it small for figs. 10 and 19, large for fig. 18 (interline this sleeve, too). On fig. 10 add an extra cap, cut by the same pattern, but left loose at the lower edge and gathered a little into the under-arm seam.

The skirts pictured in figs. 10, 13, 14, 15, 18, and 19 are straight gathered; those in figs. 11, 12, 16, and 17, four, five, or eight gored, according to the width. Add a straight flounce to the gored skirt of fig. 16. Provide petticoats to go under all dresses; except for figs. 10 and 11 they should be heavy and stiffly starched. Figs. 16 and 17 in particular need full stiff supports. For these it is well to make crinoline petticoats, gored to match the outer skirts and covered with muslin petticoats of the same shape.

Children. See this section, Chap. XIII, for advice about making boy's trousers. Cut the small boy's tunic (fig. 20) with a fitted body and a gathered skirt, the joining covered by a stitched belt. You can make pantalettes (figs. 6 and 20) by adding tubular legs to the child's own underdrawers. Make the jacket in fig. 20 by any jacket pattern, tightening it at the underarm seam and (with darts) front and back. Make the girl's bodice (fig. 6) and the boy's (fig. 19), too, by any juvenile pattern and shape it on the child by means of darts. Simulate the lines of the original seams with trimming as suggested above under *Women.*

Suggested Reading List *
(See this section, Chap. XIV.)
It is Vol. II of McClellan (op. cit.) which deals with the nineteenth century. Add to the list:

Le Luxe Français—By Henry Buchot, Vol. II, "La Restauration."
English Children's Costume—By Iris Brooke and James Laver.

Where Further Illustrative Material May Be Found
(See this section, Chap. XIV.)
Portraits by Ingres, Raeburn, and Lawrence, and by other English and American artists listed at the beginning of this chapter, are usually good sources for costume information. Examples may be seen in many museums. A few illustrations by George Cruikshank belong to this period, more to the Victorian era. There are a great many pictures by

* Couts, Joseph, *A Practical Guide for the Tailor's Cutting Room* (1848). A few of his patterns are recharted in *Period Patterns.*

artists whose names mean little to us now, but whose often second-rate works make the best of references for the costumer. Their pictures are preserved in large and small galleries, in the houses of those persons whose ancestors are portrayed, and in the form of engravings reproduced in various periodicals old and new (see bibliography). Miniature portraits abounded during the years just before the daguerreotype and a great many of them may be seen in museums and among family heirlooms. Illustrations in books and periodicals are especially useful to the costumer, since people of all sorts and conditions are represented in their appropriate dress.

A good many actual garments have been saved from the early nineteenth century, not alone in museums but in the attics of those who still *have* attics. In short, with a seeing eye you can hardly fail to encounter and recognize costumes of the Romantic Era.

Sources of Sketches in This Chapter

For the details which have gone into the accompanying sketches we have drawn upon the following sources:

Portraits by Lawrence and Ingres in the National Gallery and elsewhere; a portrait of Lafayette by Samuel F. B. Morse made during the Marquis's last visit to America; a number of portraits of once-fashionable or heroic Englishmen and women, by once-popular painters, engraved for and reproduced in the *Lady's Magazine;* fashion-plates, both English and French, in some of the publications listed in the bibliography and particularly in *The Gentleman's Magazine;* engravings of sentimental and topical subjects, notably an illustration of a scene in Irving's " Sketch Book " (*Lady's Magazine*) and " Le Rétour du Roi," a French picture; a number of engravings dated 1829–1833, used to illustrate an article on early motor vehicles, published in *The Connoisseur* for August, 1905; actual costumes in the Victoria and Albert Museum, the Metropolitan Museum, the Museum of the City of New York; the portrait of a small boy in the latter museum; and family portraits belonging to the author and her friends. Contemporary texts and modern biographies have backed up the evidence of pictures. The construction of many of the garments has been studied from actual specimens.

Chapter XVI
CRINOLINE

DATES:

1840–1865

••

Some Important Events and Names

ENGLAND	FRANCE	AMERICA	ITALY	PRUSSIA
Victoria, r. 1837–1901 m. (1840) Albert of Saxe- Coburg-Gotha	Louis Philippe, r. to 1848 Second Republic, 1848–1852	PRESIDENTS Martin Van Buren, 1837–1841 Wm. Henry Harri- son, 1841, 1 month	Victor Emmanuel II of Sardinia, 1820–1878 King of United Italy, 1861	Frederick William II r. 1840–1861 Rebellion, 1848
Edward, Prince of Wales, m. (1863) Alexandra of Denmark	Second Empire, (Napoleon III) 1852–1870 m. (1853) Eugénie de Montijo	John Tyler, 1841–1845 James K. Polk, 1845–1849 Zachary Taylor, 1849–1850 Millard Fillmore, 1850–1853	Cavour, 1810–1861 Garibaldi, 1807–1882	PAINTER Franz Winterhalter, 1806–1873 Court painter also in England and France
STATESMEN Gladstone, 1809–1898 Disraeli, 1804–1881	PAINTERS Millet, 1814–1875 Courbet, 1819–1877 (painted peasants) Delacroix, d. 1863 Chasseriau, 1819–1856 Manet, 1832–1888	Franklin Pierce, 1853–1857 James Buchanan, 1857–1861 Abraham Lincoln, 1861–1865		
Exhibition at the Crystal Palace, 1851 Crimean War, 1853–1856	NOVELISTS Balzac, d. 1850	Mexican War, 1846–1848 Annexation of California, 1848 The Gold Rush, 1849		
Florence Nightingale, "Angel of the Crimea," "Lady with the Lamp," 1820–1910	Hugo, d. 1885 "Les Miserables," 1862 Dumas, père, d. 1870 "Three Musketeers," 1844	Panic of 1857 Civil War, 1861–1865 Clara Barton, 1821–1912 (Founder of Red Cross)		
Sepoy Rebellion, 1857, resulting in English Sovereignty in India	Flaubert, 1821–1880 "Madame Bovary," 1857	WRITERS James Fenimore Cooper, 1789–1851		
WRITERS Dickens, d. 1870 "David Copper- field," 1850	Dumas, fils, 1824–1890	Edgar Allan Poe, 1809–1849 Henry W. Long- fellow, 1807–1882		
Thackeray, d. 1863 "Vanity Fair," 1848	DRAMATIST A. E. Scribe, d. 1861	Nathaniel Haw- thorne, 1804–1864 Ralph Waldo Emer- son, 1803–1882		
Charlotte Brontë, 1816–1854 "Jane Eyre," 1847		Walt Whitman, 1819–1892 Herman Melville, 1819–1891		
Emily Brontë, 1818–1848 "Wuthering Heights," 1846		Harriet Beecher Stowe, 1811–1896 "Uncle Tom's Cabin," 1852		
Mrs. Gaskell, 1810–1865 "Cranford," 1853 (earlier date for action)		Louisa M. Alcott, 1832–1888 ("Little Women," 1868; set a bit earlier)		

Some Important Events and Names

ENGLAND
(Continued)

George Eliot,
1819–1880
"Adam Bede,"
1859

George Meredith,
1828–1909
"Ordeal of
Richard Feverel,"
1859

Lewis Carroll,
1832–1898
"Alice in Won-
derland," 1865

Alfred, Lord
Tennyson,
1809–1892

Robert Browning,
1812–1889
Elizabeth Barrett
Browning,
1806–1861
Their Marriage,
1846

ARTISTS

Pre-Raphaelite
Brotherhood, 1848:
Dante Gabriel
Rossetti, 1828–1882

Holman Hunt,
1827–1910

John Millais,
1829–1896

William Morris,
1834–1896

Edward Burne-
Jones, 1833–1898

George Du Maurier,
1834–1896
first illustrations
for "Punch," 1860

George Cruik-
shank, d. 1878
illustrated
"Oliver Twist"

John Leech,
1817–1864, with
"Punch" from
1841, illustrated
Dickens'
"Christmas Carol."

PLAYWRIGHTS

Tom Taylor,
1817–1880

Tom Robertson,
1829–1871
("cup and saucer
comedy")

AMERICA
(Continued)

CARTOONIST

Thomas Nast,
1840–1902
illustrated for
Harper's Weekly
from 1858

ACTORS

Charlotte Cushman,
1816–1876
Joseph Jefferson
1829–1905
"Rip Van
Winkle," 1857

Some Plays to Be Costumed in the Period

Anna Cora Mowatt's "Fashion" (1845).
Gerhardt Hauptmann's "The Weavers, a Drama of the Forties."
Alexandre Dumas, fils, "La Dame Aux Camélias," (Camille), 1849.
Arthur Wing Pinero's "Trelawney of the Wells" (early sixties).
Tom Taylor's "Our American Cousin" (1858), "Ticket of Leave Man" (1863).
Dion Boucicault's "London Assurance" (1841), "The Streets of New York" (1857), "The Octoroon" (1859).
Turgeniev's "A Month in the Country" (the fifties).

Du Maurier's "Peter Ibbetson."
Arnold Bennett's and Edward Knoblock's "Milestones," Act I, 1860.
John Drinkwater's "Abraham Lincoln."
Rudolph Besier's "The Barretts of Wimpole Street."
Tom Robertson's "Society," 1865.
Austin Strong's "The Drums of Oude" (Sepoy Rebellion, 1857).
Dramatizations of "Uncle Tom's Cabin."
J. M. Barrie's "The Little Minister" (action c. 1840).
Plays about the Brontës (in the forties and fifties).

CRINOLINE

EUROPE and America were well embarked upon a century of wealth, material progress, scientific progress, educational improvement, social reform, democratic experiments, communist experiments, religious experiments, agnosticism, transcendentalism, pragmatism, and imperialism. According to the individual's private bias he was living in a glorious age, a sordid age; his civilization was marching toward the millennium, was headed for destruction. In retrospect there is the same difference of opinion.

If you regard this as the Early Victorian era, you are likely to hold with many writers that it was all too godly, too serious, too stuffy, in short, too closely modelled upon " the home life of our dear Queen." If, on the other hand, you think of it as the period of the Second Empire, you may decide that, take it all together, it was vulgar, ostentatious, corrupt, and vicious. In either case you will be right; right, too, if you look back upon the time as hopeful, courageous, idealistic, honest, merry, and compassionate.

England was enjoying the novelty of a sovereign young, innocent, and conscientious. During the first twenty-one years of the period, until Victoria's widowhood, her loyal subjects could bask in the happiness of their queen, her beloved consort, and their growing family. From these halcyon years date the steel engravings of royal domesticity which even yet adorn the walls of English boarding houses. During this period also occurred that super-romance of the literary world, the marriage of Robert Browning, poet, with Elizabeth Barrett, poetess.

The Crimean War brought the usual amount of needless suffering. No poem, even by the future poet laureate, could be worth such a senseless sacrifice of gallant lives as was the charge of the Light Brigade at Balaclava. Mr. Gladstone and Mr. Disraeli began their long rivalry for the leadership of England; Mr. Dickens and Mr. Thackeray theirs for the hearts and minds of the English-reading world. Though the great mass of the church-and-chapel-going public was not upset by the appearance, in 1859, of Mr. Darwin's *Origin of Species,* that book and other questioning volumes laid the foundation for the scepticism and deep religious unrest of the later Victorians. In 1851, through the efforts of Prince Albert, the first International Exhibition was held in the Crystal Palace. A great hope centered around this innovation: that it would promote world peace by the substitution of trade and artistic rivalry for the rivalry of arms. What it did do was to provide the wherewithal for the founda-

tion of the South Kensington (later called the Victoria and Albert) Museum; an admirable result, if something less than the goal.

France, after eight more years of the "citizen king," had another go at republicanism, to be caught up this time more quickly than before in the glittering net of Empire. The policy of Napoleon III, upon a precarious throne, was to rule by dazzling, in which task he could have had no better helpmate than the beautiful Spanish Eugénie. Her own exotic loveliness and that of her ladies, their Arabian Nights dwelling-places, and most of all their exquisite toilettes, were the best of advertisements for French designers and craftsmen, causing happy Paris to become the luxury and pleasure mart of the world.

Italy became at last United Italy, with the king of Sardinia at its head. Germany, not yet the German Empire, in 1848 produced a small but earnest social revolution which unfortunately failed. Banished leaders and disheartened followers emigrated in numbers to the United States, which gained thereby many excellent citizens.

The United States was young but smart. The diplomatic lessons of the Old World not being lost upon her, she went the Monroe Doctrine one better and, one hand on Texas and the other reaching toward California, declared war on the Mexican Republic. When a treaty was signed in 1848, California belonged to the United States; a year later gold was discovered. In the meantime, Yankee clippers were making their way to all the ports of Europe and the Orient, and upon the whatnots in staid New England parlors reposed strange souvenirs from far-off lands. Whalers from such ports as New Bedford went out into perilous waters and returned with riches in oil, to be transferred to the pressed-glass lamps and the crystal chandeliers of the nation.

Although in retrospect the mid-century in America is dominated by the threat of war between the states and the course of that conflict, other and less grim affairs also occupied the daily lives of our grandparents. Contemporary literature fills out the picture for us, and no sort more vividly than the topical and ephemeral stories and verses of the day. An opus of this nature is the once-popular "Nothing to Wear: an episode of fashionable life," attributed to William Allen Butler of New York. The shilling reprint gotten out in London in 1858 has an illuminating preface, which remarks: "The satire of the poem is aimed at the fashion and extravagance rampant in, but not confined to, transatlantic cities," and again, "That the poem is without application to English society, the following taken from the present week's paper will negative." There follow items from a "most extraordinary milliner's bill" presented in court during a bankruptcy case. To cull a few: "Brussels lace veil, £15, 15s.," "embroidered handkerchief, £5, 5s.," "point lace parasol, £10, 10s.," "a rich black velvet dress with Maltese lace and fringe, £27, 4s." "Miss Flora M'Flimsey of Madison Square," who "had on a dress which cost five hundred dollars and not a cent less" and the new-rich heroine of Bret Harte's "Her Letter" whose gown "cost a cool thousand in France," were daughters of the newly rich; contrast with them Louisa Alcott, who over a period of several years

possessed just one " dress-up " dress, a black silk. Inequalities rivalling, **if not** surpassing, today's.

GENERAL CHARACTERISTICS OF COSTUME

In the middle years of the nineteenth century occurred innumerable subtle changes in men's dress, difficult to trace in sequence, making it unusually dangerous for the chronicler to dogmatize. As always, some men clung to the older fashions, while others took up innovations ahead of their fellows. During the entire nineteenth century the professional classes dressed with more sobriety and sometimes more pomposity than college boys and the sporting gentry; lawyers and doctors as well as ministers were expected to wear black broadcloth, and senators to dress like statesmen, *i. e.*, in the inevitable broadcloth. Above all, the great churchgoing middle class put on Sunday clothes which were recognizably more formal than their week-day attire.

Even into the sixties some men wore tail coats in the daytime as well as for evening functions—essentially the same coat worn by their fathers in the twenties. Yet even in that garment a man of the fifties resembled his descendant of the present day more closely than he did his predecessor of thirty years back. An interesting illustration in *Harper's Monthly* for 1854 makes clear how that generation saw the contrast: the past style with its flaring bell-crowned hat, choker stock, coat collar riding high in the neck, huge, square coat lapels, snug, high-waisted body, long square coat-tails and tight pantaloons, buttoned or strapped close to the leg (Chap. XIV, figs. *passim*); the " modern " fashion with high-crowned, round-topped felt hat, low turnover collar and string tie, flat-lapelled coat collar, shapeless sack coat and tubular plaid trousers flapping at the ankle (fig. 6).

The advance of the nineteenth century brought with it increasing comfort in men's dress, *i. e.*, in the matter of looser bodies and lower collars; it also brought the discomfort and ugliness of luxuriant whiskers and garments made of stiff, ungraceful materials. Warm, rich colors gradually disappeared from masculine wardrobes; large-patterned trousers, striped neckcloths, and occasionally checked or figured vests added a less artistic liveliness. Through the forties there did remain some elegance in the long-waisted, nipped-in coats with flaring tails and in the close-fitting strapped pantaloons; the cravat, too, was high and well-shaped and the more pleasing bell-crowned hat was still holding its own beside the uglier " stovepipe."

Though women's costume was much more whimsical in its year-to-year changes, it can yet be seen to have followed a steady progression, thus: Having emerged during the preceding decade from the ungraceful and undignified extremes of the year 1830, it now (1840) adopted that graceful, ultra-feminine, and tasteful style which it kept for ten years, the distinguishing features being: demurely parted hair (arranged either in glossy curls or in smooth puffs over the ears), over it a small poke bonnet or a shallow-crowned gypsy hat; a tight, smooth bodice with long, slim, pointed waist; sleeves revealing the shape of

the arms, long full skirts, held out in a moderate bell-shape. Characteristic dress materials included lace and gauze, satin and merino in deep and soft or else light and silvery tones (figs. 10 and 11).

In 1855 the charm was already vanishing. Materials were heavy, colors were either somber or garish, chenille fringe and jet cast their respectable blight on decoration. The sewing machine with its inviting possibilities for rapid and intricate stitching induced an orgy of braiding, pleating, puffing, and tucking. The skirt grew wider and wider, more and more ornately trimmed. Just when women had reached a point where one would have said they could carry no more weight suspended from their waists, and therefore the style must surely change, behold the steel-wire hoop-skirt, which weighed only half a pound and could balance enormously wide skirts with comparatively little discomfort to the wearer. As a result skirts expanded still further. In addition, sleeves spread hugely at the lower arms. Outer wraps were cut sack-shaped, to encompass the enormous lower portion of the figure. Sloping shoulders, little hats perched on top of " chignons " or " waterfalls " that seemed in danger of sliding down the back, all determined the upper part of a silhouette which, all together, resembled a pyramid or a spinning-top upside down. Before the end of the Civil War the hoop was being pushed toward the back, and the following five years witnessed the transition from crinoline to bustle.

It must be remembered that as always many people did not follow the extremes of the mode. Plenty of women in plain circumstance dressed in accordance with what were then considered sensible ideals, though to modern eyes their snug bodices and long skirts seem foolishly restrictive.

As always, too, there were those who refused to abandon the fashions of their youth; like the old man with:

" The old three-cornered hat
And the breeches, and all that,"

of whom Oliver Wendell Holmes was thinking when he wrote " The Last Leaf." A like example is recorded of two maiden ladies up in Ontario, who had been young during the War of 1812 and, remaining loyal to the Neo-Greek, strode, a tall, gaunt pair in their scant, high-waisted dresses, among their hoop-skirted neighbors like a pair of maypoles amid the beehives.

MEN

Heads. In the forties especially, men with luxuriant locks had a good opportunity to make the most of them. Curly hair rose in a crest above noble brows and bushed out under hatbrims; even straight locks sometimes hung over the tips of the ears (figs. 1c, 2, 3). Men brushed their hair straight back (fig. 1c), brushed it forward in a curling lock or " cowlick," parted it on the side (fig. 3), in the middle (fig. 7), or, occasionally still, brushed it forward over the ears (fig. 2). All these styles, with many individual variations, persisted throughout the period. To subdue unruly locks and to give them a genteel shine, the city-

dweller anointed his head with perfumed macassar oil, while the backwoods-
man smeared his with " b'ar's grease " or tallow. It was as a protection against
these unguents that " antimacassars " were put on the parlor chair-backs.

While not all men by any means were whiskered (fig. 1c), a large number
did have some facial adornment. The sideburns which had come in just before
the French Revolution were still in favor throughout the period. In the forties
they were longer than they had been, but still closely trimmed (fig. 1b); in
the fifties and sixties longer and bushy (figs. 5 and 6), till finally they
attained the magnificent sweep of the " piccadilly weepers " (fig. 7), which in
America were sometimes called " Dundrearys " after the comedy Englishman
created by the elder Sothern in " Our American Cousin." During the forties
and later the side-whiskers were often continued right around the jaw in a
fringe of beard (figs. 1a, 2, 3, 4). Often the upper lip was smooth-shaven,
though moustaches were sometimes worn in addition to whiskers (fig. 7)
or sometimes alone. The longer, clipped chin-beard, familiar to us in the
portraits of Lincoln as President, was worn by a good many dignified men;
and a few favored still more luxuriant beards (fig. 8).

The high, brushed beaver or " silk " hat remained, with slight variations, as
the correct hat for all formal occasions. Throughout the period the straight-
sided " stovepipe " shape (figs. 2 and 3) already seen in the thirties (fig. 6,
Chap. XV) predominated, though the bell-crown had not vanished. In 1850
high hats resembled those on figs. 2 and 3; in 1860 they looked as pictured
in fig. 8, though sometimes taller, as you may see in certain portraits of Lin-
coln. While not invariably black, these " beavers " were now seldom light-
colored. Cloth was more often the material of fawn-colored or white hats.
The brims varied slightly almost from year to year, in width and in the degree
to which they were curled up.

There were other, less formal hats. Among them, the low-crowned, round-
brimmed felt, formerly considered appropriate only for children and country-
folk (fig. 8, Chap. XV) was now chosen by gentlemen for sport and outings,
especially after 1850. The wide-brimmed, flat-crowned hat not unlike the older
" Quaker " hat (fig. 4, Chap. XI), which had for so long been left to the use
of clergymen and lay members of the stricter sects, was now worn, as well,
by many conservative gentlemen (fig. 1b). The felt hat with a soft crown
and a sweeping brim was especially popular in the American South and West,
though " Bohemian " Europeans also affected it (fig. 1a). In the fifties a
highish, round-topped stiff felt hat came into use (fig. 6), and at the same
time the bowler or derby (fig. 1b, Chap. XVII). In this period, as well as in
the seventies, the latter was small-brimmed and shallow-crowned. About 1854
or a trifle earlier the stiff straw hat put in an appearance (fig. 5). It was
thought of as an informal summer headpiece.

In the forties and fifties the cap shown on the boy in fig. 20, Chap. XV,
was being worn by both children and adults. It is a style still to be seen in
various parts of the world. Another type was considered the thing for sports-

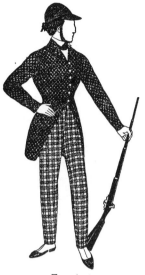

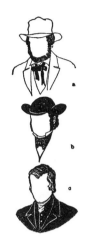

FIG. 4.
Gentleman in shooting-
togs, 1841.

FIG. 1.
a, Slouch hat, string
tie, c. 1860. b,
Clerical or conserva-
tive elderly gentle-
man in shovel hat
and cravat, c. 1860.
c, Episcopal clergy-
man, 1850-65.

FIG. 3.
Gentleman in tail coat
and overcoat with
quilted lining, 1841.
This is not necessarily
an evening costume.

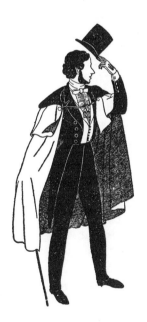

FIG. 2.
Gentleman in elegant eve-
ning dress, 1841. Note
ruffled shirt.

FIG. 6.
Man in everyday
business suit, 1854-
60. Note high-
crowned bowler hat.

FIG. 5.
A sporting gent, 1854-
1860. Note straw hat,
watch chain, gaiters.

men of the forties (fig. 4); it remained with slight variations throughout this period and indeed till the end of the century.

Necks. During the forties the wide stock was still a fashionable neck-covering. As before, it was often neatly shaped to the neck, whaleboned at the sides, and secured by a strap and buckle in back (fig. 3, Chap. XV). Often the stock was plain across the front, at other times it had a piece brought around from the back and fastened in a knot or bow (figs. 2 and 3). It was made of black, white, or (in informal dress) colored, striped, or plaided material. Throughout the period some men wore the old-style wrapped neck-cloth. All through this twenty-five years the collars with upstanding points and those which turned down over the cravat were about equally favored. In the thirties (when a few examples of turndown points had already appeared in fashion-plates) and in the forties (when the style really became popular) this collar was the less formal of the two, favored by sportsmen (fig. 4) and men who preferred comfort to style. In the fifties the turnover collar with a wrapped cravat, a stock like fig. 4, or a big bow tie (fig. 5) was even more in evidence. By 1860 the low turnover, worn with a string tie, was the accepted collar for informal outdoor occasions, and in 1865 a starched collar, turned over just as low, was allowed even with formal evening dress. Nevertheless the collar with upstanding points seems always to be just a little the more formal of the two. Fig. 1b shows one of about 1860 with points wide apart, fig. 7 another, dated 1863, whose points nearly meet.

Neckties ranged from the wide wrapped cravat with no front tie (fig. 4) or a simple bow to a flat, wide silk or satin tie. For sports, with such a suit as that shown in fig. 4, a gentleman of the forties might have worn a colored cravat which folded over and concealed the shirt front, in the manner shown in fig. 2, Chap. XV. Yet in that decade the wrapped cravat was still in the ascendency for all occasions. By 1860, if the tie were wound around the neck at all, it looked more like the style shown in fig. 1b. But even in the fifties the cravat shared honors with the necktie, often, as shown in fig. 5, rather wide and tied in a large bow. By 1860 the string tie had come in (fig. 1a) and for a long while was more popular than any other tie. Fig. 7 shows how the same tie, in white, was worn with evening clothes. Fig. 1b bears witness that the older and more picturesque neck-finish persisted among the conservative.

Sometimes the white shirt was entirely concealed by the waistcoat and cravat. When it did show, it could be seen to have either a starched or a pleated bosom (figs. 1a and b, 4, 5, 7, 8), fastened by one or more studs (figs. 5, 7, and 8). Yet the more picturesque ruffle did not disappear until the fifties (figs. 2 and 3), and instances of it with evening dress occurred till 1860. If a man were seen without his coat, his shirt would look not unlike that on fig. 2, Chap. XII, except that the shoulder was dropped a little and the sleeve was not quite so large.

Bodies. The tail coat and the frock coat dominated the fashionable world. In basic construction they were not dissimilar to those of 1830. Variations such as

the riding and sports frock coat also followed their earlier style (fig. 3, Chap. XV). Tail coat and frock coat were made either double or single-breasted, and the number of buttons on a side varied from three to five (figs. 2, 3, and 7).

Fig. 8 shows what the frock coat or " Prince Albert " (so called in America) had become in 1860, a far cry from the elegance of the thirties (fig. 2, Chap. XV) or even the forties, when waists were still nipped in. After the sixties the frock coat changed but little; it just stepped further and further into the background of fashion until finally it withdrew entirely from public life, but only as late as 1915 or even 1920. It had had an honorable career. Besides being the (alleged) habitual garb of the " upper classes " it was the festive garment of the average man. In it he was married (especially if he did not possess and saw no need to possess a " clawhammer " coat); in it, as like as not, he appeared at other people's weddings for a good many years after. He assumed it along with the appropriate facial expression for funerals, also for delivering Fourth of July orations. If he were a statesman, he wore it to Washington and finally, if he had proved to be a great man, he posed in it posthumously for his likeness in marble, bronze, or cast iron.

From the cutaway coat which was fashionable in the forties for sports (fig. 4) developed the more formal garment which we name a " morning coat " and which by 1865 had taken its present place as an urban street or calling costume (fig. 5, Chap. XVII).

The fifties saw the growing importance of the sack coat (figs. 5 and 6). This short, rather shapeless garment is the same that for years (since mid-eighteenth century) had been worn by workmen and by little boys at play. In the fifties and sixties the sack coat, though popular, was considered an informal or sports coat, its casual character being further indicated by its rough-woven material.

The relative popularity of different coats, even their functions, changed from decade to decade, as explained above: the garments themselves not radically altered, rather in small ways, thus:—(1) shape of collar and fit of waistline. Coat collars steadily decreased in height. In the thirties some collars had still ridden up in the high roll shown in Chap. XV, in the forties the height had diminished a good deal (figs. 2, 3, and 4), in the fifties and sixties collars were about as flat as they are now (figs. 5, 6, 7, 8, 1a and c). From time to time velvet collars were fashionable, in the sixties collars were sometimes bound with braid, and occasionally during the whole twenty-five years collar and lapels were faced back with silk. The dress coat had wide-open lapels (figs. 2 and 7), the daytime tail coat was often buttoned up double-breasted to about the breastline; the frock, single-breasted, was in the thirties and forties fastened rather low, later was buttoned higher (fig. 8). Throughout the period, sports coats tended to have short lapels (fig. 4). The lapels of fig. 5 illustrate an interesting variation in an informal coat.

(2) Set of sleeves. In the thirties sleeves had lost the top fullness which had characterized them earlier and from that time were set into the armseye almost as smoothly as they are now But during the first decade the shoulder-line was

still dropped (fig. 4), conforming to the bottle-necked ideal in feminine fashions. Though this tendency lingered in the fifties (figs. 5 and 6), by 1860 it had practically vanished (figs. 7 and 8). By the end of the period tailors were padding shoulders to a squareness equal to that of a modern coat.

(3) Position and fit of waistline. The greatest changes may be observed in the fashionable figure. The waistline, already moved down to normal by the beginning of the thirties (Chap. XV, figs. *passim*), in the forties was sometimes dropped still lower and nipped in sharply (figs. 2, 3, and 4). The body of the coat was cut and padded to produce almost the effect of a feminine figure (reminiscent of the Elizabethans, Chap. IX).

(4) Flare and length of skirts. The skirts which were cut separate from the body were shaped and pleated to flare over the hips. This flare was sought in tail coats, frock coats, and cutaways. In the fifties the feminized figure was no longer fashionable. Tail coats were a little high-waisted, frock coats fitted an ideal *male* figure with long slim waist and flat hips, and sack coats were rather loose all around (figs. 5 and 6). The sixties brought no radical change (figs. 7 and 8). As long as a womanish figure was the tailor's ideal, some men wore stays, but these were abandoned by normal-sized men when the natural figure came into style. Needless to say, the majority of even well-dressed men did not closely resemble the tailor's dummies and fashion-plate gentlemen.

Pockets ceased to be decorative features and became merely useful adjuncts. They were concealed in the tails of evening coats and the skirts of frock coats and in addition placed in the latter just below the waistline.

Waistcoats showed considerable variation throughout the period. The high-cut, double-breasted type pictured in Chaps. XIV and XV were worn throughout the period, especially with the day tail coat or with sporting togs. Waistcoats for evening settled into the type familiar in modern dress, with a deep oval neckline (figs. 2 and 7), though they went through numerous fluctuations. For instance, in the late fifties the vest was as low as it is in the twentieth century, while in the sixties it was rather high (fig. 7). A dress-waistcoat was generally single-breasted. Waistcoats for both day and evening might have rolled-over collars varying in width (figs. 2 and 5), sometimes with indented lapels, sometimes without. An occasional waistcoat may be seen buttoned high in the neck and finished with a small turnover collar. Small watch pockets were inserted in the fronts of waistcoats. More and more often the material of waistcoats matched that of coat, trousers, or both. In the thirties men had still worn figured satin waistcoats and they kept the plain satins longer yet (fig. 2). As long as the rich fabrics continued, so to some extent did color, but by 1850 both were becoming a little unusual. White wash material maintained its standing; light wool in plaids or checks enlivened many otherwise somber suits. The choice of fashion in evening waistcoats seesawed between black and white (figs. 2 and 7); such waistcoats, then as now, were often of a silk fabric. The inner vest or *gilet,* in white or some light shade, turned up in the fashions from time to time (fig. 3).

FIG. 11.
A walking costume, 1840-
1845. Note Paisley shawl.

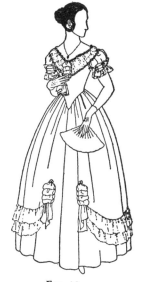

FIG. 10.
Evening costume, 1839-40.
Note hair.

FIG. 9.
Three headdresses,
a, c. 1850-60. b,
1836.

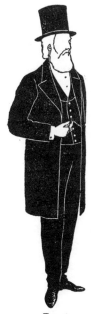

FIG. 8.
Black broadcloth frock coat,
stiff-bosomed shirt, stove-
pipe hat, 1860-1870 and
later.

FIG. 7.
Conventional eve-
ning dress, 1860-
1865. Dundreary
whiskers.

Arms. In the forties sleeves were as tight as they had been in the previous decades, and the buttons up the outside of the forearm were of practical use (fig. 2). Sleeves on formal coats were usually cuffless, though to any of the varieties of day-coats small cuffs might be added. Even the flare over the hands, so important a feature in the twenties (Chap. XV), was sometimes to be seen as late as the forties. The fifties brought in coat sleeves a little wider at the wrist, and from that time on, shirt-cuffs were important (figs. 5, 6, 7, and 8). They were stiffly starched and thus formed a sharp-edged white finish to the coat-cuff.

Legs. After the thirties knee-breeches were practically obsolete; only a few special costumes deliberately preserved them. In the forties peg-top trousers, *i. e.,* those which were fuller around the upper leg than at the hem, were occasionally to be seen; in the fifties trouser legs were sometimes wider at the hem than above. Yet on the whole the tubular shape prevailed and the whole garment was tighter than is usual in the twentieth century. In the forties evening trousers were almost as tight as they had been in the thirties (compare fig. 2 this chapter with fig. 1, Chap. XV), made of fairly elastic cloth, and strapped under the foot; in the fifties the strap was still used on dress trousers to keep them tight and neat at the ankle, though in less formal costumes the trouser-legs hung loose (figs. 5 and 6). In the sixties, even, straps had not vanished, though they were uncommon (figs. 7 and 8). In the fifties the unstrapped trouser-legs were a bit short (fig. 6), but during the next decade they had reached their present length. They were neither cuffed nor creased. In the forties trousers began to be made with a front slit instead of the wide flap which had been in style since 1790. During the same decade evening trousers could be either gray or black, but after that time they were black exclusively. Black trousers came to be considered the proper thing with frock coats also, though light trousers a-plenty were seen with dark sack suits. Throughout the period men showed a great liking for trousers in large checks, plaids, or stripes (figs. 4, 5, 6).

Feet. City people seldom wore boots outside their trousers except for riding, when they put on boots of the styles shown in Chap. XV. Ordinarily on the street men wore short " boots " or shoes which were nearly covered by the trousers, and for evening, pumps or thin shoes. Elastic-sided shoes were popular; in the later years of the period front-lacing shoes were introduced. Men's shoes, like women's, occasionally had lighter cloth tops and were buttoned up the side (fig. 6); gaiters were fashionable during the whole time (figs. 4 and 5). While the average man selected square-toed shoes with heavy soles, the dandy preferred pointed toes and thinner material; in addition, he was eager to have his feet look small and might therefore wear shoes too tight for him.

Outer Garments. Throughout the period capes with velvet collars (fig. 2) and large loose coats with cape sleeves were equal favorites for evening. In the forties well-fitting topcoats with quilted linings were smart (fig. 3). Rather

loose overcoats with skirts nearly to the heel were in style in the fifties; and light, semifitting topcoats in the sixties. During that decade, too, the plaid Inverness cape (fig. 3, Chap. XVII) became popular.

SPECIAL CHARACTERS

Clergy. Clergymen of the Protestant churches, except in the Church of England and the Episcopal Church in America, dressed like laymen, with a strong leaning toward black frock coats and white neckcloths or cravats. Up to 1850 the Episcopal clergy, like the Roman Catholic, clung to the so-called " Geneva bands " (fig. 8, Chap. XIII) which had distinguished scholars and religious men through the seventeenth and eighteenth centuries. After 1850 there was considerable variation in Episcopal " clerics." In England many of the clergy wore a high-buttoned vest with small standing collar over a white neckcloth (fig. 1c); many, like Charles Kingsley for one, dressed like laymen. The same custom held in America also, yet here from 1850 to 1870, those ministers who preferred clerics had their choice of " bands " or a neckcloth with the vest described above. By 1870 or a bit earlier " clerics " had come to include a stiff round collar fastened in back (the "Roman" collar) under the high vest of fig. 1c.

Soldiers. Military uniforms partly reflected the Napoleonic styles, partly borrowed from contemporary civilian fashions. In America they included: either a frock coat buttoned up as high as the standing collar, or a shorter coat; long trousers with distinguishing stripes; and either a cap with a stiff square visor or else a felt hat with stiff brim and pinched crown. Colors and special insignia made the distinguishing features. Special regiments in different countries sometimes went in for uniforms totally unlike these. The best known of those regiments is perhaps the Zouaves. They were French infantrymen, originally part of an Algerian corps, and for that reason wore brilliant oriental uniforms, with turbans, short jackets, and baggy, three-quarter length trousers of bright red. During the Civil War a volunteer regiment of Union soldiers copied both the name and the costume.

Policemen. The " officers of the law " in American cities were often less formally uniformed than they are nowadays. Sometimes only a badge showed that the policeman had authority over others. If he had a real uniform, it bore a striking resemblance to the uniform of the ordinary soldier. In England a " Peeler " (Chap. XV) still wore the original uniform.

Menservants. Butlers and footmen in the grandiose ménages beloved of mid-Victorian dramatists wore ornate and much-braided versions of eighteenth century dress, which did not prevent them from wearing also small side-whiskers or " mutton-chops." These whiskers in their turn continued to be the badge of a butler after they had gone out of style in other walks of life. Some ladies liked to see their footmen in powdered hair, also. Tenniel's conception of the Frog Footman in " Alice in Wonderland " gives a good idea of the complete get-up.

Coachmen and grooms wore top hats with wide light bands, riding frock coats (fig. 3, Chap. XV), breeches, and top boots. Colors were a matter of choice on the part of the employer.

WOMEN

Heads. High topknots had lingered throughout the thirties, though the most extreme types had happily vanished. Fig. 9b shows a transitional style which was sometimes carried over into the next decade, and fig. 12 still another with a topknot, albeit low. Soon the average woman moved the knot to the back of her head, and then lower down. In the fifties the coil of hair was in the nape of the neck and was, fashionably, large. Black or colored silk nets were used to hold up this mass of hair, and they offered an opportunity for decorative effects; sometimes nets were beaded, sometimes even made of gold thread set with jewels in the style of the Renaissance caul (Chap. VIII). By 1860 the mass of back-hair, or *chignon,* lay still lower on the neck, and by 1865 was arranged in the loops and braids or the "waterfall" to be described in Chap. XVII.

At the sides the coiffure preserved a good deal the same character from 1835 to 1860, *i. e.,* it was parted in the middle, drawn smooth over the temples to emphasize a high forehead, and arranged in puffs or ringlets over the ears. As early as 1837 fashion books were showing the coiffure pictured in fig. 10, with a braid brought down over the cheek and looped back again, exposing the ear; Victoria herself wore the style in the early years of her reign. Most women drew the parted hair smoothly over the ears (fig. 12), and many during the forties and fifties increased the width at the sides by putting a pad under the hair or by turning the ends up under (fig. 9a).

Curls abounded, no longer bobbing in little sausages at the temples and over the ears, but rather beginning at the ears and lying gracefully upon the neck (figs. 14, 15, and 17). During the forties the ringlets were rather longer than in the next decade and were often worn at the sides only, while the back hair was coiled and pinned up. In the fifties curls often continued around to the back, helping to make the fashionable projection (fig. 15). Between 1855 and '65 a few women began to draw their hair away from their ears, and from that time curls were massed at the back.

If a woman did not have ringlets, she might indulge instead in very elaborate braids, or coils interlaced over ears or at the back, or wrapped in a coronal around her head, as it is shown in fig. 15 (in addition to curls, here). With the radical change made by uncovering the ears, the fashionable head had to assume different proportions, and so the high forehead was masked by a fringe or "bang," and thus the long ascendency of the middle parting was interrupted (Chap. XVII).

Looking through old albums you will now and again see a girl or young woman with short hair disposed in ringlets over her head, somewhat as in the period of the Directory (Chap. XIV). Some girls wore it thus for sheer con-

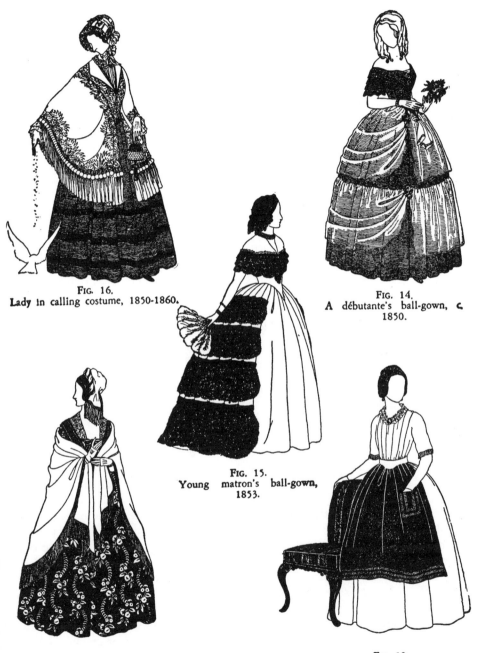

FIG. 16.
Lady in calling costume, 1850-1860.

FIG. 14.
A débutante's ball-gown, c.
1850.

FIG. 15.
Young matron's ball-gown,
1853.

FIG. 13.
Silk morning dress, house
cap, mitts, 1842.

FIG. 12.
House dress, 1840-1850. Black
sateen apron.

venience, some temporarily while it was growing out after a fever. With its ribbon fillet or " snood " and a small bow in the middle or over one ear, this coiffure looked not unlike the long-short bob of the 1930's.

During the entire period evening coiffures included jewelled bands, combs, strands of pearls, and particularly flowers and foliage, real or artificial (figs. 10 and 15).

Caps were much in evidence. Young girls did not wear them, nor were they a part of formal evening dress for any but definitely older women, but for negligée and all ordinary indoor occasions matrons, even brides, and spinsters of " middle age " (i. e., about thirty) " went into " caps. These caps, made of muslin, lace, and sometimes flowers, followed the current styles of hair-dressing (figs. 13 and 9c).

Bonnets also changed to suit the changing coiffure. Already by 1835 the extremely high crown of the preceding period had gone out, and the brim was more open, making a wide frame for the face. This pretty style continued through the forties (fig. 11). During the fifties the bonnet became steadily shallower from front to back and was set further back on the head (fig. 16). After 1860 it was made without any back, to accommodate the chignon. Then, as in the seventies, bonnet-strings were wide and elaborately trimmed, often not tied under the chin at all, but merely held together by a pin or fastened under a tiny bunch of flowers. The large lace veils, mentioned and pictured in Chap. XV (fig. 13) were very fashionable in the fifties, draped over the bonnet. Widows wore small black bonnets, and enveloping black veils edged with crêpe.

As to hats, up to 1860 the principal type was the wide, romantic leghorn, often turned down a little to frame the face in a graceful curve, or even held under the chin by ribbons, loosely drawn. Such a hat would be trimmed with a lace or tulle veil, ribbons, flowers, or all these together. Crowns were deep or shallow according to taste; both might have been seen in the same group. Fig. 17 shows a deep crown. When the chignon assumed large proportions, other, smaller hats came in. A medium size worn over a moderate chignon is shown in fig. 19, another, very shallow-crowned, in fig. 18. After 1865 such a hat as the latter was smaller; it was tilted up in back by the chignon. The round pill-box or " pork-pie " hat in fig. 20 was an adult as well as a juvenile favorite; by 1865 it also had become smaller and was worn at an angle over one eyebrow.

Upon the evening coiffure ladies usually placed a scarf of lace or silk, some-times shaped a little so that it was wide over the head with narrower lappets. A " sortie de bal " of this type illustrated among the fashions for 1852 is made of white silk trimmed with white galloon; black Spanish lace and white Brussels lace were equally fashionable. Soft, fluffy knitted or crocheted head-scarves were popular with those ladies who went a-foot in winter to evening parties.

Necks. There were high necks, medium necks, very low necks, none rising

much above the pit of the throat, some threatening to slip off the shoulders, a few V-shaped with fichu arrangements, but they all managed to emphasize or at least preserve the sloping shoulder. In the forties the wide, rather clumsy muslin and embroidery collar shown in fig. 18, Chap. XV, was gone, and to it had succeeded a much narrower turnover which persisted with minor variations through the sixties. Often it encircled the throat quite high (figs. 9a, 18, 19), again it lay flat on the collar-bones (fig. 16). This was the ordinary neck for house dresses and walking-costumes. There were some round necks, too (fig. 11), and some cut low and filled in with chemisettes or tuckers. The ruff had not entirely vanished, as witness fig. 12 in a style of the forties. In the fifties, as part of a revival of eighteenth century modes, an open V-neck filled in by a lace chemisette or vest came back to style; so did the fichu (cf. Chaps. XII, XIII and fig. 11, Chap. XV). The décolletage was of course not always as low as we often see it on court dress of the period. Fig. 10 shows a pretty style of 1840; fig. 14 one of about 1850; fig. 15 is dated 1835, but its neckline was a favorite both before and after that day. Dressy daytime frocks also were often low-necked (fig. 13).

Bodies. The close-fitting bodice persisted throughout the period, the only important changes occurring in the shape at the bottom, which varied a little almost from year to year. Whereas in the twenties the waist had been round, in the thirties it had begun to be pointed, and the point remained the usual shape for about twenty years. Although round waists are to be observed sometimes in the forties (fig. 12), during most of that decade and the next a rather long front point led the fashions (figs. 14, 15, and 17). All these bodices were put on *over* the skirtbands, either sewed to them permanently or fastened at each wearing. About 1860 the round waist began to come back again (fig. 19), sometimes even with a wide buckled belt. In the early sixties the corselet girdle was revived; it was about six inches wide at the sides with a point upward in the front and sometimes downward also.

During the thirties the bodice, even when pointed, had been sometimes a little short-waisted, but even before 1840 the fashion had shifted to a long, tapering waist, which remained the ideal for fifteen years or more. The slender bell shape of this Early Victorian silhouette is well shown in such a costume as that of fig. 11, where the high-necked, plain, back-lacing dress with its unbroken line from shoulder to hem gave the wearer an appearance of being molded in wax. Very expert dressmaking was needed for such a costume. The bodice was put together of many cleverly shaped pieces, there was a firm lining as carefully fitted as the outside, and both bodice and corset beneath were adjusted to the figure at each wearing, by front or back lacings. These bodices were all cut with a drop line which allowed a décolletage off the shoulder yet did not interfere with the smooth, unwrinkled stretch over the bust. During the whole period the long shoulder and small waist were often emphasized by a wide pleat or line of trimming running from each shoulder to a point at the waist (fig. 14). Occasionally, too, simple frocks had fullness

in the front (fig. 12). Though still made up over a tight lining, such a bodice had extra width in the front, pleated or gathered into shoulder and belt. Sometimes the fullness extended all the way across, sometimes it was concentrated into about four inches up the middle.

Whereas in the first decades of the nineteenth century bodices were sometimes made of darker material than skirts, in this period the reverse was more often seen (though it is true that one may also find dark above light, even in party-dresses). A fashion-plate of 1845 shows a garden costume with a short, tight-sleeved white waist of a very modern look except that it is a tight " body," not a " blouse." This is pictured with a striped skirt. The costume illustrated in fig. 19 is taken from a photograph of the year 1865. It is " suitable for the seashore." Separate blouses like this, buttoned up the front and tucked inside the skirtband, were classified as " garibaldis," being feminized versions of the red shirts worn by the Italian patriot and his followers. A lady's garibaldi was not necessarily red. This blouse, with its comparative freedom, was the forerunner of the shirtwaist.

In the forties and again in the sixties a popular costume consisted of cloth skirt, underblouse with large sleeves (like fig. 19) and a " zouave " jacket. It was very like a bolero jacket, but it had three-quarter length sleeves either tight or bell-mouthed and it was braided in the military fashion. In the fifties one fashion was to wear over the dress a kind of descendant of the spencer pictured in Chaps. XIV and XV; a tight jacket or vest with mannish details in collar and cuffs, a *gilet,* and a peplum. Home-knitted or crocheted spencers, " hug-me-tights," or loose jackets with cape-like sleeves furnished extra warmth for skating, coasting, or merely sitting in draughty houses.

Arms. During the thirties sleeves had still exhibited the characteristic of the previous years, *i. e.,* drop shoulders and width below. By 1840 most of the fullness had vanished from long sleeves; for the next fifteen years they were very smooth and close-fitting from shoulder to below the elbow, often indeed all the way to the wrist, which was then frequently finished with a turnover cuff. Fig. 12 shows a variant of the style, where even a double sleeve does not alter the slender shape. Gradually larger sleeves came back, but this time the fullness was at the bottom (figs. 18 and 19). In the early fifties the tight sleeve had begun to enlarge into a small bell-shape, often stopping at three-quarter length, the distance to the wrist being filled in by a puff of lace or muslin. Very soon the width expanded, so that even by 1855 the bell-shape was large, growing larger still in the sixties, through which decade they lasted (fig. 18). The white undersleeves were detachable and might be articles of considerable expense, since they could be made entirely of real lace.

The change in evening dress sleeves was not nearly so radical. Throughout the period they were puffed and ruffled or looped up in a variety of pretty ways (figs. 10, 14, 17). After about 1855 the puffs were on the whole shorter; indeed, sometimes there really were no sleeves, only the deep bertha over the arms (fig. 15). In the forties and early fifties an evening dress occa-

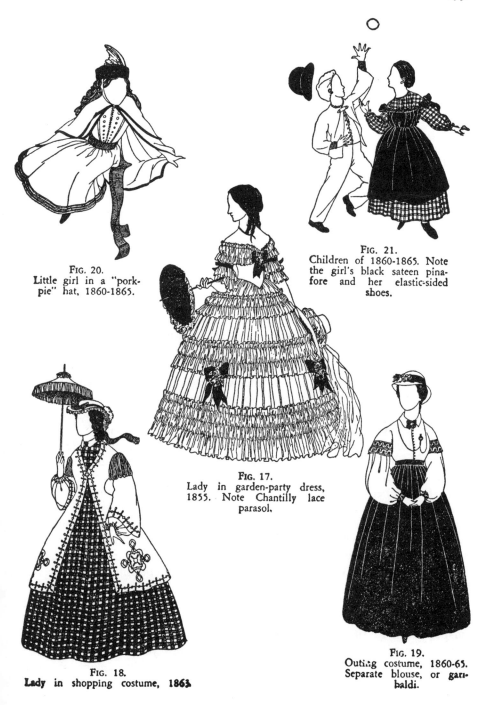

FIG. 20.
Little girl in a "pork-pie" hat, 1860-1865.

FIG. 21.
Children of 1860-1865. Note the girl's black sateen pinafore and her elastic-sided shoes.

FIG. 17.
Lady in garden-party dress, 1855. Note Chantilly lace parasol.

FIG. 18.
Lady in shopping costume, 1863.

FIG. 19.
Outing costume, 1860-65. Separate blouse, or garibaldi.

sionally had a long sleeve of lace or gauze. This might be just a "bishop" sleeve, as on house dresses (figs. 19 and 21), or it might be separated into two or more puffs down the arm (cf. fig. 10b, Chap. XIV).

Legs. During this twenty-five years the length as well as the width of skirts steadily increased. By 1840 short dresses were out; in that year instep-length was considered proper for street or ballroom (fig. 10). During the forties and fifties the skirt either just cleared the floor or actually touched it (figs. 12, 13, 14, 17) and in formal gowns even trailed a little behind (fig. 15). During the early sixties most street-dresses touched the ground (fig. 18), some "calling costumes" swept up the dust with their trains, and many evening gowns trailed impressive lengths over ballroom floors.

Soon after 1830 gored skirts had gone out, and by 1840 all skirts were gathered or pleated into the waistband and fell over their stiffened petticoats in a multitude of folds. The amount of material increased with the years, till by the mid-fifties a skirt measured a minimum of ten yards around and sometimes ran into twenty or twenty-five if the goods were very thin. The nature of the decoration also added to the real or apparent width. During the forties and the earlier fifties the skirts of woolen or dark silk dresses were left untrimmed (figs. 12 and 13) or were trimmed very simply (fig. 11), but ball-dresses of tulle, tarlatan, and lace had flounces and festoons or bunches of flowers (figs. 10, 15, 17), and silk dresses also had flounces of silk, "illusion" or lace (fig. 14). In the later fifties horizontal bands of velvet or braid were added to street skirts (fig. 16). After about 1855 silk dresses broke out from waist to hem in silk or net ruffles, and woolen skirts too were beruffled, each layer braided in elaborate patterns. To go back a little for a moment: during the forties there was a revival of interest in skirts open over flounced petti-coats, the eighteenth century mode (cf. Chaps. XII and XIII).

As to the underpinnings that held out these vast skirts, until 1857 or '58 they consisted of a multiplication of petticoats. In 1856 a lady's underwear included the following (in addition to a chemise and a corset): long under-drawers trimmed with embroidery or lace (pictures of them are frequent in fashion pages), a couple of under-petticoats, one probably flannel; then the principal stiff petticoat, about three and a half yards around, heavily quilted and even wadded to the knee and stiffened with inserted rounds of whalebone; over this another petticoat with three flounces of crinoline or heavily starched muslin, and on top of that more muslin petticoats, prettily decorated, over which a lady sometimes looped her skirt to take it from the ground. Between 1855 and 1858 came the patent tilter, *i. e.,* graduated rounds of resilient steel wire, held together by tapes; this invention prolonged the life of the bell-shaped skirt, for it weighed but half a pound and required only one stout petticoat over it, beneath the dress skirt. For a few years longer skirts went on expanding, and many and well-deserved were the gibes against them. In the early sixties the shape began to change, the greatest fullness being pushed toward the back (fig. 18) and by 1865 the difference was already marked, as

explained in Chap. XVII. Pantalettes, so often visible below children's skirts, are very seldom to be seen under the long dresses of even young women; though that long drawers were present is testified by many illustrated jokes about windy corners and omnibus steps. Occasionally pantalettes or " pantaloons " may be encountered in the fashion-plates; for instance, a design in *Harper's Monthly* of the year 1852 shows an evening dress worn with satin ankle-boots and pantaloons of plain white gauze gathered at the ankle, revealed as the lady coyly lifts her skirt. (Query: Though the name is not mentioned, was not this fashion inspired by Mrs. Bloomer of New York, who in 1849-'50 presented her scheme of dress-reform, which included loose trousers under a short petticoat?)

Feet. While heelless, soft slippers like those described and pictured in Chap. XV were worn indoors during the whole period, ankle-boots were considered more appropriate in the street (cf. fig. 18, Chap. XV). After 1840 slight heels were often added, though usually to boots rather than slippers. Between 1860 and 1865 heels became fashionable upon both slippers and boots or " shoes," and their height kept increasing, to the distress of " sensible " folk. Not that a modern woman would think them high, for in the sixties they were never more extreme than the little spool-heel we call " baby French." Toes were as often squared at the tips as they were round or pointed. Shoes and slippers were made of satin, of kid with cloth uppers, or entirely of kid, which might be white, colored, black, or bronze, the last especially stylish in the sixties. Ankle-boots often had elastic sides (fig. 21), but they also came laced up the inside of the ankle or, in the sixties, up the front. Bows and tassels were considered smart touches for the tops of boots; indeed there is a popular song of the period (or a little later, for the fashion was long-lived), which runs:

> " With tassels on their boots,
> A style that surely suits
> These Yankee girls with hair in curls
> And tassels on their boots."

White or pale-toned stockings were the rule. Silk stockings were considered a great luxury, so that most women contented themselves with thin lisle for best and heavier cotton or woolen for every day.

Outer Garments. The shawl was the standard wrap throughout the period, whether it was of heavy silk richly fringed (fig. 13), cashmere in the coveted Paisley weave (fig. 11), Spanish or Brussels lace, or only good warm wool in black or gray with a simple border. In the fifties and sixties the shawl or mantle was sometimes cut out and shaped a little. Fig. 16 gives an example of such modifications. This wrap consists of a close-fitting back, a front vest or *gilet* with turnover collar, and a scarf attached to the vest at the tips of the shoulders. The scarf might be detached from the *gilet* and worn alone. Such a garment, or one even closer-fitting, was made of silk, velvet, or a fine wool, and embroidered, fringed, or (very often) trimmed in jet passementerie and fringe

The mantelette, a long, shaped scarf with a deep V point at the back and tapering ends in front, was equipped with an inner belt by which it was held close against the body. The back point was sufficiently long to ride out over the hoop and the front ends fell free over the skirt. This mantelette also was made in materials of varying richness and warmth. There were many ingenious variations of these wraps.

In the forties and fifties a sack jacket, almost identical with the Dutch jacket illustrated in fig. 15, Chap. XI, was very popular. Made of sealskin or other fur it formed a suitable winter wrap. To the sixties more particularly belong longer, fitted coats (fig. 18). Large wraps or capes, made not unlike the style illustrated in fig. 19, Chap. XII, were used as evening cloaks throughout the period; sometimes they had cape-like sleeves.

EQUESTRIENNE

While the masculine influence entered importantly into the styles of riding-habits, feminine taste dictated details. The top hat was the most conventional riding headgear throughout the period, and it varied in style along with men's hats. That it was almost invariably wrapped with a large veil seemed not incongruous to that age. Every once in a while ladies chose to ride in hats with picturesque, sweeping brims and several plumes, or even in straw hats; and fashion sustained the decision. A boyish alternative to the top hat, one which was still in fashion as late as 1840, was the jockey-cap made of black velvet and draped, as usual, with a veil. Green chiffon veils were especially intended to protect the wearer from the sun. Contemporary pictures of " Derby Day " show even men with such veils around their toppers.

While the neck was frequently wrapped in a mannish cravat, just as often it was encircled by one of the round flat white collars, sometimes rather low in front. Occasionally a high neckband was topped by a ruching, a style observed in the fashion-plates for 1866.

During all the years from 1815 to 1870 or thereabouts jackets were cut like bodices and fitted around the waist, with no skirts and nothing more than a little " postillion back " (a sort of tail, wedge-shaped or box-pleated, riding out over the skirt). They were buttoned up the front over another cloth bodice or a *gilet* or a chemisette. Sleeves were plain, came to the wrist, and followed the current modes in the matter of fullness.

Though riding skirts were not worn over hoops, they were very full and extremely long, so that they trailed over the horse's side nearly to the ground, and had to be looped or held up when the lady walked. The skirt was worn over one starched white petticoat and a pair of dark pantaloons; the latter may sometimes be seen in pictures of dismounting horse-women. High boots were not commonly worn, elastic sided ankle-boots or even pumps being considered perfectly proper.

Up to the end of the sixties colors were bright: blue, purple, green; red jackets and blue skirts; the gold or yellow of braid and metal buttons on dark

cloth. Velvet was thought as appropriate as broadcloth or "lady's cloth," which was a lighter weight broadcloth.

CHILDREN

Usually the dress of children reflected that of their elders but sometimes made astonishing departures from it, mostly in the way of details gleaned from past periods. To appreciate these fully the student must turn over the leaves of fashion-books. Figs. 20 and 21 show children in simple garments at the latter end of the period, i. e., between 1855 and 1865. The young people in Chap. XV can be taken as models for children of the forties and fifties also. Boys just out of petticoats wore tunics (fig. 20, Chap. XV) for a while; they graduated from them into trousers and short jackets, of which one style is shown in fig. 21. A slightly older boy would wear a jacket and waistcoat, with trousers like his father's, except perhaps a little shorter. The cap illustrated in fig. 20, Chap. XV, was still going in the sixties. Some boys wore wide, shallow-crowned hats, some derbies (as the illustration shows), some top hats. As to shoes, there were elastic-sided shoes like the little girl's in fig. 21, and black laced shoes, as well as short Hessian boots, all for outdoors. In the house the well-brought-up boy changed to pumps or strap-slippers.

Most little girls had long hair, hanging loose but kept out of their eyes with ribbon snoods or round combs familiar to us in pictures of Alice in Wonderland. If curls could be achieved, so much the better; otherwise hair was brushed out smooth and straight. Some little girls had cropped heads almost like their brothers, though not nearly so many as nowadays. When forehead fringe came into fashion for ladies, little girls also began to wear bangs. Childish millinery faithfully reflected adult. Children wore poke bonnets, but never the tiny, crownless sort which ladies perched over their *chignons* during the late sixties.

The dress in which Tenniel immortalized Alice is the prettiest, because the simplest, frock a little girl could wear during the period. Unfortunately not all children were suffered to remain so charming. For one thing they had to wear crinolines, and for another they must needs be trimmed up like their mothers, in fringe and velvet, flowers and ribbon bows; both our little girls (figs. 20 and 21) have escaped very easily. Note that skirt lengths varied from just below the knee (fig. 20) to near the ankle (fig. 21).

As to pantalettes, they come and go. Fashion-plates of the same year will show one child with, another without, these curious leg-coverings, which when they do show are tubular or gathered into the ankle, long or short, with the same impartiality. Certainly one sees them less often as the years advance, and by 1865 they are seldom visible. In the fifties they were still pretty important:— An old lady who was a child in those days used to recall her pet nightmare, which was that she had gone to school without her pantalettes, i. e., the fancy ruffles which were supposed to button upon her underdrawers and show below her dress.

Pinafores (bibbed aprons of white muslin, of checked gingham, or of black silk or sateen) protected woolen winter dresses. The girl in fig. 21 wears one type of pinafore, and " Alice " another.

Little girls' shoes were like mother's, some parents being silly enough to let their children wear heels when heels came into style. Very young misses were proud enough of their bronze or red kid boots with bow or tassels which they could show off much better than their long-skirted elders. Indoors they wore pumps or, more often, strap slippers, of the sort sometimes called " Mary Janes." Longish socks are to be seen in pictures, but infrequently, long stockings being much more common. Stockings were almost invariably white. There was a story called " The Wide, Wide World," popular with little girls in the sixties, and with some a good many years later, which wrung its readers' hearts by an account of the wrongs inflicted upon the heroine, not the least being the tale of how her cruel aunts took all her pretty white stockings and dyed them a dirty home-made slate-gray, " to save washing."

MATERIAL

Men. Broadcloth was the conventional material for men's formal coats, and after about 1840 (in a thinner quality) for evening-dress trousers also. Lighter-colored trousers were of still looser-woven and more elastic material, though after the thirties not often stockinette, jersey, or " kerseymere." Mixed wools were used for sport suits (fig. 4) and sack coats (figs. 5 and 6), and drill, serge, and such weaves for both trousers and topcoats.

Silk had a limited function in evening dress, lining the coats and sometimes facing lapels, as in modern formal dress. Silk waistcoats remained popular for evening; they were still occasionally flowered or hand-embroidered on the edges, in the forties and fifties sometimes colored, but more often as time went on white or black. The greatest number of everyday waistcoats were of wool to match the suit, or a thin wool such as cashmere, or of white cotton like marseilles or piqué.

Women. There was a great variety of materials to choose from for feminine apparel. Cottons held their own throughout the period, even for party dresses, fine (" book ") muslin, lawn, and tarlatan being considered the proper materials for *les jeunes filles.* Gingham in plaids, checks, stripes, and figures, calico (which being inexpensive was the ordinary material for work-dresses and aprons), percale, and dimity were made into summer dresses. Merino (a fine, soft wool), grenadine (a loose-woven silk and wool), camel's hair, flannel, serge, and broadcloth or " lady's cloth " were used for winter dresses, the softer weaves often serving for the " best dress " in lieu of silk.

Of the silks, taffeta was perhaps best adapted to the *bouffante* dresses of the period. It was heavier and stiffer than modern taffeta, and that it was pure silk and not " loaded " with tin, like so much of the present-day product, is proved by the many uncracked taffeta dresses left from the sixties and earlier. Crêpe, brocade, velvet (that woven at Lyons was considered best), grosgrain,

satin (it was much heavier than the modern, more like cotton-backed Skinner satin), and "moiré antique" were all favorites for handsome gowns. Some of the prettiest evening dresses were made of silk net, tulle, or "illusion" in white or pale shades, draped over a silk underdress. From the Victorian era dates the "best black silk" which every woman who could possibly afford it possessed as the mainstay of her wardrobe.

This was a lace age, and large prices were paid for the real lace worn by wealthy women. Chantilly, Brussels point, Maltese and Spanish lace, "blonde" or fine net were used in quantities surprisingly large considering their expense. There were lace shawls and flounces, collars, berthas, parasol covers, detachable undersleeves (like the lawn puffs on fig. 18), pocket-handkerchiefs, and even whole dresses. Bridal veils and berthas of point-lace were handed down from one generation to the next. Every woman hoped to own at least one real lace collar; a "lady" was known by the genuineness of her lace, as much as by the genuineness of her diamonds; for though cotton lace ("Nottingham") had been machine-made since the first quarter of the century, it was held in small repute.

Ermine was sought after by wealthy women, so was Russian sable and mink. Sealskin (the genuine was then obtainable in some abundance) was most popular for jackets or "sacques." Beaver and astrachan had their wearers. On the whole, it was the short-haired pelts rather than the long-haired which were best adapted to current modes.

Children. Girls, like their mothers, wore cotton in summer, wool in winter, and if their parents could afford it, silk for best. Their play pinafores were of checked gingham or black sateen, their "afternoon" pinafores of pretty white goods.

Boys wore nankeen or denim for everyday in the summer, and wool in winter. Some boys, like their sisters, had to put on black sateen aprons to save their woolen jackets when they played or toiled with an ink-pot.

COLORS

Men. Bright hues became more and more alien to masculine attire. During the thirties and even the forties bright blue, bottle-green, and plum-colored coats were still featured and were combined with waistcoats in another tone or even another color and with trousers of light and pretty shades. But in the fifties most men had settled down to black, dark gray, very dark blue for coats and nothing gayer than fawn, gray, tan, or gray-blue for trousers. Even colored waistcoats were looked at askance in the fifties and sixties. Only the popular plaid trousers furnished a giddier note, for they came in lilac or bright blue, as well as black, gray, or brown-and-white. Topcoats were often light, but only of the grayed shades still familiar; Inverness capes (fig. 3, Chap. XVII) were always plaid.

Women. There was no limit to the colors used in women's dresses; yet the popularity of certain shades and combinations falls into two periods. In the

first there is evident a strong reaction against the garish combinations of the preceding decade. During the forties and till about the middle of the fifties well-dressed women favored delicate, grayed tones: lavender and lilac, tan, silver-gray, gray-green, silver-blue, or a combination of two soft tones in " changeable silk " for dressy day costumes, white and pastel shades for evening gowns; and for serviceable dresses they chose black, brown, dark blue, and bottle-green in solid colors or combined in plaids, checks, stripes, or " shot silks." With the late fifties and the sixties came the taste for heavy, dark colors: red, blue, crimson, maroon, brown, dark bright green, purple, plum-color, and violet. Magenta came into prominence when in 1858 Sir H. W. Perkin invented that particular color in coal-tar or aniline dye. The discovery of magenta was rapidly followed by that of other aniline shades equally glaring. Often extremes of light and dark or two complementary colors were combined in one dress. Black net or lace was draped over white or a strong color like king's blue, cerise, or emerald green. In the evening, white and pastels still led, though black velvet was fashionable and, as always, beautiful. Brides did not invariably wear white, even when they were veiled. For example, the grandmother of one family is remembered as wearing silver and blue changeable silk " to stand up in." Nevertheless, wedding-dresses illustrated in fashion-plates are always white or the popular ivory-colored " moiré antique."

MOTIFS

There is no characteristic set of motifs for Victorian costume: modistes culled here and there and with an untroubled conscience put together fragments of design from this period and that. Floral motifs, generally more or less realistic, were always popular, but as like as not they would be combined with Greek or Roman borders. The handsome floral pattern in fig. 13 is reminiscent of the eighteenth century. Throughout the period there were no more popular designs than checks, stripes, and particularly plaids, the last being, in the sixties, especially large and sometimes startling. With the introduction of the sewing-machine and its intriguing facilities for rapid stitching began an epidemic of meaningless patterns made up of scrolls and spirals and all manner of curlicues. The Gothic revival in architecture and furniture had very little effect on dress decoration, though jewelry was designed in shapes reminiscent of mediæval spires.

APPLICATION OF DECORATION

Many evening dresses were trimmed with festoons or nosegays of real-looking artificial flowers made of muslin, gauze, silk, and velvet (fig. 14). Flowers of like materials were also appliquéd upon bodices and skirts, and ribbon bows were placed here and there upon the costume. Embroidery was worked usually on small areas, e. g., vest and collars or borders of shawls (fig. 16). A good deal of careful needlework like satin-stitch, feather-stitch, herring-bone, chain-stitch, and buttonhole stitch was applied to borders, hems, and

seams. Muslin and flannel underthings had scallop-edged ruffles with further decorative dots or tendrils. Muslin chemisettes, collars, and puffed undersleeves were embellished with insertions and edges of lace as well as embroidery.

During the whole period braid was a favorite trimming upon women's cloth dresses, and in the late fifties and sixties it was admired upon silk, also. At first applied mostly in the military manner, at the edges of sleeves and lapels, in bands across the chest and down the skirt (fig. 11), later it was put any-where on skirts, bodices, and coats (fig. 18). Braid was also occasionally used on men's civilian garments, e. g., to bind the edges of sack coats. In the sixties dress-suit trousers had braid down the outside seam, quite in the modern manner.

Fringe was extremely popular, especially in the fifties and sixties. First it was put on the hems of shawls and aprons, then around the edges of mantles and other wraps, after that on flounces, and finally on sash-ends, when sashes came back to favor (Chap. XVII). Fringe could be either short and thick or as much as twelve inches long and intricately interlaced (figs. 13 and 16). Jet and chenille fringe were as popular as silk. Jet, indeed, was much admired, and sometimes mantelettes and capes were made entirely of it. The most varied and complicated trimmings were concocted with ruffles and flounces of lace, net, gauze, and silk, the last often with a " pinked " edge. Buttons were important decorative touches in this period; they were sometimes cloth-covered, often made of jet, pearl, cut-steel, or gilded metal.

JEWELRY

Men wore rings, cuff-links, and shirt-studs of gold, coral, pearl, or (occa-sionally) gems, scarf-pins (especially with the large fold-over cravat), and watch chains, the last spreading across the vest from pocket to pocket or hanging from a buttonhole down to a pocket. In the early thirties such chains had already begun to take the place of the older fobs, and from that time until its revival in the new century the fob was rarely seen.

The stand-by among women's ornaments was a large brooch or " breastpin," a real necessity for fastening the round collar or the fichu. Brooches were made in all sorts of materials, from imitation gold or " pinchbeck " to the purest real gold. They were available in great variety: set with such stones as quartz, cairngorms, and agates; made of gold enamelled in black; mosaic designs merely framed in metal; little picture-frames containing miniatures or even fancy pictures; or enclosing, under glass, the hair of some beloved person, patiently woven into tendrils and foliage, or merely laid in a coil.

Garnets were very fashionable, so were turquoises; to combine them with seed-pearls was a favorite jeweler's trick. Need it be recalled that wedding-rings were wide gold bands and that engagement rings had their stones (not necessarily diamonds) in heavy gold mountings? Cameos were as popular as ever; coral was liked, too.

Sets of jewelry, consisting of brooch, earrings, bracelets, sometimes also a

locket, were every whit as popular as in the last period. Bracelets were of various kinds:—jewels or beads strung together; rigid pieces of gold hinged and clasped; coils of gold; and gold woven extraordinarily fine and flexible like tape, drawn up on a slide to fit the arm and finished with gold fringe. Lockets were large or small, worn on linked gold chains or bits of black velvet, and they hung rather high upon the chest. After about 1840 most women had pierced ears. The ornaments they hung there varied from little studs or hoops to very large dangling affairs, hooped, oval, bottle-shaped, or showing designs fantastically derived from Gothic or oriental models. When in the latest fifties the fashionable coiffure began to uncover the ears, earrings became even more heavy and impressive. Rather large gold watches were hung on heavy gold chains and pinned at the belt or, occasionally, upon the breast (fig. 19). Little girls, who had their ears pierced at a tender age (there was a belief current that the operation was good for the eyes), had little earrings to put in them, of plain gold or set with turquoise, coral, or seed-pearls; they wore small lockets, too, of gold and enamel, and simple rings and bracelets. Mourning jewelry had its place at least once in nearly every woman's trinket box; it consisted of the usual matched ornaments, *i. e.,* brooch, earrings, bracelet, perhaps necklace and separate pins, in dull black stone or a crinkly substance called " crêpe stone."

<div align="center">ACCESSORIES</div>

Men. The quizzing-glass fashionable in the twenties and thirties was succeeded by the monocle (fig. 7), which has remained ever since, to the average American, the badge of a " swell," " dude," or " dandy." Snuff-taking was out of style, and pipes were seldom smoked by the fashionable, but cigars were omnipresent at masculine gatherings, though women protested against having their lace curtains contaminated and so smokers finished their after-dinner cigars before they joined the ladies. No such elaborate etiquette was required for smoking as for taking snuff, nor was there any pretty accessory connected with the habit. Men carried canes, usually light and small; they wore gloves assiduously, still favoring light colors for the street; at dances they put on white kids, which must have been very welcome to their partners in the waltz, the polka, and the schottische, as a protection to their delicate finery. The well-dressed man added a boutonnière as the last touch of elegance.

Women. Parasols remained small. During the thirties they had slim long handles and long tips, but a small spread; in the forties the walking-stick parasol returned to favor (cf. fig. 11, Chap. XVII); in the fifties parasols were again short-handled (fig. 17), and in the sixties not much longer (fig. 18). The small parasol which turned on a hinge, in use since the beginning of the century (an example of which is illustrated in fig. 15, Chap. XIV), during this period was very popular as a carriage parasol, for use in the open landaus in which ladies took their daily airing. It was a tiny thing now, not more than twelve inches across. One more conceit of the times was the parasol with a

whip at the end, which a lady might use when she drove in her own pony-carriage. Parasols were dainty and frivolous, trimmed with fringe (fig. 18), ribbons, or real lace (fig. 17); umbrellas, on the other hand, were large sturdy affairs of black silk or cotton, intended for service and carried by men as well as women.

Most housewives put on aprons over their dresses, and there were appropriate aprons for each household situation. Cooks wore checked gingham; waitresses and parlor-maids white aprons made with enveloping skirts and bibs; ladies sat at their sewing in dainty little aprons gathered or shirred on a shaped belt and furnished with pockets, either slit or patches. Such aprons were often embroidered or edged with lace or fringe, and were of black or colored silk as frequently as of white lawn. School mistresses wore plain little black sateen aprons over their light or dark dresses (fig. 12); so did women who stood behind shop counters.

Rather small folding fans of gauze or painted silk (fig. 10) and somewhat larger, plumed fans (fig. 15) were still favorite accessories in the ballroom; so were bouquet-holders made of silver or gold (fig. 14). Notice upon the holder illustrated the addition of a ring for the handkerchief. Throughout the period muffs were small and round, growing even smaller as the years went on. Reticules were considered indispensable: they were large or small, flat, round, or long, made of silk stuff, netted silk, or beads.

Really long gloves were not in style. With the almost invariably long-sleeved street dress gloves were naturally only wrist-length, but even with the shortest evening sleeves they came only a little distance up the arm (fig. 10). In the fifties they were a bit shorter than they had been in the preceding decade (fig. 14), and at that point they remained during the sixties also. As pictured in fig. 14, the tops of these short gloves were frequently finished by a pair of bracelets. Evening gloves were white, street gloves of delicate colors. Kid, silk, or lace mitts were still worn both indoors and out (fig. 13).

During the crinoline period, when caps were small, they were carried in little flat boxes, according to the custom described in this section, Chap. XV. It may be interesting to recall that these "bandboxes" took their name from their original function, to carry a man's "bands" or collar. Ladies carried cardboard bandboxes big enough to hold their bonnets, too, and gentlemen, leather boxes of the special shape needed to protect a high silk hat. A traveller might have a choice of luggage; he (or even she) could manage to carry a carpet-bag (a big satchel, actually made of carpeting) or a somewhat smaller bag of the same shape, made of linen crash embellished, in color, around the edge with feather-stitching and in the center of one side with an embroidered initial. For long sojourns big square trunks were available, for shorter stops, small sturdy chests which could be lifted by any husky man. These little trunks were covered with cowhide, sometimes tanned, sometimes with the hair left on, stoutly bound and cornered with metal and studded with brass nails.

SOMETHING ABOUT THE SETTING

Black walnut and haircloth sofas, high-backed chairs, marble-topped dressers and tables (everything heavily carved in designs of Gothic inspiration), scarves on the square pianos and fringed lambrequins on the marble mantels, Brussels lace curtains, heavy looped overdraperies, the whatnot in the corner: all these details of a Victorian parlor are familiar to most of us. The chair illustrated (fig. 12) is an agreeable example of contemporary furniture; with its wide seat and cabriole legs it is reminiscent of the early Chippendale styles, but that only proves again the imitative character of Victorian design. This chair is upholstered in satin instead of the more durable and familiar haircloth.

PRACTICAL REPRODUCTION

Materials. See this section, Chap. XV. Men's garments, unless they are supposed to be worn in hot climates, when they may be white linen or nankeen, really must be woolen, boys' may more often be khaki or denim.

All the cotton goods enumerated earlier in the chapter are still procurable, most of them at modest prices; many a "Crinoline" play can be dressed entirely in such materials. Several of the modern silk-substitutes look even better on the stage than expensive real silks. Of these perhaps the best is rayon taffeta. Rayon satin and moiré are excellent, too, if they are backed with thin lining cambric, or even if the petticoats they hang over are strong enough to give them the body they lack. Sateen makes pretty dresses, and you can get figured sateen in appropriate patterns. But your big stand-by will be tarlatan. Use it in white, black, or any color, cut it into flounces with pinked edges that you put on double with a heading at the top; make it up over sateen or even cambric. It will be as effective on the stage as lace, and much quicker to work with.

Trimmings. Use artificial flowers from the ten-cent store, cotton tape, rick-rack, soutache, straw braid that you buy from millinery supply places, gilt braid from the lamp-shade section, coarse and cheap fine lace, fringe, and above all jet. See if there are not people who would like to donate the jet they have been saving all these years. Nothing could be more appropriate in this period than jet, and nothing except *diamenté* trimming is more effective on the stage.

Jewelry and Accessories. You will have little difficulty in borrowing the correct jewelry or in buying at the ten-cent store modern trinkets that will be appropriate. You may be able to borrow small parasols; if the cover has rotted but the skeleton is still intact you can recover it without too much trouble. Remember that here, too, you may use tarlatan to represent lace.

To make men's collars: buy ready-made collar-bands of the correct size; cut a paper pattern of the collar you wish to imitate and make your collar from that, of doubled heavy muslin, starched. To make the fitted cravats, see this section, Chaps. XIV and XV. The other neckties are just straight pieces of doubled material (sateen will do) cut the desired length.

Millinery. See this section. Chaps. XIV and XV. You can use modern high

hats, unless you happen to find some authentic old "stovepipes." Modern felts will twist into the slouch hat (fig. 1a). You will have more difficulty with the hat shown in fig. 1b, unless you happen to find a woman's hat that approximates the shape. You can block that without much trouble (Chap. XX). You'll probably have to block the high, round-topped felt shown in fig. 6. Cut down the straw hat (fig. 5) from a modern straw. Make the visored cap (fig. 4) by a skullcap pattern in four or six sections, adding a visor or eyeshade, which you can buy cheap and cover with the cap material.

For ladies' caps, bonnets, and hats see this section, Chaps. XIV and XV. The cap in fig. 13 is just a straight piece of silk or muslin edged with braid or lace, draped and tacked upon a small inner "baby-bonnet." Roll the front edge back over a small pad and trim as shown.

You should have no trouble in copying the various styles of hairdressing sketched, provided you have some switches and curls to work with. Remember that the "snood" or ribbon around the head is very useful in holding on false hair. You can buy coarse-meshed nets of bright silk at the ten-cent store; they are sold to put over water-wave combs. Use them for the nets into which the back hair or chignon is bundled. It is even possible to fill such a net with crêpe hair and attach it to a bobbed head by means of a ribbon.

Shoes. To make shoes, see this section, Chap. XV. Provide all the men you can with elastic-sided house-slippers, or give them gaiters to cover their own shoes. Have them wear pumps with evening dress if at all possible.

Women and children may wear elastic-sided shoes if they can get them, otherwise ballet-slippers and "Mary Janes," *i. e.,* low-heeled one-strap slippers. Women's dresses are so very long that they may without offence wear modern oxfords, "colonial pumps," or kid bedroom slippers. With costumes dated after 1840 heels are permissible, though not necessary. Warn the actresses not to wear high spike heels; they will spoil the gliding walk which was an admired feature of the time. Slippers with "baby French" heels are the best; they are sometimes procurable in "growing girl" departments of shoe stores.

Renting. See this section, Chap. XIII, for opinions about renting masculine costumes. It is possible to get good and authentic clothes of the forties, but costumers do not always stock the later styles, and will try to pass off the earlier suits if you do not make your selection in person. Their hats can generally be trusted.

CUTTING THE GARMENTS

Men. You will do well to try making over cast-off modern suits into something approximating the styles of this period. With evening tailcoats this is particularly easy, for the differences that count are very slight. You can nip in the waist by tightening the underarm seams and taking darts in the back. Narrow the trousers by taking a seam on both inside and outside of the leg from the knee down. If you are not allowed to change the dress suit, use it "as is" and make a new vest, cutting it by the "Uncle Sam" pattern and

changing it to match the sketch (figs. 2 or 7). With the proper collar and tie it will make the costume sufficiently different from modern evening clothes to satisfy most of the audience.

It is probable that you can borrow " Prince Albert " or frock coats. If you must make a cutaway like fig. 4, use the " George Washington " or " Continental " pattern (Chap. XX) as a guide; change the shape of the skirt and add collar and lapels. You will have to cut them experimentally first from wrapping-paper, then from cheap cloth, before you cut into good material.

Sack coats may be altered from modern coats, if you are allowed to change the lapels. If not, merely turn them up higher and fasten over, putting one more button at the top. Choose a loose coat to begin with.

Modern trousers are all right to use, especially if you may narrow them a bit from the knee down. Adjust the length to conform to the sketch chosen; make sure that you leave neither cuff nor front crease; strap under the foot with broad black elastic, if you wish. You are unlikely to come across trousers of a plaid like fig. 5; if you can find the material or make it by batiking (see Chap. XX) you can cut the trousers by the help of the " Uncle Sam " pattern, changing the shape a bit according to your sketch.

Cut the cape in fig. 2 by a woman's cape pattern, adding shoulder cape and collar. Use a lounging coat pattern for the overcoat in fig. 3.

Women. For cutting women's bodices, see this section, Chap. XV. Any peculiarities of these bodices have been commented on in the text. If you can get an authentic pattern of the period, or are at liberty to take a pattern from a real bodice, by all means do so. Otherwise you must be content with the ordinary bodice or fitted lining pattern (see Chap. XX). You will have to cut the shoulder as long as you can and drop the trimming over the arm to give the sloping effect.

When you have made either a petticoat of crinoline with three gathered flounces (appropriate to wear under the skirts of figs. 10, 11, 12, and 13) or the steel hoops described in Chap. XX (necessary for all the other skirts pictured), the rest is simple enough so far as construction goes. What you need now is time and patience to sew together breadths of material, to gather them in to the waistband, to hem these many yards, and to put on the flounces and other embellishments. Only baste the hem of the skirt till you have seen it through one rehearsal on the stage and are sure just how long the wearer can manage it.

The construction of wraps has been suggested in the foregoing pages. Any simple jacket pattern can be adapted for the coat, fig. 18; or you can use the " domino " pattern (Chap. XX). Its sleeve is almost right as it is. Make it a bit narrower from shoulder to elbow, a bit wider from there down, and shorten it.

There are so many dresses of the sixties and even the forties still in existence and wearable, that you may be able to costume your play in part from garments ready to hand. This chapter should be of service in helping you to

identify and date such costumes and to construct others appropriate to go with them.

Suggested Reading List

(See this section, Chaps. XIV and XV.)

You will find *History of Costume* by Köhler and von Sichert, and *Dress Design* by Talbot Hughes valuable for their photographs of actual garments, *Die Mode, Menschen u. Moden in Neunzehnten Jahrhundert,* by von Boehn, valuable for its many reproductions of contemporary pictures.

Where Further Illustrative Material May Be Found

(See this section, Chaps. XIV and XV.)

No sources better repay study than the illustrated periodicals, both those professing interest in fashions and those which simply picture daily life. Look in the bibliography for names and dates of these publications. You can find some of them on file in city libraries, some in small libraries also, and some in your friends' attics.

The painters and illustrators listed in the beginning of this chapter are there because of their value to the costumer; even so we have named only a few of a large number. A visit to almost any art museum will acquaint you with many portraits by these or other artists of the time. Daguerreotypes, made between the years 1839 and 1851, and photographs after the latter date are of course of great value to the costumer. It is obvious that nothing can be more useful to the student than actual contemporary garments; you will find them collected in many places, among others the Victoria and Albert Museum, the London Museum, the Museum of the City of New York, and the Metropolitan Museum.

Sources of Sketches in This Chapter

Upon all the above sources we have drawn freely for our sketches. Every detail has been encountered more than once, so that it is very difficult to acknowledge the originals. Out of the mass of material may be mentioned, as the immediate inspiration for most of our details:—Caricatures by Cruikshank, Leech, and several anonymous contributors to *Harper's Monthly* during the years 1850–1865; fashion-plates in Godey's, Graham's, *Harper's Monthly,* and Peterson's from 1841–1865; "The Album," by A. E. Chalon, R. A., in Dr. James Nicholls' collection, reproduced on the cover of the *Connoisseur,* Nov. 1926; "The Lady With the Dove," Brett, Tate Gallery; "Mrs. Collman," Stevens (the Belgian), National Gallery; portraits of Robert Browning and Mrs. Browning by Lowes Dickinson; of Queen Victoria and Prince Albert by Sir W. Ross; of Nathaniel Hawthorne by Charles Osgood; of the Empress Eugénie and her ladies by Winterhalter; of Clara Barton by Henry Inman; of "S. M. Marie Henriette en 1853," in the Brussels Museum; a portrait by Sir John Millais of his little daughter; photographs of Lewis Carroll, Louisa May Alcott, President Lincoln, and others; a hat and a flower-holder in the Museum of the City of New York; Queen Victoria's going-away dress in the London Museum; two dresses in the Metropolitan Museum; and the family oil portraits, miniatures, daguerreotypes, and photographs of the author and her friends.

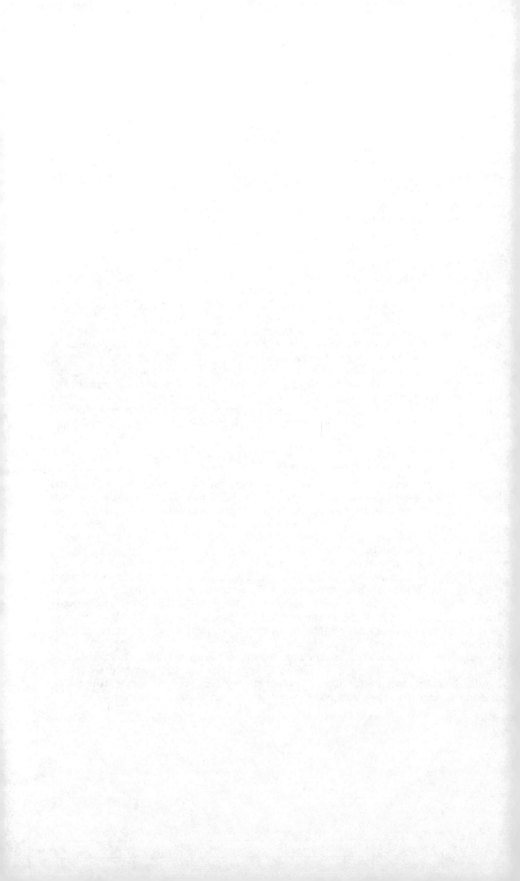

Chapter XVII
BUSTLE

DATES:

1865–1890

■■

Some Important Events and Names

ENGLAND	FRANCE	GERMANY	AMERICA
Victoria	Second Empire to 1870 Napoleon III Eugénie	William I, King of Prussia, 1871–1888 Emperor of Germany, 1871	PRESIDENTS Andrew Johnson, 1865–1869 U. S. Grant, 1869–1877
Edward, Prince of Wales Alexandra	Third Republic, 1870 Thiers, first President	Frederick III, r. 1888 m. Princess Victoria of England	R. B. Hayes, 1877–1881 James A. Garfield, 1881 Chester A. Arthur, 1881-1885
Disraeli, d. 1881 Prime Minister, 1874–1880	Gambetta, states- man, 1838–1882		Grover Cleveland, 1885–1889
Control of Suez Canal, 1875	Franco-Prussian War, 1870–1871	William II, r. 1888–1918 m. Augusta	Reconstruction, 1867–1872
Victoria, Empress of India, 1876	WRITERS Emile Zola, 1840–1902 (especially influential in the eighties)	Victoria of Schleswig- Holstein- Augustenburg	Union Pacific, first transcontinental railroad, 1869
Gladstone, d. 1898 Prime Minister, 1868–1874 1880–1885 1886 First Home Rule Bill, 1886	Alphonse Daudet, 1840–1897 Edmond de Gon- court, 1822–1896 Jules de Gon- court, 1830–1870	Otto von Bismarck, 1815–1898 Chancellor of German Empire, 1871–1890 General von Moltke, 1800–1891	Panic of 1873 Centennial Exposition, Philadelphia, 1876 Wyoming admitted, 1890, first state with Woman's Suffrage
Death of Gordon at Khartoum, 1885	Guy de Maupas- sant, 1850–1893		WRITERS Emily Dickinson, 1830–1886
Queen's Jubilee, 1887	Pierre Loti, 1850–1923 Anatole France, 1844–1924		Mark Twain, 1835–1910 "Tom Sawyer," 1876 Wm. Dean Howells, 1837–1920
WRITERS Dickens, d. 1870 Eliot, d. 1880 Meredith, d. 1909 Browning, d. 1889 Tennyson, d. 1892	PLAYWRIGHTS Dumas fils, d. 1890 Victorien Sardou, 1831–1908		Henry James, 1843–1916 Bret Harte, 1836–1902 "Poems," 1868–'71 (about the West)
Swinburne, 1837–1909 Kipling, 1865– "Plain Tales From the Hills," 1888	ACTORS Sarah Bernhardt, 1844–1923 début, 1862		ACTORS Joseph Jefferson, d. 1905 Charlotte Cush- man, d. 1876
R. L. Stevenson, 1850–1894 "Treasure Island," 1883	Coquelin, 1841–1909 début, 1860		

Some Important Events and Names

ENGLAND
(*Continued*)

" Kidnapped,"
1886
" Dr. Jekyll and
Mr. Hyde," 1886

Oscar Wilde,
1856–1900

Thomas Hardy,
1840–1928
" A Pair of Blue
Eyes," 1873
" Return of the
Native," serially
in Harper's, 1878

Mrs. Humphry
Ward, 1851–1920
" Robert Elsmere,"
1888

PLAYWRIGHTS
Henry Arthur
Jones, 1851–1929
" The Silver
King," 1882

Arthur Wing
Pinero, 1855–1934
" The Magis-
trate," 1885

Gilbert, 1836–1911
and
Sullivan, 1842–1900
Collaboration,
1872–1889

ACTORS
Henry Irving,
1853–1928

Ellen Terry,
1848–1928
début, 1856

Beerbohm Tree,
1853–1917

ARTISTS
Du Maurier, d. 1896
Burne-Jones,
d. 1898
Rossetti, d. 1882
Morris, d. 1896
Hunt, d. 1910
Millais, d. 1896
Cruikshank,
d. 1878

Kate Greenaway,
1846–1901
First illustrations,
1873

SCIENTIST
Joseph Lister,
1827–1912

FRANCE
(*Continued*)

Rejane, 1857–1920
début, 1875

Antoine's Theâtre
Libre, 1887

PAINTERS
Impressionism
Manet, d. 1888
Renoir, 1840–1919
Monet, 1840–1926
Dégas, 1834–1917
Toulouse-Lautrec,
1864–1901
Seurat, 1859–1891
Honoré Daumier,
1808–1879

SCIENTIST
Louis Pasteur,
1822–1895

AMERICA
(*Continued*)

Helena Modjeska,
(Polish-American)
début, 1868

Richard Mansfield,
1854–1907
first hit, 1883
"A Parisian
Romance"

Ada Rehan,
1860–1916
début, 1874

Mary Anderson,
1859–
début, 1875
retired, 1889

Mrs. Fiske,
1865–1932
starred in 1882

Playwright,
Steele MacKaye,
1842–1894

PRODUCER
Augustin Daly,
1838–1899
Repertory Company,
1879–1899

ARTISTS
Thomas Nast,
(cartoonist),
d. 1902

Edwin Austin
Abbey, 1852–1911

Howard Pyle,
1853–1911

Winslow Homer,
1836–1910
Illustrated for
Harper's Weekly
from 1863

James McNeil
Whistler,
1834–1903

John Singer Sargent,
1856–1925
(portraits date
from 1877)

Some Plays to Be Costumed in the Period

Tom Robertson's " Caste " (1867).

Louis N. Parker's " Disraeli " (about the purchase of the Suez Canal).

Bennett-Knoblock's " Milestones " (second act, 1880).

Sardou's " Dora " (" Diplomacy " in English) (1878), " Fedora " (1882), and " Divorçons " (1880).

Gilbert and Sullivan's " Trial by Jury " (1875), " Pinafore " (1878), " Pirates of Penzance" (1880), " Patience " (1881).

Pinero's " The Magistrate " (1885–'87), " Sweet Lavender " (1888).

Ibsen's " The League of Youth " (1865), " Pillars of Society " (1877), " A Doll's House " (1879), " Ghosts " (1881), " An Enemy of the People " (1882), " The Wild Duck " (1884), " Rosmersholm " (1886).

Tolstoy's " Anna Karenina " (dramatizations) (1873–77), and " The Power of Darkness " (1889), (mostly Russian peasantry, however).

Steele MacKaye's " Hazel Kirke."

Dramatization of " East Lynn " (1861), a novel by Mrs. Henry Wood.

James A. Herne's " Shore Acres " (1892).

François Coppée's "Le Père" (Pater Noster), about the Commune of 1871.

BUSTLE

MANY a material phenomenom which is a commonplace of our daily life had its tryout in the late Victorian decades, for example: domestic electric lighting (Edison exhibited his first lamp in 1879); the transatlantic cable (laid in 1860); the horseless carriage (an American patent was taken out in 1879); and Edison's phonograph (1877). Many a subject of discussion very prominent just before the World War was novel in the seventies and eighties, such as: strikes, settlement houses, the higher education for women, women's suffrage, the Red Cross, " modern art," the problem novel, Biblical higher criticism, Ibsen's plays, the " star " system in the theatre, musical comedy, socialism, nationalism, large-scale emigration to America, colonial expansion, Imperialism.

In the same decades " sport " was taken up in a serious way; certain ancient games were dug from a provincial setting, dusted off, equipped with rules and codes, and assimilated directly or vicariously into the lives of thousands. Tennis, an old favorite in monarchical France, burst upon the English middle class in the mid-seventies and presently travelled across to America, pushing croquet into the background even as a feminine pastime and commencing to share with archery the enthusiasm of the " weaker sex." In America, intercollegiate football was born when in 1869 Rutgers played a match of soccer with Princeton, both teams clad indistinguishably in tweed suits and caps. In 1871 baseball became the national sport entertainment of America. During the eighties the Royal Scotch game of golf captured the attention of Englishmen, and soon of Englishwomen also, and by the end of the decade began to get a foothold among the anglophiles of the United States. In the mid-seventies young men risked broken necks on bicycles with high front wheels; in 1887 they mounted " safety " bicycles and began to work up that enthusiasm for the new exercise which reached its highest pitch in the nineties.

In England the almost fabulous old Queen was overshadowed in public importance by the cosmopolitan and able Prince of Wales. Du Maurier has left us pictures of the brilliant and handsome ladies and gentlemen who filled London drawing-rooms. During those years when Princess Alexandra was the arbitress of English fashion, conservative but alert ladies gradually altered their Victorian furnishings and even their dresses under the influence of Burne-Jones, William Morris, Whistler, Japanese art, and the Esthetic movement. At select gatherings Oscar Wilde, king of the Esthetes, holding a green carnation, talked in epigrams; and audiences at the Savoy, recalling him,

laughed at the poetical hero of "Patience," who "walked down Piccadilly with a poppy or a lily in his mediæval hand." "Beauties" abounded, their archtype being the lovely Mrs. Langtry, the "Jersey Lily." Famines ravaged Ireland, and Irishmen crowded the boats to America. In English industrial areas children and women toiled in defenseless misery and men went on strikes. English soldiers and civil servants went out to the edges of the far-flung conquests and sent their children home to be educated. Gladstone pushed through domestic reforms; Disraeli built up the Empire of which Kipling was to sing.

In France the Second Empire continued for five years to dazzle compatriots and foreigners, then it vanished before the Prussian invaders; during the remainder of the century the French were busy adjusting their new government, paying indemnity to Germany, mourning Alsace-Lorraine, and planning "Révanche." Yet Paris was not so occupied as to prevent its retaining the leadership of feminine fashion.

Having established the German Empire by a policy of "Blood and Iron," Bismarck proceeded to dictate its growth, building up the army, the navy, industries, schools, universities, and the national pride, until at the end of the eighties he stepped out and left the second Emperor William to go it alone.

Austria-Hungary had its hands full keeping in their places the various subject peoples who didn't want to be Austrian or Hungarian. Russia did a good deal of seething, which became audible to the West in the writings of Turgeniev, Tolstoy, and Dostoievsky. The Scandinavian Ibsen not only altered the course of dramatic writing over Europe and America, but with the problem presented in "A Doll's House" gave a push forward to the already vocal Feminist cause.

After the Civil War the United States went through a quarter-century of growing up. Here was a kaleidoscope: reconstruction, cattle-raising, discoveries of gold, silver and oil, Indian fighting, railroad building, pioneering, trusts, strikes, panics, Chautauquas, Women's clubs, Women's votes, immigration both European and Asiatic, starving multitudes packed into city slums, millionaires in Fifth Avenue mansions. There were not lacking writers with acid-dipped pens to show up the new-rich of the "Gilded Age" nor yet cartoonists to put them on paper, nor, rarer, gentler humorists like "Mr. Dooley," who regarded the foibles of his time more kindly if no less shrewdly. Europe laughed at the rich vulgarians and hastened to sell them clothes, pictures, castles, and titled sons-in-law.

GENERAL CHARACTERISTICS OF COSTUME

Historians of dress are tempted to sum up the masculine habiliments of the late Victorian era in a phrase or two. Certainly there is little of interest in the costume, divorced as it is from nearly all graces of line or color. The best to be said is that the technique of tailoring constantly improved, that the ideal of good grooming was put steadily higher. There is perhaps a kind of art in

plain, uncompromising standardization, in which the clubman differs from the grocer's boy only because of the superior skill of his tailor and valet and in the greater sobriety of his *ensemble*. During Elizabeth's reign courtiers wore velvet and satin, scarlet and green and gold, while to the 'pothecary's apprentice was assigned a blue cloth coat and a " city flat cap "; in Victoria's later days it was the London coster who got himself up in a fantastic gala dress, the Bowery Boy who went in for red neckties, figured vests, and flashing scarf-pins, while the Prince of Wales as the *beau ideal* of fashion restricted himself to black and gray, broadcloth and tweed.

The actual changes in men's dress from the period of the Crinoline to that of the Bustle have to do with closer-cropped hair, less flamboyant whiskers, a somewhat greater variety of hats and coats, and returning knee-breeches. These last, which had been the emblem of aristocracy when pantaloons were regarded as badges of the Jacobin, were now found in the opposite camp, symbols of the free-and-easy world of sports in contrast to the trousered formality of counting-house and drawing-room. Now that restraint and care-ful grooming were the essence of good dressing, the London tailor was the dictator of men's fashions.

For the woman in whose life clothes were of major importance, the *couturiers* of Paris were the oracles; Worth was the name to conjure with, particularly in the sixties and seventies. Even after the Empress Eugénie had fled, as soon as dressmakers could recover from the horrors of the Siege of Paris, they were back at their job of gowning the smart world. And truly astonishing to later generations were the designs they made during the artificial seventies and eighties. For if it had been " ag'in natur " for a woman to look like a perambulating pyramid, how much worse to resemble a two-legged camel! Upon her head she fastened pounds of hair shorn from the heads of God knows whom, and to her rear she attached an avalanche of drapery upon the hillock of a bustle.

Yet the substitution of one grotesquerie for another did not happen over-night. The last five years of the eighteen-sixties was a transition time, during which the hoop was flattened in front and pushed out behind. For thirty years some form of crinoline or hoop had been an indispensable part of women's dress; nothing, it seemed, could dislodge it. A paragraph in *Godey's Lady's Book* for June, 1869, sets forth the considered belief of the fashion prophetess: " We are frequently inquired of in reference to hoop skirts whether they are still going to remain in fashion or not. We do not think it can be a matter on which there can be any doubt. Hoop skirts are too comfortable and economical to be readily given up. The fashion may, and in fact will change, but to give them up entirely is not to be thought of. . . . Besides the economy, durability, and healthfulness of the skirts, they have other claims than those mentioned, for in their manufacture are employed thousands of hands, mostly women, who earn from five to twelve dollars a week at this easy work." Yet after six years the hoop had vanished (alas for the thousands of hands!). Women's

figures clothed were almost as slender as they were undressed. By 1878 it was possible for a satirical pen to depict as identical the back views of a lady in a long trained dress and a mermaid *au naturel* (fig. 15). Unfortunately such a silhouette had not come to stay; about 1885 the bustle returned in a worse form than ever. During the next five years it was deprived of its greatest horrors, which have never been revived. Yet throughout the nineties a small edition of the bustle, called a " figure improver," was found necessary to emphasize the fashionable curve, and it survived vestigially even into the twentieth century.

Since shortly after Waterloo the shape of a woman below her waist had not concerned the general public, but now, *i. e.,* from the late sixties onward, her hips became important, and corseting them a matter for serious consideration. Although the " Grecian Bend," forward-tipping upon high-heeled shoes, emphasized a curving rear, the abdomen was not flattened, for the " straight-front " was yet in the future. The corset of a late Victorian lady rose up high in front, sustaining and even pushing up the bust; it pressed with cruel firmness upon her ribs, her diaphragm, and her internal organs; and then curved out with a generous sweep for a short distance over abdomen and hips. Even under the princesse gowns this shape was unchanged, the smooth modelling of the figure being accomplished by carefully cut under-petticoats.

In England during the late seventies and the eighties a certain number of women adopted a costume very different from that dictated by the fashion arbiters. French and American ladies seem to have remained cold to the appeal of this costume (early Italian as interpreted by Burne-Jones and the disciples of William Morris), but its influence cannot be ignored as a factor in English life. An eye-witness of the " æsthetic " dress has this to say of it: " It was really quite common among high-brows and artists and soulful ladies. I had a governess (about 1886-7) who wore ' sage-green,' or peacock or ' electric '-blue, or terra-cotta, woolen gowns smocked across the front, and sometimes at wrists and sleeves, too, with flowers, æsthetic flowers like daffodils, clematis, and sunflowers, embroidered on the skirt by her own hand—I daresay none too skilfully. The dress had, or seemed at that time to have, no waist. I adored her with passion, and she used to present me with pictures by Fra Angelico and Giotto, which I admired for her sake and the family disapproved of as ' papist.' She was, I daresay, rather ridiculous but there were lots like her, and her kind often comes into plays and novels (the ' twenty love-sick maidens ' in *Patience* looked just like her). Burne-Jones was her model and Liberty her draper. I do think she ought to be done." So here she is. (The influence of the House of Liberty is mentioned later in this chapter, under MOTIFS.)

Until the last years of the eighties it seemed as though women other than these English esthetes would refuse to change their dressing in response to the promptings of either art or health. But about 1889 there was a decided turn toward simplicity, though at first the reform seldom went to the extent of

loosening a corset-string. Probably that change, of which we are the fortunate heirs, may be credited more to sports than to art. Although croquet could be played in trailing skirts, and archery was possible to the hobbled, tennis required feet and even legs; eventually it was realized that lung-capacity was necessary, too. But most of these improvements were rudimentary at first. To an eye accustomed to the tennis-shorts of the nineteen-thirties, a sports-costume of 1889 is absurdly restrictive; to the contemporary eye, used to the conservative " walking costume " of five years before, the new garments were alarmingly emancipated.

Fashion-plates published in the last thirty years of the century not only lack the artistic charm of earlier designs, but put a heavy tax upon credulity. It is not possible that women ever distorted their bodies into such shapes! Indeed, on comparing with the fashion-plates photographs of even the most stylish flesh-and-blood women one is relieved to learn that the ideal of the " artist " was practically never realized.

MEN

Heads. From the seventies on, the bushy hair fashionable in the sixties was less in evidence; shorter locks were coming in. Side-parted hair looked very like modern. Parts in the middle or a trifle to one side were often worn throughout the twenty-five years (fig. 7). While during the seventies the hair was divided all the way from forehead to nape, and sometimes the front locks were trained to curl up in little horns over the temples, in the eighties the line went only from forehead to crown, and the hair lay down flat across the front. Various rather individual coiffures were also to be remarked, such as hair brushed straight back, or up in a bushy pompadour; hair brushed forward from a central back parting (fig. 1a); hair growing longish in back.

The age of hairy faces was not yet past. Side-whiskers remained for a long time, though the true " piccadilly weepers " were not modish much beyond 1870. Whiskers springing from the point of the jaw (fig. 1a) and neat mutton-chops (fig. 1b) were considered respectable adornments, such as befitted a bank president. Side-whiskers were grown without moustaches (fig. 1a) and so were beards, especially those allowed to flourish only *under* the chin (fig. 2a). Well into the eighties beards covering the lower part of the face were favored by some fashionable older men (fig. 2b), and so were the clipped beards of the style familiar to Americans on portraits of General Grant. Rather commonly moustaches accompanied beards (fig. 1b). In the eighties young men affected most often a longish drooping moustache without a beard (fig. 1c). By 1889 smooth faces were coming back to fashion.

A high silk hat continued to be the correct thing for dress; many men wore it habitually (figs. 5 and 7). A hat of the same shape, covered with light-colored cloth was a favorite on coaching parties, at the races, and even in afternoon calling. Other styles were more popular with the man in the street, a prime favorite being the derby or bowler. As in the sixties, so also in the

seventies and eighties it had a shallow crown and a narrow rolling brim (fig. 1b). It was made in tan and brown felt as frequently as in black. Midway between high hat and derby came a head-covering sometimes called a " plug," of stiff felt in white and light tones of tan, brown, or pearl-gray (fig. 1c). Though this high-crowned hat had been worn for some years before, it was particularly popular in the eighties. Again, plenty of men went about in the rather nondescript felts with shallow, flat crowns and widish brims, described in earlier pages (Chap. XVI). During the seventies a good many substituted for them fairly wide-brimmed felts with shallow *round* crowns (fig. 2a). The soft felt " slouch " hat popular among Southern and Western planters " before the war " rose in general favor. Its type may be seen in fig. 1a, Chap. XVIII. Sports had by now inspired a variety of special head-coverings. Perhaps the most amusing is a shallow-crowned, wide-brimmed felt with a button on top (fig. 1a) which came along in the sixties and held on during the following decade. A cloth hat with a stitched brim to be turned up or down was a favorite at any sport (fig. 4). It was in the eighties that straw hats sprang into popularity; at this date they were shallow-crowned (fig. 2b). Caps included the " fore-and-aft," made of checked tweed, with peaks front and back and flaps which were usually tied together on top, but could be let down over the ears and even tied under the chin (fig. 3); it was worn by hunters and travellers. Still other caps were a smaller visored shape especially favored for tennis (fig. 6), and a " tam-o'-shanter," worn, it appears, either for tennis or skating (fig. 2c).

Necks. Most collars were fairly low. The turndown collar of the sixties (figs. 1b and 6) continued to be the choice of many men, though an open wing collar was equally popular (figs. 1c, 2c, 5 and 7). A collar which stood up and either met or spread apart in front was fairly common in the seventies and eighties (figs. 1a, 2a and 4); it grew higher at the end of the decade. During the eighties somewhat more choice was permitted in collars with evening dress than is usual nowadays; any one of the fashionable types may be seen upon contemporary pictures of well-dressed men.

The string tie, often narrower than that popular before the Civil War, was common during the succeeding decades (figs. 1a and b, and 2a). As nowadays, it was white for dress, black for other occasions; yet Protestant ministers wore white ties with frock coats in the daytime. From the sixties some men affected soft silk (Windsor) ties as an artistic or Bohemian neck-finish. The sixties had seen the advent of the four-in-hand, but its real popularity began in the seventies, a popularity which it has never lost. It might be narrow, wide, or of medium height. Though in the eighties all four-in-hands were somewhat wider and thicker than at any other date, this tie seems to have been made up in so much variety that a man might follow his individual taste (figs. 2b and c, 4, 6, 7). The ascot (a version of which had been included in sports dress as early as the twenties) became very popular during the eighties and maintained that popularity for a long time after (figs. 1c and 5). It was wider than any

FIG. 1.
Outing hat of the seventies. Derby of the seventies and eighties. Light felt hat of the eighties; ascot tie.

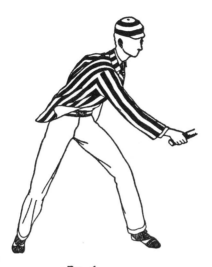

FIG. 6.
Tennis togs, 1886.

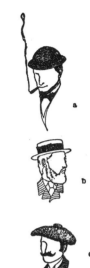

FIG. 2.
Round felt hat, 1871. Straw hat, 1882. Tam-o'-Shanter, 1884.

FIG. 4.
Sports outfit, 1880 to 1890. Note spats and a revival of breeches.

FIG. 5.
Calling costume of the eighties (1886).

FIG. 3.
An Inverness cape and "fore-and-aft" cap, 1870 to 1885.

other cravat and could actually be worn without a shirt since it completely filled the space between collar and high-cut vest. In the ascot and four-in-hand a man could find some outlet for his love of color. As now, he chose from the patterns presented to him that which suited his individual taste. Scarf-pins, necessary to secure the ascot tie, were not so often worn with the four-in-hand.

Bodies. The evening tail coat changed very little; subtle differences in the fit of the body or the set of the sleeves alone distinguish the formal dress coat of the seventies and eighties from its predecessor of the sixties or its descendant of the nineteen-thirties. Some conservatives even as late as the seventies were still wearing tail coats in the daytime.

The frock coat likewise underwent comparatively few changes (fig. 7). Rivalling it in popularity as a formal day-coat came the cutaway, a garment which had already been worn in the sixties. For calling, teas, garden-parties, day weddings, and church the cutway was the fashion (fig. 5). At such formal functions it was of black broadcloth; in lighter colors and in rougher fabrics the same coat could be seen on coaching parties, at the races, and even in Wall Street. The edges of these coats were often bound with braid (fig. 5).

The sack coat had become everybody's coat. As now, some men had no other kind; many changed from it only to a frock coat for some festive occasion. The fabrics for sack coats were as various as its functions, light or dark, rough or smooth. As to cut, except that it was on the whole looser-fitting and that it buttoned up high to short lapels (fig. 5), this earlier sack coat was very like its modern descendant. As with the cutaway, it was sometimes edged with braid. Among sports styles are to be included, besides the sack coat, a close-fitting, high-cut reefer, single or double-breasted, and a belted or Norfolk jacket, the latter coming into prominence in the eighties (fig. 4). The striped flannel blazer which reappears from time to time was new in the eighties, and very much the thing for cricket, tennis, and all summer junketings (fig. 6). In the eighties sports coats shared with sacks and cutaways the feature of high lapels. Frock coats were not always so close in the neck (fig. 7); and tail coats necessarily showed an expanse of shirt-bosom.

Evening waistcoats were low-cut, though higher in the early seventies than later. During the whole twenty-five years no hard-and-fast rule seems to have been fixed for the color of evening waistcoats, either white or black being found on equally well-dressed men in contemporary pictures. With high-cut coats vests were also high, though even so they did not always show above a buttoned-up coat. Vest necks were cut V-shaped and either left collarless or finished with a small rolled collar. Double-breasted waistcoats were not uncommon with sack or frock coats. While many men preferred the vest matching either coat or trousers, others habitually wore light-colored wash-material with either sack suits or more formal garments. Those of sporting tastes continued to affect vests in checks, stripes, or plaids.

Shirts of the seventies and the two succeeding decades were more often stiff-bosomed than pleated. Stiff bosoms were always in style with evening

dress and with other formal garments. Buttons or removable studs fastened them up the front; if the bosom was very stiff, the only opening was up the back. Often with such stiff-bosomed shirts came detachable cuffs, wide and starched to a cardboard stiffness. It was possible for those who were frugal of linen to fake a white shirt with a glossy starched false bosom or " dicky " and cuffs. Cuffs as well as collars were even to be had of hard white rubber or celluloid, which could be polished off with a damp cloth; and of paper, which could be discarded. To the " white collar " class, those above the status of laborer, this stiff band was a badge, a symbol, not to be omitted at any cost.

Legs. The styles of trousers changed frequently in such minor details as the width at top or bottom. In the mid-eighties trousers called " spring-bottom," which flared exaggeratedly at the bottom, were thought " swell " ; but a few years before, dudish young men had been wearing their trousers skin-tight. The bottoms of trouser-legs might be turned up for convenience (fig. 6), but the turn-back cuff was not an accepted part of the mode as it is today. Very large plaids and checks, such as had been popular in the sixties (figs. 5 and 6, Chap. XVI), were still fashionable in trousers worn with dark or flat-toned coats. Such lively leg-casings were even permitted with cutaway coats. So were trousers of a light flat tone (fig. 5), which were also correct with frock coats. Gray stripes (fig. 7) had not yet become the one correct pattern with formal day-coats. As to length, in that, too, no dictum held for long. During the late sixties and the seventies many tightish trousers stopped at the ankle, but others of slightly ampler cut lay upon the instep; in the eighties most trousers of citified cut were long. Not even the most carefully groomed gentleman wore his trousers creased.

Knickerbockers were the sartorial innovation of the mid-Victorians; not really new, but only the old knee-breeches returning to popularity after three-quarters of a century of banishment to the wardrobes of those few men who attended royal courts. The name is suggestive also of those loose breeches or " slops " (Chap. IX) which were undoubtedly the prototypes of these new breeches. Americans knew them principally from pictures of " Father Knicker-bocker " and the early Dutch settlers. In contemporary illustrations dating as early as 1870 knickers are shown upon sportsmen, but during the eighties they are more frequent, and generally part of a suit with a Norfolk coat (fig. 4). These loose breeches, just comfortably covering the knee, were terminated by dark woolen stockings and high buttoned shoes or gaiters.

Feet. Throughout the sixties most men continued to favor elastic-sided ankle-boots (or shoes), and even during the seventies many did not abandon these comfortable " congress gaiters," though front-lacing high shoes were by then in style. In the evening some men wore thin-soled versions of the same boot, if they did not don dancing-pumps.

The eighties saw a considerable vogue for buttoned boots with tops of cloth or kid, and (akin to the cloth top) short gaiters or spats in light colors (fig. 4). During the last years of the eighties half-shoes or oxfords sprang into

popularity for summer wear, and these gave an opportunity to display fancy socks; though more conservative dressers habitually wore black socks, even if their shoes were light. With the advent of the tennis enthusiasm came shoes suitable for that sport, shoes made of rubber and canvas, the forerunners of modern " sneakers " (fig. 6).

Outer Garments. The most interesting of the overcoats was the Inverness cape (fig. 3). It was a successor of earlier caped overcoats, and in this very form had been worn during the sixties; but the eighties witnessed its greatest popularity as a wrap for travellers and those who must face stormy weather. Made in large-plaided wool and worn with a " fore-and-aft " cap of the same material, it could be seen on ocean liners and north-bound trains. Very much the same garment, made of smooth black cloth and unbelted, was worn by the well-dressed man over evening costume. As earlier, some men still put on of an evening the yet more picturesque black cape with velvet collar.

Ordinary overcoats presented many of the variations retained during the next forty years. Some were dark, some light. In the eighties short covert-cloth topcoats (sometimes with dark velvet collars) were fashionable; they lacked the flare and the huge buttons of the later version shown in fig. 2, Chap. XVIII. Light or dark, the topcoat followed rather faithfully the lines of the suit-coat (fig. 7); the longer winter greatcoat, often of mixed woolen goods, was cut on more ample lines. Double-breasted reefers with round collars, so useful in a seafaring or a backwoods life, were adopted by city-dwellers for winter exercise. During the eighties the handy knitted cardigan jacket began its career; as a rule it was slipped on for extra warmth under a suit-coat.

SPECIAL COSTUMES (MEN)

Soldiers. Dress-uniforms of the principal national armies had smartly-fitting coats of the frock type, as a rule buttoned up the front to a standing or military collar, and trousers. The ordinary coat was a tunic buttoned up the front to some sort of high collar. Hats differed; in the United States both the visored, crushed-top cap and the wide-brimmed Stetson of Civil War times were regulation. A few groups like the French Zouaves and their American imitators still went out to battle in picturesque array, but efficiency was beginning to demand the elimination of fancy cuts and bright colors. It is said that the last battle in which British regulars fought in red coats was at Tel-el-Kebir, Egypt, in 1881. All over Western Europe and America the parade uniforms of special groups preserved (still preserve) details from the days when warriors were eye-filling as well as brave; *e. g.,* the Horse Guards and the West Point cadets.

Clergy. Non-Conformist ministers in England and Protestant clergymen in America (with the exception of many Episcopalians) wore lay dress, yet were often to be distinguished from their flocks by the formality of black frock coat and white linen tie. Church of England and American Episcopal clergy-

FIG. 10.
Negligée, c. 1870. Note
infant's long dress.

FIG. 12.
Silk costume, 1872.

FIG. 11.
Calling costume, 1870-75.
Note walking-stick parasol.

FIG. 8.
Calling costume, 1869.
Note skirt draped *en
tablier* and shoes with
heels.

FIG. 9.
Riding habit, 1869.
Note skirt looped up
over starched white
petticoat.

FIG. 7.
Frock coat, 1870-1880
Note the chair.

men could often be recognized by their vests, which were sometimes buttoned up the front to the throat, sometimes fastened behind, as nowadays. The small standing collar of such a vest fastened over a round starched " Roman collar." Plenty of Low Churchmen in both countries did not adopt clerical dress, among them Charles Kingsley and Phillips Brooks.

Servants. Grooms wore the costume described in Chap. XVI.

Footmen in grand establishments were sometimes still tricked out in ornate eighteenth century costume; butlers, on the other hand, wore civilian dress-clothes slightly modified, following the etiquette still observed.

WOMEN

Heads. This twenty-five-year period witnessed four stages in hairdressing. (1) As we have seen, by 1865 the modish coiffure revealed the ears. By 1869 many fashionable women had forsaken the long-popular central part in favor of hair carried straight back, with or without a softening fringe. The great bun or chignon was reduced or moved up much higher on the head, giving the whole structure a decided slant from crown to forehead (fig. 8). Formal hairdressing very often included one or two long curls lying upon the neck.

(2) From 1870 to 1878, while the front arrangement remained about the same, the amount of hair behind was often enormous. Sometimes it cascaded down the back in rippling tresses or loose ringlets, sometimes it was intricately confined in great loops or braids (figs. 10, 11, 12, 13). In 1878 the fashions called for less hair and a middle part came in again, but with ears still unconcealed (fig. 14).

(3) The early eighties saw a further reduction of hair; in front especially it was almost scant (fig. 17). The pleasantly simple coiffure which outlined the shape of the head, softened the forehead with a fringe, and finished with a fairly large coil at the nape, is especially familiar in Du Maurier's distinguished illustrations. (Figs. 17 and 19 show it.) Alexandra, Princess of Wales, chose to place her coil on top, and many ladies followed her example, either through loyalty or personal preference (fig. 20). The fringe was, by the way, often very tightly curled and very thick, so that it was possible to pin to it a diamond star or other ornament.

(4) During the last two or three years of the eighties fashion decreed a simple coiffure which lasted with little change for the next decade. The hair was drawn up all around, softly, but not actually puffed out, and fastened in a small knot on top; ears were of course entirely revealed. This was again the " pompadour " as it is shown in portraits of Louis Quinze beauties. As a rule the forehead fringe disappeared, but tendrils of hair curled at the temples, and escaped at the nape; that is, if nature decreed or curling-tongs could impose them.

Hats. Millinery in the bustle period can be divided into eight stages. (1) Upon the built-up coiffures of the late sixties sat small hats, tilted very far

forward; or else bonnets, equally small, with impressive ribbons or lappets, not tied but held under the chin by ornamental bows or little sprays of flowers (fig. 8). (You can read about the one Meg concocted in chapter twenty-eight of *Little Women*.) Bonnets for outdoor wear were often made entirely of lace and shirred silk, in white or delicate colors. The trimming, of lace, ribbon, foliage, feathers, was placed under the brim of bonnet or hat as often as on top. Lace veils, draped upon the top, hung down behind over the impressive hair.

(2) During the early seventies hats and bonnets still rode high upon the high-piled hair (fig. 12) or perched precariously upon the precipitous slope toward the forehead (fig. 11). Trimming stood up somewhat higher; bonnet-strings were narrower and might again be tied under the chin.

(3) In the middle seventies, while hair remained high, hat shapes changed only slightly, but they were worn further back on the head. From this time on, smaller " face veils" of spotted net took the place of the earlier draped veils. They were drawn across the face, just covering the chin, and tied at the back of bonnet or hat.

(4) In 1878, when a very radical change had come over dress and coiffures were growing smaller, bonnets were trimmed flatter, sat upon the backs of heads, and opened out in a pretty, demure way to frame the face and the crimped front hair (fig. 14).

(5) During the first years of the eighties the poke-bonnet shape of an earlier day was revived in hats which had no strings (fig. 17).

(6) In 1885 and '86, when hair revealed the natural shape of the head, a good many hats had rather flat crowns and rolling brims. At this time straw sailors entered the picture (fig. 19).

(7) During the next year or two bonnets were rather small and flat, and were set toward the back of the close coiffure; hats, on the contrary, were distinguished by high crowns. Among the styles was a masculine fedora, made of velour, with a high, pinched crown and upright feather trimming.

(8) The last year of the eighties saw a variety of pretty hats, some fairly wide and drooping; some more truly toques or turbans, worn upon the back of the head; and (very popular) a hard-brimmed sailor (fig. 19) which was made in chip straw or in glazed black leather. For outings women also adopted the masculine yachting cap (fig. 1b, Chap. XVIII) and tam-o'-shanter (fig. 2c).

Though trimming varied in the manner of its application, as has been noted above, it was almost always elaborate. There was, among milliners, a growing interest in ornithology. In 1869, for instance, one *artiste* turned out a confection of black lace with " a bird's nest of golden-hued moss on the forehead, with three tiny pearly eggs in it," and another creation adorned with both beetles and a humming-bird. Aigrettes as well as ostrich plumes were much in demand, and as the eighties advanced wings and breasts of bright woodland songsters, and finally complete birds. Widows wore bonnets only, of black crêpe edged with white ruching and draped with a long black veil.

During the entire period many married women still wore caps in the house, though there was more of this among the older generation than the younger. There was, too, a distinction governing the wearing of bonnets. Before a girl had made her début she wore hats only; after her coming out, or, in less formal society, after her marriage, she might with propriety go calling or to church in a bonnet.

Evening coiffures of the late sixties often included ribbons, flowers, or vines, arranged in wreaths or twining tendrils; later on, flowers were usually placed in the hair singly or in clusters (figs. 10 and 13). Between 1875 and 1880 the "Alsatian bow," a large ribbon bow pinned on the front of the head, was a favorite ornament with younger women. In the late eighties, when the small topknot came in, bows, small combs, and upstanding jewelled ornaments were tucked in beside it, adding a little to the height of the coiffure.

Necks. During the late Victorian era bewilderingly varied neck-finishes were in evidence. Since evening décolletage was a fairly simple matter, it may be dismissed first. During the entire twenty-five years the round, deep neckline was never completely pushed aside. It may be observed in the fashions of 1869, and again in the mid-eighties (fig. 18). Yet at that time it did not droop quite so far off the shoulders as it had done in the fifties. The seventies saw a rival design, called by the fashion-writers "heart-shaped," meaning that it comes to a point front and back, having curved up a little on the way from the shoulders (fig. 13). By the mid-seventies there was a revival of the deep square décolletage last seen in the eighteenth century (Chaps. XII and XIII). By 1889 the heart-shaped style had ousted all rivals.

A good many dresses intended for evening, as well as some less formal frocks, were cut much higher, in modest points or in fairly low but narrow squares (fig. 11). Folds of lace, frills, ruchings, ruffles, or some bit of white almost invariably finished these open necks; or, if the dress itself were cut down pretty low, the space was filled in with a chemisette or a tucker (fig. 12) which often had its own ruffled heading. The eighteenth century influence, strong in the seventies, resulted in a return of the fichu so often illustrated in earlier chapters, an accessory which kept recurring in the eighties also.

During these years high necks were the usual finish of simple house and street dresses. The turnover collar persisted, as a rule narrower in the seventies than earlier, sometimes reduced to a mere narrow band around the throat. During the late seventies and early eighties it was often folded down over the neckband of the bodice, a severe and mannish fashion. Even in the sixties a small white standing collar, also of masculine inspiration, sometimes finished the top of a low neckband (fig. 9). In the mid-eighties many women put a stiff fold of white linen inside the high standing collar of a simple woolen dress (fig. 20) or a white ruching at the top. Such necks as are illustrated in figs. 14, 16, 17, and 19, with their open throats and pretty, upstanding frills reminiscent of Elizabethan dress, finally retreated before the throat-binders like that in fig. 20, which dominated the styles for the next twenty years.

FIG. 13.
Evening dress, 1874.

FIG. 16.
A simple dress on
princesse lines, 1878.

FIG. 18.
Evening costume, 1886.

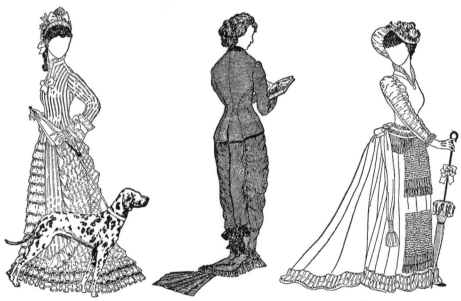

FIG. 14.
Calling costume, 1878.

FIG. 15.
A street dress, 1877-
78.

FIG. 17.
Silk costume of 1880 to 1882.

Bodies. Throughout this period bodices fitted as snug as ever. If, as occasionally happened during the very last years, a slight amount of fullness was introduced at the front, it was carefully sewed down to the inevitable tight lining. Usually a garment stretched smooth and unwrinkled over bosom as well as back (figs. *passim*).

The variations through which the bodice passed may be summed up in seven stages: (1) During the second half of the sixties the round-belted bodice described in Chap. XVI prevailed (figs. 8 and 9). (2) In 1870 and '71, this line began to share popularity with a longer point (fig. 11). (3) From 1874 to '76 fashion's favorite was the " basque " with a smooth, unbelted waistline and a " peplum " to the hips (figs. 12 and 13). (4) Between 1876 and '78 came the radical change to a " princesse " dress, wherein the basque was continued right down the body in an unbroken line sometimes as far as the knee (fig. 16). Though not all dresses had the skirt fullness so low as this, every dress had the smooth basque extended at least to the hips (figs. 14 and 15). (5) This silhouette remained in style till the mid-eighties, when a somewhat shorter basque came in again (figs. 18, 19, and 20). (6) During the last two or three years of the decade the basque was shortened still further, till it was again more properly a bodice. Evening dresses, reverting to an eighteenth century mode, developed long points both front and back but were shortened to the actual waistline on the sides. (7) In 1899 a plain "waist" came in, forerunner of the shirtwaist so popular in the next decade (fig. 18, Chap. XVIII). It was worn with a mannish turndown collar, a narrow four-in-hand or string tie, and a round belt. A new simplicity manifested itself in muslin dresses with wide ribbon sashes encircling a small round waist.

The habit-tailored coat with collar and lapels pictured in fig. 15 is, like the shirtwaist, another instance of the mannish element in feminine styles. Consorting incongruously with a very fussy dress, it became extremely popular and was the forerunner of the " suit " so ubiquitous during the next thirty years.

One garment which we have not illustrated nevertheless held an important place in the wardrobes of the eighties. This was the " jersey," in reality a slipover sweater, imitated from the ordinary dress of fishermen in little seaside English towns. It fitted the firmly corseted body like a glove, from high neck to below the hips, where it met perhaps a simple kilted skirt, perhaps one of the elaborate garments described below. Even though the jersey covered undergarments which would cause great discomfort to the modern woman, its wearer of the eighties apparently enjoyed a sensation of freedom equal to that of her descendant in polo shirt and shorts.

Bodices were fastened in front or in back, often with lacings which were carefully adjusted at each wearing, and so neatly covered by a flap of the material as to preserve the desired smooth surface. Front opening bodices were often decorated by their fastenings, the close row of buttons from collar to peplum being of pearl, jet, brass, or gold. Many a buxom matron, buttoned into her basque like the lady in fig. 20, must have feared sometimes that a

deep breath or a hearty laugh would send her buttons popping; as, in an earlier day, David Copperfield used to see them popping from the bodice of the good Peggotty. The foundation of smartness in these tight garments was the strong, high-busted corset, above which sloped an ample bosom. If nature had been reluctant to supply the needed ampleness, the clever dressmaker did something about it.

Arms. During the late sixties and up to about 1870 sleeves were made in the bell-shape fashionable earlier or, about as often, in a " coat sleeve " shape, *i. e.,* about the same width all the way down (fig. 9), often finished by a tight cuff. Later the bell-shape disappeared, leaving the field to the tight sleeve which, with different types of cuff, remained in style during the rest of the period. Wrist-length, the sleeve was tight (figs. 8 and 20), but in the three-quarter length so popular during the seventies and eighties it was often somewhat wider and elaborately ornamented, puffed, shirred (figs. 11 and 17), or finished with fussy cuffs (figs. 12, 14, 16, and 19). During most of the period the sleeve was set into the armseye with little or no fullness, but in the last two years of the eighties it began to show that accumulation of gathers on top which was to be so characteristic of the high-shouldered early nineties (fig. 7a, Chap. XVIII). Until the last years of the period evening dresses had only rudimentary sleeves with ruffles (fig. 13), tiny puffs, decorated straps, or just the ruffle of the bertha (fig. 18). The high-shouldered effect, which was first seen in 1889, was produced upon evening dress by trimming bunched on the shoulder (fig. 8, Chap. XVIII). In that year, too, some women began to have their ball-gowns made with elbow-sleeves. Even as necks were higher at the end of this period than they had been during the age of crinoline, so evening sleeves were longer and much more fussy.

Legs. The most astounding part of women's costume from 1870 to 1889 was the skirts. No exhaustive study of the various drapings and trimmings can be attempted here. We can only note the tendencies and trust to the accompanying sketches to convey an idea of the changing silhouette. First it will be well to list the supports or " bustles " which held out the numerous draperies.

(1) In the late sixties and early seventies the whaleboned petticoat or wire hoop-skirt remained, but in a changed form, flat in front and arching outward at the back (fig. 21c) to form a foundation for the accumulation of drapery. (2) In the late seventies, upon the arrival of the sheath-like princesse dress, the bustle was of course discarded, though the figure sometimes had to be assisted to its ideal shape by judiciously placed padding under carefully cut petticoats. (3) In the mid-eighties, when the style swung around again to skirts with 'drapery piled high in back, bustles returned. This time they were not so large, but were short cage-like affairs made of the same material as the hoops or, as illustrated in fig. 21a, of coiled wire, and were fastened with tapes around the waist and to the under-petticoat. (4) When, in the last years of the eighties, bunched draperies went out of fashion, a moderate protrusion at the back was still thought necessary. It was provided by a cushion or pad stuffed with horse-

hair, which filled in the hollow at the back (fig. 21b). Such a shape was also constructed of very fine wire net, lighter and cooler. The small bustle or "figure improver" was worn unacknowledged so long as small waists and skirts with many back gathers remained in fashion.

The skirts which were held out by these bustles went through four major changes, as follows:

(1) The "pull-back" drapery, which aimed at a long sweeping effect, often ending in an ample train. The period of this skirt and its many variations lasted from 1865 to about 1875. The first skirts over pulled-back hoops were not ordinarily bunched up in back. Often the skirt consisted of one garment only, gored in front to give the new straight line, straight and gathered very full in back in order to fall gracefully over the hump and to descend in a majestic sweep to the train, which was customary even in street dresses. By 1869 most fashionable skirts consisted of two parts, in two tones of a color, in different colors, or in two or more different materials. The under skirt was gored to fit smoothly over the support pictured in fig. 21c. It was frequently embellished with ruffles and flounces near the hem (figs. 8, 11, 12, 13). The upper skirt was cut gored in front and straight in back, two or three widths of material being needed for the back portion. The gored front was often arranged "*en tablier,*" *i. e.,* like an apron (figs. 8, 11, and 13), that part sometimes being, as in fig. 8, of different material from the rest. The lower edge was shaped in various ways, *e. g.,* it might be cut in scallops, or only looped up to form scallops. Fig. 12 shows an overskirt in which are revived the styles of the eighteenth century, a skirt cut straight and dependent on draping for its graceful lines. Besides this skirt, the years 1871–'72 saw another Georgian throw-back in the "Dolly Varden" dress, (*Barnaby Rudge* was a very popular book, and Dickens had been dead only a year) which reproduced the polonaise (fig. 10, Chap. XIII) over an instep-length gathered skirt, and even the fichu (which is illustrated more than once in Chaps. XII and XIII). An appalling amount of decoration was lavished on these skirts, such as flounces, ruchings, ruffles, quillings, lace falls, flower garlands, and bows placed here and there. In the sixties large and elaborately trimmed sashes spread majestically over the rear hoop; later, sashes emerged at various places (fig. 13).

(2) It was the changed skirt which made over the feminine figure about the year 1875. At that time the front was gored and even skimpy, while elaborate drapery and fullness were concentrated at the back (fig. 14). The extreme of the style was reached about 1877 and '78, when skirts were actually tight around the ankle (fig. 15). The fish-tail train pictured emphasized further the slender height of the ideal lady. During the same years the princesse line (fig. 16) was followed in skirts very plain to the knees, draped and pleated from there down.

(3) Between 1880 and 1885 the sheath part of the dress was shortened, and fullness was again placed higher up; whereupon the bustle returned (fig. 17), though not, at first, very pronounced. But between 1885 and '89, when basques

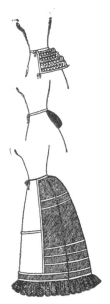

FIG. 21.
Bustles. Coiled wire, 1870-1875. Horsehair pad, after 1875. Transition from hoop skirt, 1869.

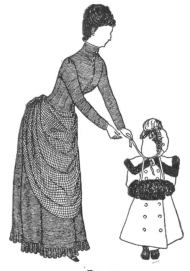

FIG. 20.
A draped skirt of about 1883 to 1889 and child's outdoor costume (1886).

FIG. 19.
Seaside costume, 1885-1889.

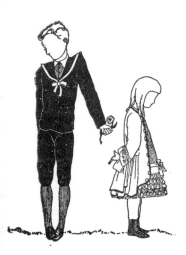

FIG. 23.
Party-clothes, 1880-1885.

FIG. 22.
Girl's skating costume, 1869-1872.

were little lower than the ordinary waistline, the bustle assumed its worst form, sticking out more abruptly than in the seventies and lacking the majestic sweep of the earlier draperies. Fig. 18 shows a fairly agreeable bustle on a fashionable gown; fig. 20 a moderate-sized protrusion on a simple dress. Note in both examples the drapery looped across the front and up to the waistline in back.

(4) Before the end of the decade the tide of simplicity had set in, and a good many dresses had simple skirts merely held out a little over small supports like the one illustrated in fig. 21a. Fig. 19, drawn from a dress dated as early as 1885, represents an early type of the new moderate styles. About 1889 evening dresses once more showed the influence of the eighteenth century, in trailing overskirts opened over very elaborate petticoats.

While, as may be seen, skirts in general were long during the entire period, either touching the floor or resting on the instep, efforts were being made to introduce walking-dresses of a more sensible length. Outing skirts of 1889–90 escaped the ground by an inch or so, and costumes designed for tennis enthusiasts were actually ankle-length.

Large bustles, elaborate drapery, long tight sheaths, even trains, belonged in their exaggerated forms to the fashionable world. Many women never wore a bustle bigger than that illustrated in fig. 20, many contented themselves with the simple princesse dress and pleated skirt shown in fig. 16, many, indeed, made their skirts in the old way with straight widths gathered into a band. On the other hand, a perusal of fashion-plates will reveal exaggerations not included in our sketches, which aim at presenting mean rather than extreme.

Feet. Heels had returned. By 1869 both walking-boots and evening slippers had fairly high heels, usually of the " French " type (fig. 8). From that time on high shoes (boots) were laced up the front or buttoned somewhat toward the outer side. In the eighties half-shoes came in. The high-heeled, high-tongued model in fig. 19, reminiscent of the late seventeenth century, was advertised as fashionable in 1885–1886. At the same time oxfords, essentially the same as nowadays, began to be seen with stylish outdoor costumes. Oxfords were made of black or russet leather, but other shoes were of white and bronze kid also, and the tops were kid, cloth, or satin, plain or brocaded. Evening slippers, of satin or kid, might be elaborately ornamented.

Up to the eighties white stockings were the usual thing; after that both women and children began to wear black, not only with black shoes but with russet as well, and even with white. Women began to favor fancy stockings also, for instance, the black and white stripes illustrated in fig. 19. It is to be remarked that silk was unusual, most ladies, even the wealthy, wearing fine lisle.

Outer Garments. The diagonally folded shawl had ceased to be fashionable, but it was followed by a variety of " mantillas," " paletots," and other capes, all distinguished by close-fitting backs, skirts shaped to fit over the bustle, and often arm-pieces more cape than sleeve. Fig. 16, Chap. XVI illustrates one of

the simplest of these wraps. " Paletot " was also the name given a jacket with open-cuffed sleeves. The " dolman " was a favorite wrap. It was half coat, half cloak, usually of about three-quarter length, cut with what we still call " dolman sleeves." Because these sleeves were in one with the body they imparted to the coat a cape-like appearance. Dolmans were ordinarily made of heavy woolen stuff, for winter wear. The close-fitting jacket, illustrated in fig. 15 in a fashion of the eighties, actually came into style before 1865, at that time having bell-sleeves in accordance with the current mode. Unlike the suit-jackets of an earlier date, this cloth coat of the eighties was worn with a skirt and bodice of different material and color. During the last years of the eighties the separate jacket grew plain, almost mannish, cut like a box-coat in front, but in the back close-fitting, with flaring peplum.

Another simple box-coat or jacket was used as a supplementary garment indoors. It was only long enough to reach the hips, made of flannel or other light wool, and called a " sacque." Still shorter jackets, to the waist only, were included in more formal day-costumes. These were named " Zouave," reflecting the military influence of the Civil War, and remained in fashion from the mid-sixties to the early seventies.

In the seventies longish capes with attached hoods (called " Capuchin ") were favorite evening wraps; throughout the period various small shoulder-capes or pelerines served as outdoor protection or adornment. After about 1885 shoulder-capes of fur were especially modish, particularly at the end of the decade, when they assumed the high-shouldered shape then coming to the fore (fig. 7b, Chap. XVIII).

SPECIAL COSTUMES (WOMEN)

Negligées followed the fashions, always a little looser and more picturesque than gowns for the public eye. In the seventies, again reflecting the interest in the eighteenth century, a fashionable robe had a " watteau " or sack back (cf. fig. 15, Chap. XII) and ruffled sleeves (fig. 10). The quilted petticoat carried out the period effect, though the manner of looping up the dress over it as well as the swing of draperies to the back was essentially late Victorian. One fashion writer who described this costume recommended that it be made up in cashmere and at the same time deplored the extravagance of a bride who had ordered in Paris one of silk and hand embroidery, to cost $300.00. During the eighties and nineties a great many women did their morning housework in " sacques " of wash material, worn especially in summer in lieu of a dress. Such a garment might be long and belted in, or only about hip-length and worn with a stout petticoat.

Bathing-suits are unlikely to be needed in plays of this period, and have therefore not been illustrated; nevertheless they deserve a word. In actual use, as revealed in surviving photographs, they look very dowdy, but in the sketches of contemporary illustrators they are charming enough. They were complete little dresses, usually of black flannel, sometimes of alpaca, with sailor collars

braided in white, short puffed sleeves and knee-length skirts. Under them were worn rather ample bloomers, showing several inches below the skirts, and sturdy black stockings. Rubber caps were not in evidence; if any woman swam, it must have been with the head well above water.

<center>EQUESTRIENNE</center>

The last stand of the really feminine riding-habit is shown in fig. 9, inspired by a color plate in *Godey's* for April, 1869. Here, along with mannish hat and collar, are the feminine touches of bright yellow braid, fringe, and a long full skirt looped up over a ruffled, starched, white petticoat. Here, if we could see them, are buttoned shoes over white stockings. The fashion arbiter, observing that the stiff silk hat is unbecoming to many ladies, gives permission to lay it aside in favor of a " low, coquettish hat," trimmed with plumes in summer even made of straw; and there you have the habit of the forties and fifties, when a woman must be womanly, even in the saddle.

After 1870 the severely tailored habit became correct, for the park as well as for the hunting-field, and took on lines which changed but little during the next twenty or even thirty years. It had a very close-fitting jacket with flaring " postillion " back, tight sleeves, simple collar and cuffs, and very long, full skirts. Until about 1875 the starched petticoat was retained; after that time skirts, still very long, were closer-fitting and worn over stockinet breeches and high boots. The low top hat illustrated in fig. 9 remained during the seventies, gradually increasing in height, and commonly retaining the large gauze veil. In the eighties the hat was about as high as a man's, and the veil was omitted.

<center>CHILDREN</center>

Boys. In the sixties and seventies some boys' heads were surmounted by ridiculous little low-crowned, stiff-brimmed hats; but these shared popularity with caps like that sketched in fig. 20, Chap. XV, with various wide hats of beaver, felt, or straw, with tams (fig. 2c), and occasionally with derbys.

In the seventies boys of school age were wearing trousers and short jackets, or trousers and tunics, as described in Chap. XVI. Smaller lads, who had just graduated from petticoats, were put into " short pants," made like trousers except that they were cut off just above the knee and trimmed with two or three buttons on the outside seam. Knickers and sailor collars arrived in the seventies, too. The boy pictured in fig. 23 is dressed in a sailor suit of the eighties.

Up to about the age of six small boys wore kilt-pleated skirts. In the eighties they often topped these (or short trousers) with the sort of jersey described under WOMEN, or with a blouse whose sailor-collar might be edged with a fluted white ruffle.

As long as little boys still wore skirts they wore curls, the front hair cut in a heavy bang, as on the little girl in fig. 23; but with the breeching ringlets

were shorn. Unfortunately for American and English boyhood, in the mid-eighties " Little Lord Fauntleroy " captured the imagination of many mothers, who forthwith inflicted upon their two-fisted sons of eight or ten or even older that sweet hero's pseudo-Stuart get-up of curls, lace collar, black velvet suit, and red silk sash. This baneful influence embittered the lives of some boys into the nineties and even later.

Except the Fauntleroys, whose legs might be encased in red stockings, most American boys wore long black ribbed cotton stockings (wool in winter) and shoes which laced up the front, either half-shoes or ankle-boots of black or brown. At dancing-school they wore pumps. Although in England long socks gartered below the knee were already in style, in America they were still strange. To save the wear and tear on stocking knees, busy mothers made their sons wear leather kneecaps which went on with a strap and buckle.

Girls. (1) The costume pictured in fig. 22, from a fashion-plate of 1869, is simpler and prettier than the outfit usually designed for fashionable little girls. This is for skating, and the hood, jacket, and round muff are suitable for the girl's older sister also. The style survived into the early seventies. Notice the curving skates, which were not exchanged for straight blades until the eighties.

(2) If you were once a devotee of Louisa May Alcott, you may remember the chapter in *Eight Cousins* called " Fashion and Physiology," wherein Aunt Clara and Uncle Alec each present winter costumes for the approval of Rose. The description of Aunt Clara's choice suggests the sort of thing thought suitable for a young girl (Rose was fourteen) in about the year 1876. Briefly, the child was to be dressed in all the over-elaborate discomfort which we have described under WOMEN and pictured in figs. 11, 12, 13, and 14, including a spotted face-veil, tight bodice, and high heels. As a rival to this fashionable outfit, Uncle Alec offered a " gabrielle " dress (a simple, one-piece frock with skirts a little above the ankle), a sealskin sack and cap, mittens, low-heeled boots, and high gaiters. An innovation thought even more radical was the underwear, a union-suit of scarlet flannel, a flannel petticoat, and long woolen stockings. Up to this time women's underwear had consisted of muslin chemise, corset, muslin drawers, and many petticoats. In real life the flannels (not infrequently red) were soon adopted and were worn in winter from the seventies till well into the nineties. After a while knitted woolen union-suits took their place, only going out of fashion when overheated city houses made them unbearable.

(3) Little girls' frocks of the later seventies and early eighties showed the influence of adult styles in their very low waistlines defined by wide sashes above elaborate ruffled skirts (fig. 23). The child pictured is in a party dress of pale blue silk faille. For play she would very likely have worn a short, kilt-pleated skirt and a pull-over jersey, or a sailor blouse like the boy's, for the note of simplicity was struck sooner in such garments than in dress-up clothes.

(4) During the last years of the eighties the pendulum began to swing toward simplicity in all juvenile garments. There was a return to high-waisted dresses with simple ribbon sashes, puffed sleeves, and round necks. Kate Greenaway, with her charming illustrations of children clad in her own version of "Empire" fashions, was probably responsible for the change. Though her illustrations began to appear in 1873, her popularity dates from the eighties, and several years had to elapse before admiration could be converted into imitation. Her influence lasted through the next decade, by which time modern theories of hygiene made improbable a return to absurdities equalling those which preceded her day.

As to hair and the hats that topped it, the progress was briefly thus: (1) During the late sixties and the seventies, when ladies piled hair upon their own heads, they cherished their daughter's abundant tresses, and arranged them to hang down the backs in carefully laid curls. Usually they had the front cut in a thick bang, often frizzed. Round combs and ribbon snoods held the hair in place. Upon the hair were tilted hats sometimes as ornate as the maternal millinery. (2) During the eighties long back-hair and thick bangs remained (fig. 23), but hats were simplified. With the jersey and skirt combinations went fuzzy woolen tams or rolling brimmed sailors of straw or beaver with long ribbon streamers. (3) In the late years of the eighties the Kate Greenaway influence produced "baby bonnets," to be worn by children as old as six, and various quaint poke bonnets trimmed with flowers or feathers, as well as wide-brimmed straw hats. The bonnet with nodding ostrich tip on the small girl in fig. 20 is a type fashionable for the very young. Hair altered only in the direction of simplicity. Throughout these years some girls had heads clipped close like a boy's, but the practice was not very usual.

During the sixties and seventies skirts were not shorter than two or three inches below the knee, and more often came about to the tops of high shoes. After 1865 pantalettes were no longer visible below hems. In the eighties the skirts of long-waisted dresses were rather abbreviated, that is they were half-way between knee and ankle, though on very little girls they might be shorter still. The Kate Greenaway mode brought long straight skirts again (fig. 20), but at play little legs were left pretty free.

Through the seventies stockings were still generally white, but in the eighties black or brown was substituted, often even with light dresses. Though black strap-slippers always had their place, especially in the period of the Kate Greenaway influence, and though half-shoes came into juvenile wardrobes when they were adopted by women, on the whole high buttoned shoes were most in evidence. Black or russet shoes with plain matching buttons for play, black, white, or bronze kid shoes with cloth uppers and pearl buttons for best (figs. 20 and 23) supplied little girls with foot covering appropriate to every occasion.

The most important accessory of almost every little girl's winter dress was the apron or pinafore. Naturally it followed the general style of the dress

under it, simple for play and household or schoolroom tasks, fussy and dainty for afternoons. Muffs (figs. 20 and 22) followed grown-up fashions.

MATERIALS

The fabric of men's clothes differed but little from the modern. There was more black broadcloth in evidence, as well as other rougher black stuff. Serge, twill, homespun, and tweed came in checks, plaids, and stripes rather larger than we see now, but in less diversity of color. Covert was about the lightest-colored cloth, and that went into topcoats and driving-coats. Marseilles and piqué were made up into white wash vests. Occasionally waistcoats were still made of silk, ribbed or brocaded.

Ladies' magazines record a bewildering array of fabrics popular during this twenty-five years, some still familiar, some surviving under different names, some lost to our experience.

Woolens were plentiful, including lady's cloth (a broadcloth of finer texture than men wore, suitable for riding-habits and tailored coats), wool delaine, Henrietta cloth (a silk-warped cashmere), grenadine (of silk-and-wool, loose-woven and semi-transparent), wool poplin, " poplin alpaca," brilliantine, bombazine (silk and wool of a wiry texture, popular in black for mourning), serge, and merino.

In the silks, Irish poplin was a favorite fabric for summer street costumes; so was figured foulard. Silk-backed satin was so handsome that it could be made up with the dull side trimming the shiny; it was nearly as stiff as the cotton-backed, which was also popular. Sharing honors with satin was taffeta, especially admired for mantles and walking-dresses. Various corded silks, silk serges, and moirés or watered silks were also in high favor. Crêpe de chine, of a heavy quality, called also " canton crêpe," was often combined with other silks in handsome costumes. Velvet was always appropriate for matronly gowns in day or evening styles, but was not considered proper for young girls. Rather, they dressed for balls in " chambray gauze " or silk tulle, sometimes embroidered with silk floss. Bridal gowns were of rich silk and laces.

Tarlatan continued to be popular for the still bouffant dance-dresses of the seventies. It came in white and colors, sometimes stamped with a floral design in gold or silver, and might be combined with lace. During that decade lace was still used lavishly, in flounces, ruffles, and berthas. Upon the princesse gowns of the later seventies and the heavy draped bustles of the eighties it had less of a place, but at the end of the decade it returned with other lighter materials.

Cotton materials included those enumerated in this section, Chap. XVI. Fine muslin or " book muslin " was considered dressy enough for a young girl's party frock, when it was ornamented with colored ribbons or artificial flowers. White piqué was the newest fabric for summer street-dress. Prints came back into style in the early seventies, when the " Dolly Varden " fad revived patterns of small sprigs scattered over a white or tinted ground.

The furs enumerated in Chap. XVI continued to be prime favorites during this period and the next.

COLORS

Opportunities for color in masculine dress had become very few. Light hats (white, pearl-gray, and fawn-color) and trousers and topcoats of the same shades afforded the best chance to be a little gay and still in good taste. Mixed wools used for sports-clothes and sometimes sack-suits helped to break the monotony of black and gray. Some men still wore large plaid or checked trousers and some displayed waistcoats in plaids, checks, or sprigs. Neckties, especially the spreading ascots, gave an opportunity for real color as well as pattern; so did socks, after low shoes became fashionable.

Women's dress made up for the lack in variety of color among men. Seldom during the seventies was a fashionable ensemble turned out which did not show at least two contrasting hues. Black combined with color was a universal favorite, and one might have seen it with bright blue, green, crimson, purple, leather-color, white, yellow, or pink. Strong, rather strident tones prevailed, for aniline dyes (discovered in the late fifties, as noted in Chap. XVI) were made in an increasing number of hues, which at this stage of their development sadly lacked the mellowness of vegetable and mineral dyes. Magenta, the first color to be procured by the new process, was unfortunately much in evidence. That bright, inescapable blue called "electric" was also inflicted upon the public all too often, sometimes made doubly difficult by the companionship of saffron-yellow. Eyes adjusted to such combinations perhaps did not flinch when fashion dictators thrust before them yellow straw hats trimmed with crimson roses. Even gray was not always suffered to remain in modest monotone. If you had a gray cashmere negligée, as many did, you probably dressed it up with cherry-colored ribbons as well as falls of white or cream lace.

Yet a true picture of the times would include also many quiet costumes of brown, steel-gray, heliotrope, dark green, or olive-drab, with trimmings of black and white at neck and wrists. Any ballroom scene showed a predominance of light tints and a great deal of white relieved only by flower-colored embellishments. Finally, the rigid mourning etiquette of the period threw some women into almost a lifetime of black and white, inadequately relieved by lavender and purple. It was doubtless with an eye to future needs that the wardrobe of a modestly-situated woman included one best black silk and perhaps no other silk dress. It was intended to last for years and to serve for all funerals and, if need be, weddings as well.

The strong colors prevailing in adult dress were reflected in juvenile attire until the end of the eighties, when the simpler styles mentioned above brought back white muslin and sprigged dimities. The serviceably dark woolen dresses necessary in inadequately heated winter houses were relieved by white neck trimmings and ruffled aprons.

MOTIFS

Stripes, checks, and plaids were the most popular patterns of the period. Patterned material was combined with plain (fig. 20), stripes were arranged in various combinations (fig. 14). "Roman stripes" (fig. 16) were woven in wide ribbon for sashes. A lady who was a small child in the eighties can still see in memory the crimson-carpeted stairs of a summer-resort hotel and descending them the dashing red-headed Mrs. Leslie Carter, in a costume of silk in black and white stripes about three inches wide.

Interest in the eighteenth century brought many floral designs, one popular from about 1875 to 1885 being "pompadour" flowers alternating with stripes of plain color. Spots and sprigs were printed on cotton fabrics and foulards. Braided patterns continued in the meaningless curlicues noted in this section of Chap. XVI. Motifs inspired by various past epochs were ruthlessly mixed together.

Yet in 1875 the famous house of Liberty's in London began to sell the beautiful silks of oriental texture and pattern for which they are still famous. In another decade these "art" fabrics, together with the earnest preachments of William Morris and his disciples, had actually begun to have an effect upon the output of the ordinary textile mills.

APPLICATION OF DECORATION

Except among the esthetes (p. 462) hand embroidery upon gowns was neglected for the easier and quicker machine-stitched braiding; but upon underwear, chemisettes, collars and cuffs, and other small areas a good deal of needlework was lavished. Braided designs were applied both to edges and surfaces of bodices, jackets, and skirts, with woolen, silk, or cotton braid according to the nature of the garment. Seams as well as edges of garments were frequently piped with silk of a contrasting color. Chenille and silk fringe and jet remained in high favor till the end of the eighties. Buttons of silver, gilt, pearl, and jet occupied a prominent place on many costumes. But the most important trimming consisted of the dress-material arranged in draping; in puffs; in pleated, fluted, or gathered flounces; in ruchings and quillings (figs. *passim*). Even underskirts had their ruffles; the first (a taffeta "drop-skirt"), its knife-pleated taffeta ruffle, the next under, of lining-muslin, its "dust-ruffle" edged with lace and again knife-pleated, which showed when the wearer held up her skirts.

JEWELRY

Men. Masculine jewelry was limited to scarf-pin, shirt-studs, cuff-links, watch-chain (with possibly a charm or emblem affixed), and a ring.

Women. Until the mid-eighties women remained devoted to earrings, which were very large during the sixties and early seventies (figs. 9, 10, 11, 12, 13). After about 1875 fashion dictated smaller designs, though drops or hoops were

still modish; then gradually studs took the place of danglers. In the later eighties the younger generation began to do without ear-ornaments entirely.

This was the period for heavy gold chains, to be looped around the neck doubled or hung in a single long strand with a watch at the end. Shorter chains with lockets were popular, too. Brooches and bracelets, large and impressive in the seventies, were smaller in the next decade. Cameos and brooches with hair in them were still much in evidence. Jewelled combs and other metallic head-ornaments were used throughout the period, during the last years assuming the form of upstanding bows or delicate sprays of flowers. The gold wedding-ring, in the seventies frequently a wide band, was narrower and more like a hoop after 1885.

A feature of jewelry in the late sixties and the seventies was the combination of different shades of gold (yellow, red, greenish) in one piece; another was the delicate tracery of black on yellow-gold. The shapes of these ornaments were derived from Gothic or Saracenic originals, but their ornamentation might be a floral pattern or a Greek motif. Mourning jewelry, as described in Chap. XVI, was *de rigueur,* according to the etiquette still governing the dress of bereaved ladies.

ACCESSORIES

Men. Watches, gloves (heavy, stitched leather for driving, softer kid in dark gray, brown, or black for the street, white kid for evening), and canes were the common accessories of gentlemen. There were light canes with silver knobs or crutch-handles and heavier sticks with crooks. A large part of the American public classed a man who carried an unneeded cane along with the man who wore a monocle and smoked cigarettes (instead of taking his tobacco in pipe, cigar, or " plug ") as a " dude," a " lah-de-dah boy." Handkerchiefs were large and white, sometimes white silk, not colored; except in rural districts, where the bandanna reigned.

Women. Through the sixties and well into the seventies with short-sleeved evening gowns women wore wrist-length gloves, as explained and pictured in Chap. XVI. By the eighties gloves had lengthened to reach the elbow and even higher. With the fashionable three-quarter length sleeves of street dresses the longer glove also came back to style. Many street gloves were still just long enough to cover the wrist well. They were worn snug and fastened up the inside with tiny buttons or with a cord which laced around little hooks. During the seventies white and light tones still predominated, but in the eighties black was very much in evidence, not only on the street but also at balls and at summer garden parties.

Throughout the period muffs remained small and, generally, round. They were often hung on chains around the neck.

Aprons were no longer considered articles of fashionable attire, but housewives, needlewomen, domestics, and shopgirls wore them, as described in Chap. XVI. The bibbed aprons worn by maids were long and full, covering

back of the skirt as well as front. Following the lines of fashionable dresses, aprons were often gored in front and put on high waistbands, almost girdles.

Reticules are seldom to be seen in the fashion-plates of the period. As an exception one was remarked with a walking-dress of 1885, a large round bag with fringe and tassels. In the early seventies little reticules or purses went with dance-dresses, bags just large enough to hold a handkerchief, made of material to harmonize with the dress, to the belt of which it was fastened. The presence of pockets (invisible in the seams of skirts or petticoats, visible on jackets) rendered the bag less indispensable. Small flat pocketbooks or else a card-case may occasionally be remarked in a lady's hand.

A parasol or an umbrella was the almost invariable accompaniment of out-door costume; the size of both shifted rapidly between large and small: (1) From 1865 to 1870 one saw mostly small parasols with ivory or ebony handles, handsomely trimmed in black lace over white, in self-colored lace, or in ribbon-bands (fig. 8), or else embroidered in flower designs; (2) in the early seventies the small parasol on a walking-stick handle (fig. 11) came in again; (3) the fashions of 1878 show both tiny umbrellas and larger parasols; (4) those for 1882–'83 rather larger, very slender umbrellas and larger, ruffly parasols with bows on the handles (fig. 17). (5) In 1885 the fashion-plates showed tiny parasols again, in 1886, larger; the mid-eighties also produced a charming good-sized parasol of white duchesse lace and black chiffon over "pompadour" taffeta, with a silver-knobbed bamboo handle, and another of pompadour silk with a deep fringe (as in fig. 19). The year 1885–'86 saw a great fad for Japanese parasols. (6) In 1889–'90 both parasols and umbrellas were good-sized. Handles varied with bewildering rapidity: crutch-shapes, knobs, crooks, square heads.

Fans, which had once played such an important part in evening costume, were rather out of style during the seventies, but in the last years of that decade and in the eighties interest in them revived. Japanese paper fans (fig. 18), coming along at about the same time as the parasols, bore witness that Japanese art was influencing the Occident.

While some people still carried carpet-bags during the seventies and even the eighties, their place was more and more taken by leather satchels, "Glad-stone bags," and "telescopes." These last were expansible containers made of a tough, water-proof cardboard, and were sometimes as large as a small trunk. Ladies packed the huge wardrobes thought necessary for summer-resort use in huge Saratoga trunks, which had the top tray in compartments for hats and a rounding lid to accommodate them.

SOMETHING ABOUT THE SETTING

The era of bad taste may be said to have reached its climax during the seventies and eighties. The chair shown in fig. 7 is a specimen of what could be made of furniture; ladies' dresses themselves suggest the sort of thing done to the draperies at windows, the portières, the mantel hangings and piano

covers. Ingrain carpets with cheerful wreaths of big red roses set up a rivalry with large-flowered wallpaper. Colors were dark and strong (red was popular), rooms were crowded with furniture, both useful and "ornamental." Enough of the style survives in remoter towns to have afforded most people a glimpse of it.

At the same time William Morris and the old Pre-Raphaelites were applying their philosophy of art to house-decoration and textile design and producing lovely wallpapers, ceramics, and drapery fabrics. Their teachings took long enough to penetrate past the circle of "esthetes," but eventually they began to influence even the wholesale manufacturers.

PRACTICAL REPRODUCTION

Materials. See this section, Chaps. XV and XVI. Most of the materials enumerated in this chapter are obtainable at modern dress-counters; some, like tarlatan stamped in silver or gold, from theatrical supply houses (Chap. XX).

For suggestions on trimming, jewelry, accessories, and millinery, see these sections, Chap. XVI.

Shoes. Men may wear elastic-sided house-shoes, evening pumps, high laced shoes, or, in a play of the eighties, laced oxfords. Select shoes with pointed rather than square toes if the character is supposed to be well-dressed.

For women, see this section, Chap. XVI. Not everybody needs to have high heels, only fashionable ladies. Remember that even these should not be what the 1930's have considered high, but rather the height put on city "walking shoes" or else low "spool" or "baby French" heels.

CONSTRUCTING THE GARMENTS

Men. Unless you are entering into a really professional production you will probably not attempt to make brand-new suits, for that enterprise needs a tailoring establishment. Rather, you will borrow evening-suits, frock coats, cutaway coats, and even sack suits of the period when you can, and for the rest adapt modern or slightly out-of-date garments to your needs, as suggested in Chap. XVI. Studying the accompanying sketches you will notice that lapels, except upon evening and occasionally frock coats, are high and rather small, an effect that you can achieve very well by fastening your modern lapels with an extra button. You may narrow the trouser-legs for costumes of the seventies especially, getting rid of the turn-up cuff and the crease. For the rest, define the period by the use of appropriate neck-dressing, head-gear, and whiskers.

Women. This chapter is designed to help you in identifying the heirloom dresses which nearly every community possesses, so that you may use them intelligently, in the proper combinations and in appropriate plays. Borrow where you can, for the elaborate dresses are expensive and tedious to make. Yet where you must make new you will find no insuperable difficulties.

Bodices are all to be cut by the usual fitted lining pattern (Chap. XX);

this rather than the " Martha Washington " pattern because it provides for a " body " long enough to reach to the hips, in other words a basque, which may be further lengthened if needed, widening at the seams as you go, till you have a princesse gown (fig. 16).

You need a gored skirt pattern for the underskirt of almost all the dresses, preferably an old pattern of many gores. Cut overskirts like those in figs. 8 and 13 gored in front, with two or more straight widths in back, which you will drape on the wearer. In fact a great deal of the success of all these elaborately draped skirts depends on suiting them to the individual. It was for skill in that art that ladies paid their modistes as much as a hundred dollars to make a frock; for that rather than for the interminable stitching and pleating and hand-finishing. So give yourself ample material and drape with your best taste.

Notice that the fish-tailed lady in fig. 15 has on a tailored, " habit-backed " jacket. You may well combine such a jacket, found in somebody's attic, with a new-made skirt. The skirt shown is very narrow, the shirrings are applied to a sheath foundation, and the knife-pleated train is added at the bottom. You may combine very similar jackets with draped bustle skirts. Fig. 9 has a straight gathered skirt tucked up on one side. Fig. 10, the negligée, is a " Watteau " dress, for the construction of which see Chap. XII. Fig. 11 needs an underskirt with gored front and straight gathered back and a straight gathered skirt pulled up behind. Fig. 12 should have the same kind of underskirt and a straight overskirt bunched up. Fig. 14 has a regular gored skirt; all the other features are applied trimming. Fig. 16 explains itself. Fig. 17 has a simple skirt gored in front, straight and full in back, with applied trimmings. As you may see, the skirt of fig. 18 is in three parts, i. e., gored underskirt, straight piece draped around, and two or three widths pleated into the basque at the back and hanging down to form the train. Fig. 19 has a simple gored skirt trimmed with ruffles and a shirred band down each side. Fig. 20 is a gored skirt with straight widths gathered in at the back and a piece of contrasting material running crosswise of the goods, draped at the front and bunched at the back.

Foundations. The construction of bustles is pretty well explained by the three sketches in fig. 21. If you are reasonably lucky you may find old bustles or hoop skirts of the transition type, some of more complicated construction than fig. 21c; if not, imitate this with a half-petticoat of heavy sheeting made with casings in which you insert spring-steel (see " hoop skirts," Chap. XX), full circles only at the bottom. If you cannot find an original bustle like 20a make it of an old spring strung on rattan, or entirely of heavy iron wire bent in the proper curve, or entirely of rattan. As to the small pad (21b), you can easily make a casing and stuff it with horsehair or cotton. Under the dresses pictured in figs. 8, 9, 10, 11, and 13 you will need something like fig. 21c; under those in figs. 12, 17, and 18 a good-sized bustle like fig. 21a; and under the others a larger or smaller pad on the order of fig. 21b. The little girl's dress

(fig. 22) needs a small circular hoop (Chap. XX); the frock in fig. 23 will stand out if it has stiffly starched petticoats.

Suggested Reading List

(See this section, Chaps. XIV, XV, and XVI.)

The American Procession, by Agnes Rogers and Frederick Allen Lewis, is a book of photographs of this and the two succeeding periods which presents living wearers of the costumes described here.

Our Times, by Mark Sullivan; his volume entitled *America Finding Herself* has illustrations of current fashions and comments on them as well as copies of contemporary political cartoons which are equally illuminating.

New York in the Elegant Eighties, by Henry Collins Brown, is a chatty book, copiously illustrated.

Where Further Illustrative Material May Be Found

(See this section, Chaps. XIV, XV, and XVI.)

Du Maurier was illustrating regularly for *Punch* and sometimes for *Harper's Monthly* and his pictures present the ideal British beauties, especially of the eighties. Reginald Birch's illustrations for juvenile books, including *Little Lord Fauntleroy* (1886) furnish excellent examples of adult as well as child costumes. This was a period in which "story pictures" abounded, many of which represent contemporary dress with great fidelity. Remember that comparatively few frocks followed the Kate Greenaway costumes literally, though all were influenced by them after about 1885. All the illustrated magazines (see periodical bibliography) are full of pictures for your enlightenment.

The English and American painters listed at the beginning of this chapter, and many more whose works you may see in museums, painted portrait studies of men, women, and children, rendered with fidelity to outline if not always to detail of contemporary dress. So did the French, on occasion. Seurat's "La Grande Jatte" (Chicago Art Institute), for instance, gives in striking simplification the silhouette of the mid-eighties. You will find samples of French figure painting in the museums, in books about French art, and in some of the costume books recommended above.

Sources of Sketches in This Chapter

Godey's Lady's Book for the years 1869, 1870, 1872, and 1874, *Peterson's Magazine* for 1878, *Harper's Monthly* for 1870, 1875, 1877, 1878, and 1885, and *La Mode Artistique* for 1883 are the periodicals which furnished specific details incorporated in these sketches. Contemporary pictures reproduced in *New York in the Elegant Eighties,* op. cit., supplied others, especially in the way of men's head- and neck-gear and sports dress. Du Maurier (*Harper's,* 1885–'6) was the inspiration especially for figs. 4, 5, and 18. Pictures by Cluymenear (Albert of Belgium as a boy), and Renoir (" L'Enfant a L'Arrosoir ") are the particular sources for the costumes in fig. 23, though the little girl's frock more closely resembles an actual dress in the possession of a neighbor. A photograph in the Harold Seton collection, another in the Theatre Collection of the Museum of the City of New York, another of the three grown daughters of Edward, Prince of Wales, and another of a little girl in 1886, contributed details to the costumes shown in figs. 7 and 20. A dress and some shoes in the Museum of the City of New York, another dress in the Metropolitan Museum, and dresses and accessories owned by our friends, have all contributed their share to the sketches, but so supplemented by other, similar material in illustrations and fashion-plates that it is impossible to assign specific credit for a sketch to any one source.

Chapter XVIII
FIN DE SIÈCLE

DATES:

1890–1900

■■

Some Important Events and Names

ENGLAND	FRANCE	GERMANY	AMERICA
Victoria, d. 1901	Third Republic	Emperor William II	PRESIDENTS Benjamin Harrison, 1889–1893
Edward and Alexandra, Prince and Princess of Wales	Dreyfus Case, 1894–1895	DRAMATISTS Frank Wedekind, 1864–1918 "Fruhlings Erwachen," 1891	Grover Cleveland, 1893–1897 William McKinley, 1897–1901
Diamond Jubilee, 1897	Clémenceau, 1841–1929 WRITERS Zola, d. 1906	Hermann Sudermann, 1857–1928 "Magda" (Heimat), 1893	Panic of 1893
Kitchener in the Soudan, 1896 Gladstone, d. 1898	Anatole France, d. 1924		Chicago World's Fair, 1893
Boer War, 1899–1902	Pierre Loti, d. 1923 Marcel Proust, 1871–1922	Arthur Schnitzler, (Viennese) 1882– "Affairs of Anatol," 1893	First Ford Car, 1893
WRITERS Hardy, d. 1928	DRAMATISTS Maeterlinck, 1862–1949	Gerhardt Hauptmann, 1862–	Spanish War, 1898–1899
Conan Doyle, 1859–1930 "Sherlock Holmes" 1891	"L'Intruse," 1890 Eugene Brieux, 1858–1932	THEATRE ARTS Max Reinhardt, 1873–1943	ACTORS Mansfield, d. 1907 Mrs. Fiske played Becky Sharp in the '90s
Mrs. Humphrey Ward, d. 1920	Paul Hervieu, 1857–1915		Ada Rehan, d. 1916
Rudyard Kipling, 1865–1936 "Barrack Room Ballads," 1891 "Recessional," 1897	Edmond Rostand, 1864–1918, "Les Romanesques," 1894		Maude Adams, "The Little Minister," 1897 Augustin Daly, d. 1899
H. G. Wells, 1866–1946 "The Time Machine," 1895	ACTORS Bernhardt, d. 1923 Coquelin, d. 1909		Repertory Company till 1899
Joseph Conrad, 1857–1924 "Almayer's Folly," 1895	Réjane, d. 1920 PAINTERS *Modernism*		DRAMATIST Clyde Fitch, 1865–1909
Anthony Hope, 1863–1933 "Prisoner of Zenda," 1894 "Dolly Dialogues," 1894 (illustrated by C. D. Gibson)	Cezanne, 1839–1906 Van Gogh, 1853–1890 Gauguin, 1848–1903		WRITER Richard Harding Davis, 1864–1916 "Van Bibber," 1892 ARTISTS Sargent, d. 1925 Whistler, d. 1903

===

Some Important Events and Names

ENGLAND
(*Continued*)
DRAMATISTS

Jones, d. 1929

Pinero, d. 1934

J. M. Barrie, 1860–1937

George Bernard
Shaw, 1856–1950

Oscar Wilde,
d. 1900

ARTISTS
Du Maurier,
d. 1896

Aubrey Beardsley,
1872–1898
" The Yellow
Book," 1894–'95

AMERICA
(*Continued*)
Abbey, d. 1911

Pyle, d. 1911

Thomas Nast,
d. 1902

Winslow Homer,
d. 1910

Joseph Pennell,
1860–1926

Charles Dana
Gibson, 1867–1944
Illustrated for *Life*
from about 1890

OTHER POPULAR
ILLUSTRATORS
F. Hopkinson Smith

A. B. Frost

E. H. Blashfield

Harry McVickar

Some Plays to Be Costumed in the Period

Wilde's "Lady Windermere's Fan" (1893), "A Woman of No Importance" (1894), "An Ideal Husband" (1899), "The Importance of Being Earnest" (1899).

Pinero's "The Amazons" (1893), "The Second Mrs. Tanqueray" (1893), "The Notorious Mrs. Ebbsmith" (1895), "The Gay Lord Quex" (1899).

Jones's "The Masqueraders" (1894), "The Liars" (1897).

Shaw's "Mrs. Warren's Profession" (1893), 1st London Performance, 1902, 1st American, 1905, "Arms and the Man" (1898), "Candida" (1898).

Barrie's "The Professor's Love Story" (1895).

Sudermann's "Magda" (1896).

Checkov's "Uncle Vanya" (1899), "The Sea Gull" (1896).

Brieux's "The Three Daughters of M. Dupont" (1897).

Schnitzler's "The Affairs of Anatol" (1893).

Ibsen's "Hedda Gabler" (1890), "The Master Builder" (1892), "Little Eyolf" (1894), "John Gabriel Borkman" (1896).

FIN DE SIÈCLE

CONCERNING THE PERIOD

W E human beings like to think that the progress of mankind fits into the pattern of man-made chronology, to see every century as a unit in the design. The young romantics of the nineteenth century's first decade believed that with the sloughing off of the shabby seventeen-hundreds they were putting on a new civilization of liberty, justice, and beauty; the young disenchanted of its last decade announced that with them that civilization had reached its climax. "After us the deluge," said they, and smiled, under eyelids a little weary, at the naïve enthusiasms of earlier Victorians. "Fin de Siècle" they styled themselves, their art, their literature, and their music. Aubrey Beardsley's illustrations for Oscar Wilde's "Salomé" embodied their tastes. The epigram-tossing youths of Wilde's comedies represent the ideal of the clever younger generation; his *Dorian Gray* the esthetic hedonist they half-feared, half-hoped they might become.

A bit of light verse, popular with parlor entertainers in more robust yet still rather "knowing" American circles, burlesques the type in this vein:

> "Life is just a bubble, don't you know,
> Just a painted piece of trouble, don't you know;
> You come on earth to cry,
> You grow older and you sigh,
> Older still and then—you die, don't you know."

You recited it with a lisp or an "English accent," and you carried a real or imaginary cigarette and monocle. That phrase "fin de Siècle" fell glibly from youthful lips; a débutante even wrote in her diary of the new balloon sleeves: "They are just too deliciously '*fin de Siècle.*'"

In reality for a much larger part of the Western World this decade marked not the end but the beginning of a new period, with new problems in education, invention, industrialism, and politics together with new formulas for their solution.

In England during this last decade of Victoria's reign the national religion was Imperialism, and Kipling was its bard and prophet. His "Recessional," written for the Diamond Jubilee, voiced the attitude almost of consecration with which Britishers took up the "White Man's Burden" and carried the products of Manchester to Darkest Africa and India's Coral Strand. With the Boer War successfully out of the way, the complex British Empire had attained to that place of power which it maintained throughout the World War.

494

A new set of writing men came along, turning out powerful social novels, imaginative tales, and, most important to a worker in the theatre, excellent dramas, a few of which are named in these pages. By following the revolutionary technique of Ibsen, English playwrights brought on a brilliant renaissance. Its expression ranged from Wilde's brittle comedies of manners, through the personal problem plays of Jones and Pinero, to the social problems posed by Shaw. There were good actors, too, such as Irving and Terry, Beerbohm Tree, Mrs. Patrick Campbell, and others who began their careers in the nineties and still hold their own. Better staging helped on the new drama, but in the nineties it took the form of meticulous realism rather than the more imaginative settings of the new century.

French foreign politics were dominated by efforts to keep up with the neighbors in colonial expansion; domestically the country was torn by the Dreyfus Affair, which brought with it anti-Semitic madness and bitter controversy between liberals and conservatives. In the theatrical world Rostand and Maeterlinck turned their attention to imaginative drama while other playwrights dealt with realism and social reform. Bernhardt and Réjane continued to hold audiences with their old characterizations while they added new creations to their repertoires. The Théâtre Française remained the stronghold of the classics, Antoine's Théâtre Libre became the haven of the new. An infant industry that was to develop into a new theatre art had its inception when Pathé made the first motion pictures. In the French art world Modernism had become the important issue, and was putting its stamp on the young artists who came from abroad to learn painting in Paris.

The German Emperor William was building up his reputation as a good showman; the German Empire waxed strong and confident. Its universities turned out diligent scholars in every branch of science and attracted more American students than any other foreign schools. German drama had its own rebirth, becoming more startlingly realistic than the English, though it also had its imaginative writers. Max Reinhardt experimented with those revolutionary methods of stagecraft which were to make him the leader of modern theatre artists.

In Russia, Stanislavsky inaugurated his remarkable work at the Moscow Art Theatre, for which Chekhov wrote his sad and quiet plays. Under Alexander III and Nicholas II (the last of the Romanoffs) liberal thinkers were sent to Siberia, Jews were hunted and slain, or, more lucky, escaped to America. Subject Poles and Finns also found it desirable to seek refuge in the New World.

Italy had the honor to be the native land of Eleanora Duse (1859–1924), the only rival of Bernhardt, or, as some will have it, her superior. Duse made famous the plays of Gabriele d'Annunzio, which were her principal vehicles, though she interpreted also the heroines of Ibsen, Sudermann, and even Dumas, i. e., " La Dame aux Camilias."

America, in the last decade of her " Gilded Age " became conscious that all was not well with the democracy. There followed strikes, anti-trust laws, bitter

class feeling, a critical evaluation of the plutocracy, and notable social work. The tide of immigration rose high. There came now not only the peasants of Northern Europe, who moved West and took up their ancient agricultural life in the new land, but also Slavs, Jews, Italians, Portuguese, and the natives of Near Eastern countries. Most of these " dagos " (as the native American called them all indiscriminately) remained stranded in Eastern seaport towns. The Melting Pot was " on the boil." Yet the point of view of native-born Americans was still preponderantly Anglo-Saxon, both in the consciously cosmopolitan East and in the provincial hinterland. The America of Mark Twain still existed; so did the America of William Dean Howells, of Owen Wister, of George Cable, and of Mary E. Wilkins Freeman. In the prairie states and the far West, while actual pioneering was about over, the pioneer attitude was not yet lost. With the Spanish War at the end of the century America started her own career of Imperialism, frowned on by many, but excused by the " white man's burden " line of reasoning.

The theatre flourished, whether it presented Shakspere, importations like Ibsen and the new English dramatists, or plays by American writers. This was the heyday of Augustin Daly's company, that training-school for good actors, some of whom are still on the boards. The illustrator's art flourished and is especially interesting to students of costume. Of all the illustrators Charles Dana Gibson had the greatest influence on contemporary styles and manners; every young lady wanted to look like a Gibson Girl, and many succeeded.

In these years of the second Chicago World's Fair (A Century of Progress), it has been fashionable to accuse the first Fair of setting America's artistic life back thirty years, by re-introducing the cult of Greek architecture. Yet to those who were brought up with the dignified buildings left from the Exposition of 1893, as well as to those who saw them new, as a revelation of loveliness, it seems unfair to condemn outright the older attempt to restore beauty to daily life.

There was a good deal of talk about horseless carriages; for had not Henry Ford, for one, produced a machine that would go, and fast, too? Yet people in general did not include such newfangled contraptions in their conception of life. In the city " society " still rode in private broughams when it went shopping; in landaus, Victorias, phaetons, or " governess carts " when it took drives in the park; in hired hacks or hansom cabs when it visited strange cities; and in coaches behind four horses when it went out for a good time. Country families owned buckboards, " democrats," buggies, and surreys, drawn by a staid horse. In winter roomy sleighs and light cutters full of fur-muffled youth flashed along snow-packed roads; and upon moonlit nights hay-lined wagons on runners carried country merrymakers to their jollifications.

The " machine " of the nineties was the bicycle. Everybody rode everywhere: in town, in the country, racing, marketing, for exercise, to get somewhere. The " wheel " took people into the open, it reintroduced city workers to the country, it afforded exercise to sedentary folk. Best of all, owning one was

not the exclusive privilege of the wealthy, for bicycles could be bought comparatively cheap, and the upkeep was slight. In America the nineties were the great cycling years. The fad lasted in a violent form till about 1900, after which those who could afford automobiles bought them, and the others came to depend upon the useful " bike " rather for transportation than for recreation. Tennis became more and more popular; international matches were played by women champions as well as men. In America golf got its start as rather a snobbish sport, taken up first by people with money enough to join exclusive clubs, buy expensive equipment, and pay for lessons from imported professionals. Both tennis and golf had a profound effect on dress, masculine as well as feminine, for they brought in the sports clothes which have so fortunately become the mainstay of modern costume.

The most popular accomplishment of the parlor entertainer was elocution. In the mid-nineties the simple technique of declamation as it had long been taught in district schools was revolutionized by Delsarte's methods, which suited gestures to each uttered speech, thus enabling the reciter to put on a whole show in himself. Books of selections, heroic, pathetic, and humorous, were published, with minute directions for performance. The older favorites such as " Curfew Shall Not Ring Tonight " were dispossessed by Kipling's " Barrack Room Ballads " and for twenty years or more temple bells tinkled on the Road to Mandalay, Danny Deever was hung in the morning, and boots slogged over Africa in the best style of fresh-voiced, bright-eyed schoolgirls.

America joined Europe in putting a finger in the Oriental pie. Everybody got in on the exploitation of China, till finally at the end of the century the Chinese themselves decided to say something about the disposition of their country, and did so in the Boxer Rebellion. At the very end of the great and progressive Nineteenth Century, embittered Orientals were murdering Westerners; the mighty British Empire went out to crush a group of Dutch-African farmers; the United States drove Spain from Cuba and the Philippines and assumed the right to boss the brown islanders;—and at the Hague was held the first International Peace Conference.

GENERAL CHARACTERISTICS OF COSTUME

At the end of the bewhiskered century smooth-shaven faces returned to style; the " Gibson man," idol of schoolgirls, allowed not a hair to obscure the square modelling of his manly jaw. But moustaches were plentiful among somewhat older men, especially the small waxed moustache affected by the " dude."

This dude was a feature of the decade in America (fig. 2) : he was a dandy who wore super-exquisite clothes, exaggerating the mode. He it was who adopted the English custom of wearing spats, who felt undressed if he went without his cane, and who, if he had the courage, sported a monocle. The word " dude " has nearly passed from colloquial speech (though it has found a place in the dictionary), but the type persists, one in a line with Macaronis, Incroyables, Beaux, and Swells.

Ordinary men dressed very much as they had done in the eighties, except that more of them felt justified in wearing informal sack suits and soft hats for nearly every occasion. Yet the feeling still prevailed that the professional man, that is the minister, lawyer, doctor, college professor, and statesman, should appear in public garbed in frock coat and silk hat. The silhouette of the nineties was rather square-shouldered, rather straight-waisted. Trousers worn with frock coats and cutaways were tightish, those with sack suits somewhat looser. The front crease was seen in some trousers ample enough to accommodate it and in some informal costumes trouser-legs were turned up in cuffs (fig. 4).

At the end of the eighties one would have thought that women's fancy was turned toward simplicity in dress, even relative comfort. Yet after a year or so the pendulum swung back. The fashions of the nineties take their place among the most absurdly unhygienic of any age. A century from the time when the liberated citizeness of Paris threw away her corset and her high-heeled shoes, her descendant (and all the feminine Western world after her) constricted her middle to an orthodox eighteen inches and squeezed her feet into patent-leather shoes with toothpick toes and heels higher than Marie Antoinette's. Moreover, this lady of the Third Republic donned sleeves the size of respectable balloons (each sleeve contained enough material to have made a dress for a *Merveilluse*), and a skirt which spread from wasp-waist to hem like an Indian tepee. With the frou-frou ruffles nestling inside the hem she swept the city streets. How could such an absurd creature be charming? Yet charming she was, as old copies of *Life*, *Harper's*, the *Illustrated London News* bear witness. But how, O how could she be athletic? Yet athletic she was also, to a surprising degree. She still played the mild croquet, but she cycled and played tennis, too, and, with more and more zeal, golf. That these sports spelled the doom of the hour-glass figure is not surprising, the wonder is that the deed took so long to accomplish; for during the whole decade neither fashion-plates nor the creations of popular illustrators show any signs of relaxing the taut corset-string. Yet it must be admitted that women did, on occasion, shorten their skirts all the way to the instep or even the ankle. The most startling sign of emancipation was the bloomer-suit favored by enthusiastic cyclists; it exposed the leg as far up as the calf! Fortunately, veterans of the decade remind us, bicycle boots saved the day for modesty.

MEN

Heads. Hair parted in the middle was the smartest style of the nineties (fig. 4), though many men parted theirs on the side, or just a trifle to the left of center, and many others brushed theirs straight back. The fashionable trim was a trifle longer in the back than it is nowadays.*

Though smooth-shaven faces were popular (figs. 1c, 4, and 5), moustaches were cultivated by some men. Little moustaches turned up and waxed (figs. 1a and 2) found favor with the ultra smart; exaggerated, this type of

* Walter Prichard Eaton reminds me that from about 1890 to 1897 young American collegians and prep school boys wore their hair very long, the front locks brushed all the way back to the ‥ like a mop. This style was known as the " football hair-cut."

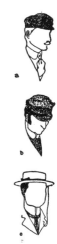

FIG. 1.
Outing cap, c. 1893.
Yachting cap, c.
1890. Straw hat,
1895.

FIG. 6.
(Top) how the wasp
waist was obtained.
Also three views of
"la Pliante" an in-
vention for holding
out skirts in back
(1896).

FIG. 2.
A dude, c. 1890-1895.

FIG. 5.
Some men visited the
World's Fair (1893)
dressed like this.

FIG. 4.
"Shirtwaist" suit, c. 1895
Note trousers creased and
cuffed.

FIG. 3.
A cyclist, c. 1893-
1896.

moustache became familiar in pictures of the German Emperor. "Walrus" moustaches (fig. 3), which always drooped and were often formidably large, were cherished by somewhat older and more conservative men. Plenty of the middle-aged clung to clipped beards and moustaches of the General Grant style, to sideburns, and even to mutton-chops (fig. 1b, Chap. XVII), and some went in for small pointed chin-beards. The last was a type particularly affected by M. D.'s, perhaps through some association of their profession with Rembrandt's " Anatomy Lesson."

Top hats were the badge of respectable importance. Going to church, calling, to the opera, to a ball, and even upon important professional affairs, a gentleman wore his silk hat or " tile," as the irreverent called it. A yellow calf hat-box was part of his travelling-equipment. Top hats varied slightly from year to year in subtle matters of height, flare, and width and curl of brim. Bands, too, were sometimes wide though not always very different from hat-bands today (fig. 5).

For more ordinary occasions there were felt slouch hats, round felts (not particularly different from today's), and fedoras (fig. 3, Chap. XIX), the latter sometimes made of mossy velour. Derbies were popular and great favorites with the man about town (fig. 2). Made in brown as often as black, these hats were somewhat higher crowned than they had been in the preceding decade. Straw hats were donned promptly at the beginning of summer (fig. 1c). Their hard brims and inflexible crowns made them such an easy prey to the wind that they had to be secured by an elastic cord from brim to coat-lapel. The variations in the width of straw hat brims was remarkable, but all the crowns were low.

Upon any occasion which smacked of sports, men might exchange hats for caps. The plaid " fore-and-aft" pictured in fig. 3, Chap. XVII, was the most popular in winter and on transatlantic crossings; it is immortalized now as the chosen headgear of the great Sherlock Holmes. Cyclists found smaller caps convenient (figs. 3 and 1a). Sometimes they liked the sort with a stiff crown and visor that protected the eyes (fig. 1b), a shape particularly associated with yachting. The tam shown in fig. 2c, Chap. XVII, was still popular, especially for winter sports.

Necks. In no particular is masculine dress of the nineties so separated from that of modern times as in the collar. Very high collars were the rule, whether they were winged, turnover (fig. 5), or standing (figs. 1c, 2, and 12). The last was most common. The corners stood up straight under the chin or were bent back slightly with the fingers. Even in summer the throat was encased in stiff linen. Occasionally a boy in a " shirtwaist" could be conceded a lower turnover (figs. 1a and 4), and some cyclists wore really soft collars (fig. 3).

Ascot tie (figs. 1b and 2) and four-in-hand (figs. 1a and c) were rivalled in popularity by the bow-tie (figs. 4 and 5). With evening " tails" the bow was white, sometimes also with afternoon costume. With the " English lounge coat" or Tuxedo, which was becoming popular for informal dinners and evenings at home, a black bow-tie was correct. Many conservative men still

clung to the black string tie; some with slightly Bohemian tastes wore soft windsor ties, especially with sports clothes (fig. 3).

Bodies. Shirts whether to be worn with city business suits or with any formal coats were opened up the back and had stiff, gloss-starched bosoms. "Shirt-waists" (fig. 4) were only slightly starched and sometimes had pleated bosoms. Working-men, farmers, and all such informal dressers, habitually wore shirts with unstarched, attached collars which could be left open in the neck.*

Both knitted cardigan jackets and slip-over sweaters (fig. 3) were firmly established in the masculine wardrobe. Younger men, especially college boys, usually wore blazers (fig. 6, Chap. XVII) for summer sports. Norfolk jackets changed little from those of the preceding decade (fig. 4, Chap. XVII).

Frock coats also had changed but slightly (fig. 5); some still had high lapels, though that style was passing. The lapels of cutaways remained fairly high (fig. 12), but those of sack coats were longer than they had been in the eighties. The long lapels of dress coats were sometimes faced with satin.

As to the tailoring, even cutaways and dress coats were rather square and boxy, and sack coats were distinctly looser and rather longer than in modern styles. Most sack coats had straight front edges (fig. 4), but upon some the corners were rounded off a bit (fig. 3). The "Tuxedo" was introduced from England as an informal "dinner" jacket suitable for quiet evenings at home or the club or for all-masculine parties; its informal, sack-coat shape made it seem unsuitable upon a lady's escort. The name is, of course, American, not English.

Vests were omitted from light-weight summer "shirtwaist" suits (fig. 4) and other sports costumes (fig. 3). With winter sack suits they followed, in general, the style of the coat. With such a suit, as with frock coat or cutaway, the vest often matched the coat, but not necessarily; it might be of white wash-material or plaid or checked cashmere (fig. 5). Some men, perhaps more in England than in America, went in for bright vests. For example, one is recalled as being knitted of green with little scarlet spots. Double-breasted vests (fig. 5) and sometimes single-breasted might be finished with collars. Evening vests were somewhat higher than those fashionable at a later day. With the Tuxedo went a black vest, with the tail coat a white, though to be sure some men wore black with the more formal coat also.

Coat sleeves did not differ appreciably from the modern. Sleeves of stiff shirts were often made with detachable cuffs of which a cardboard-like band of an inch or so showed below the coat sleeve. Softer shirts had their cuffs attached.

Legs. Most trousers in the eighteen-nineties were somewhat tighter than in the eighteen-eighties or the nineteen-thirties. If they were wider, as they were in rather informal or "lounge" suits, they might be turned up in cuffs (fig. 4), but as a rule they hung down straight and long (figs. 5 and 12). With dark coats of the more formal type went lighter trousers, checked or striped (figs. 2, 5, and 12). Business sack suits were likely to be entirely of one material, but

* Mr. Eaton says that the "hired men" of his acquaintance wore shirts with *no* collars, only the shirt-band fastened by a collar-button

summer sack coats of dark serge were often mated with white ducks or flannels. For summer whole suits were made of light-colored wash-material such as heavy pongee, white linen, and seersucker.

Knickers did not change much from the previous decade (fig. 4, Chap. XVII). However, woolen stockings and high or low laced shoes took the place of gaiters. Some cyclists favored knee-breeches cut nearly as scant as those of the eighteenth century (fig. 3); others preferred a style midway between those and the roomier knickers. In America, trousers worn with the new " shirtwaists " were upheld by belts instead of suspenders, though braces were still used with dress suits.

Feet. In winter men wore black or russet shoes laced to the ankle; in summer, oxfords (figs. 3 and 4). As early as 1894 white shoes had appeared among the summer fashions. With formal costume many men wore white or pale-toned spats. Patent leather shoes with tops of kid or cloth, sometimes buttoned, sometimes laced, were considered the thing for daytime formality (figs. 2, 5, and 12), and for evening, patent leather pumps with large flat bows of gros-grain ribbon. The shoes of those who kept up with the fashions had pointed toes, much exaggerated by extremists (figs. 2, 5, and 12).

As a rule socks were black, even with white shoes, though some young bloods displayed colored stripes below their cuffed trousers (fig. 4).

Outer Garments. The length of overcoats varied from the knee to somewhere about the calf. Winter overcoats were of heavy, dark cloth, summer topcoats of lighter woolen in gray or tan. In the middle of the decade dudes affected overcoats shortened to mid-thigh, sometimes exposing a few inches of the coat-tails, cut narrow at the shoulder, wide at the hem (fig. 2). The coat pictured is made of tan covert-cloth and its huge buttons are mother-of-pearl; the collar is black velvet. Some dudes had the temerity to wear such coats of huge plaided stuff. Travellers liked Inverness capes (fig. 3, Chap. XVII), and gentlemen in evening dress still might indulge in the picturesque caped overcoat of black cloth with a velvet collar.

SPECIAL COSTUMES

In America, where Society was still going through a period of ostentation, some mistresses of large establishments continued the custom of dressing their men-servants in eighteenth-century liveries, powdered hair and all. Those with quieter tastes preferred dark suits only slightly different from ordinary dress.

Policemen in American cities wore belted, double-breasted blue frock coats with high turnover collars and two rows of brass buttons, and hard, round-topped blue helmets.

WOMEN

Heads. From the beginning to the end of the decade most women wore their hair back from the forehead and knotted on top, in a " psyche knot," the trend of fashion being toward a larger coiffure (figs. 8 and 20). There are

FIG. 8.
An evening costume, 1892.

FIG. 7.
Hats and wraps: a, 1890. b, 1890-1892, c, 1896.

FIG. 10.
In costumes like this ladies saw the Chicago World's Fair during the summer of 1893.

FIG. 11.
A dressy waist of the year 1893. Note the chatelaine bag.

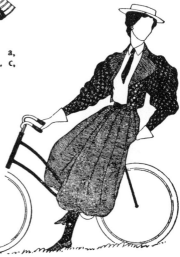

FIG. 9.
Bicycling costume with bloomers, 1893-1896.

still conservative women who have never abandoned that simple style which was becoming to them in their youth. Not that the pompadour was adopted by everybody, for some parted their hair in the middle (fig. 14), some dressed it low in the neck (figs. 9 and 19), and some rolled it into a " French twist " up the back (fig. 7a). Till about 1896 small heads were modish (figs. 7 to 13); after that some women fluffed their hair in looser puffs around the face (fig. 16), and at the end of the decade some began to brush it up over a pad (fig. 20). As a rule the ear, or at least the lower part of it, showed. Hair ornaments were simple, consisting of flowers, bows, back-combs, or some jewelled trifle standing up a bit higher than the topknot (figs. 11 and 13).

Hats. (1) About 1890–1893 hats were smallish, even those with brims not spreading wide over the face (fig. 7a). There were a good many smaller toques (fig. 10) and plenty of smart little bonnets, with or without strings (fig. 7b). All were put on the top of the head, as a rule fitting securely over the knot of hair, and most had rather elaborate trimming standing upright.

(2) In the middle of the decade, while bonnets were still small, toques were somewhat larger, in keeping with an expanding coiffure (fig. 7c), and hats had decidedly wider brims (figs. 12 and 16). In summer, leghorns with brims which drooped a little like the old poke bonnet (fig. 17) put in an appearance. Bonnets (which were tied under the chin with wide ribbons) and toques were set firmly upon the top of the head, hats often slanted a good deal over the brow. But notice that they were *not* tipped to one side. Plain mannish straw hats (fig. 9), which had come into style at the end of the eighties, were very popular during the nineties, especially with the New Woman, who went in for severe tailoring. Sometimes the stiff sailor was embellished with feminine trimming and a veil (fig. 18). For sports ladies often assumed the mannish fedora (fig. 15); those who sailed, or cruised on yachts, or took transatlantic voyages donned yachting caps (fig. 1b). Some girls wore them when they went rowing, or just on any picnic.

(3) As fig. 20 shows, really big hats came in during the last year or so of the century; and naturally enough, since hair was dressed decidedly wider. Bonnets were fast being relegated to Grandmother's wardrobe, but toques (fig. 19) remained in the mode. Some were flatter than the one pictured, and sat upon the head like a dish, a style very popular a few years later (fig. 6c, Chap. XIX).

Hats were almost always profusely trimmed, usually with decoration which added to the height. As may be seen from the examples sketched, such trimming included flowers, ribbon bows, lace and chiffon frills, *choux,* or puffs, and plumage; usually more than one kind of trimming was included on a hat. As to feathers, everybody wore them. Upon very expensive hats they took the form of ostrich plumes and aigrettes (fig. 20), or " birds of Paradise "; upon less elaborate headgear a quill, a wing, a breast, or possibly a whole bird (fig. 16). The face-veil pictured in fig. 18 which had come into style in the early seventies was no whit less fashionable in the nineties. It was

fastened neatly to the crown by means of round-headed pins, drawn tight over the face and under the chin, and pinned together upon the back hair. Though on the whole mourning was not so eclipsing as formerly, widows were still set apart by their black bonnets and crêpe veils.

Necks. Except at formal evening functions, most women wore high-necked dresses, for the round or V-necks of the eighties had gone out. The way had been prepared by the one- or two-inch band finished with a white fold or ruching (fig. 20, Chap. XVII). Neckbands of that height were common during the entire decade (figs. 10, 11, 14); often, as in fig. 11, a velvet band finished a woolen or silk waist. In the middle of the decade high and very elaborate collars were ultra-stylish (fig. 16). The stiffened petals sketched were among the prettiest finishes, which included also wide fluted ruchings or ruffs. Coat and cape collars followed the same fashion (figs. 7c, 12, and 16), very flattering, for it made the wearer's head look like the center of a flower. Toward the end of the decade collars were lower again and less elaborate (figs. 19 and 20). The large bow at the back, shown in fig. 7b on a cape and in fig. 14 on a dress was sometimes elaborated into a big puff of crisp tulle. Turnover lace (fig. 14) and a wide fluted ruffle on a narrow neckband (fig. 17) were decorations favored by those who dressed somewhat conservatively. Some suits had " officer's " or military collars, highish bands of the dress-material, neatly finished with braid. The severe turnover pictured in fig. 15 belongs to the sports type of dress and is not often met with on other costumes. With dresses for cycling, yachting, and bathing sailor-collars were the thing. With all, even the bathing-suits, went a dicky which filled in the front V and had its own standing collar an inch or so wide.

With the new shirtwaists adapted from the masculine garment, women wore mannish starched collars, not, as a rule, so high as the men's. In a collar like that sketched in fig. 9 one cycled, played tennis and golf, or went on picnics. In a higher starched collar (fig. 18) the still-rare " business woman " was thought appropriately dressed to invade the world of men. One wore with such collars either the four-in-hand (figs. 9 and 18) or the Windsor tie in a soft bow. After a bit, made bows were substituted for the straight Windsor tie, for sewed on a backing which could be hitched to the collar-button, they saved time and labor.

Evening dresses could no longer be cut with a décolletage which dropped over the shoulders, for the high-shouldered sleeves made a higher line necessary. Backs were pretty high, too, even when they were V-shaped. Some women wore dresses as low in the front as (taking into account a high-busted corset) they could without offense; others were shocked at more exposure than that pictured in fig. 13. In the first years of the decade many evening dresses had square necks reminiscent of eighteenth century modes, though usually more prudish; many others, deep but narrow V's. The " heart-shape," shown in fig. 8, with a draped bodice was considered smart during this decade and the next. It was in the middle and latter part of the nineties that a round, lace edged

décolletage came back to style, but, as may be seen in fig. 13, very unlike round necks of earlier years.

Bodices. The nineties were the years of the wasp-waist. Paper patterns of those days were designed with thirty-six inch bust, twenty-two inch waist, forty inch hip; nowadays the standard proportions are thirty-six, twenty-eight, thirty-nine. At present many a " thirty-six " is not ashamed of a twenty-nine inch waist; in the nineties all too many " thirty-sixes " managed to get eighteen-inch belts around their middles. Besides being tight in the waists, bodices were still made on snug, boned interlinings. But whereas nearly all bodices of preceding decades had had tight exteriors also, in the nineties newer-style " waists " were draped, pleated, or gathered upon their foundation (figs. 8, 10 and 15), and eventually even bloused (figs. 11 and 20). Those bodices which were still smooth outside were so ornamented with revers (fig. 12), bretelles (fig. 10), ruffles (fig. 13), or cascades (fig. 19) that they too gave an effect of blousiness. Separate waists (there were a great variety, from plain for daytime to very fussy evening models) worn with skirts were " basques," *i. e.,* they fitted *outside* the skirt band. The finish might be just a neat binding upon a pointed or round lower edge; it might be a girdle of crushed silk, boned up in front and back (fig. 11); it might be a sash of satin ribbon, with a " made " bow in back (figs. 17 and 20); it might be a wide " corset " girdle, reminiscent of peasant dress; or, finally, it might be a peplum (figs. 13 and 14). Sometimes peplums had turreted edges, quite in the manner of the seventeenth century (Chaps. X and XI). Sometimes, again, tabs appeared in the back only, a style known as a " postillion back."

The other, informal type of waist, the " shirtwaist," which had put in an appearance at the end of the eighties, was destined to supersede the basque, but not yet; in the nineties each had its function, the shirtwaist being much the less dressy of the two. Its distinctions lay in the fact that it was not necessarily made on a tight lining (though shirtwaist patterns provided for one) and that its lower edge tucked *inside* the skirt. Strictly speaking, a shirtwaist, being modelled on men's shirts, was made of wash-materials, opened up the front, and finished with a neckband to which a starched collar was attached; but by the middle of the decade it began to take on some of the frivolities of the basque, or, we might as well say, the basque began to assume characteristics of the waist.

Basque and waist shared certain features. Both were fitted neatly in the back and under the arms, in both all fullness was concentrated in the front, almost always between the curve of the bust and the belt. In gowns where waist and skirt were of the same material, the bodice was still often made separate from the skirt. This is true of a dress like that sketched in fig. 13. The later gown shown in fig. 20 has its bodice and skirt fastened together. Notice that a new element is introduced here, a decided blousiness all across the front.

About 1893 the princesse dress came back. At first it was considered a style

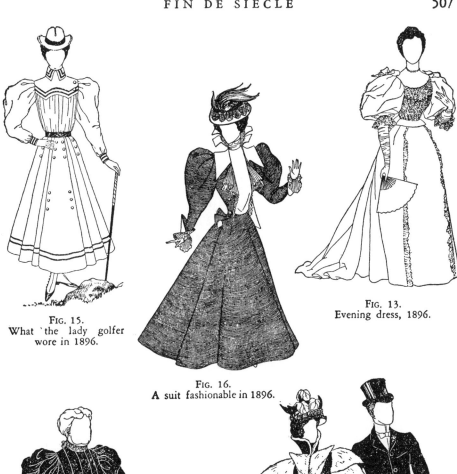

FIG. 15.
What the lady golfer
wore in 1896.

FIG. 13.
Evening dress, 1896.

FIG. 16.
A suit fashionable in 1896.

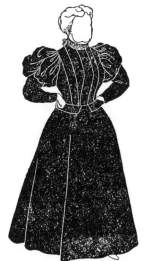

FIG. 14.
Woolen dress, c. 1894-1896.

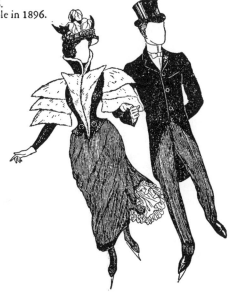

FIG. 12.
City skating costumes, 1895.

suitable for evening dresses and tea-gowns (which picturesque garment was just being introduced); in the second part of the decade tailored suits followed the same trend, a close-molded gown being worn with a short bolero or Eton jacket (the latter of the type shown in fig. 9).

The jacket of a tailored suit may be properly mentioned here, rather than under *Outer Garments,* since the blouse worn with a suit was subordinate to the jacket in interest. From the nineties the coat-suit was the backbone of a woman's wardrobe, sharing the fashion changes which other garments showed. About 1890 the tailored jacket was plain, a sort of box coat with a fitted back, a little more than hip-length. Very often such a jacket was worn with a skirt of different material. During the entire decade some women continued that custom, but not, as a rule, the smarter women. For them were made suits like that sketched in fig. 16. Flaring collar, balloon sleeves, and very wide skirt mark this suit as of the mid-nineties, and appropriate for formal calling or church-going. Much simpler suits with plain jackets and mannish revers (fig. 9) were worn at sports or by business women at their work. As to length: in the early years jackets came about to the hip, later they were often as long as to the knee, then, as in fig. 16, short again and very flaring, later still, very short, sometimes no more than boleros. Upon jackets, as upon bodices, the trimming usually served to accentuate a tiny waist, consisting as it did of revers (figs. 9 and 16) and bretelles, often augmented by cascades of lace revealed under the jacket.

Arms. Sleeves were more important in the nineties than they had been since the Romantic period (Chap. XV). In 1890 they were narrow and high-shouldered (fig. 7a); in 1892 they already had good-sized puffs (fig. 8); these grew steadily larger (figs. 10, 11, and 14) till in 1895 and '96 they attained their maximum immensity of three yards around (or two and a half in heavy material). We have not illustrated the largest possible example; fig. 13 shows a moderate size, with only about a yard in each sleeve. By 1897 the pendulum began to swing the other way, and in 1898 forerunners of fashion were wearing sleeves that fitted the arm at the top and sometimes all the way down (figs. 20 and 19). Most of the long big sleeves were of the leg-o'-mutton type, *i. e.,* cut so that they were large at the shoulder and tapered to a tight forearm (figs. 15, 16, 17, and 18). The sketches show how this pattern could be adapted to a great or a lesser puff, and how, in some instances, it was cut to give a " mousquetaire " (*i. e.,* wrinkled) effect on the forearm.

A good deal of ingenuity was expended on varying the treatment of sleeves. In the very first years of the decade sleeves with high-shouldered gathers (as in fig. 7a) might, on evening-dresses, be finished with lace frills at the elbow. Later, as in fig. 8, the puff was ingeniously draped. Big puffs were sometimes divided down the middle into two puffs (fig. 14), sometimes made to look even bigger by knife-pleated frills up the outside. Jacket sleeves might give the wide effect by means of wing-like capes over the puff (fig. 12). Evening-dress sleeves were as big around as those with day costumes, and were

often, as in fig. 13, as long as to the elbow. When at the end of the decade arm-sized sleeves returned to style, they were still frequently softened by caps (fig. 20) and puffs, and when elbow-length were once more finished with a lace ruffle.

Large sleeves had to have supports, or they would have hung limp in spite of their fullness. In part the bouffant effect was taken care of by the material if it happened to be taffeta, organdie, or starched cotton goods, but this was usually supplemented by a crinoline interlining, and even, if necessary, by crinoline "plumpers," "sleeve-bustles," or whalebone hoops. Plumpers were made thus: From doubled crinoline was cut a crescent measuring from point to point double or more the inches across the top of the armseye, and in depth six inches or more; this was pleated in to fit the top of the armseye. It stood out fan-wise and held up the sleeve-puffs. Sleeve-bustles were transferable from one dress to another. The bustle was a wire arrangement in three coils (like bed-springs) which lay on the upper arm and was hitched to a strap for the arm to go through. Nothing demonstrated the superior chic of a city modiste's creation over the product of the village dressmaker so undeniably as the way its sleeves "set" and stood out. For in those days it was a much farther cry sartorially from Paris to Centerville than it is now, when ready-made frocks in imitation of imported models are on sale simultaneously all over the country.

Legs. (1) In 1890 most skirts were plain, undraped, gored in front, and gathered in back; street-frocks had skirts of instep-length, but evening gowns, formal afternoon dresses, and tea-gowns had skirts that barely escaped the floor in front and trailed behind. Handsome evening dresses might have skirts in the eighteenth century style, *i. e.,* open in front over a rich panel or petticoat, but more often the skirt was plain or but slightly trimmed. The slightly draped effect shown on the evening dress in fig. 8 is reminiscent of the eighties, though a newer treatment; the style did not persist till the middle of the decade. Most skirts were of heavy material, *e. g.,* cloth, satin, velvet, duck, or piqué. Any of them was put on over one or two starched white ruffled petticoats and, probably, over the small bustle or pad pictured in fig. 21b, Chap. XVII. Hips, under the layers of petticoats (also, if necessary, under a little padding) rounded out abruptly from the tiny waist. The skirt hem did not spread out much wider than the hips. Such a skirt continued to be worn by even fashionable women for sports as late as 1895, and by the average woman during the entire decade (figs. 11, 14, and 18).

(2) Early in the nineties some skirts began to be wider at the bottom. They fitted smoothly over the hips, but at the back a good deal of extra width was pleated in to the waistband, giving an outward spring to that part of the figure. Immediately below the hips the skirt spread wide, because of the number of gores or because of "godet pleats" let in at that point.

(3) The widening process continued till 1896, when the extreme of a nine-yards circumference was reached (fig. 16). If a skirt had a train, the hem-

measure might be still greater (fig. 13). Sport-skirts, of course, did not reach such dimensions (fig. 15), nor did any skirts worn by the average woman. The feature that distinguishes these wide skirts is not so much their width, as their extreme stiffness (fig. 16). This was accomplished by lining skirts of satin, taffeta, or woolen goods (or the drop-skirt, when the dress was thin) with silk, lining-cambric, or sateen, and, moreover, interlining them with haircloth or crinoline. This stiffening went all the way up, so that from the hips down in front and from the waistband in back the skirt stood out as though it were made of fluted metal (fig. 16). Such a heavy garment was a real burden, especially since, unlike the earlier crinoline, a great deal of its weight was concentrated in the long back breadths which had to be held up most of the time. An inventor (whose name is not given) came to the rescue of burdened womanhood with a contraption which he called " La Pliante," described in *Godey's* for September, 1896. We have copied it (fig. 6) to demonstrate how important a part of the fashionable silhouette was this style of " organ-pipe " pleats; moreover it is a practical enough aid to the modern costumer in his efforts to reproduce the chic of the nineties. The contrivance was made of six pieces of sliding pliant steel (the same steel used for hoop skirts (Chap. XX) would probably be heavy enough) encased in " silk or cotton ribbons " (tape). " When attached by loops or ribbons to the skirt, the steels are locked; and three noble organ pleats are the result." No interlining was needed when this was worn, and the skirt was not too heavy to be held up, for the steels weighed only two and a half ounces. It could be fastened into any underskirt, to be worn under different dresses. It was, in reality, a hoop skirt for the back only and, like the earlier hoop, relieved its wearer from the weight of material dragging at her waistline. (4) The device grew out of the need, but it was never popularized like the patent hoop of 1857, for in the very year after its introduction fashions began to change, the skirt lost its stiffness and clung lower down on the hips, falling softly from there to the ground (fig. 20). While most of the remaining fullness at the top was still concentrated at the back (figs. 19 and 20), it no longer rode out stiffly but rested upon the figure. The shape of that figure had not changed, and swelling curves from ample bust into tiny waist and out again to rounding hips were still the ideal (fig. 20). Note also a gentle curve over the abdomen (figs. *passim*).

A feature of skirts during the whole decade was the ruffles put *underneath* the bottom of the dress-skirt. The taffeta drop-skirt or petticoat immediately under the dress had one set of knife-pleated ruffles, the flounced cambric petticoat under that had another, lace-edged. They all rustled and swished elegantly as the lady swept across a ballroom floor, or for that matter across a city street. " Balayeuse " was the Parisian name for these frou-frous, " dust-ruffles " was a more descriptive title, and " street-sweepers " was what the scornful male called them. As in earlier periods there had been a special elegance to be learned for manipulating wrist-ruffles, fans, or hoops, so during

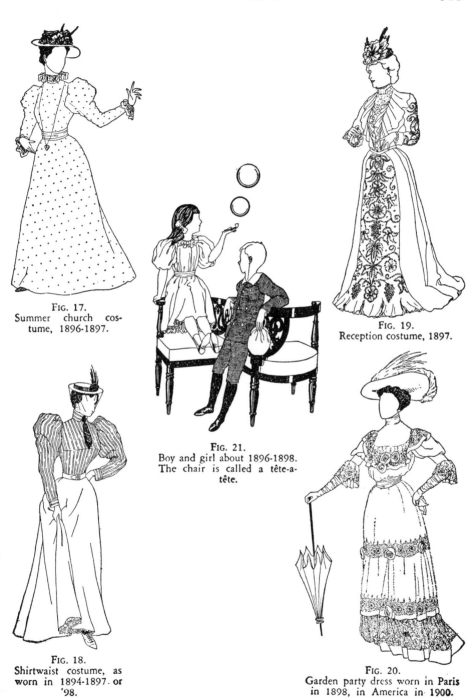

FIG. 17.
Summer church cos-
tume, 1896-1897.

FIG. 19.
Reception costume, 1897.

FIG. 21.
Boy and girl about 1896-1898.
The chair is called a tête-a-
tête.

FIG. 18.
Shirtwaist costume, as
worn in 1894-1897. or
'98.

FIG. 20.
Garden party dress worn in Paris
in 1898, in America in 1900.

this decade and the following there was an art to be acquired for holding up the skirt, daintily, gracefully, so as to display the froth of white lace below, but *not* to show the ankle beneath.

During the decade the length of skirts was suited to the occupation. Thus, for tennis, golf, bicycling, and skating ankle-length was correct (figs. 12 and 15); for walking and shopping instep-length was thought sensible and proper (figs. 14, 17, and 18); while for calling, teas, garden-parties, and all evening affairs floor-length in front and a train behind were in order (figs. 8, 13, 16, 17, 19, and 20). Some women came out in " Rainy Daisy " skirts, shortened to the boot-top; they were considered proper only in bad weather.

While suit-skirts were plain (figs. 16 and 18) or simply trimmed with braid (fig. 12), skirts of dressier costumes might be ornamented (figs. 10, 13, 19, and 20). The full flounces set on gored skirts as in fig. 20 were a new style at the end of the century, which carried over into the next period. A feature of all silk or woolen skirts was the mohair braid or bias velvet sewn just inside the hem, designed to save wear upon the bottom edge. Another feature of heavier everyday skirts, woolen, silk, or wash-goods, was the pocket inserted in the side-front or side-back seam just above the knee, where the wearer's hand could reach to the bottom easily.

Feet. Shoes and slippers had long pointed toes, less extreme in sports styles than in dressier models (figs. 9 and 12). Street-shoes were high and either laced (fig. 12) or buttoned, made of patent leather or thin " French " kid, with, it might be, uppers of lighter kid, satin, or cloth. Their heels for the street were fairly high and generally of the " French " type. For golfing and bicycling the correct foot-gear was a low-heeled laced boot of black or tan leather, or else a half-shoe with leather or cloth leggings (fig. 15), sometimes as high as the knee. In summer, with the popular shirtwaists and duck skirts, one wore oxfords (figs. 9 and 18). Evening slippers had high heels, long vamps, " toothpick " toes, and ornamental touches such as straps, small pump bows, or " Colonial" buckles and tongues.

In the first years of the nineties dark stockings, usually black, were considered correct with black, russet, and even white summer shoes. With evening slippers went fancy stockings woven in perpendicular stripes (cf. fig. 19, Chap. XVII) or embroidered with elaborate clocks. During the second half of the decade embroidery or even lace insertion adorned the instep of evening stockings. After about 1896 russet or white street shoes were matched in stockings. It may be noted here that silk stockings were not yet the inevitable accompaniment of all costumes. The majority of women regarded silk as a real luxury, and in the daytime wore cotton or lisle, if not wool.

Outer Garments. Besides the suit-coats described above, women had a choice of various separate coats, usually cut on princesse or semi-princesse lines. Some, intended for driving or travelling, were rather plainly tailored from mannish cloth, others, to wear over elaborate frocks, were constructed on more feminine lines of fine cloth or velvet with satin or fur collars. Many evening coats had

loose sleeves, dolman sleeves, or big puffed sleeves. Full-length, sweeping capes made with many gores and romantic flaring collars covered gowns worn to the opera. Their shape was adapted to fit the high shoulders or the balloon sleeves underneath.

Shoulder capes formed smart additions to street costumes. Very short and high shouldered at the beginning of the decade, they were later rather bigger and full enough to fit over the ever-widening sleeves (figs. 7b and c). According to the season, they were made of fur, cloth, taffeta, satin, faille, and even shirred chiffon; they were often elaborately trimmed in passementerie, chiffon, lace, ribbon, or jet. The golf-cape, originally intended to protect the fair athlete in inclement weather on the links, was found to fill a real need and was promptly added to nearly everybody's wardrobe as a wrap for country utility wear and as a traveller's cloak. These capes were made of warm woolen material in gay plaids, reversible with a plain color or lined with bright silk, and finished at the neck with collars which could be turned up to flare around the face. A capuchon hood, with the plaid inside, was attached between cape and collar. The capes were semicircular, fitted with darts upon the shoulder, and hung nearly to the knees.

Short fur capes were stylish during the entire decade. Some were so small as to cover only the shoulders and hang down a little lower in the back, being, in fact, the oft-mentioned " pelerine "; some were as large as those pictured in 7b and c. The latter cape is only partly fur, the rest cloth. Smart little separate jackets were made up of fur or velvet-and-fur. They followed the mode, as does the example sketched in fig. 12, with its high flaring collar and fur shoulder-bretelles. In really cold weather those who could afford them donned sealskin " sacks," loose jackets cut on the plan of the house-sacks mentioned in Chap. XVII, but long enough to reach to the knee or lower. Small fur pieces were clasped around the neck as accessories to suits and even to cloth dresses.

In enumerating outer garments from this time on mention must also be made of sweaters, cardigans, and " athletic jerseys," which sometimes took the place of cloth jackets in sports costumes, accompanying mannish shirtwaists, plain duck skirts, and sailor hats.

SPECIAL COSTUMES

Riding. Women still rode side-saddle, but their skirts were shorter and narrower and were put on over breeches and boots. A flat derby usually replaced the high silk hat and a masculine-style piqué stock the cloth collar with ruching or the linen turnover of the seventies and eighties.

Golf. A good deal has already been said in passing about golfing dress. The costume in fig. 15 is of a type advocated by *Godey's* in 1896, and is better adapted to the sport than the equally popular shirtwaist and skirt. It is a one-piece dress with a comparatively comfortable collar, a full bloused waist, and a short skirt laid in pleats stitched down part way. A mannish fedora for the

head and low-heeled shoes upon the feet, with high gaiters for warmth, complete the costume. With it the lady may have in reserve a golf cape.

Cycling. Let who would object, the really enthusiastic cyclist wore bloomers (fig. 9). It may be seen that these much-abused garments were about twice as full as the average modern skirt and not so short as a ball-dress of the 1920's. Yet some "womanly" women, rather than expose their limbs unduly, got about on their wheels in skirts as long as that on fig. 18, or at most no shorter than the style on fig. 15. For the rest, cyclists generally dressed in sailors, fedoras, or visored caps, plain shirtwaists, and jackets or cardigans.

Tennis. To play in a tennis match the summer girl of the nineties dressed in shirtwaist (figs. 9 and 18) and duck or linen skirt no shorter than that on fig. 15, a straw hat (fig. 9), yachting cap (fig. 1b) or tam (fig. 2c, Chap. XVII), and canvas shoes (fig. 18).

Servants. Domestics wore plain uniforms of blue and white striped wash-material or black alpaca, enveloping white aprons with bibs and shoulder-straps, and caps of formidable size. They wore skirts but little shorter than those of their leisured employers, that is, seldom much less than instep-length.

Negligees. The "sacque" described in this section, Chap. XVII, was the intimate garment most often worn around the house. By women who lived a bit luxuriously, the tea-gown was taken up. Generally made with a fitted princesse back, it had such graceful touches as cascades of lace down the front, a collarless neckline or a fichu, and elbow-sleeves.

CHILDREN

Boys. Youngsters wore round sailor hats of felt or straw; or beaver with streamers for very little chaps. Older boys ordinarily had caps, one or other of the types described under MEN, but most often a small skullcap with cloth visor.

Small boys wore blouses of wash-material, flannel, or serge, with wide "sailor" collars which were edged with ruffles if the blouse was white. Their sleeves were gathered slightly into the cuffs, which might be turned back and also have a ruffle. Boys a bit older wore "Eton" collars and Windsor ties with their blouses. A few years afterward the blouse would be exchanged for a jacket, shortish, round, and minus lapels, allowing the collar to fit over it. The next promotion would be to jackets still short but boasting lapels, and narrower shirt collars (fig. 21). After that their suits would resemble those of adults.

Up to about the age of five boys were still dressed in kilt-pleated skirts, then they donned "short pants" (fig. 21), a style to which most of them were kept until their 'teens; though some parents (more in England than in America) dressed their quite small sons in long trousers with Eton jackets. Complete "sailor suits" with long, flapping pantaloons were considered very appropriate for youngsters, though their vogue was not great in inland American towns. In passing it may be remarked that "Lord Fauntleroy" costumes (discussed in this section, Chap. XVII) had not yet vanished from the scene.

Knickers were very slowly entering juvenile wardrobes; men were enjoying *their* comfort in sports togs before many boys had them.

In England and on the Continent long socks and uncovered knees were common, but most American mothers looked askance at what they considered the Spartan custom of sending boys out barelegged in cold weather. For *their* sons they provided sturdy black stockings of heavy ribbed cotton or woolen yarn (Grandmother often knitted the winter supply), which were held up by garters attached to underwaists, just like Little Sister's. Leather kneecaps (explained in Chap. XVII) somewhat minimized the inevitable darning.

When a boy went to dancing-school, he wore pumps. His ordinary shoes were oxfords or ankle-shoes, more often black than brown, which prudent parents had reinforced with copper at the toes. Laced half-way up in the ordinary manner, the shoes were fastened from there up by passing the lacings back and forth around upstanding hooks.

Girls. Long hair was fashionable for girls, who still wore it cut in bangs as in fig. 21 or else parted in the middle and tied with two bows at the sides. As girls grew up to eight or ten they probably braided their hair in one or two pigtails, cut it off square at the ends, and fastened it a little way up with rubber bands and ribbon bows; though the mother of a curly-haired child tried to keep the much prettier ringlets. An occasional little girl had short hair like her brother's, but she was the exception rather than the rule. When a girl was well along in her 'teens but not grown up, she could turn the braid under at the nape to make a knob (or "door-knocker," as they called it in England).

For everyday most little girls wore plain sailors of beaver or straw with elastics under the chin and ribbon streamers down the back. For dress-up there were lots of pretty hats of velvet or beaver, some with shirred silk facings, some with ribbons to tie under the chin, and trimming of flowers or little ostrich-tips. For summer church-going there were chip-straws, milans, and leghorns with wreaths of little roses, daisies, or other field-flowers; these too had elastics to go under the chin or the pigtails. Conscientious suburban and country mothers sent their daughters out to play with their complexions protected by sunbonnets; and very hot they were, too, on a sultry day.

The Kate Greenaway influence, discussed in this section, Chap. XVII, had operated to good effect. Nearly all dresses worn by girls up to ten or twelve were made very simply, more or less on the order of that sketched in fig. 21. Some were even high-waisted and beltless, in the real "Empire" fashion. Puffed sleeves and bretelles reflected adult styles in a simpler version. A good many little girls wore sailor-suits, with kilted skirts on muslin bodies. Dickies with round collar-bands were part of the sailor-suits of girls as well as of boys; sometimes they were stitched on to the muslin body. Blouses, pulled on over the skirt, were turned under on an elastic or buttoned on the bodice. In either case they bloused over the skirt. Sailor-suits could be bought in blue or white serge for winter and in French flannel, duck, or linen for summer. Woolen

dresses were a virtual necessity in winter, and they were still protected by the bibbed aprons described in Chaps. XVI and XVII or by " tie-aprons," i. e., all-over smocks fastened up the back. In summer little girls wore wash dresses. Party-frocks were often made of challis, which came in delicate colors sprigged with tiny moss-roses, and sometimes of white china-silk. Skirts seem long to modern eyes, for they all came well over the knee. In one of the side-seams of almost every skirt was inserted a commodious pocket, very useful in carrying " jacks " as well as other personal effects. Besides a muslin petticoat, a little girl wore a thin flannel petticoat buttoned to her " Ferris waist."

In winter little girls ordinarily wore high shoes, laced or buttoned. Some-times they were made of thin kid with light cloth tops, and therefore suitable even with party dresses, but there were always strap-slippers to wear for very special occasions. In summer, low shoes or strap-slippers were the rule. Upon ordinary occasions stockings were black and ribbed, cotton for summer, wool, probably, for winter; with light dresses they might be white, though not necessarily. Some little girls owned silk stockings, but not the ordinary run in America.

By the time a girl was about twelve, her dresses began to reflect something of the fussiness of adult costumes. Yet there were great differences between girls up to seventeen and their sisters of nineteen or twenty. For one thing there was your hair, which you wore down your back, or at the most turned up in the nape, until you were officially grown up; for another, there was your waist, which you were not allowed to pinch in with real corsets till about the same time; and last and most important there were your skirts, by which your age could be rather accurately estimated. At twelve or so they stopped not much below your knees, at fourteen they dropped a bit lower, at sixteen they might reach the ankle, and then, when you put up your hair, they went down to the length of Sister's, after which you might be allowed a train.

MATERIALS

The material of men's suits shows one important change, a tremendous increase in the use of tweeds and homespuns for sack suits and norfolks. Blue serge entered upon its long era of popularity. Summer suits were made of light wool, sometimes even gray flannel, and of linen, duck, heavy pongee, and seersucker. White duck trousers were fashionable to wear for tennis with flannel blazers, and white flannel trousers with dark coats began to be correct for summer afternoons in the country.

Women's styles demanded either solid, firm wools and silks or crisp trans-parent materials. These dresses required a great deal of material, especially about the middle of the decade. Eight or ten yards of double-width material was estimated as necessary for a plain dress with big sleeves; four and a quarter yards of fifty-four inch material for a gored skirt measuring five and a half yards around the bottom; ten yards of gingham for a simple house-dress; three yards of double-width wool for a golf-cape. In 1896 you were supposed to

allow two and a half yards of silk or three yards of thin goods thirty-six inches wide for each sleeve. If any gown had a train, two yards or more had to be added to the total estimate. With such an initial outlay necessary, it is no wonder that the average woman did not cast her old dress aside as lightly as she does nowadays.

Woolen goods included serge, tweed (which mannish material had a decided influence on tailored suits), flannel (both a heavy grade and "French flannel"), broadcloth, mohair, "goats-hair," cheviot, nun's veiling, delaine (a thin stuff), challis, merino, and silk-and-wool mixtures like etamine (or "canvas cloth") and grenadine, both transparent materials with a wiry texture.

Among silks were the ever-present satin (still "stiff enough to stand alone"), taffeta, silk-backed velvet (sometimes with a changeable effect), India silk, and "surah" (a dull, rough-woven fabric), china silk, crêpe silk, and foulard. Embroidered silk gauze was modish for party dresses and chiffon for dressy waists.

Among cottons the favorites were gingham ("zephyr cloths" and Scotch ginghams), organdie, printed muslin, dimity, batiste, fine white muslin, and above all, piqué. Linen, white, "natural," and colored, was a smart material for summer-resort suits.

Thin materials, cotton, silk, and light wool, and lace as well, were made up over colored slips of satin or taffeta. Lace had a great vogue during the last few years of the decade, when it was employed profusely for sleeves, skirt-flounces (fig. 20) and indeed whole dresses. Battenberg was thought appropriate for all-over lace frocks, and so was dotted net, for those with many ruffles. Machine-made cotton lace had by now come to be accepted as something a lady might wear, though real lace was still prized.

The fashionable furs were: perhaps first of all seal, then astrachan, Persian lamb, mink, chinchilla, sable, and ermine; still, it will be noticed, short-haired rather than long-haired pelts.

COLORS

Nothing needs to be added to the earlier account of colors men might wear. Except for a possible bright flash in necktie or socks and an occasional gay waistcoat, they were dark, drab, and uninteresting.

Women, on the other hand, had developed great complexity in their color-schemes. In the first place there were the figured materials: bright plaided, checked, and striped woolens, spotted and striped piqué and linen; muslin printed in pretty flowers like roses, bluets, morning-glories, chrysanthemums, and "ragged robins" on a white or pastel ground; changeable taffetas; India silks in Persian designs; foulards in spots, flowers, and other small figures on grounds black, white, or colored.

Turning to the unpatterned materials: deep strong colors were often employed in woolen dresses and in linen suits. In wools, dark skirts were matched with bright waists, such as scarlet trimmed with black and gold. In linen, plain

dark jackets were combined with skirts in stripes of the same color and white. Cloth suits were made in mignonette green, in gray, blue, " Havana brown " and other deep tones; dressy waists in contrasting colors accompanied them.

A favorite semi-dress afternoon or evening toilet consisted of a cloth or taffeta skirt (often black) with a fussy waist or basque in another color and material; a combination suggested in 1896 for a summer-resort toilet was silver-gray taffeta with a pale pink chiffon waist.

In the middle years of the decade there was a great vogue for thin material in black, white, or a color over very bright colors. Black grenadine, etamine, or filet net over changeable taffeta in peacock colors, blue, or red; bud-green over peach or orange-peel; corn-color over myrtle-green; pale yellow over gray; gold over navy or old blue; these are some of the combinations suggested by fashion writers. White net or fine muslin, dotted swiss, and organdie over colored taffeta or even dimity were all popular, too, and flowered muslins over a color predominating in the pattern.

Suits were trimmed with facings of silk or velvet in interesting combinations such as hunter's green on turquoise, or red on blue. Costumes were sometimes worked out in shades of one color, e. g., brown.

White, worn without touch of color or with only a dark four-in-hand was very chic for the shirtwaist-and-skirt suits of the summer girl. Young cyclists wore costumes of white mohair or piqué. In England, golf suits included, by custom, a scarlet jacket with dark blue collar and cuffs, but in America the color was left to individual taste.

Mourning was not quite so heavy as it had been earlier in the century nor was it worn so long. In America there was a growing sentiment against dressing children in black at all, though many families had a rigid etiquette for keeping them in all-white during the conventional period of mourning.

MOTIFS

Quite as eclectic as the preceding decades of the Victorian era, the *fin de siècle* chose its motifs from here and there, inclining rather more toward Louis XVI designs than any others.

APPLICATION OF DECORATION

Soutache and flat braid, passementerie, jet and steel beads, ornamental buttons, and silk piping and binding especially characterize the trimmings of the early 1890's. During the latter part of the decade lace was an especially important decorative feature, freely used as insertion in fine muslin dresses, as edging, flounces, ruffles, berthas, and neck ruching.

JEWELRY

Men's opportunities for wearing jewelry were very limited. The watch was still carried in a small vest-pocket; some men spread a watch chain from pocket to pocket, or from pocket to a higher buttonhole; some, moreover, attached

emblems or trinkets to the chain. From this period on, college Greek letter fraternity pins were a good deal in evidence, as were also the pins of more democratic fraternal orders.

Although women's ears were seldom completely covered by their hair, earrings were out of fashion. The practice of piercing the ears became less common. Not even the return of earrings has brought it back, since invention has come to the aid of vanity with screw-on ornaments.

Combs with tops decorated with jewels, rhinestones, cut steel, or gold were put in at back and sides of the topknot. Hairpins with jewelled heads were included in evening coiffures, such ornaments being often in the shape of rosettes or butterflies. By the middle of the decade long hatpins were necessary to secure the elaborate hats which perched precariously on top of enlarging pompadours, and before long their heads were made in fancy designs.

Evening jewelry copied the daytime mode for high collars, in a dog-collar of diamonds or brilliants. Such an ornament, made of gold or silver, once graced the neck of an Assyrian queen (Chap. II), such another encircled the throat of a Teutonic woman (Chap. V), but hundreds of years had elapsed since it had been in fashion.

Pins, which were used to fasten the high collar, or to ornament the front of a décolletage, were no longer the massive brooches of the eighties, but rather clusters of diamonds or brilliants, wreaths and circles, finely wrought in gold and enamels. Gold or silver watches were worn upon the left shoulder, hooked upon an ornament (frequently in the shape of a fleur-de-lis or bowknot) pinned there. Sometimes an attached chain hung around the neck and dangled over the bosom. At the ends of long chains swung good-sized lockets (fig. 17); shorter chains with more elaborate lockets embellished evening toilettes. The gold hoops of wedding rings grew narrower. The fashionable rings were set with gems, either in solitaire or surrounded by chip diamonds. Every engaged girl felt that, whatever happened, she *must* have a diamond solitaire, held high on its golden prongs. Bangle bracelets and bracelets made of gold or silver links, secured to the wrist by heart-shaped padlocks which really fastened with a key, were desired by every girl.

ACCESSORIES

From the standpoint of the average American, the monocle was the badge of a dude, even though the wearer might be an Englishman. Most men who had to wear glasses and could not tolerate middle-aged-looking gold-bowed spectacles, wore pince-nez on a cord. Canes in the hands of young men were regarded as a bit of an affectation, but many carried them; crook-handled bamboo was a fashionable sort. Dancing-partners wore white kid gloves; the well-dressed man always wore gloves outdoors, even when the weather was not cold. Ordinarily gloves were of stitched leather in tan, brown, or dark gray, but for driving they might be of " wash-leather," *i. e.,* chamois.

Many women wore chatelaine bags, very useful accessories to a costume

which seldom allowed pockets. The chatelaine was a large pouch, as a rule made of pin-seal with silver mountings, hung into the belt by a hook (fig. 11). When a lady did not wear a chatelaine she probably carried in her hand a " pocketbook," a simple, book-shaped receptacle of pin-seal. Everyone owned a pretty card-case, too, accessory of that important nineteenth-century rite, the formal afternoon call.

Gloves, which were long with short sleeves, were thin, light-colored, and often made in suede instead of glacé kid. Street costumes were always accompanied by gloves of the same thin textures; with long-sleeved dresses they were short (three- or four-buttoned) and pale-toned or black, according to the dress. With summer sports clothes " wash-leather " was thought correct.

Fans were back in style, carried in the evening and sometimes in the afternoon as well. They were small and delicate, after the eighteenth century model. At concerts, lectures, and church many women also used fans, and it was there one saw those folding, wheel-shaped contrivances, an example of which is illustrated in fig. 18, Chap. XIV. Ordinarily the fan carried to a concert was dark and plain.

Both umbrellas and parasols (the former as ubiquitous as ever) had long handles (fig. 10). Umbrellas were black, silk if you could afford it, otherwise cotton. Parasols, always light-colored, were sometimes of simple design, relying for their charm upon color or a printed pattern (fig. 20); sometimes, again, they were very fussy. For instance, a parasol carried about 1895 was of flame-pink silk covered with frills of black Chantilly lace. A six-inch ruffle of the lace encircled the pointed end, and the handle was trimmed with a lace chou.

With shirtwaists one wore a buckled belt (fig. 18), which might be made of plain leather, fancy leather, or a novelty fabric. Sashes as well as ribbon girdles often added a bit of color to a white or pastel frock (figs. 17 and 20). The shirred silk belt pictured in fig. 11 was a standby for years.

SOMETHING ABOUT THE SETTING

A revival of interest in the eighteenth century extended to interior decoration; in grand houses Louis XV and Louis XVI drawing-rooms and boudoirs were the order of the day. Very wealthy householders could afford authentic pieces, or good imitations of the furniture, with hangings to accord, so that their rooms were sometimes nearly as beautiful as the originals. Unfortunately, mass-production furniture (at that time the only kind available to the average purse) does not copy successfully the subtleties of Rococo, and some terrible examples of badly-designed, rickety gilt tables and chairs graced homes which were pretentious without being impressive.

Along with the epidemic of " Louis " interiors raged another, of " cozy corners." Such a place included a divan with a striped cover, many cushions embroidered in pictorial designs, crossed firearms or scimiters on the wall, and all too frequently examples of pyrography or burnt-wood drawing. The successful cozy (or Turkish) corner was crowded about as full as it could

hold with every imaginable kind of junk and then it was, very often, veiled from the public eye by a bead portière. Akin to the enthusiasm for Turkish knickknacks was that for Japanese things, fans and open parasols, and even (among the more cultured) prints.

Heavy window-curtains, flowered carpets, and dark wallpaper characterized those houses which had not fallen under the frivolous influence of the Rococo. The tête-à-tête chair illustrated in fig. 21 gives an example of "parlor furniture" of the period. Gas was still the illumination in most city houses, and in the country, oil lamps. Therefore the center-table was the nucleus of the sitting-room, for on it rested the big lamp or gas drop-light. On the parlor table there usually reposed the family photograph album bound in plush, and a stereoscope.

PRACTICAL REPRODUCTION

Materials. There are few materials named in this chapter which are not now procurable, though perhaps under other names. In preference to all-silk satin, moiré, or velvet, use cotton-backed satin (sometimes it is sold in dress-goods sections under the name of "slipper-satin," always in drapery departments), part-cotton moirés, and velveteen, because of their superior stiffness. Line garments with horsehair, tailor's canvas, or crinoline.

Shoes. Unless you can find in trunks and closets high laced or buttoned shoes resembling those described and pictured, you must make shift with modern. This is not a serious difficulty. Though very modish young men and women should be wearing sharp-pointed shoes, ordinary folks can get along with round-toed shapes. In dressing women, avoid those modern shoes which are very open, or of any sandal design, also extremely high, narrow heels. You can be safe with oxfords, pumps (upon which you may put rosettes), and low shoes with high tongues and square buckles. If you are dressing a winter scene and can't find high shoes you may think it desirable to fit out actors and actresses with spats.

CONSTRUCTING THE GARMENTS

Men. It is improbable that you will actually make men's suits of the nineties. If you cannot borrow garments which resemble those pictured and described you can make small alterations in modern suits that will give the flavor of the period. In no detail can this be better accomplished than in collars. Wing-collars with the points turned up and laundered flat, or wing-collars worn upon occasions when moderns wear more comfortable styles, will radically change the appearance of an otherwise present-day turnout. If you are at a loss to secure appropriate collars, make them. Buy a neckband in the proper size and put on a collar for which you have first cut a pattern in wrapping-paper. Make it of heavy bleached muslin or linen, two or three ply, and have it starched and finished like any collar. You can make neckties of the styles sketched. Headgear will have to be borrowed. A modern silk hat will do;

and though the authentic derby is somewhat lower crowned, a modern derby may be used without incongruity. If you can't find a straw as flat as that shown in fig. 1c, better do without. Any modern slouch hat or soft roundish felt may easily be given the twist that will make it look " in period." You won't have much trouble finding appropriate caps. Proper hair-dressing and moustaches will go a long way toward suggesting the period.

Women. A perusal of the accompanying sketches will tell you what hats and trimmings to look for on borrowing expeditions and how to adapt and trim any hats which may come to hand.

You are likely to find at your disposal some excellent dresses of the nineties; this chapter is designed to help you identify them. What you can't find you can make. But your first consideration must be the figure which is to carry off the dress. How are you to get the high bust, tiny waist, and big hips necessary for the proper appearance of your costumes? You cannot expect a modern actress to perform in a dress that squeezes the breath out of her body. Your task will be to create the illusion of a wasp-waist by padding bust and hips. If the actress has a thirty-six bust and twenty-eight waist, cut the tight lining of her bodice thirty-eight and fill in with layers of cotton-wadding. Try to get a corset of an earlier design than the straight-front model (Chap. XIX) and lace in her waist to twenty-six inches; that much won't hurt her. Sew padding on the hips of the corset, till they round out as shown in fig. 6 and the following sketches. You may have to pad the abdomen a little, too (if the actress will tolerate it), and you must certainly add at the back the small bustle pictured in fig. 21b, Chap. XVII. Put plenty of petticoats on top of the corsets, and you will have a proper foundation for a smart costume. If the dress is of heavy material, the petticoats may be made gored but still rather full at the top, to be adjusted on a drawing-string, but if skirt material is thin and yet must fit unwrinkled, the heavy muslin petticoat should be gored to fit.

Pictorial Review carries among its fancy-dress patterns a style called " Gay Nineties." It will prove useful as a start for most of the costumes sketched in the chapter; probably you will need to use more material than is called for in order to give the authentic silhouette, as shown in our sketches (compare the contemporary yardage estimates, quoted above under MATERIALS with the estimate given on the pattern). Below are suggestions for making the dresses independent of this pattern.

In the first place, it will pay you to inquire for real patterns of the period. You will have to allow inches at the waistband, but otherwise the pattern will give an excellent shape for padding. Look for a princesse slip, a shirt-waist (most patterns include a fitted bodice), a five- or eight-gored skirt, and a princesse coat which you may cut off jacket-length. But if you can't find these patterns, you can do with modern. Use the fitted lining (Chap. XX), advocated for so many bodices, for your foundation, and include it even when you make a shirtwaist. Make the bodices sketched in figs. 10, 12, 14, 17, and

19 by the same pattern, adding external frills and peplum as needed. To reproduce fig. 8, put the lining, cut low-necked, on the wearer, drape a piece of material upon her, pin, cut, and tack to the lining before you take it off; fasten at shoulder and under left arm. For fig. 11, cut the outside by a modern waist-pattern, allowing enough width to make the fullness pictured, and adjust it to the fitted lining on the wearer. For fig. 13, gather lace upon the low-necked lining. For fig. 15, cut a yoke by the high-necked lining. Make the lower part in one piece across the front, opened up the back, and straight except for a scoop out for the armseye; gather the full part on the fitted lining; apply the yoke on top. You can use the lining pattern to cut the jacket, fig. 16, adding a peplum with many stiffly interlined godets. Cut the shirtwaist by a modern blouse pattern which has no excess fullness; attach it to a fitted lining to insure its staying in place. Cut the style in fig. 20 on a full blouse pattern and adjust it to the fitted lining. You can buy a pattern for a puffed sleeve and a leg-o'-mutton, but in most instances you will have to insert extra fullness in the middle, on the straight of the goods, as explained in previous chapters. Almost always you must line sleeves with crinoline, sometimes doubled, and perhaps you will need the plumpers or sleeve-bustles described earlier in the chapter.

Cut the skirt of fig. 8 gored in front, straight in back, but instead of goring it narrow enough to fit the waistband, drape it up from front to back. Allow extra length in the back breadths for a train, which you will round out to join the front breadths. For the bloomers, fig. 9, get a fancy-dress pattern for Turkish trousers and cut the garment the proper length, adding fullness as needed, to be pleated in around the waist. (Or use an old gym bloomer pattern if you can find one.) Cut the skirts of figs. 10, 11, 12, 14, 17, and 18 by a five-gored pattern. They should be about four and a half yards around the bottom. Cut the skirt of fig. 15 on a pattern which is gored and yet allows for pleating; the best is an eight-gored pattern which measures about five and a half yards around the bottom. The skirts shown in figs. 13 and 19 should be gored in front, straight and gathered or pleated across the back. In 19, set small godets in the hem of the front panel. To cut 16 you need a gored skirt which allows fullness in the back and extra width around the bottom. The original plan, which you may well follow, was to set in godets from about the hip-line to the hem, enough to make the skirt measure as much as nine yards around the bottom. In this skirt you will do well to insert " la Pliante " (fig. 6); the sketches explain its construction. Spring-steel (see hoop skirts, Chap. XX), or if necessary a flat steel wire still heavier, must be inserted in a panel of heavy muslin, pinned or basted to the drop-skirt. For the skirt in fig. 20 cut the top gored and gather on it two straight flounces, the lower fuller than the upper. As has been said, the secret of chic in these skirts is the interlining and the petticoats. You may assume that there are ruffled, starched white petticoats even in those sketches where they do not show.

Suggested Reading List

Few histories of costume carry their subject through the nineties.* Some exceptions are:

Von Boehn's *Die Mode: Menschen u. Moden in Neuzehnten Jahrhundert* (translated as *Modes and Manners of the Nineteenth Century*, Fischel and von Boehn). The illustrations for this period are excellent.

Iris Brooke's *English Costume of the Nineteenth Century* and *Nineteenth Century Children's Costume*. (Small, but helpful.)

A Century of Fashion, by J. P. Worth, which describes and pictures the costumes created by the House of Worth.

The American Procession and *Our Times* (commented on in this section, Chap. XVII) are valuable for this decade also.

New York in the Golden Nineties, by Henry Collins Brown, is another in the series with *New York in the Elegant Eighties*. Like the former volume, it is copiously illustrated with contemporary sketches and photographs.

The *Encyclopedia Britannica* (14th edition) has an excellent article on "Dress." Up to this period its material is a good résumé of what you may find in detail in other works, but from 1890 to 1930 its collected information is particularly useful because nearly unique. It is charmingly illustrated.

Where Further Illustrative Material May Be Found

Illustrated magazines and fashion periodicals, French, English, and American (see bibliography) furnish an abundance of information about dress in the nineties. The artists Du Maurier and Reginald Birch were still at work. Gibson, who illustrated Anthony Hope's "Dolly Dialogues," stories by Richard Harding Davis, and other contemporary fiction as well as contributing to *Life*, is the American Du Maurier in so far as he also made a full and truthful pictorial record of his era. Many of Sargent's portraits of society women, English and American, date from the nineties.

Actual garments are naturally among the most important sources of information; though they should be studied in conjunction with pictures and photographs, otherwise you will not understand how they go on. More valuable than almost any other information is that gleaned in talks with people who actually wore similar clothes.

Sources of Sketches in This Chapter

Godey's Magazine for the years 1896 and 1897, and *Vogue* for the years 1892 to 1900 furnished many details for the accompanying sketches, which are also indebted indirectly to *Life*, *Harper's Monthly*, and other publications of the same decade. Fig. 8 was inspired by a drawing by Harry McVickar in *Vogue* for 1892. The ball dress (fig. 13) relies in part on a dress in the Museum of the City of New York, in part on a photograph of Maude Adams in 1896. The dress in fig. 19 is copied from a gown (now in the Smithsonian) worn by Mrs. William McKinley in 1897, but the hat is from a Godey fashion-plate. Dress, hat and parasol of fig. 20 were found in a photograph of Cléo de Mérode, Parisian beauty, but the pompadour comes from other contemporary sources. The hat on fig. 17 is from one contemporary photograph, the dress from another. The dude (fig. 2) is re-created from contemporary cartoons and from a written description in *This New York of Mine*, by Charles Hanson Towne. Hat and cape of fig. 7b are drawn from actual garments belonging to a neighbor, the other two on the page are from fashion illustrations. We are greatly indebted to friends who have generously allowed us to make use of their family photographs, their parental wardrobes, and their own reminiscences.

* Cunnington (op. cit.) does so, triumphantly.

Chapter XIX
NEW CENTURY

DATES:

1900–1914

**

Some Important Events and Names

ENGLAND	FRANCE	GERMANY	AMERICA
Edward VII, r. 1901–1910	Third Republic	Emperor William II	PRESIDENTS Theodore Roosevelt, 1901–1909
	Exposition, 1900		
George V, r. 1910–	Dreyfus Acquitted, 1906	DRAMATISTS Hauptmann	Wm. Howard Taft, 1909–1913
m. Victoria Mary of Teck		Sudermann	
	DRAMATISTS		Woodrow Wilson, 1913–
PRIME MINISTERS	Maeterlinck	Wedekind, d. 1918	
Balfour, 1902–1905	Brieux	Schnitzler	First Automobile Show, 1900
Campbell-Bannerman, 1905–1908	Hervieu Rostand	THEATRE ARTS Reinhardt	Wright Brothers' first successful flight, 1903
Asquith, 1908		Appia	Iroquois Theatre Fire, 1903
WRITERS	ACTORS Réjane	Urban	
Conan Doyle, d. 1930	Bernhardt		San Francisco Fire, 1906
Kipling Wells Mrs. Humphry Ward	Coquelin		Pan-American Exposition, 1901
	PAINTERS Matisse, 1869–		St. Louis Exposition, 1904
John Galsworthy, 1867–1933	Picasso, 1881– The Cubists		St. Louis Exposition, 1912
Arnold Bennett, 1867– "Old Wives' Tale," 1908			Panic of 1907
Conrad, d. 1924			NOVELISTS Edith Wharton "The House of Mirth," 1905
Irish Literary Revival, c. 1900			Richard Harding Davis
J. M. Synge, 1871–1909			
W. B. Yeats, 1865–			ACTORS Mansfield, d. 1907
Lady Gregory			Ethel Barrymore, "Captain Jinks," 1902
The Abbey Theatre, Founded, 1904			
			"Florodora Sextet," 1900–1905
DRAMATISTS G. B. Shaw			THEATRE ARTS
H. A. Jones, d. 1929			David Belasco, 1853–1931
A. W. Pinero, d. 1934			"The Darling of the Gods," 1920

DATES:

1900–1914

━━━

Some Important Events and Names

ENGLAND
(*Continued*)
J. M. Barrie

Granville-Barker,
1877–

THEATRE ARTS
Gordon Craig,
1872–

"On the Art of the
Theatre," 1911

AMERICA
(*Continued*)
ARTISTS
Abbey, d. 1911
Pyle, d. 1911
Sargent, d. 1925

POPULAR
ILLUSTRATORS
C. D. Gibson
Howard Chandler Christy
E. H. Blashfield
C. Allen Gilbert
L. B. Wenzel
Henry Hutt
Penrhyn Stanlaws
James Montgomery Flagg
Harrison Fisher
Coles Phillips

Some Plays to be Costumed in the Period

Bennett's and Knoblock's "Milestones," Act III, 1912.
Bennett's "The Great Adventure" (1913).
Pinero's "Iris" (1901), "His House in Order" (1906), "The Thunderbolt" (1908), "Midchannel" (1909).
Jones' "Mrs. Dane's Defense" (1900).
Lehar's light opera "The Merry Widow" (1905).
Shaw's "Man and Superman" (first performance 1903), "Major Barbara" (1907), "You Never Can Tell" (1900).
Granville-Barker's "The Marrying of Ann Leete" (1901), "The Voysey Inheritance" (1905), "The Madras House" (1910).
Galsworthy's "The Silver Box" (1906), "Justice" (1910), "Strife" (1909), "The Pigeon" (1912), "Old English" (laid in 1905).
Barrie's "Peter Pan" (1904), "The Admirable Crichton" (1903), "Alice-

Sit-by-the-Fire" (1 9 0 5), "What Every Woman Knows" (1908), "The Twelve Pound Look" (1913).
Tolstoy's "Resurrection" (1900), "The Living Corpse" (1911). Costumes are local Russian rather than typical of the period.
Checkhov's "The Three Sisters" (1901), "The Cherry Orchard" (1904).
Clyde Fitch's "The Girl With the Green Eyes" (1902), "The Truth" (1907), "Captain Jinks of the Horse Marines" (1902).
Augustus Thomas' "The Witching Hour" (1907).
Dramatization of Conan Doyle's "Sherlock Holmes" (William Gillette played in it, 1899–1905).
Langdon Mitchell's "The New York Idea" (1906 to 1908).
Lynn Riggs' "Green Grow the Lilacs" (period about 1900–1907).

NEW CENTURY

WHAT a time for Causes it was, that first decade and a half of the new century! Women cared enough for the vote to get themselves thrown into prison for it; young men and women cared enough for their fellow men to give their lives to settlement work; laborers cared enough for their rights to get themselves shot in strikes and riots. What talk there was of the sinful in high places: corrupt politicians, trusts, Leopold of Belgium with his Congo exploitations, the Chicago packers and other traffickers in adulterated foods, the " idle rich " ! The yellow press screamed at them, serious periodicals lectured them, muckraking novelists " laid bare " their iniquities.

In America the cry of Democracy, " there ought to be a law " was followed by legislation: against trusts, for pure food, against white slave traffic, for franchise extension. Between times the reformers subsided and life jogged along as usual. Almost the entire fourteen-year period was dominated by the picturesque and vigorous personality of Theodore Roosevelt, his Rough Riders, his big stick, his teeth, his trust-busting, and his daughter Alice. For once America experienced something of the kind of fun the British get out of their royal family as they watched " Princess Alice " through her début, her trip to the Orient, her engagement, and her marriage. They observed every detail of her trousseau and especially the splendid gifts bestowed on her by foreign princes and potentates, and they felt a vicarious pride; for was it not the daughter of their president who was deemed worthy of such royal honors? The United States was taking a good deal of a hand in international affairs. After Roosevelt helped the Russians and Japanese to settle their difficulties by arbitration (1904), American voices were listened to at the second Hague Peace Conference (1907). After the purchase of the Panama Canal (1904) and its successful completion (1913), the United States could dictate the affairs of the American Continent.

France maintained her prestige as fashion designer to the world and French artists taught their newest " isms " to eager American art students.

England was no longer " Victorian " when the old Queen finally died, yet the nation's mourning was personal and sincere. Imperialism remained a dominating motive of government; many conscientious British civil servants gave their lives to administering the dependencies of the Empire. The Anglo-Saxon colonies enjoyed vigorous political lives; those of the Antipodes led the English-speaking world in democratic experiments. In English literature the

novel shared honors with the play, many serious writers achieving success in both forms. Dramatists who had something to say were offered a hearing by such advanced production groups as the London Stage Society and Miss Horniman's theatre in Manchester. The American theatre was also active in the English dramatic renaissance, for Barrie wrote plays for the American Maude Adams, Shaw had as enthusiastic a public in New York as in London, the works of American playwrights were produced in England,—in short, American and English successes were beginning to be interchangeable.

A wave of "thesis literature" swept over the stage of all countries. Galsworthy's dramas, "Justice" and "Strife" dealt with social problems; so for that matter did Charles Klein's melodrama, "The Lion and the Mouse." Stanley Houghton's "Hindle Wakes" (1912) dramatized the problem of youth and the biologic urge which Wedekind had tackled in "Frühlings Erwachen" 'way back in 1891. Several years after "Mrs. Warren's Profession" had shocked the public and set it to chattering about prostitution, Brieux's "Damaged Goods" found its way to the American boards and encouraged the more advanced minds among the younger generation here to exchange views upon social diseases.

Theatre technicians began to assume positions of importance. Just when the American Belasco had perfected stage realism, the emphasis shifted to the imaginative. The English Gordon Craig from his school in Florence, the Russian Bakst, the German Reinhardt, the Swiss Appia, and the Austrian Urban, sent out designs which revolutionized the arts of the theatre. In 1909 Djaghilev's Russian Ballet left Moscow for Paris and brought to Western theatre-goers a whole new world of sound, movement, and amazing barbaric color. Everywhere mechanical effects and the marvels of light so engaged the attention of theatre devotees that for a while it seemed that the scenic designer, the electrician, and the stage hands were to push both author and actor into the wings.

Moving pictures, which had had their tentative beginnings in the nineties, improved fast during the first decade of the new century. In the years before the war these "flickers" (shown, as a rule, at "nickelodeons") engaged the attention more as mechanical novelties than as art. Yet by 1914 Mary Pickford had amassed a fortune and become "America's Sweetheart," and the dull and shoddy "custard pie comedy" was transmuted by the unique art of Charlie Chaplin. Mechanical music claimed the attention of a large public: both player pianos and phonographs brought entertainment to musicianless homes.

Automobiles passed rather suddenly out of the class of curiosities into that of everyday phenomena. The first American Automobile Show (1900) laid much emphasis on the safety and convenience of the motor car as a family vehicle; four or five years from then most wealthy families had at least one car and a "chauffeur" (the new word when you couldn't properly say "coachman"), and prophecies were afloat that before very long horseless carriages would be so cheap that nearly everybody could own one. Some of the earliest

cars got their motive power from gasoline, but more from steam, and a great many from electricity. These last were especially favored by ladies, for although they did not attain to any great speed and were none too adequate on hills, they were safe and pleasant vehicles to guide along the city streets between tired cab horses and well-groomed equine aristocrats drawing broughams and landaus.

In the autumn of 1909 horses, gasoline cars, " electrics," and motor-busses transported Washington residents and chattering boarding-school girls out to a great field, where, the weather being propitious, they could watch history in the making as the Wright brothers demonstrated the ability of their aeroplane, forerunner of those great birds which only five years later battled in the clouds over Europe.

As though there were not enough peace-time disasters to inaugurate the new century, such as the San Francisco Fire and the sinking of the Titanic, the whole world stood upon the brink of war. Till 1901 England fought the Boers; in 1904 Russia fought Japan; in 1911 Italy fought Turkey; in 1912 the Balkan countries fought each other. All the powers built dreadnoughts and piled up armaments ready for the moment when they, too, would fight.

In the meantime, a dancing mania seized the world, as irresistible as the craze for arms and much more talked about. The romping " barn-dance " had already jolted away ballroom dignity; now to the new rhythms, " Alexander's Ragtime Band," " Too Much Mustard," and the like, men and women, both old and young, turkey-trotted, bunny-hugged, grizzly-beared, and tangoed. Syncopation stopped nowhere; it even tampered with the national anthems of those who marched to war.

GENERAL CHARACTERISTICS OF COSTUME

It is impossible, in a chapter limited as this must be, to put in all there is to be said about costume during the fifteen years before the World War. Readers who have a vivid recollection of those years will feel that some important items have been omitted; moreover they will very likely dispute the dating of certain changes in dress. This is almost inevitable, since styles arrived in one place sooner than in another, and remained chic for one community when they had passed out of date elsewhere. In this dilemma the middle path has been followed; dates have usually been assigned on the evidence of photographs and magazine illustrations rather than on that of designs from *Vogue* or *Le Bon Ton*, and as a rule from American rather than French or even English sources. If your reminiscences conflict with the author's, by all means hold out for them; there is room for more than one right opinion.

Man's appearance before the War differed from that in the preceding decades as of the following in ways easier to recognize in pictures than to describe. Less formal than in the nineties, the well-dressed man was certainly more boxed up than in the nineteen-twenties. His costume looks to us awkward and uncomfortable; to the young man himself it seemed both elegant and

easy. People old enough to remember the smart American collegian of the nineteen hundreds will recall principally that his hair was parted in the middle or brushed from the side across his temples in an elegant swoop, that his collars were cruelly high (figs. 1a, e, and d), that when his trousers were turned up in cuffs they were short enough to show his ankles, and that those ankles were encased in patterned socks, sometimes of silk.

Up to 1910 the costume of women altered from its *fin de siècle* character more in external details than in fundamental line. There were pompadours, high collars, shirtwaists, long skirts, small waists, and curving hips. These details were all emphasized by the elegant " kangaroo bend " into which, until about 1906, women forced their figures. Even though 1900 brought the straight-front corset, it did not slacken the corset-string; it was 1908 before the actual waist-measure could be appreciably larger and still fashionable, and 1910 before curving hips and busts began to be compressed to nearly the size of waists.

Nevertheless, looking back from the end of the first decade, one can see that the accumulation of little changes had produced a woman who looked very different from the lady of the early nineteen hundreds: her hair protruded in back instead of in front; her neck, even in the daytime, was beginning to be liberated from boned or starched collars; her street skirts were short enough to clear the ground; and if she were a slender girl the one-piece dress made it possible for her to lay aside corsets, or to wear, at most, a low-cut " girdle " with only a few light bones.

But the four years between 1910 and 1914 saw much more radical changes: in hats, hair, sleeves, waists, skirts, textiles, colors, and posture. The immediately pre-war young woman, with her close-fitting hat, her straight-up-and-down figure, her skimpy skirts, was all ready for the further efficient simplification of war-time uniforms, the further exotic vagaries of war-time " mufti."

Those who remember vividly the decade of 1900 to 1910 say that one great contrast in the dress of both men and women then and now lies in the grooming. Men's hair was rougher, not so close-clipped nor so sleekly brushed. Though washables were as snowy as nowadays, silk and woolen garments went but seldom to the cleaner, suits waited longer between pressings. Theatrical pictures of the time show that even on the stage, then as now somewhat an exemplar of fashion, a woman could appear in a wrinkled dress without criticism.

MEN

Heads. Up to about 1905 most young men in America parted their hair in the middle. After that a good many took up the side part, and by 1910 middle parts were practically obsolete. Young men with naturally wavy hair sometimes let the front grow rather long and brushed it across the head. After 1910 some men were brushing their hair back in pompadour fashion and most of them were asking the barber for close cuts.

During the entire period more men than not were smooth shaven. To be sure, an occasional young man of 1900 to 1905 or so cultivated a small moustache, carefully brushed away from the upper lip and waxed at the ends (fig. 1a). Older men had their moustaches clipped close and straight across the lip (fig. 1b); plenty of the middle-aged kept their walrus moustaches or their clipped beards (King Edward set the precedent for that); and some old codgers still trotted around wearing mutton-chops. Doctors (artists, too) affected the " Van Dyck " as a sort of badge of their profession.

Hats. The fedora was one of the most popular hats of the 1900's (fig. 3). Its crown was pretty high, which is perhaps the reason that it so often seems to be a little small for the wearer. Quantities of men wore derbies, which by about 1900 had acquired crowns and brims but little different from today's. Most derbies were black; in brown they were considered sporty, not to say flashy. A good many men wore slouch hats (figs. 2 and 4) both winter and summer, changing perhaps from black to gray as a concession to the season; but most of them dutifully donned hard straws in May. Essentially the same hat as that of the nineties, this straw was higher crowned and often a little broader brimmed. In place of the hard chip straw a man might wear a Panama (fig. 1e), a much more attractive and becoming head-covering, but also much more expensive. To return to felts: the hat sketched in fig. 1d was immensely popular with younger men; college boys have been known to wear around these hats ribbon bands displaying the colors of Alma Mater. Those men who clung to formality in dress still donned high silk hats for church, for afternoon receptions, and for evening; but to the theatre they wore the more convenient " opera " or " crush " silk hat. Caps were popular; the variety included all those described in Chap. XVIII; a slightly larger shape with a brim projecting well over the face and an adjustable strap across the top (fig. 1b); and in particular a very small cap, which boys liked to slap on the backs of their heads (fig. 1c).

Necks. The distinguishing feature of collars, a feature which continued scarcely altered till 1914, was their height. Doubtless the straight instrument of torture which kept a man's chin high in 1901 (figs. 1a and 3) was modified by 1910; but the alternative style, a round high turnover, which in 1901 encircled his neck, had mitigated its rigor no whit in 1910 (fig. 1e). There is something peculiarly distressing about that collar of 1910 to 1914; stiff as it was, and high, the neck inside always seems too small for it, as if it were trying to shrink away from its bondage. More than one man avoided discomfort with a lower turnover (fig. 1b); many also preferred wing-collars, which had the merit of leaving the Adam's apple free. Soft shirts, especially if they were colored, often had their collars attached (fig. 4). A number of men and boys took to wearing stocks in lieu of collars, even when they were not in riding costume; such stocks were of all-white piqué, or white with colored ends.

With a standing or wing collar and high-cut vest some men were still wearing an ascot tie (cf. Chaps. XVII and XVIII); a few conservative older men

FIG. 1.
Heads: a, Evening, 1901. b, Outing, 1908. c, Boy's cap, 1905. d, Collegiate, 1908. e, Panama, 1910.

FIG. 2.
A covert-cloth top-coat, 1901.

FIG. 5.
a, Straight front but wasp-waist, 1900. b, The "straight-front" of 1910.

FIG. 3.
Golfing costume, 1901.

FIG. 6.
a, Motoring hat and veil, 1904-1906. b, Fur toque, 1901. c, Straw hat, 1904. d, Pompadour and hat of 1908. e, Merry Widow hat, 1909. f, Scuttle hat, 1910.

FIG. 4.
City costume, 1910.

had never given up the black string tie. But the majority favored a four-in-hand (figs. 1 to 4) or a bow-tie (figs. 1a and 1c). The bow was invariably worn with evening dress, white with tail coats, black with dinner-jackets. About 1910 or 1912 some few young men had the temerity to revive the fashion of black satin stocks with dress suits, even, sometimes, to add a modest cambric frill down the front of a pleated shirt. Infinitely more becoming than the fashionable collar, it was also more comfortable. Unfortunately the innovation made little headway and was soon given up.

Bodies. Dress-shirts had stiff, gloss-starched bosoms as in the previous decade. During the last two years before the War, to be sure, this convention began to be flouted by some who wore their dinner-jackets and waistcoats over shirts with bosoms finely pleated, even shirts made of silk instead of linen. The new strenuous dances may be held accountable for this innovation. Though properly combined with dinner-jackets only, pleated shirts were occasionally to be seen with tail coats. During the first years of the new century a good many men still wore shirts with stiff, gloss-starched bosoms ("b'iled shirts," the vulgar called them) in the daytime, but the custom fell into disuse with the younger men. That soft-bosomed shirt which in the nineties had gone with the vestless summer sack suit was now usual with any suit save formal dress. Even shirts to be worn with separate collars were more and more frequently made with attached cuffs; this meant that the amount of white showing below the coat-sleeve diminished. Colored shirts (figs. 1c and 4), usually striped, acquired an increasingly better reputation.

What strikes posterity about all coats, but especially sack coats, worn by Americans of this period is the extreme squareness of the shoulders. About 1910 the climax of this style was reached; in that year shoulders were padded out to such an extent that every city clerk had the figure of a football hero (fig. 4). A comparison of fig. 3 (1901) with fig. 4 (1910) will show the progress of the fad. The second difference to be remarked is that coats were loose; sack coats seem to have no shape at all, and frocks, cutaways, and evening coats look both big-waisted and long-waisted. Finally, coats were longish, a trait which also is increasingly noticeable in suits between 1900 and 1910; even the Tuxedo or dinner-jacket shared with the sack coat this loose length. The lapels of sack coats were still rather high according to modern standards; so were those of cutaways and frock coats.

During the years immediately preceding the War the frock coat still flourished, though it had become the attire of the eminently respectable middle-aged rather than of young men, unless the latter were Protestant ministers, doctors, or statesmen. The lapels of frock coats were often satin-faced. Cutaways took the place of frocks in the wardrobes of young men who went in for fashion; they could be seen at teas, receptions, garden-parties, noon-weddings, and church. Such a coat was made of black broadcloth and worn with white or pearl-gray vest, gray striped trousers, and a top hat. In less formal materials such as pepper-and-salt mixtures or black-and-white check, the cutaway was

worn by some men as a business-suit or a costume for coaching or the races. It would then be accompanied by trousers of the same material, an ascot tie, and a derby.

Norfolk jackets, or unbelted coats cut on Norfolk lines (fig. 3), were worn with either trousers or knickers for sports. Light-weight blue serge sack coats with white trousers were more and more the standard for summer afternoons.

Until the last years of the period the " full dress suit " was the only costume in which a man might correctly attend an evening wedding, a formal dance, or a reception. Yet the " Tuxedo " or dinner-jacket was being taken up more seriously; one might wear it at small dinner-parties, at restaurants even when escorting a lady, at the theatre, and finally at informal dances. At last, about 1914, a good many young Americans came to the conclusion that they could dispense with tails and go to any function in a jacket.

Vests of business suits usually matched the coats and trousers. They were cut lower to go with the lower-buttoned lapels. With both frock coats and cutaways, on the other hand, light vests of piqué, corded silk, even striped and checked cashmere were quite permissible; though many men preferred their vests of broadcloth like the coat. The fancier waistcoats were frequently made double-breasted with rolled collars which showed when the coat was unbuttoned. The cut of evening vests, though always low, varied slightly almost from year to year. With dinner-jackets they were black, with tails, white. The material of such vests, if it did not match the coat, was faille, satin, and sometimes self-toned brocade. The buttons often added a note of elegance, for they could be of gold, enamel, or semi-precious stones like lapis-lazuli, jade, or onyx, to match cuff-links and shirt-studs.

Legs. Many trousers were now creased back and front. While as a rule trousers of sack-suits matched coats, they were sometimes lighter-colored; in the summer trousers of duck, linen, or flannel (all-white, white with pin-stripes, or gray) were worn with coats of blue serge or pin-striped cloth. With informal suits trousers were turned up at the bottom. After 1908, especially, such " cuffs " were wide, making the trousers short enough to clear the ankle (fig. 4), a feature freely ridiculed in the humorous papers. Among passing fads must also be mentioned " peg-top " trousers, which college boys were wearing in 1911 and 1912. Like their predecessors in the Romantic Era (Chap. XV), these trousers were much wider at the top than at the ankles, so that they had to be pleated in to the waistband. Most younger men in America now held up their trousers by means of belts rather than suspenders, except with dress clothes.

Knickers, of tweed or homespun, were not very full and, stopping just over the knee, were finished with a fairly wide buttoned band. Sometimes the stocking went under the band, sometimes outside, with a turnover top (fig. 3). This scant type of knicker remained in style till after the War. Woolen stockings, oxfords or high shoes, and occasionally spats (fig. 4, Chap. XVI) covered the lower legs and feet.

Feet. With turned-up trousers socks were much in evidence, and some men found in them an excuse to indulge their taste for gay colors and patterns. They could buy socks woven in stripes (up and down or around), dots, circles, squares, horseshoes, and even floral designs. Silk socks were a luxury rather scorned by the rank and file who could not afford them.

In winter most men wore high laced shoes, sometimes tan but more often black (fig. 3); in summer practically everyone put on black, tan, or white oxfords. If stockings were not gaily colored, they were black with any low shoes, even white ones. Toothpick points (cf. Chap. XVIII, figs. *passim*) went out of style, to be succeeded by reasonably round toes, and these in turn (about 1910) by exaggeratedly round, knobby toes (fig. 4). Such a shoe, especially in a violent yellow tan, was enthusiastically adopted by collegians (the scoffers called them " rah, rah boys ") and their imitators, and hung on with cheap sports during the rest of the period. The well-dressed conservative quickly rejected this "bulldog tip" and returned to a rather long-vamped, fairly pointed shoe, which persisted with modifications during the remaining years. Buttoned shoes such as those shown in fig. 4 were not favored by conservative men, who preferred laced shoes. Up to 1914 patent leather pumps with flat bows were considered indispensable for dancing; yet about 1912 patent leather oxfords with turned soles began to rival them in the favor of dance enthusiasts. With cutaways it was correct to wear spats, usually pearl-gray. Some men wore low shoes and spats all winter in preference to high shoes; as a rule such spats were of cloth lighter than the trousers, sometimes even of washable white.

Outer Garments. Sweaters became ever more popular; their styles included cardigan jackets, heavy high-necked football sweaters to be pulled over the head or buttoned up the front, thin jersey turtle-necked sweaters to be worn under a coat, and V-necked slip-overs which sometimes took the place of a vest.

The long overcoats of heavy cloth with velvet collars, and the shorter, lighter-weight topcoats showed no remarkable changes from the preceding period. Driving coats of cravenette or covert cloth with velvet collars were an English specialty; the American covert coat particularly popular during the first years of the century was a short, loose topcoat (fig. 2), often trimmed with a dark velvet collar. With evening dress some men still wore a black overcoat with a cape which hung to the waist or thereabouts. When a man travelled, he very likely took along a loose tweed overcoat in large plaids, often made with a " raglan " sleeve. One no longer saw upon modish travellers the Inverness cape so popular in the latter years of the nineteenth century.

SPECIAL CHARACTERS

Although in most houses which employed men-servants it was, as it is now, the custom to dress them in sober liveries only slightly different from the evening clothes of the master and his guests, there remained some women who preferred the old custom of eighteenth century liveries. But even they did not still exact powdered hair with the antique costume.

FIG. 10.
Blue serge suit, 1905.

FIG. 9.
Reception dress, 1904.

FIG. 8.
A shirtwaist costume, 1901,
and a boy's sailor-suit.

FIG. 11.
Evening dress and "Buster
Brown" suit, 1905.

FIG. 7.
The "Gibson Girl" evening
dress in 1901.

FIG. 12.
Negligée, 1905. Note **the**
"Janice Meredith" curl.

WOMEN

Heads. From about 1900 to about 1908 almost every young woman had a pompadour poised over her forehead. (1) Till 1903 it was rather wide (figs. 6b, 7, and 8); from 1903 to about 1905 it took on an exaggerated curve or loop over the eye (figs. 6c, 10, and 11) and became flatter on the sides. Back hair might be arranged in a " figure eight," low in the neck (fig. 6c), a "psyche knot" or a figure eight on top (fig. 7), or a "French twist" (fig. 11). About 1905 or 1906 a "Janice Meredith curl" (fig. 12) had a considerable vogue; its name was derived from the heroine of a popular novel about the American Revolution. Though invisible hairnets were not used (indeed fluffy locks were admired) ways had to be found to keep the shorter hairs in place, so everybody wore back and side combs and barettes, the last-named useful in holding "scolding locks" up from the nape. But in spite of such devices the coiffure often appears unkempt to modern eyes.

(2) From about 1906 to 1910 the hair was puffed all around, and the knot was therefore, on top. About 1904 or 1905 a few women had abandoned the pompadour in favor of a middle part, and by 1910 parted hair was very popular. The side hair was brushed away from the face and rolled upward at the sides to be secured by combs, and the back hair was coiled, twisted, puffed or curled according to the prevailing mode (figs. 7, 16, and 20). (3) From 1910 to 1912 or '13 even the pompadour was flattened in front and built out in back with puffs, bobbing ringlets (figs. 20 and 21), or a "psyche knot" (much larger than the early twist of that name, and placed at a very different angle). This pseudo-Greek hairdressing brought back false hair in the form of coronet braids, switches, and clusters of curls. From 1903 to 1910 or a little later most coiffures had to be padded out in some way: by "ratting" the hair, *i. e.,* combing the inner strands the wrong way, so that they puffed out the outer strands; or by wearing a " rat," a pad made of hair or some other substance. Since many people considered the close textured pad unhygienic, they sometimes replaced it with a rat of fine wire net, shaped like a doughnut; it was superior in lightness and airiness, but it made the coiffure look unpleasantly stiff (figs. 6d and 14). There was available also a "pompadour comb," one style with a hump, the other with a curved raised piece, sufficient support for very heavy or "ratted" hair. (4) In 1911 or 1912 some women reverted to a front pompadour, which this time was compactly waved to dip in an elegant curve over one temple and topped by a cluster of curls (fig. 18). (5) By 1914 the coiffure had grown much smaller (figs. 17, 22, 24). If it were parted in the middle it was drawn over the ears and coiled low in the nape; if it were brushed back from the forehead it was pulled out to cover the tips of the ears and drawn into a knot at the back.

Though women had frizzed their hair or twisted it in ringlets with the aid of curling-tongs, they had not set it in waves until 1907, when the hairdresser Marcel began to practice his famous process. Thereupon fluffy locks were

outmoded, and the fashionable coiffure was carefully dressed in meticulous, glossy undulations (fig. 18).

During the entire period hair-ornaments were worn with any festive indoor costume. (1) With the topknot went decorated combs, ribbon bows, tulle rosettes, artificial flowers, and enamelled or filigree butterflies quivering on a little spring; (2) with the low coil, flowers tucked in at the nape; with the French twist, a flower at the side. (3) When, about 1909 or 1910 the pseudo-Greek protruding psyche came into fashion, fillets, diadems, and broad bands accompanied evening "Empire" toilettes (fig. 21) and black velvet bands, everyday dress (fig. 16). With the advent of close coiffures, hair ceased to be decorated in any way except occasionally with a Spanish comb. As long as women had back hair to do up they employed good-sized "shell" hairpins, usually in preference to wire.

Hats. (1) Until about 1905 the sailor (fig. 9, Chap. XVIII) was especially favored; after that, while it had not disappeared even as late as 1914, it ceased to be omnipresent. At first small and shallow-crowned, it, like other hats, increased both in height and width. The sailor (also in common with other millinery) during the first year or so of the new century was set straight on the head or a little far back (figs. 6a and 8); as soon as pompadours grew really large hats were set far forward upon them, an angle which remained chic as long as the pompadour hung over the brow (fig. 6c). The elaborate hat of 1904 (fig. 9) is one type which does not project, but then neither does the lady's hair overhang. All hats had crowns so shallow and small that they could not have fitted upon any head, nor were they supposed to do so. Hats were biggish from front to back and as a rule turned up at the sides rather than down. Toques sometimes sat on top of heads like hats, sometimes fitted down a little (fig. 13). Fur toques (fig. 6b shows a model of 1901) were small and coquettish additions to a winter toilette at any time up to 1910.

(2) With the doughnut-shaped pompadour of 1907 and 1908 large hats began their years of popularity. Such hats were set flat on the head and their crowns were a little higher. The "Merry Widow" hat (fig. 6e), piled with willow plumes, was the extreme example of this mode. When hair was built out at the back, the hat, worn back from the face, stood out behind sometimes even beyond the hair (fig. 6d), a peculiarity pounced upon by the caricaturists.

(3) By 1909 turn-down brims and slightly higher crowns began to be seen; during this and the succeeding few years, versions of the "mushroom" style were numerous (fig. 15). "Willow" plumes and curled ostrich tips, large flowers and birds' wings, even aigrettes trimmed the large and dressy hats. Yet there was a growing sentiment against plumage and especially against aigrettes; some women felt more virtuous as well as more elegantly turned out if their feather ornaments were plucked from ostriches, presumably without inconvenience to the bird. Tailored hats were trimmed simply, with ribbon bands (fig. 15), wired bows, or quills. Tricornes and other hats with brims turned up on one or two sides might be seen in different versions year after

year. To appear anywhere in public after nightfall, for instance at a restaurant or the theatre, a woman needed a head-covering of lace or some handsome fabric, a wide hat loaded with plumes or a toque scarcely less view-obstructing. The nuisance had to be met by laws against wearing hats in theatres.

(4) In 1909, 1910, and 1911 very plain three-cornered hats and round sailors were considered smart; they were made of heavy, mannish felt in black and dark colors, and they shared with other hats the feature of a wide, low crown. Long-furred beavers were popular: to be worn with tailored suits they were trimmed with ribbon only; to complete dressier costumes, with flowers. In 1909–'10 white beaver was very much the fashion. Short-haired "brushed" beaver, the material used for men's high hats, was smart in tailored models like tricornes.

(5) From 1910 onward, as hairdressing grew smaller, hats took on higher crowns and as a rule rather drooping brims (fig. 20). One freakish hat, which looks as though it had been inspired by either a cornucopia or a waste basket, had a great deal of crown and a negligible rolled brim (fig. 6f); another, featured during the same year, seems to have been modelled on an old-fashioned beehive (fig. 17); still another achieved its height with a very deep crown augmented by towering plumes—it had a small poke-shaped brim. Until 1912 such extinguisher hats remained in style, varied by such less extreme hats as a sailor with a wide brim and a deep crown. Out in the evening a lady wore, usually, an "opera toque" of some rich metallic cloth, with a very high aigrette shooting straight up from the forehead, or else a gaily colored kerchief wound turban-wise around her head,—echoes, it may be supposed, of "Scheherezade" from the Ballet Russe.

(6) By 1913 crowns were lower and by 1914 most brims were narrow and often turned up from the face (figs. 22, 23, and 24). Trimming, which had been so lavishly applied in 1900, by 1914 was reduced to one or two sparse feathers or a ribbon band.

Materials. (1) During the first five years of the century the material of hats was in itself elaborate; it included velvet, satin, silk, soutache braid, fancy straws, chenille braid, and lace, all made upon foundations of wire and buckram. Toques were composed of beaver, fur, feathers, or entirely of trimming material, *e. g.,* flowers, foliage, and even fruit like grapes or currants. (2) The large winter hats of the period from 1908 to 1911 were frequently so loaded with plumes that they had no room for anything else, but summer hats of the same shape were trimmed with one or two large flowers, drooping upon the brim or hanging over it. (3) In 1910 there was evident a growing tendency to trim street hats with simple ribbon bands, bows, or quills. This new simplicity soon spread to reception hats also, where a flat wreath of appliquéd flowers might take the place of the ribbon, or an uncurled ostrich plume might drip from the crown (fig. 17). When trimming was scanty, material again played an important part in millinery; it included fine felt, velours, beaver, corded silk, lace, and fur, with fine straw, horsehair braid,

FIG. 14.
A high-school girl in
1907 or 1908.

FIG. 17.
A kimono dress and beehive hat,
1910.

FIG. 15.
A college girl in
1910.

FIG. 16.
Sports costume in
1910.

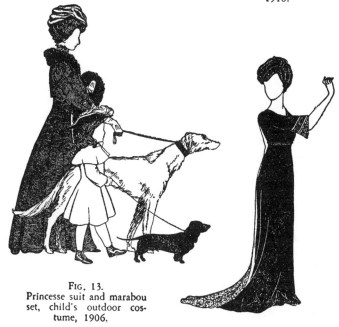

FIG. 13.
Princesse suit and marabou
set, child's outdoor cos-
tume, 1906.

FIG. 18.
Reception gown, 1910-
12. Note curls on top
of marcelled hair.

and embroidered linen for summer. Brims were often faced with contrasting silk or velvet, put on flat or shirred.

With a large hat sitting upon the top of the head, pins were obviously necessary. (1) In the nineties they had been short and unobtrusive; so they remained during the first years of the nineteen-hundreds; (2) between 1907 and 1910 they were lengthened to cope with the wide crowns, and at the same time their heads became important items in decoration. They were made in all sorts of designs and materials: insects, butterflies, and flowers done in enamel, gold, or filigree silver, sometimes nodding on little springs; bird or animal heads of feathers or fur; brass buttons (if you knew an army or navy man); blue Y's, red H's, orange-and-black P's, and other honorable and recognizable letters. (3) With the deep-crowned, narrow-brimmed hats of 1910 or 1911 to 1913 pins were shortened and their heads reduced to more modest size, being often no more than little gold or silver knobs. (4) In 1913 and 1914 (with such a hat as that sketched in fig. 24) many women preferred to use the short sharp pin saved from a corsage bouquet.

During the entire period veils were important additions to millinery. Small face-veils had the practical value of restraining errant wisps of hair and the grave disadvantage of being bad for the eyes. Spotted veils, so disturbing to the vision, were supposed to enhance the wearer's attractiveness. From time to time veils featured were made of a fine mesh upon which was worked one motif, intended to rest upon the wearer's cheek with coquettish effect; it had an unfortunate resemblance to a birthmark. (1) From 1900 to about 1909 the small face-veil drawn smoothly down under the chin and up again to the back of the hat shared honors with the longer, looser veil with an ornamental border. The latter could cover the face or be draped back over the hat; that gesture of " putting back the veil " had dramatic value! (2) During the years 1909, 1910, and 1911 the veil enclosed a woman's head in a complete cage; for it was stretched tight from hat-brim to chin, brought together in back, where it was secured to the hair with a hatpin, a buckle-shaped brooch, or a barrette, and finally twisted under the chin as tight as could be and tucked into the front of the high collar (fig. 15). (3) About 1912 this inconvenient arrangement was abandoned in favor of others which left the chin free. Wide-bordered silk-mesh veils were now popular; you put such a veil on a drawing-string which you tied around the hat crown; from there the veil fell over the brim and covered the face to below the chin, like a curtain. These silk veils came in white and colors. (4) With the small hats of 1913 and 1914 veils grew shorter, sometimes no more than covering the nose; many women omitted them entirely.

One type of veil which persisted from 1900 to 1912 and even later was the automobile veil. It was a real necessity in the early days of the motor, for it was impossible without it to keep a wide flat hat on a high coiffure while you sat in an open car or a car with a carriage-top and dashed along at fifteen or twenty miles an hour. Women were fearful for their complexions, too, on

the dusty highways and felt that enveloping chiffon would take the worst of the dirt. For the first five years or so women who rode but did not drive managed by tying a voluminous veil over a wide stiff hat (fig. 6a); meanwhile the women who directed their own vehicles adopted their chauffeurs' visored caps, which in their turn had been copied from the yachtsman's cap. After 1905 motoring veils were devised which enveloped hat and head and fastened under the chin like a bag; they were put on over small hats or visored caps, and sometimes supplemented by goggles and even masks. These large chiffon veils were very often bright green, perhaps with the idea that the color was easy on the eyes.

For other sports women wore woolen stocking caps; tams like that illustrated on a man's head in fig. 2c, Chap. XVII, made of knitted wool, cloth, or leather; sailor hats; yachting caps; and after about 1908 those duck hats with stitched brims which belonged with a sailor's outfit.

Necks. Up to 1910 or 1911 high collars were the rule with street dresses, though as early as 1904 reception gowns and informal evening frocks were sometimes made with necks cut down to the base of the throat (fig. 9). (1) Until 1905 the collar was the same height all the way around and stood up by its own stiffness (figs. 6c and d, 8, 10, 13, and 14), for it was made of the dress material or else of velvet or satin ribbon, and interlined. (2) After 1905 a boned collar finished any silk, lingerie, net, or lace waist (figs. 6e and 15). Such a collar rose up high under the chin, higher still in back, and in peaks at the sides almost up to the mastoid bone. Casings were sewed at sides and back and into these were slipped thin stiff lengths of celluloid or bone. The top of nearly every collar was finished with a lace ruffle (fig. 13), a white ruching (fig. 14), or a small turnover of muslin or lace (Irish crochet was particularly modish about 1910).

Mannish starched turnover collars still accompanied tailored shirtwaists (cf. figs. 9 and 18, Chap. XVIII). (1) During the first five years of the century such collars were still fairly low; (2) between 1905 and 1910 they became formidably high, as much as an inch higher than the collar illustrated in fig. 18, Chap. XVIII; after that, fortunately, they went out of style. During the second half of the decade another and less uncomfortable starched collar was also in evidence, the round Eton or "Buster Brown," still familiar in the costume of small boys (figs. 11 and 16). (3) After 1910, when the high starched collar was going out, softer linen turnovers were revived from the fashions of the mid-nineteenth century. About that time Maude Adams was touring in her first revival of the Barrie "Peter Pan," and the collar was named from her costume. It might be part of a white blouse, or be added as a fresh touch to a dark serge dress.

One more popular neck-finish must be mentioned, the stock. For a long time men had been wearing a stock with riding togs, and in the nineties women had adopted it for the same purpose. From about 1901 to 1906 they wore it with any shirtwaist and street suit. Between 1901 and 1906 the most popular stock

was made of black ribbon (fig. 8); from 1904 to 1906 such a dark collar was topped by a white turnover.

There were many ways of ornamenting high collars. (1) Up to 1904 or 1905 a large bow or puff of chiffon, tulle, or point d'esprit frothed up at the *back* of the collar on a dressy waist. (2) From 1905 to 1908 or 1910 the bow was placed in the *front*. With lingerie waists especially, such a finish was well-nigh indispensable. There was a great variety in these ornaments, from the soft ready-made bow with fancy ends to the tailored " pump-bow " of dark grosgrain ribbon, so popular about 1910 (fig. 16). With starched collars ties were of masculine types, though a soft wide " Windsor " tied in a bow with flowing ends was as popular as the severer four-in-hand. (3) From 1908 to 1911 with dark silk waists one wore white bows and " jabots," that is ruffled or pleated frills cascading down the front of the waist. Should a collar lack a bow or frill, it was pretty sure to be decorated with a bar pin.

Even as early as 1909 a few Paris modistes were showing street costumes with collarless waists (fig. 17); in 1912 all throats were bare (figs. 20, 22, 23, and 24) except those of ultra-conservative ladies and some who like Bernhardt made their own styles. Fig. 6f, with its round lace collar and jabot and fig. 20, with a small standing frill show transitional necklines. By 1909 or 1910 necks on one-piece dresses were already of the round (fig. 17) or " bateau " shape, finished with a flat trimming, and soon such a neck was fashionable on blouses under suit-coats also. By 1914 low-cut V's (fig. 24), sailor, and rolling collars (fig. 23) abounded.

So much for the intricacies of daytime costume; décolletage is a simple subject. (1) During all the years from 1900 to 1908 some evening dresses were made with drop shoulders; unlike the similar necks in earlier periods, all these had straps over the shoulders (fig. 11). Just as popular were necklines square (fig. 7), heart-shaped, and round. (2) From 1908 to 1914 the drop shoulder was out, and the field was left to the square or round styles. To be sure, there was launched a gown which was open in a V not only in front but also halfway down the back; but this was an extreme not approved by the average woman until later. For it must be remembered that in all the years during which women had uncovered their bosoms (sometimes pretty expansively), until the twentieth century they had kept their spines concealed.

BODIES. *Corsets.* (1) In 1900 the feminine figure underwent a drastic change with the introduction of the straight-front corset (fig. 5a). Through centuries of compression the abdomen and hips had always been left comparatively free (cf. fig. 6, Chap. XVIII); this new corset flattened the abdomen by means of heavy boning along the front from top to bottom. It was lower-busted and longer below the waist, and it had a pair of garters in front which, attached to the stockings, helped to keep the oblique line from bust to pelvis. A great deal was written and said to prove the hygienic superiority of this corset over the old, for (experts argued) it exerted pressure on the hip-bones and lower abdomen, which could bear it better than the ribs and upper internal organs.

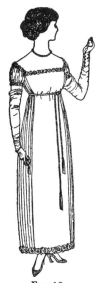

FIG. 19.
Dance-dress, 1911-1912.

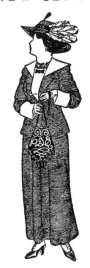

FIG. 20.
Shopping suit, 1912.

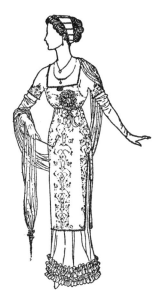

FIG. 21.
A beaded tunic of 1912.
Bandeau in hair.

FIG. 24.
Tiered skirt, 1914.

FIG. 23.
A peg-top or pannier
dress, 1914.

FIG. 22.
A lamp-shade dress,
1914.

As a matter of fact, since women were reluctant to give up the slender waist the betterment was slight. Yet the standard figure was becoming more reasonable, as may be seen by comparing the pattern measurements quoted in Chap. XVIII (p. 506) with a set taken from a similar source dated 1904:—bust (close under armpits) 36, waist 26, hips (5 inches below waist) 43½. The new corset brought in a new standing position called the "kangaroo bend," in which the curving bust led, the flat abdomen slanted in from it, and the hips and back curved out opulently (figs. 7 and 10). Slabsided girls who fifteen years later would have been successful exponents of the "débutante slouch," in the early nineteen hundreds must needs eke out their meagre curves with pads and starched ruffles where the bust should be and with gathered petticoats to make up for inadequate hips and backs. Jokes anent "bust-distenders" and hip-and-back pads abounded.

(2) In 1908 another silhouette became the ideal, a silhouette made possible by the new sheath corset (fig. 5b), which was very low-busted and very long-skirted, resulting in a bosomless, hipless, "sitless" figure and a standing-position as upright as a pencil (figs. 19, 20, and 21). Jokesmiths now dwelt upon the difficulty of sitting down in such long sheaths. A typical jingle tells of a lady who has decided to sell her place in the country:

> "I do not need a country seat
> Because I can't sit down."

(3) After 1910 the extreme length of the sheath was modified a bit and the new generation of coltish girls came into their own. They disdained bosoms and flattened down what they had with tight brassières; they wore "girdles" with very little above the waistline and not much below except hose-supporters; they affected hollow chests and somehow managed to stand so that their rears were as flat as their fronts (figs. 22, 23, and 24). In 1912, with the appearance of the new and violent dances, girls took to "parking their corsets" in the dressing-room and soon they just stopped wearing them.

Underwear changed with the changing styles. (1) Up to about 1905 women wore, besides a knitted vest or union suit under the corset, a pair of muslin drawers with tubular legs to below the knee, a short petticoat of muslin or flannel, and a "corset-cover." The last-named had a neatly fitted back and a tucked or gathered front and it was stiffly starched. (2) After 1905 a chemise began to take the place of corset-cover and short petticoat. Soon after, some women diminished the bulk of undergarments by wearing "combinations" of corset-cover and drawers in one, omitting the short petticoat. (3) This effort to take the superfluous fullness out of lingerie resulted (1908) in circular drawers which fitted smoothly over the hips and flared out at the knee into ruffles. The new style was named "umbrella," "French," or "Merry Widow." (4) From 1910 onward efforts were constantly bent toward further eliminations. Starch was omitted from muslin or linen, then those traditional

materials were largely supplanted by soft mercerized fabrics, and finally by silk, though the majority of women were not wearing entirely silk underthings till after the War. Experiments were made with china silk, pongee, crêpe de chine, and finally Italian glove silk. Up to 1910 ribbons were run in the tops of corset-covers and chemises, and showed through lingerie blouses; pink and blue were the only colors sanctioned by good taste. After 1910 the interest in ribbons waned, as chemises became scanter in front.

Waists. Until about 1911 or 1912 shirtwaists and shirtwaist dresses dominated everyday fashions, and there was a distinct cleavage between the functions of the two-piece dress and the one-piece, the latter being considered the more formal frock. During the last three years of the period the waist-and-skirt began to be rivaled by the one-piece dress of dark serge or silk.

(1) By 1900 the basque of the nineties had disappeared from modish costume; that is, waists were no longer draped over tight linings nor put on outside of skirts, but tucked inside the skirt-band, which was covered by a belt. Smooth-fitting backs and fronts in which fullness was introduced by means of pleats and tucks, were the characteristics of these waists (figs. 8, 14, and 16), whether they were buttoned in front and had stiff collars (figs. 8 and 16) or in back, with attached high collars (fig. 14). (1) From 1900 to about 1903 waistlines were round (fig. 8) and belts rather wide; sometimes they were straight strips with oblong or oval buckles, sometimes silk girdles shirred on featherbones front and back (cf. fig. 11, Chap. XVIII). (2) But from 1903 to 1908 the mode demanded a decided front dip, to obtain which there were on the market a number of ingenious devices consisting of tapes hitched to the waistline in back and hooked down in front. A waist was ordinarily equipped with a tape to hold the fullness in place in front and a row of eyes sewed across the back, corresponding to hooks on the skirt, so that the two garments should stay firmly together. With the dip-front blouse (the fullness hung over in a pouch) went a narrow belt, either shaped in a point or pulled down and pinned in that position. Figs. 9 and 12 show the slant, though the garments sketched are one piece dresses, not separate waists and skirts. The young girl in fig. 14 belongs in the period of the pointed belt, but her mother allows no such sophisticated exaggeration.

(3) After about 1908 the dip went out of style, and belts about two inches wide encircled round waists (fig. 16). Every once in a while even suits had high waistlines, obtained by cutting the skirt in a " princesse " line (fig. 13), and one-piece dresses were cut on similar patterns during the entire period (figs. 7 and 18).

Waists to accompany suits were made of dark silk to match the cloth, of thin silk or chiffon in a lighter color to harmonize with it (this for a dressy change), or of white wash material. (1) From 1901 to 1905 the shirtwaist was severely plain (fig. 8), or even more often, given fullness by the introduction of a " Gibson pleat," *i. e.,* a single deep pleat at the shoulder front and back (the style is shown on a later model in fig. 16). Incidentally, a similar

waist might be part of an entire dress made of heavy linen, velveteen, or corduroy, in white or a color. Shirtwaists to be worn with serge suits were made of mannish shirtings or striped wash-silk (fig. 16). The first decade of the new century was preëminently the period of lingerie waists. They were made of sheer batiste or handkerchief linen with pin tucks, hemstitching, drawn-work, " shadow-embroidery," or insertion of fine Valenciennes lace; often, too, of all-over eyelet embroidery, which earned them the name of " peek-a-boo waists." From 1905 to 1908 it was the fashion to wear a colored under-waist which showed through the sheer white; pale pink and blue were the proper colors, china silk the most admired material, though either silkaleen or muslin was good enough for most people. About 1909 or 1910 it became every woman's ambition to own a waist of all-over Irish crochet; but if she could not manage that, she used some of the hand-made lace for insertion or edging upon ruffle and jabot (fig. 6f).

Except in strictly tailored models both separate waists and the waists of one-piece dresses were, as a rule, fastened down the back. Lingerie waists had a great number of buttonholes and little pearl or crocheted buttons, and silk dresses were often ornamented as well as fastened with a row of silk-covered or fancy buttons and bound buttonholes. If the dresses were not thus visibly fastened, they were intricately hooked under a flap. The fashion considerably complicated the business of dressing, and a woman was dependent on the services of maid, husband, or nearest neighbor. A welcome relief from the dif-ficulties of fashionable attire came with the adoption by women of the middy-blouse; it had been for some time a feature of juvenile dress, and now became an accepted part of the sports attire of young women.

(1) From 1900 to 1906 or even 1908 the waists of one-piece dresses were nearly all loosely bloused in the front (fig. 9) and many of them were elabo-rately trimmed with yokes, berthas, simulated vests, or lace ruffles. Yet the princesse evening dress existed throughout the period as an ideal costume; it was an austerely plain garment modelled in an unbroken sweep from décol-letage to hem (fig. 7). Such a gown may be seen almost unchanged in Gibson illustrations from 1901 to 1908. In 1907 Valeska Surratt was photographed in one, representing "The Gibson Girl"; Fritzi Scheff, Lillian Russell, and other stage beauties used it to display their sumptuous curves. But it was both too exacting for the average figure and too extreme to be countenanced by the average community. Most women therefore chose evening gowns with drapery and belt-lines, like that illustrated in fig. 11.

(2) The high-waisted effect so popular after 1908 was foreshadowed in 1906 by the introduction of a very wide boned girdle, coming up to the bust-line. (3) The so-called " Empire" dress of 1908 to 1910 was shaped on " princesse" lines and was characterized by wide bretelles or suspender effects. (4) The " Empire" of 1910 to 1912 more closely resembled the neo-Greek as interpreted during the Directory (compare figs. 19 and 21 with the sketches in Chap. XIV). From 1910 to 1914 the waists of those one-piece dresses which

were not "princesse" were just a little shorter than "normal," and had a little fullness, without being bloused (fig. 17).

Jackets. During the entire period, the suit coat was omnipresent; until 1912 it was, most often, rather severely tailored. (1) The jacket illustrated in fig. 10 (of about the year 1905) borrows much from the bodice or basque, since it has a bloused body eased with gathers on to a peplum. (2) Eton jackets (cf. fig. 9, Chap. XVIII) and boleros (fig. 13) reappeared at short intervals. (3) During the first six or seven years of the century tailored coats were often not much more than hip-length; (4) about 1907 they were considerably longer in back, though sometimes cut away in front almost from the waist (following the lead of the masculine "morning coat"). (5) In 1909 and 1910 coats of half or three-quarter length were again cut straight around (fig. 15); (6) in 1912 a three-quarter coat was still in fashion. (7) In 1914, with the advent of the peg-topped silhouette, a less severe jacket was launched, shorter and flaring a little below the hips; sometimes, as in fig. 24, such a jacket was also cut away in front.

The accompanying sketches show how the tailored jacket was adapted to the modish figure. (1) Until 1908 jackets fitted close in the back and generally also in front, even boleros, though they were often designed to remain open (fig. 13). (2) After 1908, conforming to the arrow-straight silhouette, jackets were straight and semi-fitting, though not loose (figs. 15 and 20). After 1912 they were short-waisted, wide-hipped, loose-fitting, like the newest dresses (fig. 24), sometimes even cut "kimono" style, body and sleeves in one.

As to the necks, ordinarily they had collars, lapels, and cuffs modelled on masculine coats, though often with feminine touches of velvet, braid, and fancy edges (figs. 10, 15, and 24). From as early as 1907 till even as late as 1914 plain tailored coats were often lightened with washable over-collars and cuffs of piqué, linen, or a thinner material.

Arms. (1) In 1900 the long sleeves of dresses were tight all the way down, shirtwaist sleeves were a little looser and gathered into a stiff cuff. (2) By 1903 a good many dress sleeves had snug cuffs from wrist to a little below the elbow, over which the upper part of the sleeve bloused a little. (3) From 1904 to 1906 the majority of long sleeves on waists and dresses were narrow at the top, often pleated or shirred to fit the arm as far as the elbow, and puffed from there down to a snug wristband, a style called the "bishop" sleeve (fig. 10). This sleeve was sometimes developed very much in the fashion described and pictured in Chap. XVI, *i. e.,* with an open bell-shaped over-sleeve filled in by a full undersleeve (fig. 9). (4) By 1907 the bishop sleeve was out of style and long sleeves were again fairly snug all the way down, to fit under scant coat-sleeves (fig. 15); long set-in sleeves continued thus with little change until 1914 (figs. 20 and 23).

With afternoon and evening dresses, informal summer frocks, and even some suit coats, elbow or three-quarter length sleeves might be substituted for wrist-length (figs. 11, 12, 13, 14, 18, 22, and 24). An elbow-sleeve was

finished with some sort of ruffle, made of the material or of lace; a three-quarter sleeve had a cuff and perhaps a frill also. About 1910 a very radical change was introduced in the form of the " kimono " sleeve cut in one with the waist (fig. 17). In addition to giving a loose, short sleeve, this pattern changed the waist into a simple, unfitted garment, unknown to fashion for a century. With such a sleeve the only cuff possible was small and plain, with no more elaborate addition than a lace undersleeve.

The sleeveless evening dress was not unknown (fig. 7); a variation giving the appearance of a sleeve had a ribbon strap or so which fell over the point of the shoulder. (1) With the drop-shoulder décolletage one might have a good-sized sleeve (fig. 11) or only a ruffle continued from the bertha. Many evening dresses had sleeves to the elbow; others mere sleeve-caps of lace or chiffon. (2) After 1908, during the neo-classic or Directoire revival, short puffs came in (fig. 19) as well as straight sleeves cut in one with the tunic (fig. 21).

Legs. Until 1910 petticoats played an important part in costume. (1) Under all dresses like those sketched in fig. 7 to 16 it was necessary to wear either a taffeta drop-skirt, widened from the knee down with shaped ruffles, one on the bottom of another, or else one if not two muslin petticoats with full ruffled flounces, possibly lace-trimmed and always crisply starched. Figs. 9 and 12 show the resulting much-admired froth of white which was revealed when the skirts were adroitly lifted. Those who could not afford taffeta made shift with mohair or sateen under cloth skirts, but the delicious rustle was missing. How the high-school miss in fig. 14 envied the girl who moved up to the front of the classroom accompanied by that delicate susurrus which spoke of taffeta underneath her serge!

Until 1908 skirts fitted smooth at the top and flared from a little below the hips to the ground. Frequently they were gored so that they just fitted around (figs. 8 and 13); frequently also they were gored in front, straight in back, and gathered all around, though with most of the fullness concentrated in back (fig. 11). (1) From about 1904 to 1906 gored skirts of thin material were made with the fullness held in for some distance by rows of shirring (fig. 9); other skirts were made on yokes, long in front, short in back; the lower part would be either circular or a gored or straight piece, gathered on. Many women wore skirts of silk or mohair made of straight breadths accordion pleated; such a skirt with a fussy waist was suitable for afternoon or informal evening costume. From 1905 to 1909 the favorite cloth skirts were made gored and then laid in pleats, stitched part way down and emphasized by trimming. During these years an occasional skirt might be circular; some, like the princesse model in fig. 13, were gored to fit waist and hips and to flare from there down. All these skirts touched the ground or cleared it by only an inch or so; that is, except for strictly sports dresses, and common-sense or " rainy-day " skirts, which stopped at the ankle and occasionally even higher up. Some calling costumes as well as most evening gowns had trains. The

petticoats described above made skirts stand out with the necessary smartness. The art of holding up skirts modestly yet gracefully was practiced as assiduously as it had been in the nineties. Various devices to help a lady keep her skirt up without fatiguing her wrist are advertised in contemporary periodicals. (3) 1908 and 1909 saw a great change in the lower silhouette, for hips went out of style and with them long full skirts and frou-frou petticoats. In 1908 skirts definitely cleared the ground; by 1909 they were actually ankle-length (figs. 16 and 20), though quantities of women permitted their skirts to be shortened only to the instep (fig. 15). (4) In 1910 many women were still wearing skirts with deep pleats stitched down to below the hips (fig. 15), but already the fashionable world was forsaking fullness (fig. 20) and was even taking to some form of the sheath skirt, which was as straight as a bolster-case and confined the ankles with a hem not over a yard wide. In 1910 and 1911 that hideous invention (attributed to Poiret), the "hobble skirt" had its innings. A skirt of reasonable circumference was arbitrarily held in by a band not more than twenty-eight inches around, upon which the skirt was gathered somewhere between knee and ankle. The band might be only a few inches wide, then again it covered the entire distance between knee and hem. Every sort of dress, from dance frock to blue serge suit, was made in this idiotic fashion. Fortunately it soon passed, partly hooted out by the joke-smiths, partly killed by its impractical, even dangerous, features.

(5) During the next four years skirts remained skimpy. In 1912 daring designers found a way to escape the inconvenient narrowness: they slashed the garment up in front or at the side (figs. 22, 23, and 24). With scant skirts any petticoat save one of silk jersey was impossible, and with a slashed skirt even such a garment seemed superfluous. The problem was solved in various ways: some women actually did wear petticoats, extra-pretty ones, which showed when the dress fell open; some took special pains to have pretty, well-fitting stockings; and for a season some tried jersey silk ankle-length panta-loons, "pettibockers." (6) In 1912 another skirt was introduced and remained popular through 1914, a skirt which, though still narrow from ankle to knee, was wide above. This "peg-top" silhouette was obtained in one of two ways: (a) with draped panniers, slightly reminiscent of eighteenth century modes (fig. 23); (b) with overskirts or tunics, sometimes wired at the edge (fig. 22), sometimes arranged in overlapping tiers (fig. 24). The tiered skirt was used as much with suits as with dresses; the wired or "lamp-shade" tunic was obviously only suited to indoor costume.

Even when street dresses were at their narrowest (i. e., from 1910 to 1912) frocks to be worn indoors, of much thinner material, were likely to be a little fuller at both top and bottom (figs. 17, 19, and 21); they were also longer, that is, instep or floor-length, sometimes even slightly trailing. Until 1912 formal evening gowns had trains, made either in the old way, continuing the curve of the front hem (figs. 7 and 11), or with a square back breadth. For dancing the train was pulled up on a cord which was looped over the arm

and revealed a slim petticoat made of satin and daintily trimmed with lace and French flowers. About 1912, with the appearance of the new violent dances, trains proved distinctly superfluous, and dance-dresses were made ankle-length and rather wide. In the meantime the tunic costume was introduced (fig. 21). It consisted of a high-waisted dress of chiffon or net, perhaps beaded, with a slim skirt which might be either slashed or made in overlapping sections, and which was long enough to come nearly to the hem of a narrow satin slip. The same sort of tunic was worn in the daytime also, made of silk or even serge over a satin skirt. This straight up-and-down silhouette and the peg-top described above were popular simultaneously.

Feet. In the winter high shoes were correct on the street, though from about 1908 many women wore instead light-colored spats over pumps or oxfords. Walking-shoes had low heels (fig. 14), but high shoes to be worn with dressy suits or reception gowns were often given fairly high French heels. Both buttoned and laced shoes were popular, and either might be cloth-topped (fig. 20). Dressy high shoes were often made with tops of silk or thin kid to match the costume, the lower parts being patent leather or vici kid in black, bronze, white, or a color. As a rule the shoes had rather long vamps and pointed toes. During a winter or so from 1908 to 1910 both laced and button shoes were made unusually high, nearly to the calf.

In summer everybody put on low shoes, and from 1908 to 1914 younger women favored pumps rather than oxfords for all but sports wear. Oxfords were made of black or tan calf; pumps of calf, patent leather, or kid, sometimes in a dull black called " gun-metal." The " Colonial pump " (fig. 23) was a variant of the plain pump which may be traced through the entire fifteen years. The same models in low shoes of white canvas or buckskin accompanied white or light-colored dresses (fig. 12). Rubber-soled white canvas shoes were worn on the tennis-court.

In the winters from 1908 to 1910 high shoes were exchanged for pumps in the house (figs. 15 and 17); the bows which trimmed them were either wide and flat or small, according to taste. Occasionally, after 1910, pumps could be bought with straps, too. The street shoe sketched in fig. 22 is an ephemeral rather than a staple fashion. The wide silk laces in fig. 16 were a modish touch; such laces actually matched the shoe, but have been sketched as white in order to be visible.

Throughout the period evening slippers were made of satin in black, white, or colors to match the costume, and trimmed with rosettes or bows. During the later years they were often beaded over the toes (fig. 19). From 1909 to 1914 bronze kid went through one of its periods of popularity as a material for evening slippers. Heels were usually of the spindle or " French " type and might be pretty high, though neither so high nor so slender as they became a few years later. Young girls and some older women also habitually bought slippers with " baby " French heels, somewhat thicker and much lower than the ordinary heel. After strenuous dances were introduced

in 1912 many slippers were made with eyelets along the top edge through which could be put ribbon lacings long enough to wrap around the ankle in the " Directoire " manner. Very enthusiastic ballroom dancers even wore ballet slippers tied on in the same way.

From 1900 to as late as 1910 or 1911 silk stockings (to be worn with party slippers) were elaborately trimmed with drawn-work, embroidery, or inserted lace motifs. So were some of the darker silks or the fine lisle worn with reception gowns. Until about 1912 silk stockings were considered a real luxury not to be worn for everyday, when the average woman was content with cotton or lisle. As to colors:—stockings for the street were either black or the color of the shoe; from time to time black was considered the smart thing to wear even with white canvas shoes; in the evening stockings matched either the frock or the shoes.

In inclement weather women pulled on rubber overshoes or at least protected the soles of their shoes with rubber sandals. Over party-slippers those girls who went to dances in carriages wore carriage boots of quilted satin with furred edges; others, who walked or took the street-car, carried their slippers in bags and changed from their high shoes in the dressing-room.

Outer Garments. Separate coats (*i. e.,* not the jackets of suits) were worn summer and winter over one-piece dresses. The styles included: (a) both short box-coats of white serge or covert cloth with velvet collars, and plain, semi-fitting coats either three-quarter or ankle-length, made of heavier, darker, and more luxurious material; (b) double-breasted high-necked " dusters " of panama, pongee, or alpaca, for driving and motoring; (c) and loose tweed or plaid woolen travelling coats often made with raglan sleeves.

During the first five or six years of the century, short, snug-fitting fur jackets were still in vogue; squirrel, seal, astrachan, beaver, and other short-haired pelts were appropriate for them. Later, fur coats went rather out of style, except in northerly cities. It was more the fashion to have smooth cloth coats lined with furs such as gray squirrel.

Evening wraps of silk and brocaded materials, velvet, or fine broadcloth followed dress fashions, snug-fitting in the earlier years, then looser, often with large dolman sleeves. In 1910, 1911, and 1912 such big-sleeved cloaks were made with huge " cope " collars which rode high in the back of the neck. Some women wore capes, too, and during the last years of the period " burnoses " of white wool, brought home from Algeria. The golf capes described in Chap. XVIII remained in vogue for a few years and afterwards were kept in a good many households as useful extra wraps.

Sweaters were becoming recognized additions, though informal ones, to most women's wardrobes. The cardigan was popular, also a belted norfolk jacket of jersey; such jacket sweaters often had round turnover collars to button up at the throat. Girls sometimes wore heavy pull-overs with turtle necks for skating, or " outing sweaters " of mannish shape, equally warm, which could be buttoned up to a high collar.

SPECIAL COSTUMES (WOMEN)

Equestrienne. As more thought was given to safety and comfort in riding, habits were cut with skirts skimpier and skimpier. (1) In the early years of the century the skirt was made short on the right side, longer on the left, to be looped up when walking, let down when mounted. (2) Soon that last dangerous concession to femininity was dispensed with, and by 1908 even those women who still used side-saddles wore drill breeches and boots under a skirt which was no more than a scant short drapery. The hat might be derby, sailor, fedora, flat felt, or tricorne but was always secured to the head by an elastic passed under the back hair, which was arranged in a braided club tied at the neck with a black ribbon. Necks were wrapped in masculine stocks, coats were mannishly tailored. (3) By 1906 a good many women had taken to riding astride. Up to 1910 or 1912 a " cross-saddle " rider ordinarily donned a divided skirt which fell to the ankle; it was provided with a front panel to be buttoned over, forming a conventional skirt when the rider was not mounted. The costume above the skirt was as described above. (4) By 1914 cross-saddle riders might wear breeches minus any skirt; yet as a rule a small skirt was still provided to put on when the horsewoman had to go dismounted through the streets, into a hotel lobby, or even into a private drawing-room. (By 1914, incidentally, many women who went in for hiking in earnest took to wearing " gym bloomers " and then even knickers following masculine fashions.)

Negligée. As late as 1905 most nightgowns had high necks with turnover collars and sleeves to the elbow or wrist; in 1908 they began to have above-the-elbow sleeves and round necks gathered on a ribbon; by 1912 they had short " kimono " sleeves and round or square necks. During the last years before the war some girls began to wear pajamas.

Though both dressing-gowns and tea-gowns (which one might wear for dinner at home) followed the styles in a general way, they were always softer and looser than less intimate garments. Wide lace collars, lace-ruffled elbow-sleeves, cascades of lace down the open front under which were visible puffs of lace petticoat distinguished the negligées of the early nineteen-hundreds (fig. 12). The high-waisted or " Empire " styles were evident in tea-gowns before they had influenced other garments, and by 1904 ungirded silk or chiffon robes were worn over princesse slips. The eighteenth-century *polonaise* and the *robe à la française* (with a " watteau pleat ") were revived in tea-gown modes also. Dressing-sacks were popular, and when they were made three-quarter length and worn over charming silk or muslin petticoats, they took the place of full-length gowns. During most of the period flourished the " Mother Hubbard," that rather shapeless garment with fitted back and full front gathered on a shallow yoke. After the first few years it was not a fashionable, but remained nevertheless a very usual, part of a woman's wardrobe. Rather early in the period Japanese kimonos came upon the scene, one manifestation of a lively interest in Japanese art and culture which had preceded the Russo-

Japanese war. Soon the name "kimono" was applied to practically any little silk or cotton-crêpe garment made to slip on over the nightgown, even if it were cut on distinctly Occidental lines. After 1908 kimonos, following dress-styles, were cut high-waisted, usually with yoke and short sleeves in one and the long open skirt gathered on to the top section.

Servants' Dress. The formal afternoon uniform of waitress or parlor-maid was black, with small white fluted cap and small gored apron which had a little bib and shoulder-straps crossing in back. Skirts were about ankle-length, shoes black and plain with low or medium heels, stockings black cotton; it was only the "singing parlor-maid" of Frenchified comedy who wore much shorter, fuller skirts, silk stockings, high heels, and abbreviated organdie apron. In American suburban districts where the "servant problem" was acute, mistresses and maids had a good deal of disagreement about caps; many maids regarded them as degrading badges of servitude.

CHILDREN

Boys. (1) In 1904 little boys were wearing tunic suits called "Russian blouse suits," consisting of little bloomers and a skirted blouse with side-fastening and round neckband standing up just a trifle; by 1905 a rather similar costume had become identified in America with the "funny paper" hero Buster Brown. The distinguishing feature of his suit besides the tunic and bloomers was a wide starched collar and large black Windsor tie (fig. 11). Boys a little older were put into (a) knee-pants and short jackets with shirts, collars, and ties; (b) sailor blouses with either short pants (fig. 8) or long sailor trousers, the blouse worn *outside* the trousers; or, (c) Eton jackets and round collars, like those of English schoolboys, and either long trousers, as in England, or knee-pants. (2) After 1910 or thereabouts, though little fellows still wore tunics and bloomers, their bigger brothers were being put into knicker suits with norfolk jackets and shirts. Sometimes the collars were like those attached to men's shirts, worn with bow ties or four-in-hands; sometimes collars and ties followed the Eton styles mentioned above. Ordinarily American boys did not put on long trousers until their teens.

During the entire period small boys wore sailor hats or round cloth caps with widish headbands; larger boys usually wore caps, especially of the type pictured in fig. 1c.

(1) In 1900 most American boys even little chaps were wearing long ribbed stockings, probably black (fig. 8) and high laced shoes or oxfords, and, on rare occasions, pumps. (2) After about 1905 the European custom of putting socks on small children even in winter was taken up by a good many Americans, though for some time longer they kept their older boys in stockings. After a few years more youngsters were wearing short socks rather than long, and a good many also put on strap slippers in place of oxfords or high-buttoned shoes (fig. 8). Until about 1910 most American boys in short pants or knickers were still wearing stockings and, in winter, high laced shoes.

Girls. Though an occasional little girl might have her hair in a Dutch cut or even short like a boy's, most of them wore long tresses. Often the front hair was parted in the middle, rolled a little to bring it off the face, and fastened with a ribbon at the crown; often it was brushed in pompadour style over a roll, seldom as exaggerated as that worn by older people. The back hair might hang loose upon the shoulders (fig. 13), but often it was braided in one pigtail or two. Ends of braids were loose for a little way, then held firm with rubber bands, and clipped square, so that they looked like paint-brushes; hair-ribbons were tied in smart bows over the elastics. Some little girls wore the two braids looped across the back of their heads instead of hanging. After 1906 it was fashionable to wear wider ribbons, and for several years the width increased. A huge bow at the top of the pompadour as well as at the neck was much admired by the eighth-grade and high-school sets (fig. 14). Small children with Dutch cuts had their hair parted on the side and tied with a similiar huge bow. Through the early 'teens and sometimes till she was seventeen or eighteen a girl of the first decade might wear a braid, two braids, or even curls down her back. She tied them in with a bow at the nape, or sometimes she clubbed up the braid under the bow, or she even drew the back hair on top in a flat knot, but a bow (or even two bows) she kept while she was a school-girl.

As to hats, little girls wore straw or beaver sailors, flat sailor caps like boys, " tams " of wool, cloth, or velvet, and stocking-caps. For dress-up they had round beavers or straws with simple trimmings. Girls in their 'teens wore hats as nearly like adult styles as their mothers would allow, and as soon as possible they discarded the elastic which betokened childhood and skewered on their hats with long pins.

Dress. One great difference between little girls' costume in the fifteen years before the war and in the post-war years came in the length. Up to 1914 skirts always reached the knee and sometimes covered it (fig. 13). About 1900 dresses were often short-waisted, especially on children up to six, after that they were sometimes made with kilt-pleated skirts and separate waists. Party dresses were often made with accordion-pleated skirts. By 1904 the middy-blouse (like the boy's in fig. 8), worn with a pleated skirt on a washable underwaist, had become almost a uniform for girls between six and fourteen. Many boarding-schools adopted such a sailor costume, a " Peter Thompson," in all-linen, blue or white; all blue serge; or blue skirt with white duck middy, as the required school-dress, to be worn up to graduation at seventeen or eighteen. A variation of this comfortable costume, until 1908 as popular as the sailor-suit, resembled the boy's Russian tunic described above, with standing neckband and side-fastening under a box-pleat.

In England the school-uniform was already a jumper-dress pleated from square open neck to hem, belted, and worn over a simple, long-sleeved shirt-waist. With bloomers of matching serge, this was also the regulation English gymnasium suit. American girls began to do their exercise in white middies and

serge bloomers with very full pleated legs held in by elastic at the knee and blousing over.

After about 1908 little girls' play dresses were matched in scant bloomers which covered the underwear and did away with petticoats, but party dresses had under them white petticoats and white drawers with frills.

In winter girls wore high-buttoned or laced shoes, in summer oxfords or strap-slippers. As a rule they were still wearing long stockings, held up by garters attached to their underwaists. During the later years before the war very little girls, like boys, began to be put into short socks.

Before the days when grown women wore short hair and skirts as high as fashion decreed, there was a real difference between the costumes of mothers and daughters, débutantes and schoolgirls. First there was the matter of hair-dressing (described above): a definite step in growing up was taken when the hair was coiled on top and the ribbon discarded. Next, the question of covering the legs: the *jeune fille* was known by the length of her skirts, which when she was fifteen or sixteen stopped well above her ankles (fig. 14) and later went down to not lower than instep-length. Some girls in the early years of the first decade graduated from high school in trains, but after 1908 most of them had the first train for the first formal ball. When it came to party dresses, appropriateness of style had to be considered: young girls were not allowed extremes of décolletage nor sleeveless dresses, even if their mothers did go in for such things. Finally, some materials were practically taboo for the girl not out in society: she wore in the evening silk batiste, mull, crêpe de chine, china silk, point d'esprit, not satin, brocade, velvet, or metallic tissues. As a rule, mothers managed to keep their girls from extremes of high heels, tight corsets, and large pompadours.

MATERIALS

Men. Men's formal coats were still made of broadcloth, their sack suits of serge and tweed as often as of smooth-surfaced fabrics. In summer a good many men took to wearing suits of " Palm Beach cloth," and panama or light-colored washable fabrics like linen (white or natural-colored), gray alpaca, and seersucker.

Women. (1) During the first years of this period most of the materials enumerated in Chap. XVIII continued to be worn. The practice of putting colored silk linings under lace and lingerie, batiste, organdie, "pineapple gauze," and " silk muslin " as well as nun's veiling and marquisette lasted until 1909 or 1910. " Messaline " and " raw " silks like surah, rajah, and pongee were made into summer suits; taffeta, satin, china silk, and silk crêpe as well as silk velvet and brocade were popular for evening dresses; and foulard and other soft silks for church or reception gowns. (2) In 1908–1909 the vogue for slenderness brought with it gowns of crêpe de chine, chiffon, chiffon cloth, and some new and more supple satins like " charmeuse." It was between 1908 and 1910 that georgette crêpe began to be popular, and about 1911 when

manufacturers put out a heavy, rather lustrous crêpe called "meteor" which was chosen for many wedding dresses during the next few years. (3) Taffeta came back to style with the returning bouffant dresses of 1912 to 1914, but, like satin, it was of a lighter and more flexible texture than formerly. Silk velvet, too, which was in demand for dressy suits, was suppler than of old. Striped "tub-silks" were used for shirtwaists during the entire period, often combined with linen skirts.

Wash Materials. (1) The first decade of the period was emphatically the age of lingerie, lace, and white embroidery. White or pastel batiste was combined with Valenciennes lace insertion and edging, "real" if possible, otherwise machine-made. Handkerchief linen, dimity, cross-barred muslin, and dotted Swiss were made into waists and whole dresses. Waists, dresses, and little jackets were made of heavy all-over lace or of open-work embroidery. The most sought-after laces, real if they could be afforded, were rose-point, Venetian, duchesse, and its much coarser imitation, Battenberg. From about 1905 to 1910 there was a great vogue for linen suits and with them accessories such as hats and parasols, all heavily embroidered in Italian cut-work or trimmed with insertions of linen lace. Suits and tennis skirts were made of heavy linen "crash" in the natural color or white, as well as of piqué, duck, and a cotton called "butcher's linen." "Dusters," *i. e.,* long travelling or driving coats, were made of linen crash as well as of pongee. Most underwear was still of longcloth, muslin, batiste, or fine linen. Summer dresses came in dimity, percale, plaid gingham, chambray in charming shades, organdie, cotton marquisette, voile, flowered mull, and net. (2) After 1910 the crisp cottons began to be neglected in favor of softer materials, and cotton crêpe became popular, not only for dresses but for underthings. Irish crochet enjoyed an enormous vogue, the expensive hand-made product being imitated in machine lace; it was used for waists, jackets, and whole dresses as well as for edging and insertion. About 1911 Cluny lace succeeded it in the mode; and a little later filet, which many people made for themselves. In 1910 or 1911 an inexpensive lace called "shadow" was used very freely in flounces and petticoat ruffles; it was woven from six inches to a yard wide.

Woolens. During the entire period broadcloth was *the* material for handsome tailored suits, and serge or tweed for utility suits. (1) During the first five years of the century many suits were of broadcloth in white or pastel shades, many also of white serge, especially white with a black pin-stripe, a pattern which remained popular till about 1911. Light wools such as flannel, "Panama cloth," brilliantine or mohair, and alpaca, as well as serge and covert cloth, were popular as summer suitings and the material of summer coats. In winter a great many informal party dresses were made of very soft wools like challis, nun's veiling, and albatross in white and pastel shades. (2) After 1911 velveteen took the place of broadcloth in dressy winter suits, but dark blue serge became more popular than ever, especially with college girls and business women. The various new silks practically drove out thin woolens for indoor

dresses even in winter. The intensely hot, dry winter temperatures of city buildings may be held partly responsible for the thinner materials.

Furs. The short-haired pelts popular for so many decades went rather out of fashion after the first year or two of the new century; their place was taken by long-haired furs: fox, wolf, lynx, and marten. In mild weather, instead of fur many women wore feather or marabou muffs and boas. Fox, the red, black, white, and " blue " or gray varieties, was perhaps the foremost choice during the entire first decade; about 1909 or 1910 marten came in. In 1912 and 1914 opossum had a bit of a vogue, and at the same time, moleskin. Squirrel was one short-haired fur which never lost its prestige. Many girls wore it dyed brown, in imitation of Russian sable (which of course never *is* out of style with those who can afford it).

COLOR

Men. Men's costumes were growing a bit more colorful. To be sure, the majority still selected from a limited palette: black and white for evening; dark blue and white for summer afternoons; black, dark blue, gray, gray-and-white mixture, blue or gray with white pin-stripes, two-toned gray stripes with black coats, and occasionally brown for city costumes. Yet some of the browns were bright, and the blues were occasionally exchanged for green. Tweeds, which most men wore for sports and some in the city, were rather warm in tone. In summer men had a real chance at cool ensembles of white, ecru, or silver-gray.

Women. (1) From 1900 to 1910 the mode decreed that feminine street costumes should be subdued in color. One might wear all white, black, black-and-white, navy-blue, brown, or steel-gray, and vary the dark tones with dis-creet notes of one strong color, *e. g.,* red, blue, or green, or with combinations of pastels. Several shades of a color could be combined in one costume, for instance " champagne " shading into tobacco-brown. From time to time checks and plaids had a run of popularity. The black-and-white pattern called " shep-herd's plaid " was seen everywhere in 1908 and 1909; Scotch plaids were nearly always in good style for pleated skirts, golfing costumes, and travelling coats. Tints like baby-blue, shell-pink, maize, and orchid were popular for evening dresses and for broadcloth suits, too, along with a very pale tan called " biscuit."

(2) About 1912 a great change came over the palette of dress designers. It is hard to say how much of it should be attributed to the influence of the Russian Ballet which had charmed Paris in 1909, how much to the discovery by Western womankind of Balkan peasant dress, owing to the war in the Near East (1912). At any rate, in 1912 not only Paris salons but American dress-shops and ballrooms blossomed out into gay color: Russian pink, orange, jade, cerise or " American Beauty," and bright blue. Silks printed in big peas-anty patterns of the same startling hues were made into " kimono " blouses to wear with suits.

APPLICATION OF DECORATION

(1) In the beginning of the century one of the favorite methods of trimming a dress was to pipe and face it with a contrasting color. Fancy buttons were liberally employed: a row of tiny buttons down the back, larger buttons on sleeves, jacket lapels, pockets, and marking the termination of stitched pleats on a skirt. Fine handwork was lavished on silk-covered buttons. Flat trimming of heavy lace, passementerie, and soutache braid was profusely used (figs. *passim*); also lace edging and insertion, pin-tucks, and embroidery, as described in the foregoing pages. From about 1905 to 1908 it was stylish to finish the stitched part of a pleat and the corners of a pocket with an embroidered arrow-head (fig. 10). Hand embroidery was applied in white to lingerie, in colors to wool and silk dresses; old-fashioned feather-stitching was revived and satin-stitch and other solid embroidery was employed also, but fagoting was *the* fashionable stitchery.

(2) In 1912, along with the interest in peasant dress, came a vogue for wool embroidery in large patterns and bright colors, applied to silk as well as to woolen dresses. Under the same exotic stimulus both cross-stitching and smocking were revived, the latter considered especially suitable for the simple frocks of children and young girls. The chiffon over-tunics were enriched with a good deal of delicate bead-work (fig. 21). On the dresses and petticoats of the neo-Greek revival of 1909–1914 " French" flowers (made of ribbon) were appliquéd with pleasing effect (fig. 19). Such flowers were put on bandeaux for the head also.

JEWELRY

Men. In the daytime a man might wear nothing in the way of jewelry save a tie-pin, simple cuff-links, possibly a signet ring, and a watch-fob. The fob enjoyed a considerable vogue, especially among younger men, though their elders still wore watch-chains. Upon a simple strip of grosgrain fob ribbon a college boy might hang the golden emblem of his football prowess. College boys wore fraternity pins too, of course. By 1914 a few men had begun to wear wrist-watches, but in pre-War America the innovation was considered " sissy." In the evening the young man about town had a chance to be a little more decorated with his cuff-links, waistcoat-buttons, and shirt-studs in sets, of enamel, gold, lapis, jade, or onyx.

Women. (1) Some women still pinned their watches upon their waists, in the manner described in Chap. XVIII; from 1900 to about 1910 most younger women were wearing theirs on a fob tucked into the belt (fig. 16) or into a small breast-pocket in the jacket. (2) After 1907 a long watch-chain came back to style also; from about 1909 to 1912 the chain was preferably short and the watch hung from it like a locket. (3) About 1912 came the wrist-watch; at first one's ordinary watch was fitted into a case of gold or leather, clasped on

the wrist, but soon smaller watches were made which were intended to be worn only on a bracelet.

(1) Breastpins or brooches were out of fashion; in the first years of the period there was little place on the bodice for pins, that is except for fraternity or sorority pins, which were always worn on the left side of the waist about six inches below the shoulder (and in those days if you wore a man's fraternity pin you were serious about it). In the evening or with dressy afternoon costumes some women wore diamond sunbursts nestling among the laces of the corsage. " Baby pins," single or linked together, were useful as well as ornamental: they fastened the high collar in the back or held down the turnover in front, and they fastened together the corners of white turnover cuffs.

(2) From about 1906 to 1912 every girl possessed or wished to possess a small pin of delicate workmanship which combined gold and enamel and also, perhaps, jewels. Favorite among the designs were wreaths and crescents with colored flowers, or merely sprays of such flowers, or clover leaves. The pin was placed at the base of the collar or somewhere on the front of the waist. About the same time the " bar-pin " came in as the almost indispensable accompaniment of a neck-bow (fig. 16).

(1) In the earliest years of the century girls were wearing link bracelets of silver or gold, fastened with a heart-shaped padlock which really locked with a key ("friendship bracelets"); to the links one might attach charms. (2) Next came thick round metal or ivory bracelets, to be slipped upon the arm; (3) after that wider, flatter bands which fitted the arm and opened on hinges or slides; and finally, (4), slender bangle-bracelets which again slipped over the hand and slid up the arm or dangled around the wrist.

(1) The heart-shaped locket which had been stylish in the nineties (fig. 17, Chap. XVIII) remained in the mode till 1908. You wore it at the end of a long chain, or upon a shorter chain at the breast. Some lockets were large and round, usually flat, like a chocolate peppermint wafer. (2) During the middle of the period many girls wore gold crosses in place of lockets; though these ornaments were often confirmation presents, in many instances they had no religious significance. The " lavallière " was popular from the early nineteen-hundreds and throughout the period: a delicate ornament of gold and enamel or jewels, swung on a fine chain and resting on the breastbone above the décolletage (fig. 21).

(1) During the first years of the new century very small silver or gold mesh purses were also hung on long neck-chains; so, after the first few years, were coin-purses which looked like fat watches and opened with a spring. (2) Larger mesh bags came in about 1908 or 1909; some had metal extension tops, some were drawn up on chains, some had rigid tops (fig. 15). Medium-sized mesh bags had rings on their chains, so that they could be dangled from one finger. (3) During 1909, 1910, and 1911 particularly there was a fad for carrying suspended from a silver ring a cluster of silver objects such as coin-purse, ivory-leaved memorandum tablet, pencil, wee smelling-salts bottle, and

even a box of compact powder. (Not rouge; that was never applied in public and if a girl used it, nobody was supposed to know.) With these trinkets, a batch of boarding-school girls seated in church would keep up a clinking which must have been distracting to both minister and congregation.

Combs, which came in sets for the back and sides, often had elaborately jewelled or at the least patterned gold tops. The barrette which held up straggling locks of back hair was often only shell, but might be gold or silver; some girls had them in fancy shapes like arrows and feathers.

The jewels of rings were held high on prongs attached to thin gold hoops. A diamond between two other stones or beside one other stone, a colored jewel surrounded by chip diamonds or seed pearls, a solitaire jewel, were all in the mode. Engaged girls displayed diamond solitaires mounted in gold or platinum prongs; so, often, did girl graduates. Wedding-rings were narrow hoops of yellow-gold; during the last five years of the period some brides had rings with chased designs.

ACCESSORIES

Men. In the days when "Brown of Harvard" was drawing crowds of matinée girls, a college man was popularly supposed to be inseparable from his pipe, which was a meerschaum or a briar according to his means and taste. Older men smoked pipes, too, or cigars. But cigarettes were becoming more and more popular, and by 1910 most of the younger generation preferred them to cigar or even pipe. The cigarette case began to be an important accessory of a young man. (Not, be it noted, of a woman. In America the popular belief prevailed that only "fast" women smoked, and though during the last years before the War plenty of young women *did* smoke, it was usually up the chimney or in secluded corners between dances.)

During the first decade of the century light bamboo canes were considered particularly "swell"; they had crook handles or knobs of the wood. Canes were still associated in the American popular mind with the dude, the "Cholly boy," who was often portrayed with the handle of his cane in his mouth and a monocle in his eye. His more "manly" contemporary wore eye-glasses if he needed them, rimless glasses which clipped to the nose and sometimes had a narrow cord to loop over the ear or around the neck.

As during the nineties, most men wore gloves in the street, winter or summer: tan calf, gray "castor," and sometimes washable chamois. Until the War men always wore white kids at formal evening affairs.

Women. Until 1906 or so a few women still wore chatelaine bags hooked on to the belt (fig. 11, Chap. XVIII). After that, handbags and purses large and small were put on the market in bewildering variety. Good-sized bead purses with rigid or "extension" tops preceded the large silver mesh bags, that is they were carried before 1909. Plain envelope purses and satchel-shaped bags with strap handles were carried by conservative women. They were usually made of pin-seal with metal tops. Large satchel-bags were fashionable in

1908 and some of them were made in the brightest of red leather. About 1906 to 1908 there was a considerable vogue for hand-tooled leather bags, and at the same time handbags made of alligator skin were in style. About 1912 and 1914 large bags of tapestry or brocade came in, on the wave of interest in bright oriental fabrics (fig. 20).

There were innovations in luggage: the sole-leather " dress-suit case," made later also in wicker, for short trips; the flat " steamer trunk," which could be slipped under a cabin berth; the steamer-rug roll, for travel abroad; and the first wardrobe trunk, new in 1908, which cost its original price in excess baggage and had a hard time fitting into any luggage wagon or hotel bedroom. When alligator skin was fashionable for pocketbooks, it was made also into hand-satchels and even suitcases for ladies who liked such things.

Though separate coats might have fur collars, suit jackets were not furred; fur neckpieces were therefore important. (1) In 1901 and 1902 such furs were small and with them were carried round, moderately small muffs. (2) By 1905 that set was replaced by a long fluffy boa and a larger muff (fig. 13). (3) In 1909, 1910, and 1911 it was the fad to omit a neckpiece even with an open-necked coat and in bitter weather, but since the muff was now very large, pillow-shaped, and flexible, it could be cuddled up against chest or ear as needed. (4) In 1912 a separate flat fur collar or small shoulder-cape came in, along with a huge muff, as big as those carried during the First Empire (cf. fig. 19, Chap. XIV). In 1912 and 1913 some of the flat furs like opossum and mole-skin were made into very long wide scarves; at the same time the huge pillow-muffs were replaced by those of a barrel-shape, still good-sized, but not so extreme as their predecessors. Every muff during this period was equipped with a loop or a shell bracelet on a short ribbon, by which the muff could dangle from the wrist. From 1900 to 1910 muffs and neckpieces were made not only of fur but also of chiffon and particularly of feathers and marabou (fig. 13).

Umbrellas were not so invariably a part of women's street attire as they had been in the nineties. They were walking-stick length with fairly long slender points and their handles were in the form of crooks, knobs, or crutch-tops of wood, silver, or ivory. The silk covering them was seldom in brighter colors than black, brown, or dark blue. Parasols, which frequently had bamboo handles, were covered with flowered " pompadour " silks with broad satin bands, with pastel silk veiled in shirred lace or chiffon, and (in the middle years when dresses were made of embroidered linen) with washable fabrics to match. Pongee parasols were lined with green and carried as a protection from sun-glare and sunburn.

From 1900 to 1912 the fan was a usual part of a ballroom toilette; after 1912 it gradually went out of style. Fans were medium-sized, with sticks of ivory or sandalwood and covers of beaded, spangled, or lace-trimmed tissue. Up to 1908 or so the fan was carried or hung on a cord from the belt, later it might hang on a long chain around the neck. In addition to the fan a girl

probably carried a tiny " party-bag," big enough to hold a handkerchief and (during the last of the period) a " dorine " powder compact. Among earlier portable complexion repairers may be mentioned the book of tissue leaflets covered on one side with powder.

Gloves fitted the hand snugly and buttoned or snapped at the wrist. With dressy outdoor costumes ladies wore thin kid, two or three buttoned, with plain winter suits heavy leather with only one button or clasp. During the last few years of the period smart young women were wearing heavy *white* kid with their suits (fig. 20); and since the kid was not washable, the fad was an expensive one. With the three-quarter length sleeves on suits and afternoon dresses, fashionable from time to time during the entire period, one wore gloves long enough to wrinkle on the forearm in the " mousquetaire " style. Such gloves, open at the wrist far enough to put the hand through, were black or light-colored as might be needed to carry out the ensemble of suit and hat (figs. 13, 22, and 24). With summer suits these long gloves were of silk and were not extra long; since they slipped down easily, some women wore with them little shirred silk and elastic " glove garters." White kid gloves always accompanied formal evening costumes; from about 1909 to 1912 they were supposed to be long enough to wrinkle over the arm (figs. 19 and 21). While dancing a woman wore her gloves on her hands; at formal dinners and during the supper intermission of a ball she slipped her hand through the wrist opening and tucked the glove in at the wrist. With the advent of the strenuous dances there was a notable relaxation of the etiquette which kept a girl always gloved at parties.

Scarves were very usual additions to evening costume. In the first place, it was necessary to throw a scarf over the head on the way to the party, both to keep the hair neat and to protect the head in cold weather. If you walked or took the street-car you were glad to wear a " fascinator," a slightly shaped head scarf knitted or crocheted of zephyr wool. Second, women often carried a chiffon, lace, or silk scarf to put over the shoulders. During the revival of neo-Greek styles such a scarf was considered as part of the costume (fig. 21). It was made of chiffon or net trimmed with crystal beads, spangles, or sequins, if not of silk fringed, embroidered, or hand-painted.

Real and artificial flowers were important accessories to both day and evening costumes. The flowers which a girl received from her dance escort came in a " corsage boquet " arranged upon a fancy cardboard backing covered with silk and edged with lace. She pinned the flowers at her belt with one or two long and viciously sharp " flower pins."

The fashionable fresh flowers to wear in the daytime were violets, either single " Parmas " or the heavy-scented double " New York " violets. A large bunch would be pinned at the waist; or a smaller on the coat-lapel, neck-fur, or muff. If you did not have real violets you might wear artificial, which were often expensive and very good imitations. At Christmastide girls sometimes pinned a sprig of holly (again perhaps imitation) on their muffs. During a

wave of estheticism in the earlier nineteen-hundreds some young women made a point of wearing indoors a single rosebud, pinned upside-down upon the left side of the chest.

SOMETHING ABOUT THE SETTING

The preachments of the nineteenth-century esthetes had their most widespread results during the first years of the twentieth. The furniture styled in America " Mission " may have been at its worst heavy and ungraceful, but it was at least honest and substantial; the adjustable " Morris chair " had the merit of being comfortable. The " fumed " and " quartered " oak which about 1905 succeeded the earlier " golden oak " was of a harmless color and a pleasant grain. The austere lines of furniture were in keeping with a general revolt against over-decoration, a revolt which dictated the use of plain tan or green " oatmeal " or " cartridge " wallpaper, brown, tan, green, or maroon " artburlap " portières and window-draperies, and polished hardwood floors with plain-colored rugs. New houses were finished with timbered ceilings and walls panelled wholly or in part. Dining-rooms had plate-rails running around the walls which were set out with souvenir crockery, including the inevitable stein. Open fireplaces were happily reinstated.

Yet there were fussier elements in fashionable interiors. Fur rugs (luxuries of more than one decade's standing) retaining the animal's head and mounted on smooth felt gave many an unwary guest a tumble on the glassy hardwood floors. Behind the bevelled glass doors of oak buffets sparkled quantities of wedding-gift cut-glass. Upon dinner-tables glowed candles under fringed pink silk shades. In bedroom furnishings golden oak was succeeded by " bird's-eye maple," that in turn by " Circassian walnut." During the last years of the period French enamelled furniture returned to style; its color was ivory white or pale gray. Mahogany remained in fashion, unfortunately often varnished to an unpleasant degree. During the first ten years of the century wooden beds were declared unhygienic, and everybody bought enamelled iron or brass; that decade, too, saw the advent of twin beds. Before 1914 metal beds were already beginning to be scorned, and the newest bedsteads were again wooden.

After 1900, side by side with the craze for straight lines and burlap, there developed an appreciation of " art nouveau " as applied to interior decoration. Some graceful pieces of furniture were produced by this new school of design (fig. 12), also some very unlovely bits. In most houses it was not the furniture so much as the smaller articles which testified to the new influence: vases, bowls, candlesticks, and especially electric light fixtures. Taking its inspiration from natural forms, both floral and human, " art nouveau " admirably matched the woman of the first decade with her tilted figure of curves undulating from vase-shaped torso to swirling ruffles. The sleek, wand-shaped lady of 1910 did not fit so well into this sinuous background. But by that time the movement had spent its force and decorators were turning back to traditional styles, especially the Early American.

566 HISTORIC COSTUME FOR THE STAGE

It is worth noticing that both the so-called "Mission" style and to some extent even the Parisian "art nouveau" spring from the doctrines of William Morris and the Pre-Raphaelites who had labored in the eighties amid jeers from conservatives in England and America.

PRACTICAL REPRODUCTION

This chapter will have fulfilled its chief function when it has helped you to identify actual garments which may come into your hands, to combine them properly, to add new articles correctly, and to see that the ensemble is worn with the proper chic.

There is hardly a material mentioned in these pages which cannot be bought in dress-goods departments. Hats you can make by looking at the pictures, if you don't succeed in begging or borrowing real ones. Jewelry and accessories like hatpins ought also to be found on inquiry. You will be surprised at the number of pre-war shoes you can get hold of.

Men. Of course you will not attempt to make new suits. Either rely on borrowing from people who save such things, or pick out modern garments as nearly like those described and pictured as you can find. The actor's hat, his collar, eye-glasses, watch-fob, and such details will effectually date him.

Women. Fortunately it is generally the handsome suits and the elaborate party-dresses which women have saved for thirty or thirty-five years, since those are the garments both difficult and expensive to make. After you have borrowed successfully, you must then see to it that your actresses live up to the gowns. First their hair. A pompadour is not an absolute necessity, for some women always wore their hair parted; but the back must be arranged in one of the fashions of the moment. By reading the text and studying the pictures you will learn how to arrange the coiffures; all you need is long hair or switches, something for a pompadour pad, some combs, and plenty of hairpins. Next their figures. If a girl is flat-chested you must fill her out with a pad or starched ruffles and she must wear a front-gathered starched corset-cover under her shirt-waist. She should wear a corset, but it need not be tight; her waist will look small if her bust is full and her hips filled out with enough petticoats. Teach her the standing-position assumed by the fashionable in the year of your particular play, and give her instructions in holding up her skirts and managing her train.

You can very likely borrow patterns for waists, skirts, and simple dresses, and you will find them no harder to put together than modern clothes, though rather fussier in the details of finishing.

If you are not successful in finding "period" shoes, use modern. In lieu of high shoes for winter scenes you may supply oxfords with spats. Beware a too extensive and indiscriminate use of silk stockings. See that gloves are worn by both men and women in ballroom scenes and always out-of-doors. Teach the actresses how to put on a hat and stick the pins in and take them out, and how to manage a tight face-veil.

Personal instruction in all these details of dressing and deportment from someone who used to wear such clothes will help to make the actresses appear as charming to modern audiences as the original wearers actually did seem to their contemporaries.

Suggested Reading List

(See this section, Chaps. XVII and XVIII.)

A Century of Fashion—By J. P. Worth, *The American Procession,* and the article of " Dress " in the *Encyclopedia Britannica* will be found very helpful.

Our Times—By Mark Sullivan, vols. I, II, III, and IV.

All concern themselves with America between 1900 and 1914, and are illustrated with contemporary photographs, drawings, fashion-plates, and advertisements useful to the costumer.

Magazine illustrations (see bibliography) and illustrations of contemporary " society " novels will be found as useful as any text-book.

Where Further Illustrative Material May Be Found

For this last period—this section really merges with the preceding—there is much more instruction to be found in source material than in texts.

Painted portraits are less numerous than photographs (whether cabinet or snapshot), illustrations, and fashion designs and less valuable as references. Supplement the information in these pages by recourse to such sources and to the recollections of your friends who admit to before-the-war youth.

Sources of Sketches in This Chapter

The magazines containing the photographs, sketches, and advertising matter which furnished details for the accompanying sketches are: *Life* from 1901–1914; *Vogue* during the same years; the *Delineator* for 1904, 1905, and 1906; the *American Magazine* for 1910, and *Munsey's* for 1905. This *Munsey's* contains the photograph which gave all the data for the costume sketched in fig. 9, a photograph of Alice Roosevelt, copyrighted in 1904 by Pach Bros., New York. In *Vogue* for May, 1931 is a sketch of Lily Elsie (the English " Merry Widow "), which was the model for the costume on fig. 21. The " art nouveau " chair in fig. 12 is from a piece of furniture exhibited in the Museum of Modern Art (N. Y. City) in 1933, or rather (directly) from a photograph of the chair by Wurts Brothers, reproduced in the *New York Times* of April 9, 1933.

Contributing their share to the other sketches were numerous contemporary photographs and kodak pictures from college year-books and private albums, a number of garments in the possession of neighbors, and the vivid recollections of the author and her friends.

Chapter XX

SOME NOTES ON THE CONSTRUCTION OF COSTUME

SOME NOTES ON THE CONSTRUCTION
OF COSTUME

▀▀

THIS final chapter is intended as a short guide to the construction of costume in general. Here are listed the items needed to equip a workshop, including certain published patterns useful as basic guides in cutting a variety of garments. Here are named the principal types of available fabrics with their special qualities, a summary of the lists given in earlier chapters which enumerated the fabrics suitable to each period under discussion. Here are given suggestions for taking measurements and for fitting, lining, finishing, and ornamenting garments to be worn on the stage. Here are briefly explained the processes of dyeing, applying flat decoration in different media, and modelling in papier-mâché and plastic wood. Here are presented a few notes on the use of color, including a word about the effect of stage lights on colored fabrics and on make-up. Here are described the processes of making certain unusual articles included in the costumes of several periods, i. e., armor, hoop skirts, millinery, and jewelry. Here, finally, is a brief analysis of the qualities which make for effective costumes on the stage of pageant or the more intimate drama.

MINIMUM EQUIPMENT FOR A COSTUME WORKSHOP

A cutting table not less than forty inches wide, and as long as the room will accommodate.

At least one sewing-machine, preferably with an electric motor. While it is perfectly possible to make costumes on a foot-power machine, a motor is very nearly a necessity when time-saving is important.

Well-sharpened scissors and shears.

Plenty of good-grade pins, bought by weight.

Packages of assorted needles and machine needles.

Thread by the dozen spools: black and white, No. 30 for handsewing. No. 60 for the machine, and some heavy carpet-thread with needles to carry it. It is not necessary to sew costumes with thread matching in color.

Tailor's chalk, white chalk, charcoal, or a marking-wheel.

Tape-measures and a yardstick.

Thumb tacks.

A pair of pliers with wire-cutting attachment.

A roll of wrapping-paper for cutting out patterns and for various other uses.

A ball of white string about ⅛" thick for tie-dyeing and other uses.

571

A sink or set tub with running water.

A stove or gas-plate; pans for dyeing: small saucepans for making the solution and a large granite dishpan or some other large receptacle (*not* galvanized iron) for the dye-bath.

An ironing-board and iron (preferably electric).

A dress-form and a hat-and-wig block. (It is possible to do without the latter but very inconvenient.)

Experience will show to what extent it pays to duplicate these items and what others may be added to advantage, *e. g.*, a sleeve-board, a grommeting apparatus (for putting in eyelets), a studding machine, a pinking attachment and other sewing-machine gadgets.

PATTERNS

Some few standard patterns can be used as the basis for practically all the shaped historic garments, and these should be considered as part of the workshop equipment. It is desirable to have them in three sizes, small, medium, and large, that is, sizes, 32, 36, and 38 for women; 36, 38, and 40 or 42 for men. The patterns suggested are:

For Men. Pajama, both one with a V-neck and one in the Russian style, with side opening and standing collar (any standard pattern).

Domino (*Pictorial Review* and Butterick).

Cassock (*Pictorial Review*).

Surplice (*Pictorial Review.*)

" George Washington," " Colonial," or " Continental " (three names for the same costume), *i. e.*, eighteenth century. (Butterick and *Pictorial Review.*)

" Uncle Sam " (Butterick and *McCall's*).

" Mephistopheles " or " Devil " (Butterick and *Pictorial Review*).

For Women. Kimono nightgown.

Princess slip with gored skirt.

Fitted or " French " bodice lining, which includes tight long sleeves and a choice of high or low neckline (these three may be found in any of the standard pattern-books).

" Martha Washington " or " Colonial " (two names for the same costume), *i. e.*, eighteenth century (several pattern-makers carry it).

" 1890 " or " Gay Nineties " (*Pictorial Review*).

A gored skirt (any standard pattern). Get one with as many gores as possible. The old-fashioned bell-shaped gored pattern is the most useful; if you are lucky, perhaps you will find an old one of the nineties or nineteen-hundreds.

With these patterns, modified as suggested in previous chapters, you can cut nearly any garment. The " fancy dress " patterns listed are modernized versions of period garments, evolved from a rather superficial study of pictures and definitely affected by present-day fashions. Almost always they call for less material than you should use to give the real effect of the originals. Yet though it is seldom possible to follow the pattern line for line, it does give you

a good basic structure. Some dressmakers with superior skill and confidence prefer to follow patterns drawn to scale, such as are included in several of the books mentioned in the reading lists. Still more experienced cutters may find it most satisfactory to draft their own patterns from the pictures and suggestions given in the preceding chapters.

Assuming that you are using tissue-paper patterns, it is a wise plan, before you begin cutting, to mark each piece of a new pattern with its descriptive title, the title of its manufacturer, its serial number, and its size. But the paper is perishable, and if you are keeping a pattern as part of the workshop equipment you will find it best to make a copy in some more durable material. You can cut it from sheeting muslin, or from strong wrapping-paper, and identify the pieces as explained above. Such patterns may be rolled up and stored in drawers or thumb-tacked against the walls. Some people prefer thin strong cardboard (Japanese stencil paper serves the purpose); it is durable and holds its shape, but it is awkward to store. Whatever the material of your pattern, remember that you must cut from it carefully, first altering it to suit the measurements of the wearer, according to instructions given in the cutting guides which come with the original patterns.

MATERIALS

In selecting materials the quality of weight, the quality of draping, and the quality of sheen or reflection must be considered. Some cheap goods can be treated to give the effect of expensive fabrics, if they are asked to do what they *can* do and no more. Cotton can give the effect of wool and sometimes of velvet, but seldom of silk, whose beauty lies in both its sheen and its draping qualities. Highly mercerized cotton fabrics like sateen most nearly approach a silk effect.

Among cheap materials which *drape* well may be enumerated:

Cheesecloth (more satisfactory for garments if made up double), Japanese cotton crêpe, cotton voile (transparent, for veils and scarves), canton flannel or flannelette, sateen and satinette (a thinner, softer grade of sateen), ABC silk or silkaleen, and pongee.

Among those which have *weight* and also *draping qualities* may be included:

Heavy flannelette, burlap after dyeing (old sacks are often as good as new " art burlap " and may cost nothing), corduroy, velveteen, rayon damasks and other drapery materials, cotton duvetyn, ratiné, and terry cloth.

Among those which are *stiff* and *light-weight* (for bouffant effects), the principal inexpensive fabrics are:

Tarlatan, percale, gingham, dimity, thin cretonne or glazed chintz, and paper cambric.

Among those which are *weighty* and *stiff* the stand-bys are:

Unbleached or " brown " muslin (the weight of sheeting or heavier), canvas

or " marine duck " (a material used for scenery and upholstery), khaki cloth, cotton rep, denim, heavy cretonne.

The materials with *sheen* include:

Sateen and satinette, all the varieties of rayon satin, moiré, and taffeta, oil-cloth (which is excellent for shiny stiff effects, but is hard to sew and prone to pull from the stitching and crack), paper cambric (which gives the suggestion of silk when new, but as everyone knows is ruined by handling, often even in the dressmaking), and glazed chintz, more expensive than paper cambric, but also more durable. When sateen is laundered it loses its silky sheen; however, it then becomes a good substitute for light-weight wool if it is left rough-dry and made up with the wrong side out.

Velvet is most satisfactorily " faked " by an uneven, spotty dyeing of flannelette or terry cloth; this process gives the effect of depth and pile. Terry cloth with a pattern has the same quality. There is a shaded pattern sometimes to be bought in cheap cretonne which imparts to that material also some of the depth of velvet. Corduroy, considerably cheaper than velveteen, can often be substituted for it.

Metallic cloths of many sorts can be bought from theatrical supply houses. They cost from a dollar to two dollars and a half a yard, but are inexpensive in proportion to their spectacular effect.

The materials which can be most successfully dyed, and usually should be, are: cheesecloth, cotton crêpe, flannelette, burlap, pongee, and unbleached muslin (which must first go through the laundry to have the dressing taken out).

Muslin with the dressing left in, canvas, and paper cambric, can be painted on directly with show-card colors or oil-paints; oilcloth will take only oils or metallic paint.

MEASUREMENTS

In a permanent workshop where many plays are costumed, it is a great time-saver to have on hand mimeographed measurement blanks which have a space for the name of the play, the actor's name, and his rôle. One type of blank will do for both men and women. An inclusive blank, which makes provision also for the measurements to be sent with an order for wigs, follows (the italicized items are those especially necessary for rented costumes):

PLAY ..
Name of Player ...
Rôle ...
 Height (stocking feet)
 Weight
 Head (around)
 Head (forehead to nape of neck)
 Head (ear to ear)
 Hat size
 Neck
 Chest or bust
 Waist

Across shoulders: (front)	(back)
Shoulder to waist: (front)	(back)
Shoulder to floor: (front)	(back)

 Armpit to waist

Arm length (outside): to elbow	to wrist (arm bent)
Arm length (inside): to elbow	to wrist (arm straight)

 Wrist (around)
 Above elbow (around)
 Waist to floor (outside of leg)

Waist to thigh (outside of leg)	to above knee	to below knee
Inseam to floor	to above knee	to below knee

 (Inseam is measured from the crotch; it is used for breeches, trousers, and
tights.)
 Hips ⎫
 Calf ⎬for tight pantaloons
 Ankle⎭
 Stocking foot length (for tights)
 Shoe size.
 The same sort of blank is a necessity in a pageant workshop, where measurements must be taken for many costumes.

MAKING THE COSTUMES

Fitting. The costume, having been cut as nearly as possible to the actor's measurements, must be carefully fitted, once after it has been basted together and again after the stitching has been done, at which time the skirt-hem and sleeve are turned up and the position of fastenings marked.

Lining. Many garments need to be lined. It is often most satisfactory to follow the usual dressmaking method of stitching lining with outside, finishing the raw seams with tape as necessary. Another plan, sometimes followed by rental costumers, has its advantages. In this you lay the outside and the lining right sides together and stitch, section by section. Turn right side out and press flat, then seam the sections together to make the garment. By this method the

raw edges are finished and you can easily alter the size by ripping seams and restitching. The disadvantage is that the seams are likely to be a little bulkier and the lining may pull askew unless you are careful. Suit your method of lining to the type of service you expect of the costume.

Finishing. All seams must be securely stitched and the threads tied (if the ends are not backstitched), to guard against ripping. Except at skirt-hems, machine-stitching should be employed whenever possible, for greater security. It is wise to double-stitch the crotches of breeches or trousers. The objective of inside finishing is security and comfort, not necessarily looks; *e. g.,* if an arm-seam might scratch, it must be bound, if material ravels easily the seams must all be pinked, double-stitched, overcast, or bound. Hooks and loops (usually not eyes) must be sewed on securely, not forgetting the shanks, and sufficient lap allowed so that the joining will not gape open between hooks. Occasionally time is saved by using hook-and-eye tape, but this is difficult to sew neatly by machine, and the hooks are not close enough together for doublets and bodices. Snaps on these garments are risky, for they are likely to pop open at a strenuous gesture. Zipper-fastening, purchasable in various short lengths, is very neat and secure, and the expense is justifiable on valuable and permanent costumes. However, there are, among those who wear the costumes, two schools of thought on zippers. (1) The careful actor is devoted to them and makes record time in dressing because of them. (2) The impetuous actor jerks and stalls the machinery, and lays his missed cue to the newfangled contraption. Trouser-flaps may have hooks and eyes instead of the orthodox buttons and buttonholes, but the hooks must be close together and set on an ample flap. The trouser flap is an especially good place to use a zipper, which here may have a closed end, cheaper than the open-end necessary on doublets and bodices. If you use the zipper, be sure, for security, to sew one hook and eye immediately above the top of the slide.

Trousers, breeches, and tights should always be equipped with suspender-buttons. Tights will wrinkle unless they are held up from the shoulder, and so will the form-fitting pantaloons of the nineteenth century. Even knee-breeches are better off for being " braced." Suspenders give the actor a sense of neatness and security in his unaccustomed garments, very helpful to his comfort in the costume. Should the actor find himself buttonless, he may adopt the old professional trick of twisting six copper cents (or half-pence) along the top of his tights and buttoning his suspenders on them. Hook tight-fitting bodices to the bands of heavy full skirts, or they will part company when the actress raises her arms.

Trimming. From the trimmings appropriate to a period, select those which will show up at a distance. Simple designs are more effective than complicated; braiding is excellent, but fine and intricate braiding is wasted on the audience back of the first row; as a rule embroidery (except the kind made with coarse wool in large stitches) is not worth the time spent, though colorful peasant embroidery is very effective and when donated already made should be grate-

fully received; appliqué takes time but is both effective and durable, therefore worth putting on a costume which is to go into a permanent wardrobe; large buttons, pins, and clasps are excellent details; coarse lace makes a richer appearance than delicate patterned.

DYEING

There are two kinds of aniline dyes to be used by the amateur dyer, those for cotton (vegetable fabric) and those for silk or wool (animal fabric). The latter kind will dye also hair, fur, feathers, and skin. The cotton dyes are set with salt in the dye-bath; the silk-wool dyes are " acid " and can be set with vinegar or acetic acid. Dyes intended for cotton will usually take on silk, but those for silk are as a rule " fugitive " from cotton, *i. e.,* they wash out in the rinsing. But since they are much more brilliant than the salt dyes, it is a temptation to try using them on cotton. When applied with brush or spray to a cotton fabric which has already been dipped in cotton dye they will hold if the material is not rinsed. But since the surplus dye cannot be rinsed off, it tends to *come* off or " crock " and cling tenaciously to the skin of the wearer (an animal substance); it is therefore unsatisfactory to try acid dyes on cotton garments. But for hangings, banners, and parts of costume that require little handling and no contact with the body, they may be used with good effect.

The fifteen-cent package-dyes bought at the drug-store are reliable and include directions for mixing the dyes and preparing the dye-bath; but if any considerable amount of dyeing is to be done, it pays to buy dyes in bulk. Some dye-houses will sell as little as one ounce, others put up no packages smaller than one pound. Any of them will send, on request, either tiny sample packages of dye-powder or color-samples on silk and cotton, with prices.

Dip-dyeing (plunging the whole material into a dye-bath) is the way to color material evenly. Cottons boiled in the dye-bath are fast to washing and do not crock. Silks can also be made fast to washing, even at less than boiling temperature. Uneven effects can be deliberately obtained in dip-dyeing by putting the material in wadded up or twisted.

Spray-dyeing is another method of obtaining a rich, uneven surface which adds depth to the material when seen under lights. Pin the cloth on an upright frame or directly against the wall and spray warm dye on it with a small bug-poison spray.

Painting the dye on with a large brush is the third way to produce a richly varied surface but no pattern; it is quick and easy and especially useful for long-distance effects.

Dye may be applied in *patterns* in three ways:

(1) By tie-dyeing, which can be done by two different processes. In the first, the material is tied on itself, as, for instance, knotting a scarf in the middle and at each of the four corners. This produces only very simple patterns, vague in outline, but it affords the opportunity for pleasant color-combinations, since

the tying may be repeated several times, with successive dippings. The other method permits of cleaner-cut and more intricate patterns; the process is simple:—Protect the parts that are to make the pattern by wrapping a firm string tightly around those areas. Dip the whole piece, tie again and redip in a new color or a stronger solution of the first. This process may be repeated with variations which will suggest themselves. Circles, small and large, can be applied in this way over the whole surface or in a border, and arranged in groups to make diamonds or squares. This is a quick and easy method of converting a plain material into a patterned, especially suited to the dress of semi-barbaric peoples.

(2) By wax-resist or " batik." This process requires a frame on which to stretch the material. Melted paraffin or a combination of paraffin and beeswax is painted on with a small Japanese brush, outlining the pattern which has been drawn on the material (or in the case of a transparent fabric, on paper seen through the material). Within the bounds of the waxed lines dye can be painted without fear of its running. Many colors can be used in this way. When the design has been painted in, all that portion may be covered with wax and the whole piece of cloth dipped in another color for the background. The wax is removed by ironing between blotting-papers or newspapers; if the cloth is still stiff, washing in gasoline or naphtha will take out the remaining wax. While this process is ordinarily lavished on silk, it can be used in a large simple pattern on cotton with good effect and the time spent is not disproportionate.

(3) By stencilling. Dye can be applied through a stencil most safely by means of the spray mentioned above. Thumb-tack the stencil-paper tight to the fabric against a smooth upright surface, such as the wall of the workshop; cover with paper all surfaces adjoining that covered by the stencil. Spray with warm dye; iron while damp with a hot iron to set the color.

Patterns may also be applied to textiles in oil-paints, in metallic paints (radiator paint) mixed with either bronzing liquid (banana oil) or thin glue, or in tempera (show-card colors). These media are appropriate to use on stiff fabrics like unbleached muslin, canvas, paper cambric, and oilcloth. They all tend to stiffen the fabric further. They may be painted on direct, a design having been outlined on the fabric, or applied through a stencil.

RAISED ORNAMENT

Ornaments in the round, applied to flat or rounding stiff surfaces, can be modelled of papier-mâché, a substance made with flour and water paste (or glue) and scraps of paper, thus: Cook the paste till it reaches the boiling-point, stirring constantly to avoid burning. Still stirring, gradually add newspaper torn in pieces as small as a silver dollar, and cook until the whole is a thick mush, when it can be modelled like clay. Dry the relief very thoroughly, preferably in a warm (not really cooking-hot) oven; it will take several days. Then paint, gild, rub with graphite, or whatever you wish. Plastic wood, which

you buy in a can and which dries fast, may be used in place of papier-mâché, but it is more expensive.

COLOR

In each chapter has been indicated the characteristic " palette " or range of colors for the period under discussion. Choice from the palette will be dictated by the mood of the play and by the personalities of its *dramatis personæ*.

Often a scene or an entire play needs to be given a certain " tonality," a unity of color-scheme. This may be obtained so far as the costuming goes by (1) using many tones of a given hue, (2) keeping all the hues on the same level of intensity, (3) having a kind of overtone which binds all the hues together. For example: (1) The costumes might be in tones ranging from cream-color through yellow, orange, flame, to red; or from blue-white through pale blue, cerulean, royal blue, to violet. (2) All colors of the spectrum might be used in the same degree of " lightness " (having an equal amount of white in the pigment); this may result, let us say, in the so-called " pastel " effect. (3) All the costumes of whatever hue might have a top tone of some neutral like light brown or tan. This can be managed by dipping the costumes in a thin dye-bath of the color, or by spraying them with the pale dye. Such a tinting will give the costumes an effect of mellow age, rather like what is known in furniture-painting as " antiquing."

The symbolism of color is, very largely, a matter of personal feeling and will have to be worked out by the costumer to suit his play. A color changes in significance from pleasing to repellent according to the tone used, its relation to other colors on the stage, and the material in which it is displayed. This much may be said: in general red is considered a warm and exciting color, blue a cool and soothing one, yellow neither warm nor cold, but bright. The innumerable variations of these primaries are capable of producing innumerable effects, and as many more are possible as there are color combinations to be made. White and black may be negative or positive, depending on the proportion to other colors and to the background, and on whether they are shown in dull or shiny-surfaced materials. To illustrate:—Black cheesecloth is negative, because its texture absorbs light; black satin is positive, because its surface reflects light. White cheesecloth is negative, like a blank sheet of paper, because it has a dull finish; white satin is positive because its high lights reflect the colors near it, making the whole surface changeable and vivid.

Colors Under Lights. Colored fabrics must be experimented with under the lights in which they are to be seen, for the surprising changes that take place cannot always be foreseen even by the experienced. In general, a colored light enhances its hue already present in a textile and blends with a different hue in accordance with the ordinary rules governing the blending of primaries, *i. e.,* red and yellow make orange, blue and yellow make green, red and blue make purple. However, there are infinite variations due to the impurity of the colors of either textile or lighting-apparatus, so that grayed tones often result, par

ticularly in the play of lights on blues and greens. Amber is especially to be feared for this tendency; it turns blues and most greens into uninteresting gray and purples into drab brown. Some scenic and costume designers who also dictate the lighting eschew amber and for the ordinary daylight scene use a blend of pale straw, pale rose, and pale blue.

The make-up should also be tried out under lights. This is particularly necessary in the case of the blue with which moonlight effects are produced. To give an example:—Six buxom girls, the chorus in "Green Grow the Lilacs," went out before the curtain to sing a sentimental ditty. The order to light them with rose miscarried, the blues were turned on, and the poor girls appeared before the audience with horrible purple shadows in those cheeks which had bloomed with roses in the dressing-room. Warned, they might have powdered heavily over their rouge and thereby displayed only an ethereal pallor.

MAKING UNUSUAL ARTICLES

Armor. Chain-mail is the easiest armor for the amateur to imitate. (See fig. 15, Chap. V, fig. 10, Chap. VI.) If the costume design permits of an over-garment which may be thought of as covering most of the metal, and if it allows the omission of metallic leg-coverings, the effect of mail can be obtained by sewing iron pot-scrapers on the bottom of a stout unbleached muslin tunic, over which will go a garment of richer material. Pot-scrapers enough to cover neck and chin can be sewed on a derby hat-crown treated with graphite (see below), and a helmet results. The linked iron is better than metallic woven cloth which is also sold for pot-cleaning because it is of a more plausible texture and not so shiny; unfortunately it is heavy and requires fortitude in the wearer. Therefore, if the whole body and leg-covering must simulate chain, some knitted substitute should be resorted to. A gray sweater and heavy woolen stockings, the knots highlighted with silver paint, will pass at not too close range; a knitted woolen aviation helmet can be used with it for the head-piece. Costumers can supply effective chain-mail made of narrow gray or brown tape knitted into shirt, leggings, and helmet and touched with metallic paint. Such garments would be tedious to make in the workroom and not very cheap. Agnes Brooks Young (*Stage Costuming;* see bibliography) wisely suggests a substitute in mop-cloth, which is woven tubular and sold by the yard and may be dyed gray and metallized as above.

Armor in the classical styles (cuirass, armguards, and shinguards, see figs. 9 and 10, Chap. III) may be simulated in leather, bought gilded or painted in the workshop; it is not cheap, but beautiful and comfortable. A design may be painted on it in colors or sepia (the latter to suggest relief ornamentation). Armor was sometimes actually made of leather covered with metal disks, rings, or scales (see fig. 11c, Chap. IV). This can be reproduced by making a shirt of brown felt or suede leather, covered with metal washers from the plumber's supplies.

Plate armor is the most difficult to make, but often the only kind suitable (see illustrations in Chaps. III, IV, VI, VII, VIII and IX); the amateur need not be afraid to tackle it. Make the body, arm, and leg-pieces on a foundation of buckram (see *Millinery,* below), stiffened and built up with layers of paper and glue or paste. Shape the buckram to imitate your chosen type and to fit the wearer, allowing it amply large because as it is thickened it draws up tighter. Next determine where the pieces must be fastened together when it is put on, as for instance on the shoulders and under the arms. Sew small rings of metal or bone on tape and stitch this firmly to the inside of the shaped buckram pieces, on corresponding edges. Now stiffen and build out the buckram shell, using layers of newspaper in pieces no larger than two inches square, glued on. (Get flake glue by weight and melt it in the iron glue-pot that you buy for that purpose.) When you have built it up to the desired shape and to a thickness of about a quarter of an inch, cover it with larger pieces of gray charcoal-paper, neatly overlapped and smoothly glued. Into shellac which has been thinned with denatured alcohol, mix some powdered graphite (buy it by weight at the hardware store) and with this paint the paper. When it is dry, burnish with the smooth part of a hammer-head or any smooth piece of metal, and shellac. Lace the pieces together with tape or string, dyed gray.

A *helmet* of any style except the one made of linked iron starts with a skull-cap of cloth. Make it large for the wearer, remembering that it becomes tighter as it is built up. Add ear-flaps if they are required. Make any projecting pieces (brim, neck-guard, or crest) of buckram, sewed on the cap. If a brim is to be curled up, dampen it after you have sewed it on, roll it over a round stick, and dry before you proceed further. Now put the cap on a block. Cover it with paper strips and glue, making the crown of the cap the center and gluing the strips across and across until when you hold the cap up you cannot see light anywhere through it. Cover the projecting buckram pieces also with glued paper, on both surfaces, being sure to carry the paper beyond the line where the brim joins the crown inside. Use the charcoal paper and graphite as explained above. Shellac inside as well as outside of the helmet. If there are to be ornaments on either breastplate or helmet, make them of papier-mâché or plastic wood, as explained above under RAISED ORNAMENT. Put the graphite directly on the relief, and touch the highest spots with a little silver paint, to enhance the high lights. This armor, if it has been carefully fitted in the beginning, is comfortable, light, durable, and looks surprisingly like worn steel. Warning: be sure to store it in a place proof against mice.

Hoop skirts. The hoop skirt described here resembles in plan the patent hoops worn in the 1860's. While actually this light hoop was not in use till the nineteenth century, it is a practical stage device to hold out any bell-shaped skirt, such as has been the fashion in several periods. (See illustrations in Chaps. IX, XII, XIII, XVI, and XVII). The materials are: (1) *Tempered spring steel* (called also " clock wire "), size 016″ x ¼″. This can be ordered

through the local hardware store or purchased directly from steel merchants. It costs about seventy-five cents a pound; five pounds is rather more than enough for six hoop skirts. (2) *Cotton tape* an inch or, better, an inch and a half wide, at from three to five cents a yard; it takes fourteen yards or so to make one hoop skirt.

A skirt for the average-sized person, to be used on an average-sized stage, so that the skirts of the ladies do not take up disproportionate room, measures 109 inches, finished, at the bottom. For this size cut six lengths of wire measuring thus: 111″, 100″, 89″, 78″, 67″, 56″. Have them riveted (nothing else holds) into hoops, lapping one inch at each end. Cover each hoop with the tape, which should be stitched on the machine but first must be carefully basted. Use a piece of the tape for a belt, allowing plenty of length to tie in a bowknot. To this belt attach, at equal distances, nine pieces of tape 38 inches long, thus allowing one inch to turn in at the top and the same at the bottom, giving a finished skirt one yard long. Put the taped belt on the dress-form. Pin the largest hoop to the bottom ends of the tapes and the other five at about six-inch intervals up. If you want a skirt which does not stand out over the hips, omit the top (56″) hoop. It takes more shifting and adjusting than accurate measuring to make the skirt balance nicely. Sew the joinings securely: you will probably have to do it by hand, and if you do, you must use doubled thread, waxed; sew at both top and bottom of the casing, and fasten the threads well, for the strain on these intersections is great.

Once the hoops are balanced properly and sewed firmly to the tapes, this will prove a satisfactory hoop skirt. Steel, when bent, springs back to place; the skirt is light and easy to wear and holds the upper skirts out symmetrically. The hoop must always be worn with its own petticoat of stout muslin as well as the thinner, pretty petticoat and the dress-skirt proper. This hoop skirt may be adjusted in length by shortening the perpendicular tapes, but the width cannot be changed.

<div style="text-align:center">MILLINERY</div>

Materials: (1) Buckram. It can be cut and used stiff, as it comes, overlapping the edges of darts and seams, or moistened and shaped and allowed to dry. Hat-crowns can be made this way, molding them over a block. Buckram softens when painted with dye, tempera, or oils, but not so much when painted with metallic powder mixed with banana oil; painting shrinks it a little; it can be stiffened and toughened with shellac or glue; its raw edges both scratch and fray and should be bound with bias tape; it is successfully sewed by hand or machine only *before* paint or glue has been applied. Often the time saved by buying hat-crowns ready-made is worth the added expense. It is a good idea to save the buckram crowns from old hats to use in costuming.

(2) Wire in varying weights. The covered wire bought at millinery supply houses is usually strong enough to support the brim of a hat. Steel wire one-eighth of an inch thick, sold by the pound, will uphold the heavier structures.

(3) Felt by the yard. It can be cut or blocked into a variety of soft hats. Old felt hats should be collected assiduously, especially those made with crown and brim in one piece. Men's felt hats, though much heavier than women's, can be remade almost as easily. The felt can be dyed (white, light tan, or gray takes any darker shade), reshaped at will on the block and thoroughly dried on it. For tall hats a block can be made of wadded paper, smoothly bound with strips of cloth or tape. A flat-bottomed round can incorporated at the top makes the shape for a high-crowned hat such as those shown in fig. 3, Chap. X, fig. 3, Chap. XI, and figs. 1, 5, and 6, Chap. XIV. The felt must be bound to the mold at the base with a tape of the proper head-measurement; the brim must be shaped, trimmed, and held flat on the table with weights, and ironed while it is damp to make it still flatter. When the hat is dry, it may be shellacked for greater stiffness. A trained milliner can employ other tricks, too complicated for amateurs to undertake unaided.

Save old straw hats, which can often be adapted to a bygone mode, and old derby hats, whose crowns are especially useful as bases for helmets (above) and other close caps.

<div align="center">JEWELRY</div>

Papier-mâché, made as described above, can be modelled into large ornaments such as medallions to hang around the neck, and crowns. The latter should have for a basis a piece of wire screening cut in the desired shape, the medallion needs a disk of cardboard. The papier-mâché, remember, must be thoroughly dried before it is painted or gilded. While it is still soft, imbed in it the ends of a brass chain, if you are making a neck-ornament, or if you plan a crown with inset jewels, make their impression at this point, and later put them in permanently with glue. Plastic wood lends itself to a finer modelling than does papier-mâché, but it is more expensive. With this you can make the "orders" so frequently used in Renaissance costume, and the Egyptian pectoral. Build the design in high relief on a thin wood or cardboard backing. If you feel that this plastic wood jewelry is worth making permanent, you may have it electroplated; this makes it very hard and durable, as well as good-looking. Ordinarily you will just silver or gild the plastic wood.

Humbler materials which yet make effective ornaments are locks, stair-carpet holders, and other household accessories from the hardware store. Be on the alert for likely bits and you will find them, sometimes serving uses very divergent from *your* needs. Jewelry costing even less than hardware can be concocted from glass or wooden beads (the latter dyed any color, gilded or painted), sealing-wax, and even pieces of macaroni cut in short lengths and painted in oils; the last named makes excellent Egyptian necklaces. Colored cellophane can be used to represent jewels set in rings and brooches; white or cream-colored, it is especially plausible representing pearls. Cellophane folded and interlaced in a basket weave can be fashioned into belts or narrow collars representing enamel or faïence (Chap. I). Glass jewels from the ten-

cent store can be placed in new and more appropriate settings or used as they come, if the style is right for your period. You *can* use clear hard candies in place of glass jewels. Advice on the use of " cut " or faceted gems versus " un-cut " stones has been included in the preceding chapters.

DIFFERENCES BETWEEN COSTUMES FOR PAGEANTS AND THOSE FOR DRAMAS

(1) The drama is usually played indoors by artificial light. The pageant is frequently performed outdoors, sometimes in daylight. In daylight, the colors used must be simple, direct, and primitive, with probably a predominance of warm tones (such as red and yellow) to be seen in contrast to blue sky and green foliage. White and clear, light tints such as sky-blue, rose, lemon, orange, and yellow-green are generally pleasing in a sun-flecked sylvan theatre.

(2) The drama is seen at comparatively close range, and texture and finish count for much. Since the pageant is seen at a distance, all that carries is color and general line. Colors on an individual costume should not be complicated; it is usually best to employ not more than two on a costume. Figured materials also should be sparingly used and the figures must be very large and simple. All effective details of silhouette (especially for the principal characters) should be exaggerated: *e. g.,* skirts and trains extra long, hats extra high, sleeves extra large.

(3) The drama deals with individuals and each costume is usually unique, while the pageant deals with groups, often using many people in identical costumes. Variety in pageant costumes comes from masses of color, more than from details of cut.

(4) The drama is frequently played a number of times, and the costumes are made to last for the run and perhaps to be used in subsequent plays. The pageant is played once or twice and the costumes are generally not used again. Pageant costumes can therefore be made of cheap materials, provided they give the suitable effect by their draping quality or their stiffness. This is the place to use cheesecloth for soft flowing grace, and paper cambric or unbleached muslin painted with dyes or oil-paints in large splashes for stiff grandeur. Pageant costumes may be turned out with raw edges and only enough stitching to hold them together: solid, but not elegant. Fine workmanship counts little, good line a great deal; therefore good fitting is still important, especially upon any character who stands out from the group. Strangely enough, incongruous details, for example anachronisms such as wrist-watches and fraternity pins, are very noticeable and as distracting on a pageant stage as behind theatre footlights.

A WORD ABOUT THE COSTUMES AFTER THEY ARE MADE

The actor in either pageant or drama must be comfortable, must feel at home in his costume; it is the costumer's business to see that he is and does.

He must look as well as possible and know it; his hat, collar, shoes must fit him; things that are supposed to fasten must stay fastened, and when they are supposed to come off in one grand gesture they must *come* off. The actress must be able to walk in her skirt and not walk up her train; her décolletage must stay in place, so must her elbow-sleeves.

Several dress rehearsals, or rather " dress-parades," as well as trial wearings in the workshop, are of great help to both maker of costumes and wearer. The costumer must take a notebook to every dress rehearsal and to every performance, too, and never trust to her memory for the hook that must be set over or the hem that must be shortened.

Clothes should be pressed at frequent stages of their making, like real clothes; they must have a good final pressing before performance and be kept pressed for subsequent performances.

Vigilance and attention to details are as much a part of the satisfactory costumer's equipment as is the ability to design.

Suggested Reading List

Dyes and Dyeing—Charles Pellew.
Instructs in all types of dyeing and decorating with dyes. Gives a list of dye manu-facturers.

Stage Costuming—Agnes Brooks Young.
Takes up all phases of the costume workshop and gives useful information on various processes. Has some measured patterns for period garments. The book is much more valuable as a working manual than as a history.

Clothes On and Off the Stage—Helena Chalmers.
Useful for its discussion of modern dress problems applied to the stage and for suggestions on wearing either modern or historic costumes on the stage.

Dramatic Costume—Dabney and Wise.
Good for its discussion of the effect of lights on different colors and fabrics.

Stage Scenery and Lighting—Selden and Sellman.
Useful to the costumer for its study of the effects of light on fabrics.

Dressmaking—Jane Fales.
A practical handbook, of use to costumers as well as to dressmakers.

Community Drama—Playground and Recreation Association.
Useful for its suggestions on the inexpensive costuming of pageants.

Period Patterns—Doris Edson and Lucy Barton.

ADDENDA, 1956

Since this chapter was written the techniques of stage costuming have pro-gressed in many ways, very largely because of new materials on the market, but also because of experience. Hence the following notes.

PATTERNS

Since the 1930's publishers of standard patterns have tended to drop from their books many of those old standby " masquerade " or " fancy dress numbers " mentioned on page 572. In their place they offer even more fanciful designs (labeled " Colonial," etc.) which depart further than ever from the actual dress of the period. It should be noted here that at least one English publisher offers paper patterns to use in dressing well-known characters, historical or fictional. These look as though they would do very well if the costumer employs them with the reservations advised on page 572.

All other considerations aside, recent workshop experience has demonstrated the superiority of patterns "blown-up" (enlarged) from accurately scaled charts. They are as easy to cut from as any commercial pattern and produce costumes with the true period air. Such charts are provided by Köhler and von Sichert (see bibliography) and even more plentifully by Harmand in that admirable book, *Jeanne d'Arc, Ses Costumes, Son Armure*. To blow them up a person needs only the habit of accuracy, a slight acquaintance with mechanical drawing, and the ability to use a ruler marked according to the centigrade system. It takes even less experience in mechanical drawing and just the familiar inch-unit ruler to enlarge the charts in *Period Patterns*. These Doris Edson developed from actual garments. The text accompanying the charts constantly refers to specific illustrations in *this* book, indicating how these costumes may be reproduced. To use *Period Patterns* successfully, a person should read the preface with great care and always follow the advice given therein. The charts in *Period Patterns* begin with the sixteenth century because no garments of an earlier period were available in the United States. Fortunately, any sort of garment needed to dress men throughout the fifteenth century is to be found in Harmand's charts. Many of these can be used for earlier periods. Now it happens that the earlier the century the less complicated the tailoring. Hence for any one of the earlier periods the information under " Practical Reproduc- tion " in the corresponding chapter of this book should enable the costumer to go ahead.

ROUND HOSE, " POINTS " AND UNDERPINNINGS

Recent workshop experience has made habitual two useful procedures in construction that are worth passing on. The first is a sure-fire method for making *smart* round hose. Proceed thus: In place of the scant lining repre- sented in Chart III of *Period Patterns* use a pair of jersey " jockey " shorts in the wearer's size. Split at the center back and insert a *stout* zipper. Adjust the long rectangle of each leg (see chart) to waistline and leg of the shorts, fitting it neatly into the crotch. If over the full outer material you want " panes," fasten a series of finished strips to a strip of cloth and this in turn to the waistband, and catch the lower ends to the shorts around each leg so that they fall in good perpendicular lines. This method works for full breeches of any length once you have the proper jersey underwear foundation.

Sometimes an old way is the best way. The very ancient method of fastening by tying with "points" works admirably in costumes for the modern stage. Tied-in sleeves (pages 188 and 189) allow greater freedom to both men and women in violent scenes. Breeches tied to doublets (page 244) and skirts tied similarly to bodices stay put. No embarrassing gaps under strain.

No matter how authentic the pattern, accurate the cutting or careful the putting together, a garment can still lose all the period chic if the body inside, in its underpinnings, does not conform to the period shape. Never by tucks or darts coerce the garment into following the lines of a modern figure; rather pad out the wearer to meet the period shape. Provide plenty of petticoats to wear under full, gored skirts and *over* hoops. Particularly important always is the treatment of the bust, for one period's matter-of-course may be another's indecency. Some periods have outlined the separated breasts in their natural contours, others molded the bust into a single curve, and still others flattened it almost to nonexistence. You must supply whatever is necessary in underpinnings to achieve the appropriate effect.

ARMOR

Felt. The cheapest way to make armor and raised ornaments is still the buckram-paper-and-glue method described in pages 580–81 and 583. No need to reject it, especially when the budget is slim. However, there are now at hand other materials which, if more expensive, take somewhat less time in the construction and prove more durable. First comes felt, which, when heavily sized and painted, produces bold and effective armor and ornaments, as you can see in photographs of the productions at the Shakespeare Memorial Theatre at Stratford-upon-Avon. A good first-hand account of this working with felt has been given by Douglas Russell.*

Celastic. In the United States is sold a substance called "Celastic," apparently no more expensive here than heavy wool felt is in England. Saturated with its special solution it can be modeled into plate-armor, masks, and all manner of ornaments. Once dried, it becomes hard and tough. It will take paint, graphite in solution, and varnish. It can be pierced to make eyelets for lacing. When hit with a sword or dropped, it gives out a satisfactory noise. Just don't forget that handlers of Celastic-in-solution must work where there is ample ventilation to avoid ill effects from the fumes. Celastic is advertised in theatrical periodicals of the United States and England; directions for use come with the product.

NEW MATERIALS

Pelon. Of all the new products sold in our dress-goods departments none fits into costuming more handily than *Pelon*, a fabric that looks like thin felt and behaves like old-fashioned crinoline or hair-cloth. It stiffens and gives body

* Douglas Russell, "Use of Felt at the Shakespeare Memorial Theatre," *Educational Theatre Journal*, Vol. VII. No. 3. October, 1955. pp. 202–209.

to doublets and their peplums, bodices, puffed sleeves and hat crowns, collars—anything that needs holding out. To a certain extent it stands up under washing and dry-cleaning. Although it should not be expected to take the place of boning in sixteenth or eighteenth century bodices and doublets, it does help keep them smooth.

Nylon Fabrics. Equally valuable to the costumer are the stiff nylons which have developed in time to get made into the great petticoats of recent revival. Of these nylon taffeta is dense, just the thing for great butterfly headdresses and many peasant bonnets. The finer nylon nets are right to sustain a fairy's gossamer skirt, to make ruffles, pleated standing ruffs, and whisks. Finally there is nylon fishnet, the answer to nearly all the problems connected with those elaborate pleated ruffs that are a distinguishing feature of Elizabethan costume. Following the process described (pages 233–34) for making ruffs of tarletan or organdy, you can make a ruff of this new material (single-ply) in half the time. Before pleating you may stitch its outer edge with nylon lace, bias binding, or gold braid. Shrink the neckband before attaching the net; when the ruff is finished, line the band with thin plastic and baste a length of nylon cord where band meets chin, for the net tends to irritate. This fishnet ruff will be stiff and showy. Swished in suds or detergent, rinsed and hung up to dry it will very soon be as good as new.

Other nylon fabrics suggest themselves as substitutes for various silks. Not china silk, of course, for nylon never floats as does the real thing. Nylon's greatest advantages are that it doesn't crush, it dries quickly, it needs no ironing. Nylon silk "army surplus" parachutes have been acquired by many costume workshops; their best contribution is not the "silk," which is divided into maddening cross-wise sections, but the yards and yards of cord, which has innumerable uses. Glue it on armor and jewelry as raised ornament; couch it as embroidery on cloth garments; make lacings and ties of it; make tassels (each cord is composed of many fine cords in a casing). The cord ends need not be turned under if they have been melted in the flame of a match.

Of the older fabrics (pages 573-74) some have vanished, but they have commonly been replaced by others as good. Prices in general have gone up from the 1930's; even so, artificial silks are reasonable and often handsome, and cottons have taken on some of the character of the stiffer silks. Cotton woven with plastic gold or silver threads makes a wonderful showing; so does the kind stamped with gold, silver, or copper. Of the genuine silks, china silk and pongee are still available and still comparatively inexpensive. It is a comfort to dye real silk, for the colors turn out as expected, whereas with the chemist's inventions in the textile field you can never foresee the result, even when the dyes claim to be "all-purpose." Dyeing cotton-and-rayon or wool-and-rayon is particularly chancy, and the behavior of nylon is well-nigh unpredictable.

Osnaberg. Predictability in the dye-pot is only one of the reasons for recommending a homely cotton fabric, so old-fashioned as to be nearly unknown to anyone but the makers of grain-sacks. It is, in the long run, cheaper than anything else and so versatile that on the stage it can clothe either peasant or

king. This is osnaberg (named for the German town of its origin), woven originally of flax, later of cotton. Coarse, loose-twisted threads in a loose weave make it a good sacking, closer-woven than burlap and not so wiry. The advertising lists of Colonial merchants are strewn with mention of osnaberg (Oznabrigs, Ozenbrig, Ozzenbrigg, etc.). Our ancestors made coats, breeches, and gowns of it, and so can we. It comes sometimes very wide—more than seventy-two inches. In the wash and especially in boiling dye, it shrinks a good deal, becoming in the process closer-textured but also much softer. Softened still further by vigorous rubbing between the hands, it acquires the texture and draping qualities of home-woven wool. Starting out as pale grayish tan, it can be dyed in full rich hues of the color-wheel, especially beautiful on the warm side. It may be stenciled with textile paint or, if you are careful, with dye. Nowadays retail stores do not often carry osnaberg, but it can be purchased in wholesale quantities, usually through agricultural supply houses. Considering the multitudinous uses of osnaberg, a bolt of it is a good investment for any workshop that makes many costumes in the course of a year.

New fabrics appear every season. You must be alert to take advantage of their special properties. In costuming, the name of a fabric is unimportant; what counts is how it will look on the stage.

MORE BOOKS

The ADDITIONAL BIBLIOGRAPHY page (592) is full up, but there are a few more books to which the reader's attention should be called:

Waugh, Norah, *Corsets and Crinolines* (London, B. T. Batsford, Ltd., 1954). A thoroughly useful book, for it features accurately scaled patterns of corsets and scaled drawings of many types of skirt-distenders. Dresses fitted over underpinnings made from these charts acquire the chic proper for their periods. The corsets prove surprisingly comfortable, even for singers.

Cunnington, C. Willett and Phillis Cunnington, *English Women's Clothing of the Present Century* (London, Faber and Faber, n.d.). This book carries on from Mr. Cunnington's earlier volume on the nineteenth century (see ADDITIONAL BIBLIOGRAPHY, p. 592) in the same thorough style. Designers of American plays set in the New Century will note that although women's styles on both sides of the ocean followed the same main trends, English and American women themselves looked somewhat different in their clothes. It is therefore advisable to consult also the publications of the United States when costuming a play located in a city or (especially) a small town of America.

Cunnington, C. Willett and Phillis Cunnington, *A Handbook of English Mediaeval Costume, A Handbook of English Costume in the Sixteenth Century,* (both books, London, Faber and Faber, n.d.). Small reference books in the form of glossaries illustrated with line-drawings. Handy to use in connection with reproductions of the well-known sources from which these drawings were made.

Laver, James (editor), *Costume of the Western World* (London, Harper's, 1951). Essays by specialists on the costumes of France, England, Spain and the Netherlands from the later fifteenth century through the early seventeenth. Illustrated with excellent reproductions, most of them in color, or originals not often reproduced in costume books. A superior reference book.

Davenport, Milia, *A Book of Costume,* 2 vols. (New York, Crown Publishers, 1948).

With a wealth of pictures, this work covers the progress of dress from Ancient Meso-potamia to Europe-America of the 1860s. The reproductions (in black and white with a few in color) are taken from a great variety of interesting sources and accompanied by short but pertinent paragraphs of identification and comments. Division by national-ities within each period makes some confusion at first glance, but proves helpful. A short introductory 'essay precedes each division. Encyclopedic in scope, this book is best used with others like Mr. Laver's (above) which have superior colored reproductions of many of the same originals.

The decades of the twentieth century following the First World War, even the nineteen-forties, have become "'. period " and young theatre workers are asking what were the " costumes " worn in those remote days. The Cunnington book listed above is at the moment the only thorough record of changing fashions during those decades. However, material is readily available in most libraries, if not right at home, in all sorts of periodicals: women's magazines, theatre monthlies, weekly news magazines, and the picture sections of Sunday papers. Not to be overlooked are the mail-order catalogues of Sears, Roebuck, Montgomery Ward and others, which are often better guides to the dress of the average American woman than are the slick fashion magazines with their stylized costume sketches. In all the above publications, advertisements are as informative as any other part of the magazine. Finally, among important sources should be mentioned paper patterns, which home dressmakers are prone to hoard from year to year.

BIBLIOGRAPHY

ADDITIONAL BIBLIOGRAPHY

Since 1934 a few books have appeared which should be called to the reader's attention. These listed below stand out beyond the average as contributing something definitely new and important to the fast-increasing bibliography of costume.

BIBLIOGRAPHICAL

Hiller, Hilaire, and Myer Hiler (compilers), *A Bibliography of Costume* (New York: The H. W. Wilson Company, 1939). Editors: Helen Grant Cushion and Adah V. Morris. " A dictionary catalogue of about 8000 books and periodicals." Latest and by far the most comprehensive work of its kind. The cross-indexing is particularly complete and useful.

COSTUME CONSTRUCTION

Hicks, Ami Mali, *Color in Action* (New York: Funk and Wagnalls, 1937). A theory of color; discussion of the application of dye by various techniques; of textiles on the stage; of color on the stage.

ELIZABETHAN

Kelly, Francis M., *Shakespearian Costume for the Stage and Screen* (London: A. and C. Black, 1938). Like Mr. Kelly's other books, reliable and well illustrated; also practical.

NEW CENTURY

Laver, James, *Taste and Fashion From the French Revolution Until Today* (New York: Dodd, Mead & Company, 1938). Although good for the entire century, the book should be especially welcome for its discussion of dress from 1914 up to 1935. The author's philosophy is thought-provoking. The American reader will see how far, especially since 1900, middle-income women in the United States diverge in their taste and in their dress vocabulary from women with parallel spending power in England.

NINETEENTH CENTURY

Cunnington, Cecil Willett, *English Women's Dress in the Nineteenth Century* (London: Faber and Faber, 1937). The authoritative book for its period, especially in England. Year-by-year record in picture and text. Completely documented.

PATTERNS

Edson, Doris and Barton, Lucy, *Period Patterns* (Boston: Walter H. Baker Company, 1942). By means of detailed but clear and uncomplicated diagrams, helpfully labeled, it is shown how to construct representative costumes for men and women (and sometimes children) of each period up to 1914.

ROMAN

Wilson, Lillian M., *The Clothing of the Ancient Romans* (Baltimore: the Johns Hopkins Press, 1938). By the author of *The Roman Toga*. Discusses all types of dress, including the toga. Reconstructions, directions for making and wearing.

UNIFORMS

Kredel, Fritz (illustrations) and Frederick P. Todd (text), *Soldiers of the American Army*, 1775–1941 (New York: H. Bittner and Company, 1941). Foreword by Oliver L. Spaulding, chief of the historical section, Army War College. Full color plates, enlarged details, explanatory text. An expensive book for libraries.

BIBLIOGRAPHY

(This list includes (1) all books cited in the text, (2) some established works on costume not recommended at the end of any chapter, but to be found in most city or university libraries, and (3) a few publications which were examined too late to be included in the body of the book.)

Abrahams, Ethel B.—*Greek Dress.* John Murray, London, 1908.
Allemagne, Henri René d'—*Les Accessoires du Costume et du Mobilier.* 2 vols. Schmit, Paris, 1928.
Army and Navy of the United States, The—Wm. Walton, Boston, 1889–1895.
Ashdown, Mrs. Charles—*British Costume During Nineteen Centuries.* Stokes, New York, 1910.
Assyrische Plastik—Orbis Pictus, band 19. Ernest Wasmuth, Berlin.

Beck, W. S.—*Gloves, Their Annals and Associations.* Hamilton Adams and Company, London, 1883.
Bieber, Margarete—*Greichische Kleidung.* Walter de Gruyter and Co., Berlin, 1928.
Bieber, Margarete—*Entwicklungsgeschichte der Greichischen Tracht.* Mann, Berlin, 1934.
Blum, André—*Histoire du Costume.* Les Modes au XVII et XVIII siècles. Paris, 1928.
Blum, André—*Histoire du Costume.* Les Modes au XIXième siècle. Paris, 1930.
Boehn, Max von—*Menschen und Moden in Mittelalter.* F. Bruckman, Munich, 1925.
Boehn, Max von—*Menschen und Moden in Sechzehnten Jahrhundert.* Munich, 1923.
Translated as *Modes and Manners.* 2 vols. Vol. 1, *Decline of the Ancient World to the Renaissance.* Vol. 2, *The Sixteenth Century,* by Joan Joshua. C. H. Harrup, London, 1933.
Boehn, Max von, and Fischel—*Menschen und Moden in Achtzehnten Jahrhundert.* F. Bruckman, Munich, 1909.
Boehn, Max von, and Fischel—*Menschen und Moden in Neunzehnten Jahrhundert.* F. Bruckman, Munich, 1907.
Translated as *Modes and Manners in the Nineteenth Century.* 3 vols. Vol. 1, 1790–1817. Vol. 2, 1818–1842. Vol. 3, 1843–1878, supplementary volume, *Ornaments.* M. Edwardes. J. M. Dent, London, 1909.
Bossert, Helmut von—*Alt Kreta.* Ernest Wasmuth, Berlin, 1923.
Breasted, James Henry—*A History of Egypt.* Scribner's, New York, 1905.
Britannica, Encyclopedia, 14th Edition.
British Museum Handbook—A guide to the Exhibition Illustrating Greek and Roman Life. London, 1920.
Brooke, Iris and Laver, James—*English Children's Costume.* A. & C. Black, London, 1930.
Brooke, Iris and Laver, James—*English Costume of the Nineteenth Century.* A. & C. Black, London, 1929.
Brown, Henry Collins—*New York in the Elegant Eighties.* The Valentine Company, New York, 1927.
Brown, Henry Collins—*The Golden Nineties.* The Valentine Company, New York, 1928.
Buchot, Henri—*L'Epopée au Costume Militaire Français.* Paris, 1899.

Buchot, Henri—*Le Luxe Français*, vol. 1, *L'Empire*, vol. 2, *La Restauration*. Paris, 1892–1893.
Budge, E. A. Wallis—*Osiris and the Egyptian Resurrection*. 2 vols. Warner, London, 1911.
Bullfinch, Thomas—*The Age of Fable*. Henry Allen, Philadelphia, 1897; revised by W. H. Knapp. Frederick Stokes, New York, 1934.
Burnett, Frances Hodgson—*Little Lord Fauntleroy*. Scribner's, New York and London, 1886.

Calthrop, Dion Clayton—*English Costume*. A. & C. Black, London, 1923.
Calthrop, Dion Clayton—*Dress From Victoria to George V*. Chapman and Hall, London, 1934.
Challamel, J. B.—*History of France*. Translated by Mrs. Cashel Hoey and John Lillie, London, 1862.
Chalmers, Helena—*Clothes On and Off the Stage*. Appleton, New York, 1928.
Clinch, George—*English Costume*. The Antiquary's Books, London, 1909.
Cutts, E. L.—*Scenes and Characters of the Middle Ages*. Daniel O'Connor, London, 1872.

Dabney, Edith and Wise, C. M.—*A Book of Dramatic Costume*. F. S. Crofts, New York, 1930.
Davis, Wm. Stearns—*Life on a Mediæval Barony*. Harper's, New York, 1923.
Davis, Wm. Stearns—*Life in Elizabethan Days*. Harper's, New York, 1930.
Dearmer, Percy—*The Ornaments of the Ministers*. Mowbray, London, 1920.
Diehl, Ch.—*Manuel d'Art Byzantin*. Auguste Picard, Paris, 1925.
Dolman, John, Jr.—*The Art of Play Production*. Harper's, New York, 1928.
Druitt, Herbert—*Manual of Costume as Illustrated by Monumental Brasses*. London, 1906.
Du Maurier, George L. P. B.—*English Society*. New York, 1897.

Earle, Alice Morse—*Two Centuries of Costume in America*. Scribner's, New York, 1894.
Enlart, Camille—*Manuel d'Archæologie Française*. Tome III, Le Costume. Auguste Picard, Paris, 1916.
Etoffes et Tapisseries Coptes. H. Ernest, editeur, Paris.
Evans, Sir Arthur—*The Palace of Minos at Knossos*. Macmillan, London, 1821–'30.
Evans, Lady Maria—*Chapters on Greek Dress*. Macmillan, London, 1893.
Evelyn, Sir John—*Diary*, 1641–1705 (any edition).

Fairholt, F. W.—*Costume in England*. Vol. 1, *History*, vol. 2, *Glossary*. G. Bell and Sons, London, 1890.
Fairholt, F. W.—*Satirical Songs and Poems on Costume: Thirteenth to Nineteenth Centuries* (1849). Percy Society, v. 27.
Fales, Jane—*Dressmaking*. Scribner's, New York, 1917.
Fishbach, Friedrich—*The Principal Weaving Ornaments up to the Nineteenth Century*. Wiesbaden, 1901.
Frazer, Sir James—*The Golden Bough*. 3rd edition. 12 vols. Macmillan, London, 1911–1926.
Frénilly, Baron de—*Memoirs*. Heineman, London, 1909.

Gallerie des Modes et Costumes Français. 1778–1787. Extraits de l'Art Pour Tous (see Periodical List).
Galpin, F. W.—*Old English Instruments of Music*. Antiquary's Books. Methuen, London, 1910.

Gay, Victor—*Glossaire Archæologique.* 2 vols., du Moyen Age et de la Renaissance. Société Bibliographique, Paris, 1887–1928.

Gayley, Charles Mills—*Classic Myths.* Ginn and Co., Boston, 1893.

Goddard, Eunice Rathbone—*Women's Costumes in French Texts of the Eleventh and Twelfth Centuries.* Johns Hopkins Press, Baltimore, 1927.

Grand-Carteret—*Les Elégances de la Toilette,* 1780–1825. Paris (1911?).

Greville, Fulke—*Memoirs.* Longmans, Green & Co., London, 1874. Later Edition, Longmans, Green & Co., 1904–'11.

Gummere, A. M.—*The Quaker, a Study in Costume.* Ferris and Leach, Philadelphia, 1901.

Hall, H. R.—*Ægean Archæology.* P. L. Warner, London, 1915.

Hamlin, A. D. F.—*History of Ornament.* Century, New York, 1916–'23.

Harmand, Adrien—*Jeanne d'Arc, ses Costumes, son Armure.* Leroux, Paris, 1929.

Harrison, George Bagshawe—*An Elizabethan Journal* (1591–1594). Constable, London, 1933.

Hartley, Dorothy—*Mediæval Costume and Life.* Scribner's, New York, 1931.

Hauthal, Ferdinand—*Geschichte der sächsischen Armee.* Leipsig, 1859.

Haycraft, Frank W.—*The Degrees and Hoods of the World's Universities and Colleges.* (2nd edition.) London, 1924.

Hefner-Alteneck, I. H. von—*Trachten, Kunstwerke, und Gerätschaften des 17 und 18 Jahrhunderts.* Heinrich Keller, Frankfurt-a-M., 1889.

Hewitt, John—*Ancient Armour and Weapons.* Oxford, 1855–'60.

Heuzey, Léon—*Histoire du Costume Antique.* Libraire Ancien Honoré Champion, Paris, 1922.

Heuzey, Léon—*Le Costume Oriental dans l'Antiquité.* Gazette des Beaux Arts, Paris, 1922 (see Periodical List).

Hope, Thomas—*Costume of the Ancients.* Chatto, London, 1875.

Hope, W. H. St. John—*Heraldry for Craftsmen and Designers.* Pitman, London, 1913.

Hottenroth, Friedrich—*Trachten der Völker.* Stuttgart, 1884.

Houston, Mary G. and Hornblower, Florence—*Ancient Egyptian, Assyrian, and Persian Costume.* A. and C. Black, London, 1920.

Houston, Mary G.—*Ancient Greek, Roman, and Byzantine Dress.* A. and C. Black, London, 1931.

Huard, John—*A History of the Dress of the British Soldier.* London, 1852.

Hughes, Talbot—*Dress Design.* Macmillan, New York, 1913.

Jastrow, Morris—*The Civilization of Babylonia and Assyria.* Lippincott, New York, 1915.

Jones, Inigo—*Designs for Masques and Plays at Court.* Walpole Society publication, 12th Annual Volume (Masques). Oxford University Press, 1924.

Jones, Owen—*Grammar of Ornament.* Day and Son, London, 1856.

Kelly, F. M.—"Shaksperian Dress Notes." *Burlington Magazine,* June, December, September, 1916 (see Periodical List).

Kelly, F. M.—"Historic or 'Period' Costume, with Special Reference to the works of Shakspere." An article in *Robes of Thespis,* edited by Rupert Mason and George Sheringham. E. Benn, London, 1928.

Kelly, Francis M. and Schwabe, Randolph—*Historic Costume.* Scribner's, New York, 1925.

Kelly, Francis M. and Schwabe, Randolph—*A Short History of Costume and Armour.* Botsford, London, 1931.

596 HISTORIC COSTUME FOR THE STAGE

King, L. W.—*Bronze Reliefs from the Gates of Shalmanezer.* British Museum, London, 1915.
Köhler, Carl and von Sichert, Emma—*A History of Costume.* Translated by Alexander K. Dallas. George G. Harrup, London, 1928.

La Croix, Paul—*L'Armée Depuis le Moyen Age jusqu'au Révolution.* Paris, 1889.
La Croix, Paul—*Histoire de la Chassure.* Paris, 1852.
La Croix, Paul—*Costume Historique de la France d'Aprés des Monuments les plus Authentiques.* 8 vols. Paris, 1860.
Lang, Andrew—*Aucassin and Nicolete.* D. Nutt, London, 1896.
Layard, A. H.—*Monuments of Nineveh.* J. Murray, London, 1849.

Mahaffy, J. P.—*Social Life in Greece.* London, 1877.
Mariette, A. Edouard—*Abydos.* Paris, 1869–'80.
Mason, R. and Sheringham, G. —*Robes of Thespis.* E. Benn, London, 1928.
Maillot, J.—*Recherches sur les Costumes, etc. des Peuples d l'Ancien Continent.* Partie II, Asie. 3 vols. Paris, 1809.
McClellan, Elizabeth—*Historic Dress in America.* 2 vols. G. W. Jacobson, Philadelphia, 1904.
McQuoid, Percy—*Four Hundred Years of Children's Costume.* London, 1923.
Metropolitan Museum Hand-book—"The Daily Life of the Greeks and Romans"—"Hand-book of the Classical Collection," Gisella M. Richter. New York, 1917.
Metropolitan Museum Hand-book—"The American Wing." R. T. H. Halsey and Charles O. Cornelius. New York, 1926.
Moffat, James—*The Bible* (translated). Doran, New York, 1924.
Morse, H. K.—*Elizabethan Pageantry.* The Studio Publications, Inc., New York, 1934.

Nainfa, J. A.—*Costume of Roman Prelates of the Catholic Church.* Baltimore, 1909.
Norris, Herbert—*Costume and Fashion.* 2 vols. Dent, London, Dutton, New York, 1924.

Pellew, Charles—*Dyes and Dyeing.* McBride, New York, 1918.
Pepys, Samuel—*Diary* (1600–1669). Any Edition.
Perrot, Georges and Chipiez, C.—*A History of Art* in 10 volumes: Egypt, Judea, Chaldea, Assyria, Persia, Ancient Greece. Hachette, Paris, 1882–1894. Translated in 1883 and published by Chapman and Hall, London.
Petrie, Flinders—*The Arts and Crafts of Ancient Egypt.* London, 1909.
Picard, Auguste—*L'Armée en France et a l'Etranger.* Tours, 1897.
Piton, Camille—*Le Costume Civile en France du XIIIe au XIXième Siècle.* Paris, 1913.
Place, Victor—*Ninève et Assyrie.* Paris, 1867–'70.
Planché, James R.—*Cyclopedia of Costume.* Chatto and Windus, London, 1876.
Playground and Recreation Association—*Community Drama.* Century, New York, 1926.
Price, Julius M.—*Dame Fashion.* Scribner's, New York, 1913.

Quennell, Marjorie—*History of Everyday Things in England.* Botsford, London, 1918.
Quennell, Marjorie and C. H. B.—*A History of Everyday Things in England, The Age of Production*—1851–1934. Scribner's, New York, 1935.
Quennell, Marjorie and C. H. B.—*Everyday Life in Homeric Greece.* G. P. Putnam, New York and London, 1930.
Quicherat, Jules E. J.—*Histoire du Costume en France.* Paris, 1875.

Racinet, A. C. A.—*Le Costume Historique.* 6 vols. Paris, 1888.
Redfern, W. B.—"Royal and Historic Gloves and Shoes." *Connoisseur*, Nov., 1927 (see Periodical List).

Rock, Rev. Daniel—*The Church of Our Fathers.* 4 vols. (1849–1854) Edition by Murray, London, 1905.
Rogers, Agnes, and Lewis, F. A.—*The American Procession.* Harper's, New York, 1933.

Sarre, Friedrich—*Die Kunst des Alten Persien.* Bruno Cassires, Berlin, 1922.
Schaefer und Andrae—*Die Kunst des Alten Orients.* Berlin, 1925.
Schmitz, Herman—*Encyclopedia of Furniture.* McBride, New York, 1926.
Schultz, Alwin—*Hofische Leben um Mittelalter.* 2 vols. Munich, 1903.
Schwabe, Randolph—"Fashion Plates." *Print Collectors' Quarterly,* April, 1934 (see Periodical List).
Selden, Samuel and Sellmann, Hunton D.—*Stage Scenery and Lighting.* F. S. Crofts, New York, 1930.
Shakspere's England—Articles on Costume by Percy McQuoid and Percy Simpson. Oxford University Press, 1917.
Smith, Sir William—*Dictionary of the Bible.* John Murray, London, 1893.
Speltz, Alexander and Spiers, R. Phené—*The Styles of Ornaments.* Botsford, London, 1910.
Stone, George Cameron—*A Glossary of the Construction, Decoration, and Use of Armor, in All Countries and in All Times.* The Southworth Press, Portland, Maine, 1934.
Strutt, Joseph—*Dress and Habits of the People of England.* 2 vols. Henry G. Bohn, edition of 1842.
Sturgis, Russell—*A Dictionary of Architecture and Building.* Macmillan, New York, 1901–'02.
Sullivan, Mark—*Our Times, 1900 to 1914.* Vol. I, *The Turn of the Century;* vol. II, *America Finding Herself;* vol. III, *Prewar America;* vol. IV, *The War Begins* (1909–1914). Scribner's, New York, 1927–1932.
Svinin, Paul—*Picturesque United States of America, 1811, 1812, 1813.* Edited by Avrahm Yarmolinsky. Wm. Edward Rudge, New York, 1930.

Temple Bible. J. M. Dent & Co., London, MCMIII.
Tilke, Max von—*Oriental Costumes, their Design and Colors.* Ernest Wasmuth, Berlin, 1923.
Tissot, J. J.—*The Old Testament.* Brunoff, Paris, 1904.
Towne, Charles Hanson—*This New York of Mine.* Cosmopolitan Book Corporation, New York, 1931.
Traill, H. D.—*Social England.* 6 vols. New York, 1901–1904.
Tyack, George—*Historic Dress of the Clergy.* London, 1897.

Uzanne, Octave—*Fashion in Paris.* Heineman, London, 1908.

Vecellio, Cesare—*Degli Abiti Antichi e Moderne* (1590). Translated as *Costumes Ancien et Moderne.* 2 vols. Paris, 1859.
Victoria and Albert Museum Handbook—*A Guide to the Collection of Costumes.* London, 1924.
Victoria and Albert Museum Handbook—*Catalogue of English Ecclesiastical Embroideries.* London, Wyman and Sons, 1907.
Victoria and Albert Museum Handbook—*A Catalogue of Rubbings of Brasses.* London, 1929.

Warwick, Edward and Pitz, Henry C.—*Early American Costume.* Century, New York, 1929.

Webb, W. M.—*The Heritage of Dress.* L. G. Richards, London, 1907.
Weiss, Hermann—*Kostumkunde.* 3 vols. Stüttgart, 1872–1883.
Wilson, Lillian—*The Roman Toga.* The Johns Hopkins Press, Baltimore, 1924.
Worth, J. P.—*A Century of Fashion.* Boston, 1928.

Young, Agnes Brookes—*Stage Costuming.* Macmillan, New York, 1927.

PERIODICALS

(The periodicals selected for this list, some of which are cited as containing sources for the illustrations, are represented by at least one number in one or more libraries in the United States or Canada.)

American Magazine (1876–	New York
Antiquarian, The (1923–	New York
Art and Archæology (1914–	Washington
Art et la Mode; Revue de l'Elegance (1880–	Paris
l'Art Pour Tout (1861–1906)	Paris
Belle Assemblée, la (1806–1810)	London
Bon Ton, le and le Moniteur de la Mode (1853–	Paris and New York
Bon Ton, le (1833–	Paris
Burlington Magazine (1903–	London
Connoisseur, The (1901. In 1927 merged with the *International Studio*)	London
Court Magazine and Monthly Critic (1832–	London
Delineator, The (1873–	New York
Gallery of Fashion (1794–1802)	London
Gazette des Beaux Arts (1859–	Paris
Gazettes des Salons, Journals des Dames et des Modes, (1797–1838)	Paris
Gentleman's Magazine, The (of Fashions, Fancy Costume, and Regimentals of the Army) (May, 1828–December, 1894)	London
Godey's Lady's Book (or *Godey's Magazine*) (1830–1898)	Philadelphia
Good Housekeeping (1885–	New York
Graham Magazine (1841–1858)	Philadelphia
Harper's New Monthly Magazine (1850–	New York
Harper's Weekly (1857–1916)	New York
Harper's Bazar (1867–	New York
l'Illustration (1843–	Paris
Illustrated London News (1842–	London
International Studio (1897– (after 1927 with *The Connoisseur*)	New York
Journal des Dames (1817–1819)	London
Journal des Dames et des Demoiselles (1833–1891)	Brussels and Paris
Journal fur Literatur, Kunst, Luxus, und Moden (1786–1827)	Weimar
Journal du grande Monde, le (monthly) (1867–1869)	London
Judge (1881–	New York

Ladies' Cabinet of Fashion, Music, and Romance (1832–1838) London
Lady's Companion (1833–1844) New York
Lady's Home Journal (1883– Philadelphia
Lady's Magazine, The (1749–1753) London
Ladies' Museum (1798–1806) London
Lady's Pocket Magazine (1824–1840) London
Ladies' Tailor (1884– New York
Life (1883– London
London Repository (Ackerman's) (1809–1815) London
London Society (1862–1898) London
London Tailor and Record of Fashion (1876–1914) London

Magazin des Demoiselles (1851–1888) Paris
Magazin des Modes (1851–1858) Paris
McCall's (1870– New York
Monde Elégant, le or *The World of Fashion* (1824–1891) London
Mode Illustrée, la (1869–1873) London
Moniteur de la Mode, le (1843–1903[?]) Paris
Munsey's (1889– New York

National Geographic Magazine (1889– Washington

Peterson's Magazine (1840–1898) Philadelphia
Petit Courier des Dames (1836–1868) Paris
Print Collector's Quarterly (1911– London and New York
Puck (1877–1918) New York
Punch (1841– London

Revue de l'Art (1897– Paris

Sargent's New Monthly Magazine of Literature, Fashion, and
the Fine Arts (1843) New York
Sartorial Art Journal and American Tailor and Cutter (1874– New York
Saturday Evening Post (1821– Philadelphia
St. Nicholas (1873– New York
Scribner's (1870– (Until 1877 this was the *Century*) New York
Scéne, la. Revue des Succés Dramatiques (1877–1881) Paris
Simplicissimus (1896– Munich
Société de l'Histoire du Costume, bulletins (1907–1911, continued as *Costumes et Uniformes*, bulletins from April,
1907–December, 1913) Paris
Studio, The (1893– London

Vogue (1892– New York

Woman's Home Companion (1873– (From 1873–1895 known
as the *Ladies' Home Companion*) Springfield, Ohio

Zeitschrift fur Historische Waffen und Kostumkunde. Organ
des Vereins fur Historische Waffenkunde (1892– Dresden

Zeitung fur die elegante Welt (1801–1857[?]) Leipsig

INDEX